BLL
(N13461-)

10⁰⁰
CPG

12⁵⁰
0006

THE PELICAN HISTORY OF ART

EDITED BY NIKOLAUS PEVSNER

Z9

SCULPTURE IN BRITAIN: THE MIDDLE AGES

LAWRENCE STONE

LAWRENCE STONE

SCULPTURE IN BRITAIN
THE MIDDLE AGES

PUBLISHED BY PENGUIN BOOKS

Penguin Books Ltd, Harmondsworth, Middlesex
Penguin Books Inc., Baltimore, Maryland, U.S.A.
Penguin Books Pty Ltd, Mitcham, Victoria, Australia
Penguin Books (Canada) Ltd, Montreal, Canada
Penguin Books (S.A.) Pty Ltd, Cape Town, South Africa

★

Text printed by R. & R. Clark Ltd, Edinburgh
Plates printed by Lund Humphries & Co Ltd, Bradford
Made and printed in Great Britain

★

TO

M.J.S.

★

CONTENTS

Part One

Pre-Conquest Sculpture

Part Two

Romanesque Sculpture

Part Three

Thirteenth-Century Sculpture

CONTENTS

Part Four

Sculpture of the Decorated Period

Part Five

Late Medieval Sculpture

The Plates

LIST OF FIGURES

LIST OF PLATES

1 (A) Stone slab. Height *c.* 4 in. Burghead, Moray-shire. Middle or late seventh century. *British Museum, London* (Trustees of the British Museum)

(B) Head of whetstone. Sutton Hoo, Suffolk. Early seventh century. *British Museum, London* (Trustees of the British Museum)

2 Stone cross-shaft. Ruthwell, Dumfries. Last quarter of the seventh century (Warburg Institute)

3 Stone cross-shaft. Ruthwell, Dumfries. Last quarter of the seventh century (Warburg Institute)

4 (A) Stone cross-shaft. Bewcastle, Cumberland. End of seventh century (Dr O. G. S. Crawford)

(B) Stone panel. Jedburgh, Roxburghshire. Last quarter of the seventh century (B. T. Bats-ford Ltd)

5 The Franks Casket, whalebone. Length 9 in. End of the seventh century. *British Museum, London* (Trustees of the British Museum)

6 (A) Stone cross-shaft. Aberlady, Haddington-shire. Early eighth century (Dr O. G. S. Crawford)

(B) Stone cross-shaft. Saint Andrew Auckland, Co. Durham. Mid eighth century (The late Miss E. Senior)

(C) Stone cross-shaft. Saint Andrew Auckland, Co. Durham. Mid eighth century (The late Will F. Taylor)

7 The Ardagh Chalice, silver. Early eighth century. *National Museum of Ireland, Dublin* (National Museum, Dublin)

8 (A) Stone cross-shaft. Brompton-in-Allerton, Yorks, N.R. Mid eighth century (L. Stone)

(B) The Brunswick Casket, ivory. Height 5 in. Mid ninth century. *Herzog-Anton-Ulrich Museum, Brunswick* (Trustees of the British Museum)

9 (A) Stone cross-shaft. Rothbury, Northumber-land. Early ninth century. *Blackgate Museum, Newcastle-on-Tyne, Northumberland* (Univer-sity of Edinburgh)

(B) The Ormside Bowl (detail), silver. Early ninth century. *Yorkshire Museum, York* (Trustees of the British Museum)

10 (A) Fragment of stone cross-shaft. Height 14 in. Reculver, Kent. First half of the ninth century. *Canterbury Cathedral Crypt* (Dr O. G. S. Crawford)

(B) Fragment of stone cross-shaft. Height 2 ft 11 in. Croft, Yorks, N.R. Early ninth cen-tury (Trustees of the British Museum)

11 Stone cross-shaft. Height *c.* 4 ft. Codford Saint Peter, Wilts. First quarter of the ninth cen-tury (L. Stone)

12 Fragment of stone cross-shaft. Easby, Yorks, N.R. Early ninth century. *Victoria and Albert Museum, London* (Victoria and Albert Museum. Crown Copyright)

13 Fragment of stone cross-shaft. Easby, Yorks, N.R. Early ninth century. *Victoria and Albert Museum, London* (Victoria and Albert Museum. Crown Copyright)

14 (A) Stone frieze. Breedon-on-the-Hill, Leics. First half of the ninth century (N.B.R.)

(B) Stone panel. Height *c.* 2 ft. Breedon-on-the-Hill, Leics. First half of the ninth century (Sir Thomas Kendrick)

15 Stone panel. Castor, Northants. Mid ninth cen-tury (Dr G. Zarnecki)

16 (A) Stone grave-slab. Melsonby, Yorks, N.R. Mid ninth century (L. Stone)

(B) Stone grave-slab. Melsonby, Yorks, N.R. Mid ninth century (Sir Thomas Kendrick)

(C) Stone cross-shaft. St Alkmund, Derby. Mid ninth century (Miss Mary B. Routh)

17 (A) Stone cross-shaft. Colerne, Wilts. Third quarter of the ninth century (B. T. Batsford Ltd)

(B) Stone cross-shaft, re-used as font. Melbury Bubb, Dorset. Tenth century (L. Stone)

18 (A) Stone cross-shaft. Sockburn, Co. Durham. Mid or late tenth century (B. T. Batsford Ltd)

(B) Bone clasp. Diameter *c.* 2½ in. The Thames, London. Second half of tenth century. *British Museum, London* (Trustees of the British Museum)

(C) Stone grave-slab. Levisham, Yorks, N.R. End of tenth century (L. Stone)

19 (A) Stone cross. Height 14 ft 6 in. Gosforth, Cumberland. *c.* 1000 (Trustees of the British Museum)

(B) Stone 'cross of Muiredach'. Monasterboice, Louth. First quarter of tenth century (Miss Françoise Henry)

ABBREVIATIONS

Ant.	*Antiquity*
Antiq. Jnl	*Antiquaries Journal*
Archaeol.	*Archaeologia*
Archaeol. Jnl	*Archaeological Journal*
Art Bull.	*Art Bulletin*
Birmingham Archaeol. Soc. Trans	*Birmingham Archaeological Society, Transactions*
Bodl.	Bodleian Library, Oxford
Brit. Archaeol. Assn Jnl	*British Archaeological Association Journal*
Brit. Mus.	British Museum, London
Burl. Mag.	*Burlington Magazine*
Crossley	F. H. Crossley. *English Church Monuments, 1150–1550* (London, 1921)
Evans	J. Evans. *English Art, 1307–1461* (Oxford, 1949)
Jnl Warb. Court. Insts	*Journal of the Warburg and Courtauld Institutes*
Kendrick, I	T. D. Kendrick. *Anglo-Saxon Art to A.D. 900* (London, 1938)
Kendrick, II	T. D. Kendrick. *Late Saxon and Viking Art* (London, 1949)
Millar, I	E. G. Millar. *English Illuminated Manuscripts of the Xth to the XIIIth Century* (Paris and Brussels, 1925)
Millar, II	E. G. Millar. *English Illuminated Manuscripts of the XIVth and XVth Centuries* (Paris and Brussels, 1928)
N.B.R.	National Buildings Record
New Pal Soc.	New Palaeographical Society
P. and G.	E. S. Prior and A. Gardner. *An Account of Medieval Figure-Sculpture in England* (Cambridge, 1912)
Proc. Brit. Acad.	*Proceedings of the British Academy*
Proc. Soc. Antiq. Lond.	*Proceedings of the Society of Antiquaries of London*
R.C.H.M.	*Royal Commission on Historical Monuments*
Salzman	L. F. Salzman. *Building in England down to 1540* (Oxford, 1952)
Saxl	F. Saxl. *English Sculptures of the Twelfth Century* (London, 1954)
Stothard	C. A. Stothard. *The Monumental Effigies of Great Britain* (London, 1817)
V. & A.	Victoria and Albert Museum, London
V.C.H.	*Victoria County History*
Wal. Soc.	Walpole Society

ACKNOWLEDGEMENTS

No student of English medieval sculpture can fail to pay his respects to the monumental pioneer work of Professor E. S. Prior and Mr Arthur Gardner. For forty years their survey of the whole field has provided the reference point from which all subsequent research has begun. If my own dates, interpretations, and arrangements seem often to diverge widely from those adopted in that earlier work, my debt to this massive synthesis is nevertheless very great and is one which I would wish to acknowledge.

To Sir Thomas Kendrick, who carefully nursed and fostered my interest in medieval sculpture, I owe more than can adequately be said. Of the many friends acquired in the course of writing this book, Dr George Zarnecki has been the closest and the most valuable. By reading his books, by frequent conversations, and by his great generosity in allowing me to make use of his unpublished D.Phil. thesis, I have learnt most of what little I know of the Romanesque period. Among the many who have helped me on points of detail are Professor T. S. R. Boase, Professor E. M. Carus-Wilson, Mr R. P. Howgrave-Graham, Professor Ernest Jacob, Miss Rosalind Hill, Miss Kathleen Major, Mr Rupert Bruce-Mitford, Mr H. D. Molesworth, Dr Otto Pächt, and Mr Lawrence Tanner. I am very grateful to Mrs Parry of the National Buildings Record for her unfailing helpfulness and courtesy over a long period. I am also grateful to Mr A. Austin for the skill and patience he has exercised in processing my photographs.

Ecclesiastical authorities all over the country have allowed me to photograph and reproduce sculpture in their care, and museums have been equally free with their material. I must also thank Major S. V. Christie-Miller for allowing me to reproduce the Clarendon head. Photographs from the Royal Commission on Historical Monuments are reproduced by permission of the Controller of H.M. Stationery Office.

The following individuals and institutions were so generous as to put certain photographs freely at my disposal: Mr P. B. Chatwin, Mr Arthur Gardner, Mr W. L. Hildburgh, Mr C. H. Hunter Blair, Sir Thomas Kendrick, Mr H. D. Molesworth, Miss Mary B. Routh, Dr G. Zarnecki, the British Council, the University of Glasgow, the Courtauld Institute, the Warburg Institute, the Society of Antiquaries, the National Museum of Dublin, the Pierpont Morgan Library, the National Gallery of Art in Washington, and the Riksantikvariatet in Oslo. All the brasses were specially drawn by Mr Donald Bell-Scott.

Lastly I must thank my wife. In the interests of photography, she has carried heavy ladders and hot lamps into many hundreds of churches; she has sketched and made notes; she has typed and retyped increasingly illegible manuscripts, and she has criticized both sense and style. The book owes much to her.

L. S.

INTRODUCTION

THE task of the historian of English medieval sculpture is not unlike that of the palaeonto-logist, who from a jawbone, two vertebrae, a rib, and a femur contrives to reconstruct the skeleton of some long extinct creature and endow it with flesh. He even makes deductions about its environment and feeding habits, its success against its enemies, and its adaptability to changing circumstances. No less bold inferences from incomplete evidence – but based on far less scientific methods – are forced upon the student of medieval sculpture. For it is important to bear in mind that the sculptural losses far exceed those of architecture and are equalled only by those of mural paintings and glass. Two brief but violent periods of iconoclastic fervour have left behind them only a minute fraction of the sculpture with which every church was filled on the eve of the Reformation.

The first serious damage was done by the dissolution of the monasteries, in which was concentrated so much of the artistic wealth of the Middle Ages. Considerable deliberate destruction was carried out by the royal agents who accepted the surrenders. 'I have defaced the chapel inward', wrote London to Thomas Cromwell of the Grey Friars, Reading, in 1536. Subsequently the roofs were stripped of lead for immediate sale abroad, and the structures frequently abandoned to the depredations of local builders.[1] In conse-quence much of the internal and external statuary, the brasses and the tombs, was soon broken up or melted down, used as building material, or merely left to crumble away by exposure to the elements. Propaganda against the worship of images began in the 1530s and the more popular cult images were then removed, but it was not till 1547 that a deliberate iconoclastic programme was set afoot with the issue of orders against 'monu-ments of Idolatry, Superstition and Hypocrisy'. There ensued the wholesale removal from rood screens all over the country of the figures of Christ crucified, Mary, and John. At Queens' College, Cambridge, the accounts for October 1547 record: 'georgio smythe pro labore suo in sacello quum Imagines et tabula auferebantur vii*d*.'[2] The order for the indis-criminate removal of all images was issued on 21 February 1548, and by 1550 whole ship-loads of religious statuary were being exported to France.[3] The process was checked and even reversed during the short reign of Mary, and in places, for example Ashburton in Devon, the rood and its images were re-erected.[4]

But the respite was short-lived. The accession of Elizabeth in 1558 witnessed a fresh outbreak of iconoclasm enforced by Royal Visitors, and in the evening of 24 August 1559 Londoners were entertained by two great bonfires of wooden rood images from Saint Paul's and elsewhere.[5] The pressure was kept up by the more zealous bishops and was only partially checked by a Royal proclamation in 1560 designed to save the memorial effigies of the nobility.[6] In this same year occurs the melancholy entry in the accounts of Eton College: 'To Glover and his Laborer for two daies brekinge downe Images and filling there places with stone and plaister juxta xxd. – iij[s] iiij[d].'[7]

By 1640 the growth of puritanism and the deteriorating political situation made it likely that a fresh iconoclastic outbreak was imminent. Galvanized by this threat Sir William

Dugdale hired an heraldic artist to tour the country and make drawings of tombs, inscriptions, and glass.[8] He was just in time. In the summer of 1642 civil war broke out, and in the first few months bodies of puritan troops led by fanatical officers carried out unauthorized destruction of images in many cathedrals. On 26 August 1642 Colonel Sandys led his men into Canterbury Cathedral where '... were demolished that day ... many Idolls of stone, thirteen representing Christ and his twelve Apostles standing over the West doore of the Quire ...; and twelve mytred Saints sate aloft over the West doore of the Quire, which were all cast doune headlong and some fell on their heads and their Myters brake their necks.'[9]

In December Sir William Waller carried out similar destruction at Winchester and then at Exeter, where 'They strook off the heads of all the Statues on all the Monuments of the Church, especially they defaced the Bishops Tombs.'[10] After these examples of private enterprise came regulated and more systematic devastation. On 26 August 1643, an ordinance of the Lords and Commons decreed that 'all Crucifixes, Crosses, and all Images and Pictures of any one or more Persons of the Trinity, or of the Virgin Mary, and all other Images and Pictures of Saints ... shalbe taken away and defaced.'[11] Under this ordinance the notorious William Dowsing was appointed Visitor of East Anglian churches, and it is his diary that provides the most illuminating evidence of the extraordinary wealth of medieval art that had still survived.[12] In erratic bursts of activity during the winter of 1643–4 Dowsing ranged over Suffolk and Cambridgeshire smashing and hammering at all windows and images that he could reach. Equally energetic was his deputy, Francis Jessup of Beccles. At Gorleston 'we broke twelve apostles carved in wood, and cherubim, and a lamb with a cross.... We did deface the font.' Not content with this he ordered the removal of images of Moses and Aaron and eighteen angels and cherubim from the roof, and noted in conclusion 'I gave orders to break in pieces the carved work, which I have seen done.'[13]

While the Restoration put a stop to this deliberate destruction, the indifference to medieval art of the late seventeenth and eighteenth centuries continued the process of attrition. Sir Christopher Wren allowed his masons to destroy much of the external imagery at Westminster Abbey, an eighteenth-century landowner pulled down Shobdon Church and re-erected some of the remains as a triumphal arch in his park. Interest in medieval antiquities was stimulated by the Gothic Revival, and the religious enthusiasm of the Victorian era resulted in a fresh attack upon sculpture by well-intentioned restorers. Sheer destruction by the Victorians was mostly confined to architecture, but all too frequently sculpture was ruthlessly recut or replaced by new stone, the wall spandrels of Worcester choir and the carvings of the chapter houses of York and Salisbury being notorious examples of this treatment.

The result of the destruction of well over ninety per cent of English medieval religious imagery is to make it all but impossible to reconstruct the work of individual artists and gravely to distort our vision of the past. If emphasis is laid to-day upon the monumental effigy as the characteristic product of the English medieval sculptor, it is because this country has seen several periods of iconoclastic fanaticism but hardly ever a time when the nobility and gentry lost the ability to protect the memorials of their ancestors.

The only serious losses of tombs occurred when the monasteries were stripped and

demolished in the late 1530s and 40s. In particular there vanished a great many important monuments of the previous half-century, when burial in religious houses seems to have become extremely common among the nobility.[14] The extraordinary social stability of this country's history coupled with a series of religious upheavals is in complete contrast with the doctrinal conservatism and social revolution which has characterized modern French history. In consequence only a handful of French effigies and brasses have survived with which to compare the almost unbroken series of such monuments in England. 'Ignorance', Lytton Strachey once observed, 'is the first requisite of the historian – ignorance which simplifies and clarifies, which selects and omits with a placid perfection unattainable by the highest art.' But the ignorance imposed on the historian of English medieval sculpture by the chance and unrepresentative survival of so tiny a proportion of the full output is one which confuses rather than clarifies, creates doubt and bewilderment rather than assurance.

Nor is this all. The most serious disservice to scholarship of the nineteenth-century restorer was his unremitting and all too successful efforts to remove from sculpture and architecture all traces of medieval paint. The evidence of the restorers themselves and coloured prints of the pre-Victorian period prove conclusively that there had survived into the nineteenth century a great deal of that colour without which no medieval carving was complete. The present-day appearance of the bare stone would have filled sculptors and patrons with despair, and this loss of surface paint irreparably distorts our vision of medieval art. There is plenty of evidence to prove that in the Middle Ages nearly as much money was spent on the painting of sculpture as upon its carving. In 1403 Winchester College paid exactly the same to the painter as the sculptor of the images for its rood screen. In 1449 John Massingham was paid £9 6s 8d for carving an image of the Virgin for the high altar of Eton Church, and Robert Hickling £6 13s 4d for painting it. In 1512 the churchwarden of Yatton, Somerset, paid no less than £19 10s to John Wakelyn 'for peynting and gylding of ye church'.[15] The evidence is overwhelming that tombs and effigies, images, and capitals, carved wall surfaces, and even the external statuary of church fronts were all liberally covered with paint and gilding. This love of colour permeated all fields of medieval art and is one of the fundamental differences that separates that period from to-day.

★

Although in the early Middle Ages some clerics achieved fame in metalwork and other minor arts, at no time, so far as we know, was the sculptor in stone any other than a professional layman.[16] At first he was merely one of the members of the masons' yard, who might be asked to turn his hand to anything from the dressing of a wall to the carving of a tympanum. Indeed this lack of specialization persisted throughout the Middle Ages and beyond, so that when Wadham College was being built in 1612–13 the same John Blackshaw both carved the statues of the King and the Founders and built the barrel vault of the kitchen.[17] But by the mid thirteenth century there had emerged a limited number of men given the distinctive title of 'Imaginator' or 'Imageur', the first of them being John of Saint Albans, the King's Imager in 1268. Henceforward the growing demand for religious

statuary and monumental effigies imposed further specialization and a concentration of production in fixed workshops. The owners of such workshops were probably as much contractors and business men as practising craftsmen, and by the last half of the fifteenth century some of them achieved considerable wealth and status, holding important municipal offices such as Mayor of York or Nottingham. But these are the exceptions, and from the documentary evidence it is clear how modest were the rewards obtained for his labours by the medieval carver. Research during the past half-century has exploded the theory that medieval artists were anonymous creatures, passive agents of the contemporary *Weltanschauung* without a will or a style of their own. We now know the names of a considerable number of late medieval sculptors, but their humble social background prevents us exploring the details of their careers. Poor and often illiterate, hardly any were of the class that engaged in lawsuits, bought and sold land, and made wills. The aristocrats of medieval art were the painter, the carpenter, and the master-mason or architect. Henry Yevele was a prosperous and educated man, accustomed to associating with a great patron like William of Wykeham; his career shows the respect with which the successful architect was regarded and the substantial rewards which could be acquired by the exercise of his profession.

In France one or two of the court sculptors like Jean de Liège contrived a comfortable middle-class existence, but the majority, even the greatest like Claus Sluter, rarely seem to have emerged from a somewhat precarious hand-to-mouth bohemianism. The explanation seems to lie in the attitude of the public towards the sculptor, who was regarded as little more than a skilled executant. At all times in the Middle Ages the carver turned to manuscripts for ideas and designs, and as late as the early sixteenth century there is evidence that the original sketch or 'patron' was often the work of a painter and not of the sculptor himself. There was consequently some justification for regarding the sculptor as a mere technician whose products could be handled just like those of a bricklayer or stonemason. For the most revealing evidence of the contemporary attitude to sculpture is the manner in which the artist was paid: by the foot. In about 1515 an estimate was drawn up of the cost of embellishing with statuary the chapel of King's College, Cambridge. The estimate allowed for two images 8 feet high, two 6 feet high and forty-eight 3 feet high, in all 'clxxii foote. At vs the fote esteamed in workmanshipp which amounteth unto xliijli.'[18] When payment was by the individual item, the reward was equally modest. At Exeter at the beginning of the fourteenth century the main bosses for the choir vaults cost 5s each and the long corbels with their elaborate foliage carving 8s 6d.[19] In 1253 two statues, almost certainly the figures in the chapter-house at Westminster Abbey (Plate 97), cost a mere 53s 4d the pair, or about the same as the 5s a foot of the King's College chapel estimate two and a half centuries later.[20] When the sculptor was paid by the day, as sometimes happened, the scale was rarely more than double that of the semi-skilled mason layer. In 1330 Master Thomas of Canterbury was getting 1s a day for making designs and moulds for repairs at Westminster, and in 1352 Master Edmund Canon was paid 1s 6d a day for his work on the stalls of Saint Stephen's Chapel.[21] Even the fashionable sculptor John Massingham received only 4s 8d a week plus board and lodging when working at All Souls in 1438–42.[22] Sufficient accounts have thus survived to prove conclusively that however he was paid, the income of the medieval sculptor was both erratic and modest. It is only as a result of fresh

thinking at the time of the Renaissance about the role of the artist in society that the great sculptor from Michelangelo to Sir Jacob Epstein has been granted the social distinction and financial rewards commensurate with his deserts.

*

The history of English medieval sculpture is essentially the story of the reaction to a flow of stylistic influences from outside. Despite the persistence of these recurring tides, there is hardly a moment at which English sculpture is indistinguishable from continental. Some English sculpture of the late eleventh and early twelfth centuries is almost identical with contemporary work in Normandy. At the end of the thirteenth and beginning of the fourteenth century very close contacts with French art give rise to occasional works in an international style. And in the late fifteenth and early sixteenth centuries some figure sculpture is very much the same as contemporary work in the Low Countries, for the simple reason that a number of Flemish sculptors were employed in England. With these exceptions, however, there is hardly a single piece of sculpture in the nine hundred years from 650 to 1540 which, if its provenance were unknown, might reasonably be ascribed to a foreign country.

It is evident therefore that there must have been certain insular characteristics which imposed themselves upon these influences from abroad. Two of these persist with extraordinary tenacity right through the Middle Ages, of which the first is a strong sense of dynamism and of movement. English figures are taller and more slender than those abroad, the drapery tends to be handled in a restless agitated manner, and poses and gestures are abrupt and often violently distorted. These generalizations hold true of mid thirteenth-century statuary of Wells and Westminster, early fourteenth-century monumental effigies and brasses, mid fourteenth-century statuary of Exeter western screen and so down to the weepers of the early sixteenth-century tomb at Fawsley, Northants. The continuity of tradition is so extraordinary as to suggest some innate aesthetic tendency on the part of the English sculptor. This may well be so, but the source from which the tradition sprang and from which it was periodically refreshed was unquestionably the Anglo-Saxon manuscript style of the late tenth and early eleventh centuries. Treasured in every important library in the country, these manuscripts with their vivid and dramatic illustrations made a deep and lasting impression on English medieval art in all its branches. This quality of movement is in the strongest contrast with French medieval art but has certain affinities with that of Germany. There, however, the rhythm is three-dimensional and the movement one of volume; and the emotional expressionism of German art is quite foreign to the interpretation of feeling by symbolic line and gesture that was favoured by the English artists.

For the second persistent feature of English medieval sculpture was the tendency to linear abstraction and rhythmic pattern, which again and again triumphed over more naturalistic styles imported from the Continent. The pagan Saxons of the fifth and sixth centuries reduced the bust of the Emperor on late Roman coins to a disjoined pattern of hand, helmet, and ribbon interlace.[23] Both Vikings and Anglo-Saxons of the eleventh century treated the human body in an arbitrary and schematic manner (Plates 18B and

22B). In the twelfth century, the dependence of sculptors for their designs upon the manuscript illuminator led to the predominance of linear patterning even in mature and accomplished works like the Lincoln frieze or the Malmesbury tympana (Plates 53 and 61A). At the same time the predominance of geometrical ornament, of chevron, beakheads, interlacing arcades, and other motifs in architectural decoration is further evidence of the persistence of the same love of pattern. At the end of the twelfth century, French foliate crocket capitals were almost immediately transformed into the rhythmic stylizations of the stiff-leaf (Plates 74A and 75A). Mid thirteenth-century figure sculpture retained a system of hard repetitive lines in its draperies that is very different from the softer French manner (Plate 97). In the fourteenth century, the dominance of the sinuous ogee curve over all forms of sculpture was a remarkable and entirely insular phenomenon which once again sacrificed naturalism and expression to the needs of essentially linear pattern. Even as late as the sixteenth century the same process may be observed in the manner in which the midlands alabaster tomb-makers reduced and abstracted the exuberant pilaster design introduced by the Renaissance.[24]

Occasionally brilliantly successful, as in the evolution of stiff-leaf foliage, this pattern-making and abstracting tendency brought with it one very serious disadvantage. It tended to be conceived in linear rather than three-dimensional terms, and as a result the full exploitation of the plastic qualities of sculpture in stone was delayed until the sixteenth century and the carving of the prophets in Henry VII's chapel (Plates 189 and 190). Before this only the effigy-maker had partly understood the possibilities of modelling in the round. In the main the English medieval imager was content with relief sculpture, or with the statue set well within its niche and regarded primarily as architectural surface ornament. To say that the medieval English artist never understood the true purpose of sculpture would be going too far, but certain deep-seated traditions severely restricted his view. His was an art circumscribed by somewhat narrow limits; but within these limits his resource and genius, inventiveness and power were certainly equal to those of his fellow-craftsmen in other countries. Though hemmed in by steep banks, the stream ran deep and fast.

PART ONE
PRE-CONQUEST SCULPTURE

CHAPTER I
THE NORTHUMBRIAN RENAISSANCE
⟨CIRCA 670–770⟩

THE history of English Dark Age sculpture does not begin tentatively, with small, clumsy experiments from which were slowly evolved a style, a technique, and an artistic tradition. On the contrary, the first works with which we are confronted are in scale, in conception, and in artistic composition, some of the most impressive that this country produced throughout the whole early medieval period. In the late seventh and early eighth centuries, remote Northumbria witnessed the sudden intellectual and artistic flowering that produced in scholarship the Venerable Bede, in manuscript illumination the Lindisfarne Gospels, and in sculpture the group of monumental works of which the most outstanding examples are the two great high crosses at Ruthwell and Bewcastle. It is no exaggeration to say that these two are the most remarkable sculptural achievements of Dark Age Europe.

Few subjects lend themselves less easily to sweeping generalizations than art history – and few are more frequently subjected to this treatment. Nevertheless all the available evidence seems to indicate that artistic or cultural pre-eminence tends to be the outcome not of the fruition of a single tradition developing in isolation, but of the clash and consequent synthesis of two or more rival artistic or cultural strains. Certainly the seventh-century Northumbrian Renaissance can only be explained in such terms.

To understand why the wild uplands of Northumbria, on the extreme limits of a small and backward island poised on the remote confines of the known world, should have been the scene of such remarkable achievements, it is necessary to examine the historical background. The pattern of the Roman Empire was gradually dissolving under the repeated impact of barbarian and Arab invasion. Civilization was everywhere contracting and crumbling. In Northumbria, on the other hand, under the leadership of three able and vigorous monarchs, relative peace and security reigned for nearly a century. But political and social peace merely created the conditions that made artistic development possible. For its inspiration, it is necessary to look elsewhere, to the spiritual and cultural influences associated with the advent of Christianity. Seventh-century England was subject to the rival persuasions of two main Christian centres, Ireland and Rome. In the period subsequent to the collapse of Roman Britain, Christianity first took refuge from the pagan invaders in the midlands and the south-west, where it may possibly have been at the back of the enamel-workers' craft of the 'hanging-bowls', which with their Celtic spiraliform

7

designs are so frequently to be found in the graves of the invaders. Later, this British Christian tradition was driven back still further to the wilds of Cornwall, Wales, and Strathclyde, where it survived, obstinate and irreconcilable, as an insular spiritual influence now far removed from all associations with Rome, and without any visible artistic manifestations. Meanwhile Ireland had developed as the main centre of Celtic Christianity. Organized in ascetic monastic communities, the Irish monks were almost alone in western Europe of the sixth century in keeping alive the flame of Christian teaching and missionary activity. In the middle of the century, Irish monks under Columba began to spread their influence back to western Scotland and by 635 they had established a great centre of missionary activity on the little isle of Lindisfarne off the Northumbrian coast.

In the meantime the second main stream of Christian influence, that from Rome, had already penetrated to north-west Europe. In 597 the mission of Saint Augustine had landed in Kent. There the missionaries had found an opulent pagan society, centred around the court of King Ethelbert, in close contact with its Frankish and already Christian neighbours, and with a very highly developed artistic tradition in jewellery and metal-work. For while the Anglo-Saxons of the fifth century had arrived on these shores with a lower level of material equipment and artistic skill than any invader for the previous thousand years, by the seventh century the court craftsmen of Kent and East Anglia were producing jewellery of a technical perfection and intrinsic beauty that was pre-eminent in Europe at the time. After partial success in the task of converting the Kentish king and aristocracy, in the 620s a mission pushed on up to the kingdom of Northumbria, now at the height of its power under a great military leader. Flattering letters and presents from the Pope, the skilful co-operation of the pagan high priest, and proof of the military efficacy of the new religion in a series of victories, succeeded in achieving the ostensible conversion of the kingdom.

The next thirty years therefore witnessed the struggle of the two Christian traditions, Irish and Roman, for the soul of Northumbria. At last in 663 it became clear that the dual claims of the two missionary bodies were incompatible, and that a clear solution one way or the other was essential. Under the chairmanship of King Oswiu, a Synod was therefore held at Whitby to decide the issue, the Roman party being represented by the worldly aristocrat Wilfrid, and the Irish by the saintly ascetic Colman. On the one side was the insularity and the unworldliness of the Irish, on the other the continental Roman influences and the practical political activity in support of the State. Artistically, the two traditions also clashed: on the one hand the barbaric linear patterns and close-knit decorative techniques of the Celts, and on the other the whole humanistic tradition of Rome and the Mediterranean. By the decision of King Oswiu, the Roman party gained a nominal victory, and it is in the light of this that the crosses of Ruthwell and Bewcastle must be interpreted.

By the time of the Synod, Northumbria had successfully evolved a christianized synthesis of the various artistic activities that the Irish mission had discovered on its arrival in England.[1] There can be no doubt that the Book of Durrow with its interlace and its spirals, its schematic abstractions and its garish colours, represents the artistic tradition adopted by the Irish mission in Northumbria, and may be taken as reflecting the tastes of both the

Irish clergy and the Anglo-Saxon laity of that area. It is this permanent, popular art against which the naturalism of the Mediterranean was destined to win only spasmodic and temporary victories.

Into this linear and balanced synthesis of Anglo-Saxon designs in the new medium of the manuscript, the Roman missionaries introduced a third stylistic tradition and a third medium – the humanistic tradition of Rome and the medium of sculpture in stone. Between the departure of the Roman legions and the arrival of the Roman missionaries, the technique of stone sculpture seems almost totally to have disappeared. But in the Pictish areas there have survived 'symbol stones' of obviously pagan significance and therefore of pre-Columban date, from which it would seem that the powerful abstract animal drawing of the Book of Durrow was derived. A slab from Burghead, Morayshire (Plate 1A), bears an incised bull whose stylistic details are almost exactly reproduced in some animal drawings of the manuscript. The little round eye consisting of a ring, the inner line running underneath the body and curling upwards in three spirals to emphasize the limb joints, the bold and confident outline drawing all demonstrate an intimate connexion between the two works of art in their different media.[2]

Carving in wood was undoubtedly undertaken by the pagan Saxons in the south, but of this nothing has survived. The only known example of what this sculpture may have resembled is to be found in the human masks carved on the so-called 'ceremonial whetstone' from the mid seventh-century royal burial at Sutton Hoo (Plate 1B). This mysterious object appears to have been one of the symbols of royalty, perhaps of Redwald's Bretwaldaship, its significance lying in the role of the king as the master of the swords of his war-band. It is a strictly non-functional object equipped at either end with scarlet knobs and metal saucers whose purpose is obscure. Whetstones with crude heads at either end are fairly common in the Celtic areas of the west and north, but this grim, accomplished piece of paganism with its triangular stylization is most nearly akin to the Swedish elements in the *cloisonné* jewellery of the burial. The burial itself probably took place about 655, but the whetstone is most likely to have been an heirloom and may well date back to the beginning of the century.[3] This sole surviving piece of pre-Christian sculpture can have contributed nothing to the astonishing monumental crosses inspired by the Roman mission, the first of which was erected a bare twenty years later than the Sutton Hoo burial. The difference between the two is the measure of the importance of the victory of the Roman party at the Synod of Whitby in 663 and of the arrival of Archbishop Theodore in 669.

<center>*</center>

The late seventh century sees the opening of a new phase of sculpture in England, the principal characteristics of which were to last until the Norman Conquest. In the first place, sculpture is almost completely divorced from the normally associated art of architecture. Whereas throughout the whole of the subsequent medieval period sculpture appears in the main as an adjunct and adornment to the architectural triumphs of cloister, church, and cathedral, in this phase of the Anglo-Saxon period the sculptor developed his craft virtually without reference to the architect. His works were confined almost entirely to the ornamentation of the standing cross, a type of monument that was quite unknown

<center>9</center>

on the continent of Europe. At first they acted as symbols of Christianity and centres for preaching before the construction of churches. As a contemporary put it: 'It is the custom of the Saxon race that on many estates of nobles and of good men they are wont to have, not a church, but the standard of the Holy Cross dedicated to our Lord, and reverenced with great honour, lifted up on high.'⁴ In the late Anglo-Saxon period, however, these crosses must have been principally sepulchral monuments marking the grave of some nobleman, thegn, or cleric.

But whatever their purpose their construction orientated around the two dominant elements in contemporary society, the monastery and the nobility. It was the former that provided the workmen, the models, and the inspiration, the latter whose piety or pride found expression in the payment of the costs involved. Thus there was once an imposing late seventh-century cross at Glastonbury with the names of kings inscribed upon it, while that at Bewcastle appears to commemorate the name of Alcfrith, the Northumbrian prince. At the same time it was from monastic centres such as Lindisfarne or Hexham, York or Ripon, that artistic activity spread out over the neighbouring countryside. All Anglo-Saxon sculpture may thus be regarded as a product of this union of the cultural leadership of the Christian monastery with the aristocratic nature of the society that surrounded it.

The high cross itself is certainly a native form of monument, the adaptation by the Saxons and then by Christianity of the ancient menhir cult of the Celts. The Roman missionaries, with characteristic tact and adaptability, took over this insular form and made it a vehicle for their propagandist activity. The familiar rough-hewn pillar of wood or stone suddenly became adorned with elaborate sculpture, the main inspiration for which must be sought in contemporary works in the eastern Mediterranean provinces of the Byzantine Empire. Nor is the possibility of influence from such a far-off quarter by any means as unlikely as it might at first sight appear. The driving force behind the intellectual and spiritual renaissance of this post-Whitby period was Theodore, the Archbishop of Canterbury, himself a native of Tarsus in Cilicia, who had studied in Greece. Italy and Western Europe were full of workmen, scholars, and clergy fleeing from the iconoclasm and intolerance consequent upon the Moslem conquests in the Near-East. Levantine influence was strongly felt at Ravenna and at Rome, and from thence was passed on to Northumbria. Benedict Biscop, the builder of Monkwearmouth and Jarrow, and Wilfrid, the founder of Hexham and Ripon, both made several trips to Italy, returning each time laden with pictures, *objets d'art*, and books, and occasionally accompanied by foreign craftsmen.⁵

The most outstanding example of this Mediterranean influence least affected by local tastes is to be found in the first of the great crosses, that at Ruthwell in Dumfriesshire.⁶ This is a fifteen-foot red sandstone monolith, squared and tapering, on the front and back of which are depicted a series of figure-subjects within rectangular panels whose edges bear explanatory inscriptions in Roman lettering and runes. In view of the success of Rome at the Whitby Synod and of the Mediterranean character of the style, it would be reasonable to expect the themes chosen for the cross to emphasize the intellectual and the doctrinal aspects of this victory over Irish Christianity. In fact, however, it is the individualistic ascetic monasticism of the Irish which is extolled. The major scenes all refer to

the desert and to the monastic recluse. Saint John the Baptist represents the ascetic in the wilderness, as does the unusual scene of Saints Paul and Anthony in the desert sharing the bread miraculously brought to them by the raven. Of the two major themes of back and front, one is that of Mary Magdalene wiping Christ's feet, again a symbol of the contemplative life in contrast to the worldly activity of Martha (Plate 2). The other, the dominant scene of the whole cross, is a great full-length figure of Christ being worshipped by the beasts in the desert (Plate 3). An attempt was thus made – only to be abandoned almost at once – to substitute a theme of peaceful worship for the more familiar story of the hero or the gods in combat with the dragon of Evil such as is described in the late seventh- or eighth-century Northumbrian poem of *Beowulf*. Even bolder was the attempt to depict on a public monument – admittedly in a subordinate position – the scene of the Crucifixion. To a primitive people brought up on traditions where might and worldly success are the main criteria of morality, the Crucifixion is a bewildering example of shame and degradation. Only a society with a fairly highly developed moral and intellectual background can appreciate the implications of the Passion, and, as we shall see, only in the cultivated atmosphere of the immediate pre-Conquest period, and again in the thirteenth century and beyond, did the Church venture to use the Crucifixion as a central theme on great didactic works of art exposed to the public gaze. At Ruthwell the Crucifixion is present, but hidden away on the bottom panel of the back face of the cross and transformed into a pagan contest by the contemporary explanatory poem carved in runes upon the shaft:

> Heroic, fair,
> This young knight who was God made bare
> His breast..
> He climbed the gallows and gave
> No second thought, being brave and sure.[7]

The sides are covered with full-length vine-scrolls inhabited by birds and beasts busily engaged in pecking at the fruit, another example of which motif, probably by the same sculptor, is to be found on a slab from Jedburgh (Plate 4B). This theme, which was later to lend itself to such ferocious interpretations, is here treated with frivolous gaiety. The birds and animals, though largely of fantastic anatomy, are friendly pet-like creatures and adapt themselves gracefully to the rolling sinuosities of the vine-scroll.

There is nothing whatever on this cross that has been borrowed from the northern repertoire of pattern, ribbon-style animals, trumpet-spirals, frets, and interlace, which are so prominent in the pages of the Lindisfarne Gospels. The inspiration is wholly southern. This does not mean, however, that the cross is of foreign workmanship. Intensive search for Mediterranean originals has revealed nothing, either in vine-scroll ornament or in figure sculpture, with which Ruthwell can be directly paralleled. The iconography probably comes from some small piece of ivory or metal rather than a manuscript, but there is no known contemporary parallel to Christ and Mary Magdalene, or to Christ towering over two identical animals. And while the inhabited vine-scroll finds its nearest analogy in sixth-century Coptic work, the playful ferocity and the fanciful anatomy of the birds and beasts, the curious type of flower with its double fan effect, and the great emphasis laid upon the spiral framework of the vine-stem itself are all three singular and undoubtedly

English adaptations.[8] It is remarkable how different is all near-eastern sculpture of this period. Coptic work from Egypt has a harsh jagged silhouette treatment that is quite unlike the soft contours and curving lines of the Ruthwell sculpture. Nor does Coptic work ever attempt anything but small-scale, miniature pieces to which the life-size monumental dignity of Ruthwell provides a striking contrast. Other parallels are to be found in Syrian work such as the mosaics in the Dome of the Rock at Jerusalem, the stone reliefs from the façade of Mschatta, and panels of the throne of Maximian at Ravenna, in Italy. But even these examples are in aesthetic content and in scale fairly remote from the Northumbrian crosses. The unresolved problem thus remains how English workmen evolved a technique of full-scale figure sculpture in stone at a time when, so far as is known, nothing like it in scale or quality of execution was being performed anywhere in Europe or the Near East. For what is perhaps most astonishing is the confident mastery of the problem of suiting figure sculpture and scroll ornament to a vertical squared shaft. The solution shows an awareness of the relationship between the sculptured decoration and the architectural field of a large-scale work, that was not to occur again until the late eleventh century. In the second place, where are to be found the works of the foreign craftsmen who, as we are told, were imported into Northumbria and from whom these Englishmen must have learnt their craft? Unless the battered shapeless mass over Monkwearmouth porch that was once a six-foot statue is one of these foreign works (and there is good reason to believe it is not[9]), all must be supposed to have vanished utterly. So until these two *lacunae* in the Levant and in England can be filled, more problems remain unsolved than those that can even tentatively be answered.

The figure sculpture of Ruthwell is of two types: the rather flat, extremely light and delicate workmanship of the Saints Paul and Anthony and the Christ Triumphant (Plate 3), and the ponderous, deeply undercut style with heavy ribbed drapery of the Christ with Mary Magdalene (Plate 2). This latter is faintly reminiscent of late antique provincial sculpture, examples of which were certainly still visible at the time at Carlisle and elsewhere.[10] The most extraordinary thing about the figure scene of Christ and Mary, and a feature which marks it off most sharply from any Mediterranean prototype, is the remarkable clumsiness and crudity of the arms and hands of Mary. This truly barbaric exaggeration of gesture reveals a lack of interest in natural proportion that jars painfully in this otherwise noble humanistic piece. It is clear evidence of the latent power of the old barbaric artistic traditions only temporarily submerged by the high flood of Mediterranean fashion. One possible explanation is that the Anglo-Saxon sculptor lacked an iconographical model for the figure of Mary; that he was perhaps copying an ivory that merely portrayed the figure of Christ. Similarly, the two dragons under Christ's feet on the other side of the cross show some uncertainty of craftsmanship. But whatever infelicities may be observed in details of these two great figure panels, they nevertheless remain examples of a monumental dignity in the treatment in stone of the human form that is almost unique in Dark Age art. With all its faults, Ruthwell succeeds in resurrecting once more in a barbarian world the grandeur of conception and the rational humanism that had once been the glory of Roman civilization.

Further evidence of the artificial and precarious nature of this humanistic style is

provided by the second cross, at Bewcastle in Cumberland. Here only one face bears figure sculpture, the central theme of which is again Christ worshipped by the beasts (Plate 4A). But the figures are now less natural in proportions, austere and elongated, and no longer in the high relief of the Ruthwell cross. The full undercutting that occurs twice at Ruthwell[11] is now quite alien to the sculptor's technique, for the linear representation of surface pattern, so dear to Northern art, has already supplanted the plastic modelling of Rome. Similarly the inhabited vine-scroll has drifted yet further from its original, the fruit and leaves becoming more unrecognizable and the birds and beasts being depicted in rigid attitudes in flat two-plane relief, instead of with the easy rounded grace of Ruthwell. Furthermore, Bewcastle sees the introduction of purely abstract ornament in the form of panels of interlace and chequers that are identical with similar patterns in the Lindisfarne Gospels and which must have been copied from southern pagan jewellery like that found at Sutton Hoo. But Bewcastle is not merely a more barbaric copy of Ruthwell. Fresh influences from the Mediterranean kept pouring in during this period of Northumbrian renaissance, as more works of art were imported. And so at Bewcastle are found two panels with new Mediterranean motifs: the uninhabited figure-of-eight vine-scroll and the double scroll with central binding ties. Thus styles changed with a remarkable rapidity as the opposing waves of influence poured into Northumbria, as the battle continued between linear, mannered abstraction and plastic naturalism. In their very different ways Ruthwell and Bewcastle are attempts, closely inter-related and yet distinct, at a synthesis between the two traditions.

If certain political assumptions are well founded, it would seem that Ruthwell can be dated with some precision. It must be some years subsequent to the Synod of Whitby in order to allow the training of English artists in Mediterranean styles based on the workmen and *objets d'art* brought to Monkwearmouth by Benedict Biscop in 674. On the other hand, it is likely to be before 685, when the defeat of Ecgfrith by the British seems to have driven the Northumbrians out of most of the Strathclyde area. For since the poem on the cross is in the Northumbrian dialect, foreign to Strathclyde, the erection of the cross must necessarily precede Pictish reoccupation. On these assumptions the cross must have been erected some time between 675 and 685.

If only on the grounds of stylistic similarity with the Lindisfarne Gospels, and the wooden panels of Saint Cuthbert's coffin which are precisely dated to 698, the once popular ascription of the Bewcastle cross to the mid eighth century must be rejected, while if the runes on the cross do actually refer to Alcfrith, Wilfrid's old patron at Whitby, the erection of the monument cannot possibly be subsequent to the latter's death in 709.[12] No one else would have bothered to record the memory of this relatively unimportant and politically unfortunate prince. If Wilfrid did actually erect the cross, it must have been in the early years before his exile in 691, or in the last years of his life after his return, between 705 and 709. The most convincing argument for putting Bewcastle later than Ruthwell is based on the height of the inscriptions. At Ruthwell the inscription is something of an afterthought, and all the letters are of the same height, those at the top of the cross being consequently unreadable; at Bewcastle they are graded in size according to the distance from the eye.[13] The conclusion is surely quite inescapable that the artists

discovered that in practice the inscriptions at the top of Ruthwell were illegible and took steps to remedy this defect in the subsequent work.[14]

The most extraordinary feature of this Northumbrian Renaissance was its wide eclecticism, the manner in which it cheerfully borrowed, adapted, and amalgamated art forms, intellectual traditions, and even religious beliefs and iconography from a host of violently contradictory sources. The two great crosses derived the idea of a standing stone from the pagan Celts; the interlace and chequer patterns at Bewcastle from Kentish or East Anglian pagan jewellery; the figure themes from the Irish ascetic tradition, borrowed in turn from Syrian desert cenobitism; the vine-scroll pattern and much of the figure style from the Near-East via Rome, while further influences on the figure style may have come from local antiquities at deserted Roman sites near Hadrian's Wall. Lastly, part of the inscription at Ruthwell and all at Bewcastle are in runes in Northumbrian dialect, and the text at Ruthwell is from a poem probably by a recent local convert to Christianity. It would be hard to find monuments which more strikingly illustrate the tangled and complex inter-relation of intellectual and artistic strands from many quarters.[15]

<p style="text-align:center">★</p>

A further example of this eclecticism is the contemporary whalebone carving of the Franks Casket, where Romulus and Remus from classical mythology, the Christian Adoration of the Magi, and pagan stories of Weland the Smith are all jumbled together in a meaningless sequence of figured scenes.[16] The casket is the first introduction into Anglo-Saxon art of the narrative method by which a succession of scenes is strung together to illustrate a story. The most probable source for the subjects chosen by the artist is an illustrated Chronicle of the World such as is known to have been current in Europe at the time, and of which one example at least had reached Northumbria. But the choice of theme is quite arbitrary and governed by no rational choice of related subject matter. This inconsequentiality and the complete confusion of pagan and Christian subjects provide a most revealing illustration of the nature of the society which produced it. Part christianized but still clinging to the legends of the pagan demi-gods, largely ignorant of the past of his own people but instructed in the broad outlines of the history of Rome, obstinately clinging to a barbaric art tradition in the face of classical influences from the Mediterranean – the artist of the Franks Casket was as typical a product of the intellectual confusion of the age of the Northumbrian Renaissance as the author of *Beowulf*.

The panel illustrated shows Egil the archer, a character from Norse mythology, besieged in his house which he is defending by his bow (Plate 5). Within crouches his wife holding a spare arrow. On the left the attackers, armed with swords and spears and small round shields, and two of whom are wearing a kind of link-mail armour, rush forward under a shower of arrows. Below, a woman tears her hair in lamentation over a stricken warrior, while the sky above is thick with missiles. Once the conventions of the art form are accepted, once the mind is attuned to a design with no fraction of the background left unfilled, it becomes apparent that as a method of depicting a scene of action, the style has very considerable merits. It is vigorous and lively and conveys a sense of movement that is not easily achieved in such a medium; and it is just this liveliness and vitality which

distinguishes it from any Frankish or oriental prototype. The outstanding qualities of the work are its purely two-plane fretwork technique, its utter disregard of spatial composition, and the *horror vacui* which led the artist to fill up every tiny corner of the carving, all of which are typical features of barbaric art. That it is contemporary with the Lindisfarne Gospels, and thus the Bewcastle cross, is revealed by the pieces of interlace and bird's heads with hooked beaks that serve to fill up space, for example inside Egil's house.

The dialect of the runes proves conclusively that the casket was the work of an artist from at least as far north as south Yorkshire,[17] and the similarity of the casket to Pictish carvings at Inchbrayoch (Angus) and Murthly (Perthshire),[18] notably in the use of animal-headed human beings, is really the only evidence that leads us to attribute the casket to northern Northumbria. The stranding on the shore of the whale whose bone, as the inscription records, was used for the casket might have occurred on any part of the northern coast of England. There are certain signs, notably the strange animals and parrots within the gate of Jerusalem on the back panel, which may point to the influence of Merovingian manuscripts, and since Merovingian influence was negligible in the Durham area at this period it has been suggested that the Franks Casket came from further south, possibly York. On the other hand, these beasts and parrots are also to be found on Egyptian Coptic textiles, the import of which into Northumbria is inherently probable, and is supported by other signs of Coptic influence upon the art of Northumbria at this period. On the whole, therefore, it seems most reasonable to conclude that the casket was made in the same geographical area as were the Bewcastle cross and the Lindisfarne Gospels.

Another example of the varied styles and influences at work in Northumbria at this date is provided by the wooden panels of Saint Cuthbert's coffin, of which the technique is crude but the models Mediterranean.[19] This naïve piece is quite certainly the same wooden coffin that is known to have been constructed in the year 698 to house the relics of the Saint. The work is strictly utilitarian and functional and is devoid of all the lavish ornamentation of the manuscripts and stone carvings of the age. Its purpose is not didactic but magical, the invocation of the protection of the figures represented to act as guardians of the holy and valuable contents: the expression in visual terms of a pantheistic incantation to a series of powerful deities. Thus the arrangement of the apostles is in accordance with the list of saints in the prayers of the Roman Mass, the archangels, including Apocryphal figures like 'Rumiel', are drawn from Anglo-Saxon prayers, and Christ surrounded by the Evangelists and the Virgin and Child must be similarly interpreted as protective agents. The artist has made no attempt at modelling or depth, but has contented himself with shallow outline incisions in the wood. But although he is not in full control of his tool even in executing this simple technique, the attempt to imitate Mediterranean humanistic prototypes is evident. The principal interest of the work is in showing the wide variety of Mediterranean sources upon which the Northumbrian artist was able to draw for these simple *graffiti*. These sources evidently range from ivories to manuscripts and embody iconographical details drawn from diverse parts of the Mediterranean. The choice of subject, the linear interpretation, the runic inscription beside the Virgin are the native contributions to this curious piece, while the long angular fingers betray the innate longings of the artist for stylization and exaggeration of gesture. This one feature alone,

in which the carver departs from his model, is full of life and vigour and saves the panels from the depressing mediocrity of bungling copywork.

<div align="center">*</div>

The drift away from Mediterranean influence and back to barbaric art, checked occasionally by fresh importations from Rome, is shown in the few crosses that may be ascribed to the half-century subsequent to the high peak of the Renaissance. At Hexham are the remains of a cross, which, according to literary and archaeological evidence, seems to have been erected in 740 over the grave of Acca, the celebrated Bishop of Hexham and learned patron of Bede.[20] Upon the fragments is the uninhabited symmetrical double vine-scroll that had been first seen at Bewcastle, but now treated in a harsh, fretwork manner. The leaves and berries themselves are such faithful copies of the real vine as to suggest new oriental influences. On the other hand, naturalistic handling of the theme has been abandoned in favour of a surface pattern of thin flat interlacing lines arranged in rigidly symmetrical order. This attempt to turn the vine-scroll back into abstract linear decoration results in a most unattractive compromise that lacks both the taut vigour of barbaric and the plastic naturalism of Mediterranean art.

A much more agreeable evolution is shown on the two-foot fragments of a cross at Aberlady in Haddingtonshire (Plate 6A). The technique of short panels that was visible on the sides of the Bewcastle cross is here developed as a vehicle for embracing upon the same monument subjects of widely differing treatment. Above the modelled and dignified human figure of an angel is a panel filled with a decorative pattern of enlaced serpentine animals that is a pure derivation from pagan Anglo-Saxon art. On the edge of the cross is a hard but fairly faithful representation of a running vine-scroll that probably owed its inspiration to fresh Mediterranean importations, and on the back is a key pattern and a remarkable panel of animal ornament composed of the diagonal interlocking of the necks and legs of four birds. Different forms of this savage theme were visible in the Lindisfarne Gospels, but the ferocity and violence of the composition are in striking contrast to the playful animals of the Jedburgh panel half a century before (Plate 4B).

In manuscript illumination of this mid eighth-century period, the barbaric tradition of the Book of Durrow re-emerged in full vigour and combined with Merovingian Frankish influences to stamp out the Mediterranean naturalism that was such a feature of the first phase of the Northumbrian Renaissance. But the triumphant resurgence of decorative abstraction and linear complication that led on through the Saint Chad Gospels to such masterpieces as the Book of Kells, failed in almost every case to have a similar stimulating effect in the field of sculpture.

The degree to which figure sculpture has now changed may be seen in the fretwork dolls with their ribbed incised drapery, on the cross at Saint Andrew Auckland, Co. Durham (Plate 6B). The iconography of the scene provides one more proof of the predominant influence of the Eastern Mediterranean. It illustrates the oriental and Byzantine motif of Ecclesia being led by an angel, which is usually accompanied by that of the Synagogue being expelled by another angel and found in association with the Crucifixion. In this case the Crucifixion is also of an oriental type,[21] but the style, for example the very long fingers,

<div align="center">16</div>

is derived from that of the Saint Cuthbert's coffin panels of half a century before. A similar change has overtaken the inhabited vine-scroll motif on the other face of the shaft where barbaric influence has produced a new composition of real merit (Plate 6c). The vine-scroll itself has shrunk in importance, the foliage and berries have disappeared, and there is left only a taut-springing coil to form a light framework within which the animals may disport themselves. And it is the animal world, so dear to the Anglo-Saxon artist, which is now the dominant theme of the scroll. Savage, hook-beaked, long-legged, equipped with ferocious claws, the birds and animals are well advanced in that long process of expansion and escape from their surrounding vine-scroll that was to continue for a century. Cruel and unfriendly as is this scene of the hunter and his prey, it is no uninspired degenerate copy of the soft coils and cheerful little creatures of the Jedburgh scroll, but a gaunt and stark expression of the new barbaric tendencies of the generation following that of Bede and Acca. The influence of Rome was in full retreat once more.

By the end of the eighth century, there are signs that here and there this barbaric resurgence was undergoing modification and softening as the result of influences from France. On the front of a cross at Brompton-in-Allerton, Yorks., there are the same ribbed doll-like figures as at Saint Andrew Auckland. On the back, on the other hand, are three square panels two of which are filled with an amiable pair of little ducks standing alone within their frames (Plate 8A). This detached animal portrait is a feature of Merovingian art, and the work well exemplifies the Frankish influence on Northumbria at the end of the eighth century and beginning of the ninth. But as if to emphasize the continuity of Northumbrian art despite this new influence, the bottom panel of the three contains a pair of dragons with crossed paws that clearly trace their ancestry directly back to the two beasts worshipping Christ on the Ruthwell and Bewcastle crosses of a century earlier.

It cannot be claimed that many of these later pieces are of a high quality either in design or execution. Much of the historic importance of the great contemporary Northumbrian scholar Alcuin of York lies in the fact that he acted as a bridge to pass on to the Carolingian world the accumulated learning of the past. Similarly these late eighth-century crosses are important because they preserved for the future the three principal features of Northumbrian art, the system of decorative panels, the vine-scroll, and the inhabiting animal who was gradually emancipating himself from the leaves and tendrils in which he had at first been enmeshed.

There is, of course, no easy identification of artistic excellence with Mediterranean influence. Barbaric and humanistic art each have their own individual qualities, and comparisons between two such different traditions are worse than odious. On the other hand, barbaric art is characterized by a taste for linear surface pattern, and this quality is best suited to other media than sculpture in stone. The finest products of the Anglo-Saxon popular tradition are undoubtedly in the fields of jewellery, metalwork, and manuscript illumination, and the sculptor of stone rarely showed the extraordinary mastery of technique that is so marked a feature of these other media. Whereas in the manuscript the struggle between the two opposite conceptions of art produced syntheses that commonly rose above the best that either had to contribute, such fertility is far more rare in sculpture.

★

The history of Irish sculpture, unlike that of Irish manuscript illumination, pursued a course virtually independent of that of England, and at no point approached it in artistic distinction. Indeed the powerful imagination and the technical mastery displayed in Irish illumination and metalwork forms a startling contrast to the fumbling work of the sculptor in stone. Cut off from contact with the main stream of influence from Rome, Irish sculpture contemporaneous with the Northumbrian revival was limited to the incision of a cross or the Chi-Rho monogram upon roughly hewn pillars, or occasional childish and incompetent scratchings of the human figure. Though direct Coptic and Syrian influence seems to be evident in the design and layout of some of these crosses, for example the slab at Fahan, the powerful regenerative effect visible in Northumbria seems to have passed Ireland by. The survival of paganism in the form of vaguely christianized totem images was alone responsible for figure sculpture more elaborate than crude shallow incisions.[22]

Defective though the technical, intellectual, and artistic capacity of the eighth-century Irish stone sculptor may have been, his fellow-worker in metal was unquestionably a supreme master of his craft. The close-packed, vividly coloured ornamental decoration that appealed so strongly to all northern barbarian peoples here achieves its highest expression. The heirs of the technical processes and many stylistic features of the pagan Anglo-Saxon jewellers' craft of the Sutton Hoo hoard, the christianized Irish set about producing ecclesiastical and ritual objects of the greatest splendour to give a hint of warmth and light and colour to the cold and gloomy churches of the age. No more striking evidence of the popularity of the art can be offered than the fact that the great bulk of this Irish metalwork has come to light to-day as a result of excavations in the graves of the Viking invaders of the ninth century. Owing to the immediate appeal these works made to the conquerors, far more survive to-day in Norway than in their native land.[23]

The finest of all the surviving examples of this eighth-century Irish metalwork is the Ardagh Chalice (Plate 7), a perfectly proportioned silver goblet, decorated with gold, gilt bronze, and enamel, which was made for holding communion wine for the laity.[24] Here the Irish artist has shown a capacity for classical restraint by a deliberate decision to prevent the ornamentation from spreading so copiously as to blur the proportions. In this quality, the Ardagh Chalice stands alone in the history of Irish metalwork, contrasting markedly with the lavish ornamental spread of the almost contemporary Tara brooch[25] and the still more elaborate systems of the later period. The bulk of the decoration consists of exquisitely drawn spiral or interlace patterns, given depth by the soldering of two layers of gold thread one on top of the other. At intervals are set *cloisonné* enamel bosses of blue and red, the complicated manufacture of which shows direct continuity with the Anglo-Saxon jewellers' craft of the preceding century. But apart from the extraordinary perfection of execution of this elaborate decoration, what gives to the Ardagh Chalice its outstanding position in Irish metalwork is the strictness of the relationship between the simple swelling lines of the cup and its base and the arrangement of the glittering studs, bands, and roundels that adorn its surface.

CHAPTER 2

THE CAROLINGIAN REVIVAL AND
MERCIAN ROCOCO
⟨ CIRCA 770–870 ⟩

As has been seen, Northumbrian art by the end of the eighth century was in full decline. The political stability of the earlier period had given way to a semi-permanent state of anarchy which had its unavoidable consequences even within the secluded monastic walls. In the generation after Bede, intellectual activity shifted southward to York, and then moved altogether with Alcuin to France. There this Northumbrian artistic and intellectual influence combined with the deliberate political and cultural antiquarianism of Charlemagne to produce a remarkable revival of those arts and sciences associated with the higher forms of civilization. Painfully immature and self-consciously archaizing though much of this Carolingian work undoubtedly was, it stimulated a regeneration of artistic and intellectual activity which was destined powerfully to affect the course of Dark Age history. Strangely enough England was one of the chief gainers by this revival, by adapting and absorbing in a highly distinctive manner the main inspiration of the new schools.

As might be expected, it was those areas nearest to the Continent which were the first to come under the new influences, and we now have definite proof that Canterbury has taken its expected place of artistic leadership in the English Church. In a series of magnificently illuminated manuscripts, the monks of Canterbury evolved a highly eclectic style with borrowings from Northumbria, Merovingian Gaul, and the Carolingian Rhineland. These manuscripts were characterized by the heavy Gallo-Roman solemnity of the figures with ponderous tubular drapery and an air of mournful dignity about their faces. Later, at about the beginning of the ninth century, the style becomes noticeably lighter, fussier, and over-elaborated, and it is perhaps to this later phase that must be attributed the unique expression of Carolingian sculptural influence in south-east England, the remarkable cross that once stood within the church at Reculver on the north Kentish coast. Built up of separate blocks, itself a unique feature, the shaft of the cross was circular, which is something quite new to English experience, all previous crosses having been rectangular in section. This characteristic alone should suffice to destroy the view current until recently that the cross could be dated to the late seventh century in the days succeeding Theodore's great mission. There can be little doubt that the round shaft is here a wholly foreign import, probably derived from the heavily sculptured column that was known to the Carolingian Rhineland. If we may believe the geological report that the stone of which the cross is constructed is itself an import from the Seine Valley, then it provides further evidence of the foreign influences here at work. Upon the fragments from Reculver which now survive it is possible to distinguish at least three distinct sculptural types. The figures within vertical panels, perhaps of apostles, show a handling of drapery which is full of gentle grace. The slight bending of the left knee gives a suppleness and vivacity to the figure

which is further emphasized by the flowing lines and zigzag hems of the drapery (Plate 10A). This highly accomplished and delicate work undoubtedly shows a more mature treatment of the draped body than the Anglo-Saxon sculptor had hitherto achieved. On the other hand the figure within a roundel is much more crudely executed. The drapery loop is stiff and artificial and the drapery itself reduced to a series of straight tubes. Yet a third type is shown on the fragment containing human busts enclosed within a scroll, that is reminiscent of a Northumbrian cross at Otley, Yorks. This variety of style would be quite baffling were it not for a similar diversity to be found on contemporary and more easily datable work at Breedon-on-the-Hill, Leics., in Mercia. The tip-toe stance, and the plainly carved front and back hems of the drapery occur at Fletton, Hunts., and the striated leaf-form on an early ninth-century carving at Acton Beauchamp, Herefordshire; the acanthus leaves clinging inside the volutes appear in the Canterbury Psalter; the lotus-shaped capitals and the same interlace bands are found in the ninth-century Codex Aureus. There are thus many links with sculpture and manuscripts of the late eighth and early ninth centuries, which suggest a date for the Reculver cross in the first half of the latter century.[1]

In the north the Carolingian influence was probably due to the cultured Francophile Alcuin, who had been educated at York, and who kept in touch with his old diocese after his migration to Charlemagne's court at Aachen in 782; and it is in the cross shaft at Easby, in the North Riding (Plates 12 and 13), dating probably to the first decades of the ninth century, that the finest example of the new style is to be found.[2] The nature of the vine-scroll is now radically different from that which preceded it, for instance at Saint Andrew Auckland. The vine bears numerous delicate tendrils and naturalistic leaves, and the schematic savagery of the encircled fauna has altogether vanished. The birds are now softly modelled, gentle, and friendly, though their great size in relation to the encircling scroll shows clearly the influence of the earlier work. The same may also be said of the figure sculpture with its delicate well-proportioned Majesty panel, and the remarkable variety of pose and expression introduced into the group of apostles' heads. Carefully modelled in the round, and imbued with the human dignity of their remote late antique prototypes, these heads display the English sculptor of this period at his best. All the grace and delicacy that the continental Carolingian artist occasionally infused into his ivory carvings is here brilliantly reproduced in the far more difficult medium of stone. On the other hand the interlace on the narrow sides of the cross is thoroughly Northumbrian in treatment and is convincing evidence that the cross is the work of an English artist.[3]

This Carolingian sculpture has none of the majesty and grandeur of the first Northumbrian Renaissance. It is modest in proportions, careful and delicate in execution, being essentially the transference of the ivory sculptor's meticulous craft into the medium of stone. For a time it succeeded in softening the barbaric harshness of the northern tradition, of reviving a plastic feeling in the treatment of human and animal figures, and of introducing into the northern repertory that four-square, determined quadruped, the Carolingian lion.

But degeneration from this high standard was very rapid. The harsh savagery of Saint Andrew Auckland was artistically far superior to the uneasy, groping compromise of the

cross from Rothbury, in Northumberland, which shows the Northumbrian style of perhaps a decade or two after the high peak of Easby. The human expressions are dull, lifeless, and monotonous, the drapery mere mechanical tubing (Plate 9A); the vine-scroll is heavy and lacks spring, while the gripping and biting animals have neither the ferocity of the previous northern style, nor the grace and charm of the Easby fauna; the most vigorous, if not the most attractive, of the Rothbury sculptures is the panel containing a design of interlacing lizards plastically conceived, that chew, bite, and tear at one another with all the savagery of barbaric invention. But a pattern that had a high artistic value when outlined in Scandinavian art, has become repulsive when given a semi-naturalistic content through the influence of the Carolingian animal style. Once again Northumbria had failed to synthesize the Mediterranean influences with its own innate barbaric tastes, and this time there was no further chance. Political and cultural leadership now finally moved southward, and it is to Mercia that we must turn to see the most brilliant and original handling of the new Carolingian themes.

<div align="center">*</div>

Military hegemony of England had been achieved in the last half of the ninth century by a remarkable leader, King Offa of Mercia. Not content with this achievement, there is ample evidence that he made every effort to open up this hitherto backward and geographically isolated area to the latest cultural influences. Diplomatic and commercial relations were maintained with Charlemagne's Empire; presents of silks and *objets d'art* were exchanged; and, as a symbol of the authority of the new kingdom, a great gold coin was struck – with the exception of the inscription, '*Rex Offa*', a faithful copy of the Arab dinar. In sculpture, however, these efforts did not bear fruit till after Offa's death in 796. Before the turn of the century, Mercian art was content with inferior versions of more elaborate Carolingian works, such as the slab at Wirksworth, Derbyshire. This coped tombstone, whose shape is reminiscent of the top of a late antique sarcophagus, is covered with elaborate figure subjects of Christian iconography. They include the Annunciation, the Nativity, the Massacre of the Innocents, the Presentation in the Temple, the Crucifixion, the Ascension, the Burial of the Virgin, and the Washing of the Apostles' feet. This choice of subjects, many of which were hitherto quite unfamiliar in England, is explained by the fact that all are feasts in the liturgical calendar of the Byzantine Church and must have been copied from some imported manuscript or ivory.[4] But though the subject matter thus bears witness to the new continental influences at work in Mercia under Offa, the execution of the work is in a crude style, the drilled eyes and tubular drapery of which shows it to be a yet more degenerate relative of the Rothbury cross.

Further south still, in Wessex, this heavy imitative work, imbued with all the self-conscious solemnity of the careful copyist, underwent radical treatment at the hands of the insular artists. At Codford Saint Peter, near Salisbury, there has survived a single example which shows what could be done with such unpromising material (Plate 11). In a panel on the face of a four-foot tapering shaft there is the figure of a man clutching a fruited branch above him in one hand, while the other grasps a curious object which is perhaps a musical instrument. Heavy though this carving is in its faithful reproduction of such

features as the shoes and pin for the cloak, and harsh as is the chiselled ribbing that represents the drapery, yet the posture of the figure, the twist of the head, the interplay of light and shade on the ribbing, and the perfect adaptation of the design to the framed space creates that sense of drama and artistic unity that was so conspicuously absent at Rothbury and at Wirksworth. The source of this style is plain enough in late eighth-century Canterbury manuscripts under continental influence, where are found the banded clothes, beaded fillet, tip-toe stance, stepped imposts, fret ornament, and lobed leaves curling off the stem.[5] In view of these minute parallels there can be little serious doubt that it belongs to the first quarter of the ninth century.

While the sculptors were busy at Rothbury and Codford Saint Peter, there was being evolved in the monastic scriptoria of Canterbury and more particularly of Mercian monasteries, a brilliant and creative style of manuscript illumination which was powerfully to affect the sculptor's art for the next half-century. The Book of Cerne, which must be dated to about the third decade of the ninth century, provides the fullest expression of this new midlands school. The main features were a small-scale delicate figure style, but hardened in outline and with the drapery transformed into a linear pattern of elaborate pleats orientated about a deep central fold between the legs. The architectural frameworks are treated with a flippancy that is unknown at any other time or place, the capitals not infrequently taking on a characteristic cup-like appearance. Flippant also is the treatment of the animal designs, bipeds and quadrupeds of fantastic shapes and sizes twisting and turning in elongated ecstasy. These animals are most commonly in striking heraldic attitudes with rampant paws and thrown-back necks. The fantastic extravagance of the style with its over-elaboration, its dainty grace, and its almost surrealist absurdity gives some justification for the use of the epithet 'rococo'.

As usual in the early Middle Ages, the new artistic impulse reached the sculptor through the medium of metalwork and ivory carvings. Thus the best example of the new animal types and the new taste for rich decorative effects is provided by a small bowl of embossed metal found at Ormside, in Westmorland. Since the find probably came from Viking loot, its location gives no evidence of its place of manufacture, which may well have been as far south as Mercia. Within ivy scrolls are found animals that are the product of the wildest imagination. Pterodactyl-like birds with fierce jaws disport themselves in the scrolls, while below prance lively quadrupeds (Plate 9B). Pending the full re-examination of the bowl after its recent cleaning and restoration, little can usefully be said about the source of this remarkable fauna, earlier comparisons having proved singularly vague and unhelpful. Nevertheless it seems clearly to fall into place amid the strange fantasies of early ninth-century Mercian art.[6]

Another example of the same period, the little cross shaft at Croft in Yorkshire, shows the usual Northumbrian layout of scroll sides and inhabited double scroll on front and back (Plate 10B). But now the plant itself has entirely disappeared into a thin surface pattern and the birds and animals have taken on totally unreal shapes. One animal on the front of this cross resembles the great pre-Roman Celtic hill carving, the White Horse of Uffington in Berkshire, in its elongated, disjointed stylization. More significant still is the way in which the fauna conform themselves to the pattern of the scroll itself, so that both

vegetables and animals lose all individuality of shape and merge into a single close-knit surface pattern.[7]

Some time in the second quarter of the ninth century, a craftsman at Ely produced for the monastery a remarkable little box in bone, known from its final resting place in Germany as the Brunswick Casket. It is entirely covered with patterns of reptiles enmeshed in interlace (Plate 8B). The first impression derived from an examination of the panels is of an extreme mastery of technique and a strong sense of symmetry and of spatial composition. Only later does the fantasy and irresponsible inventiveness devoted to the lizards and animals become apparent. It is in fact the peculiar attraction of this early Mercian style that it gives full rein to its disordered imagination only within the limits set by a strong sense of formality. Thus on the front panel of the casket, the biped reptiles, creeping or rampant amid the elaborate interlace of their own tails, are nevertheless arranged in neat symmetrical pairs within well-defined rectangular frames. The end panels contain similar lizards seen from above, but the thin spiral coils in which they are involved are derivatives of the ancient vine-scroll ornament of Northumbria, whose earliest beginnings were seen at Jedburgh (Plate 4B). The vine has now lost flowers and fruit, and indeed all semblance to a plant, and has become a mere device for creating a symmetrical surface pattern that captivates the eye.[8]

In the Mercian area, in the early ninth century, sculpture for a time became the handmaid of architecture, expressed mostly in friezes and relief panels, rather than in the free-standing independent cross or tomb slab that both before and after remained the almost exclusive medium for the Anglo-Saxon sculptor north of the Trent. This harnessing of sculpture to architecture is itself evidence of Carolingian influence which concerned itself with the adornment of public buildings. Thus in stone sculpture it is the friezes built into the church walls at Breedon in Leicestershire, which can be dated to the first half of the ninth century,[9] that best illustrate the lively imagination and the remarkable individuality of Mercian artists (Plate 14A). These narrow bands between seven and nine inches in height, running around the church, possess two outstanding features. For the first time since Ruthwell, the sculptor shows a three-dimensional awareness and a mastery of the technique of high relief and even full undercutting in the development of his themes. In the second place, the sculpture possesses a novel and unique pictorial quality. Birds and animals are no longer shown either as adjuncts to a linear pattern or in isolated portraits, but as moving pictures in their own right, lively and animated like figures in a film strip. There is a remarkable row of cocks and falcons strutting perkily across the field of vision; some long-legged, long-necked, hollow-eyed quadruped monsters that paw and tear at each other as they move along; a group of combat sketches of men and animals, and a vigorous scene peopled with mounted spearmen and their captives, the whole broken up by isolated human heads in the round.

This central period of Mercian rococo before full spatial decomposition had set in was unquestionably a time of great artistic experiment and achievement. Remarkable as are the friezes at Breedon, perhaps even more striking are the accompanying panels containing figure sculpture. Medieval art is normally characterized by stereotyped non-individualistic mannerisms, and it is very rare to find such wide divergences in style as are shown in these

groups of figures at Breedon. Indeed were it not for overwhelming historical and typo-logical evidence to the contrary, one might be tempted to separate these sculptures into three different groups widely separated in date.

The least successful is the three-foot high panel with the full-length figure of an angel. His ostentatious classicism has betrayed the artist into a ponderous, fleshy treatment of head, hands, and drapery that in spirit, though not in execution, is reminiscent of Roth-bury. The heavy uninspired provincialism of the figure is still further emphasized by the characteristic Mercian fantasy of the cup-like capitals on which floats the surrounding arch. In striking contrast to this deeply cut neo-classical figure is the hard linear silhouette of a bust with draped head (Plate 14B). The drilled eyes, the tiny face, the long fingers and the hard edges and simple lines of the drapery all show the old Anglo-Saxon tradition. On the other hand the bust possesses a dignity and a humanism, albeit austere, that only Carol-ingian influence could provide. The central theme of Anglo-Saxon sculptural history is the successive attempts to evolve a synthesis between the classical and the barbaric tradi-tions; in this relief such a synthesis would appear to have been successfully accomplished.

The third figure style to be seen at Breedon is that which achieved greatest popularity, derivative sculpture being found at Peterborough and Fletton, Hunts., to the east, and on the Lechmere stone in Worcestershire to the west. At Breedon, the figures are fairly fully modelled in the round, but some years later, towards the middle of the century, the flat linear patterning so dear to the Anglo-Saxon artist again reasserted itself. At Castor in Northamptonshire there is the figure of an apostle or prophet within a flimsy architec-tural frame with bulbous capitals and slim reed-like columns (Plate 15). The slight bend of the knee, which was seen at Breedon and at Reculver, is still present, together with the dancing tip-toe stance. The drapery has lost its fullness and now clings closely to the outline of the stooping body, emphasis being given by swathes of incised parallel lines.

<p style="text-align:center">*</p>

By 829 Mercia in its turn had succumbed to the political and military domination of the more southerly kingdom of Wessex, which henceforth takes the lead as the cultural centre of Anglo-Saxon England. Until well beyond 850, however, and indeed up to the eve of the great Danish invasion of 865 it is Mercian influence which predominates. In south Yorkshire, for example, a few isolated carvings of remarkable vigour survive to testify to the pervasiveness of this southern taste. At Melsonby there is a grave slab that shows the neat perfection of craftsmanship that is so marked a feature of this period. The noble dignity of the human form displayed at Easby has now vanished, and it is in the treatment of interlace and of animal forms that the artist excels. Indeed the interlace of this period, such as that on the lower part of the Melsonby slab (Plate 16A), is the finest that the Anglo-Saxon sculptor ever achieved. The two strands of each strip give a sumptuous effect that is emphasized by the intricate symmetry of the composition. Based on a series of regular figure-of-eight knots, it avoids the monotony of an indefinitely repeated pattern by short breaks between each knot series, and by occasional carefully planned angles to break the mesmeric influence of the ever-curving lines. Interlace is the most frequent single decora-tive pattern in Anglo-Saxon sculpture. But of the thousands of examples that still exist,

the works of this short period in the mid ninth century were those in which the artist best succeeded in avoiding the Scylla of infinite repetitiveness and the Charybdis of irritatingly eccentric irregularity. In the animal panel at Melsonby the strange elongated winged lion at the top is of great interest (Plate 16B). His curious shape and the detached piece of scroll that passes behind his neck prove him to be a creature from the ancient vine-scroll, whose gradual expansion and escape has been traced through Jedburgh to Saint Andrew Auckland. Only the floating scroll remains of the toils in which he was previously enmeshed. On the other hand, the frontal attitude that has replaced the profile denotes the influence of the Carolingian lion.[10] Below this great beast at Melsonby is seen for the first time the second major motif of mid ninth-century sculpture in the north, the twin reptiles, whose erect sinuous bodies are entwined and interlocked in an interlace scroll formed of their own tails or limbs. Compared with the lizards on the Brunswick Casket (Plate 8B), Melsonby shows a smoother, less excitable treatment of the same theme. The vertical view has been replaced by the sinuous profile, itself soon to be yet further transformed by a striking resurgence of barbaric traditions.

In Wessex, at the court in Winchester, the Mercian taste for rich decoration and fantastic heraldic animals was tempered by a more sober attitude stemming from the Canterbury school of manuscript illumination with its grander manner and more conscious and dignified imitation of its Carolingian prototypes. Unfortunately, surviving cross fragments at Winchester itself and elsewhere are now too battered and weathered to be of much more than archaeological importance. In their original condition, however, they must have been imposing pieces. Carvings at Kelston in Somerset and Littleton Drew in Wiltshire bear heavy fleshy acanthus scrolls. At Winchester itself there is a section of a round shaft divided into arcaded panels within which are the same fat, heavy scrolls, interlace, and the powerfully drawn but now much weathered portrait of a stag. This stag, whose more sober prototype must be of Frankish origin, provides a link with the forest animals depicted on other round-shaft crosses of the north.[11]

In west Wessex, however, in Wiltshire and Somerset, there grew up a rival and totally different style that openly rejected this artificial injection of continental motifs and indulged in a revival of barbaric tastes far more frank and unashamed than had been seen for many years. Only the metalworkers seem to have made some attempt at compromise, the most outstanding example of their craft usually ascribed to the period being the so-called Alfred Jewel, discovered near Glastonbury in Somerset. It consists of the enamel bust of a man bearing two flowering wands, that, despite a somewhat primitive technique, is consciously classical in approach. This is protected by a thick plate of rock crystal and is set in an elaborate gold mount with a modelled boar's head terminal. On the back is engraved a symmetrical acanthus scroll derivative, hardened and stylized into a pattern of elongated tendrils, the background of which is filled with a kind of cross-hatched basketry design. The most pronounced 'Celtic' feature of this lavishly ornamented jewel is the boar's head with its curling filigree ornamentation that looks forward to the tenth-century sculptured head at Deerhurst, Glos. The basketry background and the stylized tendrils of the scroll are also symptomatic of a strongly Celtic flavour, while the enamel figure itself and the rock crystal are both evidence of Frankish influence. Nevertheless the

conventional ascription to the late ninth century seems at least open to doubt, and a case might be made for putting the jewel almost a century later. Use of the jewel as evidence of artistic trends in the days of Alfred is therefore somewhat unsafe.[12]

At all events no attempts at fusion of the two influences can be detected in the work of the western sculptors in stone. The earliest and most successful of this series of crosses is at Colerne, Wilts., which may be ascribed tentatively to about the third quarter of the ninth century, just before or just after the shattering impact of the Danish invasion.[13] On one fragment the Mercian lizards at Melsonby have undergone drastic change (Plate 17A). Although the symmetrical pattern and leonine heads of the beasts betray their origin, the treatment is now harsh and flat, a two-plane contrast of light and shade. The double edging of the creatures' bodies, the spiral limb-joints, the loose cross-hatching on the bodies, all emphasize again this strictly linear treatment. The rigidly controlled and beautifully executed interlace of the Melsonby period has now given way to an irregular maze of tangled strands in which the beasts are enmeshed, and already the abstract taste of the sculptor has transformed the limbs into sections of interlace with claws dangling feebly at their extremities. The second fragment shows very similar treatment, but this time of the Mercian heraldic beasts with thrown-back heads which were so common a feature of manuscripts like the Book of Cerne, and were to be seen strutting so proudly on the Breedon frieze (Plate 14A). They too have been reduced to a flowing ribbon pattern caught up in the toils of an interlace that springs from their own limbs. Tastes that in manuscript had been fashionable before the Roman mission of Theodore and had revived again in the days before the fresh Carolingian impulse, for a third time made themselves felt owing to influences from the Celtic west, but now in the form of monumental sculpture exposed to public view. Nor can it be denied that the savage vitality of this sculpture contrasts favourably with the somewhat effete work of the Winchester court school. It is perhaps insufficiently appreciated that Alfred's efforts to preserve the Anglo-Saxon cultural inheritance against the barbarian did not merely consist in beating back the Danes. As he himself was at pains to point out and as the tenor of his laws suggests, the danger lay as much within as without. And to this fact the cross at Colerne and the half-dozen others in the same style bear ample witness.

*

Irish sculpture during the ninth and early tenth centuries continued to pursue its own highly idiosyncratic course. Ireland was affected like England by the renewed interest in human figure subjects of a rather clumsy late antique type that was a feature of the Carolingian revival. In the late ninth and early tenth centuries, even while the country was being ravaged by Viking marauders, this influence bore fruit in the erection at monastic centres of great high crosses bearing upon them elaborate scenes of Christian iconography in a heavy but well-modelled figure style. Artistically they are the product of the same Carolingian influence which many years before produced in England the Rothbury cross, grafted on to the great Irish wheel-head cross of the type seen earlier at Ahenny. The earlier close carpet of abstract decoration is replaced by figured scenes in panels, the iconography being now exclusively Christian and related to the complex needs of the

monastic liturgy. One of the finest examples of this development, which seems datable by its inscription to shortly before 924–5, is the cross of Muiredach at Monasterboice, Co. Louth (Plate 19B). There the vigorous modelling in the round, and the heavy bearded heads, are strongly reminiscent of the Carolingian prototypes. Nevertheless, so close-packed and so rigidly schematic are many of the figure scenes, some of which alternate with panels of bulbous spiral bosses, that at a distance the impression of the sculpture is one of knobbly pattern. Interest in the human figure and in the dramatic content and meaning of an illustrated scene are evidently still very slight. Although on all these crosses the Irish were boldly setting the Crucifixion in a place of prominence, a century before the English dared to make any such attempt, yet even this subject is robbed of its meaning by the latent abstract schematization and the *horror vacui* which crowded the open areas of the scene with projecting bosses. It is not surprising therefore that this grandiose figure sculpture of the high crosses had no future and soon gave place to the new Irish Viking style of linear pattern, complicated wandering interlace, and running scrolls of ribbon animals.[14]

ANGLO-DANISH ART AND THE
APOGEE OF WESSEX
⟨CIRCA 870–1066⟩

IN the autumn of 865 a highly-trained and disciplined body of Danish marauders, probably not more than three or four thousand strong, landed on the East Anglian coast. For the next nine years this 'Great Army' systematically looted the length and breadth of England. Highly mobile, without ties or local attachments of any sort, the Danes roved freely about the countryside summer after summer in the quest of objects neither too hot nor too heavy which they might carry off to make their fortunes. The monasteries were the almost exclusive repositories of the jewellery and precious metals for which the raiders were seeking, and they were consequently singled out for special attack. One after another, the great religious and cultural centres went up in flames, the monks were slaughtered, the manuscripts burnt, the works in precious metal carried off and melted down, and the craftsmen dispersed. By the turn of the century the situation deteriorated still further by the arrival of the yet more savage Norsemen from the Hebrides and the Isle of Man who began to penetrate through Cumberland and Lancashire right across into the now Danish area of Yorkshire. But thanks to the vigour of Alfred, Anglo-Saxon artistic traditions survived after a fashion in Wessex, and when the Danes and Norsemen finally settled down to farm the land which they had for so long ravaged, it was from Wessex that the continuing influence of Mediterranean culture seeped back into the barbarized north.

The Danish invasions had the most disastrous effects upon English sculpture. The dispersion of the skilled workmen and their patrons throughout the whole of the north of England meant the permanent loss of those traditions of craftsmanship which had so recently been responsible for work of the quality of the Melsonby slabs. It was not a question of the triumph of barbaric artistic tastes over more mature and more classical traditions of an older civilization. In itself such a victory might result in work of as high or higher quality than before. The real disaster was that the whole technical tradition of working in stone seems in a large measure to have disappeared in the north. The sculptor now lacked the skill to execute the tasks he had in mind. And so while the output of stone sculpture in the north continued unabated, and may even have increased in volume, the quality suffered permanent deterioration.

But it would be false to give the impression of the total collapse of the old art forms and intellectual attitudes in the face of Viking influence. In actual fact quite the reverse occurred. By the year 900 there was an archbishop back in York and a bishop at Chester-le-Street, and there is every indication that the great bulk of the Danes had adopted Christianity, albeit of a somewhat garbled and debased kind. Consequently they also accepted and developed with enthusiasm the artistic medium of the free-standing stone cross whose existence they had only discovered on their arrival. Even the vine-scroll and

the solid animal form of the pre-invasion crosses were absorbed and incorporated into the new Anglo-Danish and Anglo-Norse styles. And it is in the interplay of these factors, some Scandinavian, and some Anglo-Saxon, that lies the whole interest and importance of sculpture in the north of England between the Danish and the Norman invasions.

Political events and changes in taste both combined, therefore, to introduce new features into Anglo-Saxon sculpture. In the first place this racial division of the country into two groups, each with its own laws, customs, systems of land tenure and administration, social structure and aesthetic traditions, led to a marked dichotomy between the sculpture of the north and that of the south and south-west. There is virtually no relationship between the great monumental figure sculpture and delicate ivory and goldsmiths' work of the monastic centres of Wessex and the continuing cross sculpture and grave slabs of the north. Political unity, which was achieved once more by the latter half of the tenth century, only resulted in the interpenetration of the two schools – Scandinavian art down to London and Wessex art up to the great Fenland monasteries. But for a long time there was little amalgamation, hardly so much as an attempt at synthesis. The Wessex craftsmen all but ignored the Viking tastes, and in the north attempts to imitate the elaborate figure sculpture of the south only resulted in clumsy and bungled workmanship. Not until the eleventh century was far advanced did a fruitful interplay of ideas begin to take effect. Partly as a result of this dichotomy, partly from other causes, the whole dating system for the sculpture of these two centuries from 860 to 1060 becomes highly speculative. Hitherto it has been possible to date the pieces of sculpture under discussion with some confidence to within half a century, and to offer an opinion to within twenty-five years or so. Such relative precision is rarely possible again until the twelfth century. In the north, apart from certain works that show obvious traces of well-known Scandinavian motifs, styles changed slowly and erratically, though in general a slow deterioration of the sculptor's craft may be observed throughout the period. In the south difficulties arise from the fact that the most striking pieces of sculpture are of human figures, while in the absence of documentation it is foliate or animal ornament which provides the art historian with his best guides to date and provenance. Forced back upon a study of drapery details, iconography, and treatment of the human body, he is at once on less certain ground. All attempts at dating these Wessex carvings in any but the most general terms must therefore be treated with the utmost caution.

<p style="text-align:center">*</p>

On their arrival in England, the Danes found a flourishing tradition of barbaric sculpture which far excelled their own tentative and clumsy attempts. This style of the mid and late ninth century was clearly seen in the Wessex sculpture at Colerne (Plate 17A). In the midlands and north, moreover, the same process was at work. From Gloucester in the south-west to Collingham in Yorkshire in the north-east, sculpture has survived to demonstrate this pre-Danish taste for the savage ribbon animal with his double contour lines, spiral joints, hatched body, and loose mesh of entwining interlace.[1] Perhaps the most striking witness of this revival of barbaric art on the eve of the Danish invasions is the cross that was erected at Saint Alkmund, Derby (Plate 16C). Here is depicted a

Mercian heraldic lion with thrown-back head, but now shown with flat double-line contours and in barbaric posture, and on the reverse face is a ribbon animal of the Colerne type. The importance of this barbaric lion portrait is that, situated as it was in what later became a main Danish headquarters, it may well have been a source of the great beast enmeshed in interlace that forms a characteristic feature of subsequent Anglo-Scandinavian art. If the beast had not already been adapted to barbaric tastes before the conquest, it is doubtful whether it would have made so striking an impression upon the invader. By abandoning the fussy ornamentation of Mercian art in its later stages, and rejecting all semblance of natural portraiture, the Anglo-Saxon artists were able to impress their ideas upon their conquerors. Equally effective in its influence on the future was the scene of animal combat which was observed in all its elegant fantasy at Breedon (Plate 14A). In the late ninth and the tenth centuries it occurs again and again in Anglo-Saxon sculpture. On the round-shaft cross at Melbury Bubb, Dorset, is a combat of hart and dragon that derives from Carolingian models (Plate 17B). This battle, or that of a hart and a wolf, signified the trials of the Christian, but its popularity lay in the identical symbolism for good and evil in pagan Norse mythology, thus leading to its ready acceptance in the half-pagan half-Christian world of tenth-century northern England. At Melbury Bubb the stag is still a recognizably naturalistic representation, though in Scandinavian hands it was destined to undergo strange transformations. The backward-turning stag and the clawing, biting dragon with its sinuous figure-of-eight tail form together a single well-balanced composition, whose vigour makes it one of the more attractive achievements of the Anglo-Saxon artist of the tenth century.[2]

Precisely to trace the evolution of these Anglo-Saxon styles throughout the first century after the Danish invasion is now an almost impossible task. Of the vast corpus of dreary and shoddy cross fragments which are to be found in so many parishes in the north of England, none can be dated with any precision, and little continuity of evolution can be worked out. When the sculptor loses control of his medium to the extent that occurred in tenth-century Northumbria there is little purpose or value in attempting to catalogue and analyse his efforts. All that we can say, and all that is worth saying, is that the tradition of the upright panelled cross-shaft with its vine-scroll and its animal designs continued with remarkable pertinacity. The importance of these carvings lies not in their intrinsic artistic merit, which is negligible by any standards, whether barbaric or classical, but in the evidence they provide of a continuity of tradition despite the shattering blows of the invasions. They preserved a legacy of art forms, in however crude a shape, until a genuine artistic revival again became possible, thanks to interpenetration with Scandinavian taste in the last thirty years of the tenth century.[3]

By this time Danish art was dominated by a mannered and immediately recognizable style, known as Jellinge from a site in Denmark of royal graves and grave-goods, and of Harald Gormsson's memorial stone, which is dated at about 980. The name is somewhat misleading, since art historians are now agreed that the Jellinge style was principally developed in the British Isles as a result of contact with Irish and Anglo-Saxon art. As we have seen, an important feature is the 'great beast' which is probably an adaptation of the Anglo-Saxon animal seen at Saint Alkmund, Derby. The old features are now

heavily accentuated, the double contour, spiral joints, and wandering interlace taking on a new ponderous emphasis quite unlike the lively ferocity of the Colerne or Saint Alkmund crosses. The human figure appears on the Harald Gormsson stone in a Crucifixion scene in which Christ has become an abstract shape enmeshed and enveloped in heavy two-strand interlace that wanders unsteadily around and about the face of the composition. It is indeed this irregularity of design and this 'evenly distributed heaviness' of treatment that are the main characteristics of this type of Jellinge work.[4]

One of the more successful objects in this style is a small bone belt-fitting found in the Thames at London (Plate 18B). It represents the figure of a man in mail armour (the head is broken off), whose arms and legs are loosely bound by the intertwining of a pair of serpents, whose vertically viewed long-snouted heads are visible to left and right. The artist, faced with the problem of fitting the subject of Gunnar in the snake-pit into a circular frame, has abandoned all attempts at naturalism in favour of a striking linear pattern. The body of the warrior has become a double incurving shape dominated at the four corners by huge joint-spirals. The legs are turned vertically upwards in defiance of anatomy and the arms hang limply down, all thus fitting neatly into the circular frame. To complete the abstract stylization of this curious composition, the base of the body tails off into a vague interlace, while the fingers and thumbs resemble thin sprouting leaves.

Apart from the 'Great Beast' element of the Jellinge style, there is a second motif in Danish art in the mid tenth century, a loosely composed row of racing ribbon animals whose limbs and bodies form irregular runs of interlace in which the animal shape is only barely discernible. Though far removed from the graceful, flowing lines of this type of animal decoration in Anglo-Saxon art of the seventh century, it is unquestionably a mannered derivative from that source. But the Anglo-Saxon artist had been familiar with this type of work for at least four hundred years and had been reverting to these ancient traditions on the eve of the invasion. It is not surprising therefore that he took up and modified this running style with enthusiasm. Three faces of an imposing cross-shaft at Sockburn, Co. Durham, exhibit interlace and isolated animal panels in the pre-Danish tradition, while the fourth has a run of ribbon animals of Jellinge type, below which is a serpent's head seen from above, exactly as on the Harald Gormsson stone and at Kirkby Stephen (Plate 18A). Nevertheless the bodies of the running animals are strongly emphasized and clearly distinguishable from the interlace. In some crosses of the period, for example at Cross Canonby in Cumberland,[5] there is a panel with contorted backward-biting animals resembling pure seventh-century Anglian work on one side, and on the other the same animals thrown into a Scandinavian running interlace design. Indeed in many cases it might almost be truer to say that Anglo-Saxon motifs were modified by Scandinavian influence rather than that the invaders' art was altered by that of the Anglo-Saxons. In most cases the basic rhythms and even patterns remained Anglo-Saxon.

Later on, towards the end of the century, this lacertine creature developed still further into an isolated panel-portrait yet more firmly distinguished from its interlace, and appeared on a group of crosses in the North Riding of Yorkshire.[6] The last stage of this evolution may be observed on a tomb slab at Levisham in the same area, where the sinuous beast with its joint spirals, double outline, and lappets is yet more strongly distinguished

from its background (Plate 18c). Here, moreover, the interlace shows a tendency to break into little spirals and volutes which indicate a change to foliate ornament that is a characteristic of the next stage in Anglo-Scandinavian art of the early eleventh century. But the heavy, awkward style of this ungainly animal is still firmly Jellinge, a product of the backward Danelaw.

The outstanding monument of Anglo-Scandinavian art of the tenth century in the north of England comes not from the Danelaw but from the area of Norse settlement in Cumberland. The first thing that strikes the eye about the Gosforth cross (Plate 19A) is its graceful shape, beginning with a rounded lower section, sliced off into a tall, tapering, square-sectioned shaft surmounted by an elegant wheel-head cross with prominent central boss.[7] Its date can be put with some confidence at about the year 1000 by comparison with a long series of Viking monuments on the Isle of Man whose chronology has been carefully worked out.[8] The degree of Manx influence in the cross is proved by the prevalence of a 'scale' or 'vertebral' pattern of surface ornament which is characteristic of the island, and which is found in three different forms on the cross, once as decoration of the upper part of the rounded section, and twice as the body of dragons. The sculpture on the squared sections is in the heavy ungainly manner that is recognizably Jellinge in inspiration. The zoomorphic patterns of vertebral or interlace bands ending in ferocious gaping heads have all the abstract stylization of primitive art, while the inconsequential arrangement of the figured scenes with the animals and humans now sideways and now upside down is also typical of the barbaric artist's contempt of logical composition. It is important to note, however, that the human figures, the horses, the stag, and the wolf are all naturalistically drawn with none of the artificial conventions of Jellinge art. This feature sets Gosforth apart from Anglo-Danish sculpture of this period and points to influence from Ireland or Galloway.

The precise meaning of these jumbled scenes remains obscure, though by considerable imaginative guesswork the carvings may be made to fit into a sequence of events in contemporary Norse mythology.[9] Whether or not this is correct, it is clear that all the scenes but one represent purely pagan subjects, and the only Christian element in this cross is a section on the face showing Christ crucified with Longinus and Stephaton below. We are thus thrust back into the intellectual atmosphere of a mixed pagan and Christian world such as that of the Franks Casket at the end of the seventh century, in which priest, artist, and congregation found nothing strange in such a confusion of mythology. There is strong evidence, moreover, from the not infrequent representations of the Sigurd legend upon crosses of this period, that this semi-Christian, semi-Pagan outlook continued to flourish in the north up to and beyond the Norman Conquest.[10]

★

To turn from this Anglo-Scandinavian sculpture of the late tenth century in the north of England to contemporary work in Wessex, is to move from one civilization to another. Highly conscious that they were the defenders of an old and superior cultural tradition, the Anglo-Saxon patrons and artists of the Wessex court evidently prided themselves on their rejection of northern influences. This hostility naturally took longer to make itself

felt in the more secular, more popular art of monumental sculpture than in the esoteric crafts of illumination and embroidery and probably also of metal and ivory work. Consequently the painstaking classicism of the court circles of the immediate post-Alfred period of the first decades of the tenth century is now only evidenced by the episcopal stole which was embroidered by the Queen herself between 909 and 916, given by King Athelstan to Saint Cuthbert's shrine in 934, and rediscovered on the opening of the Saint's coffin at Durham in 1827.[11] The full Romanesque feeling of these figures worked in the grand manner is the sole indication extant that this was the deliberately cultivated taste of the court at Winchester. No manuscripts are known for the early period of the tenth century, and in sculpture there are only further developments of the ribbon-like animals of Colerne.[12] Indeed the scanty surviving Wessex sculpture which is usually ascribed to the first half of the tenth century shows the persistence of those Irish influences of the late ninth century which were so striking a feature of the age of Alfred.[13] But what distinguishes all this sculpture from that of the Danelaw area is the technical perfection of execution. The tradition of working in stone was not broken and there survived a school of craftsmanship capable of executing major works of art if once given the impetus of fresh inspiration. Though pursuing art forms that were essentially barbaric, the Wessex sculptors would have despised the bungled efforts of their contemporaries at Levisham and elsewhere. They would have appreciated the vigorous strip of running animals at Sockburn (Plate 18A), but would have recognized it as springing from a tradition markedly distinct from their own.

As almost invariably occurs in early medieval art, it was in the medium of the illuminated manuscript that the new impulse was provided which was destined to give to Anglo-Saxon sculpture of the south a century of most vigorous and most distinguished activity. The classicism of the court at Winchester, based upon Byzantine and Frankish rather than Celtic models, emerged twenty years later under King Athelstan as a powerful new manuscript style. Heavier, more imitative of Frankish prototypes, and less graceful than the figures on Saint Cuthbert's stole, the pictures of these court manuscripts nevertheless show a conscious desire to keep the humanistic tradition alive, and a resolute hostility to any hint of the barbaric tastes either of the King's Danish subjects to the north or the Anglo-Saxon sculptors further west.

Something was needed to turn this esoteric court fashion into a dominant national style, and it was just at this moment that the process was violently stimulated by an energetic ecclesiastical reform movement. Headed by three gifted and capable men, Dunstan, Oswald, and Æthelwold, the English Church in the years following 960 came under a powerful regenerative influence from the Continent. The old monasteries of the west and south were given a new and more disciplined spiritual enthusiasm, the devastated Fenland monasteries were refounded on an even more grandiose basis, and material wealth was assured by lavish territorial gifts by King and nobles. By this means the wealth necessary for artistic patronage, the monastic security required for the evolution of a school of craftsmanship, the religious zeal that demanded the harnessing of the artist to the task of illuminating the word of God, were all three simultaneously provided. Furthermore, Æthelwold and Dunstan had both had experience of the artistic school of the great

monastery of Fleury, and both were generous donors of manuscripts and ornaments to enrich and inspire their new foundations. The result was the astonishing manuscript style conveniently, though inaccurately, known as the 'Winchester school' of illumination. Some were based on Carolingian originals of the more monumental type of the Ada school, and others on the vivid impressionistic pen-work of the Utrecht Psalter, but it was the nervous, vivacious outline drawing of the latter whose influence was ultimately the most pronounced.[14] Later the barbaric concept of the abstract patterned page reasserted itself by confusing the foliate frame with the central figure, the acanthus leaves of the former being developed and expanded into elongated frills and lobes that curl and sway freely over the page.

How long the new style took to make its impact upon stone sculpture we do not know for certain, though there can be little doubt that there was a time lag of twenty years or more. The first piece of sculpture that seems to be associated with this movement is the pair of angels that are preserved high up on the east nave wall of the contemporary church at Bradford-on-Avon (Plate 20A). Though the style of the Saint Cuthbert stole of half a century earlier suggests caution in asserting that these carvings are not earlier than 960, the closest English parallel that can be found is the New Minster Charter of 966.[15] The most compelling argument is that the concept of a set piece of this scale (each angel is about five feet long), with a now vanished *Agnus Dei*, crucifix, or perhaps even crucifixion between two angels, must surely be the outcome of the intellectual and missionary fervour of Saint Dunstan's reform movement. The whole idea of introducing large-scale sculptural tableaux into an architectural structure for the benefit and edification of the lay worshippers is hardly conceivable before this time.

The supporting angel with draped hands is a familiar Byzantine composition and is frequently found in European manuscripts of the tenth century. But this translation into stone is indeed new, and if the figure lacks spring and vitality, it is nevertheless a delicate and elegant work showing a faint hint of the lightness of touch, the levitation, that was shortly to be so familiar a hall-mark of the manuscripts. Nevertheless, Romanesque though these angels are, the lack of modelling on the figure, and the incised method of depicting drapery details show a persistent adherence to the technique of linear pattern with which the sculptors were familiar. The barbaric tradition thus died hard, or perhaps it would be truer to say that it did not die at all, but merely vanished temporarily from view until a favourable intellectual and artistic climate again made itself felt. Proof of this hypothesis is provided by the dramatic and powerful head of a boar set over the tower doorway in the little Saxon church of Deerhurst, in Gloucestershire. Strongly reminiscent of the gold boar's head surmounting the Alfred jewel, this modelled head with its curving linear decoration that was originally picked out in vivid red paint, spiralling round the eyes and ears, provides a vigorous reminder of the qualities that were being sacrificed by this late Anglo-Saxon concentration upon the human figure and acanthus foliage. The merits of the Deerhurst head were only appreciated once more in the twelfth century after the decline of the Anglo-Saxon school in the post-Conquest period, when it provided the inspiration for the carving of many west-country door arches.

To the more sober of the two 'Winchester' manners a three-inch high triangular panel

at Winchester provides a precise sculptural parallel (Plate 27B). Two angels back to back float effortlessly through space with upraised hands and upturned heads, borne up by the same force that is tossing in the air the trailing strips of their drapery. This grace and delicacy accompanied by firm confident drawing are precisely those of certain early eleventh-century manuscripts like the Grimbald Gospels in the British Museum.[16]

Parallel to this quieter Winchester manner, there flourished a vivid and impressionistic style of manuscript illumination that also had its inevitable repercussions in the field of sculpture. This style owed its origin to late antique painting and re-entered Europe in the days of Charlemagne with the Utrecht Psalter of the school at Rheims. This celebrated manuscript reinterpreted the ancient Hellenistic impressionism with fidelity and with high technical skill, but the tradition was so directly antithetical to the stolid grandeur of the Carolingian Renaissance that its influence remained limited for over a century. But the school survived at Rheims and at the end of the tenth century an English artist at Canterbury copied the Utrecht Psalter, giving it a fresh nervous vivacity that even surpassed the airy delicacy of the original. It seems that this excitable manner was immediately attractive to the Anglo-Saxon, who developed the style with great gusto until its more exaggerated mannerisms became one of the most marked and persistent characteristics of insular art in every medium. Though naturally best suited to the swift strokes of the calligrapher, the hunched shoulders and tiny chinless heads, usually in profile, the glaring eyes, extravagant gestures and wild, windswept drapery all find their way into sculpture in stone and ivory.

The closest imitation in sculpture of the second Winchester style of illumination at the turn of the century is provided by a pair of superb ivory statuettes of Mary and Saint John from a Crucifixion, that are preserved in the Museum of Saint-Omer (Pas-de-Calais) (Plate 27A).[17] The manuscripts which these ivories most closely resemble, such as a Prudentius at Corpus Christi, Cambridge, or a Psalter in the British Museum, date from about 980–1000, so that even allowing for a twenty-year interval before absorption into the new medium, it is unlikely that these figures are later than 1025.[18] The drapery details offer a marked contrast with those of the Winchester triangle. They faithfully imitate the squiggly crinkled frills of the nervous pen-drawing of the Utrecht Psalter style, while the elongation of the bodies and the slight thrust of the heads well illustrate the lightness of touch and dramatic force of the Anglo-Saxon miniaturist. The large heads, and even details such as the position of the feet or the rectangular fold of clothing in front of the neck, are faithfully copied from the manuscripts. Particularly noticeable is the brooding gloom and tragedy that surround the figure of Mary, evidence of the introspection that characterized this late Saxon period. The causes of this melancholy are not easy to discover, but its effects are obvious both in literature and in art, shown by an intense interest in the torments of Hell and a marked emphasis placed upon the element of physical torture in the Crucifixion. Christ, who had hitherto been shown either as a hero undergoing a test of endurance, as at Ruthwell, or as an awe-inspiring judge devoid of all capacity to feel pain or pity, now became a tormented human being suffering to redeem the world. Although this new attitude to the Crucifixion owes its origin to a changed intellectual approach in the Byzantine Church, it was a change taken up with exceptional enthusiasm by the Anglo-Saxons. In the first half of the eleventh century the Crucifixion forms a principal theme of

Anglo-Saxon sculpture on a large-scale on buildings attended by the laity. At the same time manuscript illumination, literature, and sculpture all devote much space to and show greatest imaginative inspiration in elaborate representations of Hell and the tortures of the damned. One possible answer to the problem of causation of this psychological outlook is that it was the emotional reaction to a wave of devastating epidemics that are thought to have swept the country in this period. But this introspective, intellectual school of sculpture was strictly confined to the great cultural centres of the south, and before pursuing its manifestations into the eleventh century, it is necessary first to turn back again to the more robust and extrovert sculpture of the Scandinavian north.

<div align="center">★</div>

The most curious and inexplicable phenomenon in the Danelaw area of the early eleventh century was undoubtedly the emergence for a brief period of three-dimensional naturalistic animal sculpture. Nearly contemporary with the mannered contortions of the Jellinge animal style at Levisham (Plate 18c), and with the even more elaborate Ringerike style that was to follow, a sculptor in central Yorkshire stumbled upon the practice of representational art. The type of monument that he carved appears to be the representation in solid stone of the pagan practice of erecting a house of the dead. The 'hog-back' roof line, which gives these monuments their name, follows the natural constructional method for building a long low hut, while the imbrication ornament that so often covers the top of these blocks is obviously a vestigial relic of the original shingled roof. Examples showing ninth-century vine-scroll, as at Dewsbury, Yorks., indicate that this type of funeral monument dates back to before the Danish invasions and is indigenous to Yorkshire. In the late tenth or early eleventh century, however, a sculptor at Brompton in the North Riding of Yorkshire radically altered the type by placing at either end a large three-dimensional muzzled bear, clutching at the roof with his paws (Plate 20B). Beasts' head terminals were a commonplace of metalwork in this period from Ireland to Denmark, but without exception they show the mannered idioms of the age. These remarkable Brompton carvings must therefore be treated as a more or less freak adventure in art, out of the main line of sculptural development and hopeless of posterity.

The main feature of eleventh-century sculpture in the north was the persistence as a dominant element, though in a highly degenerate form, of the Anglo-Saxon cross styles whose lingering survival was noticed in the tenth century. The layout of panelled faces and vine-scroll sides persisted, for example on a cross at Leeds, Yorks., though the treatment continued to deteriorate.[19] The interlace became heavy and irregular, the vine-scroll a mere flat coil of rope, the human figures crudely incised dolls. The sculptor now lacked the capacity for either the humanistic forms of the classical tradition, or the abstraction of barbaric art, and his hand was incapable of executing even the feeble concepts that occurred to him. Moreover, the elaborately worked-out propaganda pieces of earlier periods, such as the Ruthwell cross, had now given place to crosses whose subject matter had ceased to illustrate any didactic theme or even to tell a story. The artistic degeneracy of these northern English works of the eleventh century was thus paralleled by an equally serious intellectual collapse. There is not a single work of art of this period that shows a

rationally conceived plan worked out to its logical conclusion. The lack of mental concentration that is characteristic of primitive peoples is reflected in scraps of interlace tailing off into space, in figures half finished and inserted erratically in the midst of vague wandering abstract patterns, in incongruous jumbles of Christian saints and pagan heroes.

On one occasion, however, the violently barbaric tastes of the age were adapted to the old cross traditions to produce a work of some importance. At Shelford, in Nottinghamshire, there is a mid-century cross-shaft panelled in the usual manner, the edges being ornamented with the normal interlace and scrolls. On the faces are cut arched recesses with beaded surrounds, in which are projecting carvings of the Virgin and Child and a bearded Seraph (Plate 22B). Although the relief is an inch deep this has not been used for any genuine attempt at modelling, but merely to enable figures to stand out the better from their background. The Virgin, whose voluted halo shows the connexion with the cross at Leeds, Yorks., is given an appearance of great height and dignity by the use of parallel drapery folds handled in bold sweeps. The conventional incisions seen at Leeds are now used to great dramatic effect by grouping them and throwing them across the face of the sculpture. Similarly the seraph with his symmetrical stylized beard and clothes is given force and significance by the towering wings that rise above him. Using the conventions of his age, the sculptor at Shelford has produced a work of real artistic significance.[20]

Lastly there are the genuine primitives whose date is utterly uncertain but which seem to fit somewhere into this confused eleventh-century picture. The vast majority are crude and ugly. But at Buckland Newton, in Dorset, there is a tiny fragment of figure carving that is more reminiscent of Africa or Melanesia than of English art as we are familiar with it (Plate 22A). Each feature of limbs, body, face, and drapery is treated as an isolated unit exaggerated or compressed at will to suit the overwhelming needs of formal composition; nose, eye, and eyebrows are merely elements in an ornamental system. The abstraction of barbaric art can go no further unless it is to decompose completely. There is no surviving piece of sculpture extant which better typifies the demonic element that was still a latent influence in eleventh-century England than this sinister totem image. Taken together with the dozens of fertility carvings built into village churches, particularly in the west midlands, in the late eleventh and early twelfth centuries (of which one even represents a grotesque phallic parody of the Deerhurst angel),[21] it is not unreasonable to suggest that this carving is an expression of a paganism that lingered on below the outward Christianity of eleventh-century England.

The dominant Scandinavian style of the first half of the eleventh century that superseded the clumsier Jellinge work is known as Ringerike from the stone quarry in south Norway whence came a number of its most typical monuments. It is a style that was equally popular in Scandinavia and in southern England, where it flourished under the Danish royal dynasty of Swein and Cnut. It thus became the current style of the new conquerors in a way that was never the case with Jellinge, the art of the ultimately defeated invaders. The main feature of the new style was the introduction of foliage in the shape of elongated twisted leaves into the familiar animal sculpture of the 'great beast' and 'ribbon' types. There is no room for doubt that this foliage was derived from the overflowing acanthus borders of Anglo-Saxon manuscripts in the 'Winchester' style. For

the first time since the Danish invasions, nearly two centuries before, the best artistic traditions of the two races began to act fruitfully upon one another. At first the introduction of foliate frills did little to lighten the clumsy woodenness of the Jellinge great beast. As was seen at Levisham (Plate 18c), it merely added a touch of incongruity into an otherwise stiff and awkward piece of sculpture. But far more important than this foliage was the acquisition by the sculptor of the skill and delicacy of the manuscript artist. The wind-swept qualities that were seen in Winchester illumination in the early eleventh century were transmitted to the worker in bone, metal, and stone. In this last medium is to be found the finest example of late Viking art in either England or Scandinavia, the oolite tomb slab in memory of Toki from Saint Paul's Churchyard, London, which probably dates from about the 1030s (Plate 23).[22] Originally highly coloured, this two-foot slab is carved in the shallow quarter-inch relief of Jellinge art. But in place of the clumsy figures of Levisham, there is now a taut, excited scene of combat. The composition is a careful study in elaborately controlled curving lines, and elongated writhing tendrils. Exaggerated emphasis is placed on the great joint spirals, the long ear lappets, and the curving feet of the stag, while the body of the dragon has become little more than a mass of rolling spirals. It is this lively agitation – an agitation that increased as the style developed – that gives Ringerike its most distinctive stamp. In its late and most fantastic form of about 1050, as on a bronze plate from Winchester, the animal form disappears entirely, leaving only a composition of lobes, tendrils, and eccentrically swirling lines in which can vaguely be detected the limbs, eye, and ears of the decomposed animal.[23] It is clear that this style was not reached without influence from some source quite different from that of the Winchester manuscripts which first provided the leafy tendril element in the composition, and it has been suggested that Russian and Hungarian works of art passed through the Viking centre of Kiev to Scandinavia to play their part in this development. This suggestion is supported by actual finds in Swedish graves and provides a very reasonable explanation of the rapid evolution of so highly mannered and perfected a style.

Only scanty evidence is available to demonstrate the action of this Scandinavian art back upon Anglo-Saxon sculpture and manuscripts, and these cases must be regarded as exceptional.[24] Artists trained in the tradition of the Saint-Omer ivories had little use for the abstract fantasies of the Guildhall stag, for the two races were each striving after mutually incompatible aesthetic ideals. In the early eleventh century England was ruled by a series of Danish conquerors, thanks to whose patronage the Ringerike style flourished in the London area. Nevertheless there is strong evidence to show that Cnut appreciated, or at least respected, the artistic achievements of the Anglo-Saxon illuminators, since the manuscript that he presented to the New Minster in 1020 was in the purest Winchester style. It was clearly thanks to this attitude of the King, if not of his Viking courtiers, that Ringerike made so little impression on sculpture in the south.

★

Of the series of figure carvings in stone which are among the great achievements of early eleventh-century southern art, now only a handful remain intact. In conformity with that morbidity which has already been noticed, the two favourite themes were those of

Christ on the Cross and the Harrowing of Hell. Following up the beginning made at Bradford (Plate 20A), the sculptors proceeded to use the walls of churches as frames in which to insert these great pictorial compositions. Of these the finest that has survived the hammer and chisel of the iconoclast is the seven-foot slab in Bristol Cathedral (Plate 24). The figures stand out against a deeply scooped background, reminiscent of that of the Shelford piece (Plate 22B), the drapery details and features being merely incised upon the flat surface. The treatment is in the quieter Winchester manner. The profile of the figure within the jaws of Hell is highly characteristic in the single sloping line from forehead to nose, and Christ retains much of the buoyancy of the angels on the ivory panel, the towering figure appearing to flit lightly across the mouth of the Dragon. At the same time the twisted face of the soul in Hell and the upward stretch of the two figures that are saved give this carving that emotional poignancy which has already been commented upon. As the nearest manuscript parallel for the figure of Christ which can be ascribed to about 1050, it is likely that this Bristol slab was carved only a very few years before the Conquest.[25]

The two other important sculptural set pieces of the first half of the eleventh century are now mere battered fragments. Of one, however, at Braemore in Hampshire, enough survives to hint at the loss that English art has suffered. Here the tragic drooping pose of Christ on the cross has become yet more accentuated, the body sways limply from the nails, the head droops upon the breast, while by a strange stylistic mannerism the arms curve upwards and then sweep down once more in long sagging hands. Body, arms, and head all form a composition of drooping curves to build up a sense of pathos and tragedy.

In these curiously long and drooping hands we can first detect a new influence in English art, coming from the Ottonian Empire. Here peace was secured under a series of capable monarchs, contact was re-established with Byzantium, and an artistic renaissance took place under the leadership of a number of the higher clergy, whose great wealth gave them ample means for patronage and whose zealous cultivation of the arts rapidly created new and flourishing schools of craftsmanship. Of these the most important was Bishop Bernward of Hildesheim, whose bronze doors and candlestick made for his cathedral in the first decades of the century are the outstanding products of this new cultural centre. It has been the practice of certain art historians in recent years to solve the complex problems of late Anglo-Saxon art by ascribing everything to direct Byzantine influence. Such dogmatic assertions seem to be the result more of an act of faith than of a scientifically demonstrable argument, and they have not advanced the proper study of the subject. That Byzantine iconographical influences were strong in eleventh-century England there can be no doubt whatever. But all the evidence suggests that these factors were limited in the scope of their effect upon existing Anglo-Saxon traditions, and that they penetrated the country mainly through the medium of this 'Hildesheim' art of Germany. Commercial and political connexions between the Ottonian Empire and Anglo-Saxon England were close, and the Emperor Otto I married Eadgyth, the sister of King Athelstan. As the century wore on, more and more English bishoprics were filled with Lotharingians who would naturally bring with them the tastes of their native land. Contemporaries are at pains to record this artistic connexion, referring to the rood erected in Beverley Minster

in the 1060s as of German workmanship; explicitly drawing attention to Bishop Bern-ward of Hildesheim's study of insular art; and stating that the famous English needlework was taught by German craftsmen.[26] The closeness of the connexion becomes apparent when it is discovered that certain iconographical types such as Christ upon the naturalistic tree-cross are shared by both countries,[27] and that certain works in metal can be ascribed with almost equal probability to either English or German provenance. Thus those remarkable drooping hands of the Braemore Christ derive from a similar mannerism found in both illuminations and ivories of the Ottonian German school.[28] But the exag-geration of the gesture is very significantly English. The main features of this Ottonian influence, apart from the introduction of new iconographical scenes, were a more frigid and less exciting handling of the human figure and of draperies than was natural even to the quieter Winchester manner, and the introduction of a new type of acanthus scroll within which climb athletic little men with prominent eyes.

The most convincing example of this new iconography is the little crucifixion panel at Romsey, Hants, whose composition can be almost exactly paralleled by a Byzantine ivory. Here a tall cross with cherubim above the arms supports a rigid, straight-armed, symmetrical Christ deprived of all the emotional implications of the Braemore type. On either side are the usual figures of Saint John and the Virgin, and below are Longinus and Stephaton in energetic attitudes. The vigour of posture and the waving acanthus tendrils both mark the work off from the Byzantine prototype and suggest comparisons with the later Winchester style in England and the bronze doors of Bishop Bernward at Hildesheim.[29]

Apart from these carvings, which are generally admitted to belong to this pre-Conquest Wessex group, there are others whose date is still vigorously disputed. Two of the most important are the crucifixion scene with Saint John and the Virgin at Langford, Oxon, and a life-size crucifixion at Romsey, Hants. The latter has the body carved from a single block in very high relief (Plate 21). Christ is depicted in solemn hieratic pose with the body almost completely vertical, while the *dextera Dei* emerges from the clouds above. The body is carved with a strong plastic sense, and an adherence to natural proportions, while the loin-cloth with its central fold hangs close to the flesh and makes no attempt to conceal the outlines of the thighs. But this does not seem to be the same as the mid twelfth-century 'damp-fold' style, with which Sir Thomas Kendrick would associate it, and although it is certainly reminiscent of some of the sculpture on the Lincoln front panels, it can also be found in pre-Conquest ivories. The main arguments for a twelfth-century date are the heavy plastic feel of the sculpture, the high relief, and the total absence of 'Winchester' lightness of touch. But manuscripts such as British Museum Arundel 60 show a wooden effect with rigid central pleat far more ponderous than the Romsey rood, and certain German ivories have the same full modelling, stiff pose, and hand of God above.[30] Furthermore, this use of the *dextera Dei* seems to be an exclusively pre-Conquest iconographical fashion, and the concept of the isolated panel bearing no relation to the architectural frame of the building was natural to the Anglo-Saxon, but alien to the twelfth-century builders. The most convincing argument of all is that the panel is evidently not in its original situation, but is set in the mid twelfth-century wall

of the south transept. As such it must be the work of many years earlier, and may well have been situated over the chancel arch of the original Saxon church. Thus it seems probable that the Romsey rood is the stone sculptor's version of ivory and manuscript work of the first half of the eleventh century rather than an outstanding example of the southern tympanum style of the mid twelfth century.[31]

The principal difficulty about accepting an early eleventh-century dating for these pieces of monumental figure sculpture is that it postulates an extraordinary precocity for English art. Early Romanesque sculpture as it emerged slowly and painfully in the late eleventh century on either side of the Pyrenees evidently owed nothing to these remarkable English achievements. Therefore if we accept this early dating we are obliged to emphasize a cultural isolation thanks to which England evolved a technique of figure sculpture which had to be worked out all over again by Europe half a century later. Our knowledge of late Anglo-Saxon England hardly justifies any such assumption of isolation, and yet the weight of evidence in favour of an early eleventh-century date, at any rate for such works as the Bristol slab and the Braemore rood, seems utterly overwhelming. Here is a dilemma that remains unresolved.

Contemporaries were agreed that the most striking contribution of the Anglo-Saxons to eleventh-century art was in the fields of metalwork, jewellery, and ivories. The wealth that successive monarchs had showered upon the great monastic houses enabled them to adorn their churches with quantities of work in precious metals, rivalling anything that could be undertaken elsewhere in western Europe. Indeed this capital wealth, when coupled with political weakness, was one of the factors that caused the Norman invasion. But the artist who wishes his works to come down to posterity should eschew the use of precious metals, the temptation for subsequent authorities to melt them down being normally too great to be resisted. Our knowledge of Anglo-Saxon art in these fields is therefore derived mainly from inventories of things long vanished, and from the delighted observations of the plundering conquerors. For example Ely alone in this half-century was given, among other things, four female saints in silver, a gold crucifix, a silver crucifixion, a silver-plated crucifix with a life-size image of Christ, and bronze figures of the Virgin and Saint John.[32] Similar records of works of extraordinary richness and great size come from Peterborough, Exeter, Winchester, and elsewhere. William of Poitiers, the chaplain of the Conqueror, became quite lyrical in praise of the loot brought back to Normandy: 'Transiret illac hospes Graecus aut Arabs, voluptate traheretur eadem.'[33] But of all these riches hardly a fragment has survived. Two objects have come down to us and they must serve to give an inkling of the splendour of material, the varied ingenuity of craftsmanship and the aesthetic qualities of the Anglo-Saxon artists in the last decades before the Conquest.

The first is the well-known reliquary cross now in the Victoria and Albert Museum, which displays a walrus ivory figure upon a gold filigree cross with enamel medallions (Plate 25). Owing to their similarity to other work which has survived in Germany, it has been argued that the golden background and the enamels are of continental origin.[34] On the other hand the enamels have features which link them to the evidently English Alfred Jewel – notably the little tendrils curling in from the frame, and the use of red spots as

decorative fillings; moreover, an exact parallel to the filigree background and the use of green enamel as a background to the lettering is found in the Pierpont Morgan book-cover (Plate 26), whose English provenance is likely on historical grounds. The hypothesis that this cross is an English ivory on a German background is therefore not proven, and it may well be of wholly English workmanship. The ivory figure of Christ so closely resembles manuscript illuminations of the Winchester school of 980–1000 that its provenance has never been in doubt, though, owing to the uncertainty of the time-lag to be allowed between manuscript and ivory styles, a precise dating cannot be given to it.[35] All that can be said is that it must have been worked some time between about 990 and 1030. Christ is handled in the quieter Winchester manner: the arms are almost straight, the ribs do not show, and the legs are firmly and symmetrically placed upon the *suppedaneum*. Nevertheless the droop of the head, the tragic expression of the face, the twisted locks of hair and the knots and swirls of the drapery contrive to give the figure the life and grace and the touch of morbid introspection that were the characteristically English contributions to the art of the age.

Since it was metalwork for which the Anglo-Saxons were perhaps most famed, it is fitting to conclude this survey of pre-Conquest art with some indication of what they could achieve in this medium. The disintegration of late Anglo-Saxon society was greatly assisted by the polarization of the thegn class by the system of commendation around two or three families, of whom the greatest was the house of Godwin. From the point of view of art history, the significance of this phenomenon was the great opportunity for patronage provided for the leading members of these aristocratic houses. They possessed the necessary wealth, and the ramifications of their influence enabled them to draw upon the services of the finest artists in the country. And when Judith, the daughter of Baldwin V of Flanders, married Earl Godwin's son Tostig, just such a patroness was provided. Among other works of art which were executed for her was a manuscript which is now in the Pierpont Morgan Library,[36] the cover of which is made of silver and gilded metal (Plate 26). The background is covered with gold filigree, upon which are two figure scenes also in gilded metal: Christ in a mandorla, supported by seraphim, above a Crucifixion of the expressionistic type with a twisted body dangling from the nails. The effect of the whole is one of dazzling splendour, of green enamel and gilding, and of a lavish ornamental profusion. Indeed it is perhaps over-ornate, over-fussy in the multiplicity of decoration. The wig-like hair and sullen chinless faces are both features of the manuscript illuminations of the period, and are to be found in contemporary Anglo-Saxon metal-work such as the cruet now in the British Museum,[37] but the stiff draperies of the Christ in Majesty and Mary and John do not seem to have any obvious manuscript parallel.

<p style="text-align:center">★</p>

This survey of Anglo-Saxon sculpture before the Conquest ends on a note of luxury and splendour in material and skill in the minutiae of craftsmanship. The story for three hundred years has been one of a perpetual struggle between the barbaric, abstract tastes of the native Anglo-Saxon and humanistic impulses from the Mediterranean. Of the three great waves of influence, the Levantine in the late seventh century, the Carolingian

in the late eighth and early ninth, and the 'Winchester' styles of the late tenth and early eleventh, only the last achieved permanent results. In the last century of Anglo-Saxon England monastic and aristocratic patrons obtained from their craftsmen works of art that were distinctively and unmistakably English and yet which embraced the best that the Continent had to offer. The artists of no other country responded more readily to the revival of late antique impressionistic art than did those of England. The English version of the Utrecht Psalter was wilder and more imaginative, the drapery more storm-tossed, the gestures and posturing more mannered and exaggerated, the background more un-ashamedly romantic than that of the school of Rheims. Handling of the acanthus decora-tive *motif* by the Winchester school was equally extravagant and irresponsible. At the same time the haunting melancholy, the preoccupation with the fires of Hell and the torments of the Crucifixion, though shared with German contemporaries, was perhaps most strikingly apparent in the Anglo-Saxon world and was destined to become a feature of English medieval aesthetic psychology. What is perhaps most impressive of all is the determination to break away from the solemnity of so much Carolingian, Ottonian, and Byzantine art. Anglo-Saxon sculpture and manuscripts were frequently imbued with a vitality, an eccentric individuality, that its continental models lacked, while in miniatures was first developed that irrepressible taste for caricature which is the most lasting and perhaps the only English tradition in literature and in art, evidence for which can be traced back in unbroken sequence for a thousand years.

It would be rash, however, to claim too much for the Anglo-Saxon sculptor. The greatest achievements of the period were not in sculpture, but in the illuminated pages of the vellum manuscript. In the hands of the calligrapher this exuberant enthusiasm resulted in works of supreme beauty, but in the three-dimensional medium of sculpture it was undoubtedly less successful. The disregard for the shape and size of the allotted space, the habit of throwing figure work profusely in a disorderly array upon an unsympathetic background, the tendency to overstep the limits of the frame, were weaknesses that detract from ingenuity of design and skill of craftsmanship. Great sculpture must be used in harmonious conjunction with the architectural setting. For the isolated monument, even the free statue in the round, must fit the architectural surroundings, if it is perfectly to succeed. As long as sculpture remained confined to minor *objets d'art* or isolated cross shafts and grave slabs, it was bound to remain subordinated to the art of the calligrapher. Only the advent of the Normans and the rigid welding of sculpture to architecture that characterizes the full Romanesque period made limited emancipation possible. Secondly, sculpture must be designed with a strict regard to the limits of the frame. With the excep-tion of the designers of the two great crosses of Ruthwell and Bewcastle, the Anglo-Saxons were almost totally unaware of this conception. Usually they were content to throw their sculpture on to crosses, panels, friezes, and wall spaces without regard for the suitability of the space. If necessary, the scenes were twisted and bent, human figures were squeezed in sideways to fit the frame – as in the Franks Casket – and odd spaces left over were filled up with snatches of interlace or other decorative patterns. It was the achieve-ment of the twelfth century to develop the principle of the relationship of space and its content, so that the awkward shape of the semicircular tympanum was filled with

E

sculpture that perfectly fitted the frame, and the pillar statues and the sculpture of the capital were both made to serve a strictly architectural purpose. Finally the growing intellectual order of the twelfth century tended to replace the haphazard iconographical choice and casual juxtaposition of disconnected scenes that characterized so much of the sculpture of the Anglo-Saxons. It cannot be denied that the liberty of the Anglo-Saxon sculptor was his greatest virtue. But it was also a source of temptation that not infrequently degenerated into licence, and the new age was to provide that intellectual and artistic discipline which the Anglo-Saxon lacked. The result was part gain, part loss.

PART TWO

ROMANESQUE SCULPTURE

CHAPTER 4

THE EARLY NORMAN PERIOD

⟨CIRCA 1066–1120⟩

IN 1066 political events intervened dramatically to curtail the remarkable productivity in southern England of large-scale sculpture and tiny esoteric *objets d'art* in metal and ivory. Although it has for some years now been the fashion to minimize the significance of the Norman Conquest, both in the political and the cultural fields, there can be no doubt whatever that it must remain as the most important single event in English medieval history. In the course of four years an alien ruling class some 6000 strong established itself securely in control of the wealth and institutions of Anglo-Saxon England. In such positions they were enabled to dictate the type of art and architecture that they desired, and it is this abrupt change of the patron class that is the most significant artistic feature of the Conquest. For the Normans, unlike the Anglo-Saxons, were not aesthetically a strikingly gifted race. They were above all the technocrats of Europe, hard-headed and capable soldiers and administrators with a genius for the adaptation of existing institutions. As such, the decorative arts interested them but little. Quantity was more important than quality, intrinsic value more prized than aesthetic merit, architecture of greater significance than sculpture or painting. Much of their immediate contribution to English culture was consequently destructive, with the sole but supremely important exception of the will and the technical and financial ability to construct huge architectural works in stone. The choir and transepts of Durham form the most characteristic memorial to the new conquerors, both as a symbol of power and a remarkable achievement in engineering technique. Their aesthetic merit is very largely the natural by-product of their functional utility.

This alteration in the taste of the patron class was made all the more important by the completeness of the change of personnel in all the higher ranks of society. All over the country the many petty Anglo-Saxon thegns were replaced by fewer and therefore richer Norman overlords. These new lords were no longer content with the modest timber church and the stone cross. They demanded, and in the south could soon pay for, solid, imposing, well-constructed churches in stone. That these buildings should be bare of decorative ornament, that the Anglo-Saxon cross shafts should be broken up and used for walling, was a matter of indifference to them. Hardly less important than this change in lay patrons was the replacement of Anglo-Saxons by Normans in the great monastic houses. These splendid institutions with their immense capital accumulation in treasure,

their revenues amounting to about one-sixth of the total wealth of the kingdom, and their art schools in the scriptoria, were, as has been seen, the main centres of artistic activity in pre-Conquest England. By 1089 there was not a single English abbot left in the country and more and more of the monks themselves were being replaced by Normans. It is hardly surprising therefore that manuscript illumination virtually ceased in England in 1066, and when it picked up again in the late 80s or 90s, it was either the work of Norman scribes or under powerful Norman influence. But Norman illumination before the Conquest was itself strongly affected by Anglo-Saxon style, so that the new Anglo-Norman manuscripts provided some continuity for pre-Conquest art. Anglo-Saxon traditions survived by their prior permeation of the art of the conquerors.[1]

Perhaps the most significant long-term effect of the Conquest was to wrench England once and for all out of the Scandinavian orbit, and to link her indissolubly to Rome and western Europe. Both politically and artistically there was just a possibility in 1066 that England would form part of a North Sea cultural unit and would cut herself off, like Norway, from the main stream of European history. By creating a cross-Channel Empire, the Norman Conquest turned England's face firmly towards France and, beyond France, Rome and Byzantium. The great Archbishop Lanfranc tightened the discipline of the English Church, introduced the teachings of the new Canon Law and opened English monasteries to the influence of continental Benedictine art and learning. Such success, however, was only won at a cost – the price being the greatest material devastation of the countryside that England has ever suffered. In order to deprive any Scandinavian invaders of their potential allies, large areas of northern England, and particularly the Vale of York, were systematically laid waste. It was not till the turn of the century that the north had recovered sufficiently to play its part in the economic and artistic life of the country.

★

From these general observations upon the main social and political consequences of the Norman Conquest, it might be expected that all continuity of Anglo-Saxon or Scandinavian traditions would be broken. But this was not the case. Abrupt dichotomies tend to exist more frequently in history books than in real life, and the institutions and artistic traditions of a conquered nation have often proved remarkably persistent. Sculpture, in so far as it was practised at all in the first forty years after the Conquest, tended therefore to draw much of its inspiration from the older sources, if only because of the relative barrenness of the Norman contribution to the plastic arts.

One of the most surprising features of this survival was the persistence right up to the turn of the century of Scandinavian tastes. Politically highly successful in defending their new conquests, the Normans failed to keep out the art styles of their rivals for the prize. Scandinavia in the early eleventh century was dominated, as has been seen, by the Ringerike style, whose finest expression in England is the superb Guildhall stag (Plate 23). Later on, however, there was introduced a further modification into this already strained and stormy interpretation. The still recognizable body of the great beast became a thin elongated ribbon, while the sprouting Ringerike tendrils became longer and thinner and curved in sinuous asymmetrical patterns around and about the serpentine body. This new

'Urnes' style is in fact a fresh emergence of an old taste, a reversion in a new manner to the ribbon-style art of the pagan world four centuries before, but achieved not by a revival of those old forms but by a sinuous elongated extension of the familiar theme of the great beast and its enemies. No other style of barbaric art better displays the love of linear pattern and the genius for composition in writhing and twisting curves that roll and sway in eccentric abandon across the field of decoration. For boldness of design and a capacity for creating emotional excitement by mere linear virtuosity, the gable panels of the wooden church at Urnes in Norway stand second to none. Scandinavia was not alone in experiencing the urge to adopt this new manner, and before 1100 it may be seen modifying and enlivening previous styles in Irish ecclesiastical metalwork. A number of metal objects found in England demonstrate the popularity of the style in this medium in the early Norman period, and while most of these works are of poor quality, a brooch found at Pitney, Somerset, serves to convey a not inadequate idea of the swirling rhythmic qualities of the treatment at its best (Plate 28B). The theme is still the ancient one of the combat of the great beast and the serpent, though by now both animals have all but vanished into curving sweeps of pure pattern. But the joint spirals of the great beast, the vertically viewed head of the serpent, and the curling mouth lappets survive to provide unmistakable evidence of origin.

Urnes was not a mere imported style, but a manner that could affect any native tradition with which it came in contact. That as such it played an important role in English art in the last half of the eleventh century is proved by its appearance upon a number of monuments of the first rank. Of all the ruthless administrators of the reign of Rufus, none could rival Ranulf Flambard in ability or cynicism. An archetype of the new patron, later one of the builders of the great cathedral at Durham, Flambard himself encouraged Scandinavian art to the extent of having his pastoral staff decorated with a design in niello inlay in a highly mannered English version of the Urnes style, which seems to be a modification of the Anglo-Saxon manuscript initial.[2] It may well be therefore that this barbaric art made an appeal at the court of Rufus and in consequence achieved a degree of popularity that it would not otherwise have won.

However this may be, it certainly succeeded in imposing itself upon a few pieces of large-scale sculpture evenly distributed to north and south of eastern England. Thus at Jevington, in Sussex, there is a three-foot slab of Christ triumphing over the beasts (Plate 29B). Itself a pre-Conquest theme that can be traced back to Ruthwell, the figure of Christ is executed in the heavy, deeply cut manner of rustic work of the early twelfth century, and is lacking in artistic distinction of any sort. The dragons, on the other hand, are alert and fiery creatures of barbaric imagination. The one on the left, though solidly constructed, has a taut vitality of its own imparted by the body slant, the twisted neck, and the huge staring eye. It is a thing of life and spring, perched upon a platform composed of swirling coils from its own tail and hindquarters that owe everything to Urnes influence. On the other side of the straight, column-like legs is a pure Urnes composition in which the great beast has all but dissolved into the surrounding coils, and the serpent is a mere sinuous band. Of the original animal there have survived only the head and eye, and the double contours that still follow the ribbon body.

A similar mixture of stylistic influences may be observed in the midlands' Danelaw, where at Southwell and Hoveringham, Notts., are tympana which are both strongly affected by Urnes. The Southwell tympanum (Plate 29A) is of an earlier date than the Jevington slab since it was cut down and re-used in the early twelfth-century building of the Minster. The relief depicts two combat scenes, David and the Lion on the left, Saint Michael and the Dragon on the right, while the under edge has independent strips of interlace and foliate scrolls. The Anglo-Saxon contributions to this piece of sculpture are David and Saint Michael, the one a little kneeling figure with frilly skirts, the other a delicate and elegant creature holding a tiny circular shield of the Utrecht Psalter pattern, and whose draperies splay out in a fan, characteristic of Anglo-Norman manuscripts of the period.[3] But these figures are overshadowed by the dynamic representation of the dragon, the curving loops of whose writhing body fill up a full half of the slab. There can be no doubt that this dragon with its curving nose lappets and the thin Urnes loops that enfold and enmesh the tail and hindquarters was the subject that most attracted the sculptor. The contrast between the stiff tapering rod of a tail and the loose curling bands around it creates a formidable sense of power and tension. The puny figure of Michael with his absurd little shield seems defenceless before this monster conjured up from the pagan deeps of barbaric art.

But this sinuous and dramatic style of linear carving failed to survive the flood of Benedictine manuscript influence which dominated southern England after about 1110–1120. Urnes style is remarkable for its lack of influence upon manuscripts, which suggests that its contacts with the learned world of the monasteries were weak. As will be seen, Viking art had some influence upon English sculptors in the first half of the twelfth century, but it is noticeable that it took the form of a harking back to the earlier Ringerike style. This throwback can be explained by the dominant role of the manuscript in providing the patterns for the sculptor of the period. Libraries were full of eleventh-century manuscripts influenced by Ringerike, but contained nothing that could suggest Urnes designs.

Consequently in the new sculptural schools of the second quarter of the twelfth century, there is, with one exception, no piece of carving which shows signs of the Urnes style of a few years earlier. The exception, significantly enough, comes from Norwich, the centre of an area of predominant Scandinavian settlement, where a capital from the cloister, datable to as late as about 1140 (Plate 49A), shows a sharply defined pattern of thin sinuous dragons amid loose coils of voluted bands, which unmistakably recalls the metalwork style of the Pitney brooch (Plate 28B). Here in East Anglia it seems likely that this Urnes fashion had been kept alive in wood-carving, all of which has now completely disappeared.

<div align="center">*</div>

It thus appears that Scandinavian artistic influence persisted, and even won court patronage, for at least half a century after the Conquest. The question of direct continuity of Anglo-Saxon tradition in figure sculpture of the south presents more intractable problems. It is true that the very numerous examples of figure sculpture on fonts and tympana of the first half of the twelfth century are nearly all concentrated in the west midlands,

which suggests some continuity of technical training. On the other hand, such a conclusion should not be pushed too far in view of the fact that the area of concentration also co-incides with the geological formations that provide the most readily worked stone for such carvings, and that these carvings show little sign of the virtuosity of pre-Conquest work. The Norman architects did not feel the need for sculptural adornment of their huge new cathedral buildings, and it would seem that the local styles of the pre-Conquest period must have faded away into the naïve carving of rustic fonts and tympana.

There is one case in which the source of an Anglo-Saxon revival may have been sculp-ture rather than illumination, and this is a loose capital now in the choir of Hereford Cathedral, carved about 1115.[4] It may well be inspired by the Harrowing of Hell of the great Bristol slab, with all the early features of hunched shoulders, scooped-out back-ground and even a somewhat congealed little drapery flutter. But this is exceptional, and normally pre-Conquest traditions made themselves felt in twelfth-century sculpture by their success in influencing the art of the manuscript illuminator. The tests of Anglo-Saxon influence must be signs of the elongated buoyancy of figure style, the characteristic twisted neck, hunched shoulders and straight profile of the face, or alternatively evidence of the survival of acanthus foliage in its disorderly 'Winchester' manner. These features survived in varying degrees in the new Anglo-Norman manuscripts of the 90s, illuminated at Durham, Exeter, Canterbury, and probably elsewhere. And with them were incor-porated the Norman elements of thick fleshly acanthus scrolls and a more squat and solid figure style. Any discussion of pre-Conquest stylistic survivals in sculpture involves therefore an examination of works executed under the influence of these Anglo-Norman manuscripts.

Such evidence of continuity may be seen on a tympanum at Moreton Valence in Gloucestershire, which in thin outline manner depicts Saint Michael fighting the dragon (Plate 30A). The subject is treated not as a dynamic conflict, but as a purely static study in formal pattern. Saint Michael is a slim figure with a little drapery flutter under his left arm, who leans lightly forward to rest a spear within the mouth of a dragon. The knobbly background is a well-known and ancient manuscript convention, and the knotted foliate tail of the dragon is a common device in manuscript initials before and after the Conquest.[5] Behind the dragon is a spray of thick foliage of the more substantial Anglo-Norman type seen, for example, in a Durham manuscript.[6] This tympanum is clearly a copy in stone of a late eleventh- or early twelfth-century illumination. The rocky background, the feet of the archangel overstepping the frame, the foliate spray and the splendid balance of the composition as a whole, the sense of ease and quiet grace, all betray the influence of the Anglo-Norman illuminator's art.

It is not only in sculpture in stone that this manuscript style of the late eleventh and early twelfth centuries made itself felt. At the home of one of the most striking of this group of manuscripts the metalworker also borrowed from this source. On the north-west door of Durham Cathedral there still hangs what is probably the same bronze knocker that was placed there when that section of the building was completed, which was at least before 1133 (Plate 28A). The knocker takes the form of a cast bronze interpreta-tion in three dimensions of those savage dragon heads that are characteristic of the initials

of the Durham manuscripts of Bishop Carilef, and which derive from similar pre-Conquest initials.[7] There is a solid, fleshly realism about the head, whose strongly marked eyebrow line, the curves and wrinkles around nose and mouth, the sharp little heart-shaped ears, and the long curling mane are all to be found in the manuscripts. But the transformation of the drawing into solid bronze without loss of the savagery and dynamic energy of the original, and the conversion of the mane into a flat halo surrounding the ferocious head, were technical and aesthetic feats of a high order. There has survived no other piece of English metalwork during the whole twelfth century that approaches this barbaric work in its perfect adaptation of design to material, technique and function. And that which gives it its finer qualities, the savage vigour and energy imparted by the flowing pattern of cheek and mane, owes as much to Anglo-Saxon influences passed on to the Anglo-Norman manuscript illuminator, as to the new sense of plastic values contributed by the continental artists.

At Highworth on the north-east borders of Wiltshire is a tympanum with the combat of Samson and the lion which in yet another manner shows clear evidence of Anglo-Norman manuscript traditions.[8] The lion with his huge eye, curling tail, and dramatic slant to the body recalls the creature writhing beneath the staff of Christ on the Jevington slab. Firmly astride the beast and wrenching apart his jaws is the cloaked and skirted figure of a beardless Samson in three-quarter profile. The sculpture is conceived not in flat outline as before, but in the deep two-plane relief with softly sloping edges characteristic of Anglo-Saxon sculpture in this area from the Bradford angels to the Bristol Harrowing. Evidence of manuscript influence is provided by the taut and highly schematic scroll border surrounding the upper edges of the tympanum. The manner in which the elongated leaves turn back and pass both before and behind the thick stem is very distinctive, and is only to be found on one or two examples of early twelfth-century Wessex sculpture.[9]

Surviving traces at Norwich, Ely, and elsewhere have made it abundantly clear that it was a common, perhaps a normal habit, to paint designs and scenes upon the plain cushion or scalloped capitals of the great cathedrals. One may suspect that in some cases the adherence to painting into the first decade of the twelfth century was caused by reasons of economy. The crisis in monastic finances resulting from the ruthless depredations of William Rufus and Ranulf Flambard probably led to a postponement of more elaborate sculptural decoration. Both at Ely and Durham there is evidence of a reversion to plainer and less accomplished work, which might be the result of financial stringency. By the first decades of the century, however, the earliest examples of post-Conquest figure sculpture on capitals were being carved, consisting of outlines in low relief to give added emphasis and depth to the painted scene. At Ely there are little animal or bird portraits closely resembling those on the edges of the Bayeux tapestry, while at Westminster there has survived a capital depicting the Judgement of Solomon which uses a slightly more developed technique (Plate 32B). The figure-work has none of the levity of the pre-Conquest style, though the twisted neck of the mother and straight line of brow and nose and the receding chin of King Solomon are direct survivals of the mannerisms of the Anglo-Saxon scribe. This capital is indeed a reflection of the somewhat wooden figure style of Anglo-Norman manuscripts on both sides of the Channel at the turn of the century,

and is closely paralleled by the Bayeux tapestry.[10] Still basing themselves on contemporary manuscripts, sculptors elsewhere developed a greater subtlety of composition and drapery detail, as may be seen on capitals high up over the crossing at Southwell, Notts, which are firmly dated at about 1109–14 (Plate 30B). They bear a complex iconographical system of scenes from the life of Christ, whose explanation may lie in their relationship to the liturgy. They are carved in very shallow relief on the flat surface of volute capitals with huge projecting lobes, a distinctive feature of early Norman work. One capital has fumbling, irregular Scandinavian strapwork within which are birds of the Bayeux tapestry type. The figure sculpture with the clumsy hands, three-quarter facing attitude, and many of the drapery details, is very similar to that of the Hereford capitals.[11]

The Anglo-Saxon tradition in post-Conquest sculpture does not end with these monuments of about 1110–30. A generation later, southern England seems to have seen a conscious revival of the more characteristic features of the 'Winchester' figure style, which combine with obviously late Romanesque elements to provide a remarkable and most surprising mixture of old and new. Although the few surviving monuments of this mixed style contain distinctively late features of the second half of the twelfth century, it seems more appropriate to include them in this chapter. It is important to emphasize, however, that there can now, nearly a century after the Conquest, be no question of continuity of sculptural tradition. These works embody deliberate archaisms derived from a renewed study of Anglo-Saxon manuscripts in monastic scriptoria. They signify a revival, not a continuing tradition.

At Water Stratford, near Buckingham, there is a tympanum in very shallow relief depicting Christ in a mandorla supported by angels, above a lintel ornamented with an interlacing arcade against a diapered ground. This diaper background, coupled with work of similar style on another tympanum in the same building, shows conclusively that this tympanum cannot have been carved much before the middle of the twelfth century. But the capitals, with their loose straggling interlace ending in animal heads and little tail-knot terminals, are direct descendants of initials in Anglo-Saxon manuscripts, only the pelleting being a new Anglo-Norman device. Similarly the huge angels with their upward-straining necks and tense linear posturing are quite unlike the more monumental figures of conventional twelfth-century style, and unmistakably recall identical dramatic poses in late Anglo-Saxon work. On the other hand their drapery has lost the agitated flutter of pre-Conquest art and hangs heavily about the body, while the figure of Christ in Majesty could be a faithful copy from a contemporary manuscript, unusual only in the linear outline technique employed.[12] Here, therefore, we have a mid twelfth-century work by an accomplished artist free from all suspicion of rustic archaism or provincial conservatism, who in the capitals and the pose of the angels recalls pre-Conquest manuscripts, while his use of background diaper is in the latest continental style.

This harking back to pre-Conquest styles during the reign of Stephen is a curious phenomenon. The cause of such a throw-back is as yet without a satisfactory explanation, though the striking difference between the solemn Byzantinesque seal of Matilda, and the splaying Anglo-Saxon draperies of those of Henry I and Stephen, may indicate the influence of court politics and propaganda.[13] Did Stephen pose as the upholder of the

English traditions in order to win popular support, by contrast with the Poitevin Matilda who is known to have been responsible for the introduction of German and Byzantine artistic influences? It is significant that this revival of the Winchester style is not the only sign of a re-emergence of pre-Conquest ideas, for, nearly a century after the Conquest, more primitive elements seem to have reasserted themselves in the artistic life of the 1140s. In architecture the advanced Norman technique of vaulting was actually abandoned at this stage, and in sculpture, besides this revival of the Winchester style, there was a rejection of the plump acanthus scrolls of Anglo-Norman monastic art. In the Reading cloister there is a clear division between the scroll-work capitals and voussoirs which link up with southern monastic craftsmanship, and the adoption of the savage beakhead ornament and geometrical patterns of rosettes, cones, and semicircles. Here, at the most important artistic centre in the country, there occurred a sharp change in taste towards more barbaric themes. And it was by this return to primitive ideas in sculpture and architecture, and not by the occasional revival of the Winchester style in drawing, that the movement made its permanent mark on English Romanesque art.[14] For while these examples of pre-Conquest influences in Norman England are of great importance owing to their outstanding qualities, the subject has here been treated at a length which might lead to the loss of a proper sense of proportion. They are the rare isolated exceptions and not the best examples chosen from a multitude. Furthermore, as has been shown, they owe much of their quality to a survival of Anglo-Saxon influence in manuscript illumination, rather than to any direct heredity from pre-Conquest Wessex figure sculpture. These were not the works that replaced the massive sculptural tradition of the south or the shoddy but prolific mason's art of the north which adorned so many cross shafts right up to the Conquest.

<div align="center">*</div>

We must therefore turn from this pursuit of Anglo-Saxon influences in the twelfth century to see what was the contribution of Norman masons themselves to English sculptural techniques and repertoire in the first forty years after the Conquest. The main change was the extinction of the pre-Conquest tradition of using sculpture as an independent feature, either on the free-standing cross or as haphazard mural embellishment. Sculpture, in so far as it was encouraged at all, now became more functional and was subordinated to the major preoccupation of architectural design. It was not merely that the sculptor transferred his attention to capitals and tympana, instead of crosses and slabs, but that even here the design itself was made to conform with the architectural needs. In capitals whose purpose was to convert the circular pillar into the square abacus, the emphasis was placed upon high-shouldered protruding bosses at the corners which served to provide the maximum constructional support. On tympana the theme was similarly rigidly dominated by the need to fill a semicircular frame, and subjects were chosen which fitted naturally into such a shape.

To begin with, the Norman taste that imposed itself upon the conquered country in the 1070s was one to which sculptural ornament was almost entirely superfluous. Only the Cistercian builders of the late twelfth century and the ferro-concrete architects of the twentieth have produced works of major architectural importance so utterly devoid of

sculptural detail as the great naves and choirs of some early Anglo-Norman cathedrals. It must be realized, however, that the austere frigidity of the present-day appearance of these buildings bears little relation to their original condition, when walls, pillars, capitals, and arches were covered with a profusion of painted decoration in vivid reds, blues, and greens. Indeed the greatest handicap of the twentieth century in appreciating medieval art is the impossibility of visualizing the extent to which colour was spread upon the interiors. The admiration that is so often expended upon the colour and texture of the bare stone is the reflection of a modern attitude that the medieval artist and architect would have found incomprehensible. It is only if a wealth of colour is constantly borne in mind that the sculptural achievements of the twelfth century can be appreciated, since at first they were little more than the transformation into stone of a decorative system that for long had been confined to surface painting.[15]

The only sculptural advance made by the eleventh-century Normans was the popularizing of a new type of capital, upon the elaboration and adornment of which much of the twelfth-century sculptor's skill was to be lavished. At the time of the Conquest the current type was the volute capital, derived ultimately from the Corinthian and transmitted by way of the Carolingian Renaissance and tenth-century Lombardy and France. This type is to be seen in Norman work at the Tower of London, Canterbury, Durham Castle, Richmond (Yorks), and elsewhere, and persisted in small country churches, especially in the west, well into the twelfth century. A handsome example, firmly dated to 1078 or very soon after, the work of a local mason imitating more polished prototypes, is to be seen in the crypt at Lastingham up on the bare moors of the North Riding of Yorkshire. But this type was almost immediately ousted by the immense and spreading popularity of the plain cushion capital which most readily solved the problem of linking the circular pillar to the square abacus and which lent itself first to painted and then carved ornamentation. This capital was to be found in England before the Conquest and seems to have been one of the many borrowings from the Rhineland. But it was not till after 1066 that it became really widespread, so that although it is more common in England than in Normandy, its popularity must be due to its adoption by the Normans. No sooner was this capital introduced than more elaborate variants, first the double-, then the multiple-scalloped capital made their appearance, both cushion and double cushion appearing together with the volute type in the chapel of the Tower of London.[16] This type of capital was to remain the favourite throughout the first three-quarters of the twelfth century, for it was well suited to the geometrical ornamentation, much of it mere 'chip-carving', that distinguished Norman and English work of this period from that of the rest of western Europe.[17] The design that achieved the greatest vogue, particularly in England, was the chevron, which came into use in the second decade of the century and was employed in ever-increasing elaboration to adorn the voussoirs of doors, windows, and arches. At the same time lozenge, billet, fret, and other geometrical designs were widely used. The panelling of interior walls with rows of interlacing arcades, or the grooving of nave pillars, as at Durham, are other signs of this geometrical taste.

Generally speaking, the eleventh-century Norman mason made no attempt at figure sculpture, and one of his rare early attempts on the capitals of Durham Castle chapel, of

about 1072, is striking evidence of his immaturity. Squat devils with huge faces and protruding eyes are carefully arranged on the corners of the capital as supports for the abacus, while the face of the capital is filled with a stylized flower pattern of angular lozenge-shaped leaves (Plate 32A). It is a work that owes nothing to the polished figure style of pre-Conquest Wessex, or the fumbling, disorderly, ornamental array of late northern crosses. Both its rigid subordination of design to function and its squat powerful figure-work are novelties to eleventh-century English art. Its ultimate source is to be found in Burgundy, at Dijon, whence in the early eleventh century Burgundian ecclesiastics, William of Volpiano and Thierry of Jumièges, had introduced similar work to Normandy at Bernay.[18] Thus this Durham carving was the height of sculptural accomplishment for the conquering Normans.

Tympana and fonts in little rustic churches continued to be carved in a crude but vigorous style right up to the middle of the twelfth century. They owed something to this Norman art of Durham and more to the Scandinavian style and the Anglo-Saxon tradition of figure-work that had flourished before the Conquest. Primitive in their technique and arrangement of subject matter, they nevertheless possess a certain naïve charm of their own, for example the leonine creature striding across the face of the font at Topsham, Devon (Plate 31B). The subject matter of the tympana differs markedly from the monastic themes of the Last Judgement, biblical scenes, symbolic representations of months and signs of the zodiac and other literary topics. The *Agnus Dei* holding a cross was popular in imperfectly christianized areas such as Spain and England, since it served as a magical symbol for warding off evil spirits: 'In hoc signo vincitur inimicus.'[19] Equally frequent is the Maltese cross, both an ancient sun symbol and a Christian sign. Commoner still are combats of animals or of animals and men. Sometimes the scene can be explained as representing the triumph of Christianity over the forces of evil, but frequently no possible didactic meaning can be extracted from the subject. Many of the uncouth animals seem more like propitiatory representations of pagan demons, a reversion both to the old religion and to a persistent barbaric taste for savage dragons. What spiritual comfort, for example, could the parishioners of Everton, Notts, derive from their tympanum of two great maned dragons facing one another?[20] More curious still, however, is the popularity of the oriental theme of the Tree of Life, either alone or with two affronted birds or beasts, of which there are over forty examples still in existence.[21] The problem of whence the village mason derived his knowledge of this Eastern subject is difficult to resolve, though the influence of oriental stuffs displayed in the greater cathedrals and monasteries was no doubt an important factor. The symbolism of the theme, that only through the sacraments of the Church was access obtainable to pardon and remission of sins, is explained in an inscription on a tympanum at Dinton, Bucks.[22] This popularity of oriental themes is well illustrated by the tympanum at Leckhampstead, Bucks, which shows a puny human figure being seized by two enormous winged griffins, one of whom has his paw upon a pyramidal altar (Plate 31A). The lozenge-shaped leaves and little spirals link this carving to the Durham capitals and serve to date it to the late eleventh century. In technique it is an elementary piece with gouged-out background and cluttered up with the knobs and leaves that preserve the barbaric artist from his *horror vacui*. The iconography

is no less than a version of Gilgamesh fighting the beasts, a theme adapted to Christianity by identifying it with Daniel in the lions' den.

The first fifty years after the Conquest are full of confused and confusing experimentation. Vague memories of the Wessex figure style of before the Conquest survived in some of the rustic tympana of the south; Scandinavian styles found occasional but remarkable expression in the east and midlands. Anglo-Saxon manuscript traditions passed on to Anglo-Norman scriptoria and thence spread their influence into sculpture; the Normans contributed a bold but crude style of capital carving at Durham, and later on Anglo-Norman masons developed a rich repertoire of geometrical ornament; and lastly the Anglo-Norman paintings on buildings and in manuscripts began to be copied in stone on the capitals of the more important churches. It was this last process that was to be the inspiration for the sculptural revival of the next generation.

THE SCULPTURAL REVIVAL

⟨CIRCA 1120–1140⟩

B Y the third decade of the twelfth century, the rural areas of England had recovered from the ravages of the Conquest, the Church had regained control of its administration and finances thanks to the agreement between Henry and Anselm, feudal violence was reduced to a minimum under a strong monarch anxious to enforce the central legal authority, flourishing schools of Anglo-Norman illumination had been established for many years at Canterbury, Durham, Exeter, and probably elsewhere, and close contact with the Continent had been fostered by study of the Canon Law. Political, economic, and cultural factors thus all favoured a revival of the arts, and it is against this background that the remarkable sculptural output of the first half of the twelfth century must be seen. Only rarely, however, does sculpture in this period take the initiative. It was not merely that it was strictly subordinated to architecture, but that its themes and style were closely dependent upon the allied crafts of manuscript illumination and metalwork. The story of Romanesque sculpture tends to be the story of Romanesque illumination with a time-lag of up to one generation. The Norman sculptural tradition was largely barren, the pre-Conquest monumental art had been all but forgotten, and it was only by turning over the pages of manuscripts in monastic scriptoria that the sculptor could obtain patterns for his craft. It is consequently no accident that the earliest important sculptural school of the twelfth century should appear at Canterbury, side by side with one of the most vigorous scriptoria in the country. But the manuscript styles available for imitation were far from uniform, and the treatment of them by the individual sculptor varied widely. There is consequently no clear thread upon which to hang a study of these critical twenty years of sculptural activity. All that can be done is to analyse with some care the style of the two principal *ateliers*, at Canterbury and Reading, and to indicate the variety of sculpture in progress at the same period in other areas.

The dating of the capitals of the Canterbury crypt has been subject to much dispute in the past, but there can now be no doubt that they were carved about 1115–25.[1] The fact that one capital still remains unfinished indicates that they were worked *in situ*, but since some capitals of the crypt find exact parallels in others on the external arcading of the ambulatory, the carving of the two must be coeval. The choir and ambulatory walls, which must have been finished before the dedication of 1130, thus provide a key to the date of the whole series, with the exception of some simple volute and palmette capitals of an eleventh-century type, which must be re-used pieces from Lanfranc's earlier building. Furthermore, the chevron ornament occurs once in the crypt. Since it is known that this decoration was invented in England in about 1115 and spread rapidly, it serves to narrow the date to between 1115 and 1130, or more likely before Conrad's death in 1126. This dating is further confirmed by the fact that many of the designs on which the capitals are based are to be found in Canterbury manuscripts of 1100–25.

The capitals are of two main types, of which the first consists of cushion capitals whose shape is emphasized by heavy acanthus scrolls enriched by rows of beading (Plate 33A). The designs themselves are adapted from 'Winchester' manuscripts of the early eleventh century, examples of which were still preserved in the Canterbury scriptorium. Nevertheless these designs persisted in post-Conquest Anglo-Norman manuscripts, and it is not impossible that it was from a contemporary manuscript that this ancient design was drawn. The carving is still of a coarse quality, the acanthus lacks spring and the beading is very uncertain. Nevertheless this capital is a successful translation into stone of the Anglo-Norman calligrapher's designs, and already shows a capacity to handle planes and give depth and focus to a simple pattern. The incised reproduction of the design has ceased to satisfy, and sculpture proper has begun.

Other capitals show a bewildering variety of fantastic animals playing musical instruments or fighting ferociously one with another. Contemporary Canterbury manuscripts show similar scenes and the theme of a fox playing on a pipe (Plate 33B) can be almost precisely paralleled from a collection of Decretals dated by internal evidence to 1114–22.[2] Here occur the same beaded lines and the same modelling, while the remarkable zest and realism of the scene mark it off from anything that had gone before. The most effective example of this group is another capital depicting a combat between a winged dragon and a dog (Plate 34A). The design, with the great sweep of the dragon's body and arch of the dog's back curving upwards together and balanced by the slanting spear and hooked forepaws, is a masterly essay in controlled movement. While it is the perfect balance of the composition that gives it its force, the faithful naturalism of the dog and the breasts and arms of the dragon provides the carving with that sense of reality and solidity without which all barbaric art must remain in the last resort unsatisfying. It is difficult to resist the conclusion that the author of this remarkable carving, or of the manuscript from which it may have been derived, was influenced in some degree by the ferocious dynamism of Viking art. Both the little nose lappets of a beast on another face of the same capital, and the double contour outlines of eyes and mouth suggest such a source of inspiration.

It is a remarkable fact that here, in the crypt of the church that was the centre of English Christianity, the home of Benedictine monks, not a single one of the themes chosen for illustration on the capitals bears the slightest relation to any religious or moral purpose. Jugglers and contortionists (Plate 34B), fabulous animals playing musical instruments, combat scenes of monsters and dragons, such are the themes, pagan or secular, that are illustrated. This is a feature that was to persist throughout the twelfth century, for England never succumbed to the orthodoxy of Christian iconography which imposed itself in such a large measure upon continental art. A very high proportion of rural tympanum carvings in England continued to display scenes of fierce human and dragon combat rather than incidents from the Bible. Didactic, strictly Christian sculpture is in fact not very common in twelfth-century England, the bulk being purely decorative in purpose, and much of the rest concerned with scenes such as would find favour among a still latently pagan population.

The carving of the Canterbury capitals is an event of the greatest significance in the history of English twelfth-century art, since it laid the foundations of a sculptural school

which dominated the south of England for twenty years. This was the great age of the Benedictine order, and here as on the Continent the period witnessed intense building activity at the various monastic centres. It is from one Benedictine house to another that the influence of Canterbury can be seen radiating out, to Romsey and Saint Albans, and even as far north as Durham. Work was in progress in all these buildings during the 1130s and 40s, and it is evident that there was much migration of masons from one workshop to another. The stylistic connexions of one site with another are thus of extreme complexity, and only the salient features of the broad evolutionary trend can here be analysed.

At Romsey in Hampshire, the east end of the great conventual church was built soon after the Canterbury transepts, and its capitals show a marked resemblance to those of the Canterbury crypt.[3] There are the same elaborate acanthus scrolls with rows of beading, now on twin-scalloped capitals, though there is here no sign of the virtuosity of the Canterbury artist in his treatment of animals. Instead there is a fumbling attempt at human figure sculpture, showing clumsy doll-like figures which contrast surprisingly with the subtle treatment of the foliate scrolls (Plate 35A). The triangular cloaks of the kings reduce the human body to geometrical form and the coarseness of detail and crudity of design and execution bear no relation to the shallow but polished carvings of Southwell that were based on manuscript sources. These simple productions, on one of which the artist was sufficiently proud to sign his name, 'Robertus me fecit', are evidence of the immaturity of the Norman masons, who had developed only slightly since the Durham Castle capitals of half a century before. It was only when he took his designs from Anglo-Norman manuscripts that the sculptor could achieve success in his difficult medium.

Further evidence of this manuscript influence is provided by the carving of the cloister capitals of Hyde Abbey, Winchester, loose remnants of which have survived. These capitals, which must closely antedate the fire of 1141, display animals within beaded medallions and regular symmetrical scrolls curling freely with considerable modelling. Soft contours, deep undercutting, and the use of the drill for punching holes have given greater subtlety and depth to the composition. Altogether new are delicate little human heads nestling in the tops of leaves (Plate 36A), and little trefoil flowers with a fruity core known technically as 'Byzantine blossom', both manuscript tricks current as early as the beginning of the century.[4]

<p style="text-align:center">*</p>

While some sculptors were pursuing this polished style with a strong tendency towards more plastic treatment, others were developing in exactly the contrary direction. The reaction back to pre-Conquest aesthetic tastes of the period 1135–50 has already been emphasized in its more obvious, imitative forms. What we are now concerned with is the modification and adaptation of the Anglo-Norman Benedictine style of the south of England in conformity with the general tendency towards abstraction, pattern-making, and the development of essentially barbaric motifs. A good example of the tendency towards flat abstraction is provided by the evolution of that acanthus foliage pattern that was first seen at Canterbury. At Checkendon, in south-east Oxfordshire, the capitals of the chancel arch bear the same theme, but were carved some twenty years later (Plate 35B). The leafy scrolls have now been transformed into flat straps, the volutes have taken

on the appearance of bossed nails and the beaded ornament has been enlarged until it dominates the composition. Equally significant is the abandonment of the careful emphasis upon the cushion shape of the capital at Canterbury in favour of a pattern which sprawls loosely but symmetrically over the whole surface.[5]

In this development the crucial role is played by the workshop of Reading, whose influence in the 30s is as significant as that of Canterbury in the 20s. This great new Benedictine abbey was founded in 1121 by King Henry himself, the first abbot and monks being drawn from the Cluniac order. Its situation on the Thames provided easy water transport for the popular and easily worked Caen stone, which was extensively used for sculptured surfaces. By 1136 the building was sufficiently far advanced to permit the King himself to be buried in the choir. No doubt the nave was under construction by then and it is reasonable to suppose that work on the adjoining cloister was going on at the same time. Of the sculpture that must have adorned the capitals of the church itself and the great west front, nothing has survived the predatory activities of the local builders and the cannon of the Civil War. But by a remarkable stroke of fortune a very substantial number of capitals and arch voussoirs from the richly ornamented cloister were dumped a few miles down river at Borough Marsh to form a flood wall. Excavation of this site in the late nineteenth century and again in 1949 therefore makes it possible to appreciate something of the artistic importance of this building, which seems to have exercised a powerful influence upon the whole of English twelfth-century sculpture.[6]

In its original condition Reading cloister must have been splendid in the extreme, since almost every available surface – pillars, capitals, abaci, imposts, arch voussoirs, corbels, and string courses – was richly carved. Here converge the various strands of the early twelfth century, merging in a style which sacrifices depth of modelling and simplicity of design for a lush surface pattern. The figure-work, for example the capital with two winged and nimbed saints within beaded frames, is a study in pattern rather than an attempt at monumental representation (Plate 36B). The figures are quite improperly set within mandorlas – which by rights is a sign of glory reserved for Christ – and the wings curl upwards with geometrical precision to recall the shape of a twin-scalloped capital. The wig-like hair, huge eyes, slit mouth, and conventional ribbed drapery show a total lack of interest in the human form, and the woodenness of these figures is in strong contrast with the dynamic vitality displayed by the same sculptor in his animal studies on another face of the same capital.

The commonest ornamental device at Reading is the thin beaded or banded scrolls emerging from the mouth of a little cat's head (Plate 37A), a manuscript convention that goes well back into the Anglo-Saxon period, the best examples occurring in the great 'B' of the Beatus page of the psalter. But whereas at Canterbury the sculptor had taken for his models the orderly and formal acanthus clusters of the early Winchester manner, at Reading it is the later, wilder, and more dishevelled versions under Ringerike influence which have been copied. It is possible that this is not an archaism of the sculptor, but follows a similar trend in certain manuscript drawings of about 1120–30. Much more striking evidence of a Ringerike revival, however, and one for which a contemporary or nearly contemporary manuscript parallel cannot be found, is displayed in a corner stone

of the cloister. This shows a bird biting her breast, while long curling tendrils interlace themselves in and out of wings, legs, and neck (Plate 37B). For this an extremely close parallel can be found in a manuscript of about 1050, now in the Cambridge University Library, whose Beatus page also provides a prototype for the mask and foliage capital.[7] If the Reading sculptor had not seen this manuscript itself, he must have been influenced by one extremely like it.

There were others at work on the cloister who broke away from this predominant emphasis on pattern when faced with the task of illustrating an important religious theme. The recently discovered capital of the Coronation of the Virgin, though of limited artistic value, is of great political and iconographical significance. The cult of the Virgin, which was to enjoy outstanding popularity from the thirteenth century, was only slowly making its way in the early twelfth century. After enjoying precocious popularity in late Anglo-Saxon England, the cult languished immediately after the Conquest and only revived in the early twelfth century, when the ideas of the conquered gradually forced their way into acceptance by the Norman conquerors. It was the 1120s which saw a renewed interest in the Virgin, popularized by Anselm of Bury and supported amongst others by Hugh of Reading. The Immaculate Conception became a recognized feast in 1129 and one of the first representations of the Coronation of the Virgin by Christ in Heaven occurs in Rome before 1148. But this Reading capital is probably rather earlier in date, and is convincing evidence of Abbot Hugh's zeal in reviving the cult of the Virgin by this iconographical novelty.

So wealthy and important a monastery and so striking a school of sculpture could not but make its influence felt for many miles around, and subsequent work in Oxfordshire and Berkshire can be seen to stem from this single source.[8] At Charney Bassett in Berkshire is a tympanum which within a stylized leaf border displays a king clutching two winged griffins. This is an eastern motif, interpreted in the west as Alexander being carried to Heaven, which found its way into Europe through the import of oriental silks. It seems likely that the sculptor took his pattern for the tympanum of this little Berkshire church from a Persian silk in the treasury of some monastery, perhaps that of Reading itself.[9] At all events the griffins with their savage hooked beaks and exaggerated claws show a strong family likeness to the animals within medallions from a carved pillar at Reading.

The barbaric tendencies that are evident in this group of sculptures from Reading are carried a stage further in a second group, evidently by different workmen, and probably carved a few years later. But the difference in date must be small, since the dominant feature of the new school, the beakhead ornament, is found at Kilpeck in Herefordshire in the late 1140s. This second group adhered strictly to geometrical ornamentation, with chevron incisions on octagonal pillars, trefoil scalloped capitals and voussoirs with a wide variety of beakheads, rosettes, projecting ornamented bosses, embattled designs and other repetitive patterns. An example of these beakheads by the same school of masons at Saint Ebbe's, Oxford (Plate 38A), shows the elaborate punched and chiselled surface decoration that characterized this *atelier*.

The hall-mark of this new style is the beakhead voussoir, and it thus becomes of some

importance to determine the origin of this feature. The extreme rarity of its use in the south-east precludes any suggestion of influence emanating from the powerful centres of Rochester, Canterbury, or Winchester, besides making prior development in Normandy an unlikely hypothesis. Unfortunately the insecurity of dating for most mid twelfth-century monuments makes any clear attribution of the origin of beakheads now impossible. But it is significant that its greatest popularity was achieved in the Oxfordshire area under Reading influence, that it appears in the Hereford school, itself in part a Reading offshoot, and is prominent in the York school which also shows strong links with Reading. Although virtually unknown in the south-east, the distribution pattern of the beakhead bears no relation whatever to the Danelaw boundary, which makes it difficult to argue that its development has any direct connexion with the ancient Scandinavian gripping-beast motif, found on wood-carving such as the Oseberg ship. Nor is it true that it was used exclusively in minor churches, and expressed the barbaric taste of the local population and the local masons. On the contrary it was widely employed on buildings of the highest importance, for example at Reading, Saint Cross Winchester, Canterbury, Southwell, Old Sarum, Bury Saint Edmunds, Westminster, Peterborough, Dorchester (Oxon), Lincoln, and Oxford. The fact remains, however, that the gripping beak is a feature familiar to barbaric art, and with an immediate appeal to pre-Conquest and especially Scandinavian aesthetic tastes. Whether the motif evolved from now vanished wood-carving, or whether it was a transference to stone of similar beaked animal heads used in Anglo-Norman manuscript initials, is impossible to determine with certainty. But at least it is clear that Reading played a primary role in the dissemination of this motif, and that it was frequently employed on major architectural works.[10]

The later Reading work thus breaks right away from the animal and scroll patterns derived from manuscripts which had hitherto dominated the more accomplished sculpture of southern England. Modified first by pre-Conquest tastes, the style finally succumbed to the geometric ornamental system of the backward Norman mason in the cloister of one of the leading Benedictine abbeys in the country. Coupled with so retrogressive a move as the abandonment of the stone vault, this change in sculpture back to the repetitive abstract designs of barbaric art is a most extraordinary feature of twelfth-century English art. If not the originator of the new style, Reading seems definitely to have been the most powerful influence in its widespread distribution.

★

At the same time as these developments in stone sculpture were taking place in the south and south-west, the bronze founder and ivory carver were producing works of even higher quality. The inventories and records of the time are full of tantalizing references to the glories of great metal retables and altars of which to-day nothing whatever survives. But of the candlesticks which are known to have adorned so many of the monastic churches and cathedrals, one diminutive example from Gloucester remains (Plate 39). Only sixteen inches high, it is a bewilderingly intricate piece in which nine puny human beings writhe and twist to escape from the loose haphazard coils of beaded and ribbed foliate scrolls, and from no less than forty-two clawing and biting animals.

Astonishing though it is as a *tour de force*, it must be admitted that the piling of so much fussy ornamentation on such a tiny curving field is distracting to the eye. The candlestick shows the same passion for rich surface ornament, irrespective of material or field, that was so noticeable in some pre-Conquest work. The dating of this piece and its association with Gloucester is fortunately secure, thanks to an inscription which places it without any doubt between the years 1104 and 1113. But the question remains whether it is of English or foreign workmanship. The centre of European bronze-work had been north-west Germany ever since the days of Bishop Bernward, and the similarity of the theme with that of the familiar climbing figures of the 'Hildesheim scrolls', as well as doubts whether the English at this period were sufficiently experienced in bronze-work to accomplish the very remarkable technical feat of casting such a complicated piece, lend support to suggestions of German manufacture. On the other hand, the beaded scrolls and the little climbing figures were already acclimatized in Anglo-Norman manuscripts of this date, particularly of the Canterbury and Durham scriptoria, so that the stylistic argument remains weak. It is difficult to envisage the execution of such a work without a very long technical experience behind it, proof of which in England, thanks to the destruction of the evidence, is now entirely dependent on contemporary accounts like that of William of Poitiers. However this may be, the theme of the Gloucester candlestick found favour with the stone sculptors in the south, and a font at Alphington, in Devon, shows similar neat, energetic little human figures struggling with animals amid coils of ribbed and beaded scrolls (Plate 38B). At the same time the ivory carver also adopted this style, and two fragments, one of which was found at Saint Albans,[11] show the same anxious little figures enmeshed in banded foliate coils. Later on in the 1140s the stone sculptors of the Hereford school also developed a mannered version of the theme, so that it is evident that it enjoyed a wide vogue at this period.

<p style="text-align:center">★</p>

In the midlands, and perhaps dependent upon a school of masons at Peterborough, where all traces of their work have now vanished, there evolved a style of sculpture that at first was very different from the elaborate ornamental surface decoration that was characteristic of this southern Benedictine work. At Seaton in Rutland, the capitals of the chancel arch, which date probably to the first decade of the century, show strong affinities with those at Southwell (Plate 30B). They are of volute form with the huge protuberant bosses of Southwell while some of the animal ornament bears traces of elongated Viking lobes. Both capitals and abaci are covered with a spread of untidy two-stranded interlace with little pointed leaves that have little resemblance to the usual acanthus type. At Castor, near by in Northamptonshire, the capitals of the arches of the splendid central tower bear sculpture that shows a further evolution of the same style. Since there is an inscription over the chancel doorway which puts the dedication of the church at 1124, the capitals must have been carved only a year or two before that date. At this time a manor and the church were owned by Thorold, a knight of the Abbey of Peterborough, which itself owned another large manor in the parish, facts which may strengthen the hypothesis of Peterborough as the centre of the school.[12] Here at Castor appears the same straggly interlace with little pointed or voluted leaves on the same volute capitals that elsewhere

had already been displaced by the cushion or scalloped type. The formal symmetrical sprays of foliage from pre-Conquest manuscripts that were seen at Canterbury and at Checkendon reappear in jagged, angular forms, now handled in the shallow outline technique of the Southwell capitals. On other capitals occur figure scenes of men fighting, of Samson and the lion, and of a boar hunt, all in a stubby, rather clumsy style in which the squat sturdy bodies stand out on the capital, entirely uncomplicated by the usual space-filling scrolls (Plate 44A). It is a style that relies upon boldly defined outline rather than elaborate detail, and the surfaces of both body and background are left utterly bare in a manner which is rare in twelfth-century sculpture. This simple, rather naïve narrative style is evidently copied from early twelfth-century manuscripts, and one capital at Castor of a man in a short skirt gathering fruit can be closely paralleled by a drawing from the same Canterbury manuscript which provided some of the themes, treated in so different a manner, of the contemporary masons at the Canterbury crypt.[13] Later on at Wakerley, also in Northamptonshire, ornamental neckings and increased use of beading indicate influence from the southern Benedictine style, but the heavy, deeply cut figure-work betrays the continuity of evolution from Castor. On the north side there is a scene of a mounted knight attended by a foot soldier, both in chain mail and helmet. Behind appears to be a fortified town or castle, while in front is a many-domed structure with shingled roof. The true interpretation of the scene is obscure, though a possible suggestion is that it represents the miraculous appearance of Saint George to assist the Christian army at the siege of Antioch during the First Crusade. One of the more unusual features of this sculpture is the manner in which the carving strays out of the formal frame of the capital itself to wander across the surface of the abacus. This contempt for the rigid conventions of the age forms a link with pre-Conquest habits in these matters which persisted in certain Anglo-Norman manuscripts far into the twelfth century.[14]

The capitals of nave and choir at Saint Peter's in Northampton itself are some of the most remarkable in the country. One explanation for their extraordinary richness is the fact that the church was appropriated to the Cluniac priory of Saint Andrew's, Northampton, then at the height of its prosperity.[15] But Cluniac monasteries are chiefly remarkable for their passion for lavish ornamentation rather than the widespread propagation of any specific artistic style, so that although Saint Andrew's may explain the richness of the decoration, it does nothing to explain the style. Some of the capitals at the east end are of the volute type with huge protruding bosses and animals in bold outline, not dissimilar to some of the Castor work. That local masons were employed on the building is further confirmed by the peculiar indented pattern on the bases of the pillars, which is also found at Castor. Other capitals show the beaded and banded ties and little cat's heads that were a feature of Benedictine work at Reading and elsewhere, while others again bear scrolls with fat, rounded stems and long, lobed leaves. More characteristic of these carvings at Saint Peter's are the capitals with thin projecting coils that immediately suggest *appliqué* metalwork (Plate 44B). Indeed the whole nature of this sculpture, with the chipped and punched surface of the animal bodies and these thin coils with their tight little spirals in two clear planes, seems to be little more than an attempt to imitate in stone the work of the gold and silversmith. If the origin of the elaborate spirals may be seen in the much less

accomplished capitals of the south door at Castor, the whole treatment is now hard and metallic, and the standard twelfth-century theme, derived from eastern textiles, of animals or birds pecking at the fruit of the Tree of Life is reduced to an angular surface pattern of light and shade. The raw, jagged quality of the capitals is further emphasized by the chevron mouldings of the arches, which have sharp angular projections within the hollow of each indentation. These and other features suggest a date of about 1150 for the nave of Saint Peter's, whose capitals represent the apogee of Romanesque craftsmanship in the south midlands. Both the strength of this type of work in its elaborate surface texture and minute precision in detail, and its weakness in its avoidance of clear outline and its fussy ornamentation, are well brought out in these Northampton carvings.

<p style="text-align:center">★</p>

The southern English taste for predominantly decorative themes either of plain acanthus foliage or of human figures within foliate scrolls did not go entirely without challenge from more monumental sculptural influences. Wall paintings dating from about 1100 from the Sussex churches of Clayton and Hardham show a mixture of the stiff hieratic poses and tall elongated figures of north German work and the thrust and sway of pre-Conquest Winchester manuscripts. This combination is also found in manuscripts from Saint-Bertin at Saint-Omer (Pas-de-Calais) and from Liège, and it has been demonstrated with some plausibility that the wall paintings reflect the style of a north French school. It is to this Liège influence in the first decades of the twelfth century that must be ascribed the whalebone panel of the Adoration of the Magi now in the Victoria and Albert Museum (Plate 41). It is unfortunately impossible to establish with any certainty whether or not this splendid piece was carved by an English craftsman, for it belongs to a Saint-Omer–Liège–Lewes group which can only be described as a 'Channel school'.

The central scene is framed by a stylized building on the roof of which crouch an owl and a man blowing a horn, evidently copied from similar little creatures which adorn the tops of the Canon-tables of Carolingian and post-Carolingian manuscripts. Below are scenes of animal combat in which the enormously long, carefully articulated claws and the wiry, muscular legs of the beasts give an impression of intense ferocity. It is noticeable that the feet of the animals spread out over the edge of the panel, as do other details of the main figure scene, a trick which was characteristic of pre-Conquest work but tended to become more rare in the early twelfth century. The huge tragic face of the Virgin is thrust forward out of the richly embroidered and beaded folds of the drapery which fall in carefully arranged zigzag pleats about the body. The Magi are slim elongated figures with jewelled crowns of the same type as are found on the Clayton wall paintings. All these features, the architectural frame, the animal combat at the base, the ornamental zigzag folds and the elongated figures are found in the north French and Flemish manuscripts with which this work must be associated.[16] But what makes this little panel one of the outstanding artistic achievements of the twelfth century and marks it off from another Virgin and Child of the same *atelier*,[17] is its perfect technical virtuosity, the formal grace of the composition, and the rich surface decoration of shingled roof, jewelled crowns, striped and beaded draperies, and embroidered edges.

Between 1119 and 1146, there was illuminated at Saint Albans a manuscript, the 'Albani Psalter', which is one of the most important achievements of English medieval artists. It introduced into England a figure style of which the Channel school of Saint-Bertin and Liège had provided some indication, but whose principal source of inspiration was north German. The figures are tall and tapering, the expressions intense and dramatic, the grouping close and formal, conforming to a carefully designed pattern whose main emphasis is on vertical lines. It was a style not confined to Saint Albans, but spread east to Bury Saint Edmunds and west to Shaftesbury, Wilts.

It was only to be expected that so impressive a figure style would find some reflection in sculpture, and two outstanding works, a battered rood at Barking in Essex, and two panels at Chichester, Sussex, are evidence that this very soon occurred.[18] The panels at Chichester are built up of detached blocks of Purbeck stone, which in 1829 were found built into the eastern piers of the crossing above the line of the stalls. There is no reason to believe that this was not their original position, which means that they cannot be much earlier than 1108 when the eastern section of the church was first dedicated. Two panels of the original four are intact and show Mary and Martha kneeling before Christ at the gates of Bethany (Plate 40), and the Raising of Lazarus. The iconography of the latter episode is further indication of a twelfth-century date, since the emergence of Lazarus from a tomb rather than a cavern does not appear before this period. But it is the details of style, linking these panels unquestionably with the Albani Psalter, that serve to clinch the arguments for a date in the second quarter of the twelfth century. The very odd foliate base to the door jamb of Bethany and the sharply drawn faces with slanting eyes and eyebrows, the lines running down from the nostrils and the drooping mouths and moustaches, the enormous tapering bodies and heavy draperies with zigzag hems all appear in the Psalter. Furthermore, the strong sense of drama, the anguished expressions and wig-like hair (Plate 42), the solemn posing as if for a charade, are also characteristics of the same manuscript. The Christ at Bethany panel is artistically by far the most satisfactory of the two owing to the unity of composition provided by the huge pyramidal figure of Christ, towards whom all lines converge. The heads are in high relief with ribbed hair, eyes drilled for metal fillings, and slanting lines of eyes and mouth. It is these solemn, ecstatic expressions together with the harmony of composition, the kneeling women at the gate balanced against the four apostles crowding in from the rear, that gives this three-foot panel its claim to rank as one of the outstanding pieces of English medieval sculpture.

Of twelfth-century wood carving in England nothing whatever has survived except the painted head and one foot from a small crucifixion, found in 1913 hidden in the church wall at South Cerney, Glos. (Plate 43).[19] This brilliant little head with its striated hair, drooping black moustaches, and dead slanting eyes has certain affinities with the intense face of Christ on the Chichester panel of the Raising of Lazarus. It probably also belongs to this mid-century period and is inspired by the Albani Psalter style. On the other hand the possibility cannot be excluded that it is not English at all. So small an object is easily portable and surviving north Spanish wooden crucifixions of the period are very similar.[20] It might therefore be a mid-century Spanish work, brought home by a pilgrim to Compostela.

MID-CENTURY ROMANESQUE

⟨CIRCA 1140–1160⟩

DURING the reign of Stephen two contradictory trends may be detected in English sculpture: a barbaric tendency to abstract and geometric ornament, and a beginning of continental influence. Before about 1140 it is impossible to discover any sign of awareness by English sculptors of the remarkable achievements of their colleagues in Burgundy, Toulouse, Saintonge, or the Loire valley. The French development of monumental sculpture only made itself felt at this very late stage, and as a result the inner tension always latent in English art grew more acute than ever. Whereas some artists developed the geometrical forms of the second Reading *atelier*, enriched only by modelled beakhead voussoirs, others more in contact with continental trends began experimenting in true monumental sculpture and the display of genuinely Christian and didactic themes.[1]

It was at this juncture in the artistic history of twelfth-century England that there developed for a brief space in a remote western county a sculptural workshop of a highly accomplished and distinctive nature. In Herefordshire, on the Welsh border, there are a number of minor churches containing fonts or architectural sculpture of extreme richness, whose style points unmistakably to the overall direction of a single master craftsman.[2] Like most vigorous artistic developments, this school was the product of an interplay of complex influences, often contradictory in style and in aesthetic purpose. The centre of the school is to be sought, as usual, in a Benedictine monastery, and it is to Leominster, an offshoot of Reading, rather than to the cathedral of Hereford that we must look. The east end of Leominster was consecrated in 1130, and despite obvious alterations of the nave structures it seems not impossible that the west front was completed by about 1145. Most unfortunately the cloister capitals, which presumably dated to the 30s and may have been modelled on those of the first Reading group, have now entirely disappeared. One of the chief sources of inspiration for the school is thus now missing, and the links have to be supplied direct from Reading. One other building of the series, the little church of Shobdon, has a far more precise dating, with documentary evidence to prove that it was constructed by Oliver de Merlemond at least a year or two before 1143.[3] Since the whole series bears the strong impress of the hand of an individual artist, the modifications of whose style are relatively slight, and since there is only one example of the use of the beakhead that in Reading in the 1140s was sweeping all before it, it seems fairly clear that the whole output of the workshop was compressed well within the years 1140–55, subsequently collapsing as dramatically as it arose, on the death of the master craftsman. The oddest feature of this apparently incontrovertible dating to the 1140s is that the anarchy during the reign of Stephen was severely felt in this county, which was ravaged between 1137 and 1143 by warring bands of rival barons and by Welsh raiders exploiting Norman weakness.

Four main influences may be seen at work, which combine in various ways to produce the style of the school. Of these the least important was the local Norman mason's craft, whose geometric decorations of chevron and chip-patterns and whose corbel tables of grotesque heads were absorbed together with certain basic architectural formulae into the more dominant features of the school. These local influences were perhaps strongest in the south door of Kilpeck (Plate 45). The second element was the earlier group of Reading capitals, with their emphasis on ornamental patterns of banded foliage and animal or human masks.[4] Even the segmented drapery so characteristic of Leominster figure-work is not unlike the Reading treatment, as shown on the capital with two nimbed saints within voussoirs (Plate 36B), while certain motifs, for example the decorations of the abaci at Leominster and Shobdon, are direct copies from Reading.[5] Thirdly, there is strong evidence of the reproduction of ideas and motifs current a little earlier in western France, particularly in the Anjou–Saintonge area. Cultural contacts evidently preceded the political link of the Angevin Empire. Whether the link was due to the wine trade with Bristol, to the pilgrimage route to Compostela, or to some accident of travel of which we have no record, it seems likely that the principal artist of the Leominster workshop had in his possession a sketchbook with notes and drawings of churches in that area of France. The architectural feature of the pointed arch as used very early at Leominster, the system of arch voussoirs with radiating human or animal figures at Shobdon and Brinsop, certain individual tricks of human and foliage treatment, and iconographical themes for tympana of a mounted horseman with flying cloak at Brinsop and Ruardean, and the struggle of Samson and the lion at Stretton Sugwas, all come from churches mostly in or near the present *département* of Charente-Maritime.[6]

The fourth stylistic contribution came from Ireland, deeply penetrated as it was with Viking influence. It seems more than likely that the main vehicle for this influence was architecture and sculpture in wood, all of which has now entirely vanished, and we are left to reconstruct what links we can from surviving remains in ivory, metal, or stone. Support for this suggestion is provided by the appearance upon Kilpeck church of projecting dragon's heads at the ends of the corbel table, which would appear to be translations into stone of the decorated ends of wooden roof-trees such as are found in Scandinavian architecture. Furthermore, the arrangement of lush sculptural decoration over impost capitals, nookshafts, and jambs, consisting primarily of interlace patterns, is one familiar to the doorways of surviving late twelfth-century wooden churches in Norway. Now the only area in the British Isles in which Viking art persisted as a dominant style in the early twelfth century was Ireland, where crosses, metalwork, and ivories all show strong Urnes influences. Only in Ireland was it still the practice to cover large surfaces with interlace patterns, and the typical Leominster school motif of the fat snake entwined in thin pipe-like scrolls was also still familiar to Irish art. Much of the Irish art of this period has disappeared, and it is only from occasional dated crosses like that at Tuam, from metal-work like the cross of Cong or the bell shrine of Saint Cuillean, or from ivories like the crozier head from Aghadoe, that contemporary evidence can be derived.[7] This last item is of particular interest since on the same piece is to be found a human figure in the same striated clothes and trousers as is seen at Kilpeck (Plate 46A), the scrolls with long voluted

stalks that appear on the Leominster capitals, and an Urnes pattern of beaded snakes and interlace. What therefore we seem to have in this Leominster workshop is a highly selective choice of certain items in the repertoires of the contemporary Irish sculptor, most of whose architectural work was probably confined to wood and has thus now vanished.[8] Furthermore, there remains what can only be described as the 'feel' of the whole group. All these Hereford carvings are without exception compositions in asymmetrical curves. Apart from Norman motifs like the chevron, there is not a single straight line or flat surface among them. The eye is everywhere confronted with soft curves, both in depth, provided by the ribbing and rope-like drapery, and also in outline. Vague concepts such as Celtic aesthetic taste are dangerous ideas to conjure with unless supported by more precise and detailed evidence, but it does seem that a powerful influence making for sinuous line and interlace pattern has been at work upon the motifs presented by western French and southern English art.

The most elaborate of all the buildings of the school was the church at Shobdon, and there can be little doubt that for a few years before 1143 every available sculptor in the yard must have been employed upon the ornament of this small building. Unfortunately the church was pulled down in the eighteenth century, but the chancel arch and north and south doors were re-erected as a kind of triumphal arch in the near-by park. The action of wind and rain over the past 150 years has since weathered the stone so that most details are to-day too blurred to be readily discernible. Recourse must therefore be had to a cast in the Victoria and Albert Museum, poor in quality but taken before the weathering had progressed too far, and to some excellent nineteenth-century drawings.[9] It appears that profuse interlace of scroll, animal, and human ornament was spread over the whole surface of bases, pillars, capitals, abaci, and voussoirs. Every feature of the school that is found elsewhere is here brought into use: the banded and beaded interlace, the beaded trefoil scrolls with binding ties, the beaded medallions with mask bindings containing birds and animals; the fat coils of a serpent intertwined with a thin single strand of interlace; the rows of little angel figures in their enveloping cloaks; the signs of the zodiac, detached animal portraits and foliate sprays in voussoirs; the tympana of Christ in Majesty in a mandorla supported by angels, and of the Harrowing of Hell. On the arch voussoirs is a row of quadrupeds, rampant and looking backwards. This motif is of unmistakable Saintonge or Poitevin origin and is not unlike carvings on the west front of Notre-Dame-la-Grande at Poitiers itself. This was a source destined to have a strong influence upon Kentish work late in the century, but this almost contemporary copying by the Leominster school shows how close were its contacts with the Continent.

In the earlier carvings of this workshop, at Leominster or Shobdon, the profuse decorative fancy that is the main feature of the style is kept within fairly rigid architectural boundaries. At Leominster (Plate 48A) the two doves within foliate scrolls are strictly symmetrical and carefully designed to emphasize the shape of the capital. Carved in the soft red sandstone of the locality, these birds and scrolls and the adjoining reaper in his pipe-like clothing are well modelled up from the ground, showing strong signs of that movement towards more plastic treatment that was observed in southern England in the early 1140s. By the time the sculptors moved on to Kilpeck, this plastic sense was still

more strongly developed, and the exuberant designs of the artist were beginning to spill over out of their natural architectural boundaries (Plate 45).[10] The shafts and jambs of the south door at Kilpeck are covered with fat-bodied sinuous dragons and a mannered version of the twelfth-century theme of human figures caught within foliate scrolls (Plate 46A). Men with trousers, rope-like clothes an and Phrygian caps are standing amid, irregular flow of interlace, the foliations of which have been reduced to long tapering leaves that are themselves little more than prolongations of the coils. These figures have often been described as Welsh soldiers because of their curious costume, but trousers are not unknown in the twelfth century and the Phrygian cap was a common headgear for such climbing figures in manuscripts.[11] The little figures of the Alphington font (Plate 38B) have been elongated and distorted to fit the architectural frame in which they are now set, and the interlace has lost the symmetrical regularity of Shobdon and now meanders haphazardly about the composition. Surrounding a tympanum with an ungainly beaded vine pattern is an arch of three orders, the inner of chevrons set on edge, the middle of beakhead and other animal designs, and the outer of signs of the zodiac, doves, and animals set in beaded medallions held together by masks, as on a pillar at Reading. At either end of the outer order is a huge inverted dragon's head, a local feature that, without the inversion, occurs frequently in Gloucestershire churches.[12] The field in which the twelfth-century sculptor was able to give a free rein to his unbridled fancy was the corbel table. Rarely, however, did he take advantage of the opportunity to do more than a series of grotesque heads, dragons, and other simple stock subjects. But at Kilpeck there was an artist of individuality who struck a fresh note. Besides the female fertility figure that is found so frequently elsewhere during this period,[13] there is a pair of lovers locked in fond embrace and the forequarters of a hare and a hound nuzzling together in friendly association. What is remarkable about this latter carving is the sense of caricature that it displays and the evident signs of observation of nature. These are living creatures, not copies from some illuminated manuscript.

The chancel arch is chiefly remarkable for the little figures in the round, possibly apostles, three of which are attached to each shaft (Plate 46B). These are the first examples of the pillar figure in this country, but their source of inspiration is probably *appliqué* cast bronze figures such as those found on Irish shrines, rather than contemporary sculpture at Saint-Denis near Paris. The close enveloping folds of the cloak transform the body into a compact vertical shaft that would be easy to mould in metal, and the prominent bosses that represent the ankle bones may well be reproductions in stone of the original nails that attached the bronze to the background.[14] On the other hand such an arrangement of small figures in place of pillars appears in north Italy at Verona and Ferrara, and it may well be from these that the idea was derived.[15]

The sculptors of this school were not afraid of handling large-scale figured scenes, mostly in a flat, ribbed style but almost always showing a fine sense of composition. At Rowlstone and Shobdon are two tympana of Christ in Majesty within an oval beaded mandorla supported by four angels, in which the deep shadowed lines of Christ's draperies and the curving wings of the angel together form the soft and flaccid linear pattern that is so characteristic of the school. The iconography of a mandorla supported by four angels,

instead of either the more usual two or the attendant symbols of the four evangelists, is admittedly found in pre-Conquest manuscripts, but it is perhaps significant that it also occurs in northern Italy.[16] The tympanum at Stretton Sugwas with Samson and the Lion (Plate 47A) is the iconographical complement of the Brinsop tympanum of the horseman, the two being found together on the same building at Parthenay-le-Vieux, in Poitou. The powerfully constructed body of the lion ranges across the whole face of the composition, and Samson, his drapery reduced to rope-like coils about the body and his hair to a great curving mane, seems far too weak a figure to succeed in wrenching open its jaws. This carving has a limp quality, the head of the lion with its curving mouth and lolling tongue possessing none of the dynamic ferocity of other work of the period. Indeed one of the more curious features of the group is this gentle pet-like treatment of fauna, and the entirely static quality of its figure scenes. It has all the appearances of the last, decadent phase of a once vigorous school, and yet there is nothing to show that it has any such lengthy history behind it.

At Fownhope there is a Virgin and Child between banded foliate scrolls containing the Evangelists' symbols of a lion and an eagle. The scene is notable for the rigidly frontal position of the Child, who is now set squarely in the middle of the Virgin's lap instead of perched on one knee in a more natural manner, as in the panel in the Victoria and Albert Museum (Plate 41). This is the first example in England of the Virgin appearing alone in a central position on so important and public a situation as a tympanum, and is witness to the success of the cult of the Virgin.[17] The central and frontal position is due to Byzantine influence which had caused almost all early and mid twelfth-century images of the Virgin in France to adopt this solemn pose.[18] The Leominster sculptors were thus well aware of current continental ideas and styles.

The most attractive of these scenes is the charming Baptism of Christ on the font at Castle Frome (Plate 47B). All signs of leaves have here vanished and there is a return to the pre-Conquest technique of pure interlace to fill up space. A heavily moustachioed Christ sits in a prudish attitude in a completely circular river within which swim four enormous fish. Saint John the Baptist is blessing on the left, while the hand of God and the dove of the Holy Ghost are descending from above and to the right. The hair and drapery details of John are treated with greater depth and realism than the usual rope ribbing and the hands are executed with a skill which is best appreciated by a comparison with those of the Virgin at Fownhope. Together with the total disappearance of foliate decoration all this suggests that this font is one of the latest works of the school and should be placed soon after 1150. Another font of the same type and date is to be found at Eardisley on which there are soldiers fighting with sword and spear amid loose bands of interlace (Plate 48B). The scene has muscular energy, and the interlace is designed to emphasize the thrust and movement of the limbs, both features that are absent from much of the flaccid carving of the school.

At this point the Leominster school peters out as abruptly as it began. Feeble imitations occur at one or two isolated places near by, but on the whole the arrival of more peaceful political conditions under Henry II sees the relapse of this remote western county into the state of sculptural backwardness from which it had so surprisingly emerged. With the

death of the master craftsman, whose hand can be detected with some certainty in comparison with the products of other workmen in the shop,[19] the *atelier* disperses and the tradition dies.

<div align="center">★</div>

In the early twelfth century the Cluniac order was at the very height of its influence both artistic and spiritual, and the great mother church in Burgundy had just been completed. The order was highly centralized administratively, though it seems doubtful whether such centralization extended to the arts. No such thing as a general Cluniac style is recognizable but rather the production of outstanding examples of the various local schools of the districts in which the houses were situated.[20] Thus the surviving fragments of sculpture from Lewes in Sussex show no trace of influence from the church at Cluny. These carvings can probably be dated by the fact that the massive extensions to the priory nave, which were completed by 1142–7, were almost certainly accompanied by an enlargement of the cloister, converting it from the original square into a rectangle.[21] Many of the fragments from this cloister show carved foliate ornament from voussoirs, capitals, corbels, brackets, and pillars, much of which closely resembles the beaded foliage that began at Canterbury. On others occur the geometrical designs of chevron, pellet, half-moon, and so on that were the contribution of the Anglo-Norman mason. But in the figure sculpture upon a Caen stone capital with cabled necking from the cloister, now in the British Museum, it is evident that some outside influence has been at work. The four faces of the capital appear to bear episodes from the life of Saint Peter, the patron saint of the parent church at Cluny. The scene of Saint Peter and Saint Andrew fishing in the sea of Galilee (Plate 49B) shows two heavy figures in high relief with large heads and ribbed wig-like hair, sitting in a wildly disproportionate boat and casting their net into the sea. It is in many ways a clumsy style, but it contrives to tell a story in a convincing way. This type of work seems to bear no relation to the wall paintings in the near-by churches of Hardham and Clayton, which are almost certainly by Lewes craftsmen.[22] The sculptor has broken free from the domination of the manuscript to create a more monumental and plastic style of his own. If continental sculpture was of influence here, it was certainly not at Cluny or Vézelay but rather to the south-west in Auvergne. At all events it was a style that continued well beyond the middle of the century at Lewes, as is shown by the sculpture of a font at Brighton (Plate 50). In the scene of the Last Supper, the large heads, beards, and moustaches, and tight-drawn swathes of drapery are a development of this solemn style, and the scroll at the base is a more wiry version of the familiar English manuscript foliage scroll.

One of the finest examples of the new monumental influence at work can be seen in a stray capital from Winchester. One side depicts a winged lion striding across the whole face of the capital (Plate 51B). The decorative mesh of foliate coils or beaded medallions has now disappeared, the modelling is full and round, and the animal emerges in its own right, a piece of sculpture whose purpose is not merely to please by its quality of linear patterning. With this bold and powerful portrait English art evidently enters on a new phase.

In the Fenlands at Ely much sculptural work was in progress at the same period. The

Prior's Doorway was inserted in the south wall about 1140 and is one of the most richly ornamented works of the age. The jambs consist of an outer order of plain circular openings with charming little silhouettes of animals and human beings ingeniously fitted into their frames and standing out from a deeply cut background (Plate 54B). The middle order is an engaged shaft heavily carved with a foliate scroll inhabited by lions, birds, and dragons, all arranged in well-defined spiral bands. The dragons are of the long-necked, long-tailed, hump-backed and winged variety that entered manuscripts in the second quarter of the century and were to persist in sculpture well into the Gothic period. The leaf scrolls, which are best seen on the inner jamb, are mostly of the trefoil type with central boss which tended to replace the formalized acanthus of the early twelfth century. A more novel feature of this remarkable door is the fully moulded forequarters of a lion and a human head which project from the sides of the capitals and beneath the corbels supporting the tympanum. The human head with its mournful expression and huge protruding eyes resembles a similar figure supporting the font at Castle Frome. Both the projecting lion and the jamb ornament strongly recall north Italian sculpture, whose influence upon some aspects of this Ely doorway can hardly be doubted.[23] Once again, therefore, we can detect that sudden influx of continental influences that is such a feature of the 40s and 50s.

The tympanum itself contains a large-scale representation of the continental theme of Christ in Majesty within an oval vesica supported by two winged angels (Plate 54A). This is a typical translation into stone of a manuscript drawing, and the sculptor relies more on the linear effect of his design than on the three-dimensional possibilities of his medium. But within these limitations the tympanum is an intense and powerful work, skilfully planned to fit the semicircular frame and involving reckless distortion of the human body to conform to the upward view of the observer and the need for pattern-making. The lower half of the tympanum consists of outward-fanning lines around the central pleat between the knees of Christ. First the legs, then the vesica, and lastly the immensely long legs and thighs of the angels all run in parallel lines, brought up finally by the vertical hang of stray wisps of drapery and counter-balanced at the edges by the multilinear sweep of the huge trailing wings. To counter these upward-slanting lines, the central area of the tympanum is rigidly horizontal. The belly bands of the angels, the body drapery of Christ, the writing on the great book, and – most important of all – the brazenly distorted upper arms of the angels, all combine to give weight and solidity pressing upon the thrusting and straining lower section. The detached drapery trails of the angels and the frozen little bunch of folds above Christ's right knee are both ancient and persistent manuscript conventions, deriving ultimately from the windswept draperies of the Winchester school, while the clear emphasis of flesh beneath the clothes, as in the angels' thighs, indicates the beginning of a new convention of monastic calligraphy.[24]

Further east still, at Norwich, there have survived the battered remains of a fine series of cloister capitals which must belong to the end of the main building period, 1121–45.[25] They seem to have been the work of artists of differing traditions. One capital shows the thin pipe-like scrolls with little volute lobes wandering irregularly about the composition, whose Urnes character has already been pointed out (Plate 49A). Another bears vigorous

and delicate figure sculpture projected against a background of scrolls with the trilobe foliations and central boss that were seen at Ely. On one side is a fight, and on the other a mysterious scene comprising two figures, one of whom holds a bucket and what looks like a stick. The drapery hangs heavily and entirely conceals the body beneath, but the gestures and positioning have life and movement. This particular capital is clearly the work of a sculptor who had worked on the Prior's Door at Ely. A third much damaged capital shows crossed legs, long thighs, and fluttering draperies that are strongly reminiscent of Anglo-Saxon manuscripts and so bear witness to yet another stylistic influence.[26]

<p style="text-align:center">★</p>

By far the most important sculpture of the mid twelfth century in eastern England was neither at Ely nor at Norwich. What splendid work there must have been at Bury Saint Edmunds we can now only guess at,[27] but at Lincoln there remains sufficient of the original west front to give some idea of what a wealthy and energetic prelate of the middle of the century considered suitable for such an important sculptural field. In the year 1141 there was a disastrous fire at Lincoln, and in the remaining seven years of his life Bishop Alexander set himself the task of restoring the damage and adorning and enriching the huge west front, which had survived intact. Whether the scheme was completed in his lifetime is uncertain, but at least it is clear that the design and layout took place under his direction. It provides the earliest evidence of the influence of French sculpture of the Île-de-France, at Suger's great new building at Saint-Denis, and consequently it forms a landmark in English Romanesque art. The sculpture was set in rectangular panels ranged high up over the doors along the whole western face of the cathedral, a decorative system unique in England, but known to central France in the form of early twelfth-century friezes, and executed on a large scale at Modena. Some of the panels have vanished altogether, but the original composition seems to have presented selected episodes of the Old Testament, such as the Temptation and Expulsion, Noah and the Ark, and Daniel in the lions' den on the south half, and scenes of the Last Judgement on the north. The surviving panels of these tell the stories of Dives and Lazarus and Christ's descent into Limbo, though the main emphasis is placed on the Torments of Hell. In the centre was a Majesty figure flanked by two apostles, fragments of which still remain loose in the cloister. The surviving pieces of this great composition, which must have run in a continuous band right across the front of the three immense arched recesses of Bishop Remigius's west front, show clearly that sculptors from more than one school were here employed. In some of the scenes are human figures with naturally proportioned bodies in wooden stances. They have heavy, squat heads and boldly defined features, often in three-quarter profile, and the drapery tends to cling closely to the body to reveal the shape of thigh and limbs. A very close parallel to this style is to be found on the slightly earlier sculpture at Saint-Denis – so close that it has been suggested that the artist was brought over from Paris.[28] Another sculptor worked in much the same general style, but his drapery is more deeply chiselled and less clinging, and the relief is much higher. A good example of his work is the panel with the scene of Dives and Lazarus (Plate 52A). The figure style of another sculptor is in almost complete contrast. The bodies are elongated,

<p style="text-align:center">73</p>

the postures and gestures excited and contorted, the cross-legged stance being much employed, and the heads are long and well-proportioned. The carving is in low relief and the drapery details are incised in bold multiple scorings. Part of the centre of the composition seems to have been reserved for this artist, and the apostle group in attendance on Christ in Judgement shows the skill with which the sculptor avoided the monotony of a row of identical figures (Plate 53). Little tricks, like the band of drapery grasped by the seated apostle on the left, betray the manuscript origin of this style, in contrast with the more independent sculpture of the other type. These cross-legged figures with the thin drapery lines and fluttering hems are often taken to prove the influence of French sculpture of the Toulouse region, with which they certainly have some similarities. These likenesses, however, may arise from an identical origin in the calligrapher's art of the Anglo-Saxon manuscript. Since all the tricks of style on these Lincoln sculptures and other works of the same type can be paralleled in pre- and post-Conquest manuscripts, there seems no reason to believe in the influence of south French sculpture. What was new and can in general be attributed to continental influence was the growth of a desire for grandiose iconographical schemes with large-scale figure-work.

Perhaps the most impressive of these Lincoln sculptures are neither the elongated cross-legged apostles nor the heavily modelled figures of God and Noah, but the gruesome scenes of the Torments of Hell (Plate 52B). This had been a favourite subject with the Anglo-Saxons and was to continue to appeal to the morbidity and the sense of caricature that distinguished the English artist throughout the Middle Ages. At Lincoln an enormous panel thirteen feet long is devoted to a series of carvings in which naked human beings are clawed and savaged by hideous-faced devils, while sinuous long-tailed serpents bite at their genitals and entrails.[29] As a method of encouraging virtue and a devotion to the Church among the illiterate citizens of twelfth-century Lincoln, such a terrifying representation so prominently displayed was no doubt exceedingly effective. As a work of art it is successful by reason of its dramatic content and its imaginative power rather than by its plastic or linear qualities.

Within the centre of the three great arches and below this range of large and didactic sculpture, Bishop Alexander inserted a richly carved west door. Nineteenth-century restorers dealt hardly with the sculpture, but enough remains loose in the cloister to obtain a clear idea of its original quality. The door consists of a single great arch of no less than five orders supported by richly ornamented nook-shafts, a system that had earlier appeared at Verona and thence spread to the Île-de-France at Saint-Denis. Of these shafts the outer two bear a criss-cross diagonal pattern with a rose ornament within each lozenge. The middle bears beaded medallions within which are the oriental motifs of animals or birds affronted to a tree of life, or else a high conventional flower pattern. The two innermost shafts show an elaborate version of the climbing figures within scrolls and a new type of beakhead consisting of heads with varied tongues curving round the pillar. There are in this work considerable resemblances to the second type of Reading sculpture. The octagonal nook-shaft, the embattled ornament flanking the five orders, the rosettes on the soffit, the beaded medallions on the shaft are all features common to both, and it has been seen that the idea of the beakhead first achieved popularity at Reading. The Lincoln work,

however, has strong individual features of which the most striking is the richly sculptured shafts with naked human beings writhing and twisting amid swirling scrolls. These vivacious little nudes within fat coils are found on nook-shafts a little earlier at Saint-Denis, and this and other details provide clear evidence of the influence of Abbot Suger's work.[30]

The most controversial and certainly the most beautiful achievement of the period is the mutilated figure of the Virgin and Child, now set up in the crypt of York Minster (Plate 55). The date and provenance of this work have long been hotly disputed. Carved from a slab of Tadcaster stone, it must have been worked at York and cannot be a foreign import. The most hopeful clue to date, the archaic lettering of the inscription SCA MARIA, is unfortunately inconclusive, since exhaustive research has shown that although the type of A and C used are more frequently found in eleventh-century work, yet there are a sufficient number of well-authenticated examples on seals and coins of the twelfth to make such a dating possible.[31] If the sculptor was copying an earlier example, the old-fashioned lettering would be easily explained. The position of the Child supported by both arms of the Virgin on her left knee is one sufficiently confused in type to be without a date,[32] and the most obvious conclusion to be drawn from this iconographical muddle is that the artist was drawing on Byzantine and Levantine models not directly but at second or third hand. One of the more remarkable features is the manner in which the cushions for seat and footstool with their long drapery cover are used not as genuine supports but as an ornamental background. It is not immaturity in the handling of perspective but deliberate aesthetic purpose which has placed the seat cushion as a vertical back-cloth high up under the Virgin's waist, and the foot-rest as another vertical pattern suspended some inches below the shoes. This detachment from spatial conventions was certainly a Late Antique and Byzantine device, but it had long penetrated the west and cannot be used to argue direct Byzantine influence.

As for the general drapery arrangement, foreign parallels are equally too vague in date to be of much assistance. The arguments for a mid twelfth-century date and a Lincoln sculptor are none the less very compelling. In the first place it is said that Tadcaster stone was not used for building or sculpture before the middle of the twelfth century.[33] Nor does this relief, with its careful attention to detail, weighty solemnity of pose and slick finish, bear any relation either to the Winchester style of manuscripts or to pieces of sculpture of generally admitted pre-Conquest date. But the manner and depth of relief, the disproportionately elongated legs, the technique of rendering drapery in finely cut double line incisions swinging across the composition, the pleats and zigzag hems are all almost exactly paralleled in a fragmentary figure of an apostle at Lincoln.[34] So similar is this figure that it seems absolutely clear that the two works emanated from the same workshop, the York carving being the more mature and therefore dating probably to about 1150.

<div align="center">★</div>

The most convincing evidence of foreign influence in this mid-century period comes neither from the Leominster school with its Poitevin connexion nor from Bishop Alexander's sculpture at Lincoln, but from surviving fragments of the cloister and chapter-house of Durham. Despite its geographical remoteness, the great wealth of the monastery

and the immense power and prestige of the bishop at all times served to attract the best craftsmen from the south, though the general poverty of the area never provided sufficient employment for the development of an established regional school. The cloister carving consists of a tall square block, probably the corner of the arcade, bearing in shallow relief the now battered figures of bishops and laymen.[35] So far as is known this type of relief is unique for an English cloister, though it is frequently met with in southern France in the first half of the century, as at Moissac or Saint-Bertrand-de-Comminges. Though the figure style is far more primitive than the work of Lincoln, this remarkable copying of a south French idea bears witness to far-reaching artistic contacts.

The chapter-house was completed between 1133 and 1140[36] and was destroyed in 1796. But some huge roof corbels have survived, consisting of capitals with foliate scrolls and dragon ornament supported by hunched human figures in bold relief.[37] The source for this feature can only be north Italy, where at Ferrara, Piacenza, and Cremona similar figures are to be found in the work of the artist Niccolò during the second quarter of the century.[38] These atlas figures thus raise in an acute form the whole problem of Italian influence in England in the period 1135-60. It has been noticed in the Leominster school in the supports of the Castle Frome font, in East Anglia on the Prior's Door at Ely, and at Lincoln in the idea of a great sculptured frieze; it will be seen in the York school at Barton-le-Street, and it appears here at Durham. There can be no question of Italian artists themselves working in England, since the borrowing is so irregular and haphazard and the accompanying stylistic detail so wholly English. Nevertheless Lombard influence is known to have passed through Germany and powerfully affected the south Swedish cathedral at Lund in the first half of the century, so that there is nothing inherently surprising in its further penetration to England.[39] But more probably the influence was direct from Italy. Many of the great ecclesiastical patrons of the day, like Bishop Alexander of Lincoln, Abbot Anselm of Bury, or Archbishop William of York, had visited Rome and must have seen and admired the north Italian sculpture. It seems probable that some of them were accompanied on their travels by artists whose sketches and memories were subsequently incorporated in designs for sculpture in England.[40]

LATE ROMANESQUE
⟨CIRCA 1160–1180⟩

As has been observed, the anarchy and destruction of the reign of Stephen seems to have had but little effect upon the output of monastic and cathedral buildings. It seems uncertain whether this was due to the relative immunity of ecclesiastical property from the worst of the destruction, or whether losses in landed income were being compensated for, either by increased donations from magnates not unreasonably concerned about their prospects in the life to come, or by increased reliance on the credit organization of the Jews. At any rate there is no sign of arrested activity or of building on the cheap, such as can perhaps be discerned during the reign of Rufus. More significant for the future than the political troubles was the arrival in England of the Cistercian monks. This order, the creation of an autocratic and passionate philistine, Saint Bernard of Clairvaux, spread that hatred of architectural grandeur and sculptural adornment with which its founder had been imbued. In architecture he objected to the 'immoderate length, superfluous breadth, costly polishing, and strange designs' of Benedictine and Cluniac churches; in sculpture, he violently attacked just those lavish cloister decorations which were the glory of Reading, Lewes, and Norwich. 'What profit is there in those ridiculous monsters, in that marvellous and deformed comeliness, that comely deformity? To what purpose are those unclean apes, those fierce lions, those monstrous centaurs, those half-men, those striped tigers, those fighting knights, those hunters winding their horns? Many bodies are there seen under one head, or again, many heads to a single body. Here [is] a four-footed beast with a serpent's tail; there a fish with a beast's head. ... We are more tempted to read in the marble than in our service books and to spend the whole day in wondering at these things than in meditating the law of God. For God's sake, if men are not ashamed of these follies, why at least do they not shrink from the expense?'[1]

This rigid neglect of natural aesthetic demands could not persist, but the strong personality of Bernard and the administrative centralization of the order enforced conformity with his views for over two generations. Chapter 20 of the *Statutes of the General Chapter*, completed by 1152, was categorical in its language: 'Sculpturae vel picturae in ecclesiis nostris seu in officinis aliquibus monasterii ne fiant interdicimus', and this prohibition was repeated in 1213.[2] These ideas were propagated in northern England by the dominant English Cistercian of the Age, Ailred of Rievaulx,[3] with disastrous consequence to the future of English medieval sculpture. At Tintern, Rievaulx, Fountains, and elsewhere, on sites deliberately chosen for their remoteness or deliberately isolated by the wanton destruction of whole village communities, there sprang up buildings whose stark simplicity and austerity, whose total lack of adornment of any kind, forms the most striking contrast to the lush decorative systems of their Benedictine or Cluniac contemporaries. In time this style was bound to make its influence felt, and the Cistercian bell-shaped capital with

its simple water-leaf ornament is to be found on an increasing number of churches in the second half of the twelfth century.

The significance of the Cistercian buildings was enhanced by the fortuitous fact that by the mid-century the major constructional programmes of the great houses in the south of England were more or less completed, and fresh building was now mainly confined to repairing destruction wrought by the not infrequent accidents of fire or the collapse of a central tower. It is not surprising, therefore, that the most powerful and distinctive of local sculptural schools of the 60s should have developed in the plains of the Vale of York. The recovery of this area from the deliberate destruction carried out by William the Conqueror in 1069–70 was naturally not swift, but the rich soils of the Vale were the first to be repopulated and it seems that substantial recovery had taken place here by the end of the century. But the bulk of the churches of the area date from a period not earlier than the 1130s, and many are substantially later. The sculptural school which grew up in this district was not the product of a single generation under the unifying influence of one master craftsman like that of Leominster, but was spread over a prolonged period in which considerable stylistic modification took place. The later phases of the school can be associated with the great and wealthy Benedictine Abbey of Saint Mary, York, but the destruction of the monastic buildings and the fragmentary nature of the surviving sculptural remains make it impossible to prove that this was the centre of the workshop. Nevertheless the similarity of the earlier work with Benedictine sculpture of the south, particularly in the Reading area, the popularity of themes taken from books only available in monastic scriptoria, and the association of one of the outstanding churches with property held by the Abbey tend to support such an ascription.[4]

The York school, like the earlier Reading offshoot in Herefordshire, evidently also came under western French influence. The bestiary carvings on the voussoirs of Alne, the corbel table at Barton-le-Street (Plates 57B and 58A), the love of rich figure-work on radiating voussoirs, and the rejection of tympana – these and other features prove that this school drew its inspiration from Poitou as much as from Reading. In addition to these influences, the Vale of York was an area of heavy Scandinavian settlement and it is hardly surprising that the school shows traces of the flat, sinuous dragon carving of Viking art, and of the interlace patterns of pre-Conquest cross shafts.

The earliest examples of the school, such as the north door of Saint Lawrence extra Walmgate, at York, can hardly be earlier than 1150, judging by the architectural device of the porch-like projection within which the arch is set, the austere type of running scrolls, and the fully moulded head terminals of the hood-mould. The carving of the voussoirs is executed in shallow relief on flat orders, without trace of beakhead, chevron, or other moulded decoration. Some of this work, for example the south door of Healaugh in the West Riding, shows a certain resemblance to the Reading school. The beakheads of the second order are of the same punched, ribbed, fully moulded type that were seen at Oxford. The nook-shafts are grooved in beaded spirals and the capitals decorated with complicated scrolls that show signs of Urnes influence (Plate 56A). What is new about this Yorkshire style is the extreme richness of the figure-work spread in lavish profusion and minute detail over the voussoirs – the reproduction in stone of the little vignettes with

which manuscript initials of the age were commonly adorned. Here at Healaugh for example are a female dancer with contorted body and flowing hair – a subject taken from illustrations of Salomé dancing before Herod – a bird, more dancing women, and an obscure figure scene over the centre which may possibly represent the Coronation of the Virgin. On the other hand, these cultivated sources from the literary repertoire are modified in this harsh northern environment by features of a more primitive type. The female figure with arms akimbo placed horizontally upon the imposts suggests a barbaric contempt for siting and arrangement that was strongly in evidence in pre-Conquest northern crosses. Furthermore, the capitals of the chancel arch of the same church, possibly of an earlier date than the south door, bear loose scrolls with tight spirals and long volutes that are direct descendants of the Scandinavian Urnes style, visible near by on the capitals of Kirkburn.[5]

Later, in the 60s and 70s when the style reached full maturity, the mannered acanthus leaf scrolls of the south and the earlier Reading trick of filling up empty space by ribbed leaves or little fluted channellings like leaves both became popular. At Fishlake appears the characteristic feature of the oval or circular beaded medallion on the arch roll used as a frame for figured scenes. The iconography of these scenes on the outer order is as confused as with all others of this York school, hunting scenes, the *Psychomachia* taken from a Prudentius manuscript, Christ and Saint Peter, animals and demons, being strung out in complete disorder. Excellently preserved examples of this middle phase of the York school are provided by some voussoirs from an unknown provenance in the city, now in the Yorkshire Museum, which show a series of spirited animals enmeshed in interlace and ribbed leaves of a Reading type and set within beaded medallions (Plate 56B). Here again the long curling lips and the emphasis on the leg-joints are both signs of Viking influence. Sometimes flat as at Saint Margaret's, York, sometimes boldly projecting as at Brayton and Stillingfleet, sometimes with fluted concave centres as in Foston, the varied use of these medallions is evidence of their great popularity in the school. This popularity was probably due to their ornateness, for there can be no doubt that the principal ambition of these Yorkshire sculptors was to produce a bewildering effect of complicated detail piled on with minute precision and care. Nowhere in this small-scale, precious, Yorkshire work is there a hint of the grand didactic iconographical schemes of Bishop Alexander of Lincoln. In essence it was an attempt, doomed in advance to disappointment in view of the sullen northern climate, to give a church doorway something of the dazzle and splendour of a brilliantly illuminated manuscript page. Even to-day traces of red paint survive on some of the doorways, for example at Brayton, to prove that they were originally highly coloured.

At Brayton, one of the richest of all the middle period churches of the style, the capitals of the chancel arch display all the characteristics of the group (Plate 57A). Three-stranded or beaded interlace with leaf terminals wander unsteadily across the face of the capitals, encircling prancing Romanesque lions. But the little heads at the corners are no longer the conventional cat's heads of Reading, but fully moulded human portraits. The curving soffits of the abaci are adorned with boldly projecting bosses, and the surfaces of the abaci bear symmetrical sprays or leaf scrolls.

The south door at Brayton shows all the desperate elaboration and intricacy of design of a style that is past its prime, the beginning of a late twelfth-century geometrical ornamentation that was the last defence of Romanesque against the new austere traditions introduced by the Cistercians. The beakheads of this door are of a late type – thin elongated tongues that barely curve over the roll. The figure scenes on the projecting medallions show the casual inconsequence of the artist's fancy: combats of lions and dogs; scenes of aristocratic life such as boar-hunts and knights fighting on horseback; a stray Sagittarius from the zodiac cycle; Samson and the lion; a female figure with sleeves so extravagantly long that they have to be knotted to keep them off the ground, all strung together in their medallions to form a meaningless chain of casual illustrations. Elsewhere the sculptor has limited his choice of subject to extracts from a single manuscript source, and on the outer order of a doorway at Alne he has provided the richest example of a carved twelfth-century bestiary in the country.[6] The edge of this outer order has a double-cone moulding which is almost unknown in English sculpture, except in the contemporary local school at work in the Broadlands of Norfolk and Suffolk. The inner order, on the other hand, with its disorderly array of scenes within beaded medallions, some of them taken at random from zodiac and labours of the months cycles, is in the usual Yorkshire school style. Though many of the voussoirs are unfortunately new, nine of the originals survive. Under semicircular arches bearing the names of the animals, and resting on fluted filling ornament, the beasts are depicted in attitudes and shapes which conform to the symbolic meaning attached to them in the manuscript commentaries (Plate 58A). At Alne the Caladrius is seen hovering over the bed of a sick man, for it was a bird possessed with the power of foretelling whether a patient would recover. This it accomplished by the practical method of sucking all the disease out of the sick man's mouth when it had decided that he would live. Then there are the Terribolem, male and female stones that burst into flames when brought into contact, thus illustrating the dangers of association between the sexes. One of the odder legends concerns the Panther, which in the Middle Ages was considered a gentle animal symbolic of Christ. After three days in hiding it emerged roaring and giving off a sweet savour that attracted all animals towards it save its enemy the dragon, the symbol of evil, which retired into its hole discomfited. At Alne the Panther has his mouth open, plainly roaring, while before him is the dragon half sunk into his hole. To what extent the parishioners or parish priest at Alne were ever sufficiently instructed to appreciate the symbolism of their doorway, must remain open to doubt. The illustration of such recondite themes in a village church at this early stage of the Middle Ages is convincing evidence that the sculptor went for his designs to a manuscript in a monastic or cathedral library.

The most splendid product of the school at its peak period is the extraordinary sculptural system lavished upon the tiny church of Barton-le-Street, in the North Riding. The original church was destroyed in 1871, but much of the sculpture has been incorporated into the new building. The appearance of binding ties shaped something like a pair of buttocks, which are confined to this school, is sure evidence of the local workshop. But the absence of medallions as frames for the subjects, the remarkable corbel table, and the even more remarkable heads with which the chancel arch capitals are carved are all signs

of a new influence. The flat orders and lack of geometrical elaboration suggest a fairly central date in the evolution of the style, perhaps in the early 60s. The hood-mould of what was originally the south door, and is now the outer door of the porch, bears affronted birds, elongated birds and dragons, Saint Michael and the dragon, Sagittarius, and Pisces, a female erotic figure, a tree of life, a winged dragon, etc., in shallow sunken relief (Plate 58B). The nervous quality of the carving is unusual, but the confusion of iconography, the use of space-filling leaves or flutings, and the details of some of the figures all link up with other carvings of the York school. The same type of work, but more clumsily executed, occurs also on vertical rows of square panels down the jamb of what was origin-ally the south door (Plate 59). Over the north door are set some figured panels which seem to show signs of the jagged, agitated, impressionistic effect of pre-Conquest pen work. The panels depict an Adoration of the Magi and a Nativity with censing angels that are outstandingly successful examples of the translation into the uncongenial medium of free-stone of this vivid calligraphic style. Other panels in similar style show within two beaded circles a pair of human figures in short skirts, bearing a scythe and a wheatsheaf and perhaps intended to be symbols of the seasons.[7] The corbel table consists of small arches with pro-jecting heads and foliage in the spandrels supported by richly carved corbels (Plate 57B). The heads, beautifully executed as they are, are still highly abstract schematizations of the human face, in which the sculptor is more concerned with the pattern of eyes, nose, and moustaches, than with naturalistic representation. What makes Barton-le-Street so im-portant is that here more than anywhere else in the York school is evidence of foreign influence from western France and Lombardy. The system of square panels with random figure subjects down the jambs, the zodiac signs in roundels on voussoirs, and the corbel table with animal and human figures carved within the arches are north Italian features, although the last is also western French, being found most prominently at Poitiers.[8]

Later on the school simultaneously underwent two conflicting developments, the one towards progressively more elaborate geometrical decoration, and the other towards more boldly stated figure-work.[9] Skill in modelling in depth developed so that the figure scenes, which emerge from their encircling medallions, as at Riccall, stand out more and more from the heavy roll mouldings. But in general the beakheads shrink to grooved triangular shapes, as at Etton; repetitive rosette medallions or a curious double circle, the schematized evolution of a tree of life, become popular in ever increasing elaboration and complexity. Thus by about 1180 the varied figure-work and lavish individual ornament of Barton had been superseded by a geometrical elaboration such as that of the arches of the great west door at Selby, which rest upon the new water-leaf capitals. The evolution of the Yorkshire school followed that of Reading thirty years before, repeating the trend towards abstract geometric ornament which is a persistent feature of English sculpture in the twelfth century.[10] It is curious that it should be in the north, where Cistercian pressure was most intense, that geometrical decoration developed to its most fantastic pitch of sophistication and over-elaboration, apparently in flat defiance of the Cistercian canons of taste. On examples dating to about 1180, such as at Bridlington chapter-house and a doorway of Bishop Puiset in Durham Castle (Plate 63), the sculpture becomes heavier, more deeply carved, richer in surface ornament, more contemptuous of the

architectural frame it adorns. The chevron is used like broken sticks in every conceivable combination, and hollow or projecting bosses and oblongs proliferate. Against this is to be set the austere Cistercian taste at Fountains Abbey where the simple water-leaf capital is the only hint of sculpture in the whole building. In the north therefore, the two aesthetic traditions conflicted strongly, each going its own way until at last the old decorative style was completely eliminated.

<div align="center">★</div>

Elsewhere English sculptors continued to follow in the wake of experimentalists in manuscript illumination. One of the most remarkable innovations by the calligrapher was the 'damp-fold' style by which drapery was represented as clinging closely to the contours of the body. The advantage of such a technique was that it encouraged a study of the human form, virtually in the nude, and taught the draughtsmen much about anatomy. The English love of pattern, however, almost immediately transformed this drapery style so that the ridges of cloth were used as double-line contours to form rhythmical oval shapes.

The most harsh and metallic treatment of the damp-fold system appears in the Lambeth Bible, while a softer version with an added wildness and energy that obviously owes much to pre-Conquest calligraphy forms the style of the 'Master of the Leaping Figures' in the Winchester Bible. A treatment that retains much of the rigidity of the Lambeth artist but combines it with the frenzied drawing of the Master of the Leaping Figures is found in the five-and-a-half-inch panel in *champlevé* enamel with vague Winchester associations known as the Masters Plaque (Plate 51A).[11] The *champlevé* technique, which consists of scooping out the parts of the metal field to be filled with enamel, does not seem to have been practised in England before the twelfth century, when it arrived as an import from north-eastern France and Lorraine. Indeed this extraordinary work is the only piece of enamel of the twelfth century which can with complete confidence be attributed to an English *atelier*. The plaque represents the Last Judgement, with Christ surrounded by angels above, and below that favourite English theme, the tortures of the damned in Hell, here depicted in graphic detail. This lower scene is messily conceived and quite unsuited to the technique, which requires simple figure-work to be boldly stated against the solid blue enamel background. The upper portion, however, is a splendid composition in which the swaying windswept draperies of the great figure of Christ with human heads nestling in the folds, and the twisted, straining head postures of the angels are both inspired by Winchester illumination of the early eleventh century in its wildest and most extravagant manner. The artist has succeeded in reducing the scene to a study in pure line, combining a repetitive ovoid rhythm over the body and a violent sweep of draperies around the sides.

A softer, less doctrinaire version of the same damp-fold system appears in sculpture in far-off Durham on some panels probably from the now vanished *pulpitum*. One scene is of Christ on the road to Emmaus, and shows two prostrate figures enveloped in long cloaks which cling closely to the shape of the body but are still divided up by the gently curving double lines of the damp fold (Plate 64). The closest analogy to these clinging draperies is the illustrations of the Bury Bible, a work of before 1148, though the beaded hems and the interlacing trees do not occur in this manuscript.[12] This little panel shows a

mastery of gesture and attitude in a conversation piece which is derived from Byzantine iconography. The slight bend of Christ's left knee as he moves away, the backward-looking movement of his right hand as he gathers up his garment in his left, the strain and stretch of the prostrate apostles as they reach out to touch him, are all tenderly conceived and perfectly executed. Here is emotion conveyed not by the wildly exaggerated mannerisms of the Anglo-Saxon or the agonized grimaces of the Chichester panels, but by carefully controlled grouping and sensitive, delicate gestures.

Similarly in the west sculptors adhered to the same manuscript conventions. The rebuilding of Malmesbury Abbey did not begin till after 1142 and it is unlikely in view of the use of pointed arches that the nave was completed much before 1163, when there is evidence of a consecration.[13] Certain peculiarities have been recognized in the architecture and sculpture of Malmesbury which show close links with other works in the west of England and which justify the identification of a west-country school that flourished throughout the whole transition stage from Romanesque to Gothic and played a leading part in that revolution. Of the sculptural features of the school the most striking are the use of continuous roll orders for doorways, without capitals or nook-shafts; the adornment of wall surfaces with large projecting rosettes, such as are found as far west as Llandaff, and also on the highly sculptured church at Lullington, in Somerset; and label stops with dragon head terminals of a special type with long, slightly twisted snouts and curving lines running around ears and eyes which seem to be copies of the tenth-century boar's head at Deerhurst (Plate 76A).

Many signs point to the influence of western France upon this group. The arrangement of sculpture along the sides of a porch, as at Malmesbury, is unique in England but found in south French churches, at Moissac, Souillac, and elsewhere. The style of the Malmesbury tympana bears analogies with work at Aulnay-de-Saintonge, one of the patterns on the outer arch moulding is also found there,[14] and the capitals of the allied church at Lullington in Somerset might very well be by a Saintonge sculptor.

In the elaborate south porch at Malmesbury there has survived a carefully planned scheme of the Romanesque period, which, apart from the Lincoln frieze, is unique in this country for its iconographical complexity. The outer doorway has three continuous roll orders with shallow medallions enclosing scenes from the Old and New Testaments: the creation and the early story of man on earth, and the later redemption of man seen in the life and death of Christ, the two cycles balancing one another. Within the porch on either side are huge tympana with seated figures of the twelve apostles looking down on the small inner tympanum, which bears the usual Christ in Majesty in a vesica supported by angels. The medallion carving of the outer doorway is now crumbling rapidly and within a few years only photographs are likely to survive to testify to its quality. The system of figured medallions on roll mouldings is met with both in Yorkshire and in Kent, probably under the influence of western French sculpture, but here at Malmesbury it is treated with greater freedom and the figures are made to play a more important role than the enclosing frames. Those medallions which until recently were still relatively well preserved show compositions of great dramatic intensity coupled with exquisite technical execution. Though not adhering to the rigidly schematic damp-fold conventions of the Lambeth

Bible, or even the modified version of the Durham sculptor, the figures are tall and slim and the draperies cling closely to the body. The creation of Adam and Eve (Plate 61B) depicts God the Father as an immensely elongated figure, the linear harmony of whose body is emphasized by the close-fitting ovals over the thighs and leg and concentric circles around the stomach. These tricks of drapery coupled with the crossed legs and hunched shoulders give the illusion that God is floating effortlessly through space. This buoyancy and grace, and many of the details by which they are achieved, are a legacy from the pre-Conquest manuscript style, passed on to the late twelfth-century sculptor via the mid-century Winchester Bible and Psalter.[15]

The tympana under the porch with the apostles seated on their long arcaded benches (Plates 60 and 61A) are in a somewhat different style. Carved in fairly high relief, their drapery is conceived in even more mannered and conventionally linear terms than that of the arch medallions. Ovals emphasize prominent features such as the stomach and elbow, cloaks loop and drag in parallel curving folds, gestures are exaggerated and anatomically impossible, the head of the central apostle is awkwardly bent sideways to make room for the hips of the angel overhead. But for all these somewhat old-fashioned tricks, the figure sculpture is more powerful and arresting than any since the Lincoln frieze, with whose panel of the apostles (Plate 53) it has obvious affinities. Great care has been taken to break up the monotony of the seated figures by changes in the attitudes of legs and hands and by varying the pose of the formidable bearded heads. The awkward but conversational stance of these Malmesbury apostles forms a strong contrast with previous west-country large-scale figure-work, like the Christ at Lullington, in Somerset, or the two apostles in the tower at Sidbury, in Devon, which are in the stiffest of hieratic poses. This Malmesbury sculpture, both of the medallions scenes and the rows of apostles, resembles the Bible and the Psalter illuminated at Winchester some years earlier for Henry of Blois, and it looks as if the Malmesbury carvers were combining local architectural and sculptural traditions with stylistic influences emanating originally from the Winchester scriptorium. The broad curving bands across the body, the sagging treatment of the drapery between the knees, and the use of the double-line contour are all found in the wall paintings of similar seated apostles at Kempley in Gloucestershire, which in turn are closely allied to the Shaftesbury Psalter, a manuscript written between 1161 and 1173, though not necessarily in the west.[16] Both the manuscript and the wall paintings have been ascribed to Winchester influence. In view of Henry of Blois' influence and interest in the west of England, due to his tenure of the Abbey of Glastonbury and his ambitions for a metropolitan see in the south-west, such a connexion does not seem unlikely.

<div align="center">*</div>

The only distinctive local school in the south-east in the third quarter of the twelfth century was to be found in Kent. Canterbury seems to have played no part in its development, and its earliest and most important work was executed at Rochester. The west door of the cathedral is evidently of at least two dates. The pillars with their East Anglian binding knots half-way up, and their interlace and scroll capitals, seem to belong to the first building of the 1130s. But Kent by its geographical position was widely open to

continental influences. Built early in the century, the churches of Sandwich and Saint-Margaret-atte-Cliffe are more purely Norman, unaffected by insular art, than is normally found elsewhere. In the same way the influence of the sculpture of the Poitou and Charente area, though also observable in the Leominster and York schools, is more pronounced at Rochester. The tympanum and arch erected soon after the middle of the century upon the original capitals of the west door are more obviously inspired by work abroad than any other twelfth-century English sculpture (Plate 65A). The voussoirs have the same distinctive birds with bent-back necks and upturned tail-feathers as at Poitiers. The tympanum – itself a non-Poitevin feature – bears Christ in Majesty seated within a vesica supported by two angels and surrounded by the four signs of the evangelists, below which on the lintel are the seated figures of the apostles. The layout of this composition, while frequent in France, is unknown elsewhere in England in this form, although the inward-facing bodies of the evangelistic symbols are commoner in England. But the thin figures of the angels with their tenuously attached wings and the handling of the draperies of the seated Christ and apostles are both different from earlier English examples, and are clearly the result of Burgundian influence.

Despite the marked stylistic differences, it was probably at the same time that one of the pillars on each side was cut away to make room for two shaft statues, evidently copied from those at Saint-Denis and the earliest series on the *Portail Royal* at Chartres, of *c.* 1145–1150.[17] These represent King Solomon and the Queen of Sheba, taken allegorically to represent Christ and the Church respectively, and thus providing a suitable explanation for the iconographical identification of the supreme lay power with both the Son of God and the organized spiritual authority.[18] Like their French prototypes, they are strictly subordinated to the architectural need, being elongated and tubular in shape, with the emphasis laid on parallel vertical groovings for the falling draperies. With the same long tresses falling over her shoulders, and holding the same scroll, the connexion between the female Rochester figure and those of the great doorways of the Île-de-France is very plain (Plate 65B). Only the slight asymmetrical flutter of drapery at the foot which enables the statue to escape the iron rigidity of the vertical lines may perhaps be taken to show the touch of the English artist, imposing his own sense of rhythm on the patterns of the Continent. This Rochester door thus shows stronger French influence than any previous English piece of sculpture. But though the voussoirs are copied from Poitou, the pillar statues from the Île-de-France, and the tympanum influenced by Burgundy and Île-de-France, it is evident that all have been subjected to the filter of English taste, and the total result is something that remains distinctively insular.

It is also, it must be admitted, much humbler in conception and poorer in elaboration than the huge façade sculpture of contemporary France. England has nothing to compare with the west front of Notre-Dame-la-Grande at Poitiers, or the *Portail Royal* at Chartres. This inferiority must be explained largely on economic grounds, since this Rochester sculpture shows evident desire for emulation. The great French centres, possessing the strong magnet of some famous relic, were able to attract pilgrims, and therefore donations, on a scale which no English monastery could hope to rival. For the population of twelfth-century France was some six times as great as that of England, to say nothing of

German and Spanish pilgrims. Royal and papal taxation was also more onerous in England than elsewhere, and many English monasteries in the latter half of the twelfth century were experiencing financial difficulties, so that some, such as Bury Saint Edmunds before the reorganization of Abbot Samson, were mortgaging more and more property and administrative offices to Jewish creditors.

Of the other examples of the Kentish school, the closest parallel to the Rochester work is provided by the doorway and tympanum of Patrixbourne, whose voussoirs with birds and leaf scrolls show clear signs of influence from that source. But it is evidently a later work, for the hood-mould has the new dog-tooth ornament, and the innermost order bears flat straps on a thin roll, the final geometric and devitalized evolution of the beakheads, which is purely insular. Furthermore, the tympanum of the Majesty and the lintel of leaf scrolls and sinuous dragons are in the shallow, two-plane technique of the earlier Rochester work such as the chapter-house tympanum, and bear little relation to the new French influence.[19] The other major Kentish work of the 1170s is at Barfreston, where the voussoirs are carved in the medallion style with the usual inhabitants: grotesques, signs of the zodiac, labours of the months, and so on. The appearance of goats playing musical instruments recalls similar themes on Canterbury capitals fifty years before. The capitals are square in shape and bear knights on horseback, very much like contemporary work at Iffley, near Oxford. The tympanum itself shows Christ seated in an oval aureole that is itself a leafy bower, a device that was to be very popular in thirteenth-century English sculpture. The modelling of the figure of Christ and of the heads of the king and queen within the foliage, symbolic of Sol and Luna, and the shape of the little human-headed tailed bipeds that also lurk there, are all evidence of the minute delicacy of the illuminator or the goldsmith. Though the facial expressions are naturalistic, clumsy attempts at the new humanism of Early Gothic, yet this Barfreston door is basically in the old tradition of dependence on other crafts, rather than according to the new idea of treating sculpture as an artistic medium in its own right.[20]

<p style="text-align:center">*</p>

The element of drama and emotional intensity was an intermittently persistent feature in twelfth-century English art, the result of an inheritance from its Anglo-Saxon past. The Chichester panels, the Masters Plaque, and the Malmesbury medallions all reflect this tendency, and it is therefore not altogether surprising to find a tiny ivory crozier that shows all the romanticism, the tortured intensity and the contempt for an orderly relationship between frame and composition that were the hallmarks of the Anglo-Saxon artist. But the beading and billets running round the inner edges of the crozier are never found in pre-Conquest work, and the draperies and bodies are handled in the plastic style of the mid twelfth century. The extremely difficult iconography also indicates a date no earlier than the twelfth century, since it has recently been suggested that it represents the legend of Saint Nicholas which only then reached full development and popularity. By this interpretation the subject of the lower half of the crook (Plate 62) is the same as that of the Winchester font (Plate 68),[21] with which the contrast in style and atmosphere is complete. The font is monumental and static, the crozier wildly emotional and mobile.

Agony is depicted on the face of the nobleman as he lies in bed drooping an elongated arm upon the bedclothes to reach the bag of gold thrust up towards him by the outstretched figure of Saint Nicholas. It is the human emotions evoked by this gesture of the Saint in saving the nobleman's daughters from prostitution that is here given the greatest emphasis.

The middle and late twelfth century in England was a period of remarkable intellectual vigour in which full rein was given to personal and individual initiative. The cynical satire of Walter Map, the rambling anecdotes of Giraldus Cambrensis, the brilliant imaginative fiction of Geoffrey of Monmouth, the administrative genius of Richard FitzNeal, the philosophical works of John of Salisbury, the competent and comprehensive historical records of William of Malmesbury, all bear witness to this many-sided intellectual activity. Inevitably this ferment is mirrored in the arts, where there is a similar absence of standardization and uniformity. The three main schools of architectural sculpture in the Late Romanesque period, in Yorkshire, Wiltshire, and Kent, possess distinct characteristics of their own and develop along parallel lines of increasing geometrical ornament and increasing sensitivity of modelling in figure sculpture. But it is not to be expected that any simple stylistic development should occur in the sculpture of objects like fonts.

Being to a limited extent portable, fonts lend themselves to production in a central workshop, and for the first time there appear groups of sculpture which seem to be the product of a fixed masons' yard. In the Buckinghamshire plain are to be found fonts of closely similar design which seem to be imitations in stone on a large scale of the shape and ornament of the gold or silver chalice of the metalworker. Of these the finest example is at Aylesbury (Plate 67A), but the source of the group may well have been the great Benedictine house of Saint Albans, the absence of whose sculptural influence would otherwise be somewhat remarkable. The base of the font takes the shape of an inverted double-cushion capital, the faces of which are adorned with symmetrical sprays, which, in imitation of manuscripts, are curled over at the end and have lost all hint of their earlier foliate character. The depressions of the cushions are adorned with long stylized leaf tongues, in imitation of similar ornament on pillar bases which occur early on in the century at Rochester and become more frequent at about this time. From a ribbed neck, with shallow roll and hollow chevron ornament, springs a splendid convex bowl with elaborate fluting topped by a band of foliage ornament held together with horizontal beaded binding ties and displaying bulbous fruit emerging from the leaves. The most remarkable feature of this font is the sure mastery of the technical problem of carving in the round from a single block of stone so complex a shape with such absolute symmetry. The perfect balance between base, neck, and cup, and the skilful choice of decorative motifs both point to a long antecedent tradition whose source must lie in small-scale work of the gold and silversmith from the treasury of some great abbey or cathedral.

A consequence of their mobility was that fonts were not merely confined to local stone, and lead became a popular material for heavily ornamented fonts. The technique was to carve patterns in wood, impress the wood on the molten lead as many times as was necessary, and then run it out in a flat strip. At a later stage the strip was bent round and soldered together, a circular bottom fitted to it, and the completed work transported, preferably by water, to its final destination. These fonts were the natural products of the

two lead-mining districts. Thus an example at Ashover represents the Derbyshire mines,[22] while a mid-century group scattered around the Severn valley of six identical fonts struck off the same mould represents those of the Mendips. The pattern of these six consists of seated figures and spiral scrolls alternating beneath an arcade, four arches completing the pattern which is then repeated (Plate 66A). The pillars and arches are thickly ornamented with the geometrical designs popularized in the second Reading school, and the trape- zoidal bases are enriched with interlacing and other linear patterns. The nearest manu- script parallel to the figure style with its wig-like hair, curling beards, and complicated drapery arrangement is a figure of Christ from the Bury Saint Edmunds Bible, of the second quarter of the century.[23] The interlace on the base of the pillars and the alternating scrolls with their fat stems, absence of binding ties, long curling acanthus leaves and smoothly flowing asymmetrical rhythms, are to be found in the mid-century Winchester Bible.[24] On the other hand the little frozen flutter of the drapery hem is rare in either manuscript, and there are no traces of the geometrical architectural ornament. Thus the sources of the mould for this font are mixed, including two manuscripts and the geo- metrical style of the second phase of Reading sculpture.[25] These products of the Mendip lead-mines are in the full English tradition and bear no trace of the exotic.

The other important series of twelfth-century fonts not in local stone is a totally alien product, an import from Flanders. By the early twelfth century the town of Tournai had become famous for its beds of black marble, in the use of which material the local sculptors soon developed great proficiency. Thanks to direct access to water transport via the Scheldt to the sea, the products of this school achieved great popularity throughout northern France, Flanders, and west Germany.[26] One of the specialities were huge fonts with square bowls standing on a central column and supported by four pillars at the angles. Seven examples of these survive in England, all in places with direct access to the sea. Four of them are in Hampshire, one at Winchester, and the other three in churches in the gift of the Bishop, so that it is fairly obvious that they were imported by one of the twelfth-century holders of the see. The most likely to have effected such a purchase is the immensely wealthy aristocratic pluralist Henry of Blois, whose patronage of the arts was widely commented upon and of whom it is recorded that no one was 'in rebus ecclesiasticis augendis vel decorandis sollicitior'.[27] If this is so it seems likely that the import of these fonts, including the finest of all at Winchester, occurred in the 1160s. Henry's attention was probably directed to them by an enterprising merchant of the Tournai trade guild, *La Charité Saint-Christophe*, whose members were specifically per- mitted to do business at Winchester.[28] The Winchester font (Plate 68), like another at Zedelghem near Bruges, is carved with scenes from the life of Saint Nicholas. The episode illustrated shows Saint Nicholas before a church, handing a purse of gold to a kneeling figure who passes it on to three females, behind whom is a fashionable young man carrying a hawk on his wrist. This is the story of how Saint Nicholas saved the three daughters of an impoverished nobleman from being obliged to take to prostitution for a living by providing them with dowries in order to marry suitably to their rank and condition – one eligible suitor being the youth with the hawk. On the other side is represented the manner in which Saint Nicholas again came to the aid of the aristocracy, this time by providing a

male heir, and how he revived three young students after they had been converted into sausages by a rapacious innkeeper. The sculpture has a solemn, restful quality in which full use is made of the darkly gleaming, highly polished surface of the marble. The figures stand out about an inch from the plain sunk background, while dress, hair, jewellery, and other details are carefully if coarsely engraved upon the flat surface. Impressive as these fonts were, they seem to have had little or no effect upon English sculpture of the period. On the other hand memorial slabs of the same provenance and in the same smooth relief style, examples of which are to be found at Salisbury, Lewes, Ely, and Bridlington, probably provided an inspiration for the Purbeck marblers at the end of the century.[29]

Another work of this period which was possibly imported from the Continent is the lead font at Brookland in Kent.[30] It bears a complete and well-arranged layout of the signs of the zodiac and Labours of the Months (Plate 66B). These signs and months are taken from calendars attached to psalters for liturgical purposes, and there can be little doubt that this is the source for the iconography of this font. The sculpture is divided up by a light double arcade, one on top of the other, the arches of which bear the names of the signs or months, the former in Latin, the latter in French. The French inscriptions of the months are of interest, particularly since October is written VITOVVRE, a known Norman-French form of the twelfth century. This, and the presence of an almost identical font from the same workshop at Saint-Évroult-de-Montfort, in Normandy, make it doubtful on which side of the Channel the Brookland font was actually cast. The most important feature of the scenes of the months is that they are some of the earliest introductions to the twelfth-century sculptor of genre scenes taken from contemporary rural life. September shows a man bared to the waist threshing with a flail, March a man in a hooded cloak pruning a vine, and December the braining of a pig with an axe.

Another of these allegorical cycles was the battle of Virtues and Vices, popularized in a manuscript well known to the Anglo-Saxons, the *Psychomachia* of Prudentius. In it he describes an elaborate series of duels, in which each Vice is destroyed by its opposite Virtue in an appropriate and symbolic manner. For example, Patience stands impenetrable to the darts of Anger until the latter in despair falls on her own spear.[31] In sculpture, such elaborations had to be simplified into more straightforward battles, as on two Late Romanesque fonts of the 1170s at Stanton Fitzwarren in Wiltshire and at Southrop close by in Gloucestershire (Plate 69A). On the latter *Patientia* is flogging *Ira* in a most unsuitable manner. It will be observed that the name of *Ira* is cut the wrong way round, clearly the result of an unlettered sculptor tracing his pattern in reverse. These figured scenes are within trefoil arches on light octagonal pillars with simple capitals, above which runs a band of beaded foliate sprays of a type found on one of the pillars of the Lincoln west door. The figures themselves are modelled up out of the deep background, the drapery is naturalistically conceived, and awakening interest in realism is shown by the gesture of *Ira* to protect her body from the whip.

At the very end of the Romanesque period font sculpture took firm root in the remote and backward area of west Devon and Cornwall, where there lingered curious survivals in art and religion from an earlier age. One group of eleven in the valley of the Exe have cushion-shaped bowls resting on heavy octagonal stems, each face of which bears a

hexagonal rosette, a favourite device of the Dark Age Cornish pillars, surrounded by a tailless two-headed snake (Plate 67B). The pagan significance of these heaven and hell symbols can hardly be in doubt. At the corners are projecting human masks, many as at Launceston, Cornwall, of the bearded and moustachioed Norman variety. Fonts with human masks at the four corners have a distribution pattern almost exclusively limited to the 'Celtic' areas of Cornwall, Wales, and Ireland, which can hardly be purely coincidental.[32] This Exe valley group, of which Launceston is the best example, shows signs of being of an advanced date in the twelfth century, though the heavy stylization of the masks has little in common with Early Gothic taste. Further west still, in the Cornish peninsula up and down the Fal valley, is another group even later in date than that of the Exe valley. Its finest product, at Bodmin, may well be of the very end of the century.[33] In shape the font is probably an imitation of the Tournai marble group of the 1160s, since it too consists of a circular central pillar supporting a huge bowl, with non-functional pillars at each corner. The mask capitals of the angle pillars have become winged angels of a strongly Gothic flavour, but the bowl has hideous, heavily ornamented dragons, and the beaded and banded foliage of Romanesque work, now executed in great confusion and with full three-dimensional technique of undercutting. This Bodmin font is thus an example of the retention of Romanesque designs and styles in a backward area already affected by Gothic sculptural virtuosity and the Gothic feel for naturalistic human heads.

Together with this development of heavily sculptured fonts went an equally striking output of figured tympana, concentrated largely in the west midlands. To the west of the main area, at Bishopsteignton in Devon, is a tympanum of the Adoration of the Magi, in which the Magi advance under a pillared arcade towards a seated Virgin. The three Magi are reduced to pure geometrical shapes by their heavy triangular cloaks, from which protrude their huge heads with blank staring eyes. The Virgin is squarely seated and is of the wasp-waisted long-sleeved type that was so familiar to the York school. But for all these stylistic conventions and the frozen immobility that is consequently imparted to the scene, the tympanum has a haunting quality that is not easily forgotten. The shape of the capitals, the clothing of the Virgin, and the half-medallion containing a rosette at one corner all suggest a date not earlier than 1150.[34]

Another type representing the delicate, small-scale craftsmanship of the metalworker or seal-engraver is to be found at Elkstone in Gloucestershire, where there is a Majesty scene with Christ sitting on an elaborate and many-arched throne, surrounded by the symbols of the four evangelists and the Lamb. The shallow bas-relief technique and the minute attention to detail both unmistakably recall the craft of the gold or silversmith. The capitals with full masks and absence of necking show western, perhaps ultimately Irish influence, and the lively inventiveness of the beakheads of the voussoirs is in marked contrast to the monotony of the early Reading type.[35]

Later still, in the 1170s, appears heavily moulded figure sculpture in the round, where emphasis is laid on body mass and not on decorative detail. The tympanum of Christ attended by angels at Little Barrington, Glos, is an example of this type.[36] It is noticeable in all these tympana of the second half of the twelfth century that Christian subjects,

particularly that of Christ in Majesty, tend to replace the earlier semi-pagan or magical themes of the Tree of Life, the *Agnus Dei*, or animal combat. In this may be observed the influence of the monasteries and monastic teaching spreading out across the English countryside. The role of the twelfth-century Benedictine monastery as an educative and civilizing factor in a still primitive society can hardly be over-stressed, and to this activity the change in iconography on the tympana in remote country churches bears ample witness.

One of the last pieces of English sculpture that can reasonably be called Romanesque is the carving in the little church of Iffley, near Oxford, built about 1175–82.[37] The great door in the west front with its roll moulding running right down to the ground without capitals, and its ornamental layout of zodiacal signs within beaded medallions, proves that the Oxford area at this time was under influence from the west.[38] The beakheads are flatter and thinner than the earlier type at Reading, but their evolution from this model is unmistakable. The interior is of the greatest importance, since the chancel arch shows what may be the earliest use of columns of black marble, probably from Tournai, Purbeck imitations of which were to dominate the next century. The voussoirs of the chancel arch are covered with a coarse variety of big flat fruit that seems unique in England. The hollows between the twin columns supporting the arch are enriched in the same coarse style with square blocks mostly decorated with rosette patterns. On one, however, the sculptor has depicted a bird sitting in her nest, in which he displays a realism and a power of observation of nature that has hitherto been lacking in Romanesque art (Plate 70A). In this charming scene from nature, the threshold of Gothic has been reached and even crossed.

<div align="center">★</div>

This century of activity described as Romanesque is one of the most fertile and important in the history of medieval art. To the nineteenth century a mere fumbling precursor to thirteenth-century Gothic, it is now recognized as a period of most vital and significant artistic creation. When discussing English sculpture, however, this extreme view is hardly tenable, since most of the great experiments and inventions of the age were the achievement of the painter and scribe and not of the sculptor in stone. Following the lead given in manuscript illumination, the Romanesque sculptor took over and absorbed the sign language of complex symbols. For the Romanesque period is above all the age of symbolism, in which the northern peoples, unaccustomed to representational art, worked out a system by which to express their ideas in visual terms. The strange visions of the Apocalypse, the connexion of the Old and New Testaments, the role of Christ as Redeemer, the struggle of Virtue and Vice, the problem of man in his relation to the stars and seasons, all these great issues were expressed symbolically by the Romanesque artist in complex iconographical systems which were to last as long as the Middle Ages themselves. So complicated and abstruse was some of this symbolism, so strange the thought processes that lay behind it, that a hundred years of intensive modern scholarship have still not fully decided on the correct interpretations to be placed on many of the scenes. For the visual image as the symbol rather than the copy of reality has only recently returned as one of the aesthetic concepts of the west.

Comprehension has been made yet more difficult by the habit of the English Romanesque artist of reverting to his barbaric traditions and mixing with this esoteric Christian symbolism a range of subjects of animal combat or pure fantasy entirely devoid of intellectual meaning. Furthermore, unlike the manuscript illuminators, many – probably most – of the masons and sculptors were illiterate and unless carefully supervised tended in their ignorance to muddle and distort the symbols. This must be the explanation of those jumbled scenes on the voussoirs of the doors of the York school, which seem to have been drawn at random from the illuminations of a variety of books. This is also the explanation of some tympana in which the *Agnus Dei*, the Cross, or the Tree of Life are the central figures surrounded by worshipping animals, but the precise interpretation of which must at all times have been highly obscure.[39]

The principal qualities of English Romanesque sculpture are vigour and variety. There are all the signs of that energy, often naïve and sometimes misdirected, of an art form that is barely or only recently mastered. Blending ideas and styles borrowed from pre-Conquest Wessex, from Scandinavia, from Normandy, from the Benedictine scriptoria, and later on from western France, the Île-de-France, and Lombardy, the English Romanesque sculptor attacked the ever varying problems of synthesis and the pressing task of translating linear designs into a three-dimensional idiom. His achievements in this field were deliberately limited owing to his basic preoccupation with pattern and surface texture. Nor, within the strict bounds that confined his artistic ambition, did he achieve a piece of sculpture that can compare with the achievements of his French colleagues. Though much has been destroyed it seems certain that at no time could England boast of anything to rival Cluny or Autun, Moissac or Vézelay.

English Romanesque sculpture, when all is said, has in the main a strong provincial flavour, partly due to the strength of the barbaric taste for geometrical decoration and linear pattern that was so persistently recurring, and partly to the relative poverty of English monastic houses compared with those of the Continent. Moreover, it abounded in tiny local schools of primitive craftsmanship whose naïve and often charming products demonstrate the inability of the great monasteries to dominate the art of a whole region to the degree that occurred in France. Slavish acceptance of continental styles at no time appeared in the twelfth century, nor did it appear later. As the waves of foreign taste swept over England century after century, her local artists accepted and rejected freely, evolving a compromise with the native past that marked its products off from those of the Continent. English artists had been selective in their acceptance of Carolingian influences in the ninth century; of Ottonian in the late tenth and early eleventh; of French in the twelfth. And now, when the major artistic revolution of the Middle Ages was about to burst on England, the same discriminating process will be observed.

PART THREE

THIRTEENTH-CENTURY SCULPTURE

CHAPTER 8

THE AESTHETIC REVOLUTION
⟨CIRCA 1180–1220⟩

THE last years of the twelfth and the early years of the thirteenth centuries witnessed the only major aesthetic revolution in Europe between the end of the Roman empire and the beginning of the Renaissance. The change is recognized in art history by a change in nomenclature from Romanesque to Gothic, though few names of styles could be less appropriate and illuminating than these two. The problem of the nature and causes of the transformation of the arts in this period remains unsolved. For a long time attention was mainly directed to architecture, and the evolution of medieval building was interpreted almost exclusively in terms of engineering. The nineteenth century tended to see medieval architecture as a struggle by engineers to cope with the problem of the outward thrust of a stone vault. Viewed in this light the Romanesque architects were bungling incompetents, and the introduction of the pointed arch and the flying buttress were no more than solutions to a technological problem. But it is now fairly clear that this functional analysis is at best only a partial explanation of the complex series of phenomena involved. It is certainly true that the introduction of the pointed arch into England by the Cistercians was intended predominantly to solve vaulting problems, the round arch being retained, as at Fountains, for wall decoration and smaller spans. On the other hand, the pointed arch is only slightly more efficient than the round, and the flying buttress is in essence the architect's confession of defeat, an extraneous prop that spoils the external lines of his building and betrays its weakness. The chronology of the development is in any case eccentric, since the value of a pointed arch to simplify vaulting problems was discovered early in the twelfth century at Durham, and was later abandoned. Nor does the technological interpretation explain the elaborate system of shrines within shrines by which the whole face of a Gothic cathedral is dissolved into a series of niches, as at Wells; or the use in the vaults of prominent ribbing, which is now said to serve no functional purpose whatever; or the multiplication of the mouldings and the increasing depth of their grooving; or the extensive use of detached shafts, often used in clusters as a substitute for the earlier massive piers; or – and this is the conclusive point – the contemporaneous transformation in the arts of painting and sculpture, which can bear no relation to any engineering difficulties and their solution.

The nature of the changes and the explanation for them must therefore be sought as much in the aesthetic as in the technical field. In architecture it is evident that there is a

fundamental change of purpose. The Romanesque period was characterized by insistence upon weight, solidity, and mass by means of emphasis on horizontal lines, the use of walls and piers of unnecessary thickness with loose rubble fillings, and the concentration of sculptural decoration on limited fields such as capitals, tympana, and arches. The Early Gothic builders set out with the diametrically opposite purpose of creating a structure which gives the illusion of defying gravity, of hovering without mass or weight just above the surface of the soil. This illusion was created by breaking up every solid feature of the building and placing the main emphasis upon vertical as opposed to horizontal lines. Vaults were broken by ribbing, arches by deep multiple mouldings, capitals became mere clusters of leaves, piers split into groups of detached shafts, some in the startling colour contrast of black marble, doorways became elaborate niches often surrounded by multiple shrines bearing statuary, roofs and door arches appeared to be borne up by flying gargoyles. Solid wall buttresses were made into crazy scaffolding for sculpture, wall surfaces were dissolved into multiple niches, sometimes intended to hold statuary, sometimes for no functional purpose whatever; at Amiens and Wells even the strong lines of buttress angles were broken into by quatrefoils with sculpture curving round the corners; supports for the outward thrust of the roof became the fantastic sky-tracery of flying buttresses; walls became thinner, divided into multiple lancet windows in England, or abroad made mere surrounds for huge glazed openings themselves broken by upward-rising tracery.

The fundamental nature of this aesthetic revolution can be regarded in a number of ways. It can be thought of as an expression of the principle of the 'diaphanous wall' in which the basic structure is an open canopy supported by four corner pillars; or it can be argued that it is a materialization of the absurd 'aedicule' architecture of late antique paintings, transmitted via such works as the Utrecht Psalter. It can be explained as the domination, in a new manner, of the barbaric northern passion for the indefinite multiplication of lines. By this view, the clustered pillars, the numerous deeply scored mouldings, the multiple ribs, flying buttresses, and niches are all manifestations of the aesthetic taste that in earlier ages had produced the interminable interlace of Anglo-Saxon cross shafts and the lavish geometrical sculpture of the Anglo-Norman period. Alternatively it can be argued that the crazy articulation of the huge thirteenth-century cathedral is a victory for the Celtic taste for fantasy; or it can be demonstrated that the compact use of sculpture represents the triumph of Mediterranean traditions over those of the north and west. Inadequate and unsatisfying though all these racial and historical explanations may be, the fact remains that the shift of emphasis away from engineering and towards aesthetic criteria has thrown fresh light on the problems involved.[1]

It is against this general background that the new sculpture is to be viewed, as the complement and the adjunct of an architecture whose ambition it was to dissolve the substance of stone into an airy fantastic vision. The principal purpose of sculpture was to provide capitals that accorded with this objective, fillings for the spandrels left by rows of pointed arches, and full-length statuary to fill the niches with which the entrances and external surfaces of buildings were disguised. At least two complementary influences may be seen at work, here in England as on the Continent, together with continental influence itself upon England. The first was yet another wave of Byzantinism that had begun to

make itself felt in manuscript illumination towards the middle of the twelfth century. Under this influence there developed the desire for a more realistic representation of the human form, for faces that were no longer mere symmetrical patterns, bodies that conformed to anatomical curves and proportions, drapery which was something more than artificially arranged linear grooves, and generally the replacement of the energetic nervousness of Romanesque drawing by a restful monumentality. This Byzantine influence in England seems to have had its centre at Winchester, where the initial impetus may have been given by the humanistic tendencies of Henry of Blois. Two pages of a Winchester psalter provide one of the earliest illustrations of the new style.[2] From here the influence spread, and hints of it are to be found on wall paintings of the third quarter of the century in south-west and south-east England.

But this late twelfth-century Byzantinism was not the only influence at work on sculpture in this revolutionary period. A second source was a revived interest in antique sculpture. The significance of this factor is only just beginning to be appreciated at its true value, but there can be little doubt of its reality. The conscious classicism of some of the sculpture of Rheims cathedral is now thought to derive from the survival of Roman statuary on the site. The notebook of Villard de Honnecourt contains drawings from such classical models, and in south Italy Frederick II von Hohenstaufen was showing a deliberate interest in antique art.[3] The beginning of classical antiquarianism in England is provided by Henry of Blois, who in 1151 transported to Winchester a whole ship-load of works of art collected in the ruins of Rome, and who used an antique gem as a counter seal. Indeed so notorious was he in hunting for antiques that the wits applied to him the line of Horace, 'Insanit veteres statuas Damasippus emendo'.[4] But this antiquarianism is of limited significance in England, and a hundred years later at the court of Henry III direct examples of antique art were still only to be found in cameos imported by the King and in a number of early thirteenth-century seals made out of others.[5]

In the third place, there was influence from northern France, where both the Byzantine and the classical factors were already strongly at work. In consequence, this French influence is hard to distinguish from independent English evolution on the same lines. But in architecture there can be no doubt of the debt owed, and in a number of instances, for example the capitals of Canterbury choir, the same is equally clear in sculpture, though in figure-work it is not until the carving of the statuary on the west front of Wells after 1230 that the effect of French examples can be clearly detected.

Against these powerful new forces playing upon English sculpture in the early thirteenth century there are to be set two factors, the continuing insular tradition and the austere iconoclastic practices of the Cistercians. It is noticeable that the distinctions between continental and English thirteenth-century buildings are more marked in the decorative and ornamental spheres than in the basic architectural structure. For there are a number of features common to both England and Normandy and unknown in France which are clearly the result of the powerful late twelfth-century Anglo-Norman sculptural tradition of linear pattern and repetitive motifs. In this Anglo-Norman area the arch-mouldings are more deeply cut and more numerous than elsewhere, multiple shafting with clusters of free-standing pillars is more extravagantly and non-functionally

employed, and foliate sprays are used in profusion for covering bosses, wall surfaces, and spandrels. English artists, no doubt aware of their deficiencies in figure-work, rejected the great doorways of France, flanked by multiple statues, in favour of foliate ornament for covering vacant wall surfaces. Of equal significance is the choice of French features that became popular in England. Largely for accidental reasons, it was French architecture of the Laon–Soissons area which had the greatest influence. It was the banded and free-standing shaft and the dog-tooth moulding that were most widely copied in England, the former owing to the possibility which it afforded for greater interplay of light and shade between the pillars composing the pier, and the latter as a direct successor to the geometrical ornament such as the chevron so popular with the Anglo-Norman sculptors.[6] The insular tradition also had its effect on both the style and choice of subject of figure sculpture once the first powerful impact of the new style was spent. It has been rightly pointed out that 'the proportions of English figures are generally slenderer and convey a stronger impression of motion' than continental work.[7] This sense of mobility is but a consequence of the ineradicable native passion for linear rhythm that reasserted itself again and again during the Middle Ages.

In modifying the choice of subject the most important school was that of the south-west, where the Romanesque habit of using heads as label stops and the insertion of figured scenes into capitals survived into the new era. Many of these heads and scenes exemplified that taste for caricature which was a feature of the Romanesque period. It has been argued that some of the heads were merely reproductions of the masks worn by actors in the contemporary religious plays, the *dramatis personae* of which usually contained a full complement of devils. On the other hand, these plays were common all over the Continent, and it is hard to see on these grounds why English artists particularly should have chosen them.

Another factor affecting the nature of the change was the extraordinary power of the Cistercian influence. Already at work for fifty years, by 1180 its austere attitude to decoration and to architectural innovations was rapidly becoming more popular. One of the most striking results of the revolution was to introduce greater simplicity into the sculptural adornment of buildings. In some spheres the movement was absolute in its effects and figured fonts such as those at Castle Frome (Plate 47B) or Brighton (Plate 50) disappear completely at the end of the twelfth century. Elaborately historiated capitals are also largely abandoned – entirely so in the north – and multiple mouldings replace the voussoir decoration of the Romanesque style. The success of this movement was in part due to the fact that the earlier style had reached a stage beyond which no further evolution seemed possible. For the geometrical ornamental system of the late twelfth century as displayed on the Durham Castle doorway (Plate 63) had evidently reached a dead end, and future progress could only occur as the result of a major break with the past.

Finally there took place a significant change in the nature of the patron. In the twelfth century the major constructional and sculptural activity had predominantly been devoted to or had radiated from the monastery, and some of it, such as that of the Herefordshire school, had flourished remote from large centres. Monastic foundations were essentially the creation of the rich patron who endowed them as a form of personal insurance

against the perils of the next world. But by about 1200 the major impetus to monastic foundation ceased, partly because nearly every wealthy landowner in England had by then acquired an interest in some religious body whose duty it was to pray for his soul. This tailing off of new capital investment, together with the fact that most monastic buildings were now completed, resulted in the surrender by the monasteries of the leadership in architectural and sculptural patronage. Moreover, the late twelfth and the thirteenth centuries witnessed a remarkable economic expansion, one aspect of which was an increase of population and a consequent growth of towns. As a result art in England at last became urban, which it has ever since remained. A concomitant of this economic expansion was a steady rise in agricultural prices throughout the whole late twelfth and the thirteenth centuries, much of the profits of which were funnelled off into the hands of the state and the landlords in the form of increased taxes, rents, or services. The clergy, as large-scale landowners and holders of tithes, benefited greatly both by the increase of prices and the great extension of the area under cultivation. In the thirteenth century therefore, there was, as never before or after during the Middle Ages, surplus wealth available for building on a really gigantic scale. In sheer volume, to say nothing of quality, the thirteenth century consequently stands supreme. It was the secular clergy rather than the monks who mostly profited by the new opportunities, and it is to the building of urban cathedrals that the architectural and sculptural energy of the century was principally devoted. For these cathedrals were all situated in towns of some importance, and where the see was still sited in a village, it was moved to a town: Old Sarum was deserted for Salisbury.

One of the principlal reasons for the growth of cathedrals was the skill with which the bishops and their chapters succeeded in diverting the growing cult of relics to their own uses. The murder of Thomas Becket was the making of Canterbury, where between 1198 and 1213 offerings to the sanctified remains produced no less than 25 per cent of the gross revenue recorded in the Treasurer's rolls.[8] In 1224, the Bishop and Chapter of Worcester agreed to divide on a fifty-fifty basis the profits from offerings to Saint Wulfstan, whose miracles they had recently and successfully advertised, and they at once set to work to build the great eastern extension.[9] Similarly Lincoln energetically exploited Saint Hugh, York propagated the thaumaturgical powers of the disreputable Saint William, and Westminster made good use of Saint Edward. In consequence, those urban centres capable of accommodating and entertaining the flow of pilgrims now took the lead both in the cult of saints and in architectural expansion for suitable display of the relics, and it was the grandiose reconstruction of the eastern ends of cathedrals, whether Benedictine or secular, that provided the chief activity for thirteenth-century builders. In addition to provision for convenient access to the jewelled and gilded shrine of the saint, itself a structure to whose vanished glories only inventories now survive to bear witness, churches had to be enlarged in order to house the tombs of the secular rulers who began in increasing numbers to demand additional security for their souls by the interment of their mortal remains within the church itself.[10]

This change of location and patronage did not necessarily involve a change in technical organization, for there is no reason to suppose that buildings at any period in the Middle Ages were erected by any other than professional laymen working under ecclesiastical

supervision.[11] But the change of patron did involve a change of audience and therefore a change in the choice of subject matter. In the twelfth century, when art was predominantly monastic, appealing to a limited public, iconography was principally concerned with complex symbolism whose meaning could only be unravelled by the learned. But cathedral sculpture and painting were intended as the *Biblia pauperum* for the edification of the unlettered, and iconographical schemes tended to concentrate more and more upon the Nativity and Passion, the Life of the Virgin, and miraculous episodes in the lives of those Saints whose feasts were regularly celebrated in church. All these were scenes whose significance was direct and not symbolic, and which were illustrations of whom and what the Church was celebrating throughout the year. A secondary cause of the shift from the symbol to the concrete image was a change in the nature of philosophical thought, away from the Platonic ideas of Saint Augustine, and towards the Aristotelian viewpoint, re-interpreted and made respectable for medieval Christians by Saint Thomas Aquinas. But this tendency should not be exaggerated. Medieval scholars continued to construct religious symbols out of every conceivable pictorial representation, and types and antitypes, such as the Synagogue and the Church, and scenes from the Bestiaries with their complicated inner meanings continued to be popular. It may be suspected, however, that the latter served as much for a convenient excuse to carve genre scenes as for the conveying of a spiritual message, and once art became a vehicle of propaganda to the ignorant, its content inevitably tended to become more and more direct, and less and less erudite and allusive.

A further feature of the thirteenth century was that the increasing unity of the country, political and economic, naturally made itself felt in the artistic world, and the local schools are henceforth less strongly differentiated in their stylistic mannerisms than in the twelfth century. Other accidental factors helped to create this greater uniformity, not least the pressure of the new influences from abroad and the urbanization of art which have been described. Furthermore, in the early thirteenth century there grew up the first workshop for the large-scale production of sculpture – that of the Purbeck marblers.

On the northern slopes of the south range of the Purbeck hills in Dorset there are thin seams of a dark shell conglomerate whose colour varies from a dull red to black.[12] This marble had been worked a little in the twelfth century for fonts and tomb effigies, probably as a substitute for the expensive imported products in Tournai marble like the Winchester font. But when French Gothic influences began to seep into England, there took place a rapid expansion in the use of this local stone for architectural and sculptural purposes. First used by William of Sens at Canterbury for pillars, probably in imitation of north French employment of Tournai marble, as at Valenciennes, the possibilities of such a polychrome decorative system were seized upon and it became a predominant feature in thirteenth-century buildings. The black Purbeck marble was used for pillar bases, capitals, and shaft rings, for string courses and heads, for pillars themselves, and also for effigies, lecterns, shrines, and other sculptural work which did not require greater depth of stone than eighteen inches or two feet at the most. To what extent the stone was worked *in situ* is still not entirely clear. The ten to twelve feet of débris including carved fragments that were found in West Street, Corfe, Dorset, is evidence that at any rate a good deal of preliminary rough hewing was done on the site, which in view of the cost

and difficulty of medieval transport was only to be expected. Finished effigies were certainly being turned out at Purbeck in the middle of the century, for example in 1254, when an effigy was carved for Tarrant Crawford, Dorset.[13] But the most important workshop in the thirteenth century seems to have been London, to which large quantities of Purbeck marble were shipped for subsequent re-working. For example five ship-loads were sent in 1250.[14] Some of the London workmen were *émigrés* from the local area, bearing names such as Robert de Corfe, Nicholas de Corfe, Adam de Corfe, and so on.[15] But this is of less importance than the fact that the main workshop was London, the artistic centre of the kingdom, and that it was from the capital that the diffusion of Purbeck marble heads, foliate capitals, reliefs and effigies took place. Nor was it a small-scale industry. In one week in 1253, Henry III was employing at Westminster no less than forty-nine marblers and fifteen polishers, though this was probably very nearly the total of London craftsmen in this material.[16] The extensive use of Purbeck stone and the fact that the main workshops were in London were thus very important factors in unifying English sculptural style in the thirteenth century and in reducing the significance of local differences.

The other prime factor was the emergence of a court school which attracted the finest craftsmen available and inevitably tended to dominate the artistic output of the country as a whole. This development can principally be attributed to the personal initiative of Henry III. By about 1235 he had developed a passionate taste for building and for acquiring *objets d'art*, in which he indulged with a disregard for cost that was politically suicidal but aesthetically of the highest value. To his versatile artistic administrator, Edward of Westminster, son of Odo the goldsmith, flowed a steady stream of detailed and imperative orders for building, carving, painting, jewellery, purchase of relics, and so on. Thus the King wrote in 1245: 'Because we recall to memory that you told us that it would be more magnificent to make two bronze leopards to be placed on either side of our throne in Westminster, than to make them out of chiselled or sculptured marble, we command you to get them made in metal as you told us.' The orders for purchases hardly ever set a maximum on the price to be paid, and often contained the careless phrase 'whatever it may cost'. An independent financial organization was set up in 1245 under the direction of Edward, son of Odo, into which money from the Jews, from wardships, and from other sources was paid directly for use on the rebuilding of Westminster Abbey. Indeed during the 1240s and 50s, it is evident that a substantial portion of the revenues of one of the most powerful states in Europe was being devoted to artistic purposes.[17] The emergence on such a scale of a Maecenas for the visual arts naturally revolutionized the distribution of artistic energy throughout the kingdom. Westminster and the court acted as a magnet for the finest sculptors and artists of the age to an extent that earlier patrons such as Henry of Blois at Winchester had been quite unable to achieve. This concentration upon the court and the extensive use of Purbeck marble both acted together to make London the artistic centre of England by the second quarter of the thirteenth century.

*

Having discussed the basic factors that were beginning to affect sculpture in England during this revolutionary period, we must now trace the chronological evolution in

detail. For reasons which have already been explained, the principal sculptural output of the forty years between 1180 and 1220 was not in figure-work large or small, but in such minor fields as foliage and heads, the one employed on capitals and the other as label stops for hood-moulds. In consequence our knowledge of the development of figure style during this crucial period is extremely scanty and what little we know indicates divergent progress in different areas. Up to and including the Malmesbury apostles, Romanesque figure sculpture tended to be copied from the linear representations of the calligrapher, rather than to emerge as works of plastic art in their own right. A development of boldly modelled sculpture in stone or ivory was observed in the late Anglo-Saxon period, but this progress seems to have been interrupted by the Conquest. Lacking all indications of what the life-size statues of the gold and silversmiths of that period may have looked like, the degree to which pre-Conquest artists achieved full three-dimensional values in their large-scale figures cannot be known. At all events, it was an evolution that, so far as can be seen, lacked the strength to survive, and late twelfth-century stone sculpture owes nothing to it. Some experiment was in progress in almost all regions during the latter half of the century, for example the heavy sculpture of the midlands tympana and the column-like figures at Rochester. In the west of England the more advanced style can be observed in the sculpture of the washing fountain from the cloister of the Cluniac priory of Much Wenlock, in Shropshire, which must belong to the last quarter of the century. In the scene of Christ walking upon the waters (Plate 69B) appear thick grooved folds of drapery, enveloping squat figures with very large heads. The features and hair are now carefully and naturalistically modelled and the gestures of arm and hands are more sensitive in conception. The head of Christ is an almost exact reproduction of a classical dramatic mask, including the odd-shaped hole for the mouth through which the actor spoke, and must have been taken from a contemporary illustrated copy of Terence.[18] The style of this carving with its heavy figures and parallel rolls of drapery is typical of much of this later twelfth-century work, in which attempts to achieve greater fidelity to nature result in the same ponderous effect as occurred in the Carolingian period under similar circumstances.

One of the few surviving pieces of evidence of late twelfth-century craftsmanship in metal is the Warwick Ciborium, a copper bowl decorated in *champlevé* enamel with figure scenes from the Old and New Testaments, set in medallions of conventional many-petalled Late Romanesque leaf scrolls. Though the layout and intellectual plan is thus similar to the carvings in the Malmesbury porch, the figure style, for example in the sacrifice of Isaac, shows signs of the new influence (Plate 70B). For while the drapery arrangement of the long smooth ovals over the thigh, the fan-shaped flutter at the feet and the cross-legged attitude of Isaac are evidence of the Malmesbury tradition, the figures of both Isaac and Abraham are naturally proportioned, the former's heavy cloak falls easily over his shoulders, the large bearded head is skilfully drawn, and the gestures of his hands are not exaggerated. It is a transitional figure style whose closest parallel is in the earliest stained glass at Canterbury.[19]

It was only in the north that sculpture in the round reached maturity in this transitional period, and by a strange twist of artistic history, it was a development that was entirely

barren, an evolutionary dead-end. The lack of influence of the Lincoln frieze of the 1140s upon northern sculpture is very surprising in view of its imposing nature and advanced technique. That there was a link with York is shown by the contemporary relief of the Virgin (Plate 55). But subsequently only the tympanum and the large relief depicting scenes from a great composition of Hell have survived to indicate any continuity of large-scale figure sculpture, and there can be little doubt that the tiny voussoir carvings of the York school of the 1160s reduced the desire for big compositions.[20] Consequently when at the turn of the century the Abbey of Saint Mary, York, erected a great sculptured doorway, it represented a break with the immediate past of that region. Of this door substantial fragments remain, enough indeed to permit a partial reconstruction of the original.[21] With its free-standing statues ranged against the shafts, and its voussoir carvings of Biblical scenes within battlemented niches, it is the only English copy of the great Île-de-France doorways of which we have any record. Of the ten surviving life-size statues, which were originally painted and gilt, only four remain undamaged.[22] It is evident that they represent Prophets of the Old Law and Apostles of the New (Plates 71 and 72). Though draperies are treated in heavy parallel grooves and the details of the hair are purely schematic, the figures are now firmly modelled, with feet set squarely on the ground and heads in full relief.

If one regards these great doorways with pillar figures as an international development with its centre in the Île-de-France, it is evident that the York statues come somewhere between the *Pórtico de la Gloria* at Santiago de Compostela of 1188, and the west door of Laon of about 1200–10. The heavy drapery and the huge heads both occur at Compostela, but the Romanesque mannerisms are there far more noticeable. On the other hand the drapery at York is distinctly less developed than at Laon. The comparison with Compostela does not imply any direct influence from Spain, for the differences are as great as the likenesses, and in any case the *Pórtico de la Gloria* and the York doorway are both local interpretations of a sculptural system of the Île-de-France. The Romanesque elements at York such as the stylized hair and the pleats about the feet are to be found on the Malmesbury apostles and can be explained as insular features. The heavy heads and sagging loops of drapery under the arms are in the tradition of the Much Wenlock fountain and can be seen in local north-country manuscripts such as the Bible and Pauline Epistles of Bishop Puiset of Durham.[23] But in the splendid head of Saint John (Plate 73) there appears a fresh lyrical quality that evidently owes its inspiration to the classical revival that was just beginning to affect sculpture and metalwork. It is the strength of local influences that makes it very dangerous to attempt a firm dating of these York statues on a basis of French examples. If found in northern France, they would be placed with some confidence at about 1200. On the other hand French influence in figure sculpture was very slow in making itself felt elsewhere in England, and it is therefore more likely that these transitional figures belong to the first or even second decade of the new century. Owing to the triumph in the north of Cistercian sculptural austerity, this York doorway remained a unique and isolated phenomenon, and it was in the south-east and the west that the most fruitful advances took place.

★

The construction of Canterbury choir between 1174 and 1179 by a French architect, William of Sens, is a landmark in the history of English architecture, and the capitals of the presbytery, together with those of the Trinity Chapel erected in 1182, show the earliest pure French influence in English sculpture (Plate 74A).[24] The shape of the capitals is based on the Corinthian, which never went out of fashion in twelfth-century France as it did in England and Normandy. The heavy curling crockets and the untidy many-lobed leaves, the whole disorderly effect and three-dimensional feel, are quite unlike anything previously known in England and closely resemble capitals from Saint-Rémi at Rheims of 1170–81. Thus at a very early stage Gothic foliage sculpture was introduced into English art, and one of the most interesting developments of the next twenty years was the modification and transformation of this foreign import under the pressure of insular tastes.

 The first triumph of the native tradition was the rejection of the elaborate foliate crockets and semi-naturalistic leafage of this French Early Gothic in favour of the 'stiff-leaf'. This was a highly distinctive mannerism which froze the evolving experimental luxuriance of three-dimensional leaf forms into rhythmical patterns that are reminiscent – though in a new form and with full plastic lobes – of the pre-Conquest sculptor's interpretation of 'Winchester style' acanthus. When William of Sens was incapacitated by a fall in 1179 he was replaced by William the Englishman, and only five years later the native genius for luxuriant linear pattern had produced one of the most beautiful foliate designs ever carved (Plate 74B). The choir bosses of William of Sens had been fairly simple affairs with leaves of considerable variety arranged either in spirals or radiating from the central hole. The commonest leaf form was of five lobes with scalloped edges and central grooving. The eastern bosses of the high vault of the crossing were carved about 1184 and are strikingly different from the earlier works. The radiating or spiral layout has been retained, but the design is far more complex in its multiplicity of curving lines, and the foliage has become stylized into a conventional system of smooth-surfaced, bossed leaves with projecting central spines on the end of extremely long stalks, the prototype of the Early English stiff-leaf foliage. These curving linear rhythms with their subtle interplay of slow-moving stalks and restless leaves are of masterly design and execution; they appear to be a native composition owing nothing but the original idea of spiral leaf bosses to French inspiration.[25]

 Coeval with the fully developed French crockets at Canterbury, the capitals of the presbytery of Oxford Cathedral show English sculptors making their own individual experiments in new forms. Most of the capitals are bell-shaped with an extremely simple crocket design of little budding three-dimensional volutes springing from stems that bury themselves in the body of the capital itself. Others bear straggly flat scrolls with tiny flowers, but with carefully modelled heads in the round within large corner crockets. Yet others have little trefoil leaves on long stalks set flat against the smooth surface of the capital, sometimes vertically, sometimes at an angle, and sometimes crossing each other in an untidy fashion.[26] The arches are now quite plain with multiple roll and hollow mouldings set on square abaci, but the corbels for the vaulting shafts have as terminals the old-fashioned grimacing animal heads with gouged eye-sockets, and the piers are as huge and solid as ever. This mixture of old and new is continued in the transepts and nave

which were presumably erected after the initial building of the presbytery and the trans-
lation of the bones of Saint Frideswide in 1181. The experimentalism of the presbytery
is continued and the capitals show a remarkable variety of emergent stiff-leaf trefoils,
water-leaf, and crockets. Some of the last are now of a luxuriant foliate type that is clearly
influenced by William of Sens' work at Canterbury, though a characteristic feature of
stiff-leaf foliage, the central leaf-rib pressing into the leaf itself, is already to be observed.
Most of the leaves are of the bossed type, but some are hollow, a mixture common
throughout the thirteenth century.[27]

Similar experimentation can also be observed in the capitals at Boxgrove and New
Shoreham, in Sussex, and Abbey Dore, in Herefordshire. Dore was a Cistercian building
and displays the absence of ornamental work usual to the Order, as well as very advanced
architectural features of French Gothic. Its capitals, however, are English and even local
English. The palmette and water-leaf in various forms predominate, and Romanesque
beading is still employed in places. Elsewhere in the choir the new trefoil with hollow
leaf is set flat upon bell-shaped capitals. The arrangement is clumsy and untidy, and there
is no hint of three-dimensional sculpture. On the other hand Dore has a number of
capitals with the outward-curving cones that were the local variant of the normal scallop-
ing. Their importance is great, since they were a feature that persisted as late as Wells nave
and undoubtedly had an influence upon the shape and layout of the new stiff-leaf capital.
The transepts and nave of Saint David's, Pembrokeshire, are an important link in this
chain, since upon their capitals the cones may be seen in the process of sprouting stiff-leaf
foliations at their extremities.

It was here in the west country that the new foliage capital was fully evolved. The
eastern vaulting shafts of Glastonbury nave, datable to the 1190s, rest on capitals with
crockets of a French type, shooting straight up from the base. Only a few years later,
certainly before 1210, the transepts and eastern nave of Wells were erected, and here at
last is the fully developed stiff-leaf foliage, the tall stems springing out of the high bell-
shaped capitals and curling gently over in asymmetrical and disorderly clusters of trefoil
leaves, some hollowed out and others bossed up (Plate 75A). These capitals still retain the
local feature of the outward-turning scalloping by which the west-country school
achieved the transition between the plain scalloped capital of the twelfth century and the
curling stiff-leaf of the thirteenth. At its best, as here at Wells, this Early English capital
is an extremely successful and restful simplification of the fussy foliage and heavy crockets
of French Gothic, and in varying forms and varying degrees of undercutting it dominated
English sculpture for half a century.[28]

On these Wells capitals there also occur figured scenes of a grotesque character which
are conspicuously English and indeed west country in origin. In France the historiated
capital virtually disappeared, and the retention of figure sculpture in England was due to
the obstinate adherence to Romanesque decorative systems by these local sculptors. No
longer, however, were capitals used for sacred scenes, and one of the charms of thirteenth-
century capital sculpture is that the choice of subject would seem to have been left largely
to the masons. A Wells corbel with a horrifyingly realistic sinuous and scaly dragon
(Plate 76B), or a capital showing a peasant grimacing with the toothache and another

extracting a thorn from his foot (Plate 75B) are both entirely without didactic purpose.[29] Equally significant is the intense realism carried to the length of caricature that is expressed in the face of the man with toothache. In both these carvings the designer has shown the greatest skill in fitting his subject matter into the very different and complicated fields provided by the conical surface of the corbel and the curving band of the capital.

The evidence for the history of large-scale English figure sculpture in the south in the forty years between 1180 and 1220 is scanty in the extreme. With the virtual elimination of figured tympana, fonts, capitals, and doorshafts, what figure-work there must have been was mainly confined to images in wood and metal that have now vanished, and to tomb effigies. The earliest sculpture in Purbeck marble was memorial effigies of bishops, which display no interest in bolder relief and less linear representation of drapery. West-country examples of the 1170s at Exeter and Salisbury are probably products of the local workshops at Corfe, judging by their similarity to some western font sculpture, and are extremely backward in their flat, slab-like treatment of the body and their patterns of shallow scorings that serve for drapery details.[30] Twenty years later an East Anglian workshop emerged with a series of five effigies of Abbots at Peterborough carved in a local stone, Alwalton Lynch. Of these the earliest retains the primitive drapery treatment and low relief, but the small round head is carefully and competently modelled. The next in the series, of about 1200, is still carved as a flat slab, but has incorporated a new handling of drapery by gouging the folds deep into the body.[31]

Some idea of the quality of wood-carving at the turn of the century can be obtained from a recently discovered statuette of the Virgin and Child, in which the new style is somewhat inexpertly reproduced (Plate 78). The proportions of the figure are now harmonious, a broad facial type is employed, with rounded eyes, pronounced cheek bones and flattened nose, and the drapery flows easily with simple, rather heavy folds. At the same time the drapery over the left arm shows the smooth oval surfaces of the Malmesbury voussoirs, while the curious U-shaped grooves over the chest are evidently attempts to reproduce the manuscript convention for depicting folds. On the whole it is a placid, somewhat uninspired piece of carving whose principal interest is in showing the wood-carver experimenting with new ideas.[32]

The most serious gap in our knowledge of the artistic forces active in this period is a result of the almost total destruction of the metalwork of the day, the great abundance of which can now only be traced in the inventories of vanished treasures. Seven-branched candlesticks seem to have been part of the equipment of most great English churches, records of them being known for Winchester, Canterbury, Durham, Lincoln, York, Salisbury, Westminster, Hereford, and Bury.[33] The centre of this type of work was the Meuse–Rhine area where we know the name of one great artist, Nicholas of Verdun, who was at work about 1200 and some of whose products have survived. There is a great bronze candlestick of about the turn of the century, now in the Cathedral of Milan, for which it is at any rate possible that it might have an English origin or have been for an English purchaser.[34] The main importance of metalwork like this Milan candlestick lies in providing models for the Purbeck marblers of the next generation. The heads on the candlestick display the same bold double-lined oval eyes, sharp nose, and curling hair as

heads on Hubert Walter's tomb at Canterbury. And in the Purbeck effigy of King John we shall find the same provision of sunken roundels and ovals for the insertion of glass or paste jewellery as adornment of neckings and hems of clothing.

In the west of England the most important figure sculpture at this period is to be found at Worcester and Wells. On the wall of the Worcester refectory there is an enormous, much battered panel of Christ in Majesty, seated within a quatrefoil.[35] The figure was executed in shallow relief, the drapery detail being carved with precision and skill. The dress with its belted tunic and flowing cloak is derived from Byzantine models and is increasingly common during the early thirteenth century. What is new is the treatment of the drapery in multiple folds of fine texture, falling loosely over the body and caught up by the belt. The dating is difficult to determine with accuracy. The texture and arrangement of the drapery are very close indeed to those of King John's effigy of about 1225–1230, and look forward to the statuary of the Wells west front, but the low relief and the curling loop of the drapery running down from the right shoulder like that of the wooden Virgin (Plate 78) are both signs of archaism. In view of these divergent features it would be unwise to attempt a dating more precise than 1210–30, though the continuity of style at Wells would suggest the end of the period rather than the beginning.

The other sculpture at Worcester consists of a series of figured scenes that decorate the spandrels of the wall arcade of the eastern extension, and belong to the first stage of the work that began in 1224.[36] Many of the reliefs have suffered from recarving in 1857, but a number survive which are genuine. These are important, since they play their part in maintaining the continuity of tradition of rich wall decoration that died out elsewhere in the early thirteenth century. In the west of England it survived at Glastonbury, at Bristol, and here at Worcester, not only in the form of didactic scenes from the Bible but also of purely mundane and frivolous subjects such as fabulous beasts or an elegantly dressed lady patroness telling a master mason of her wishes (Plate 77A). Other spandrels are filled with sprays of foliage similar to the ornament of the roundels in the triforium spandrels of the Wells nave, the westernmost of which are only slightly earlier in date. The style of the earliest of the series at Worcester has broken away from the fussy elaboration of Late Romanesque decoration still visible at Bristol in favour of one of extreme simplicity. The figures now stand out clearly from the plain flat background, only an occasional stiff-leaf spray showing the continuing reluctance to leave space unfilled. The figure-work is in harmony with the design, being also extremely simple. The heads and features are tiny, the bodies thin and wispy, and the drapery mostly a series of curved grooves and sharp ridges. By use of dramatic gesture and skilful composition the artist of the best carvings, those of the Last Judgement in the south-east transept, has contrived to evolve a brisk and racy narrative style that tells a story with the minimum of complication. There can be no doubt that in these spandrel carvings the sculptor was inspired by contemporary manuscripts, in some of which are to be found the same compact bodies, tiny heads, jutting chins and vestigial eyes, mouth, and nose.[37]

At the same time as this work was in progress at Worcester, the monks of Glastonbury at last decided to hire sculptors to carve the doorways of their Lady Chapel. Held in plurality for forty-five years by Henry of Blois, the great Bishop of Winchester, Glastonbury

was one of the richest abbeys in the country. Here as elsewhere, Henry had been a lavish patron, and one of the most serious gaps in our knowledge of Romanesque sculpture in the west is the disappearance of all trace of his buildings in the great fire of 1184.[38] After this disaster King Henry had placed an able administrator, Ralph FitzStephen, in charge of the rebuilding, to which the surplus revenues of the abbey were devoted. The providential discovery of the royal and saintly remains of King Arthur and the resultant increase in popularity of the Abbey provided further ample funds, the total of which probably exceeded even the resources of Canterbury itself. Since the site of the '*vetusta ecclesia*' was the main centre of attraction for pilgrims, its reconstruction was undertaken immediately after the fire, and the new Lady Chapel seems to have been ready for consecration possibly only two years later, in 1186.[39] But there is every reason to believe that for a long period the two doorways remained uncarved. That they were worked *in situ* is proved by the fact that part of the south door still remains unfinished, and the whole style of the sculpture precludes a date in the 1180s. The layout of the voussoir carvings in oval medallions with leaf scrolls between is evidently in the same tradition as the near-by Malmesbury work, but there the resemblance ceases. The figures of the Malmesbury voussoirs were dominated by a complex series of artificial mannerisms such as the elongated body, the oval drapery folds on thighs and stomach, and the feet in profile. Glastonbury, however, is permeated with a powerful if somewhat coarse naturalism, handled with a plastic sense and employing a drapery style that belong to the third decade of the thirteenth century.

In the scene of the Adoration of the Magi (Plate 77B), the Virgin is a dumpy figure whose drapery hangs in close folds over her knees. Her posture with raised left knee and half-turned head is easy and assured, and the Kings are trotting away with realistic determination. Furthermore, the foliage scrolls are of developed stiff-leaf, and the fantastic grotesques on the other orders, especially heads on long stalks, are very like those found in Wells nave and on wall spandrels at Worcester. Both the figure style and the decorative elements are thus closely linked to work of the 1220s and the Glastonbury doors provide yet another example of the achievements of the west-country masons immediately before they embarked on the great west front of Wells.

In the early years of the thirteenth century the canons of Wells were fighting the monks of Bath over the right of election of the bishops, the see having been transferred to Bath at the end of the eleventh century. In pursuit of this quarrel it was natural to emphasize the antiquity of the episcopal history of Wells, and it was probably for this purpose that the imposing effigies of the Saxon bishops were commissioned. Five of these belong to a single group, perhaps by the same sculptor, but two are in a more developed style, probably additions to the series carried out some years later. The earlier group may be taken as representing work of the first, and the later of the second or third decade of the century. All seven are of the near-by Doulting stone and are evidently of local workmanship. The earlier group of five have rather squat bodies, their feet rest on supports and their heads are sunk within canopied niches of stiff-leaf foliage that still lack any great depth of undercutting (Plate 79). The effigies are clothed in full canonicals with alb and stole, and wear the high-peaked mitres of the twelfth century. There is still little boldness in experiment in the depth of modelling, and heads, hands, and feet all cling closely to the level of

the body. Thus the hands of 'Levericus' are made to lie flat on his stomach in order to avoid the problem of carving them in the round. The drapery is handled in simple solid planes with few rounded folds, the chasuble being cut in more or less parallel roll and hollow mouldings, not unlike a contemporary archway. The facial type is of the familiar rounded variety of the turn of the century, with wide cheek bones, rather short flat nose, bulging eyeballs, and forbidding down-turned mouth. The second group has the odd feature of low and rounded mitres that were current in the Anglo-Saxon period and very much simpler canonical robes, which are clear signs of genuine antiquarianism. The facial type shows little change, but the draperies are treated in a very different manner, with folds that genuinely imitate the natural fall of the fabric. Furthermore, the figures are now fully modelled up from the ground, free from the earlier niche, the feet and hands boldly project above the level of the body and the pastoral staff is a separate attachment of wood or metal.[40]

There is no doubt that the period from 1180 to 1220 witnessed an aesthetic revolution, as can be demonstrated by comparing the Malmesbury Apostles (Plate 60) with the oak Virgin and Child (Plate 78). The fact that there has intervened a transitional stage of some forty years of uncertainty and hesitation, advances and regressions, does nothing to diminish the revolutionary nature of a change that has eliminated the elaborate artifices of Romanesque figure-work; has evolved new forms of drapery more naturally and more plastically conceived; has toyed with French crockets and semi-naturalistic foliage only to reject them in favour of a flowing trefoil foliage, deeply undercut but preserving the linear rhythms of the past; and, at any rate in the south-west, has preserved a tradition of figured sculptural decoration for wall surfaces and capitals, in successful defiance of the austerity both of English Cistercian and French architectural tastes. So far as sculpture is concerned, the essence of the change has been a shift from abstract symbolism to a more representational concept of the artist's purpose. It is important to stress the fact that there is involved in this revolution an important psychological change from an attitude of pessimism about the nature of the universe, to one of more buoyant if qualified optimism. The Romanesque artist, haunted by his pagan past, remained essentially morbid, his concern was more with the Devil than with God. Even when his theme was strictly Christian in iconography, his Christ was a remote and formidable figure, as on the Prior's door at Ely (Plate 54A), his Virgin and Child a forbidding fetish as at Fownhope. It was Hell and all its implications that most attracted him, and his concept of man was of a puny creature helpless before the evilly directed powers of destiny. The popularity of the twelfth-century theme of the human being struggling amid enveloping coils of foliage containing monstrous beasts is surely of more than purely stylistic significance.

With the thirteenth century a different approach is apparent. The intercession of the Virgin provides hope of succour in this world and salvation in the next. The crucified Christ is humanized once more, and there are the rows of powerful Saints carved upon the west front at Wells who are ready to do battle against the hosts of darkness. A move towards representational humanistic art reflects, in the thirteenth century as during the Renaissance, a new psychological attitude of secular confidence in man's present status and man's future prospects.

THE IDEALISTIC PHASE:
WELLS, SALISBURY, AND LINCOLN
⟨CIRCA 1220–1255⟩

IT is with the construction of the west front of Wells with its 176 full-length statues, its thirty half-length angels, and its 134 smaller reliefs that English Gothic sculpture can be said to have achieved maturity. Wells Cathedral had been under construction since about 1190, beginning at the east and proceeding west. Building was not continuous, however, and there is an evident break in the masonry three bays from the west end of the Nave. Argument continues as to whether or not this represents a cessation of activity during the financial troubles of the Interdict, 1208–13, when King John appropriated to himself some of the resources of the English Church. Be this as it may, there are strong arguments for thinking that the last three bays of the nave were not built till the early 1220s and that the erection of the west front itself was therefore not begun till close on 1230.[1] Probably organized at first by the most distinguished building administrator of the age, Elias of Dereham, and urged on by Bishop Joscelin, who had returned from his exile in France in 1213, the work was one of the most ambitious building projects of the century. The front is designed as a great screen of tabernacle work extending across the west end of the building and projecting beyond and round the corners at either end (Plate 80). In marked contrast with north French examples, little emphasis is placed on the doorways, which remain simple cavities in the huge cliff of a front with its hundreds of niches filled with statuary. In this arrangement Wells is following the Romanesque tradition of south-west France and Spain rather than the contemporary pattern of the Île-de-France, though whether Wells was in fact inspired by these Aquitaine examples, it is difficult to say. Aesthetically Wells represents the 'aedicular' architecture of shrines within shrines carried beyond the bounds of moderation, so that the whole immense front becomes a mere crazy scaffolding for sculpture. Originally the impression was even more grandiose than it is to-day since much of the statuary and niches was brilliantly coloured. The main central figures were the most elaborately treated. On the tympanum of the Virgin and Child the robe of the former was red and the mantle black with a green lining. The Child's robe was crimson, the bench green, the background red with green diaper, and there are plug holes for attachments, presumably of gilded or painted metal. Other statues were treated with a strong yellow ochre wash so that they stood out sharply against the red background of the niches, and eyes and hair were often picked out in black and lips in red. Alternatively, as on the row of heavenly angels, the whole of the statues themselves were painted a rosy red. There can thus be little doubt that to modern taste the front in its original condition would have appeared exceedingly vulgar.

Both architectural and sculptural details make it plain that the Wells craftsmen who had been responsible for the nave and its capitals and the effigies of the Saxon bishops had

been subjected to a new influence. Monolithic shafts and capitals with round abaci appear for the first time; on the inner arch of the central doorway there are foliate bosses with a new type of leaf with serrated edges; and the statuary shows heads and drapery details of a quite new and advanced type. There can be no doubt that this influence was French, from the Île-de-France; and there are strong likenesses between the Wells front statuary and those on the north door of the west front of Notre-Dame, in Paris, whose date is usually put at about 1210–20. On the other hand there are certain differences with Paris which suggest that Wells is a contemporary of Rheims and of the Amiens west front, which was completed by 1236. Wells and Amiens both have the awkward feature of sculptured quatrefoils which go round the corners of buttresses, and whereas the Resurrection scenes on the central door at Paris show the souls emerging clothed from their tombs, at Wells and Amiens they are naked. In some respects Wells is thus closer to Rheims and Amiens of the 1230s than to Paris of twenty years earlier.

The iconographical plan of this front is of the greatest complexity and must have been the work of a church dignitary, possibly Bishop Joscelin himself. The central position, the tympanum over the main door, is devoted to the Virgin and Child with above it a representation of the Coronation of the Virgin. To north and south of this central division are ranged figures and scenes from the New and the Old Testaments respectively. The images of the lowest tier probably represent the Apostles, the Evangelists, and important persons in the life of Christ on the one hand, and prophets, patriarchs, and other Old Testament figures on the other. Directly above each niche is a quatrefoil with the bust of an angel, and between them are larger quatrefoils with scenes from the book of Genesis for the Old Law and from the life of Christ for the New. Above these quatrefoils are two more tiers of niches with full-length figures, those to the north seeming to represent mainly lay benefactors and patrons of English Christianity and those to the south Saints and holy persons, principally those with English associations. Some of these figures can be directly identified by objects they are holding, but the majority now have no distinguishing features and must remain anonymous. Above these two tiers of statues there is a continuous row of small trefoil niches running right round the screen and containing scenes of the Resurrection with naked figures emerging from their tombs at the sound of the Last Trump. This completes the main screen, but above the central door there is a further pediment of two tiers now filled with statuary of the fourteenth and fifteenth centuries, and finally surmounted by a figure of Christ in Majesty towering over the whole gigantic ensemble.

It is evident that this huge sculptural undertaking could not have been quickly accomplished, and since all but one of the pieces of carving are detached from the wall the building may have been completed in advance of the filling of all the niches with their statues. There are remarkable discrepancies between the height and width of the statuary and the space afforded by the niches, so that some figures fit tight into their surrounds and others have to be raised on deep pedestals to bring them to the correct height. Nor is there any uniformity in tackling the problem of the very tall niches, one enormously elongated statue being in close juxtaposition with another that is normally proportioned but raised on a pedestal. From these extremely vague arrangements it seems likely that the statuary

was worked elsewhere, presumably at the quarry at Doulting, and was brought to the site in a finished state. The problem of the stylistic evolution of this masons' yard over the twenty-five years or so, from about 1230 to 1255, which would be necessary for such an undertaking has only recently been systematically tackled. The difficulties in the way of a satisfactory analysis arise from the numerous workmen employed, some of whom evidently used a more advanced technique than others, the lack of certainty about which statues were undertaken first, and the relative smallness of the stylistic differences that can be detected throughout the whole work. Even the costume of the various figures is uniform throughout. The ecclesiastics are all vested for mass; the male laymen wear loose or belted tunics reaching to the ankles and cloaks over their shoulders; the ladies are dressed in long gowns, mantles, and veils, the knights in chain mail and surcoat. The whole series is characterized by a total lack of detailed ornament such as brooches, jewels, and decorated bands, though it is possible that these adornments were originally picked out in paint. Wooden adjuncts, such as staves, sceptres, swords, and lances, were frequently employed, as on the second group of effigies of Saxon bishops inside the cathedral. The drapery style of these effigies bears hardly any resemblance to that of the west front statuary, but the use of wooden attachments and the bold modelling are both evidently derived from these earlier carvings. They provided the experience in figure-work which combined with powerful influence from France to produce the sculptural school of Wells.

The earliest piece is almost certainly the central tympanum of the Virgin and Child, since it is carved out of a solid slab that is part of the wall. Stylistically this hypothesis is supported by the fact that the draperies are of a somewhat archaic type marking only a moderate advance over the Majesty slab in the refectory at Worcester. That this particular handling of draperies is a sign of early date is proved by its appearance on Henry III's Great Seal of 1219.[2] It is reasonable to assume that all the figures of the lower tier, the Coronation of the Virgin, and the Old and New Testament scenes were the next to be undertaken, and it is here that is to be found the most accomplished work of the whole series. The niches are best proportioned for statuary, delicately carved socles are provided, and the niches are arranged in pairs to relieve the monotony. These aids of the architect were used to the full by the sculptors, who grouped their statues in pairs turning inwards towards each other. Some of the finest of all are the statues of deacons on the east buttress of the north tower, which well display the characteristic features of the early Wells school (Plate 83). There is an assured, restful quality about this sculpture in the sensitive treatment of drapery with its thin texture and tiny pleating, in the serene expression of the faces, and in the quiet gestures, easy stance, and firm poise of the heads. It is a style in its prime, having achieved full maturity of technique, and forms a remarkable advance on earlier work such as the effigies within the cathedral. There is every evidence that the sculptors were themselves English, since the foliage used on socles, capitals, and in the background of the quatrefoil carvings is almost without exception of the stiff-leaf variety. But the new subtlety of drapery treatment with flattened vertical folds in very thin material, often caught up by a light belt, the oblong shape of the heads with the fine classical profile of the nose, and the full freedom of modelling in the round, are all to be found in earlier French work at Notre-Dame, in Paris.

More or less the same style, though handled in a different manner by another artist, is to be seen in the Coronation of the Virgin over the central door, now unfortunately headless (Plate 82). Here are the same flowing draperies, the same grace and poise and the same sober, unemotional approach. The drapery is deeply undercut, with sharp contrasts of light and shade, but the folds are treated in the same flattened planes, and the same gathers are to be seen at the belt, so that the difference in depth cannot be taken as a fundamental difference in style. There are, however, some real differences, particularly the strong emphasis on diagonal lines in the cloak of Christ, which he is holding looped up in his hand, and which breaks across the stern verticality of the usual Wells figures. The clumsy, jagged fall of the drapery over the ankles with its deep sharply-chiselled angularity is another peculiarity which bears no relation whatever to the Virgin and Child. But since both occur together on the quatrefoil reliefs and on the rows of statues, there are evidently two styles of workmanship coexistent at the same time at Wells. The second may perhaps be derived as much from the Purbeck marbler's craft as from foreign influences, for the jagged lines of drapery edges of the Christ at Wells are similar to those of Archbishop de Gray's effigy at York some twenty years later.

Of the half-length figures of angels in the small quatrefoils, some are in the new manner of the Virgin and Child with belts and tight thin pleating, but others seem to hark back to an earlier tradition with small round heads, flat features, and drapery artificially arranged with total disregard for the natural fall of cloth, a schematized pattern-making that is remarkably successful (Plate 81A). Some of the most skilfully executed work was carried out not upon the great standing figures but upon the dramatic little reliefs within the quatrefoils. The figures are set in space in romantic rocky and leafy surroundings whose ancestry goes back to the Utrecht Psalter and beyond to late antique painting. Both the stiff-leaf foliage and the skilful employment of towering rocks with their shelves and many planes are different from the otherwise comparable quatrefoil reliefs at Amiens, where the ground is a mere flat platform and the foliage is of naturalistic type arranged in stilted bunches. The skill with which this background is executed is well displayed in the quatrefoil with the death of Cain. On the right, Cain slumps down among the bushes (Plate 81B); on the left is the stern figure of the blind Lamech stumbling downhill and bending his bow as he moves, while his cloak flies out behind him. The older conventions have here been brilliantly adapted to the demands of the new age in which naturalistic proportions and normal gestures are used in conjunction with fantastic background, artificial foliage, windswept drapery, and idealized portraiture.

The sculptors of the Resurrection slabs show little of that close attention to human anatomy displayed in the similar scenes at Amiens, but are content to indicate the drama of the theme by the most energetic variations of pose and gesture. The naked figures are about half life-size and carved so that the bodies stand out sharply against the deeply cut background (Plate 85A). The attitudes of the figures vary from those who are still asleep to others who have thrown off the long lids of their tombs and are standing, kneeling, or sitting in a tumbled rocky landscape and gazing upward at the heavens. It is noticeable that the tombs are all of the elongated variety, whereas French representations of the same subject at Amiens or Rheims include numerous circular urns of antique type. The second

difference from French models is this rocky landscape, the use of which makes it possible to avoid the confusion of Amiens and the neat rows of coffins of Rheims.

Of the upper tiers of statues of kings, bishops, ladies, and warriors, the majority are more or less in the same dignified and assured style, though some sculptors were employing rather more boldly cut faces and draperies (Plate 84).[3] But it is evident that as time went on there were artists in the Wells workshop who were dissatisfied with this sober, grandiose manner. Their solution was to revert to the native taste for extravagant gesture, distorted forms, and conventional facial types. At the intermediate stage, in the 1240s, some of the kings are made to sit with elbows stuck out in ungainly attitudes, and the formality of the ordinary seated figure is broken by exaggerated use of a pedestal on which to place one foot (Plate 85B).[4] Other figures of this second group begin to show all the worst defects of mass-produced shop-work. They are lifeless and wooden with stereotyped faces and unimaginative treatment of drapery. With several hundred statues to be carved it is indeed natural that the artists' inspiration should show signs of flagging towards the end. Finally, by about 1250 some of the female saints revert to the elongated columnar shape of an earlier age with dense drapery in parallel vertical folds; the heads become smaller and the features less pronounced, while a sharply bent wrist movement, derived from Romanesque art, becomes more and more in evidence.[5] So far from progressing on French lines the Wells sculptors in fact reverted towards older aesthetic habits of distortion and tension. The natural hypothesis of progressive development towards greater plasticity, greater freedom of drapery handling, and more pronounced Gothic features is directly contradicted by the evidence. After the first impulse no fresh influences from abroad seem to have made themselves felt, and within their own yard the masons' experiments took the form of a return to the traditions of the past, which in some cases was brilliantly successful but in many others resulted in somewhat insipid hack-work. This return to tense gestures and distorted proportions was not an isolated phenomenon of the Wells workshop, but a development common to many branches of English art in the second quarter of the century.

The carvings on the west front of Wells provide only a partial understanding of the varied accomplishments of the west-country sculptors. A statue found at Winchester, and said to be of Doulting stone, shows evidence of more subtle and naturalistic forms than the early Wells figures (Plate 86). The measurements of the base indicate that this statue, which may have represented either one of the four Virtues or *Ecclesia*, originally stood in one of the four niches of the porch of the Prior's House.[6] Now only a headless and armless torso, it remains for all that one of the most beautiful and delicate pieces of sculpture of the whole thirteenth century. The drapery is constructed of dense folds of very fine texture that flow closely over the contours of the body, revealing the swelling of the breasts. The figure is full of movement, indicated by the curving sweep of the draperies over the base, the advanced right foot and the just perceptible twist of the torso. Originally the statue was adorned with metal attachments for the neck fastening and the belt with its long trailing end, and a small metal object was carried in the left hand. Both in this use of metal adjuncts and in the texture of the drapery the nearest likeness to this statue is the early Wells relief of the Virgin and Child, and a date in the early 1230s is further supported

by the type of stiff-leaf frieze which runs around the base. It is difficult to resist the specula-
tion whether this sensitive treatment of the female body and these thin draperies were
inspired by antique statuary either via French influence or directly, although the inter-
pretation and the details are thirteenth-century and English. Indeed a very free rendering
of a late fifth-century Greek statue or a Roman copy seems the most likely explanation
for the advance that is here made upon the Wells style. The drapery, the attitude with the
slightly bent left knee, and the modelling of the body beneath the cloth are all reminiscent
of classical work. On the other hand the flow of the drapery train across the feet, the
V-shaped series of folds up the left side and the little stiff-leaf frieze around the base are
all devices of thirteenth-century tomb effigies from this western area such as that of
Longespée at Salisbury (Plate 88). The statues of Rheims of the 1230s bear no relation
to this Winchester figure since their classical prototypes were radically different. But the
drapery style, the body structure and the pose of the female statues under the north porch
of Chartres are very similar to those of this Winchester figure, and it seems probable
that both spring from the same classically derived design.[7]

It must not be supposed that the Wells school were the only skilled freestone sculptors
even in the west. The new cathedral at Salisbury was begun in 1220, though the sculpture
there was for many years confined to corbel heads. But it was in just these heads that the
early thirteenth century excelled, and the corbels of canons in the chapter-house of Christ
Church, Oxford, are fine examples of the idealized portraiture of about 1240 (Plate 89A).
The eyes are now a full Gothic shape with straight lower lid, and the mouth has a trace of
that intimate smile which was shortly to become much more pronounced in other works.
Sensitive and intelligent as is the handling of facial expression and the pose of the hands,
particularly the crooked little finger of the right hand, there are strong elements of styliza-
tion which mark this work off from similar carvings below the statues on the west front
of Amiens. The drapery is treated in hard thin ridges, the hair is a purely artificial flame-
like halo, and the wrist is bent sharply back. The combination produces an effect that is
less noble, but more intimate and more alert than contemporary work abroad.

In the north-east the construction of Lincoln nave walls from about 1220 to 1235 and
the vault between 1235 and 1253 provided the same focus for building activity as Wells
and Salisbury in the west. Here as at Salisbury sculptural work was restricted to bosses and
corbels, but within the scope permitted by such remote and diminutive fields the invent-
iveness and skill of the Early Gothic craftsmen were well displayed. Indeed the elaborate
care lavished on these tiny carvings, many placed so high as to be totally invisible before
the days of spotlighting and the telescopic lens, is evidence of a suppressed passion for
decoration that was severely limited in opportunity in these early thirteenth-century
buildings. The great majority of the bosses show spiral or radiating patterns of stiff-leaf
foliage, most of which are of the 'depressed rib' variety, while others are of short and
stubby trefoils. In the south aisle, however, there are some bosses of human heads with
highly finished surfaces and boldly chiselled features.[8] A large number of these Lincoln
carvings are distinguished by extremely dramatic facial expressions, often verging on
caricature, the inspiration for which was probably derived from the religious dramas
whose development was a feature of the thirteenth century. The horrifying demon

clutching at an anguished naked man on a corbel from the west front must surely have been taken directly from the stage (Plate 90A). The enormous head with its flapping ears, huge nostrils, and gaping mouth has all the characteristics of a plaster or wooden carnival mask.

<p style="text-align:center">*</p>

It must never be forgotten that the predominant role of tomb sculpture as surviving evidence of English medieval art is the result of an historical accident. Two periods of iconoclastic destruction have resulted in the almost total disappearance of the roods and cult images of which every church could boast, and the destruction of all but a tiny remnant of architectural statuary. Consequently the bulk of surviving statuary of the mid and late thirteenth century is tomb effigies, and of these the majority are of men in armour.

The cause of this large-scale production of military effigies in the middle of the thirteenth century was the emergence of a new patron class. During the thirteenth century the knights in England diminished in numbers but increased greatly in wealth, power, and prestige, and the tombs so freely scattered throughout the parish churches of the country are as much a sign of this development as are the tentative beginnings of Parliament. Both are evidence of the self-assurance and the social and political significance of the new middle land-owning group. The problem of satisfactorily dating these numerous effigies is far from simple. All too often the current system of dating depends on the tautological process of fixing a date as a result of stylistic analysis, finding a personage whose death approximately coincides, and then using the latter to demonstrate the reliability of the former. It is true that in many, perhaps most, cases money was either left in the will of the deceased or raised by his heirs for the erection of a memorial whose construction usually followed in the next two or three years. On the other hand one of the very few cases of which we have record, that of John IV of Brittany at Nantes, shows that the tomb was sent over in 1408, which is nine years after death.[9] There are cases in which the memorial must be many decades later than the year of death, for example over half a century in the case of Robert de Vere, 3rd Earl of Oxford, at Hatfield Broad Oak, Essex, and nineteen years in the documented case of Cardinal Langham, who died in 1376 but whose tomb was not commissioned till 1394.[10] There are also plenty of instances of the commissioning of a tomb well within the lifetime of the individual, for example by John of Gaunt in 1374, a practice which seems to have become commoner towards the end of the Middle Ages.[11] Weever wrote in 1631: 'It was usuall in ancient times, and so it is in these our dayes, for persons of especiall ranke and qualitie to make their owne Tombes and Monuments in their life-time.' By way of explanation he quoted an inscription on the wall of Saint Edmund's Church, Lombard Street: 'For widowes be sloful, and chyldren beth unkynd / Executors beth covetos and kep al yat yey fynd.'[12] Other recorded examples raise even more difficult problems. In 1438–9, a quarter of a century after his death, the executors of Archbishop Arundel had sent from York to London 'j imagine de ligno facta pro exemplari'. This seems to mean that the Archbishop had caused a wooden pattern to be made when he was at York, and had left it behind on his transfer to Canterbury in 1396.[13] If this is the case, the intention must have been to carve an effigy on the basis of a pattern made over forty years earlier. So numerous are these known and presumed

exceptions to the rule that confident attributions based on date of death must be treated with extreme caution. In any case almost all thirteenth-century effigies now lack inscriptions, and as isolated works of art they cannot be dated by their architectural settings. Furthermore, they are usually entirely without foliate detail, the conventional fall of the surcoat offers only limited scope for a study of drapery style, and military costume did not alter greatly till towards the end of the century and then at a very irregular pace.[14] The most reliable evidence for dating thus tends to be the attitude and treatment of body and to a lesser extent the style of the drapery, supported so far as possible by the details of costume. But this is necessarily a speculative process, and it is clear that the final arrangement of these thirteenth-century military effigies has yet to be undertaken.

The first important development appears to have been made by the Wells sculptors in about 1240 when they began to give their effigies a more realistically recumbent attitude. First they showed the figure in repose, the arms laid quietly on thigh or breast and the head turned slightly to one side. Of this style the best and earliest example is the effigy of William Longespée, Earl of Salisbury (Plate 88). The Earl died in 1226, but the stylistic analogies are with the Wells statues of the 30s.[15] Not merely does it closely resemble the first group in drapery style, costume, and attitude, but it appears to be in Doulting stone. A feature of the effigies of the Wells school which appears here for the first time is the coped slabs upon which they rest. At Salisbury the coping is decorated with a delicate row of little stiff leaves, over two of which a corner of the surcoat is flung in an elegantly careless gesture. Originally the whole effigy was brilliantly coloured, the chain mail was gilded, the shield and surcoat bore the gold lions of the Bassets on a blue ground, the surcoat lining and the cushion were red.[16]

Some years later the same Wells workshop invented the cross-legged effigy, a development inspired partly by the psychological change from the standing statue set horizontally to the recumbent effigy, and partly by the technical need to give support at the knees if the effigy was to be carved fully in the round. Some of the earliest examples of this development are two effigies at Shepton Mallet, Som., carved in Doulting stone and datable to not later than 1250.[17] Subsequently most west-country effigies are said to be carved in the finer oölite from Dundry, near Bristol, and the drapery style becomes noticeably heavier.[18] It is in this area, whatever the centre may have been, that we found the earliest examples of the entirely original device of making the knight place his left hand on the sheath and his right on the sword, a trick soon taken up by the London Purbeck marblers.[19] So far as it is possible to tell, it seems therefore that the main changes in the attitude and posture of the recumbent effigy were developed by the west of England monumental masons and were then copied by the more conservative shop-workers in Purbeck marble in London. It is odd that the developments were in the direction of greater naturalism and greater mobility, at a time when the artists of Westminster and Lincoln were using more elaborate and artificial mannerisms and a more linear drapery style.

*

Meanwhile the Purbeck marblers were developing their own trade in corbel heads and tomb effigies that flowed from the London workshops, and the problem arises as to

whence their technique was derived. This whole question has been bedevilled by the assumption that the series of early thirteenth-century effigies of abbots at Peterborough is in Purbeck marble. These are now stated to be of a local stone, Alwalton Lynch, and are therefore no evidence for the development of the style of the Purbeck marblers.[20] As has been seen, the earlier Purbeck tombs were mere flat slabs in low relief with smooth conventional features. On the other hand the heads within quatrefoils on the tomb of Archbishop Hubert Walter at Canterbury, who died in 1205, show clear evidence of a different influence.[21] Like others on the corbels of Lincoln choir, these heads are boldly modelled with strong, high-boned features, flowing hair, and sharply jutting eyebrows. The most probable source of inspiration for these Purbeck marblers was the metalwork of the day, an example of which survives in the candlestick now at Milan.[22] Whatever view is taken of the origin of the candlestick, there can be little doubt that it was such metalwork of the turn of the century that was the stylistic source for the effigy of King John at Worcester.

There is no record of when the tomb of this unfortunate monarch was erected, but there seems no strong reason to believe that it was more than ten or fifteen years after his death in 1216. By then the new east end was nearly finished and was ready to receive the tomb. Indeed since the effigy closely follows the clothing and attitude of the body within the tomb, including the sword in the left hand, it is likely that it was carved when memories of the corpse being borne into the church were still fresh.[23] Whether or not the forbidding but powerful face of the effigy bears any relation to the true appearance of the King remains open to question (Plate 87). When portraiture in effigies first definitely appeared in England a century and a half later, it was largely confined to royalty and was based on the realistic images carried in the funeral procession upon the coffin. Whether such images were carried at this early date, we do not know. But the squat head with its close beard is a standard feature of subsequent Purbeck marble effigies, and it is on the whole unlikely that genuine portraiture is intended. At the head of the effigy are the small figures of Saints Oswald and Dunstan, between whose shrines the tomb was originally placed, and the feet are supported by a standing lion which bites the point of the drawn sword held by the King. The device of filling in the upper angles of the oblong block with small attendant figures, usually angels, had its origin in manuscripts and was taken over by the Purbeck marblers for tomb effigies early in the century, for example on the tomb of Bishop Marshall at Exeter. On this latter monument is also to be found a crouching lion at the foot, and the Peterborough effigies of abbots show reptiles biting the croziers. Thus the carvers of the effigy of King John took over many features from earlier work and incorporated them into the new plastic style they took from the metalworkers. For the drapery is in softly rounded hollows and ridges, great emphasis is laid upon the settings for imitation jewels on the crown, sword hilt, belt buckles, neckband, gloves, and sleeve border, and the whole figure is in squat proportions and heavily and boldly modelled in the round. This royal effigy is in effect a somewhat coarse but energetic copy of the metalworker's style of the period, carried out in a material whose polished surface provides the same highlights and shadows as cast bronze.[24]

The same bold modelling and powerful portraiture persisted for some years in the Purbeck marblers' workshops, and the corbel heads in the transepts of Salisbury of the

1230s show much the same characteristics as the effigy of King John (Plate 89B). These harsh, domineering heads with their wide-open eyes, high cheek-bones, and stylized hair give an impression of great latent power, combining the last signs of the awe-inspiring character of Romanesque with the high idealism of thirteenth-century Gothic.

Subsequent figure-work by the London Purbeck marblers is disappointing by comparison with the effigy of King John. For a period in the second quarter of the century the modelling becomes distinctly flatter, as in episcopal effigies at Worcester and Saint David's.[25] By about 1250, a new florid style of monument develops in which both effigy and niche are deeply undercut and richly ornamented with stiff-leaf foliage.[26] This luxuriant foliage was developed in the architectural work of the Purbeck marblers and is well seen in the corbels of Ely choir. A good example of the mid-century tomb style is the effigy at Ely of Bishop Kilkenny, who died in 1256 (Plate 90B). He lies within an elaborate niche whose detached pillars are supported and adorned with stiff-leaf sprays, and whose trefoil canopy bears free-standing little angels. Set within this cradle of sculptured stone, the effigy is heavily modelled. The hands no longer cling flatly to the body but are fully moulded in the round, the right arm being raised in benediction and the left holding the crozier. The drapery is handled in the sparse pleated style of Wells, the material clinging closely to the body. But the edges of the robe hang in long irregular ripples, the first hint of a new treatment.

This Ely tomb represents the style of the Purbeck marblers at the transition from one phase to another. A noble piece of sculpture with strong face and powerfully modelled body, the bishop is nevertheless an intellectually unsatisfactory figure. For the head is carved lying on a cushion, and yet the hanging drapery and the corbel at the feet are those of an erect statue. The insertion of the figure in an architectural niche merely accentuated the difficulties by making the whole composition identical with the standing statuary of a church front such as Wells or Salisbury. So far from evolving a method of dealing with this problem, the Purbeck marble tomb-makers actually rejected the beginning made in the effigy of King John, and reverted to imitations of architectural statuary in freestone.

Unlike the effigies of bishops, those of knights were left free upon their slabs. Until recently the series of military effigies in the Temple Church, London, made it possible to study the stylistic evolution of drapery from the subtle ripples of the early Wells style to the harder ridging that was the hall-mark of Westminster Abbey sculpture of the 1250s.[27] At the same time the pose of the effigies became progressively more natural and recumbent, first by crossing the legs and finally by placing the hands upon the sword. All this was the consequence of the influence of the western sculptors, who had developed these features some years before they reached London. But this western influence upon the Purbeck style of London is overshadowed by the more important connexions revealed by the great architectural sculpture in Westminster Abbey, the rebuilding of whose choir and transepts was the most important undertaking of the middle years of the century.

THE IDEALISTIC PHASE:
WESTMINSTER AND LINCOLN
⟨CIRCA 1245–1275⟩

INSPIRED by personal piety, intense aesthetic ambition, and a desire to emulate the architectural activity of Saint Louis who was just beginning the Sainte-Chapelle in Paris, in the year 1245 King Henry III embarked on one of the major undertakings and primary preoccupations of his life, the rebuilding of Westminster Abbey. For over ten years he had been ordering large-scale building in his many palaces, but from these little or no sculpture has survived except some capitals from Windsor and a single head recently recovered from the ruins of Clarendon Palace. Some of the former are identical with capitals at Westminster, and prove conclusively that the same masons were at work in both places. The latter, which must be later than 1236 since the main work at Clarendon began at that date,[1] is one of the finest examples that have survived of the idealistic phase of English Gothic portraiture (Plate 92). The block is clearly the terminal of a drip-mould, and probably comes from a doorway. It shows the head of a boy whose eyes are puckered up into mere slits in which the black-painted pupils are scarcely visible, and whose mouth is half-open revealing a row of large, coarse, upper teeth. The head may be a mere personal conceit of the artist, or it may possibly be intended to symbolize the Dead, in contrast to the Quick carved on a corresponding corbel on the other side of the door. The intense intellectual quality of the carving is achieved principally by the pinching in of the cheeks about the mouth and the narrowness of the lower jaw, features which appear also in contemporary heads at Salisbury. The boy's smooth face, the narrowed oval eyes, and half-open mouth are all to be found occasionally in French sculpture, but in no case employed with such exaggerated intensity. Indeed the disturbing psychological over-tones of this head are far more like contemporary German work than French.[2] The hair is summarily treated in a very primitive manner, being little more than parallel scorings ending in the tight little spirals that derive from the Romanesque tradition. Although it is evident from some corbels that the same artist was employed at Westminster, it is none the less true that for all its extraordinary intensity this head has a certain provincial flavour about it. It is indeed the lack of the metropolitan touch that makes it such a powerful and evocative piece of sculpture. Less noble and self-assured than the great French work, less violent and brutal than the German, this Clarendon carving is distinctively insular in its treatment, even if nearly all the elements of the style are continental derivatives.

The first important work at Salisbury was the carving of the choir screen with fourteen statues of kings, which have now vanished, and above them a series of angels holding musical instruments.[3] The east end of the church had been consecrated in 1225 and it is reasonable to suppose that by the late 1240s the crossing and nave was sufficiently advanced for the screen to be undertaken. The idea of an angel choir to fill spandrels may have

derived from France, though a series in the choir aisles at Lincoln seems to be as early as any similar work abroad. The execution of both the tiny corbel heads and the angels themselves is of the greatest delicacy, and there are a number of features that suggest the work of the group of sculptors from the royal palace of Clarendon near by, who soon after moved on to Westminster. The drapery is treated in the sharp-edged grooves that originated in the later Wells workshop and some of the angels have the bent-back wrists of the same group. But the treatment is far more accomplished and less schematic, and is approaching that of the Westminster Annunciation (Plate 97). Moreover, the heads have the brushed-forward hair, pinched-in cheeks, and very narrow lower jaw of the Clarendon head and some of the corbels of Westminster. Further evidence of the fact that this is the work of the budding court school is the striking difference between this refined work and the powerful modelling of the Purbeck marble corbel-heads (Plate 89B) that had hitherto been the sole sculptural adornment of the cathedral.

The more polished craftsmanship of the London Purbeck marblers under the influence of these court sculptors in freestone is well displayed in the head of a prince, perhaps intended to represent the Lord Edward, from inside the north transept at Westminster and datable to about 1250 (Plate 91A). Here the technical perfection of execution with rigidly symmetrical curves of nose and eyebrows, square-set coronet, and the little fringe of hair, has nevertheless not suppressed that remote, detached quality which characterizes so many of these English corbels. The freestone label-stop from this north transept with the head of an elderly bearded man with parted lips provides another splendid example of that inner vision that illuminated the Clarendon head (Plate 92). More realistically treated than the Purbeck head of a prince, more skilful in its handling of details like hair and lips than the Clarendon boy, it is perhaps more confident and self-assured than either.

But these somewhat idealized show-pieces in prominent situations give little idea of the range of which one or two of these Westminster artists were capable. On remote corbels concealed in dark corners or high up beyond the vision of the naked eye, the sculptors were at liberty to exercise their talent as they pleased. One of the most arresting and powerful individual portraits that have come down to us is carved on a corbel tucked away high up in the triforium, and which was rediscovered only a few years ago (Plate 91B). Here is a thirteenth-century Londoner brought suddenly to life, talking and laughing with an engaging blend of cunning and good humour. This is not a realistic portrait in the strict sense, in the manner of Late Roman art. It is a brilliant caricature which emphasizes the inner personality as much as the physical appearance and whose technique is enhanced by the artificial conventions of spiral hair and parallel drapery folds. The subtle composition with its hunched shoulder and thrusting elbow, its twisted head and upturned chin, is more than a piece of accomplished virtuosity. It is a deliberate experiment in three-dimensional form, carefully contrived to focus and grip attention by providing a startling angle of vision. This combination of perfect technical control, an approach to portraiture that is a mixture of realism and artificiality, a love of the distorted in pose and angle of vision, and an intense masculine vitality, is peculiar to the mid thirteenth century, to the Westminster workshop, and to the one or two great artists who must have been responsible for the production of these outstanding pieces.

Other small sculptures, such as the bosses in the north transept of Aaron and Moses and David playing the harp, or the statuettes, perhaps of Henry III and Edward the Confessor, within small niches in the same transept, are carved in a primitive manner with drapery of close pleats, plain knee surfaces, inordinately long legs, and summary gouging of eyes and mouth.[4] A noticeable feature of many of these carvings is the exaggerated hunching of one shoulder, which is a further development of that distortion of body attitudes that was seen in the latest phase of Wells sculpture. Here at Westminster, despite the new French influences also affecting their art, there were sculptors who were pursuing a return to mannerisms and exaggerations. The statue of Edward the Confessor with its outward splayed feet, twisted left hand, humped shoulder and head cocked awkwardly to one side, is a good example of the result of such a development in the hands of an unskilful craftsman.

Of the major sculpture at Westminster only fragments now remain owing to the total disappearance of the great north transept front with its three portals heavy with statuary and carving. This front was the most important undertaking of the court school at a moment when medieval art was reaching its apogee, and as such its loss is probably the most serious single disaster that English sculpture has suffered. For this, much of the responsibility must be borne by the early eighteenth century. Thanks to the 'ingenious Mr Dickinson', we are told in 1723, 'this stately portico is now lately beautified, the time-eaten sculpture and masonry pared away, the Gothic order justly preserved.'[5]

The general appearance of the front can be reliably reconstructed from early drawings, from its prototype at Amiens and from its descendants at Lincoln, Higham Ferrers (Northants), and elsewhere. The tympanum of the central porch probably contained a Last Judgement within a quatrefoil, and below it was a Mouth of Hell within the spandrel formed by the double arch of the doorway. Within each of these double arches were three further quatrefoils with trumpeting angels and the Resurrection of the Dead. The arch orders probably contained the wise and foolish virgins and kings and ladies, as at Lincoln, and on the jambs were full-scale figures of apostles. Of the side porches there is some reason to suppose that the right hand contained a tympanum with scenes of the Life of the Virgin within small medallions.[6] The total destruction of this great undertaking, coupled with the disappearance of contemporary statuary from the fronts of Salisbury and Lichfield, makes the study of Early Gothic sculpture extremely hazardous. But if these major works have now vanished, we are fortunate in possessing in almost perfect condition two sets of Westminster sculpture of the utmost importance – the Annunciation figures from the chapter-house doorway, and the censing angels from the triforium spandrels of the north and south transepts.

The statues of the Annunciation (Plate 97) stood in niches on either side of the doorway, the arch of which was carved with small figures enmeshed within foliate scrolls, and the spandrels filled with diaper and large trefoils containing censing angels. The date of this work can be fairly precisely fixed at between 1250 and 1253, at which latter point the finishing touches were being put to the chapter-house. In the accounts for this year there is an entry 'in ij imaginibus ad tascham cissis liij s, iiij d.', which it seems reasonable to suppose records the payment for these two figures. Another record of about 1253–4 refers to the payment of 53s 4d for two statues to William Yxeworth, which may possibly

be identical with the 1253 reference. It may be, therefore, that these figures are the first major items of English sculpture for which it is possible to give the name of the artist.[7]

Much of the architectural plan of Westminster Abbey has been shown to be closely modelled upon French examples, particularly Amiens, and it is therefore of considerable importance to examine possible French sources of these figures. That there was at least one French sculptor at work at Westminster on some of the capitals has long been evident, and is supported by the statement of Matthew Paris. Furthermore, much of the arrangement of the detail, such as the use of square diaper and of rose decoration, the placing of statues on the buttresses of the *chevet*, the studding of outer window arches with foliage, and the placing of angels within internal window spandrels, are all derived from French examples at Amiens, Rheims, or the almost contemporary work at the Sainte-Chapelle. Nevertheless with only a few exceptions the foliage at Westminster is of the exclusively English stiff-leaf type and the statuary which has survived shows powerful insular influence. Nothing is more revealing in this respect than a comparison between the famous Annunciation figures on the west front of Amiens and their counterpart at Westminster. The iconographical relationship between the two sets of statues is extremely close, the gestures and general relationship of the Angel and Mary being in essence almost identical. But here the likeness ceases. Instead of the quiet, confident poise, natural proportions, and easy stance of Amiens, the Westminster Gabriel is all anxiety, tension, and mobility. His body is disproportionately elongated and the lower half has the erect, pillar-like quality of the later Wells group. His legs are crossed in the dancing attitude of eleventh- and twelfth-century art with his right foot turned sharply outwards,[8] the drapery is caught up in a thrusting, forward gesture of his left hand, and the upper half of his torso is swung back. This backward swing was originally accentuated by a pair of large wings of which only the mortice attachments remain. The head of the angel is long and oval, set on a slender neck, and the hair runs in stylized rhythmical ripples far down over the nape of the neck – features alien to contemporary French work. Nor does the drapery show any very great change from the Wells style, though the rendering of the body beneath the cloth is far more sensitively handled. It is composed of the same simple V-folds or vertical pleating, both treated in narrow stiff ridges between flat planes scored by hardly visible creases. The zigzag fall of the hem revealing triangular segments of lining can be seen on the tomb of William Longespée at Salisbury and on some of the latest group of statues at Wells.[9] Even the trick of catching up the drapery in front so as to hang well clear of the body appeared at Wells in the quatrefoil panel depicting the Transfiguration. In short the Westminster Gabriel is a more mature, more subtle, and more accomplished development of the latest Wells style, showing all the resurgent English mannerisms and little of the latest French drapery treatment and quiet dignity of figure-work that was just now reaching perfection at Rheims.[10]

The other surviving group of sculpture of major importance at Westminster is the reliefs of censing angels high up in the triforium spandrels at the north and south ends of the transepts (Plates 96A and B). Originally these angels flanked figures who composed a central theme, the battered remnants of which at the south end suggest that they may have been representations of the legend of Edward the Confessor and the Pilgrim. The whole

idea of large-scale censing angels within internal spandrels was copied from French examples at Rheims and the Sainte-Chapelle in Paris. It is evident that the two sets of angels are the work of different hands, though both follow the same model, and that the southern pair is superior in quality. The precise dating of these sculptures remains obscure, though it seems likely that the transept triforium and high vault were erected soon after the completion of the great north front and the royal gallery to the south, both of which would be needed to buttress the walls to take the weight of the vault. If this is correct the spandrels would seem to be the work of the latter part of the first building period, that is between about 1254 and 1258.

The south-east angel (Plate 96A) is leaning easily against the arch, while his feet rest on a delicately executed little rampant lion, identical with others found on a capital in the chapter-house.[11] The upper half of the angel's body is bent backwards as in the angel of the Annunciation, and he is swinging a censer with outstretched left arm, the whole figure being framed by the two great wings. The continental contribution, which is more marked in the south-west angel (Plate 96B), lies principally in the character of the face, which is soft and rounded with short nose and a faint smile about the mouth. The hair is composed of rich waving tresses which are caught up in a tight band and then spread out in loose serpentine curls to frame the face. This gentle, almost effete facial type falls midway between that of the angels of the *Portail du Sauveur* at Amiens and the more consciously smiling angels of Rheims, and there can be no doubt whatever of its French derivation. The only other evidence of new French influence on these angels is the irregular chiselling of that section of the drapery which flutters out below the outstretched arm, which must derive from similar treatment on some of the statues on the north porch of Chartres and at Rheims.[12] But apart from their soft and sensuous faces, the angels are full of the dynamism of English statuary of the mid-century, and there can be no question of direct French workmanship, if only because of the little tufts of stiff-leaf foliage in the extreme inner corners of the spandrels. The drapery consists of deep and sharply chiselled grooving more boldly and summarily treated than before, but employed with telling restraint to emphasize the curve and twist of the body. The mantle is swung forward in a tumbled flow of drapery around the outstretched left arm, the left hand of the south-east angel is turned back in the abrupt wrist gesture first noticed in the later Wells statues, and the whole composition is alive with movement and latent energy. The skill with which the figure is fitted into the awkward space, the vivacity of line and gesture, the ease and grace of the body movement and the gentle modelling and expression of the face, all conspire to make these some of the most successful pieces of medieval English relief sculpture.

Although the angels of the north transept are identical in design they show differences in treatment and are evidently the work of another and less accomplished artist. As an explanation of this different workmanship, it has been suggested that the best artists, notably John of Saint Albans who emerges as the King's Imager at least by 1258, were still busy on the north porches and only finished in time to tackle the southern group. An objection to this theory is that the northern pair look very much like copies of the southern, which are closest to the French prototypes. The heads are no longer almost circular

in shape, set in thick necks and with soft languorous expressions; they are oval with firm masculine features of chin, nose, and mouth. The hair is now thinner and flatter and no longer bulges out from the ribbon in tumbled ringlets. The drapery is less complex in arrangement, with far more smooth surfaces and less of the deep chiselled folds. The posture of the body has none of the subtlety of the southern angels, though the attitudes are identical; the taut vigour of wrist gesture and flying drapery has been lost and the feet and hands are clumsily executed.[13]

Associated with these big angels in the spandrels is a set of medallions in the soffits of the lancet windows of the north transept, containing a set of twenty-four busts of angels playing musical instruments or bearing a variety of objects (Plate 95). The concept of such medallion decorations comes from wall paintings, which had long employed similar schemes, but the style of the work belongs strictly to the sculptural school of Westminster. The heads are of the same filleted type, mostly showing the stern features of the north transept angels rather than the smiling grace of the southern. On the other hand some have the drapery treatment in sharp-edged folds of the southern pair, and the hair has the same bulging exuberance. The work of a number of artists of differing skill, the set nevertheless bears a very strong family resemblance, representing imitations of the brilliantly original composite style first evolved by the artist of the south transept angels.[14]

Of the other surviving sculpture of Westminster Abbey the most important figure work is in the spandrels of the wall arcades of the transepts, but this is now in a much battered condition and in any case was evidently of inferior workmanship.[15] Its interest lies mainly in the similarity of certain motifs, such as that of an angel carrying two crowns, with reliefs in wall arcades at Troyes and the Sainte-Chapelle.

The highest skill of these Westminster artists was not confined to major works such as the chapter-house Annunciation, the transept sculpture and – we must suppose – the reliefs and statues of the north transept porches. The quality of some of the corbel heads has already been observed, but equal care was lavished on the small circular fields of roof bosses.[16] Of these the most accomplished are to be found in what is now the Muniment Room, but was originally the royal gallery from which the King and his closest retinue could attend services. As such the room naturally engaged the attention of the master craftsmen, and the boss in the centre of the window recess showing the combat of a centaur and a dragon, is an extraordinary eerie fantasy (Plate 93).[17] Such combat themes were a permanent feature of minor initials in twelfth-century English manuscripts, and if their finest expression in sculpture was achieved early in the twelfth century in the capitals of Canterbury crypt the manuscript tradition maintained a vigorous and unbroken life.[18]

This thirteenth-century combat contains all the old elements of a long scaly dragon with an extra head at the top of a curly tail, and a semi-human figure thrusting at it with spear or sword. The horrific quality of the design is now greatly increased by the plastic realism of the sculptor whose lion-centaur and dragon are both three-dimensional creatures of flesh and blood. The centaur is brilliantly executed, the sweeping curves of his leonine hindquarters and muscular forepaws, and the vigorous thrust of his spear arm, giving an impression of intense energy and power. The artist of this and another near-by boss showed great interest in the structure of the body, emphasizing the ribs, collar-bone,

navel, and stomach muscles, and the muscular grooving of arm and hand. That this may be another work of the artist of the corbel-head in the triforium (Plate 91B) is suggested by a similarity in the treatment of the face. The harsh lines of mouth and eyebrow and the large coarse nose differ from both the symmetrical idealism of the marble head of a prince and the soft features of the French-inspired angels. The cloak worn by the centaur, pinned by a huge brooch in front and falling loosely over both forearms, is treated in much the same manner as the drapery of the angels, in which a complex pattern is built up by a series of deep, sharp grooves. This new style of drapery contrasts with the thin ripples of the Wells school and the more carefully modelled rendering of the Purbeck marblers, both of whose techniques were being discarded in this mid-century period in favour of a treatment that was soon to develop at Lincoln into a series of flat, sharp-edged planes like bandages.

This analysis of the stylistic details of the surviving individual sculptural items misses one of the most significant features of the whole Westminster school, its extraordinary passion for lavish surface decoration. The inside of the transepts, with carved diapering and foliate scrolls covering most of the wall surface, is without parallel in France and owes more to the traditions of the metalworker and manuscript illuminator than to those of the sculptor proper. There can be little doubt that, like so much else at Westminster, this *horror vacui*, this determination to enrich all surfaces, to break up all simple lines, is the heritage from the English Romanesque past, in particular the extravagant surface decoration of the late twelfth century. Diaper can be seen on the west front of Dunstable Priory (Beds), early in the century, and spandrel sculpture occurs regularly in the west of England at Bristol, Wells, and Worcester. The Ely presbytery marks the transition from the relative bareness of Wells nave, relieved only by its capitals and spandrel foliage, to the rich elaboration of the Westminster transepts. Begun in 1235 and completed by 1251,[19] the Ely presbytery is enlivened and diversified by the contrasting colours of Purbeck marble and plain stone; by huge clumps of foliate capitals and elongated conical corbels with curling stiff-leaf foliage; by arch-mouldings making a dazzling display of light and shade thanks to rows of dog-tooth ornament; by inner triple arches sprouting foliage branches at the joints, and by quatrefoil piercings of the spandrels flanked by foliate relief sculptures.

Although the square diaper of Amiens is the direct prototype of Westminster and the spandrel carving of the Sainte-Chapelle is equally significant for the transept angels, it is the lavish use to which these motifs were put that is so very English. Similarly the vanished tympana of the north transept at Westminster were made up of a series of roundels and quatrefoils instead of the horizontal tiers of statuary which were standard in France. This system, like that of the surviving angel choir on the inner window soffits, evidently derives from manuscript painting which made extensive use of such frames. The arrangement may also be regarded as the transference to the body of the tympanum of the figured medallions that at Malmesbury were confined to the voussoirs, while the seated or standing statues have taken the place of medallions on the arch moulds and jambs. But however it is regarded, it is evident that at Westminster the taste for linear pattern and complicated surface decoration is in conflict with the need of the sculptured figure to be set off against a simple architectural background. In its original condition the effect must have been

infinitely richer and more dazzling than to-day, when one is obliged to peer myopically through the gloom. It was said by a nineteenth-century restorer that part of the transept diaper was gilded on a red ground, and it is known that the foliage capitals were picked out in gilt, red, and green, and the arches themselves were gilt above the black marble columns. The flesh of the great angels was picked out in natural colours, their brown hair caught in vermilion fillets, their red-lined mantles decorated with green spots joined by brown bars, the rest of their drapery powdered with large brown stars and their wings composed of blue and red feathers. The whole was illuminated by the great rose windows filled with *grisaille*, the only occasional touches of solid colour in the glass coming from heraldic medallions and a few figures. In these pristine conditions there can be little doubt that the architectural proportions and the great sculptured figures were dissolved and lost in this closely textured display of painted and chiselled surface. As seen and approved by Henry III and Edward, son of Odo the goldsmith, the Abbey must have appeared as a huge coloured shrine in which the proportions were lost in the dazzling variety of patterns which distracted the eye at every turn, the reproduction on a gigantic scale of both the fussy ornamental system of the metalworker and the vivid colouring of the manuscript illuminator. At this, the apogee of Early Gothic art, in spirit England was already in the midst of the Decorated period.[20]

<div align="center">★</div>

The great cathedral at Lincoln had been under slow reconstruction ever since the last years of the twelfth century, but it was not until after 1256 that the retrochoir was undertaken, the whole being presumably finished in time for the solemn shrining of the body of Saint Hugh on 6 October 1280. The south porch was evidently undertaken soon after 1260, since its figure style is distinctly earlier than that of the angel sculpture within. The arrangement of the porch is almost identical with what we can reconstruct of the vanished north transept porch at Westminster. But even this Lincoln porch did not survive the nineteenth century unscathed, and it is now disfigured with false and inartistic restorations of missing limbs and heads. Fortunately a plaster cast was taken of its original condition and it is to this that one must turn to-day in order to study the thirteenth-century work (Plate 98). Taking the Last Judgement as its theme in accordance with the standard French practice, the arrangement has the same English characteristics that were first employed at Westminster. The tympanum area is broken into from below by two pointed arches, and the composition of the tympanum itself is grouped around a great central quatrefoil, instead of being built up in a series of well-defined horizontal tiers. The subject is the old one of Christ in Majesty within a mandorla supported by angels that was found in twelfth-century tympana such as that at Ely, and has here obstinately survived in a mid thirteenth-century setting.

The angels themselves, who are placed both within and without the quatrefoil mandorla, are carved in a nervous, lively manner with crossed legs, strange body contortions, and fluttering windswept drapery, which recall manuscript illuminations in the pre-Conquest 'Winchester' style. These features, however, are all to be seen in minor sculpture at Westminster, some of whose bosses show much the same attitudes and draperies.[21] The two kneeling angels within the mandorla probably held the instruments of the Passion,

the cross and the spear, in harmony with the gesture of the central figure of Christ who is exposing the wound in his breast. The calligraphic intentions of the sculptor are well displayed in the treatment of the drapery. The extremely violent attitudes of the angels are deliberately accentuated by a schematic pattern of sharp edges that bears no relation whatever to reality. One angel even employs the twelfth-century convention of the lifted drapery flutter in order to emphasize the raised right hand. This hard, austere elegance is also employed in the huge figure of Christ which displays much the same sharp edges and flat folds. Even the French feature of the deep cone-shaped loops of the mantle between the legs is composed of projecting knife-edged ridges that give it a harsh angularity. Further evidence of the predominantly linear approach of the Lincoln artist is provided by the acute slope of Christ's throne, giving the false perspective natural to the painter. Although the drapery here at Lincoln is not reduced to pure schematic pattern and though the figure style shows a continued respect for the realities of human anatomy, the new humanistic elements of thirteenth-century continental art have been subordinated to the linear conceptions, nervous rhythms, and vivacious mannerisms of insular art of an earlier period. Even what might appear as a novel device imported from abroad, the waist-belt consisting of a cloth scarf knotted in front with the loop above and ends below, is in fact nothing of the sort but rather a copy of the same feature found on the Christ in Majesty of the Prior's door at Ely, carved a century before (Plate 54A).[22]

Outside the mandorla the composition consists of five supporting angels arranged in lively postures, as well as two others springing forward at either side. The bottom left section of the tympanum is filled with the Resurrection, with fully clothed figures emerging from their tombs at the call of the archangel Michael. On the right are devils seizing the bodies of the damned, and in the central spandrel gape the jaws of Hell which more devils are industriously stuffing with human beings.[23]

This tympanum is set in an arch of three orders, the outer consisting of oval medallions formed by the interlacing stems of a stiff-leaf foliage plant within which are figures of the Wise and Foolish Virgins and the Apostles; the middle order is of stiff-leaf foliage fully undercut so that the scrolls compose a convex arch over a concave hollow, forming a kind of openwork tube. Such technical virtuosity in undercutting had appeared in some of the bosses at Westminster, but this arch order was the first occasion in which it was displayed on a large scale. The innermost order of all is composed of a series of shrines within which are seated figures of kings and queens and other women, probably royal martyrs and virgins, assembled like all the others to witness the Last Judgement. The figures of this inner order are seated upon the old-fashioned X-shaped thrones with lion's feet, and display the vigorous attitudes and long arms that began with the last series of Wells statues. The drapery is the same as that of the central figure of Christ, with the deep cone-shaped folds of the French style transformed by sharp-edged ridges. Closer still to some Westminster bosses, so close as to suggest direct migration of workmen, are the tiny, beautifully executed figures within their scroll surrounds on the outer order (Plate 100A). One of the Foolish Virgins holding an inverted empty lamp has a loop of her mantle lifted high in the air and falling clear of the body in big conical folds and irregular S-curves which is an exaggerated development of the attitude of the Gabriel of the Annunciation

at Westminster, and the arrangement of her hair and her features closely resemble those of the figure of Mary from the same group. Among the apostles on the other side there is one with the bent-back wrist of the Westminster spandrel angel, and the heavy beards and mass of flowing hair framing broad oval faces are to be found on some Westminster bosses.[24]

Of the series of life-size statues that once filled the niches on the jambs and in near-by buttresses, only seven now remain, all of whom have lost their heads – on this occasion thanks more to early nineteenth-century neglect than to Reformation iconoclasm. The finest are the two jamb figures, which portray the antithetic types of the Synagogue, who once held a broken staff and was dropping the Tables of the Old Law from her hand, and Ecclesia standing triumphantly erect and bearing the model of a cathedral. In style these figures are close to the Annunciation at Westminster and the Longespée at Salisbury, in which the Wells arrangement of drapery is retained, but with much greater freedom and subtlety of movement. The Synagogue is a strictly vertical composition.[25] The scarf waist-band with its big loop is the same as that of Christ on the tympanum, and her left hand which is letting fall the Tables is turned sharply back in the familiar wrist gesture, accentuating this act of surrender and defeat. The drapery folds over the left arm are arranged in those sharp-edged ridges like bandages that are significant indications of the linear hardening characteristic of this Lincoln work. The drapery of Ecclesia, on the other hand, is built up of strong, deep loops and conical folds falling down from the bunch of drapery gathered up in the left hand (Plate 99). The central feature of the statue is the firm diagonal line of the fall of cloth from the left hand to the bottom hem by the right foot, a line accentuated and enriched by the oval loops on the one side and the zigzag folds of the hem on the other. When new, this dignified composition was set off against the heavy line of the mantle falling over the upraised right arm and then running on vertically down the right side. In its original condition, complete with head and right arm, it must have been the finest of the erect and noble statues of the English thirteenth century.[26]

Surprisingly few traces of this Westminster–Lincoln style can be found in the work of the sculptor of monumental effigies. However, at Pershore, in Worcestershire, there is a knightly effigy in yellow Cotswold stone which seems to reflect something of these influences (Plate 89c). The figure is unique for the meticulous realism of the details of military costume like the thrown-back flap of the chain-mail hood and the attachment of mail mittens. In contrast to this faithful naturalism, the drapery of the surcoat is treated in the flat, sharp-edged style of the Lincoln porch, and it is this combination that stamps the effigy as a work of the 1270s. The knight is unique in his attitude, for one hand holds a horn; and the dragon biting the foot of his shield is also without a parallel at this period, though it occurs later on in the Yorkshire school.

There can be little doubt that quantitatively the most important type of English thirteenth-century sculpture was the cult image, usually of wood. Of this hardly a single example to-day survives. But Norway maintained the closest economic, political, and cultural relations with England during the twelfth and thirteenth centuries, and did not experience the iconoclastic zeal of early Protestantism in quite so ruthless and methodical a form. Consequently it has preserved a number of wooden images, a few of which can

with some confidence be ascribed to import from England. Of these one of the most beautiful is the oak statue of Saint John from the church of Heggen in Vestfold, now in the Drammen Museum (Plate 100B). The source of inspiration is evidently English and the execution is carried out with the assured mastery of court craftsmanship. The slight twist of the body with bent left knee and the projecting V-folds of drapery over the elongated right thigh are both suggestive of the Westminster Annunciation, and the angular ridges across the stomach are a narrower version of the drapery details found on the Christ in Majesty at Lincoln. Saint John's coiffure, with the hair cut short and brushed forward to form a tight halo round the head, is a characteristic of Late Antique portraits and is one more sign of thirteenth-century classical influence, another mid-century English example of which is a head from the choir-screen at Salisbury.[27] The face bears the same expression of dreamy, melancholy introspection as those of some of the Westminster corbel heads or the north-east spandrel angel; the details of the long pinched cheeks, slanting eyes, long nose, and high arched eyebrows are identical. There is no reason to suppose that a Norwegian artist was capable of such perfect execution, and the strong affinities with surviving English sculpture and the differences from contemporary work in France and Germany make its attribution to an English court artist all but certain. As such it ranks as one of the most accomplished expressions of that refined idealism heightened by adherence to earlier stylistic conventions that characterized the best of English art of the middle of the thirteenth century.[28]

PART FOUR

SCULPTURE OF THE DECORATED PERIOD

CHAPTER II

THE AGE OF ELEGANCE

⟨CIRCA 1275-1310⟩

TO suggest that English sculpture between 1220 and 1270 pursued the steady course of yet another cycle of foreign influence followed by insular reaction is an over-simplification. French influences under Henry III were very strong indeed and powerfully affected the court artists of the Westminster transept angels. Nevertheless so far as stone sculpture is concerned this renewed impulse from outside was rapidly transformed by insular modifications. The history of painting, however, is somewhat different, perhaps owing to the greater influence exercised upon this medium by the personal choice of the King. By about 1270 a richer, more emotional style under strong French influence made its appearance in works produced about the English court: in the illuminations of the Douce Apocalypse, in the embroidery of the Syon Cope, and more obviously still in paintings, the leading surviving evidence of which are the Westminster Panel and the Westminster Saint Faith.[1] A new drapery style appears that uses rich gathers and pointed folds with strong lateral and diagonal emphasis, plain surfaces that bring out the form of the body, and borders and edges of irregular zigzags, exposing the lining. The figures become distinctly less refined, with thick necks, plump faces, and slanting eyes, and the body itself is given a slight twist by placing the weight upon one foot. The style possesses strong decorative qualities, and it was this element that proved most attractive to the English artist. For the outstanding feature of the half-century after 1270 is a desire to break away from the serene idealism and the simplicity both in architecture and sculpture that characterized the early thirteenth century. On both sides of the Channel there was a move towards grace and elegance of design, disciplined by a strong sense of form. Of course the contrast was far less marked in England than in France, since the whole trend of English thirteenth-century art had been towards a decorative effect that was far richer and more comprehensive than was ever contemplated on the Continent.

In architecture, this evolution took the form of experiment in spatial pattern, notably the use of polygonal shapes such as the triangular and hexagonal plans of the Eleanor crosses. At the same time the architects and draughtsmen experimented in two contradictory forms, both borrowed from France. The sinuous, four-centred ogee arch makes its first appearance on the Eleanor crosses in 1291, and at Saint Stephen's, Westminster, a

year later. At least as early as the second decade of the fourteenth century local artists of the west and north had developed the three-dimensional ogee or 'nodding arch' with its complex spatial vistas.[2] But this experiment with curves was carried on in competition with others in the rectangular geometry of Perpendicular tracery, whose emphasis on strong verticals first appears also at Saint Stephen's, Westminster. Both innovations of this surprisingly experimental period had long and distinguished futures before them; for if the undulating rhythm of the ogee triumphed in the minor decorative arts, it was the formal angularity of Perpendicular which came finally to dominate architecture.

The desire for novelty and diversity of form achieved its greatest development in sculpture. Only after some forty years of experiment did English artists arrive at their final selection and modification of motifs provided from abroad to produce a style entirely different from that current upon the Continent. Before this synthesis was complete there was a period of two generations of activity of the highest quality, during which were tried out a variety of stylistic devices and motifs.

One of the most surprising features of mid thirteenth-century English sculpture is the delayed impact of the baggy draperies and broad figures already employed at Rheims, Amiens, and Paris by the 1250s.[3] As late as the Lincoln porch there is little sign of a change from the strongly vertical lines of Wells and Westminster statuary. When the rebuilding of the east end of Lincoln began soon after 1256, the design included provision for a series of carved and painted reliefs of angels playing musical instruments, situated in the main triforium spandrels.[4] Though the design, the characteristic broad head and filleted hair, and the belted drapery are those of Westminster, the folds of cloth below the waist are now treated in the French manner with smooth surfaces and baggy, crumpled folds. The artist is still uncertain of his technique, and the plastic qualities inherent in such treatment are not yet fully developed. Furthermore, the strong vertical chiselling running from the knee forms a fold of a highly artificial nature that contrasts strangely with the surrounding naturalistic draperies. This trick occurs occasionally in French sculpture, but rarely with the Lincoln emphasis, and its constant appearance in English-inspired wooden statues of the period in Norway suggests that originally it was a device of the wood-carver.

To the west of the second bay from the east there is architectural evidence of a break in building activity, probably while the then existing apse was being pulled down. Work was resumed in the late 60s or early 70s, and the choir was probably finished in time for the solemn translation of the bones of Saint Hugh to their new resting place in 1280. The remaining spandrel carvings now break away from the earlier musical angels, to include scenes such as the Expulsion from the Garden of Eden, the Weighing of Souls, Christ showing his wounds, the Virgin and Child, and an angel with the remarkably secular equipment of lure and hawk. It is impossible to be certain whether this last had symbolical significance, or whether it is evidence of the increasing penetration of baronial sports and pastimes into ecclesiastical decoration, a counterpart of the heraldic shields along the nave of Westminster Abbey.

This new series shows the more mature work of the earlier artists (Plate 102). The drapery has now taken on a rich baroque quality with fully modelled, tumbling folds. The huge wings of the angels are carefully carved with six rows of feathers closely

resembling the treatment of the Rheims angels, and the face of the angel of the Weighing of Souls wears a somewhat austere version of the famous Rheims smile. It is evident that a new element of emotionalism has entered English sculpture, by which a directly sympathetic relationship is achieved between the figures in the scenes depicted. The Infant Christ strokes the face of the Virgin, Christ tears back his clothes to reveal the wound on his breast with a gesture modelled on that of the tympanum figure of the south porch, but now imbued with a touch of sentiment that is enhanced by the revolutionized drapery treatment. On one of the last works of all, an angel has the wings fully extended as if in flight, thus making a wild, jagged pattern in the background against which is set the twisted body in its tumbled mass of drapery.[5] Such a piece of sculpture with its insistence upon the break-up of rhythm and regularity is striking evidence of the desire to escape from the restrained conventions of Westminster.

The reaction, however, was far from complete. The angel of the Expulsion retains much of the austerity and even the mannerisms of the previous generation.[6] The drapery below the knee is dominated by two strong vertical chisellings, the left arm is shamelessly distorted and elongated to retain that sharp gesture that had been so popular at Wells, and even the drapery on the arm is handled with the flat bandage technique of the Lincoln tympanum. The hair has lost the thick curls that once bulged out over the fillet, and is now cut short and brushed forward over the forehead. Though the face is smiling, it bears a detached and slightly cynical expression with strong masculine features, in contrast with the femininity of the Rheims statues. It is evident that the naturalistic treatment of body and drapery, and the soft romanticism of the French style has passed through a powerful insular filter.

At almost the same date sculptors were at work on the relief carvings in the spandrels of Salisbury chapter-house, which was begun soon after 1272.[7] The scheme is one of great iconographical interest, since it comprises a very complete set of Old Testament scenes ranging from the Creation through the stories of Cain and Abel, Noah, Lot, and Joseph, to the declaration of the Old Law by Moses. The scenes are in moderate relief and the figures are set firmly in a landscape of bulging crumpled ground and sparse artificial trees consisting of stumps with interlacing branches. Like the earlier west-country reliefs of the Worcester Lady Chapel and the Wells west front, these little scenes are distinguished by an extreme simplicity of statement, which forms a strong contrast to the untidiness of the Westminster transept arcades. Some of the figures have the naturally proportioned heads and thin draperies of the Wells quatrefoils, but others revert to the livelier style of the Worcester reliefs with tiny heads and animated gestures. The strong sense of dramatic composition of the reliefs, and the refined and sensitive facial expressions of the corbel-heads below are well displayed in the scene of the destruction of Sodom and Gomorrah (Plate 101A).

In the figure style there are no signs of the sharp-edged folds of drapery of the Westminster artists; some show the new baggy draperies and others a wispy fluttering that has not hitherto been met with in mid or late thirteenth-century sculpture. It is clear that these Salisbury carvings are more closely related to contemporary style in painting than to the great independent sculptural works of the same period like the Lincoln angels.

Their qualities are not those of contemporary sculptors but of manuscript illuminators, wall-painters, and tile-makers. The much restored paintings of the Months on the ceiling of the choir at Salisbury display the same trees and vivacious figures with little loops of fluttering drapery.[8] The tiles of Westminster Abbey chapter-house, which are firmly dated to 1253–8, use the same stunted trees to punctuate the scenes, and the figure-work of the rather later Chertsey tiles is also in the same style.[9]

★

A feature of late thirteenth-century art is the increase of secular subjects and secular monuments within religious buildings. By the 1280s the medieval economic and social structure was reaching its apogee. Population was attaining its maximum for the Middle Ages, prosperity was evident in expanding towns and increased acreage under cultivation, and the devastation and diversion of resources due to war had not yet begun to reach serious proportions. Of this material wealth the benefits were reaped almost entirely by the landowning class, whose resources, self-confidence, and pride of possession were steadily increasing. An expression of this social phenomenon is a growing pre-occupation of both painters and sculptors with scenes illustrating the activities of this class in war and in peace. As early as the 1250s, King Henry was ordering the decoration of his state apartments with themes drawn from romance legends, for example the painting of the Antioch Chamber at Clarendon Palace in 1250–1, and during the next decades a workshop at Chertsey Abbey under royal patronage produced a series of paving tiles for Westminster chapter-house and for Chertsey Abbey that illustrated the romances of Tristram and Iseult and of Richard Cœur de Lion.[10] Another example of the same trend is a boss from the south aisle of the Lincoln Angel Choir depicting a queen playing with her lap-dogs, while her attendant waits upon her (Plate 103A). It is possible that this subject was intended to illustrate the evils of worldly and frivolous toys, but such an interpretation is far from obvious, and indeed is quite impossible in many similar cases. In these, the hunting and hawking, jousting and feasting of the great are evidently depicted for their own sakes, a mark of approbation for the hierarchic social structure and the ethical values of a leisured class becoming increasingly preoccupied with the codes of chivalry which governed their sports and pastimes. The Lincoln boss is as interesting stylistically as its iconography is significant, for it employs all the ancient tricks of pre-Gothic mannerisms to convey the new humanized sentiment of the late thirteenth century. The lap-dogs are portrayed with vivid and tender naturalism, the one at the Queen's side being shown in three-quarter position, involving a careful attempt at foreshortening. The Queen's gesture as she supports the puppy in one hand and gently strokes its head with the other is a cleverly executed piece of sentimentalism enhanced by the bend of her neck as she gazes down at her pet with a rapt expression. The attendant, however, with his filleted hair, twisted head, crossed legs, and posturing hands has all the graceful artificiality of a pre-Conquest 'Winchester' drawing. The disposition of the two bodies and of the stiff-leaf sprays in the centre and round about combine to form a cup-shaped pattern whose smooth curves dominate the composition. The alert gestures and taut design of this little scene are purely English and owe nothing to outside influence, the expression of emotion by symbolic

pattern rather than heightened expression being one of the most persistent characteristics of English medieval art.

Another boss from the north aisle of the Angel Choir shows two lovers kissing above a scowling male head, apparently a representation of the vice of Luxuria, in which the head below is expressing its disgust at the exhibition of sensuality occurring above (Plate 103B). As interpreted by the artist, the scene has a strange, surrealist quality, in which the bodies of the lovers are caught in the thick, rope-like coils of their own lust, and the necks are artificially extended as the man and woman stretch out towards each other with expressions of intense sensual concentration. It is noticeable that the faces are extremely individual and yet the details, particularly the hair, eyebrows, and beard of the man, are highly stylized abstractions.

The most important decorative element introduced into English art by the secular trends of the age was the heraldic shield. The expansion of the tournament as an amateur sport necessitated the development of visual signs to enable spectators to distinguish the combatants, otherwise anonymous behind their vizored helmets. The result was a flowering of heraldic devices employed upon caparisons and shields for the information of the crowd. Soon the fashion spread to members of the community who did not engage in these competitions, such as the higher clergy, and by the end of the century there had grown up an esoteric heraldic sign-language, as erudite and as obscure to the unlearned as the earlier Christian allegories. Such attractive decorative effects soon found their way into sculpture, especially on the tombs of distinguished laity and clergy, whose effigies increasingly invaded church interiors. Appearing first in a modest way in the 60s, by the 80s rows of shields suspended from loops or twigs had become familiar in the illuminations of court manuscripts; in 1292 they appeared in wall paintings in the royal palace at Langley and on Eleanor crosses.[11] The decorative fancy and exquisite craftsmanship of late thirteenth-century heraldic art is most fully developed upon the shields of benefactors that adorn the spandrels of the nave aisles of Westminster Abbey (Plate 101B). In their original highly-coloured condition these ranges of shields along the nave of one of the most important churches in England must have formed an overwhelming display of secular ostentation to the greater glory of the King, his relatives, and his baronial associates.[12]

The same secular trend was also responsible for the conversion of churches from their earlier function as buildings designed for the celebration of mass and the housing of relics. It was in the middle and late thirteenth century that they began to turn into mausoleums filled with the self-important memorials of the great of this earth. The most important evidence of this trend is naturally provided by the royal church of Westminster Abbey, where also the most advanced technical achievements of tomb-making were taking place. It was in the last twenty years of the century that Purbeck marble began to lose that grip upon the effigy-making craft that it had held for almost a century. Thanks to changes in taste and in technique, the usefulness of the material had become outweighed by its disadvantages, and it was rapidly and completely superseded by other materials. No Purbeck effigy has survived which can be dated after about 1315 at the latest. The finely carved effigy, probably of Sir Robert de Keynes, at Dodford, Northants, is agreed to be the last

of the Purbeck series.[13] A polished if conventional figure in the usual cross-legged, sword-drawing attitude, it shows the meticulous fidelity to detail of the London workshops. The knee- and elbow-plates and the semi-conical helmet suggest a date in the second decade of the century rather than the first, an old-fashioned piece in the outmoded wooden posing of a generation earlier, but dressed up in the latest military equipment. The laborious cutting of the chain mail and the bearings on the shield are signs of an attempt to satisfy the demand for intricate detail.

If the Purbeck marblers' trade in effigies was virtually ruined by 1315, right up to the end they found an occasional outlet for their skill in the carving of bases for shrines, where durability was thought to be more important than cost. They had been employed on Saint Frideswide's shrine at Oxford in 1288–9; and they were commissioned to carve the shrine base of Saint Alban in 1305, where they adopted the French plan of filling gables and spandrels with free figure-work in high relief. But the impression is messy and the little figurines have a stiff, marionette-like quality.[14] One of the last surviving pieces of figure sculpture in Purbeck marble is the base of the shrine of Saint Edberg of Bicester, now at Stanton Harcourt, Oxon. The date of the shrine is firmly fixed by its heraldry between 1294, when Thomas Earl of Lancaster married the daughter of the Priory's patron, Henry Lacy, Earl of Lincoln, and 1317 when they were separated. An indulgence for the fabric was granted in 1305, which suggests expansion to provide suitable accommodation for the shrine; this would presumably be in course of erection soon after, and before the reconsecration of the three altars in 1312. Henry Lacy, who died in 1311, was a munificent patron of churches, and the shrine may well have been a personal gift from him. If this is so the date narrows to 1305–11.[15] The foliage of the capitals is still fairly naturalistic, but the crockets and finials are of an early bubble type, which supports a date in the 1300s. The shrine base consists of a series of open ogee arches with shields bearing the arms of the patrons of the Priory in the spandrels, and topped by a flat cornice with delicate and strikingly individual human heads set in the hollow of the moulding. At each corner is a niche under an ogee arch containing a small figure of one of the four evangelists, and from the cornice above projects a large human bust (Plate 110A). The style of the carving, precise, meticulous, and sharp, is in the thirteenth-century Purbeck tradition rather than the softer, more impressionistic style of the fourteenth-century freestone carvers.

There were a number of causes working for the decline of Purbeck marble, but the most important was undoubtedly the increasing demand for lavish and meticulous detail picked out in colour. The carving of a material so difficult and expensive as marble was made unnecessary by the use of a gesso coating which could be stamped and moulded at will while still wet, and then finished off with paint and gilding.[16] By this means a coarse freestone effigy could be given the minute detail and smooth finish that was so much desired, and the result was just as successful and very much cheaper than anything the Purbeck marblers could hope to achieve in their stubborn medium. Enriched tabernacle work such as that on the canopy of Bishop Northwold at Ely or the details of military costume carved with meticulous accuracy on the knight at Dodford could be reproduced at a fraction of the cost in either wood or freestone with a gesso coating, and once painted was indistinguishable from marble.

Great efforts were made by the marblers to keep abreast of the times by adopting such new devices as the 'translucida' technique of using painted ornament superimposed upon gold, giving an effect of translucent enamel. But its use upon complicated sculptural work like the shrine of Saint Frideswide at Oxford (Plate 110B) only served to emphasize the futility of carving so intractable and costly a material as marble if it was to be entirely enveloped in surface colour.[17] Painted gesso was thus the main cause of the ruin of the Purbeck marble trade in effigies, though other factors were the limited depth of the marble seams which precluded large-scale sculpture in the round, and growing evidence of the friability of the stone if exposed on edge.

Before settling down to the new materials, the court indulged in experiments in gilt and chased metal. One of the first effigies to be placed in the new royal mausoleum at Westminster Abbey was that of William de Valence, without doubt a foreign import from Limoges in central France. Ever since the twelfth century, workmen from this centre had specialized in chased enamel plaques with which to adorn book covers, reliquary chests, and other minor objects, and in the late thirteenth century they developed their technique to satisfy the new demand for effigies. Of these, one has survived in France, the figure of Blanche de Champagne, from the Abbaye de la Joie (Morbihan), now in the Louvre; one, which was imported in about 1276 for Walter de Merton, Bishop of Rochester,[18] has now vanished, and only that of William de Valence survives in this country (Plate 105). Blanche's effigy was still not paid for in 1305, and thus may well not have been completed till the late 90s, which would explain its close similarity to that of William, who died in 1296.[19]

The effigy has a core of oak upon which are nailed plates of chased and enamelled copper, the joints being covered with filigree strips. This technique was a compromise which gave some of the effects of cast bronze without the technological difficulties involved in large pieces of casting. It enabled full relief to be given to arms and hands without the stiffness and constant strain imposed upon the cast metal. Furthermore, it allowed full play to those minute decorative fancies that were so attractive to the age. The cushion upon which William's head is resting is brightly enamelled with blue and white quatrefoil flowers and tiny heraldic shields of England and Valence; his sword belt is adorned with gold bars and rosettes; the shield at his side bears the little red birds of Valence in enamel superimposed upon elaborate chased scroll-work, and his surcoat is adorned with more little enamel shields. It is significant of the unscientific state of heraldry at this period that on different parts of this effigy there are to be found five, nine, eleven, and fourteen bars to the Valence arms. The studding of the effigy with small shields and the placing of the shield upon the hip instead of the arm are both French rather than English habits, and serve to provide further confirmation of the fact that the effigy is an import from France.[20] The figure itself, with its straight legs resting on a lion, symmetrically posed body and hands clasped in prayer, is a work of sober competence. This quiet style made a great impression on the court school, which for years afterwards adhered to a restrained and restful design at a time when all other tomb-makers were adopting more vigorous and dramatic poses.

The less exalted, equally eager for self-commemoration, demanded something cheaper,

and it was to satisfy this new market that the art of the brass-engraver grew up. Incised stone slabs had long been employed for memorials, and it was in imitation of them that brass engravings first developed in northern Europe. The opportunity arose from that development of metallurgical techniques which was to affect both architecture and art during the next half-century. The iron cross-bars that held together the vertical mullions of the window tracery, the forged iron tie-bars attached to hooks which hung the West-minster chapter-house to its central pillar without supporting buttresses, the brass rings which bound the detached clusters of shafts, the lead joints of Purbeck marble shafts, capitals, and bases, the iron plates which revolutionized the military equipment depicted on sepulchral memorials, and the great cast copper effigies of Henry III and Eleanor, are all symptoms of the same process by which new materials were being placed at the disposal of architects, sculptors, designers, and soldiers.[21] By the beginning of the thirteenth century the expanding metallurgical industries of the Rhineland and Flanders, particularly the Dinant area, began turning out sheets about one-eighth of an inch thick of a 75 per cent copper alloy called latten, and there is evidence that they were soon being used on the Continent for memorial purposes as substitutes for the incised slab. Carefully chiselled and polished, with the incisions sometimes filled with coloured cement, they presented a far richer and more impressive appearance than the simple marble slab, and their popular-ity consequently grew. As an imported product, latten was obviously a rarer and more expensive material in England than in Flanders and Germany, and this may be the reason why from the very beginning English brasses employed an independent technique. Instead of using the whole rectangular sheet of metal with the effigy displayed against an ornamented latten background, in England the effigy alone is in metal, standing out sharply against the grey marble slab in which it is sunk. Aesthetically this results in far bolder pattern and more striking contrasts, but in view of the prevailing taste for fussy enrichment it may be questioned whether this happy technique was inspired by more than the dictates of economy. Judging from later evidence the makers of these brasses seem to have been professional tradesmen who also dealt in effigies, and were to be found principally, if not entirely, in London. For the sixteenth and seventeenth centuries there are plenty of documents to prove that the tomb carver and the brass designer were often the same artist, and there is no reason to think that the medieval practice was any differ-ent.[22] Indeed the link between the effigy and the brass is provided by engraved alabaster slabs, which combine the material of the one with the technique and design of the other.[23] Finally we know that in 1486 the London Marblers' Gild was exercising control over all work in marble, latten or copper.[24] Not unnaturally, therefore, the designs of the early brasses were based on those of the contemporary Purbeck marblers and freestone carvers. The crossed legs and the lions at the feet of the knights in brass are directly copied from contemporary effigies, and Sir Robert de Bures at Acton, Suffolk (Figure 2A), seems to be a linear representation of a freestone effigy such as that at Threckingham, Lincs.[25]

The earliest of the surviving English brasses is probably that to Sir John d'Abernoun, at Stoke d'Abernon in Surrey (Figure 1). He died in 1277, but the brass must be rather later in date. He carries a small heater-shaped shield and a lance, and his legs are straight, but there is otherwise little difference in costume, style or technique between this and the

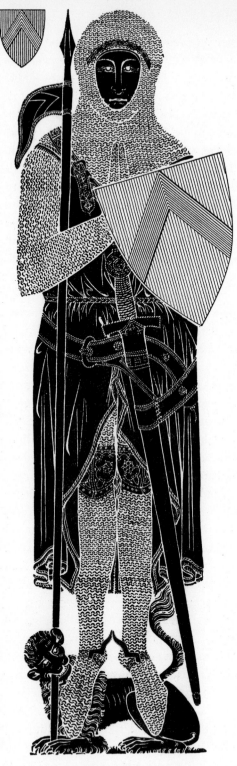

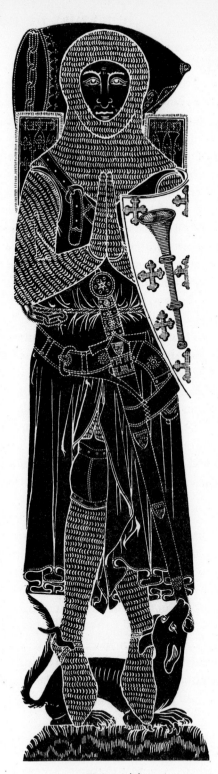

Figure 1(A).
Brass of Sir John d'Abernoun. *c.* 1290–1300.
Stoke d'Abernon, Surrey

Figure 1(B).
Brass of Sir Roger de Trumpington. *c.* 1290–1300.
Trumpington, Cambs

137

Bures brass a quarter of a century later. The lance is unique in brasses and stone effigies, though some of the knights on the west front of Wells originally held them in their hands. This Stoke d'Abernon brass and other examples at Trumpington, Cambs (Figure 1B), and elsewhere tend to show that the brass engraver was no mere slavish copier of the tomb-maker, closely though he followed the general layout of the modelled figure with feet upon an animal and enclosed within a decorated niche. Particularly during the period of rapidly changing fashions in costume, the engraver was bolder in depicting new details. It is highly significant, however, that the sword-drawing pose of knightly effigies of the late thirteenth century was never adopted on brasses. This points unmistakably to production under strong court influence, where the quieter, more classical style prevailed. Furthermore, such canopies of early brasses as have survived and the matrices of others show those features of the special use of *oculi* and *mouchettes* in the spandrels, the employment of the arch and gable and of blind arcading which are identified with the court school of architectural design.[26] As a result of this dependence upon London models, English brasses display almost entirely insular characteristics despite the foreign manufacture of the raw material. This stylistic evidence of insular workmanship is supported by the technique of few and narrow deep incisions and a complete absence of shading, thus achieving an elegant simplicity of statement. The finest early brass that has come down to us is that of Sir Robert de Bures at Acton, Suffolk (Figure 2A). Robert, who died in 1302, is shown in the restful 'Westminster' attitude of prayer with crossed legs resting upon a large and lively lion with turned head and waving tail. The most effective use is made of the contrast between the artificial symmetry of the face, the restful pose, and the simple lines of the surcoat on the one hand; and on the other the highly decorative effect of the skilfully executed chain mail, the minute elaboration of the *cuir-bouilli* knee caps, the chased and jewelled sword hilt and the heraldic ornament of leopard and ermine on the shield.

<p style="text-align:center">★</p>

The thirteenth century witnessed a fresh intellectual approach to natural science by which the trammels of theological convention were ignored and a beginning made in the study of man's environment. When the first elephant arrived in England, a gift from Saint Louis to Henry III in 1255, the animal was drawn from life by Matthew Paris, who was no longer content with the fanciful reconstructions of earlier artists. In physics Roger Bacon's experiments are well known, but equally far-reaching was Albertus Magnus' application of the inductive method in his book *De Vegetabilibus*, in which he broke away from the accumulative errors of the past to compile an alphabetical list of trees and plants containing descriptions drawn from life. At last a medieval Christian could say: 'We must seek to know every individual thing according to its own nature. For this is the best and most perfect kind of knowing.'[27]

The emergence of naturalistic bird life in manuscripts[28] and the brief outburst of naturalistic foliage sculpture from 1275 to 1300 are visible witnesses of this intellectual movement. The first examples in sculpture in this country are a few precocious capitals and bosses at Windsor and Westminster Abbey, and an isolated boss in the south aisle of Lincoln nave. All are datable to about 1240–50 and may well be the work of a French

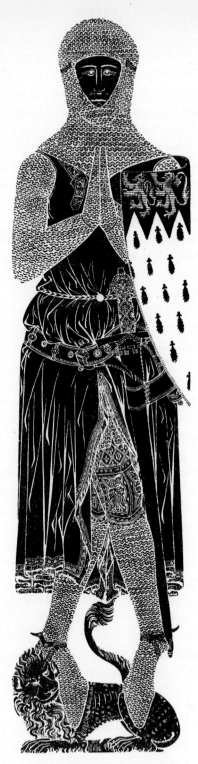

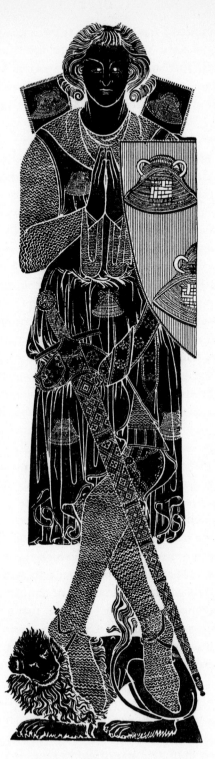

Figure 2(A).
Brass of Sir Robert de Bures. *c.* 1295–1305.
Acton, Suffolk

Figure 2(B).
Brass of Sir Robert de Septvans. *c.* 1305–15.
Chartham, Kent

sculptor.[29] It was not till the triforium at Rheims that the French developed this natural-istic foliage to a high degree, and it is thence that it spread rapidly east to Naumburg and west to England.[30] By the late 1280s it had been adopted by the London Purbeck marblers, appearing in somewhat laboured execution on the Purbeck marble shrine of Saint Frides-wide at Oxford in about 1288–9 (Plate 110B).[31] But it was at Lincoln that this naturalistic foliage took strongest root. By the time the bosses were carved for the Angel Choir in the 1270s, the sculptors retained stiff-leaf foliage only as bowers for figure-work, and devoted full bosses to skilfully planned naturalistic foliage. These are principally hawthorn, maple, oak, and vine, which is much the same choice as that at Rheims. It is noticeable that though the most meticulous realism is shown in the drawing of the individual plants, including galls upon oak leaves, yet the design is still strictly subordinated to the rhythmical spiral pattern that ever since Canterbury nearly a century before had been the accepted method of boss decoration. Some years later – work was in progress in 1293 – these artists were busy on the new chapter-house at Southwell. Here is found much the same limited choice as at Rheims and Lincoln, maple, oak, hawthorn, vine, ranunculus, and potentilla being the most important. By now the sculptors had achieved far greater virtuosity in workman-ship and their capitals are almost completely hollowed out underneath, consisting of a rough inner cone lying deep inside a network of leaves, berries, and stems (Plate 106A). The arrangement is less strictly rhythmical than that of the Lincoln bosses and the foliage has a playful tendency to spray out from the capital and spill over on to arch-springers and jambs. It is here at Southwell that the perfect balance is preserved between the sculptural demand for order and arrangement and the intellectual need for realism: the earlier bosses at Lincoln were too obviously schematic, the contemporary spandrels of the Oxford shrine too untidy.

This naturalistic style did not last, and already in the central boss of Southwell chapter-house can be seen the sinuous undulation of the 'bubble foliage' which was very rapidly to replace it after the turn of the century. In the face of the new demand for indefinitely repeated undulation that was to characterize the early fourteenth century, the naturalistic foliage with its angularities and inequalities was to give way to a conventionalized orna-ment based on the oak-leaf which the experiment had itself provided. The presence in Southwell chapter-house of one capital of stiff-leaf foliage, over eighty capitals of natural-istic foliage, and a central boss of undulating foliage is proof of the extreme brevity of the experiment, sandwiched between two schematic and repetitive stylizations.[32]

A curious feature of this brief outburst of botanical naturalism is its relative failure to have a similar effect upon the treatment of human and animal forms. The occasional animals or faces peering out of the leaves at Southwell are flat abstractions or clumsy representations out of all proportion to the size of the foliage. But if the Southwell artists failed to extend their sense of realism to the study of man, there were others at work at the same period who were not so intellectually inhibited. At almost the identical period, soon after 1296, the eastern cloister of Lincoln was given a wooden roof, complete with ribs and bosses in imitation of stone vaulting.[33] Weathered and damaged though they are, these bosses show the impact of the realistic approach in the treatment of domestic scenes. The most common study of such scenes was in the illustrations of the occupations of the

months, in which a chronological picture of agricultural activities of the seasons was displayed. This was a theme well known to twelfth-century illuminators and had occurred on the lead font at Brookland; in the late thirteenth century it acquired fresh popularity in illustrations of books of hours. The iconography of the scenes had long been stereotyped, but the Lincoln boss depicting the work of December, an old man braining a pig, derives its freshness from close study of the human body in movement (Plate 107A). So subtle is the carving of the muscular twist of limbs and torso that the imminence of the blow is given almost painful actuality. And yet all the old stylistic tricks of the age survive: the old man's head in its close skull cap is a highly idealized and refined portrait comparable with the head from the Westminster north transept of nearly half a century earlier (Plate 94), the loose peasant smock flows in carefully arranged loops and swathes, and the oak-leaves in the background are utterly disproportionate in size.

In the west the chief centre of activity had shifted from Salisbury to Exeter, where as early as about 1275 a grandiose reconstruction of the whole cathedral was begun, which was to last with intermissions for nearly a century. As usual the east end was rebuilt first, and it was in about 1295–1301 that the bosses and corbels were carved for the presbytery vault.[34] The eight corbels were of the huge conical type that had appeared sixty years earlier at Ely, and were luxuriantly adorned with naturalistic foliate designs (Plate 106B). The range of botanical subjects is much the same as that of Lincoln and Southwell and the individual plants and leaves are handled with minute fidelity to nature. But the composition is schematic and repetitive and the leaves are arranged in a single plane standing out against a deeply undercut background. As such these Exeter carvings differ entirely from the sprawling foliage of Saint Frideswide's shrine at Oxford and to a lesser extent from the subtle rhythms and many planes of the Lincoln and Southwell carvings. They serve to show that naturalistic foliage, though admittedly most highly developed in the north-east, was nevertheless essentially a style defined by the chronological limits of 1275 to 1300 rather than by any geographical boundaries.

★

Important as are these provincial works, it was London that henceforth was to exercise most influence upon English art, and it is to the products of the court artists of the 90s that we must turn in order to discover the most significant developments of the period. One of the most striking features of court art was its eager experimentation in new materials that would give added colour and splendour. King Henry had long ago summoned workmen and materials from Italy to enrich Westminster with mosaics. These workmen, of the Cosmati family, were responsible for the pavement of the presbytery, signed by Odericus, 1268; for the base of the Confessor's shrine by Peter the Roman in 1269, for the tomb of the King himself, probably begun about the same time, and for three tombs of the children of the King and of William de Valence.[35] The materials are red and green porphyry, Purbeck marble, and coloured glass, used to construct geometrical patterns of bright colour and intricate complexity. Their significance to subsequent English art is the legacy of a taste for coloured mosaics and other artificial adjuncts which they encouraged in the court school of sculptors. In the tomb of Edmund Crouchback of about 1300

we find the openings in the canopy tracery filled with coloured glass on a tin-foil backing in imitation of stained-glass windows, and similar glass inserts also occur on the Coronation Chair.[36] This was a French technical invention used inside the Sainte-Chapelle, whose adoption was yet further to extend the range of materials at the disposal of the artist anxious to embellish and enrich his sculptural figure- and canopy-work. In this search for dazzling richness to satisfy the social aspirations for grandeur of their royal patrons, the court artists remained blissfully unaware of the danger of vulgarity inherent in such an eclectic attitude to materials, and in their pristine state some of these London works must have had an air of meretricious *chichi*.

The full development of the court school as a well-defined centre of artistic activity, exporting its wares and its ideas all over southern and eastern England, was accelerated by the death of the much beloved Queen Eleanor of Castile in the autumn of 1290. Hitherto the personal contribution of Edward I to English art had taken the form of the stopping of much of the building activity in northern and western England by the forcible conscription of very large numbers of masons to work on his great chain of castles in Wales. Beginning in 1277, this activity at the peak years of 1286 and 1295 was absorbing well over 500 masons, which must have comprised a very large proportion of the skilled building labour of the country.[37] But by about 1290 Edward seems to have realized the weakness in prestige of the English monarchy compared with its French rival, that was so skilfully exploiting the sanctity of Saint Louis. The result was a series of measures, mostly copied from French examples, that were designed to remedy this relative inferiority. Taking advantage of the great popularity of Queen Eleanor, as witnessed by contemporary accounts, Edward ordered the most lavish memorial arrangements. These included a series of crosses at the twelve resting places of the bier between Harby in Nottinghamshire, where she died, and her final burial at Westminster. The idea, and possibly also the design, of the crosses were inspired by similar memorials to Saint Louis erected twenty years before.[38] At the same time Edward also commissioned life-size cast bronze effigies of his father Henry III and of Eleanor for the family mausoleum around the Confessor's Chapel of Westminster, again in imitation of the French series at Saint-Denis, where in 1263–4 Saint Louis had ordered a set of sixteen effigies of his ancestors. In the next year work was in progress on Saint Stephen's Chapel in the royal palace at Westminster, a deliberate imitation both in concept and in many details of design of the Sainte-Chapelle, in Paris. Finally Edward had the sacred stone of Scone brought south and installed in a new and splendid Coronation chair in Westminster Abbey in 1300–1. The evidence for a consciously imitative prestige policy is overwhelming. If the court style which emerged as a result of this activity was in many ways old-fashioned, it was because its inspiration lay in the Paris fashions of over a generation earlier, at Notre-Dame and the Sainte-Chapelle.

In a little over fifty years the English royal family was to surround the Confessor's Chapel at Westminster with a series of grandiose funeral monuments to themselves that to-day, after the substantial destruction of Saint-Denis, is without parallel in Europe.[39] The first important step forward in the development of this mausoleum was taken by Edward in 1291, when he commissioned William Torel, an English goldsmith of London, to make three life-size cast bronze effigies, one of his father Henry III to rest upon the

Cosmati-work tomb, one of Eleanor for her tomb near by, and a duplicate for Lincoln Cathedral, where her entrails had been buried after their removal during the normal embalming process.[40] As a goldsmith Torel was accustomed to the technical process of casting by the *cire-perdue* method, and he owned in his house considerable stocks of wax for this purpose. But it is evident from the unnecessary thickness of the bronze that he had never before undertaken work of such size. Indeed so far as is known this was the first attempt in England to make a life-size casting such as had long been practised by the north French and Belgian metalworkers. Torel set up a wooden shed in the churchyard of Saint Margaret's close by the Abbey, where he worked on the project for the next two years at a remuneration of £113 6s 8d.[41] The casting of Eleanor's figure was carried out in a single piece, which was then gilded with gold obtained by melting down florins bought off some merchants of Lucca. Finally the cushions were elaborately chased with the arms of Leon and Castile, and enamels or paste jewels were attached by small pins, for which only the sockets now remain (Plates 108 and 109A). Torel took as his model the Queen's seal, which he may himself have designed some years before,[42] and turned to paintings and stone effigies for further assistance. The gable at the head and the lions at the feet are borrowed from the marble and freestone tomb-makers; the full modelling of the figure, in which only the back of the head is re-entrant, and the sinuous rippling of the edges of the cloak, are both features of effigies of thirty years before, for example that of Archbishop de Gray at York. The high forehead, the shape of the crown, the thick neck and firm chin, the slight sway of the figure, were all seen in the painting of Saint Faith's Chapel at Westminster. The vertical draperies and the hand fingering the ribbons of the cloak were conventions of the Wells statuary of a generation earlier still and were standard in the effigies of royal ancestors ordered for Saint-Denis in 1263-4. Thanks to its superb technical execution this effigy of Queen Eleanor by Torel is one of the most successful of all the medieval royal tombs; it represents the highest achievement of the idealistic preoccupations of the mid thirteenth century, modified by a hint of movement both of form and of line.

The twelve Eleanor crosses undertaken between 1291 and 1294-5 placed a greater demand upon the court school of sculptors than they could meet. Four of the lesser crosses, at Dunstable, Saint Albans, Stony Stratford, and Woburn, were put into the hands of a single master mason, John of Battle, who presumably did his own sub-contracting.[43] The important cross at Cheapside was also a contract job, by Michael of Canterbury at a price of £300.

Of the three sets of statues from the Eleanor crosses that have survived relatively undamaged, only that at Waltham, Herts, can be ascribed to the court school. Hardingstone, Northants, reflects possibly the Salisbury workshop, and Geddington, Northants, the midlands style. The Waltham cross is a hexagonal three-tiered erection, designed by Roger of Crundale and a Frenchman, Nicholas Dymenge de Legeri (de Reyns). Apart from its hexagonal shape, the cross is a restrained and simple piece of architecture with heavy vertical lines emphasized by graduated buttresses. The close connexion between metalwork and stone statuary is demonstrated by the statues of Eleanor on this cross, the work of Alexander of Abingdon.[44] Alexander also supplied some small cast bronze figures

for the monument erected at Blackfriars, London, to hold Eleanor's heart, and it is consequently not surprising to find that his stone statues at Waltham are similar to Torel's bronze casting at Westminster. In both the queen is idealized with flowing hair, the left hand toying with the cloak ribbon on the breast and the right holding a sceptre. The body has the same old-fashioned drapery of narrow vertical pleats ending in angular folds as it trails upon the ground. Both in architectural design and in figure style the Waltham cross evidently represents the conservative style of the court school.

By way of contrast the cross at Hardingstone, near Northampton, is an experiment in luxuriant undulating ornament of cusped ogee arches, crocketed gables with bulging foliate finials, pediments filled with careful patterns in naturalistic foliage, horizontal rows of roses, and pierced fret-work constructed entirely of arcs of circles. The work of John of Battle, this cross has only tenuous links with the court style, for example the suspended shields with armorial bearings and the use of arch and gable. Essentially it represents a break-away into a new Decorated style. It is obvious that the sculptor of the statues, William of Ireland, was not a court artist, although we know that his workshop was in London, whence in 1292 William of Barnack carried the statues to Northampton. William of Ireland's style is nervous and restless (Plate 109B). The drapery hangs in sagging loops and tight little folds with tubular voluted ends, and the cloak is brought across the body in a curving horizontal hem. The body is much shorter and fatter than in the work of Alexander and Torel, the neck is narrow and the torso sways backwards and to the right.

Were it not for the firm documentation of this statue, there would be a strong temptation to ascribe it to a period some thirty years later when such a style was popular on both sides of the Channel. But as it is, William of Ireland must be given the credit for a work of great precocity. Some confirmation of this early date is derived from one of the few surviving figures from the west front of Salisbury, the destruction of almost all of whose statuary has created one of the most serious *lacunae* in our knowledge of late thirteenth-century sculpture. Structurally complete by 1266, it appears that the front was not immediately filled with statues, and certainly the few that survive seem to date from the 1290s at the very earliest. One is so close in style to the Hardingstone Eleanor as to suggest not merely that it is of the same school, but that it is the work of William of Ireland himself.[45] If this is so it follows that the simplified linear style of the late Wells statuary did not persist in the west but was replaced in the 1290s by mobile attitudes and romantic draperies. It was against this tendency, as evidenced by William of Ireland's work, that the court school was putting up its rearguard action.

Of the third surviving cross, at Geddington, Northants, the account roll tells us nothing. In design it is the translation into stone of an intricate and delicate piece of goldsmith's work. Triangular in shape, its lower tiers are entirely covered with rich diaper which spreads luxuriantly even over the buttresses. The niches have trefoil heads with the usual crocketed gabling and foliate finials, and within them are statues of the Queen carved from local stone and in a style much coarser and less accomplished than the work of either Alexander or William. These have a strong family resemblance to the work of the midlands freestone sculptors such as the architectural statuary that survives at

Lichfield, Staffs.[46] This midland work was influenced by the court style, but the coarse material imposed a less polished workmanship in which the pleatings and folds of drapery were cut deeply into the soft stone.

The *déhanchement*, the slight sway of the hips imparted to all these Eleanor statues, is ultimately due to the more naturalistic approach of the third quarter of the thirteenth century. The weight in these swaying figures of the late thirteenth and fourteenth centuries is usually on the left foot and the most likely explanation is that this habit arose in images of the Virgin and Child. In these the child was normally carried on the left arm, and any naturalistic portrayal consequently showed the Virgin swaying to the left under the weight and thrusting out her left hip to support him. But this development of the mid thirteenth century was in the fourteenth adopted for queens, knights, and indeed all standing figures in order to satisfy a desire for romantic poses and sinuous lines; what began as realism rapidly became one of the most stereotyped of conventions.

While it is legitimate to refer to the court school as conservative in view of its adherence to French stylistic conventions of forty to fifty years before, it was nevertheless far from static. The insularity of the style is now seen to be due to the selective exploitation and development of certain decorative elements found earlier in Parisian *ateliers*. But the mingling of artists on the Eleanor crosses and the constant awareness of continental developments precluded rigidity and isolation, and the work of the court artists in the next twenty years reflects a gradual modification of this conservatism.

In the last years of the century fresh steps were taken to develop the royal family mausoleum at Westminster by the erection of tombs to Edmund Crouchback, Earl of Lancaster, second son of Henry III, and to his wife Aveline. The canopy over the former shows the tabernacle work of the court artists carried to a high degree of intricate complexity, in which cusped and crocketed arches are surmounted by gables, pediments, and tall crenellated pinnacles. This developed niche-work was first seen on the Eleanor crosses, and was one of the most important and most original features of the court style. The tracery of this canopy was red, the ground gilt and incised, and inlays of coloured glass were set in buttresses and spandrels.

While the main arches are still of the simple thirteenth-century shape, the decoration of the side pediments includes the new ogee tracery, and other novel features are the brackets sprouting from the central pediment upon which once stood little figures bearing candles. In the middle of the centre pediment is a trilobed panel filled with a diminutive relief of the Earl praying on horseback, obviously based on thirteenth-century seals of equestrian knights. He is in full armour with a scarlet surcoat, and is riding upon a richly canopied horse bearing the golden royal leopards on a scarlet ground (Plate 120A). Minute details like the sword hilt are picked out with that meticulous care and lavish colouring that characterizes this opulent, extrovert court style with its emphasis on display and its goldsmith technique.[47] The two effigies of the Earl and Countess are executed in much the same quiet manner as before, but the influence of the freer figure style is already apparent. The Earl is turning his head to the right, to look towards the high altar, the *déhanchement* of the Countess is more marked, and her drapery arrangement more complicated, with elaborate folds and sinuous edges originally enhanced by the colour contrast between

facing and lining.[48] Furthermore, there appear two features which were to influence English tomb decorators for the rest of the Middle Ages, the pair of angels supporting cushions at the head, and the rows of 'weepers' under an arcade below. Kneeling angels holding censers had long figured on French engraved slabs and English Purbeck and free-stone effigies, but set outside the arch of the niche to fill the awkward empty corner of the slab.[49] The double cushion, the upper set diagonally, and the concept of combining both features to make the angels kneel gracefully at each side and hold the cushions, were new to England. The careful hanging of the angel's drapery over the heel to leave the lower half of the bare sole exposed was directly copied from France and was henceforward to be a hall-mark of the London carvers.[50] Equally French was the idea of filling the sides of the tombs with 'weepers', instead of with the rows of heraldic shields that had hitherto been customary. The origin of this was a pictorial representation of the funeral *cortège* of friends and relatives, popularized by the mid-century tomb of Louis de France at Royaumont (Oise). The system of breaking up the procession by a series of niches and of setting the mourners facing outwards was first developed in France,[51] but its universal employment in England is further evidence of the insular habit of thinking in terms of decoration rather than expression in this late thirteenth-century period. Figures within quatrefoils had occurred in the second half of the thirteenth century on Purbeck tombs, for example the later tomb on which the effigy of Bishop Marshall now rests at Exeter.[52] But the earliest representation of weepers beneath arches in this country seems to be on Bishop Thomas de Cantelupe's original tomb at Hereford (Plate 118B) whose date can be firmly established at about 1282–4.[53] The ultimate source of inspiration for this arrangement must have been French, but the stylistic connexions are, as might be expected, with the west country rather than with Westminster. The weepers consist of knights seated on benches with their feet resting on various animals. Their attitudes are vigorous and varied and their surcoats fall in baggy naturalistic folds. The poses, the arm gestures, and thin drapery style, all owe much to western effigies in Purbeck marble and freestone. On the other hand, the hanging of the shields at the hip is a French habit, and the whole arrangement is probably inspired by some lost north French original. The delicately executed semi-naturalistic foliage sprays in shallow relief in the spandrels are quite unlike the heavy, deeply cut work of Westminster, or the fertile inventiveness of Southwell and Lincoln.

The earliest weepers of the court school occur on a tomb of a lady at Chichester, though still set within quatrefoils in the Purbeck manner and alternating with heraldic shields,[54] and it is not till the tombs of Crouchback, Earl of Lancaster, and his wife Aveline that they appear under arcades.

The Crouchback weepers are some of the most attractive of the whole subsequent series; for they combine the classic dignity of the thirteenth with the grace and mobility of the early fourteenth century. They are arranged in pairs turned slightly inwards as if in conversation, and are stepping out of the frames, with their feet stretching down over the outer moulding. Some of the figures are in the quiet style of Alexander of Abingdon (Plate 111A); these are naturally proportioned, the gestures are restrained, the body sway is noticeable without being exaggerated, and the drapery has the same loose, vertical fall

as on the Waltham statue. Other weepers are rather more nervous and excited in the style of the Hardingstone cross, with strained necks, voluted folds at one side, and cloaks draped like shawls with the hem reaching only to the knees (Plate 111B). Originally the weepers themselves were painted and stood against an alternatively red and green background diapered with gilt patterns. It is perhaps a consequence of their elegance and refinement that these figures seem somewhat detached and haughty. This London style of the turn of the century was above all aristocratic and class-conscious. The deliberate product of the patronage of a rich and powerful monarchy, its determination to avoid any trace of vulgarity fought its love of glittering display, and its almost classical dislike of enthusiasm was in strong conflict with developments in the provinces.

This conservative court school from the Waltham cross to the Crouchback tomb suggests the influence of a single dominant artist, the development of whose style dictated the course of sculptural evolution. A strong candidate for this role is Alexander of Abingdon, '*le Imaginator*'. He was responsible for the statues of the Waltham and Charing Crosses in 1291-2; he built the tomb at Lincoln to support William Torel's brass effigy, and made three metal images for the tomb at the Black Friars in London; we find him supplying work for Stanwell Church in 1312, and we know that he was still alive in 1316 and still closely associated with Michael of Canterbury, who was the architect of the Cheapside cross and had been employed on Charing Cross twenty-four years before.[55] The likeness of some of the weepers of the Crouchback tomb to the statue of the Queen on the Waltham cross is very close, and the stylistic unity of the whole series has already been demonstrated. It cannot be proved that Alexander was personally responsible for the statuary of the Aveline and Crouchback tombs, together with those at Chichester and elsewhere.[56] But the surviving evidence would suggest that he must have played a leading part in the development and preservation of this court style of sculpture; and it may be that Michael of Canterbury was equally important in the evolution of the architectural canopy.

It was this Westminster school with its restless experimentation in materials and its conservative figure style that first developed a widespread trade in wooden figures.[57] It is clear that there were no separate shops and craftsmen for the wooden effigies, whose style is closely similar to figures in bronze, freestone, and Purbeck marble. Wood was a very suitable material for effigies, once the techniques of the thick gesso covering and the painted and gilt finish had been perfected. The light weight as compared with freestone and marble greatly reduced transport difficulties and costs, which in the Middle Ages were always severely limiting factors.[58] In consequence areas as far removed from the capital as Cumberland in the north or Monmouthshire in the west could at last obtain the finest products of the London workshops.[59]

A pair of wooden effigies at Woodford, Northants., show all the signs of London workmanship of the late 80s, just before the introduction of the more subtle draperies and slightly twisted posture of the Crouchback effigies at Westminster (Plate 112). The double cushion, the folded hands and large lion of the man and the hitched draperies and rippling edges of the lady's cloak, are all London features. The effigy at Canterbury of Archbishop Pecham, who died in 1292, is an even more typical Westminster product. The drapery falls at the sides in smooth ripples, the hands are clasped in prayer, the head resting on double

cushions has bold rounded features, and the whole effigy is set upon a tomb with weepers on the sides and surmounted by the usual pinnacled and pedimented canopy. The tomb probably dates from about 1300, for there are two niches at either side of the canopy with ogee heads such as had not yet occurred on the tombs at Westminster.[60] A little later, perhaps about 1305–10, this London workshop was still turning out wooden effigies with the same quiet pose and simple drapery pleats. By now major changes in military costume were under way, and the effigy at Burghfield, Berks, provides a rare example in sculpture of a fluted steel cap worn over the chain mail (Plate 111c). Despite this novelty the angels, the pose of the body, and the style of the drapery are very similar to those of the Crouch-back effigy, so that the provenance can hardly be in doubt.[61] This London trade was ruined by about 1330 with the development of alabaster as the standard material for effigies, and the use of wood died away as rapidly as it had sprung up. Its use depended on the popularity of the pressed and painted gesso finish, and its great period is thus the forty years between the decline of Purbeck marble and the rise of alabaster.

It has already been shown that brasses were also closely associated with the court style. But very occasionally other influences affected the art of the London brass engraver, inducing him to modify his normal type of military effigy. A brass in memory of Sir Robert de Septvans at Chartham in Kent (Figure 2B) follows the design of north French engraved slabs or effigies in showing the knight bare-headed and with long hanging mittens of chain mail.[62] But the general arrangement of the body with crossed legs and the shield on the shoulder instead of at the hip is entirely English, as is the technique of cutting away the brass around the effigy and sinking the latten into a plain slab. A detail of military costume common enough in manuscripts and in French memorial slabs but rare in English effigies or brasses is the *ailettes*, leather or metal plates engraved with the wearer's heraldic device, that were apparently used to protect the shoulders from downward sword-blows. They are found over a long period ranging from the Chertsey tiles of about 1275 to a manuscript firmly dated to 1338–44, so that they cannot be used for accurate dating purposes.[63] Sir Robert de Septvans died about 1306, and the elaborate sinuosities of the hem of the surcoat and the metal ring of the sword-belt attachment suggest that the brass was cut no earlier.

This mixture of London and French influence was not confined to tomb-work in stone, wood, or brass. An ivory diptych which may be ascribed to about 1305–15 is evidence of the same elegant refinement conveyed in another medium (Plate 104). Here both the drapery style and the facial type that had begun with the Eleanor statues have undergone some modification. At first sight the drapery of the two figures of Christ and the Virgin appears close to a naturalistic interpretation, though details such as the hang of the loose end of cloth over Christ's right arm show that this impression is more apparent than real. The simplicity of composition is in fact the result of the most elaborate artistry, and the easy grace of the two figures is carefully contrived. The faces have very high foreheads, slanting almond-shaped eyes, long noses, and narrow lower jaws, the whole set in a frame of spiral coils of hair. This facial type is also found on the wooden corbel heads of the Westminster sedilia of about 1308 (Plate 113A), and drapery details like the decorated hems, or the looping of the cloak round the arms and shoulders and diagonally across the body, are present

on the sedilia paintings. It is to French influence *via* paintings and manuscript illuminations like those of the Arundel Psalter that the principal features of this ivory are due.

Comparison with French ivories of the same period shows conclusively the distinctly insular flavour of this carving, the calm immobility and the frigid, slightly inhuman expressions.[64] The iconography of the Virgin and Child follows the Parisian ivory carver's romantic innovations by which both Mother and Child are humanized, the former smiling tenderly and the latter playing with his toys, a flower and a little ball. But the Virgin's smile is frozen on her face and the Child's handling of his toys is more symbolic than real. The final and conclusive evidence for an English origin for this ivory is the use of the ogee arch with high rounded crockets, for no surviving French ivory of this period uses anything but the old two-centred arch. The ogee arch is by its very nature a purely decorative feature, since it cannot be used to span major structural openings. Though found occasionally on French tombs of the early fourteenth century, it was English artists who adapted and developed the ogee till it became one of the most characteristic features of insular decoration. Employed occasionally in the 1290s by the court artists, at Saint Stephen's, Westminster, on the Hardingstone cross, and on the tomb of Archbishop Pecham at Canterbury, it spread very rapidly both north and west, where the desire for complex undulating forms was more highly developed than at the court school in London.

The Caen stone tomb at Wells of Bishop William de la Marche, a prominent politician and friend of the King, who died in 1302, is also a work of the court school of about 1305–10. The beautifully executed relief head of Christ on the side panel of the tomb recess (Plate 113B) is very close to the head of Saint Edward painted on the back of the Westminster sedilia.[65] But the draperies of the angels at the back of the tomb are in the full romantic style of billowing, crumpled folds, more freely and excitingly treated than those of the ivory or the Sedilia paintings. Furthermore, sculptural ornament is sited more carelessly on this tomb than has occurred before. The five reliefs are thrown on to the vaulted walls at the back and sides of the tomb, and the plinth below the effigy bears six fully modelled heads awkwardly protruding from the recess of the large squared moulding.[66]

<div align="center">★</div>

It might be expected that, thanks to the wide distribution of its products such as brasses and wooden effigies, this prolific London school would have had a dominating effect upon English sculpture. But this was not entirely the case, and it is by local schools in the west and north that some of the most important steps were taken in the development of the new romantic style. The explanation for this lies largely in the deliberate restraint exercised by the London artists. Adventurous in the use of showy materials and colours, they were conservative in design and style. The elaborate pinnacled tomb canopies in which they specialized were always designed in a single spatial plane, and made very limited use of the new ogee arch. Ornamental carvings like corbel heads, bosses, and crockets of bubble-foliage were employed by them with a strict sense of economy, their figure-work was cautious in the use of *déhanchement*, and they rejected the energetic pose of the sword-drawing knights.

There are signs, however, that when working for provincial clients, the Londoners were prepared to adopt a less conservative approach. The effigy of the third Earl of Oxford at Hatfield Broad Oak, Essex, has the angels, double cushions, slightly turned head, long sleeveless surcoat, and loosely fitted chain-mail that point unmistakably to the sculptor of the Crouchback effigy at Westminster. But at Hatfield the knight retains the sword-drawing pose of the earlier freestone and Purbeck effigies, now employed with great verve and energy. The sword is pulled some two inches out of the sheath and the twist of the mail is used to emphasize the muscular effort.[67] In the hands of the local sculptors this treatment became even more highly charged. The alabaster quarries of the north midlands emerged with an effigy in feeble imitation of the same style at Hanbury, Staffs, and the Bristol workshops produced a bold and dramatic figure, this time using the baggy draperies that were first seen on the Lincoln angels.[68]

There is plenty of evidence to show that the Abingdon workshops were very active,[69] and it is no doubt to them that we owe one of the most remarkable effigies of the Middle Ages, the sword-drawing knight at Dorchester, Oxon. (Plate 115). Although the nearest parallel is an effigy in the Temple Church, London, the chief problem of this effigy is its uniqueness, its failure to conform to any definable school.[70] The outstanding quality of the effigy is its dynamism, the alarming sense of power and vitality compressed within the polished golden-yellow stone. The thin-textured surcoat falls in narrow swirling folds, curling back over the left knee, and flowing in sinuous ripples over the right thigh and down the chamfered edge of the slab to emphasize the twist of the hips. The right foot has a firm purchase on the lion's back, the chain mail is rolled round the forearms, and the wrists are sharply turned to heighten the tension of the muscular pull of the sword from its scabbard. This impression of latent energy is heightened by the expression of iron determination, achieved by deeply sunken inner corners to the eyes, a pug nose, and a wide thick-lipped mouth forming a smooth arc turning down and inwards at the corners. The small lion, long shield, single flat cushion, thin ripple treatment of the surcoat folds, and the very narrow sword-belt, are all old-fashioned features that would appear to preclude a date any later than about 1280. On the other hand the marked twist of the lower half of the body, the energetic withdrawal of the sword, and the grim facial expression are signs of the romantic movement, which hardly seem possible much before the turn of the century.

To the west, on the Marches of Wales, the sculptors of Hereford and Worcester evolved a smooth, highly accomplished style of drapery and portraiture that was based on the last of the Purbeck effigies of bishops.[71] The finest example of this group is an effigy of about 1310 of one of the Swinfield family[72] in Hereford Cathedral (Plate 116B). The extremely delicate head and the elaborately voluted folds of the silken robes show that this local school was capable of great technical skill and refinement of expression. The figure has an air of graceful elegance that is very different from the strength and dignity of thirteenth-century effigies. The aim is no longer to impress but to please the eye.

One of the more engaging features of late thirteenth- and early fourteenth-century English art was its increasing use of what to contemporaries were known vaguely as 'babewyns'.[73] Literally meaning 'baboon', the word was used indiscriminately to

describe the profusion of ornamental scenes of grotesque character, misshapen jesters, dancers, and jugglers, apes and other animals imitating the doings of human beings, birds and monkeys riding on the backs of other animals, and similar profane and often obscene subjects. Some of this imagery can be identified with stories from popular fables, particularly that of Reynard the Fox, for example the scene of the fox seizing the cock and being pursued by the housewife, which is carved around the base of the central pillar of Salisbury chapter-house. Others came from the Bestiaries and from illustrations of the Marvels of the East as described by Isidore of Seville and Rabanus Maurus. Still more were the product of the rich invention of the artists themselves, sometimes for satirical purposes, more often with no obvious particular meaning at all. The ancestry of many of these fanciful subjects goes back to that rich Romanesque imagery which had so offended Saint Bernard, and a late medieval writer described the 'babewyn' in terms very similar to those of the twelfth-century saint: 'figures called babewynes which artists depict upon walls. For some of them they draw with a man's face and a lion's body; others too with a lion's face and the rest of a body of an ass; yet others with the head of a man and the hindquarters of a bear, and so forth.'[74] Although Flemish and Artois manuscripts contain such subjects, the lead in the development of a widespread and pro-longed fashion was given by the East Anglian school of manuscript illuminators, begin-ning with the Peterborough Psalter and running on to the Luttrell Psalter of the middle of the fourteenth century.[75] It was from these brilliant manuscripts that babewyns spilled over into embroidery, hangings, plate, wall paintings, and of course sculpture. Early examples of this taste occur in the chapter-houses of Southwell and York. In the former, of about 1293, an arch springer is adorned with a tiny long-eared mouse, and a capital with two hounds attacking a hare.[76] The York chapter-house was probably begun in about 1290, and the heraldry of its glass suggests that it was completed by 1308. Drastically restored in the nineteenth century, the sculpture to-day has none of the gilt and painting of the original, and it is doubtful how much of the sculpture itself is genuine.[77] The capitals of the canopies show the same intricate naturalistic foliage as those of Southwell, but the arch-springers have developed a series of carved corbel heads. Most are human heads, laughing and grimacing with that cheerful jollity that characterized early four-teenth-century art, but one is of an actual monkey faithfully drawn from life.

The wood-carvers were equally swift in adopting little secular scenes and subjects from the manuscript illuminators, particularly for the decoration of 'misericords' beneath the seats in choir-stalls. They also revelled in that minute attention to irrelevant detail that characterized the manuscripts. When in 1308–9 William Lyngwode of Blofield, Norfolk, was making wooden stalls at Winchester Cathedral, he carved a tiny head the size of a walnut and gave it a movable tongue pivoted on a pin.[78] The fact that Lyngwode was brought from Norfolk is of great interest since the falconer in a long peaked cap carved at the back of one of the stalls (Plate 107B) is derived from a drawing in an East Anglian manuscript, the Ormesby Psalter.[79] The canopies over the stalls are substantially of the London type, handled in a single plane with open circle and *mouchettes* within the spandrels, and the use of the ogee arch is severely restricted to details of the cuspings. Lyngwode's work, both in design and in detail, is thus very much a product of south-east England.

We have seen that the naturalistic foliage sculpture of the north-east was merely the leading example of a style that was nation-wide in its distribution. But the large-scale figure-work of this region was not the same as that prevalent further south, the difference lying in a more romantic approach whose most obvious feature is a drapery style quite unlike anything to be seen in the capital. This must either be an indigenous development or the result of influences exclusive to this area. The Hanseatic League had depots at York and Hull, and the York Merchant Adventurers were established in north German towns ranging from Cologne to Danzig. The most likely source of influence is therefore Germany, and in fact German sculpture of this period displays some of these Yorkshire features. But it would be unwise to overstress German influence. No very close relationship of stylistic detail can be proved, and the connexion is shown only in a common tendency in both countries towards a baroque handling of drapery. Elements of this were present in the Lincoln angels, and their development by northern artists can more easily be interpreted as an insular evolution.

The first clear evidence of this extravagant figure style is provided by two five-foot angels on brackets high above the triforium of Durham choir.[80] Their ebullient draperies are composed of smooth, bulging surfaces that sag over the waist-belt and fall in deep irregular folds, and the hair fans out into circles of thick curls that serve for haloes. Now there can be no doubt whatever that one of the sculptors of the Lincoln angels was also responsible for the four evangelists carved in the centre of the vault of the Chapel of the Nine Altars at Durham, presumably in the early 80s. The reconstruction of the choir vaults followed immediately on the completion of this work and the angels are therefore probably of the late 80s or early 90s, and a development of the Lincoln style.

A further development of this tendency is revealed in the sandstone effigy at Bedale, Yorks, apparently of Lady Fitzalan and dating to the first decade of the fourteenth century (Plate 117B).[81] She is shown holding a scroll, a unique feature for English medieval effigies. Her very narrow shoulders and extremely long bust are common to northern effigies, but the single cushion and tempestuous, billowing drapery style point to the Durham *atelier*. Indeed this figure marks the apogee of the baroque of northern England, in which the twisted pose, elongated bust and tumbled clothing ending in intricate sinuous hems, all combine to push to its limits the style of the Durham angels. It is symptomatic of the international quality of this style that the closest manuscript parallel has been variously ascribed to an English or a German source.[82]

It was only in Germany that the plastic qualities of monumental sculpture were fully exploited at this early period. At Naumburg, in about 1260-70, there was carved the most accomplished work of High Gothic sculpture, remarkable for the vivid individuality of the portraits of the Margraves and their wives, the full modelling and the subtle use of gesture and drapery to emphasize emotional relationships and personal characters. Something of this individuality and this concept of the statue as an independent work of art is seen in the Lincoln figure of an ecclesiastic, possibly Saint Giles (Plate 114). The furrowed brow and heavy jowl, the careful shaping of the neck within the high collar of the cope and the drag of the alb over the waist-belt, reflect something of the formidable impression of the Naumburg figures.[83] The sloping shoulders and sagging folds over the belt occurred

on the Durham angels of before 1280, but the Lincoln figure belongs to a naturalistic rather than an emotional group, and its affinities with Durham are thus technical rather than stylistic. Since later work in Lincolnshire and the north bears little relation to this heavy-featured independent statuary, it must presumably date from 1280–1300.[84]

The effigies of Yorkshire are mostly carved in deep-bedded magnesian limestone, which lends itself readily to bold relief and summary execution of detail, and in consequence they differ markedly from those of both the London and the Bristol centres. French influence is evident in the early adoption of the double cushion with or without attendant angels, and of the attitude of prayer to replace that of the martial pose with one hand upon the sword hilt.[85] And we find on Yorkshire tombs that can hardly be later than 1310 that the heads of the effigies are sheltered by gablets with nodding ogee arches, with which London was as yet unfamiliar. Yorkshire military effigies of the period 1280–1320 fall into two main schools, each of which makes occasional borrowings from the other. One, obviously inspired largely by London work, produced a long series of effigies in sleeveless, calf-length surcoats, knee-caps, and wide-necked chain-mail hoods, lying squarely on two cushions and holding smallish shields carved with heraldic devices. An effigy at Goldsborough of the 1320s provides a good though late example of the group.[86] Local features that were to be strongly developed in the course of the next generation were the emphatic undulation of the ogee canopy and its bubbling crockets, and the energetic characterization of the little heads at the sides with their protruding eyes and arched upper eyelids (Plate 118A). The other school based itself upon north French incised slabs and effigies more than any other workshop in this country, though it incorporated many English and specifically local features. This foreign influence shows itself in the portrayal of the knight bareheaded and wearing a long-sleeved surcoat falling to the ankles.[87] On the other hand the crossed legs and shield at the shoulder are English habits, and the use of a florid drapery style, ogee gablets, and a plethora of little human and animal adjuncts are local elements. The fertile inventiveness, the florid style and the coarse finish of this York school are all well displayed in an effigy at Bedale, apparently of Brian Fitzalan who died in 1306 (Plate 117A). A scaly dragon gnaws the tip of the shield, at the knight's feet sit two priests reading books, little heraldic shields are attached to the top of the sword hilt and the knee-caps, the sword belt is studded with lion heads, the surcoat falls loosely about the body in tumbled folds, and the ogee canopy is lined with ball-flower ornament. The date of this effigy and the associated group is not easy to determine. The sleeved surcoat occurs as early as the 1290s on the Lincoln Easter Sepulchre, the metal attachment for the sword came gradually into use between 1300 and 1330, and the other details of costume are of no avail to narrow the possibilities. But there is no reason for rejecting a date in the first decade of the century, which appears to be the period of the similar French and Belgian incised slabs.[88]

It must not be supposed, however, that this florid style went unchallenged in the north. The mobility of medieval masons is fully attested in surviving documents,[89] and no surprise can be aroused by the appearance over the chapter-house doorway at York of a Virgin and Child which bears no relation to the usual northern style (Plate 116A). It seems certain that the statue was carved in the first decade of the century when the

chapter-house was being completed and fitted up. This dating is supported by the arrangement of the Virgin's drapery, which during the early fourteenth century was superseded by the shawl arrangement with a knee-length hem. The figure differs from contemporary northern work because it is nothing less than a harder and more stylized version of an elegant French ivory or stone statuette, of which there are numerous examples all deriving from the famous *Vierge dorée* at Amiens.[90] The poise of the head, the sway of the body, the attitude of the Child, the zigzag curls beneath the crown, the arrangement of the drapery running diagonally up the left arm are all closely modelled on the French original. But whereas French statues possess the irregular loops and folds of full Gothic draperies, those of the York statue are rhythmical and linear, built up by nearly parallel lines of deep shadow. The rigid verticalism of the drapery below the left hip and strong looped folds down the right leg are both made up of these linear systems emphasized by the elongation of the body. Similarly the curls running down the side of the face are realistically carved in depth on French ivory and stone statues, but are here treated as flat pattern. Although the French origin of this type of statue cannot be in doubt, the interpretation is full of English mannerisms all designed, as usual, to emphasize rhythm by the repetitive use of line.

CHAPTER 12

THE AGE OF THE DECORATOR
⟨CIRCA 1310–1350⟩

IT is fairly clear that the period covered by the previous chapter saw a transition from one sculptural style to another. The nature of the change was to some extent concealed by the conservative figure style of the court artists, whose elegant products were becoming increasingly anachronistic as time went on. Nevertheless it was at the court that some of the most significant elements in the new style first made their appearance, and it would be wrong to place too much emphasis upon this division between the capital and the provinces. Essentially a twofold change was in progress, in the nature and purpose of sculptural ornament itself, and in the method of its use within the architectural framework. In the thirteenth century the sculptor had deliberately set out to create an impression of humane nobility, and to provide large-scale monumental sculpture whose scale and positioning harmonized with, but did not dominate, the designs of the architect. This happy relationship was achieved partly because the architect was also the designer if not the executant of the sculpture, as is proved by the notebook of Villard de Honnecourt. But the very demands of the thirteenth-century architect for large-scale sculpture soon tended to make this lack of differentiation impossible. Signs of the times are the emergence by 1268 of John of Saint Albans as the King's imager and the names bestowed by 1291 upon Alexander of Abingdon, of 'Imaginator', 'le imagineur', or 'le imagour'. This specialization was imposed not merely by the amount of statuary and reliefs required for architectural settings but also by a growing demand for tomb effigies. By the turn of the century, as the accounts of the Eleanor Trustees demonstrate, the architect, the mason, and the imager had in some cases become three different persons with their own clearly differentiated occupations.

A consequence of this functional divorce was that the control of the architect over the siting and character of sculptural decoration of buildings was weakened at the very moment when a change of taste on the part of the patron was rapidly enhancing the importance of such decoration. Inside the transepts of Westminster Abbey architectural design had been deliberately obscured to give pride of place to a coloured decorative system that spread over almost every possible surface. This precocious triumph of the decorator over the architect was but the first symptom of a development that was to dominate the first half of the fourteenth century. Sculptural ornament was no longer part of the vertebral structure of the building, but was applied to or inserted in the available surfaces with reckless disregard for the preservation of architectural lines and proportions. There have been two subsequent periods in English history, the late sixteenth and late nineteenth centuries, when there was a similar triumph of the decorator over the architect. It is fashionable nowadays to explain these phenomena in sociological terms, by the advent of a *nouveau riche* class of patrons who lacked good taste and insisted on ostentatious

display. But there are reasons to doubt the validity of this simple hypothesis, at any rate for the late sixteenth century, and it has yet to be shown that the early fourteenth century witnessed an upheaval in the upper strata of society on the scale of the Late Tudor and Late Victorian periods.

The most frequently employed of the new decorative motifs was the canopied niche, in which the setting for the statue with its copious and heavy detail was treated as of greater importance than the statue itself. Those cusped and crocketed arches, those lofty pediments with floriate finials, those towering crocketed pinnacles that began with the Eleanor crosses and were developed in the Westminster tomb-canopies, now spread out over great buildings for arcadings and sedilia, reredoses and screens, doorways and tiered niches.[1] Everywhere this fussy elaboration of ornament broke up architectural surfaces, so that even vaulting was divided and subdivided by lierne ribs with bosses proliferating at every junction. One result of this growth of the art of the decorator was that sculpture became slighter, prettier, and less monumental, more concerned with minutiae than with overall impression. Moreover, the size of sculpture tended to shrink, with increasing emphasis on bosses, corbels, tomb-weepers, and similar minor fields. Of course, full-scale statuary was far from abandoned, as the expansion of the tomb effigies shows, but the bulk of the work was now on a smaller scale.[2]

Just as important as the change in the use and scale of sculpture was the change in style of sculpture itself. The aim of the thirteenth century had been to maintain a strong sense of the vertical, to enhance the dignity of the human figure and to assist the soaring impression of the architecture. The objective of the fourteenth century was entirely to supersede the straight line by an indefinitely repeated undulation, both in outline and in depth. In consequence, the two-centred arch was replaced by the contrapuntal sinuosity of the ogee; the rounded rhythms of the ball-flower succeeded the angularities of the dog-tooth as the prevailing ornament for arch-mouldings; the same S-curves were imposed upon the human body by the trick of *déhanchement*, a thrusting out of one hip counterbalanced by a return movement of the torso; the vertical folds of thirteenth-century drapery gave place to sagging loops and curving diagonal hems; foliage ornament was reduced to a series of bossy undulating leaves with sinuous edges, a somewhat monotonous stylization of naturalistic oak-leaves. Mouldings were made shallower, to soften the lines and provide a rippling effect, and window tracery created flowing patterns composed of soft curves; in York chapter-house the wall itself was given an undulating surface by the projections of the canopies over the stalls. Such straight lines as survived, the edges of pinnacles and of gables that topped the ubiquitous niches, were weakened by rows of rippling crockets spreading out and running up towards the apex, where in the thirteenth century they had been small and compact and had curled back earthward and so did not disguise the nature of the line.

This passion for undulating decorative rhythm owes little to foreign influence and is essentially an insular development. It is true that *déhanchement* was probably most actively developed by French ivory carvers, whose cold, light-absorbent material encouraged the artist to achieve his effect by such distortions. It is also true that undulating foliage appears in France by about 1275, a generation before it spread to England.[3] But in France these

were not developed, combined, and joined with ogee arches and reticulated or foliate tracery to form a distinct style pervading the whole range of visual arts. The lead in giving decoration so important a role in architecture was due to a royal taste for ostentation, perhaps encouraged in King Henry by his artistic administrator and adviser, Edward, son of Odo the goldsmith. Indeed the role of the goldsmith becomes more and more obvious, when it is recalled that the focal point of every great church, the objective of all pilgrims, was the shrine of the local saint. Studded with jewels and encrusted with gold and silver ornament, these shrines were the natural victims of the financial needs of the Renaissance monarchy; their total destruction by Henry VIII has irreparably distorted our vision of medieval art, of whose most expensive products we now know nothing.

But imitation of the work of the goldsmith to satisfy a royal taste for splendour cannot account for the growing English desire to adorn and embellish. Essentially it marks a recrudescence in yet another form of that deep-rooted insistence upon linear patterning that has so repeatedly been observed. This is also at the bottom of the desire for indefinitely repeated undulation. Although this undulation soon took on spatial qualities with such features as the nodding arch, its principal characteristic was a determination to impose a pattern in which the predominance of the double-curving line recalls a like tyranny in dark age Celtic art. This is not to suggest that there is any connexion between the two – of which there is no sign – but merely to point out a similarity of stylistic purpose.

Finally in figure-work there was an end of that inner tension, that sense of strain that in thirteenth-century sculpture found its expression in the remote intellectualism of the faces and the taut spring and nervous dynamism of body and limbs. The objectives of the fourteenth-century sculptor were an easy, relaxed grace, a sensuous expression, and avoidance of the stern verticality of the thirteenth century. Standing figures sway and bend as the York Virgin (Plate 116A), or move about and chatter, like the John of Eltham weepers (Plate 123), and seated figures twist their knees to one side or cross their legs, as at Exeter (Plate 138A). The half-turned body and the three-quarter profile for a time become very common, and considerable skill is displayed in dealing with the consequent problem of foreshortening. Draperies undergo radical changes both in nature and treatment. The stern vertical folds that dominated the thirteenth century give way to drooping ridges, to strong diagonal hems, and to cascades of voluted cloth to emphasize the eccentric pose of the figure. The flowing cloak of standard female dress is converted into a sort of huge shawl thrown around the shoulders and giving the curved horizontal lines that were desired. In men's attire the element of fantasy, so common in the early fourteenth century, emerges with trailing liripipes hanging from the caps, sleeves that touch the ground, and shoes whose ends are extravagantly prolonged; at the same time tights and short cloaks give greater variety and interest to the treatment of the body. The result, most obvious perhaps in the weepers of the John of Eltham tomb (Plate 123) or the Hastings brass (Plates 126A and B), is a modish and jaunty attitudinizing that is far removed from the stately grace of the thirteenth century. In part this is a reflection of a new moral outlook, resulting from the growth of sentiment, and even of sentimentality, both cause and effect of the popularity of such *romans* as that of Tristram and Iseult.

The element of fantasy plays a large part in early fourteenth-century English art. In

architecture it can be observed in works as different as Saint Augustine's, Bristol, the octagon at Ely, and the spreading palm vault of Wells.[4] Most firmly entrenched in the west country, it was responsible for a remarkable development of the Westminster canopy system which resulted in a dizzy three-dimensional frame of openwork struts and pinnacles, whose finest surviving achievements are the wooden bishop's throne at Exeter and the stone canopy over Edward II's tomb at Gloucester.[5] Despite the use of the nodding ogee arch, these western canopies are lean and spiky, with little of the rich sinuosity of northern work. It is such local differences of interpretation of an identical mood of restless experiment that give early fourteenth-century English art its wide variety and its refreshing sense of freedom from convention.

In sculpture this sense of fantasy is perhaps less noticeable than in architecture or in the irreverent inventions of East Anglian manuscripts. One remarkable example is the substitution of a row of little sleeping angels for the usual crockets on the canopy over a tomb attributed to Bishop Mortival at Salisbury. The doorway from the cloister at Norwich, whose date is probably about 1310,[6] provides another excellent example of the refusal of sculpture to be integrated in the architectural frame (Plate 127). Here there is none of the majestic flanking statuary and massive tympanum of the Lincoln porch half a century before. The arch of the door is of four orders with deep ribbed mouldings. But set across these ribs and hollows in a radiating pattern are seven small figures beneath arches alternately gabled and ogee. The figures and their arches are carved out of the same blocks as the voussoirs, so there is no question of a later addition. What is extraordinary about this arrangement is its contempt for architectural lines and its use of sculpture as irrelevant *appliqué* ornament. But this siting of the sculpture across the mouldings is perhaps not so surprising as the emergence of the figures from their frames. The angels' wings spread out over the arches so that these no longer act as surrounds but serve as a backcloth for the emancipated little beings that move in the free space of the foreground. This stepping out of the frame, which was also noticeable in the carvings of naturalistic foliage some twenty years before, is a symptom of a more adventurous attitude towards the problems of space.

It is tempting, though perhaps dangerous, to probe for the psychological causes of these stylistic changes in the political, social, economic, and intellectual background of the early fourteenth century. It is becoming increasingly evident that the beginning of the economic decline of the Middle Ages is to be sought not in the cataclysmic event of the arrival of the Black Death in 1348, but further back in the reign of Edward II, when for the first time in well over a hundred years rents in many areas began to decline, the profits of high farming decreased, and the population may have begun to fall. Perhaps associated with a change in climatic conditions in northern Europe and resulting periodic famine, the decline of the economy was further accelerated by the increasing pressure of war taxation and royal manipulation of currency and trade in the interests of war finance. At the same time the roots of the later highly unstable social and political system known as Bastard Feudalism are to be sought in the military organization of indentured retinues which developed at this time. If material conditions of life gave cause for anxiety, the intellectual aspects of the time show similar tendencies. The most recent student of medieval scientific thought and learning has concluded that the fourteenth century was

'a period of unusual fermentation, of liquidation and chaos, and this becomes even clearer if one compares it with the thirteenth century, which was in many respects [not by any means in every one] an age of synthesis, of faith, of relative stability. In contrast, the fourteenth century is an age of incipient doubts, of restlessness and rebellion.'[7]

Attractive as is the association of the style of early fourteenth-century England with these material and intellectual developments, the thesis is rendered improbable by the failure of French art to follow any such trend to more than a very limited extent. Though admittedly softer, prettier, more sensuous than thirteenth-century work, it rapidly became absorbed in the most rigid of iconographical and stylistic conventions, a fate which was not to overtake insular art for another fifty years. Thus whereas the French development was towards a facile sterility, that of England was in the direction of a reckless use of rhythmical surface decoration, imaginative use of grotesques, and an extravagantly mobile figure style. In consequence, it is perhaps safer to describe this evolution as one more result of certain innate tendencies towards dynamism, fantasy, and linear abstraction that have been repeatedly noted as persistent undercurrents in English art.

<p style="text-align:center">★</p>

The most convincing evidence of the strength of the new stylistic influences is the speed with which the court artists succumbed, despite their conservative traditions. The change is best illustrated by a comparison between the tomb of Edmund Crouchback, of about 1300, and the next addition to the Westminster mausoleum, that of Aymer de Valence, Earl of Pembroke and cousin of the King, who died in 1324. The general layout is the same with a military effigy set on a high tomb, the sides of which are decorated with weepers within gabled niches, while above towers the same flat-faced canopy with pinnacles and a crocketed central gable enclosing a trefoil relief of a mounted horseman. But this superficial similarity of construction imperfectly conceals a profound change in style and treatment. On the tomb-sides the shields in the spandrels have given way to cusped *oculi*. The main arch of the canopy has retained its old two-centred shape, but the cuspings are bold and prominent ogees. The foliate decoration in the spandrels and of the crockets is now mostly, though not entirely, composed of the undulating bubble-leaf, and the line of the gable has been smothered by the creep of the leaves of the crockets on the outside, which meet a row of little rosettes running up the internal soffit. The pinnacles are shorter, the finial of the central gable no longer stretches up but spreads out in fat side tufts, and the extremely narrow side gables have vanished altogether. As a result the canopy ceases to reach skywards, and rests firmly and solidly earthbound.[8]

The effigy itself shows least change from the Crouchback model, the style and attitude being almost identical save for changes in military costume, such as the shortening of the surcoat and the employment of metal attachments for the scabbard instead of leather thongs.[9] But the Earl is now laid flat, instead of turning slightly to one side, thus actually decreasing the impression of mobility, although the body is more carefully modelled and the stomach bulges prominently, a feature that will also be found in allied sculpture at Aldworth, Berks.[10] Another difference is that the angels at the head no longer hold the pillow, but assist a tiny half-draped *eidolon* as it mounts to heaven, a concept symptomatic

of the growing arrogance of the laity in its dealings with the problems of religion.[11]

If the effigy is on the whole conservative, the weepers and the horseman in the spandrel both display the new trends. The draperies of the former have few, highly polished parallel folds that are quite unlike the complicated arrangements of the graceful little figures from the Crouchback tomb. The male draperies no longer fall to the ground, but stop at the ankle, and the arms and hands are arranged in more varied poses. The structure of the body is visible beneath the tighter clothing, and it is significant that emphasis is laid upon the breasts and legs of the ladies (Plate 122B). The total effect, which before was stately and remote, is now pretty and even amorous.[12]

It is in the horseman in the canopy spandrel, however, that the new tendencies are most pronounced. That of the Crouchback tomb had been set off against a gilt surface, the horse stood quietly upon firm ground, the caparison hung smoothly over his back, and his rider gazed heavenwards in an attitude of prayer (Plate 120A). The elegant solemnity of the carving was only enlivened by the folds of the surcoat over the thigh and the bright heraldic painting. All the lines of the carving were either vertical, as the caparison folds, the horse's legs and head, and the rider's feet, or were horizontal, as the horse's back. The Valence relief is set against a carved diaper background,[13] and the horse's feet are perched precariously on two isolated tufts of rock as he gallops furiously across the picture (Plate 120B). The sense of unreality, of being detached from the rules of time and space, is enhanced by the mantling of the helmet which flies out not merely behind but also before, in utter defiance of reality. Found in contemporary East Anglian manuscripts, this remarkable head-dress appears to derive from the fillets of antique portraits, though here it is doubled to form a pair of fluttering drapery wings.[14] Equally distinctive is the manner in which the main lines of the carving are at a slant, the legs of the rider and horse and the hems of the caparison all running diagonally. The spiral folds round the thigh are more pronounced and the sinuous rhythm of the age appears in the triple undulation formed by the line of the horse's tail, back, and neck. Originally this little relief was brilliantly coloured. The horse's caparison and the rider's surcoat both bore the blue and white stripes and red martlets of Valence, the linings and the reins and stirrups were red, the plate armour on the legs was silver- and the knee, and elbow-caps, the gorget and helmet were all gilt.[15] Separated at most by thirty years, the difference between these two canopy carvings provides vivid evidence of the nature of the stylistic changes during the reign of Edward II. The close similarity of the general plan serves to emphasize a radical change of treatment which, despite both the vagueness and the irrelevant associations of the two words, can best be described as the substitution of the romantic for the classical approach.

The work of the court artists during the 30s may be studied in the tomb of Edward III's younger brother, John of Eltham, at Westminster, and the effigy of Edward II at Glouces-ter. In the latter the artist was obliged by his subject to seek an impression of solemn majesty. Horribly murdered in 1327, the King's body was finally accepted for burial by the Abbot of Gloucester, an act that can be interpreted as one of moral courage or shrewd far-sightedness. Three years later Edward III seized power by a *coup d'état* and set to work to foster a cult of his murdered father to rival that of Saint Louis, which had been skilfully

exploited by the Capetians, and also of Thomas of Lancaster, the increasing local popularity of whose sanctity must have been embarrassing to Edward, the son of his executioner. A first step in building up the reputation of Edward II as a saint was to provide him with a fitting monument, a work that was probably set in hand in the early 30s. The tomb itself and the canopy are in a mixture of local and London styles in Purbeck marble and local oölite. The local features are the towering three-dimensional construction of the canopy and the use of the nodding arch with little pointed cuspings, whose relationship to the Exeter sedilia of fifteen years before is evidently very close. On the other hand the gable within a gable and the battlemented strings are London features, and the mixture of stones appears to have been a favourite habit of London workshops.[16]

For the first time the court artists were using English alabaster. This is a special form of sulphate of lime found in Nottinghamshire and Derbyshire, translucent and white in colour, soft and easy to work, which if not exposed to the weather will preserve its smooth finish almost indefinitely. As such its rapid achievement of popularity in the second third of the century was only to be expected in view of the prevailing demand for the delicate execution of rich detail.

The head of the King possesses a haunting, magical quality of romantic refinement that once seen can never be forgotten (Plate 119). Here in this royal head are concentrated the outstanding features of early fourteenth-century English sculpture, the passion for undulation, the lack of stern masculinity and the hint of decadence, the close attention to detail and finish. Revelling in the possibilities of the new material, the sculptor has transferred into stone the illuminators' conventional representation of God.[17] For as yet, even in the effigies of kings, there is no sign of any attempt at genuine portraiture, which was only to emerge in England in the late fourteenth century. Above all, the predominance of undulating rhythm is given full play in the winding, artificial contours of hair, moustache, and beard, and the soft curves of the broad forehead, bulging eyebrows, and wide nostrils. The determination to avoid a straight line in either dimension is well brought out by the little roll of hair under the crown, which is deliberately twisted to one side as it curls over. Within this rolling mass of hair lies the calm, majestic face, whose chief characteristics are smooth flat cheeks without lines or prominent cheek-bones, pouchy eyes, and a mouth whose long drooping upper and thick undivided lower lip gives an impression of mild sensuality.

Built up of thick rounded stems like rubber tubing, separated by narrower stems and weaving in and out in profound sinuosities that repeat the pattern of the domed leaves at the top of the sceptre, the hair of Edward II provides the *locus classicus* of the undulating style of the early fourteenth century as applied to the human figure. The first beginnings of this hair style may be detected in some of the bosses of the Angel Choir at Lincoln, and its development as a general convention traced through the bosses of Exeter presbytery, the clerestory glass of Wells choir, and the corbel heads in the nave of Saint Albans, this last an unquestionable court work.[18] But the full exploitation of this hair style as a lush three-dimensional patterning is the work of this unknown London sculptor whose other products, such as the alabaster John of Eltham, show the identical trick of style in the manes of the lions at the knights' feet.

The similarity of Edward II's effigy to that of John of Eltham, and the association of both with the court style are proved by numerous details. Both combine the use of white alabaster and other materials, and both employ details such as cushions with little rose buttons; the facial type is very like, and the long fingers and large lions are identical. Moreover, the robes falling straight to the ankles in smooth vertical rolls, the forward-stepping posture and slight turn of the body of Edward II, all recall the weepers of the Valence tomb some ten years before.[19] Edward II's second son, John of Eltham, Earl of Cornwall, died in 1336, and since he was only twenty years old it is highly improbable that he had commissioned a monument for himself before his death. Furthermore, there survives a letter from Edward III the contents of which suggest that the tomb had not been erected before August 1339.[20] The canopy, which was destroyed in 1760,[21] and the arrangement of the side-panels both show strong signs of the rectilinear architectural tendencies that had been present in the London workshops as early as the building of Saint Stephen's Chapel in 1292. The canopy consisted of three equal arches with no trace of the ogee, the spandrels were filled with plain *oculi* and *mouchettes*, and the buttresses were stripped of most of their ornament. The only element which gave added complexity to the design was the siting of the buttresses askew, whereas in every other respect the canopy marked a return to a cold, academic precision of statement. In the same way, the side-panels are laid out with very strong emphasis on horizontal mouldings and vertical buttresses and arches. The arcade within which the weepers stand lacks capitals and gables, and is the simplest of frames set above a row of square panels enclosing shields. It is evident that the architectural designer of this tomb has abandoned the fussy decoration, the ogee and the emphasis on diagonal gable lines that characterized the Valence tomb, and is already moving towards the 'Perpendicular' decorative system of rectilinear panels that was to be fully developed in the second half of the century.

But if the design is a precocious academic experiment, the figure style of the sculptor himself shows no such modifications of the prevailing minute decorative fancy. This second experiment by London workmen in the new material of alabaster makes full use of its possibilities in the very elaborate treatment of the lion-head studs and the buckle of the sword-belt and the carving of the leopards and fleurs de lis on the shield (Plate 124A). The Earl wears the latest military costume of full plate armour on arms, legs, feet, and hands, and a tight-fitting surcoat cut away in front at the top of the thighs that is generally, if inaccurately, known as a cyclas. His head is turned to the left, his right leg is crossed over, and the whole body has a pronounced bend at the hips. The alabaster weepers (Plate 123) continue the development towards artificial mannerisms that was apparent upon those of the Valence tomb. Set off against a black composition ground,[22] the little figures with their dangling sleeves, twisted bodies, and long crooked fingers are grimacing and posturing with all the extravagant exaggeration of the ballet dancer; representing the aristocratic and royal relatives of the deceased, they are the quintessence of courtly artificiality.

There is some reason to suggest that one and the same artist was responsible for the weepers on the tomb of de Valence, probably the effigy of Edward II, and certainly that of John of Eltham, and for at least three other military effigies in freestone in the home counties.[23] It is evident that he was employed extensively by the court and indeed must

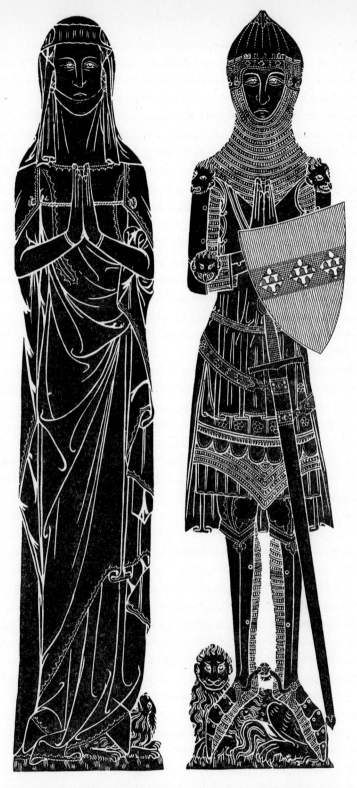

Figure 3. Brass of Sir John and Lady Creke. *c.* 1325–30. Westley Waterless, Cambs

have been the leading artist of the day. Unfortunately our knowledge of royal craftsmen of this period is somewhat limited, though we hear of a Master Richard of Reading at work on the sculpture of Saint Stephen's chapel at the palace in 1333.[24] But this is a totally inadequate basis for hazarding a guess at the artist's name, and we must be content with emphasizing the great importance of the anonymous 'Master of the effigy of John of Eltham', who dominated the court between 1325 and 1340 in the same way that his predecessor, perhaps Alexander of Abingdon, had dictated style between 1290 and 1315.

Early in the century the metallurgical industry of Europe began to make possible a revolution in military equipment that would restore to the mounted knight the superiority in battle that he was in danger of losing to the archer with his powerful long-bow. The industry that could produce large sheets of latten for monumental brasses could obviously also manufacture sheet-iron for protective purposes. The first thirty years of the fourteenth century therefore witnessed a series of somewhat bizarre experiments in combining plate armour and chain mail, until by the middle of the century the knight emerged encased cap-à-pie in a close carapace of plate. This evolution is best studied in the line engravings of brasses in which the most minute details of costume are preserved, whereas much of the gesso finish of effigies has disappeared. A good example of an early phase in the transition is the brass of Sir John and Lady Creke at Westley Waterless, Cambs (Figure 3). The armour of Sir John is slightly earlier than that of John of Eltham and probably dates to about 1325 to 1330. The brass, however, is not a court work, for the small-headed lion, the lady's drapery with its little voluted folds trailing on the ground, and the heavily cusped ogee canopy bear little relation to Westminster tombs. On the other hand, the calm, frigid elegance, the elongated bodies, the perceptible asymmetry of pose, the slight turn of the head represented by a profile stroke for the nose, are all strongly reminiscent of the court style. The probability is that this is the product of a London artist inevitably influenced by the royal workmen, but not one of them.

A more complicated relationship with the court is provided by what is with little doubt the most accomplished and aesthetically successful of all surviving brasses, that at Elsing, Norfolk, commemorating Sir Hugh Hastings (Plates 126A and B; Figure 4).[25] Its complicated manufacture, vivid colouring, minutely engraved detail, and violently mobile figure style mark the highest point of early fourteenth-century English rococo. Sir Hugh, who rebuilt the church in which he rests, possessed strong aristocratic and court connexions and was a distinguished military leader in the early stages of the Hundred Years War. He died in 1347, and since his only known link with some of the weepers is joint participation in the Gascony campaign of 1345–6, the brass must have been cut later, and probably posthumously in 1347–8.[26] The present condition of this brass, mutilated and lacking all colour, bears no relation to its original condition.[27] All the armour of Sir Hugh was gilt, the coats of arms on the surcoats were brilliantly coloured, the engraved lines were filled with variously coloured pastes, the backgrounds to the weepers were also coloured, and the shields, the piercings of the canopy, the openings above the gables of the side supports were all filled with glass. It is very unlikely that the heraldic details of the shields were themselves composed of coloured glass, as has been suggested. The more probable

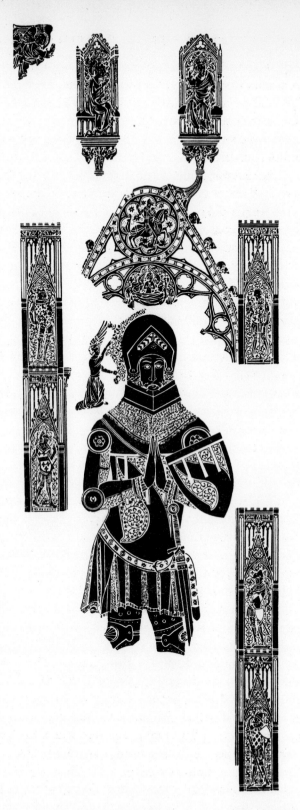

Figure 4. Brass of Sir Hugh Hastings. *c.* 1347–8. Elsing, Norfolk

explanation of the glass is provided by an account of the long-vanished decorations of the early fourteenth-century wooden effigy near by at Fersfield. Here also the chain mail was gilt all over, and 'severall embellishments were gilded on a cement and let into the wood in several places ... and then covered with glass.'[28]

Numerous scholars have studied this brass but have disagreed as to whether it is a product of the English court artists or a foreign import.[29] The truth appears to be that it is an English court work, the swan-song of a great tradition, but that the artist was strongly influenced by some continental brasses that he had seen. There are a series of foreign brasses, mostly in East Anglia and of the 1360s, which are part of a large group of Flemish origin. Of these the most famous is the Braunche brass at King's Lynn, and it is by comparison with this series and others on the Continent that the degree of foreign influence may be assessed.[30] The system of displaying an elaborate iconographical scene in the upper section of the brass, in this case a Coronation of the Virgin, is unknown to England, but common abroad. The naked soul being swung up to Heaven in a sheet by two angels was certainly employed by the court artists of the Aveline and the Valence tomb, but it is also an almost invariable feature of foreign brasses. The single, highly decorated octagonal cushion and the elaborate scrolls and patterns on the backgrounds to the weepers are certainly unknown in English brasses, though the latter are common enough in contemporary manuscripts and stained glass.[31] Finally some details of the armour, such as the heart-shaped shield of Saint George and the hanging of Lord Stafford's shield by his thigh, are never found in English brasses.

But these borrowings are insignificant in comparison with the basic English elements. The trick of pushing gables up into a traceried background filled with coloured glass, the use of ogee cuspings, the horseman in the spandrel, the supporting brackets springing out of the main gable, are all accustomed features of the Westminster tombs. Equally conclusive is the style of the effigy and weepers whose *déhanchement*, vigorous jerky movements and extravagant gestures are obviously connected with the earlier work of the London school, which in manuscripts produced the Treatise of Walter de Milemete and in sculpture the weepers on John of Eltham's tomb.[32] Nothing even approaching this vivacious style can be found in any continental brass or engraved slab.

But it is not only the court style which has influenced this brass, but also the art of the East Anglian painters and illuminators. Particularly close similarities can be found with the retable now at Thornham Parva, Suffolk, a work of about 1320–30 and probably executed for one of the Dominican houses in East Anglia.[33] The elaborate backgrounds and the detail of the scalloped line around the inside of the haloes are both found on the retable. Making allowances for the difference in costume between saints and knights, the figure style is also very close: thus Saint Edmund is pointing to his arrow exactly as Lord Stafford to his lance on the brass (Plate 126B), a gesture which has lost all significance in translation from saint to soldier. A further feature of considerable interest is the complicated perspective drawing of the niches and seats for Christ and the Virgin. This shows a sense of the three-dimensional that is very early evidence of the influence of Trecento Italian painting (Plate 126A). Nothing like this perspective drawing can be found in the surviving East Anglian manuscripts in which this influence was most evident, and it

is perhaps significant that it is a court work of the 50s, the painting in Saint Stephen's Chapel, Westminster, that provides the closest English parallel.[34]

<center>★</center>

Of the local workshops of southern England during the early fourteenth century, the most distinctive was that of Abingdon, which we may assume was responsible for the series of effigies at Aldworth, Berks, of various members of the de La Beche family. The earliest, of a lady, is extremely close to the effigy of Countess Aveline at Westminster of about 1300, and may well be the work of Alexander of Abingdon himself. Most of the rest date from about 1320–40 and have strong common characteristics, such as thick bolsters into which the head sinks, protuberant stomachs, and the relaxed postures of the court style. But one knightly effigy, whose armour suggests a date in the 1320s, is revolutionary in treatment (Plate 121): he is leaning on his elbow with his legs crossed, and an attendant at his feet. The semi-recumbent posture, found in an even more dramatic effigy in wood at Chew Magna, in Somerset,[35] is taken from manuscript paintings of Jesse at the base of the Jesse Tree, or of the soldiers sleeping beside the tomb of Christ as he rose from the dead.[36] The former scene occurred frequently in psalters and thence spread to stained-glass windows and sculpture. The latter achieved equal popularity at just this period, owing partly to its repetition in psalters, and partly to the annual rubrical ceremony performed at Easter in which a symbolic representation of this episode was enacted against a painted or carved backcloth.[37] The Easter Sepulchres of the north and east and the effigies at Aldworth and Chew Magna are thus all symptomatic of two important elements of fourteenth-century life, religious play-acting and the illumination of psalters mainly for the use of aristocratic laity. The adoption of a semi-recumbent position for memorial effigies is a sign of the brief romantic phase of English art from 1320–50, and was an innovation that was to win no permanency. In part, of course, this was due to the fact that only an artist of considerable technical accomplishments was capable of executing in stone so complex a study in human form. It was not a design that lent itself to the shop methods which were to dominate English sculpture in the second half of the fourteenth century. The habit of turning the effigy into a participant in a living charade by the addition of human attendants was equally of brief duration. It may be regarded as a sign of the intense desire for life and movement that is the characteristic of English art of the second quarter of the century, and perhaps also as evidence of an equivocal attitude to religion and death. Pagan tribes used to slaughter horses and servants to accompany their dead chieftains to their graves; on a tomb at Exeter of about 1320, the knight is accompanied by his squire standing at his head, while a groom holds his horse at his feet; at Minster, Kent, Sir Robert de Shurland lies on one side upon his shield gazing upward, an attendant lies at his feet, and at his side protrudes the head of his horse, a symbolic representation of the whole animal;[38] here at Aldworth, a servant squats at one end of the tomb holding in his lap his master's foot.

The apogee of romantic tomb design occurs some years later, in about 1340, in Norfolk, where there are two related memorials to Sir Roger de Kerdeston at Reepham and to Sir Oliver Ingham at Ingham (Plate 124B). The latter lies on a bed of blue pebbles and is

<center>167</center>

portrayed as if suddenly aroused from sleep: he is rolling over on one side, one hand clutching at his sword and the other crossed over the body and resting on the ground to help him to leap to his feet. The cyclas was emblazoned with the Ingham arms, the plate armour was either gilt or black, and against the back of the tomb was painted a forest in which roamed wild animals pursued by bowmen.[39] Behind Sir Roger's head a pair of angels hold his great tilting helm with its pale green and deep blue mantling and its gilded crest. The use of angels, no longer to raise a soul aloft to heaven but to act as pages to hold a tilting helm, provides a revealing commentary on the growth of a confident self-assertion in face of the supernatural.

The Reepham tomb, whose details of costume and armour suggest a date some five or more years later, still retains the old court design of the flat arch and gable with *oculus* within, the buttresses and pinnacles, and the traceried panelling behind the gables. But the growth of Perpendicular architectural design has forced an awkward compromise upon the artist, by which the finials of the gables poke up well above the strong horizontal lines of the top of the traceried panels.[40] Already the warm luxuriance of the early fourteenth century has passed its peak, the ogee is on the retreat, and the design, both in conception and in detail, has an unfamiliar air of cold precision. The weepers have little of the grimaces and absurd gesticulations of those of John of Eltham. They are now genuine mourners in sober attitudes of grief tempered by fortitude, each with an individuality of his own in costume and in position. This lively and imaginative monumental art in stone and brass of the second quarter of the fourteenth century provides a complete contrast to the sterile monotony of effigy sculpture and engraving in France, where the wooden frontal style with bare head and hanging sleeves was indefinitely repeated.[41] After their close French connexions of the late thirteenth century, English artists have now broken right away to form a distinctive style of their own.

<p style="text-align:center">★</p>

None of these local styles can be called the product of a 'school', since there is no sign of the dominance of all the work of a given area by a single workshop with well-defined peculiarities. Neither the Aldworth effigies nor these two Norfolk tombs are more than isolated sculptures. In east Nottinghamshire and Lincolnshire, however, it is clear that a prolific group of masons working in Ancaster stone was responsible for almost the whole artistic output for over forty years. Before the turn of the century it was evident that the tendency of the sculpture of the Southwell chapter-house was towards small-scale carvings treated as *appliqué* ornament. It was to the development and decoration of flat wall screens that these early fourteenth-century masons principally devoted themselves. At Lincoln and Southwell there was a demand for a screen to separate the laity from the clergy; in smaller churches patrons were induced to spend their money on sedilia and Easter Sepulchres, which latter became one of the most popular of this workshop's products. These were designed to serve as repositories for the consecrated host from Maundy Thursday to Easter Day, a function served in most churches by a temporary wooden scaffolding draped with cloth. The earliest of these, dating from the 1290s, is at Lincoln Cathedral, where a simple canopy rises over a flat tomb with relief sculpture of the three

sleeping soldiers let into the side. Some twenty years later the school had evolved a fully-fledged style which may be studied in the detail of the choir at Heckington, Lincs, in the Easter Sepulchre in the same church, and in the sedilia at Hawton, Notts. The exterior of Heckington choir is remarkable for the extraordinary richness of ornament in which gargoyles, corbels, openwork wave parapets, cornices with foliage tufts, crocketed gables, and standing statuary smother the architectural surfaces like the decorations of a wedding cake. The Easter Sepulchre is a flat screen of complex and obviously experimental design surrounding a small aumbry for the host. The whole available wall surface is covered with a carpet of figure sculpture in relief and shallowly carved, seaweed-like foliage. The ogee arch is not used except for minor cuspings, and the crockets are of high-domed leaves set well apart. Large human and animal heads are freely employed as label stops, and along the cornice are a row of musicians. A new feature is the employment of a wave parapet built into the body of the screen. This design, so characteristic of the prevailing undulating rhythm, was in common architectural use in south Yorkshire, as at Selby, and in Lincolnshire, as at Boston and Heckington itself.[42] But its use in a diagonal band on the flanks of a screen appears in a court work, the obverse of the Great Seal of October 1327, and is probably evidence of the pervasive influence of London.[43] It cannot be claimed that the figure sculpture of this school was of a very distinguished order. At this fairly early stage it was based on French-inspired London manuscripts and ivories, and the relief panels at Heckington containing the angel and the three Marys at the tomb reproduce in a slick manner the *déhanchement* and the shawl-like draperies of its models.[44] The long-eared grimacing heads with flame-like hair that serve as label stops, and the positions and equipment of the sleeping soldiers below are both to be found in East Anglian manuscripts.[45]

Later on, by about 1330, the purely ornamental purpose of the artists became still more highly developed, as in the reredos at Heckington and the Easter Sepulchre at Hawton. The ogee is now used exclusively both for arches and for cusping, and the florid foliage spreads out like a weed, lapping over the main buttresses and enveloping and obscuring the line of the gables (Plate 125). Shallow foliage scrolls and diaper form the background to the sleeping soldiers below and to the Resurrected Christ above. Even the cornice disappears beneath a mass of billowing cloud from which emerge angels bearing scrolls. Signs of the growth of Perpendicular architectural design can be discerned even within this essentially Decorated work. The finials of the moulded buttresses had hitherto been composed of two short side leaves and one long central leaf, and so had retained the thrusting verticality of their origin, even if they now stopped short at the top of a horizontal cornice. At Hawton, however, all three leaves are of the same size to form a flat line at the top, thus destroying all sense of upward pressure. As for the figure sculpture itself, the crowd scene of the Ascension in the upper level is dissolved into the general effect of sprawling ornament. The sleeping soldiers display a genuine attempt at realism in their expressions (Plate 128B), and it is evident that the English sense of caricature, so pronounced in the contemporary East Anglian manuscripts, has modified the dignified and graceful slumbers of the soldiers at Lincoln and Heckington.[46]

Soon afterwards sculptors from this prolific school were probably drawn south to work on the elaborate screenwork in soft Burwell stone that runs all round the three sides of the

Lady Chapel at Ely. The foundation stone of the Chapel had been laid as long ago as 1321, but the almost immediate collapse of the central tower of the Cathedral and its subsequent reconstruction evidently put a temporary stop to further activity. Surviving accounts are silent upon the progress of the Chapel, though it is said to have been completed before the death of John of Wisbech in 1349.[47] It seems likely therefore, and stylistic evidence supports this view, that the carving of the screenwork was carried out in the late 30s and the 40s.

But if the general plan of a richly decorated screen with cusped and crocketed, nodding ogee arches and figure sculpture in the spandrels owes something to the Ancaster crafts-men, and if the battered remains of the statuary suggest that some of the same workmen were employed – indeed it is difficult to see whence else they could have been drawn – there is no doubt that the master-mason was not a Lincoln man. The buttresses follow the court pattern of a square section ornamented with tracery and battlements instead of the moulded form of Lincolnshire; the parapet repeats the square design of the base of the Eltham tomb at Westminster, instead of the wave pattern of Lincolnshire, and the decoration of the background of the relief sculpture is almost entirely in the old London rose diaper, and not the shapeless sprays of foliage that were popular further north. The intention of these now badly mutilated sculptures was to tell the apocryphal story of the life of the Virgin, and the scenes were based on a series of local illuminated manuscripts.[48] Indeed in their original painted condition these small-scale carvings must have given an impression very close to that of the pages of an illuminated manuscript of the time with their clusters of tiny pictures.

Further to the west, in the Banbury area of north Oxfordshire, there flourished another local school indulging in the same use of small-scale figure-work for architectural orna-ment. A series of churches in this area were decorated in the 1320s and 30s with elaborate cornices bearing friezes of musicians, animals, and grotesques drawn from the common babewyn repertory of the day.[49] The best-executed of the series is that at Adderbury, Oxon, where human beings playing musical instruments, composite creatures with human heads and animal bodies, fantastic dragons, and other figures are strung together with no possible intellectual plan or purpose. Elsewhere, as at Brailes (War.), there is the Lincolnshire wave parapet above and rows of monotonous human heads below. The same carver also adopted a unique form of capital with human heads, which was first developed in the thirteenth-century nave at Woodstock, Oxon. At Hanwell, Oxon, the nave capitals are decorated with large busts carved in a smooth, confident, but undis-tinguished manner that is characteristic of all the work of this school (Plate 128A). At Oxford itself the most important work was the spire of Saint Mary's, of the 1320s or 30s, whose multiplicity of gargoyles, corbels, and over-decorated niches is the local equivalent of the exterior of Heckington, Lincs.[50]

<p style="text-align:center">★</p>

It was the south Yorkshire sculptors in Tadcaster stone who pushed the florid tenden-cies of mid fourteenth-century art to their highest point. After about 1320 the local output of effigies declined markedly in the north, and all but died away completely.[51]

Attention evidently shifted to the decoration of the great architectural undertakings at Selby, Howden, Beverley, and York. If the carvings in York chapter-house had shown a development of the style of Southwell, it was at Beverley that the most impressive and best documented progress was subsequently made. Owing to the Scottish wars, royal visits to this northerly region suddenly became frequent, and the proven efficacy of the Banner of Saint John of Beverley in affording supernatural assistance in battle against the Scots led to increasing royal interest in Beverley itself. To exploit this growing popularity the chapter began plans for an elaborate shrine to house the relics of Saint John. In 1292 a London goldsmith, Roger of Faringdon, was commissioned to do the work, and it was still in progress thirteen years later. This enormously expensive piece of metalwork with its columns and canopy, pinnacles and images has utterly vanished, but its existence as the focus of attention and as a model of inspiration for the local stone-carvers must constantly be borne in mind.[52] In 1308 work was begun on rebuilding the nave, financed by professional itinerant collectors operating all over the north and East Anglia. The label stops of the arcade of the north aisle, which was built after that of the south and probably in the mid 20s, have the same air of realism as those of the York chapter-house. A bagpiper (parts of whose pipe and hands are restorations) shows the gouged irises of the eyes that derived from the carvings at York chapter-house, and became a distinctive feature of the Beverley workshop (Plate 130A). Documentary evidence proves the altar screen to have been in the course of erection in 1334,[53] by which time the artists had fully developed their style and their technique. The treatment of the same theme of a bagpiper well illustrates their superb *panache*, their exuberant if slightly coarse vitality, and their smooth finish (Plate 130B).[54] A boss from the same screen repeats that very familiar medieval design, copied from the antique, of the human head lapped in foliage growing out from its mouth and ears. Whether in fact that theme had any genuine significance, symbolic of the pantheistic ideas embodied in the May day ceremonies, is very doubtful, for its popularity can equally well be explained by its pictorial possibilities. This Beverley head goes as far as possible to reduce the human and the vegetable elements to a common pattern of undulating forms (Plate 131A). The moustache, beard, and hair are even more stylized variants of the rubbery coils of Edward II (Plate 119), the cheeks and nose form more smooth convexities, repeated again in the rounded cups of the acorns and the rippling of the oak-leaves. Other bosses are purely abstract studies in which, for example, a pair of leaves are made to captivate the eye with their carefully veined and deeply undercut rippling and bubbling movement (Plate 131B).

Almost immediately upon completion of this screen and the staircase leading to the rood loft above it, the same artists began work on an abutting structure, generally known as the Percy Tomb (Plate 132A). This was probably not a tomb at all and almost certainly had nothing to do with Lady Eleanor Percy, who died in 1328, and with whom it is generally associated. It is far more likely to have been an Easter Sepulchre erected at the expense of Lady Idoine Percy,[55] and its completion must certainly be subsequent to the adoption by Edward III in 1340 of the arms of France quartered with those of England, since one of the knights in the spandrels carries the new arms (Plate 133B). The design is an interesting combination of northern and southern elements. The angels standing upon supports

springing out of the gable were derived from the Westminster tombs, the nodding ogee arch topped by a sculptural group and backed by a straight gable was taken from the Ely Lady Chapel, and God the Father receiving the naked soul swung upwards in a sheet was both a London and a north French motif. Also derived from London, possibly via Ely, were the flat buttresses with tracery and battlements. But the multiple ogee cuspings, the plethora of deeply undercut figures, and all the details are thoroughly Yorkshire, so that the final impression is one of a supreme achievement of this northern school, rather than of a borrowing from the south. Iconographical details such as the fight between the lion and the dragon repeat the themes found forty years earlier in the York chapter-house.[56]

The master-sculptor is now even more recklessly extravagant in his handling of human and vegetable themes. Absorbed in the technical pursuit of undercutting, dazzled by his own virtuosity, his detail such as the royal shield (Plate 133B) and the knobbly fruit and leaves that form the gable crockets reaches a pitch of elaboration that has rarely been surpassed in the medium of stone. Similarly intensified is the search for dramatic effect. The stems of the foliage are deeply undercut and the leaves now blown up in many-veined bubbles, the smaller figures are scowling, grimacing, and twisting their arms and legs in the violence of their emotions (Plate 133A).[57] At the supreme moment, however, the artist's nerve failed him. Topping this baroque extravaganza is a carving of God the Father receiving the naked soul which, for all its sensitivity and accomplishment, is somewhat insipid by comparison with the pulsating energy of the minor sculptures.[58] This is significant since it illustrates the limitations of these northern craftsmen. Like most early fourteenth-century artists, they excelled in the small-scale and the trivial, the grotesque and the pretty, but were often at a loss when faced with a theme of divine or tragic significance. An exception to this generalization is the face of the effigy of Edward II.

It is impossible not to be impressed with the strong family resemblance between these Beverley carvings, from the nave arcades to the Percy Tomb. It indicates the dominant role of a single individual whose style evolved over a period of some twenty-five or thirty years. But there is nothing to show that he was a man of national reputation, and with the exception of the carvings in York presbytery other sculpture in Yorkshire shows little connexion with Beverley. The stiff figures standing on the parapet of the clerestory at Selby form a conceit that is very characteristic of this adventurous Yorkshire school,[59] but stylistically they have none of the florid luxuriance of Beverley.

<p style="text-align:center">*</p>

In the south-west the main centre of activity continued to be at Exeter, where earlier than anywhere else in the country there appeared the first intimations of the effete languor of the mid fourteenth-century style. The choir corbels, perhaps the work of William of Montacute and carved before 1308–9, already show the undulating foliage, puffy faces, fat necks, bulging hair, and sentimental attitudes that were to replace the aristocratic refinement of the thirteenth century. In the second decade of the century attention was concentrated upon the fittings of the presbytery and choir, and it was not till 1326 that the energetic and cultivated Bishop John de Grandisson began pushing ahead with the

reconstruction of the nave.[60] Purchase of scaffolding in 1326 marks the beginning of the work, in 1334 accounts were finally settled with William Canon of Corfe for the Purbeck marble pillars, and in 1338 large quantities of timber were bought, presumably for the roof. It therefore seems clear that the main building work, excluding the stone vault and the western screen, was complete by 1342,[61] and that the great corbels of the nave must be dated to the middle 30s. They show alarming signs of the deterioration of the art of sculpture in the south-west in the previous thirty years. The deeply cut foliage of the presbytery corbels (Plate 106B) has given way to a shallow carpet of ungainly and untidy bubble foliage that presses in around the figures (Plate 129). The Virgin's drapery envelops the body like a sack and the face is wooden and expressionless. Sensitivity and vitality had evidently departed from the Exeter workshop at least as early as 1335. The gallery set over the aisle by the north porch, probably designed to hold a pair of organs, is an integral part of the building and not an addition, and must therefore also be dated to before 1342 (Plate 128C). The angel musicians set in niches along the side of the gallery display the same coarsening of style. The figures are shorter than before, the details of hands and features are clumsily treated, and hair is becoming a fuzzy, wig-like frame to the head. A noticeable feature of these carvings is the shape of the heads, which are nearly oblong with thick necks and chins and very high, domed foreheads.

This dolichocephalic type reappears in a group of ivories made for Bishop Grandisson, whose arms are carved in the spandrels. One ivory now in the British Museum is a triptych with the Coronation of the Virgin in the centre flanked by Saints Peter and Paul, an arrangement that was also that of the sculpture of the main altar reredos at Exeter.[62] The second triptych is of importance since a disproportionately large panel of the Virgin and Child is evidently based on a Sienese painting. Though the goitrous necks of the Virgin and Child are a local feature, this ivory panel is none the less evidence of direct Italian influence on English art of the 1340s. The painting may either have been acquired by Grandisson when he was at Avignon, or have been bought in England, for this is not the only evidence of the high respect with which Italian works of art were regarded.[63] The third surviving ivory bearing Bishop Grandisson's arms is a diptych, one panel of which, now in the British Museum, shows the Annunciation above and below the Bishop's name-Saint, Saint John the Baptist (Plate 135). The Annunciation has now taken on the complex iconographical trappings that it was to retain for the rest of the Middle Ages: the lily, the dove, God the Father in the clouds, and the scroll in the hands of the angel. The Saint John is realistically portrayed with shaggy hair and dressed in skins, and stands in front of a waist-high earthen rampart, a common mid-century trick that was an unsuccessful attempt to give a sense of depth to the background.[64] Upon this background are growing two trees, the one withering away with the axe hard to its roots and symbolizing the Old Law destroyed by the message of Saint John, the other the flourishing plant of the New Law. In view of the international contacts of Grandisson, he might have employed artists from anywhere in western Europe. But the use of the depressed ogee proves these ivories to be English, and the firm, unsentimental style is unlike that of the French or Italian ivory carvers. Indeed there is reason to think that the ivories may be the work of west-country artists. The huge domed heads are similar to those of the musician's gallery, and the tiny

lines in the corners of the eyes and wrinkles on the forehead are found in a more primitive form on a corbel in the church of Ottery-Saint-Mary, Devon, built by Bishop Grandisson between 1337 and 1342.[65]

In the west the most important event was the redesigning of the choir of Gloucester in the 1330s as a suitable resting place for the remains of Edward II. A combination of emphasis on vertical and horizontal lines resulted in the first full experiment in Perpendicular architecture. This style slowly affected the screenwork of the area, to judge from the tomb at Hereford of Peter, Lord Grandisson, the Bishop's brother, which from the details of the armour, in particular the cyclas, is unlikely to be much later than 1350.[66] This is an essentially rectangular structure, the ogee arches above the niches in the upper portion appearing as awkward and alien excrescences.[67] The representation of the Coronation of the Virgin that filled the two centre niches has survived, though now headless, to give some idea of the figure style of this area (Plate 134B). The drapery is treated with heavy, broken surfaces devoid of any sense of pattern. Only the trail of drapery over Christ's right arm recalls the conventions of an earlier period, for example the court school ivory of thirty years before (Plate 104). The only trace of little voluted folds is to be seen immediately under the left wrist of Christ. How far this style was typical of the west we have no means of knowing, since this Hereford sculpture is an isolated piece without parallels in the same area. But it has obvious connexions with the Grandisson ivories and the Exeter gallery in drapery style, body structure, and details like the projection of the feet of the figure over the edges of the frame. The loss of the heads prevents final confirmation of the relationship between these two sets of carvings commissioned at almost the same time by the Grandisson family.

At much the same date the vaulting of Tewkesbury nave was in progress, the keystone of each bay of which was carved with an elaborate scene from the life of the Virgin. The increasing intricacy of boss sculpture is clearly displayed in the crowded scene of Pentecost (Plate 136A). The Virgin is all but lost in the throng of apostles pushing and jostling their way to the front. The draperies have all the mobile tricks of contemporary painting, with deep borders emphasizing the spirals and diagonals of the hems. The large bearded heads set on thrust-forward necks, the *déhanchement*, and the crossed legs give the scene that restless sense of movement that was a characteristic of early fourteenth-century art, a legacy from similar tendencies displayed in the bosses of the Lincoln Angel Choir over sixty years earlier (Plate 103A).

It is unfortunate that the Exeter Fabric Rolls for the second quarter of the fourteenth century are of an extremely summary nature. In consequence there is no agreement upon the dating either of the nave vault with its many bosses or of the screen across the west front. That both undertakings were not far removed from each other in date is proved by the similarity between the shallow, knobbly foliage of the nave corbels and of the capitals of the pillar supports of some west front statues, and by the fact that at least one boss was evidently the work of the sculptor of some of the west front kings.[68] Timber was ordered in 1338, apparently for the nave roof, so that the stone vaulting is unlikely to have been commenced before 1342 at the earliest. The 1346–7 accounts contain no reference to vaulting, but in 1353 timber was purchased for centring and we are told that an important

'new work' was begun. It seems fairly clear, therefore, that the stone vault was not undertaken until that year.[69]

The problem of the western screen is more intractable. Work was being carried out at the west end from 1326 onwards and in 1342 the statue in the gable was painted. But these references prove nothing with regard to the screen itself, which is set up in front of the porches of the west front. Changes in design of the supporting pillars and the canopies show clearly that even the lower part of the screen was erected over a fairly long period. But the style of the central and southern section of the lower tiers of statuary, excluding those of the buttress and the side, makes it unlikely that they were carved any later than 1360.[70] In the first place the cross-legged knight to the right of the central door wears the cyclas, which is generally assumed to have gone out of use by the middle of the century. Secondly, the crowns of the kings are all of the low, thin type of the early fourteenth century which were later superseded by towering foliate erections rising well above the top of the head. Thirdly these statues are all rendered with a maximum of dramatic tension and movement, with crossed legs, arms flung in all directions, and drapery falling in agitated folds below the knee. This tendency was observed most markedly in the effigies at Aldworth and Chew Magna, and evidence from elsewhere in England indicates that it perished around the middle of the century. The first appearance of the cross-legged king in English art occurs at the beginning of the century in the Peterborough Psalter, and emerges in sculpture on a misericord at Wells of the late 30s.[71]

Two or more artists were employed upon these statues.[72] Both indulge to the full in dramatic poses and contorted gestures, and drapery falling below the knee in nervous little volutes. Above the waist the drapery is either drawn skin-tight or clings wetly with little sagging ripples. One artist treats the hair as a coarse bulging growth that pushes out in thick rolls at either side of the head; the other converts the side hair into a kind of plait, falling stiffly out to the shoulders and thus forming an inverted triangular frame to the long, melancholy face (Plate 138A). This last is a stylistic trick confined to a few manuscript illuminations of the third quarter of the century, none of which has any west-country connexions, and the relationship between them and these Exeter statues remains obscure.[73] If, as seems most probable, the sculptor was imitating the painter, then these particular statues can hardly have been carved much earlier than 1360.

The iconography of the west front has been variously interpreted as representing the royal saints of the English Church, as at Wells, or the Kings of Judah, such as are commonly found abroad. The latter interpretation, which seems the more plausible, is witness of the extreme popularity of the theme of the Tree of Jesse, by which the descent is traced from Jesse through the royal line of Judah to Christ himself. Repeatedly found in the numerous psalters of the day, made for the most part for royal and aristocratic patrons,[74] the theme achieved popularity because of its association of Christ with a long royal lineage. Christ was thus forcibly incorporated into the brotherhood of the feudal nobility, and the repetition of the Jesse Tree motif, the foundation of the Order of the Garter, and the writings of Froissart are all expressions of the same social philosophy of the fourteenth century.

The finest sculptural representation of this theme that has survived the iconoclasts of

the sixteenth and seventeenth centuries is to be found on the reredos at Christchurch, Hants, which has evident stylistic links with the Exeter kings. The niches have the same pearl beading and elaborate ogee canopies, and the statues have the damp, clinging draperies, long sad faces, fuzzy hair and beards, and crossed legs of the Exeter sculptures.[75] This huge undertaking consists of a recumbent Jesse below, flanked by his descendants David and Solomon, and from whose loins springs a tree bearing an Adoration of the Magi (Plate 132B). The principal flanking figures were of wood covered with silver plate, and have naturally long since fallen victims to human cupidity, but the stone statuary is excellently preserved. The peaked and worried face of David is that of a group of Jesse windows, for example at Lowick, Northants.[76] The Adoration is an iconographical mixture in which the Nativity with Joseph and the Ox and Ass is united with the offerings of the Magi (Plate 134A). In it the dramatic vigour of the Exeter carvers is triumphantly asserted. Joseph is sitting and gazing skyward with a rapt expression. Two kings are standing talking to each other in the background, and the third kneels at the bedside in a thrust-forward attitude by which he endeavours to emphasize the intensity of his sense of worship by a total disregard of the laws of mechanics. This temporary suspension of gravity creates a feeling of uneasiness that is accentuated by the disparate interests of the background figures and the preoccupations of Christ – here a child of some two years old – with the game he is playing with his mother. These separate scenes of action crowded together on a single stage strongly suggest the influence of religious drama, in which inexpert direction has destroyed the essential unity and emotional content of the scene. As such this carving is typical of so much late medieval art, in which an increasing barrenness of religious passion is inadequately compensated for by an accumulation of irrelevant iconographical detail. Stylistically attached to the art of the early fourteenth century, this sculpture of the 1350s is nevertheless looking forward to the more mechanical products of the second half of the century.

PART FIVE
LATE MEDIEVAL SCULPTURE

CHAPTER 13

THE REACTION

⟨CIRCA 1350–1410⟩

IT has long been axiomatic among historians of English medieval art that the middle of the fourteenth century marks another fairly well defined change in the style and content of architecture, painting, and sculpture. Following in the wake of the economic historians, who ever since the turn of the century have tended to emphasize the cataclysmic significance of the Black Death of 1348–9, art historians have also argued that the disaster had abrupt and revolutionary effects upon style. More recently, however, it has been realized that, appalling though its demographic effects undoubtedly were, the Black Death was only one of a series of such blows, which together combined to accentuate and perpetuate an economic depression that was already under way. Complementary to this revision of the economic evidence, it has been shown that Perpendicular architecture had a long past behind it, stretching back to Saint Stephen's Chapel at the end of the thirteenth century; that it is difficult to show that any building operations were held up for more than a very few years as a result of the plagues; and that links do in fact exist between the East Anglian manuscript school of the early and the Bohun group of the late fourteenth century. Nor, upon reflection, does the sculptural evidence for a sudden change appear any more convincing. The middle of the century unquestionably witnesses a transition, a noticeable shift of emphasis both in style and in choice of field, but there is nothing dramatic about the change, and its explanation may well lie in other factors relating to supply and to demand. Nevertheless, the consequences of the recurrent plagues should not be minimized. Groups of persons living semi-communal lives, such as monks in their monasteries and masons in their lodges, were inevitably more liable to suffer from the epidemics than private individuals, and the elimination by plague of most members of one or two masonic lodges in 1348–9 is by no means an impossibility. Furthermore, at all times, both in the Middle Ages and to-day, the responsibility for the maintenance of artistic leadership rests upon the shoulders of a few individuals whose premature death can have far-reaching consequences. The virtual disappearance after 1348 of the gifted and prolific school of sculptors at Beverley may well be due as much to mortality as to curtailment of opportunity.[1]

The demand for architectural sculpture shrank rapidly about the middle of the century, thanks to the inevitable reaction against the florid decorative systems of the early fourteenth-century architects. Their very luxuriance encouraged the growth of an opposition that

177

concerned itself with simplicity of line and structure. Coinciding with the growth of the Perpendicular style, this reaction was brought to triumphant and successful popularity by Henry Yevele, William Wynford, and their associates. Acting also as designers of tombs, men such as Yevele succeeded in permeating most fields of sculpture with their ideas, with the result that the opportunities for independent exercise of his talents by the sculptor were seriously reduced. At the same time monumental effigies complied with the new aesthetic mood and were laid flat on their backs in cold repose, with straight legs and – for the men – the body structure concealed by the steel casing of plate armour.

This change of mood from the emotional and mobile to the reserved and static was accentuated and accelerated by the slow spread of a desire for realism in figure-work, and more especially in the choice of subject matter. The most noticeable result was an increased complexity of iconography by which the ancient scenes from the Old and New Testaments and the lives of the saints became crowded with ancillary props and figures, a development whose relation to the contemporary stage is hardly to be doubted. Moreover, in the last quarter of the century, the influence of Flemish and Parisian realism in portraiture made a limited impact upon England, thanks to the commissioning by the court of an effigy made by one of the more conventional artists of the Parisian *atelier*, Jean de Liège. This mild realism was, however, of very limited range and hardly affected the artificial bubble foliage of the early fourteenth century. Its main achievement was to damp down the exuberant romanticism that had gone before and greatly to reduce the use of *déhanchement*.

It cannot be denied that there is a bourgeois quality of mediocrity, of latent vulgarity, and of unadventurous smugness about much late fourteenth-century sculpture. Nor is it entirely accidental that these qualities should coincide with a period in which an increased proportion of sculptural output was being devoted to satisfying the demands of a new class. It was not, of course, the merchant who was of the greatest social significance in this context. Though John Curteys, Mayor of the Staple, rebuilt the church of Wymington, Beds,[2] and William Greville, Stapler, left 100 marks to the church of Chipping Campden, Glos,[3] these are exceptions, and there is little warrant for arguing that the merchant class was socially much more important by 1450 than it was a century earlier. But there can be no doubt that the smaller landed gentry, together with a scattering of business and professional men, were growing in importance as artistic patrons, either owing to the aping of the habits of their betters, or to an improvement in their relative economic status.

The combination of this demand with the decline of architectural sculpture led to a reorganization of supply. There have survived well over 1000 brasses with figures, about 2000 misericords, 3000 fragments of alabaster panels, and about 350 alabaster tombs, of which a very high proportion indeed were worked between 1350 and 1540.[4] Apart from carving misericords, the late medieval sculptor was thus principally occupied in the production in quantity of sculptural memorials and of *œuvres de piété*, both evidently aimed at satisfying a more numerous and less discriminating group of patrons than before. One element needed for shop production – a large market – was satisfied, and the second – standardized raw materials in ample quantities – was provided by heavy imports of latten

sheets for brasses, and the extensive quarrying of alabaster. The distribution pattern of brasses shows clearly its dependence upon central production in London,[5] and there is good reason to believe that the military brasses of the late fourteenth century emanated, with negligible exceptions, from only three main shops working to standardized patterns, to which minor alterations were made from time to time.[6] It is evident that in this medium there has occurred the complete triumph of the shop, a triumph that was both cause and effect of the relative cheapness of the product. The most expensive brass, of several full-length figures and inclusive of the marble matrix, cost between £10 and £15 in about 1400, and cheaper ones were to be obtained for £5. This was just low enough to put a brass within the economic range of the lesser gentry and upper urban bourgeoisie. When the size of brasses diminished, the standards of craftsmanship declined and shop production methods increased after about 1460, prices dropped very markedly to from £1 to £3, and a far wider market was thus opened up.[7] Even before this, however, there is evidence to suggest that at least one workshop was turning out standard products in anticipation of customers' orders; in this particular case the orders seem to have been slow in coming in, with the result that some very similar brasses bear dates ranging over twenty-five years.[8]

The more highly specialized and expensive alabaster tombs and effigies seem to have been the work of a limited number of prominent firms in London, Chellaston, Nottingham, and York. The best known of these, Thomas Prentys of Chellaston, in the second decade of the fifteenth century apparently possessed a fully integrated combination of quarry and workshop. He was the main if not the only quarry owner at Chellaston, to whom French customers travelled to purchase blocks of stone for export;[9] and he and his workmen seem to have been turning out elaborate alabaster tombs for patrons all over the midlands and the south. Production was facilitated by the fact that no personal features were required by the patrons, but merely visible evidence of their social position and genealogical connexions. It was family status not individual personality whose record these tombs were intended to secure, and in consequence the art of portraiture remained unsought by all but royalty. Sir Walter Manny in his will in 1371 made provision for 'une Tombe dalabastre... fait ove un chivaler de mes armes tiel come est faite sur monsire Johan de Beauchamp a seint Poul en Londres'. Even contracts were little more precise. That for the tomb of Ralph Greene at Lowick merely stipulated 'deux images d'alabastre, l'un counterfait à un Esquier en Armes en toutz points... avec un helm de soubs son chief, & un ours à ses pees, & l'autre image serra countrefait à une dame gisant en sa surcote overte avec deux Anges tenants un pilow de soubz sa teste, & deux petitz chiens à ses pees' (Plate 156).[10] Such a general description conforming with the standard of the shop left the sculptor with a free hand. But it is unlikely that alabaster tombs were ever begun before the commissioning, even if in many cases the crest of the helm and the heraldic devices on the jupon were almost the only features that clearly distinguished one effigy from another. Even the most regular shop products were never precisely identical one with another, and in any case these tombs were too expensive to permit the medieval craftsman to tie up his capital on such a speculative venture. Moreover, not all customers were as easy to please as Greene, and in 1421 Richard Hertcombe at Bisham Abbey insisted on the copying of a 'patron' which must presumably have been designed according to his

instructions.[11] But the close similarity of the basic designs and style of the various tombs produced by the same artists together with the use of the extremely easily worked material of alabaster combined to make possible the sale of highly finished and elaborate work at a price that was within the purse of the middle and upper landowning classes: the Lowick tomb cost £40, and that at Bisham only £22 13s 4d.

The most striking growth of standardization occurred in the manufacture of alabaster panels for retables and altar pieces. Beginning about the middle of the century with the opening up of the alabaster quarries on a large scale, the workshops of Nottingham and London, and possibly also York, soon developed an active industry distributing carved and painted panels and images throughout England and the Continent. In 1360 Queen Isabella's goods included alabaster images of the Virgin and Saint Stephen,[12] and by 1382 the reputation of this craft had become such that the Papal Collector in England exported 'Tres Ymagines de alabaustro magnae formae' of the Virgin, Saint Peter and Saint Paul, and a smaller one of the Trinity.

Unfortunately there exists no basis for distinguishing these English works from those of foreign craftsmen. Alabaster was quarried abroad, that for the tomb of Philippe le Hardi at Champmol coming from Tonnerre, near Auxerre, and Vizille, near Grenoble, in 1384 and 1391. As early as 1339 Demoiselle Béatrice de Louvain had ordered the weepers for her tomb to be 'de boin fin alebastre', and a leading carver of Philippe le Hardi's tomb at the end of the century was a Tournai sculptor Claus de Haine, described as 'ouvrier d'ymages de pierre d'alebastre'.[13] At present alabaster panels and images are almost without exception attributed to English workmanship, but this evidence of Low Countries carving in the same medium makes it at least possible that some of the less standardized-looking of these objects are in fact foreign.

At first English alabasters were fairly diversified in shape and iconography and included some free-standing statuary, and the best were a much sought after luxury product. Peter Maceon of Nottingham received no less than £200 for the carving and transport of a great alabaster reredos for Windsor in 1367–8, and in 1372 an even higher price was paid in London for a shrine of marble and alabaster for Saint Cuthbert at Durham.[14] But by this time such elaborate and expensive pieces were the exception, and the craftsmen were beginning to settle down to the manufacture of large numbers of panels on stock themes and according to a stock iconography. The commonest subjects were the Five Joys of the Virgin Mary and a cycle from the Passion of Christ. There are a number of tricks of style which suggest that the sculptors of alabaster effigies were also responsible for panels. But whereas effigies remained at all times relatively limited in numbers, the demand for alabaster panels grew and grew. The reasons for their popularity were their cheapness, their rich appearance with the liberal decoration of gilded knobs and red, green, and blue paint, and the appeal of their subject matter to the devotional tastes of the age. A natural consequence of the extraordinary growth in output was a steady deterioration in artistic quality, and during the fifteenth century they became the precise medieval equivalent of modern *Saint-Sulpiceries*.

A result of all this standardization with its inevitable conservatism and imitativeness is that the difficulties of the art historian are increased. He is faced with sculpture in much

larger quantities than before, and he has the advantage of very many more individual items that are securely dated by documentary evidence. But the local schools of freestone sculpture, particularly of effigies, almost disappear at this period thanks to the competition of the 'alablastermen', and it becomes increasingly difficult to detect any well-defined stylistic evolution. Thus if it were not for the documents it would be quite impossible to place within fifty years the Virgin of the Annunciation over the gateway at Winchester College.[15] The intensity of artistic experiment which had led to a ceaseless modification of style in the earlier Middle Ages now slackened off considerably. Progress became both erratic and slow.

<p style="text-align:center">★</p>

For the hundred years before 1350 it has been possible to hinge a study of the growth of sculptural style on the dominant influence of the court at London. Unfortunately our knowledge of the achievements of this school during the twenty-five years after 1350 is to-day very defective. Nothing has survived of the architectural sculpture of the York-shireman William Patrington for Saint Stephen's Chapel, Westminster, between 1351 and 1358, and nothing of the stalls made by Edmund Canon for the same building.[16] In view of the revolutionary nature of the fragments of painting that survived the fire of 1834, this sculptural void may well be the cause of a grave distortion of our vision.

But it seems at least possible that in the row of kings on the west front of Lincoln Cathedral we have a work by the London artists (Plate 138B). There is documentary evidence to show that these statues were carved while John de Welbourne was Treasurer, that is between 1350 and 1380,[17] and stylistically they seem to belong to the 60s. Some of the kings are in the mid-century cross-legged attitude, and all wear the tall crowns and deep tippets of the latter half of the century. They retain the earlier desire for life and mobility, and each is individually treated in a conversational posture. But there is nothing strained or theatrical about them as there is, for example, about the Eltham weepers or the Exeter kings, and an easy naturalism characterizes the poise of the heads and movement of the arms. What suggests most strongly that they are the work of a London artist is the faces. The long upper and small receding lower lip, the broad forehead and the elabor-ately rolling artificiality of the abundant hair and beard, all recall the head of Edward II at Gloucester, carved a generation earlier (Plate 119). There is the same dignity and nobil-ity combined with the same hint of human weakness.

Apart from these Lincoln kings we are obliged to trace the London style in the effigies of alabaster and freestone made for provincial patrons. Lady Elizabeth Montagu com-pleted the foundation of a chantry at Saint Frideswide's, Oxford, in 1348 and the docu-ments suggest that her tomb was erected at about that time or shortly after. It shows signs of the new restraint in both body attitude and design and is unusual in that it retains much of the original painted gesso finish.[18] The effigy itself is laid flat on its back on the usual double cushions and has lost much of the romantic mobility of the earlier London style. The weepers are lords and ladies and prelates of the church who can be identified with the relatives and friends of Lady Elizabeth for whose souls she specifically ordered the two chantry priests to pray. They are set in the usual London arrangement under a flat cusped arcade with shields in the spandrels, and, unlike the effigy, retain much of the languorous

<p style="text-align:center">181</p>

postures and complex draperies of the early fourteenth century (Plate 122A). Against the background can be seen the remains of a decoration of gilt gesso bosses that a little later on was to become the standard ornament of alabaster panels.

The 50s saw the emergence of another London workshop using the usual court conventions, but in a coarse and florid manner. An excellent example of this style is the knightly effigy of Sir John Lyons at Warkworth, Northants. (Plate 142). There is the same restful posture, with the legs now straight, the same angels with the heel of the foot covered by the alb, the same little animal under the tip of the shield and the same use of lion-mask ornament on the armour as were found on the John of Eltham series thirty years before. But the material is now a soft white clunch, all the details are bolder and larger than before, and the carved ornament has greatly increased in scope, particular attention being paid to the sword belt and knee-caps. It is evident that at this period the London workshops were using freestone, clunch, and alabaster indiscriminately, and there had yet to develop any specialization in alabaster alone. Thus the freestone effigy of Bishop Ralph of Shrewsbury at Wells is based on the same model as the alabaster effigy of Bishop Sheppey at Rochester, both belonging to the early 60s.[19] On both occur the distinctive props of the shop, fat cushions with beaded or looped edges or with rose buttons at the corners.

Soon the principal London shops were settling down to a steady output of alabaster and brass effigies of a finished but monotonous character. The full-facing posture with straight legs and hands clasped in prayer is only very occasionally varied by the sentimental device of making husband and wife hold hands. The knights are given an inevitable rigidity by the nature of the armour, a close casing of mail and plate with the body covered by a tight-fitting jupon, and a uniform facial type is evolved with clean-shaven chin and long moustachios drooping over the mail aventail. The ladies are similarly constricted by the fashion of the day, which dictated a symmetrical U-shaped arrangement of the hair on a wire frame and a close-fitting kirtle that hugged the body. An early example of this standard type occurs in the 50s in the effigies of Sir Hugh and Lady Despencer at Tewkesbury, and by the 70s production was in full swing. An exceptionally fine example of this date is the tomb of Thomas, Earl of Warwick, and his Countess at Warwick, probably a London work, which well displays the cold, impassive style that in mood is the sculptural equivalent of late fourteenth-century Perpendicular architecture.[20] Even the fact that the pair are holding hands fails to bring life and warmth to the design (Plate 139B). The alabaster weepers are the jaunty figures in the latest fashions in dress that for fifty years had been the hall-mark of the London tomb-makers (Plate 136B). But they are now fitted tightly into thin niches with little freedom of movement, and the draperies have lost that tumbled effect apparent on the Montagu tomb at Oxford. Although the postures and gestures are still varied and animated there is none of the delicacy of execution of the earlier work. In particular the faces are very summarily handled, a sign of waning interest in the human factor in sculpture.

But even now there were rare exceptions to this monotonous pattern of tomb effigies. Though the treatment of the effigy itself is conventional enough, the design of the chantry tomb of Edward, Lord Despencer, at Tewkesbury is strikingly original. It consists of a freestone figure of a knight in armour who kneels on a tasselled cushion on the roof of

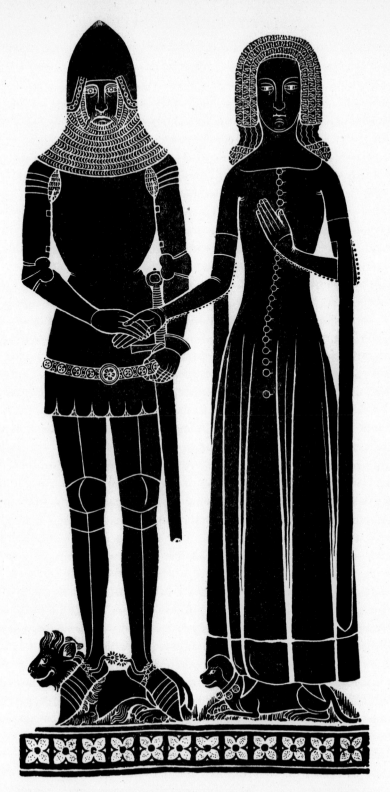

Figure 5. Brass of Sir John and Lady de la Pole. *c.* 1380. Chrishall, Essex

the chapel, sheltered by a lofty pinnacled canopy (Plate 137). He is facing the altar in an attitude of prayer, symbolizing that repetition of prayers for the dead which the institution of the chantry chapel with its attendant priests was meant to perpetuate. Probably erected before Lord Despencer's death in 1375,[21] this monument is evidently a London work inspired by the similar figures painted on the wall of Saint Stephen's Chapel, Westminster, some twenty years earlier.[22] So far as we know by the surviving evidence, this attractive conception was never repeated and remained an isolated experiment.[23] Its significance lies in the fact that it represents fully three-dimensional sculpture designed to be seen from all round. As such it anticipated by over twenty years the kneeling figures by Claus Sluter flanking the doorway of La Chartreuse de Champmol, near Dijon,[24] though of course it has none of the vigour and realism that makes these latter great works of art.

The distribution pattern of alabaster tombs would suggest that manufacture had already begun in the Nottingham area, and also perhaps at York.[25] The products of these provincial shops are indistinguishable from one another and vary only slightly from the basic London pattern. At Swine, Yorks, the knight rests his head on his tilting helm instead of upon cushions – a habit adopted from the west-country makers of freestone effigies[26] – and the lady's drapery is handled in a freer and more sharply cut manner than is found in London products like the Warwick effigies (Plate 139A). It is significant that this drapery style and the long, heavy-jowled face are also found in the alabaster 'Lady of Pity' at Breadsall, Derbyshire,[27] probably a Nottingham product, which suggests that the same workshops may have been producing both tombs and images. This belief is strengthened by the embattled moulding along the edge of the tomb, which just now, in the 1370s, was beginning to be a standard decoration of all panels.

It is fairly certain from the style, the distribution pattern, and the fact that the raw material was imported from abroad, that in brass engraving London continued to retain that near monopoly which in alabaster carving she was already in danger of losing. There are indications that by this time the sculptural contractor had emerged, ready to produce to order alabaster effigies, metal weepers, or brasses. Such a one was John Orchard, 'Latoner de London', whose title suggests that brasses were his main stock-in-trade. But in 1376 he provided six copper angels for the tomb of Philippa of Hainault, and two small alabaster effigies of the two children of Edward III.[28] In view of this integration, it is not surprising that the designs of brasses followed very closely on those of alabaster effigies.

The principal output of brasses in this period was of military figures in full armour, intensive study of which has revealed the operation of three workshops during the late fourteenth century.[29] The products of the first, known as 'Series A', are distinguished by a profile nose and clumsy drawing, combined with a wealth of engraved detail. Continuing into the second decade of the century the shop then petered out, or was absorbed into a new and very prolific shop, 'Series D'. Another workshop in production from about 1380–1410 seems to have been responsible for a small group ('Series C') characterized by a very tall thin bascinet, widely spread feet, long pointed sabbatons, a sword-grip with criss-cross diagonals, and wide-winged elbow and knee pieces. But these two were working on a small scale compared with the output of the main workshop, 'Series B', which

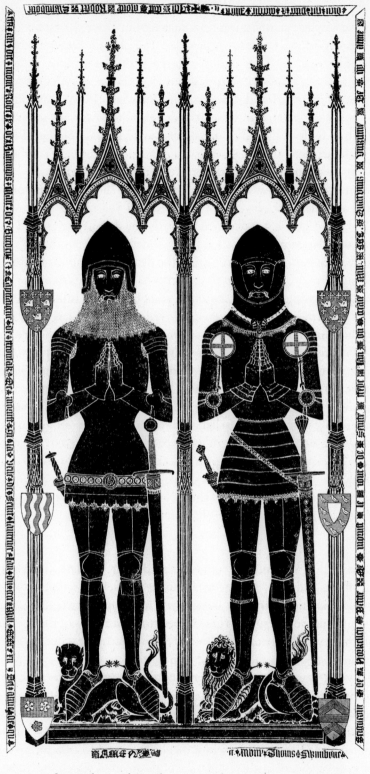

Figure 6. Brass of Sir Robert and Sir Thomas Swynborne. *c.* 1412. Little Horkesley, Essex

to judge from surviving examples was now turning out twice the number of 'Series A' and over three times that of 'Series C'. It may therefore claim to represent the most typical London style of brasses, of which a good example is that to Sir John de la Pole and his wife at Chrishall, Essex, which dates from about 1380 (Figure 5). A comparison with the alabaster effigies of the Earl and Countess of Warwick (Plate 139B) shows without possibility of doubt the manner in which the designers followed the same patterns. The sparse, close-fitting folds of the lady's dress, her hair style, the holding of hands, almost every detail of the armour, and the placing of a dog beneath the lady's and a lion beneath the knight's feet are common to both the brass and the alabaster effigies.[30]

A later example which throws a vivid light upon the shop methods employed is the 'Series B' brass at Little Horkesley, Essex, to Sir Robert Swynborne and his son, Thomas (Figure 6). The latter died in 1412, which is clearly the date of the brass. The father had died in 1391, and the engraver was evidently instructed to emphasize the difference between the two generations by reproducing the details of armour of 1391. This, however, he was unable to do, and it is to the patterns of about 1402–6 that he had recourse. This suggests that drawings of some six to ten years back were still lying about the shop but that earlier patterns had already been destroyed.[31] None the less the brass provides a most useful indication of the revolution in armour that took place in the first decade of the century, involving the replacement of the aventail by a plate gorget, the protection of the vulnerable armpits by pauldrons, and the abandonment of the jupon. The knight now emerges completely encased in plate armour. The canopy is a thin, many-pinnacled structure which perhaps owes something to the influence of the series of manuscripts written for the Bohun family a generation earlier. This brass marks the apogee of late medieval engraving, in which a cold perfection of linear pattern is produced by rigid symmetry, a mathematical accuracy of drawing, great restraint in the use of detail and complete absence of shading. Only the rakish set of the dagger at the right hip and the waving tail of the lion relieve the severe classicism of this ascetic style. It is based on the use of pure line as restrained and as hard as the interior of Canterbury nave.

<p align="center">★</p>

Though increasing in volume and importance during the late fourteenth century, monumental effigies had not yet come to dominate the field of sculpture. Architects still used sculptural enrichment for vault bosses, of which some outstanding examples date from this period. But they all suffer from the besetting weakness of the age, the tendency to sacrifice simplicity of design to complex and minute narrative schemes. Such crowding of figure compositions upon the tiny and remote field of the roof-boss meant that the quality of the work was entirely lost to view until the advent of the telescopic lens. It is very significant of the outlook of the late fourteenth-century artist that this inevitable consequence of his fussy designs seems never to have suggested to him the advisability of larger scale and simpler patterns. This weakness is apparent in the most important series of the period, that of Exeter nave, whose vaulting apparently began in 1353.[32] Many bosses are of very mediocre quality, and even in those upon which the leading artist was engaged, such as that depicting the murder of Becket, the actors are huddled together in

a grossly overcrowded composition (Plate 141A). No serious attempt is made at arousing an emotional response. The faces of the Archbishop with the top of his skull sliced off, of the murderer Fitzurse, and of the clerk Grim are all identical in their impassivity. The impression is one of carefully arranged figures grouped for a charade. The execution of this boss is far more skilful than that of the earlier corbels below (Plate 129), which is evidence against the theory of a decline in craftsmanship subsequent to the Black Death. There is, however, a remarkable change in mood as compared with the Tewkesbury boss of the 40s (Plate 136A). Both are overcrowded, but the one derives its strength from the mobility of pose, gesture, and drapery, while the other is a static representation of a moment frozen in time. The moment chosen is one of great symbolic significance, but it is depicted as if lacking a past or a future. It is representational art that bears the same relation to nature as the elaborately posed family groups in the Edwardian photographer's studio. As a type of pictorial expression, it was to endure in alabaster panels for the rest of the Middle Ages.

A less agreeable aspect of late fourteenth-century provincial art was the element of vulgarity. First apparent in Exeter work of the 1330s, it spread slowly over the west and south. The angel musicians that decorate the bosses of Gloucester choir, probably of about 1345–50, have the same fat necks, coarse features, and wooden limbs as the figures on the Exeter gallery (Plate 128C), though they retain something of the vigour and movement of earlier work.[33]

The same features can be seen in the more accomplished and mature wooden Annunciation now in the hall of the Vicars Choral at Wells (Plate 140). The Virgin sways back in the usual elegant *déhanchement*, while the feet of the angel are turned at precisely the same impossible angle as those of the Westminster angel of the Annunciation a century before (Plate 97), a stance derived in turn from Anglo-Saxon manuscripts. There has occurred, however, a significant change in treatment. It is not merely that the heads are long, heavy-jowled, and lacking in character and expression. Such coarsening of treatment and such anonymity are to be expected. But the angel has been transformed from the supernatural messenger of the Westminster chapter-house to a well-dressed lady such as might be encountered in any fashionable mid fourteenth-century street. The divine element in the Annunciation has entirely vanished in this down-to-earth scene of daily life. Only the pose and features remain of the former representation, an empty iconographical husk enclosing the new secularized core. The buildings of the Vicars Choral were the work of Bishop Ralph, and the deed by the Chapter of 1348 confirming this munificent gift refers to chambers 'built and to be built'. It is thus evident that work had already begun before 1348, and the Bishop's will makes it clear that all the buildings were completed before 1363.[34] Provided they did not come from elsewhere, these statues are therefore datable with some confidence to the 1350s.

The same identification of the secular *haut-monde* with the divine and the semi-divine is displayed by a fragmentary ivory of a Virtue thrusting her sword at a vanished Vice (Plate 141B). The Virtue is a great lady in the elaborate netted hair-style of the period and the close-fitting cote-hardie with liripipes at the elbows, as worn by Joan de la Pole on the Chrishall brass (Figure 5). There is no reason to reject this fragment as evidence of the

craft of the English ivory carver of the middle of the century simply because other examples of his art have now almost entirely vanished. The lines of the drapery are artificially arranged to accentuate the gesture of withdrawal of the left arm and to exaggerate the thrust on the right leg as the Virtue drives home her sword. This drapery style is like that of certain early alabaster panels such as those from Kettlebaston (Plate 146), which suggests that at the beginning some of the ivory carvers may also have worked in the new medium.

Both the coarsening of texture and the increasingly secular treatment of religious art resulted in a strengthening of the persistent English love of caricature. A certain vulgarity is essential for such an art, and its utility is well displayed in the head of a bishop from the cornice below the triforium of the nave of Winchester Cathedral (Plate 141c). The artist of this sensual, avaricious, and gluttonous head conveys something of that popular distaste for the material wealth and secular preoccupations of the higher clergy, that found more practical expression in the murder of Archbishop Sudbury and the looting of the property of William of Wykeham during the Peasants' Revolt of 1381. The date of this sculptural ornament of the nave is very hard to determine. The walls to the south were certainly up in Wykeham's time, but the carvings include the emblems of his two successors Waynflete and Beaufort.[35]

The most convincing evidence of the secular preoccupations of the late fourteenth-century artist is to be found in the carvings of misericords. Among the most complete series of this period are those of Lincoln and Chester in the north, and New College, Oxford, in the south. The two former are evidently the work of the same group of carvers, that at Chester being perhaps some ten years later than the Lincoln series. It has been suggested that these two sets of stalls with their fully developed, soaring canopies were the work of the court carpenters, William and Hugh Herland,[36] but no reasons have been put forward to support this view. This type of spired canopy remained a characteristic of northern rather than southern carpentry, and the style of the misericords shows little evidence of court influence. The only document that refers to the construction of the Lincoln stalls is tantalizingly vague, but it seems to indicate that the stalls were begun, but not completed, when John de Welbourn died in 1380.[37]

Out of well over sixty carved misericords, only five illustrate scriptural subjects or episodes from the lives of the saints. There are three certain scenes from the popular romances, the Romance of Alexander, Tristram and Iseult, and the legend of Sir Yvain. The misericord carvers were undoubtedly familiar with a number of stock subjects which were in wide circulation. Alexander's flight with the aid of griffins is carved on seven misericords scattered from Hereford to Beverley. The crushing of the hindquarters of Sir Yvain's horse by the descending portcullis of a castle gateway similarly occurs in four places, including Lincoln and New College. But the great majority of misericord subjects are purely decorative or satirical, consisting of caricatures, the representation of fabulous animals, and the portrayal of homely scenes such as ploughing and reaping, or the ever popular medieval joke of the virago belabouring her husband. It was in these scenes from daily life that the sculptor developed the realism that was a powerful element in late fourteenth-century art. The carving at Lincoln of a knight falling from his horse (Plate 144A)

is a remarkable exercise in the faithful reproduction of detail. Every plate and every strap of the armour is diligently portrayed, and the instant of collapse of man and horse is brilliantly captured. And yet flanking this extraordinary display of fidelity to nature are a pair of winged dragons of the most conventional variety. So much of the physical world remained a terrifying mystery to medieval man that at no time was his grasp very secure upon the evidence presented by his senses. The most pragmatic and realistic of artists was for ever troubled by his imaginings of the unknown.

This disordered imagination is more freely expressed by the carvers of the misericords at New College, where not a single one of the sixty-two has the slightest religious meaning.[38] Some are brilliantly conceived masks based on the bearded human face, examples of which also occurred at Lincoln. They owe something to the rubbery curls of the early fourteenth century, but the grimacing stylization of a triple head (Plate 144B) may have been inspired by a classical design. Others are savage caricatures, like the head of the hideous old woman with her fashionable netted coiffure, and many are of horrible demons emerging into the world to persecute puny human beings. Unlike the subject matter, the foliage is evidently based upon that of contemporary court manuscripts, particularly in the use of the characteristic kite-shaped leaf.[39] Building of the college was begun in 1380 and formal possession was taken of the chapel in 1386. But it is unlikely that the stalls were completed so quickly, and the date of the misericords is probably about 1390.

*

Throughout the whole of the late fourteenth century the alabaster carvers steadily increased their output of panels.[40] Owing to extensive looting during the Reformation only a handful of the carvings remain in, or can be associated with, the church which they once adorned. There is thus no hope of reconstructing a distribution pattern, and documentary evidence for these early alabasters is almost entirely lacking. It is quite impossible at this stage to identify the products of shops in different towns. One document proves that Nottingham was a centre, and another strongly suggests that the London carvers were also turning their hands to the new trade; whether York was also a centre is far more doubtful.[41] Nor is it possible to be at all certain when the production of these panels began. The theory that they were being carved as early as 1340 rests on somewhat unconvincing comparisons with the alabaster weepers from John of Eltham's tomb, and even a fairly satisfactory parallel of the drapery style with an early crucifixion panel loses much of its value from the fact that such draperies were being carved and drawn throughout the whole of the middle third of the century.[42] However, it is reasonable to conclude that a decade or more of image carving, if not of panels, had preceded the important contract given to Peter Maceon of Nottingham in 1367.[43]

At first there was considerable diversity of shape and size in the panels, and a good number of free-standing statuettes were also made. The earliest panels, of about the third quarter of the century, were in the smooth, level style of both tomb effigies and ivories. The figures are in low rounded relief and there is no undercutting. The draperies fall in broad vertical swathes, and the ladies' dresses frequently trail on the ground below the

feet. The panels themselves are indiscriminately tall or broad, with finished edges cham-fered forward to form a frame. Though no set of this date survives intact, there can be little doubt that a great many of the panels were originally grouped together and placed in wooden reredoses to tell the story of the Life of the Virgin or the Passion of Christ. The background of most of these figures was covered with gilt gesso knobs, probably a trick of the London sculptors since it also appears on the Montagu tomb at Oxford (Plate 122A), and the figures themselves were carefully painted and gilded. This final treatment in itself led to a carelessness in the execution of detail, and from the very beginning we find the eyes carved as a pair of simple projecting buttons to be picked out in paint with pupils and lids. The connexion with contemporary sculpture is strengthened by the similarity of certain details. For example the combination of the Adoration and the Nativity on the reredos of Christchurch, Hants (Plate 134A) is almost exactly reproduced in an alabaster panel now at Paderborn, Germany, and the buttons on the cushions of another panel at Long Melford, Suffolk, are those of the London effigies.[44]

These earliest alabasters are among the best, since they retain much of the freshness of the original designs. In 1882 there were dug from the walls of Kettlebaston Church, in Suffolk, four mutilated fragments which evidently formed part of a reredos of the Life of the Virgin. The much damaged Coronation of the Virgin (Plate 146) is a splendid example of the new humanized iconography and of the elegant stylization of the early alabasters. Hitherto, the Virgin had been seated on a throne side by side with Christ. Now she kneels below and stretches up to receive her crown, an arrangement found also on a rather earlier freestone reredos at Christchurch, Hants.[45] A marked feature of the alabaster is the slimness of the Virgin, whose simple drapery is scored and grooved to emphasize the stretch of the body.[46] The degree of linear stylization is such that the bend of the knee is made to form a purely schematic triangulation. The fact that this stylization also occurs on a panel with embattled cornice indicates that these Kettlebaston carvings come fairly late in this first group and belong to about the 1370s.[47]

This finely wrought simplicity is undoubtedly best suited to the translucent material of alabaster, but it was not destined to endure for long. The scene of the Descent from the Cross (Plate 147A) from a series of panels found at Bordeaux is probably a little later in date, of about 1380–5; a certain woodenness of expression and gesture and an overcrowd-ing of figures and of background detail is now noticeable. The paste knobs are arranged in a lozenge pattern and the scene is complicated by the addition of a soldier in the fore-ground. This figure, whose quilted coat and sleeves give the best clue to date, probably represents the centurion sent by Pilate to see if Christ was dead, a personage who occurs occasionally in fifteenth-century miracle plays.[48]

At this period the alabaster carvers were also producing free-standing statuettes of the highest quality, of which the best examples are three figures found at Flawford, Notts. The Virgin is handled with the *déhanché* pose and elaborate draperies of the standard French court style of 1340–60, and the podgy Child is playing with the Virgin's exposed breast in the humanized fashion of the mid fourteenth century (Plate 145). The heads are quite unlike those of the usual alabaster figures in the careful treatment of the features, and there is no sign of the conventional bulging buttons that normally serve for eyes. Accurate

dating of such a figure is obviously impossible, but it seems unlikely that so accomplished a handling of drapery of a mid-century type can be much later than 1370.[49]

By about the 1380s, the type of panels in shallow relief and with forward chamfered edges was giving way to a new type whose principal characteristic was a projecting embattled cornice and bayed-out base. These battlements are thought to have been the conventional representation for heaven on the medieval stage, and it may have been from this source that the artists adopted the device. But whatever the symbolic interpretation may be, this projecting embattled head encouraged carving in much higher relief. In the present state of our knowledge there is no evidence to suggest that the adoption of the 'embattled' type was the work of one shop more than another, and there exist closely similar panels with and without the battlements. There was evidently considerable over-lapping for some years, rather than any sudden break with past designs.[50] Many of the commoner iconographical themes show an increasing mutual interrelation between sculpture and the stage. For example, in one pattern of the Resurrection, Christ emerges from the tomb with his right arm pointed skywards in a typically histrionic gesture, and the human interest is increased by making him step out of his tomb directly on to the body of a sleeping soldier (Plate 147B). This may well have been a stage device to facilitate the graceful emergence of the actor from the high-sided tomb.[51] This type of the figure of Christ in a tight-fitting loin cloth with parallel folds, with strong emphasis on the ribs and leg muscles, the cross of thorns carved as a thick roll and the beard as a series of stumpy spiral tufts, was one which lasted for nearly a century. Its survival for so long is evidence of the poverty of invention of the fifteenth-century alabastermen.

So far as we can tell, the free-standing alabaster statuette was becoming rarer by the end of the fourteenth century, and the few such items as have survived are all of exception-ally high quality, as though they were executed for special commissions. The commonest subject for these free-standing compositions was a 'Trinity' that included souls in a napkin and omitted the dove; of this a fine example of the first half of the fifteenth century is now in the Museum of Fine Arts in Boston, Mass.[52] The donor and his wife kneel at either side, and between the knees of God the Father is Christ crucified, treated exactly as in the Resurrection panel of at least a generation earlier. Far more unusual is the splendid statuette of Saint George and the Dragon that turned up in Spain and is now in the National Gallery of Art at Washington (Plate 148A). Horse and horseman are carved with tender romanticism and perfect technical virtuosity, both of which are unusual by the early fifteenth century, though the dragon with its grossly disproportionate head fails to convey a convincing sense of bestiality. The type of armour worn by Saint George, the bascinet and camail, jupon and horizontal bawdrick disappeared from use by about 1420, and the oblong shield was known well before then.

It must be confessed that the alabasters here described and illustrated do considerably more than justice to the aesthetic merits of the increasingly hackneyed and pedestrian output of the shops. By choosing outstanding examples, of which at least the Saint George and the Flawford Madonna were evidently specially commissioned and executed with unusual care and feeling, the impression is given of works of general high quality. But such was not the case, since the growth of a mass market abroad for such devotional

panels encouraged monotonous and soulless repetition. We learn casually from a lawsuit that in 1390 a ship, the *Saint George*, sailed from Dartmouth for Seville laden with 'draps de layne de diversez colours, ymagez d'alabastre, et autres merchandizes'.[53] By then alabasters had, it would seem, become general export goods along with English cloth and other mundane wares.

<div align="center">★</div>

The marriage of Edward III to Philippa of Hainault was destined to have a certain effect on the London sculptors, since she continued to patronize her fellow-countrymen. Of these the most distinguished were André Beauneveu of Valenciennes and Jean de Liège, who were drawn to the French court in 1364 by lavish commissions from Charles V.[54] Beauneveu introduced into French art a style of effigy sculpture that was characterized by an approach to portraiture and a strong sense of volume in the treatment of the body. Jean de Liège was far less extreme in the fidelity of his portraiture; he retained many formal tricks of style, and his draperies were of a severely simple and conventional type. It was he who finally triumphed over his rival and became the exponent of official art at the court of Charles V. It was most probably thanks to the influence of Philippa that this successful Brabanter was commissioned to execute the white marble image of the Queen for her tomb in Westminster Abbey, for which in 1367 he was paid £133 6s 8d.[55] It is probable that Jean visited England, for the effigy is evidently taken from life, an unkindly faithful representation of the heavy body of an old woman in her fifties (Plate 148B).[56] The tomb itself, and most of the seventy-odd little statuettes that originally adorned the sides and the open-work niche in which the effigy was laid, were probably also foreign work, though John Orchard was supplying copper angels for it ten years later. The tabernacle work along the sides of the tomb is also executed in white marble. Both base and canopy are heavily projecting and the design forms an intermediate stage in the development towards a completely open arcade, first seen a generation later on the tomb of Philippe le Hardi at Champmol. The effigy and the weepers were elaborately coloured and gilt and decorated with insets for paste jewels, and the openings of the niches over the Queen's head were filled with blue glass.[57] But these ornate trimmings cannot conceal the extremely simple vertical folds of the draperies and the new element of realism introduced into the treatment of the body.

When some ten years later English artists were called upon to execute important royal commissions for effigies, the influence of this work of Jean de Liège is not unnaturally visible. The gilt copper effigies of the Black Prince at Canterbury and of Edward III at Westminster are probably the work of the same artist, and must have been made in about 1377–80. The former is no more than a highly finished and ornate specimen of the coldly impersonal statuary of the alabaster tomb-makers (Plate 143).[58] The latter is more interesting since it follows the simplified drapery and the realism of the effigy of Philippa (Plate 150). For some time now it had been the habit to make a model of the dead monarch dressed in the robes of life that was carried upon the bier during the funeral procession. The wooden effigy of Edward that was carved for his funeral has fortunately survived. The head is evidently based on a death mask, since one side of the mouth is twisted by the

paralysis that is known to have struck the King some time before his death.[59] In the bronze effigy the mouth has been straightened out and a purely schematic arrangement of hair and beard has been added, but it remains none the less a recognizable reproduction of the features visible in the death-mask. The gilt metal weepers are equally revolutionary in treatment, for the jaunty little figures which lasted with modifications from the Eltham tomb of about 1340 to the Warwick tomb of about 1375–80 (Plates 123 and 136B) have now been replaced by ladies and gentlemen in attitudes of impassive calm (Plate 149). There are no more wild gestures or flowing draperies; all is now grand and cold and digni-fied, and the draperies exactly fit the new mood.

No documentary records have survived to tell us the name of the artist responsible for this tomb. But it is perhaps significant that John Orchard supplied the copper angels for the tomb of Queen Philippa, and that in 1377 with a certain Richard Rook of Knights-bridge he rented a house and garden in Tothill Street.[60] Taken together these two scraps of information suggest that Orchard had been given an important contract, which necessitated taking a new house in the vicinity of the Abbey. Such a contract can only have been for casting the effigy and weepers for the royal tomb.

The next major commission did not occur until fifteen years later when in 1394–5 King Richard ordered a tomb for himself and his beloved wife, Anne of Bohemia. There are indications that Richard took a genuine interest in aesthetic matters, as well as appreciating the value to authoritarian monarchy of suitably directed works of art, and the tomb was evidently entrusted to the most outstanding artists of the day. The great architect Henry Yevele was commissioned in conjunction with Stephen Lote to design the tomb, to be ready by 1397. For this they were to have £250. The two effigies, twelve weepers, and eight angels were ordered from Nicholas Broker and Godfrey Prest, 'Citeins & Coper-smythes de Loundres', and were to be executed in return for £400 'solone un Patron as ditz Nicholas & Godfrey monstrez.'[61] It seems clear that for this truly enormous sum, Prest and Broker of Wood Street, assisted by their apprentice Nicholas Fraunceys,[62] were to design as well as to cast the images. This is a point of some importance, since we know that the designer of the 'patron' and the executant of the casting were different persons in three fully documented cases in the next century, those of the Earl of Warwick, Margaret Beaufort, and the Earl of Derby. Owing to the great depth of modelling, the effigies had for the first time to be cast in more than one piece. The making of the moulds had begun in 1394 and the casting was probably finished by 1 March 1396, when King Richard stood the workmen a drink, though Broker and Prest were not paid the £100 for the gilding till 1399.[63]

The effigy of the King 'conterfait le corps de nostre dit Seignur le Roy', and is evidently taken from life, though the details of nose and eyebrows show some recession from the realism of the Edward III head (Plate 151). It is a portrait of the King, but an idealized portrait. The draperies, on the other hand, are handled with greater sensitivity for texture, and represent an advance on the hard flat surfaces of the earlier work. They are elaborately chased with Richard's personal emblem of the white hart and other devices, and are thus in keeping with the growing love of minute enrichment displayed by the alabaster effigy-makers. The haunting face above these richly chased draperies strikes the perfect balance

between the somewhat prosaic realism of Philippa and the mechanical stylization of the Black Prince. It is a brilliant piece of royal portraiture, at once noble and intimately personal.

The only evidence we have of London architectural sculpture of the reign of Richard are the images of kings set up at the inner south end of Westminster Hall in 1385 (Plate 153B). The original niches, which have not survived, were by Walter Walton, and some of the statues themselves by Thomas Canon – one of the long line of that name who for a century had virtually controlled the Purbeck marble trade of Corfe. He carved two Kings for 66s 8d each and a further thirteen for 46s 8d, including materials. The accounts seem to be quite categorical on this subject and the statues must have been incorporated in the major reconstruction of the Hall ten years later.[64] The long faces, heavy heads, and wig-like hair topped by enormous, towering crowns have a crude vigour of characterization that bears little relation to the more mature and refined products of the effigy-makers. But these portentous statues are handled in very high relief with adjuncts such as swords and orbs carved completely in the round, and as models for figures of kings they were to have great influence in the next century.

CHAPTER 14

'CURIOSITAS'

⟨CIRCA 1410–1460⟩

IT was hardly likely that the architectural and sculptural austerity of the two generations after 1350 should persist for very much longer. By the early years of the fifteenth century it becomes apparent that artists in all fields were adopting a new attitude to their work. There was no return to the romantic artifices of the early fourteenth century, but rather a desire to make room for minute technical virtuosity in stone cutting, a wish to create rich surface textures and yet further to develop the already pronounced trend towards crowded narrative. Nor did this development go unnoticed by contemporaries, though such comment as survives is mostly hostile. In 1448, King Henry VI drew up his 'will' respecting his two foundations of Eton and King's. In his instructions concerning the latter, he wrote: 'I wol that the edificacion of my same College procede in large fourme clene and substancial, settyng a parte superfluite of too gret curious werkes of entaille and besy moldyng.'[1] Nine years before, the University of Oxford in its instructions to the new architect for the Divinity School had expressed itself in terms still more hostile to sculptural enrichment, alleging that 'plures magnates regni et alii sapientes non approbant, sed reprehendunt, nimiam curiositatem incepti dicti operis.' The architect was ordered henceforth not to indulge 'in tabernaculis ymaginum..., casimentis et fylettis et in aliis frivolis curiositatibus qui ad rem non pertinent.'[2] But as the Oxford document goes on to make plain, it was not so much aesthetic prejudice as financial stringency and a desire to bring the undertaking to a speedy conclusion that dictated this attitude.

The chronology of this movement towards 'frivolous curiosities' varies slightly in the different arts. In architecture the lead was taken, amongst others, by Richard Winchcombe, who built the new chancel at Adderbury, Oxon, between 1408 and 1414, and who fifteen years later began the Divinity School at Oxford; his subtle mouldings and deliberate use of architectural sculpture provide a striking contrast to the style of Yevele and Wynford. Increased elaboration of surface detail and of costume in alabaster effigies is noticeable by the first decade of the century, and the new Great Seal of 1407 shows a complex and minute pictorial quality in an elaborate Perpendicular screen behind the throne, crowded with no less than seventeen human beings and animals.[3] On the other hand in alabaster panels the development of narrative scenes with detached many-pinnacled canopies does not seem to occur before the third decade, and increased surface enrichments and the use of shading in brasses do not appear before 1420.

The fifteenth century is at present undoubtedly one of the most obscure periods in the history of English medieval sculpture, and it is likely long to remain so. One reason for this is the destruction of so much of its architectural statuary. The screens of Saint Albans and Winchester, the reredoses of New College and All Souls, are now empty of their original images. Such statues as have survived, in Westminster Hall, on the Canterbury

screen, and on Henry V's chantry at Westminster, consequently appear as isolated phenomena whose place in a chain of stylistic evolution it is now very difficult to establish. When carvings can be precisely dated they fail to fit into a chronological framework. For example the broken drapery treatment that first appears in the 40s at Warwick and Westminster has no effect upon the sculptor of the architectural statuary of the 50s at Winchester, who copies the tricks of the alabaster panel carvers. Again, the firmly dated figures on the screenwork of the Divinity School at Oxford, of 1481, show little advance on statues in the east window at Warwick of 1443–7. Were documents lacking they would confidently be attributed to the same decade. To say therefore that in the light of present knowledge the little that remains of fifteenth-century architectural statuary cannot be fitted into any simple evolutionary pattern is not so much a confession of defeat as a statement of demonstrable fact. Tomb sculpture, on the other hand, was governed by a strong shop tradition in a single medium, a great deal of the output has survived, and we are therefore able to trace its development with some confidence.

It seems clear that, with few exceptions, English sculpture of the early and mid fifteenth century was remarkably isolated from the continental development of realistic art, and much of the carving that has survived is hackneyed in treatment and stereotyped in invention. In tomb sculpture, the intricacy and delicacy of execution, even at its peak in the first quarter of the century, can hardly conceal an atrophy of feeling. In brasses, as in alabaster tombs, a decline of technical and artistic quality becomes very evident by about 1430, and by 1460 craftsmanship is in full decline. Similarly alabaster panels during the fifteenth century show evidence of an increasingly slipshod production at ever decreasing prices. With certain notable exceptions therefore, the period is one of declining aesthetic standards.

The causes of such a decline are far from clear. One powerful factor was no doubt the disappearance of a well-defined 'court style' capable of spreading its influence and its standards of quality all over the country. An inevitable concomitant of the growing financial embarrassment of the Crown was its temporary withdrawal as a great patron of the arts. Henry IV had to be content with an effigy in alabaster, and when Henry VI revived royal patronage in the 1440s with the Chantry of Henry V, it can hardly be said to have set a high standard in sculpture. The impoverishment of the patron class may well be an important factor in explaining the decay of sculpture. It is now tentatively suggested by medieval economic historians that the fifteenth century may in general have been characterized by a prolonged decline in rents and a stagnation of economic activity. If this is so, a decline in rental income, coupled with heavy military expenditure for self-defence during the civil wars, may have reduced the surplus capital of the lesser landowning class. The fabulously wealthy, such as some of the bishops or magnates like the Earl of Warwick and the Duke of Gloucester, could build expensive chantries to house their mortal remains; the ordinary gentleman or burgher could not afford such luxuries, and the drastic reduction in both quality and price of brasses in about the middle of the century provides persuasive evidence that not even the modest expense of fourteenth-century memorials was any longer within his means.[4] Judging from the very rare analyses available, it seems that there was an increase in the amount of impurities in the metal of brasses, particularly of lead. At the same time the percentage of zinc increased from about

20 to nearer 30.[5] This would result in a metal that was far tougher and more difficult to work, and the shallow engravings of the period are probably partly to be explained by this change in the nature of the material. Nevertheless the decline in size of the brasses and the deterioration of design cannot be explained on these technical grounds.

<div align="center">★</div>

The first quarter of the fifteenth century marks the apogee of the alabaster tomb-makers, whose products now dominated the whole of England except for the south-west, where Bristol, Bath, and Exeter continued to turn out freestone effigies in fair numbers.[6] It is now possible to distinguish three clearly defined centres for the alabaster trade, at London, at Chellaston and Nottingham, and at York. Some of the London effigies are obviously influenced by the realistic portraiture introduced with the royal effigy of Queen Philippa. The drapery treatment of the effigy of the rich and worldly politician William of Wykeham in his chantry at Winchester Cathedral is in the standard London tradition. The trick of wrapping a fringe of drapery around the stem of the crozier goes back to episcopal effigies of the 1360s, like that of Bishop Sheppey at Rochester,[7] and the angels are sitting bolt upright with their wings trailing at the back in the accustomed London manner. The three little clerks seated at his feet are treated with a strong sense of character and expression (Plate 154A) and the Bishop's head, like that of Archbishop Courtenay at Canterbury (Plates 152A and B) which is evidently a work of the same artist, is an unflattering study of the worldly politician-bishop of the late fourteenth century. In his will of 1403 Wykeham refers to 'a certain chapel lately built by me' where he wishes to be buried.[8] Since he makes no provision for the construction of the tomb it is evident that it also had been finished and can therefore be dated fairly firmly to about 1399–1403.[9]

The effigies of Henry IV and his wife at Canterbury are also made of alabaster (Plate 155A). They are set below the big 'gablets' introduced by Jean de Liège on the tomb of Queen Philippa, and repeated on those of Edward III and Richard; they show the same personal portraiture modified by a need for grandeur as those of their predecessors, the same attendant angels and the same niche system on the sides of the tomb. When the tomb was opened in 1832 it is said that the head and beard of the King were found excellently preserved and showed that the alabaster carving was a fairly faithful likeness.[10] A thorough cleaning of the effigies in 1936 revealed many signs of the original elaborate colouring, including evidence of the 'translucida' technique of painting on gilt. Upright angels with carefully depicted wing feathers are in the London manner, and the niches for statuettes along the edges, the architectural design of the tomb-sides, the gablets and the flat tester are all signs of London workmanship. In any case, it is unthinkable that a royal tomb should have been commissioned in the provinces. There is no documentary evidence for the date and authorship of this tomb. Nothing had been begun when the King made his will in 1408,[11] and the chantry was not dedicated until 1427, so that the tomb may not have been finished much before 1420.[12] At this time the sculptor normally employed by the Crown – to carve a swan and an antelope in wood for the royal ship *Holigost* in 1415, or swans for the King's chamber at Sheen in 1418 – was a certain Robert Broun.[13] In 1421 'Robert Broun Kerver' of the Savoy, London, was commissioned to make an alabaster

tomb of Richard Hertcombe and his wife for Bisham Abbey, Berks. Complete with 'les images appelez morners' and executed according to 'un patron ent fait et monstrez par le dit Richard a dit Robert', it was to cost £22 13s 4d.[14] This tomb has unfortunately now disappeared, so that comparisons are impossible. But as Broun was evidently familiar with alabaster tomb-carving, and as he was also the sculptor normally employed by the Crown at this time, it is at least not unlikely that he was the author of the royal tomb at Canterbury.

The big heads and powerful characterization of these London effigies are very different from the small anonymous features and minute elaboration of ornamental detail that were favoured by the midland alabaster tomb-makers. They took over the London motif of the heavy gablet behind the head and adopted the shield-bearing angels of the tomb sides that are found on the monument to Henry IV. While retaining the little curving tips at the edges, they preferred to leave plain the upper half of the wing itself with no attempt to carve the feathers (Plate 158A).[15] Their effigies of knights were often enriched by a thick orle with pearl and jewel ornament that encircled the bascinet, and by increased use of a four-leaf flower pattern to decorate the joints of the armour.[16] At the same time the ladies blossomed out into fantastic jewelled hair-nets that spread out from the ears like wings. A good example of this elaborate decoration on rather clumsy and heavy-jowled faces is provided by the Greene tomb at Lowick, which is known to be the work of Thomas Prentys and Robert Sutton of Chellaston and is dated 1419 (Plate 156).

This slightly coarse 'Chellaston' type of carving is easily distinguished from the more sensitive and delicate style of the effigies of Sir William and Lady Wilcote at North Leigh, Oxon, which is probably a Nottingham work of the same period (Plate 155B).[17] Lady Wilcote wears the attractive turned-up collar of the *houppelande* that is also met with in contemporary alabaster panels.[18] It is noticeable that despite the elaborate treatment of detail and the graceful features there is a marked recession from variety and depth in draperies towards a monotonous pattern of vertical pleats arranged with perfect symmetry. Already, at the highest peak of the alabastermen's achievement, the lazy tricks of shop production were beginning to make their appearance. The identity of these Nottingham alabastermen is unfortunately not known, but we have the names of the three craftsmen who in or before 1408 made the tomb of John IV, Duke of Brittany, that until the Revolution was to be seen at Nantes.[19] Thomas Colyn, Thomas Holewell, and Thomas Poppehowe may have been inhabitants of either London or Nottingham, and the early eighteenth-century drawing, which is the only evidence that survives of the nature of the tomb, is too inaccurate on details to be very useful on this point.[20] The nature of the armour and the niches of the tomb sides suggest a comparison with the tomb of the Earl of Westmorland at Staindrop, Durham, which is clearly an imported work from either Nottingham or London. The decorated armour joints of the Duke of Brittany create a suspicion that both may in fact be Nottingham products and that in Colyn, Holewell, and Poppehowe we have the names of the leading alabastermen of the town in the first decade of the century.

The third clearly distinguished centre of alabaster tomb-making was York, where were produced more florid versions of the Nottingham–Chellaston type. The effigies of

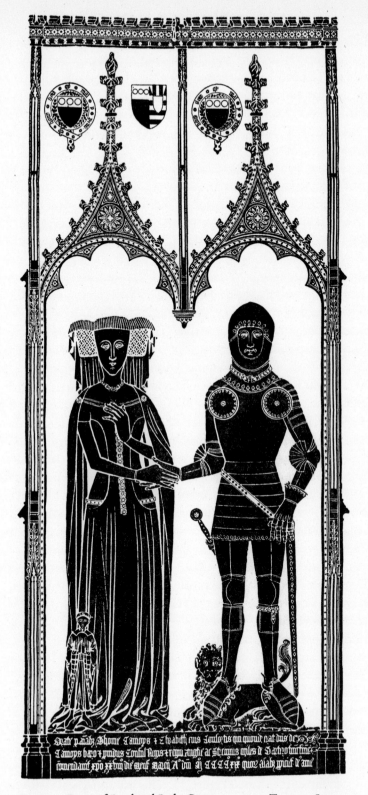

Figure 7. Brass of Lord and Lady Camoys. *c.* 1419. Trotton, Sussex

Robert Waterton and his wife at Methley, Yorks (Plate 157), of about 1425, provide excellent examples of this style. The detail is heavier and more crudely carved than the midland work, but the features and drapery are much bolder in design and execution. The face of Robert Waterton is of considerable interest since the bulging eyeballs and the double spiral tufts of the beard are both tricks of the contemporary alabaster panel carver; it therefore provides more evidence of the identity of the artists of tombs and panels. The collar decorated with rows of SS, worn by both Waterton and his wife, becomes very common indeed on brasses and effigies of this period. Originating as a livery collar of the Lancastrians, it naturally became the fashionable thing to wear after the change of dynasty of 1399, and the Vicars of Bray hastened to appear with it round their necks.[21] The tomb sides of this Yorkshire group differ from those of the midlands in their treatment of the angels. They kneel sideways to support the shield, instead of standing upright with the shields before them, their hair fuzzes out in the familiar spiral tufts, and the wings have carefully drawn feathers and inwards turning edges (Plate 154B).

Brasses pursue exactly the same course of increasing elaboration of surface detail as alabaster tombs. The early fifteenth century was undoubtedly one of the two high peaks of brass engraving, and there is considerable evidence that its aesthetic merits were widely recognized. Within twenty-five years no less than five peers elected to be commemorated in brass instead of by the more usual monumental effigy.[22] That of Lord and Lady Camoys at Trotton, Sussex, of 1419, is an excellent and early example of the new style which left the basic design unaltered but greatly increased the surface ornament (Figure 7). Comparison with the Little Horkesley brass of a mere seven years before (Figure 6) shows clearly the change in taste. The forbidding plate armour of the day has been made to provide scope for decoration: double lines have been used where one would serve, as on the sollerets and over the shoulders; the roundels over the armpits, the sword, and the dagger have all been given a patterned finish, and the mane and tail of the lion have been enriched by minutely engraved lines. The lady wears the wide jewelled hair-net so popular with the tomb-makers and has the unusual feature of a diminutive figure of her son standing beside her. Very ominous for the future is the first introduction of shading into English brass-engraving, visible in the folds of drapery around her feet. This brass, with its fan-shaped elbow-pieces and long-fingered gauntlets, is an early example of the work of a new shop, 'Series D', which emerges in about 1410. At first based fairly closely on the designs of the three earlier shops, it soon breaks away and becomes a major rival to 'Series B' during the middle years of the century.[23]

In 1421 the statutes for the Order of the Garter were revised by Henry V, and internal evidence proves conclusively that advantage was taken of the opportunity to enforce the rule that every knight since the foundation of the order should have a brass plate with his arms set up over his stall at Windsor.[24] Paid for by the Dean and Chapter, the plates were evidently ordered in a hurry in 1421–2, and were made by some six different firms. Four plates consist of solid oblong sheets and cost 7s each. Twenty-seven others have a striking cut-out design in which the shield is set at an angle below the helmet and cresting and is framed in a loose flow of foliage (Figure 8). This asymmetrical design for a coat-of-arms was not new – it occurred on a seal of John of Gaunt at least as early as 1374[25] – but

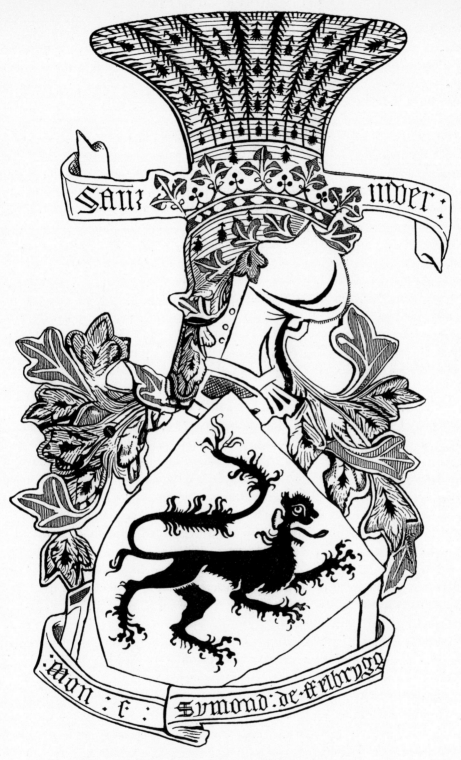

Figure 8. Enamelled brass stall-plate of Sir Simon Felbrigg. 1421–2.
Saint George's Chapel, Windsor, Berks

its popularity only became assured in the early fifteenth century. The artist of these twenty-seven plates was undoubtedly a very distinguished draughtsman and his designs have all the vitality, technical virtuosity, and decorative enrichment of the best of contemporary brasses.

<p style="text-align:center">★</p>

By the middle of the fifteenth century there are documentary proofs that the manufacture of alabaster panels was becoming a distinctive national industry. The style of the panels sticks fairly closely to that of the tombs, and tricks such as the abrupt folds of drapery over the feet are common to both at the same period.[26] On the other hand the tombmakers, even at the height of their output, only catered for a limited market, whereas the panels and tables had a far wider distribution both at home and abroad, and were consequently the first to suffer a deterioration of standards. The change from the panels with embattled headings to those with detached traceried headings seems to take place in the second and third decades of the century and is itself a significant sign of shop methods: for manufacture of separate headings in quantity by a specialist would inevitably speed up the rate of production. The subject matter of the panels remained much the same as before, but the iconography tended to change in the direction of increased pictorial effects and heightened dramatic relationships between the figures. Thus the Annunciation abandons the old formula of the Virgin and Gabriel standing in space in solemn conversation. On a tomb-side at Wells the Virgin kneels beneath a pinnacled canopy, praying at a desk. At her side is a huge conventional lily-pot. A diminutive Gabriel emerges from the sky bearing a long scroll, and the Holy Ghost in the form of a dove is swooping down from heaven to the ear of the Virgin with exhaust streamers trailing behind it (Plate 158B). These streamers are intended to be a visual indication of the breath of God the Father, from whose mouth the dove was originally conceived and shown as emerging. In the hands of these early fifteenth-century alabastermen this new version of the Annunciation in a firm physical setting, which was introduced by Italian painters at the middle of the fourteenth century,[27] is transferred into an assembly of conventional symbols arranged in strict conformity with a graceful rhythmical pattern. Executed with exquisite delicacy, the long curves of the right flank of the Virgin are picked up and repeated by the curling scroll and by the stems of the lily. Such masterly handling of what was by then a set design is nevertheless a rarity, and cannot be taken as evidence of the general quality of early fifteenth-century alabasters.

A retable at Nantes in Brittany, of about the middle of the century, displays something of the same characteristics (Plate 159A). The scene of Christ carrying the Cross is made a vivid scene of struggle, nearly all the details of which are to be found in contemporary miracle plays.[28] The ferocious-looking crew of executioners are tugging Christ along by a rope and are pulling down on the Cross to add to the burden, while Mary and Saint John are countering this pressure by lifting up one arm of the Cross. A feature common to this panel and the tomb slab is the linear emphasis and exaggeration of certain details, here exemplified in the extraordinary upward curl of the toes of Christ's left foot and the prominent muscles pulled taut around the knee.

No such distinction enlivens the ruck of mid-century alabaster panels, whose usual style is that of a retable at Santiago de Compostela in north-west Spain (Plate 159B). This is the only firmly dated alabaster panel of the whole fourteenth and fifteenth centuries, and as such is very precious. The retable was presented to Compostela in May 1456 by an English pilgrim, John 'Gudguer' (Goodyear?), rector of Chale, Isle of Wight, and since it is unique in representing the life of Saint James, it was evidently commissioned for the occasion.[29] It is preserved intact in its wooden case and topped by its detached open-work pinnacled canopies. The scene of Saint James preaching shows the usual pictorial effects tempered by artificial rhythms. The rolling waves, the identical nets, and the sweeping scroll bearing Saint James' words all betray the artist's preoccupation with pattern. But the empty, expressionless faces, heavy hands, and awkward gestures are evidence of an art form in decay. The draperies of the Saint are of interest since the manner of pulling the cloak sharply across the stomach with no apparent means of support is repeated in the weepers of an alabaster tomb chest at Tong, Salop, whose occupant died in 1451, and serves to date with fair precision some loose freestone statues at Winchester (Plate 160A).[30] The mid-century imager whose independent output now dominated all fields of sculpture thus imposed his tricks of style indiscriminately upon tombs, alabaster panels, and statuary.

<div align="center">★</div>

Though to-day only scattered fragments remain of early fifteenth-century architectural sculpture, sufficient has survived to give some indications of style and quality. The principal employment of freestone sculptors at this time was in the adornment of the enriched screen-work that everywhere proliferated in this age of chantries. The practice of founding chantries had begun in the thirteenth century as a cheap alternative to the foundation of a monastery, and as providing greater security for the execution of the prescribed masses than a casual benefaction to a religious house. By the fourteenth century, kings, lords, and prelates had begun to take the process a stage further by the erection within churches of small detached chapels set aside exclusively for the use of the endowed priest. This growth of private ownership of church space, by which a building designed for communal worship was cut up to provide room for the personal display and spiritual salvation of the individual, was the logical culmination of a process which began with the placing inside churches of ostentatious tombs in the thirteenth century. The fifteenth-century form of chantries exemplifies the ambivalent psychology of the age. Surrounded by screen-work that in many cases was covered with the personal devices and coats-of-arms of the individual, and in the case of Henry V with the exploits of the deceased, chantries were on the one hand evidence of the increasing confidence in secular power and riches. But their ultimate purpose, to ensure that priests should say masses for the dead, is witness of the deep uneasiness that underlay this ostentation, and of a panic-stricken retreat into the mechanical externals of religious practice.

It is clear that this growth of screen-work was no ephemeral or local movement but one of general significance. Local schools developed their own systems in general conformity with the prevailing taste. In the north, Beverley provides a large-scale example of niche-work covering a whole church front. The Norwich masons were responsible

for the florid but uncouth decoration of the Erpingham gate and the extraordinary tomb canopy at Hingham close by;[31] while in the midlands the Oxfordshire area shows much simpler external niches and even coarser statuary. The architectural sculpture of London in the early decades of the century can best be studied at Canterbury, where there is documentary proof that the choir screen itself was built by Prior Chillenden some time between 1390 and 1411. To judge from the great complexity and enrichments of the tabernacle work it seems certain that it must have been carried out towards the very end of the Prior's life, an hypothesis that is supported by the fact that the surviving statues in the niches are of a later date. The upper row of statuary and others round the door were destroyed by the Puritans in 1642, but the six main figures of kings were left undamaged. Of these the two flanking the door, of Ethelbert (Plate 153A) and Edward the Confessor, were paid for out of a benefaction during the time of Prior Woodnesborough, 1411–27.[32] The other four kings on the screen have been taken to represent Richard II and Henry IV, V, and VI, thus presupposing that they were not carved till towards the middle of the century and were designed to emphasize the dynastic claims of the Lancastrians. But such identifications are very uncertain and it is impossible to detect much stylistic difference between these four and the other two. The importance of these kings lies in the fact that they set the pattern for London figure-work for the next half-century. The impressive, rather sulky features, the compact heads, the holding of some symbolic object, the carving in the round of heads and arms, the smooth, deeply cut flow of drapery with pronounced vertical zigzags persist through the Warwick window of 1443–7 to the Oxford Divinity School screen-work of 1481 (Plates 166 and 176–7). All these features are evidence of the impact upon London of Flemish–Burgundian sculpture in its calmer mood of the generation after Claus Sluter, though interpreted in a far colder and less imaginative way than the originals. The value of this new influence can be gauged by comparing the crude and clumsy kings from Westminster Hall of 1385 with these mature and dignified monarchs at Canterbury. They are not great art, but they have the self-assurance and technical accomplishment that one expects from the style of the capital.

The principal activity of the court sculptors during the 30s and 40s was the execution, according to the designs of John Thirsk, the King's Master Mason, of the screen and of Henry V's chantry at Westminster Abbey. Of the screen which separates the presbytery from the Confessor's Chapel not a single statue remains, but even in its fragmentary condition it provides an excellent example of enriched tabernacle work. Completed in 1441, it was presumably erected in the late 30s just before work on the late king's chantry was begun.[33] Running along the cornice of the screen is a band of ornament consisting of a scroll of flowers and berries executed in high, undercut relief over a hollow, a system of ornament that was becoming almost universal in fifteenth-century sculpture both in France and in England. Below is a run of little narrative scenes relating the life of Saint Edward, each scene being separated from the others by a large trefoil. The usual strong pictorial sense, the insistence upon a straightforward and dramatic representation of the story, is well in evidence. But if typical of the art of the court sculptors, the style of the carving is very disappointing. The relief is shallow, the crowded, stumpy figures fail to emerge clearly from the background, and there is no sense of movement whatever.[34]

On 7 November 1422 the body of King Henry V was interred at Westminster Abbey with unprecedented pomp and ceremony.[35] But no immediate steps were taken by the executors for the construction of his tomb and effigy, and the iron grating around it was not put in place before 1431. The tomb itself is a simple affair of Purbeck marble ornamented with quatrefoil panels like those of Edward III and Richard II. But for the effigy the executors were unfortunately tempted to experiment in a new material, a wooden core covered in silver gilt plate, with solid castings for the hands and head, the angels beside the cushion and the beasts at the feet. Such a display of precious metal placed too great a temptation in the path of human cupidity, and as early as 1467 many of the cast fittings had already been stolen. The remainder disappeared in 1546, and to-day nothing remains except the headless wooden core.

In his will drawn up in 1415 the King left orders for the construction above his tomb of a chantry chapel with an altar dedicated to the Annunciation of the Virgin. The building of this first-floor edifice with its bridge spanning the ambulatory was not taken in hand till 1438, and had probably not advanced very far before 1441. In view of its size and complexity it is unlikely to have been completed before 1450, though we know that the floor was in place before Thirsk's retirement in 1452.[36] The screen-work of this chantry marks the apogee of early fifteenth-century sculptural ornamentation. The whole available surface is bespattered with openwork pedestals and tabernacles, statues large and small, narrative reliefs, and row upon row of heraldic devices. These last consist of an antelope chained to a beacon, and a swan with a chain hanging from the crown about his neck. The swan is the device of Henry's mother, Mary de Bohun, and the antelope and beacon is a garbled interpretation thirty years later of Henry's emblem of an antelope drawing a horse-mill, representing the first part of the motto: 'After busie labour commeth victorious reste.' The main body of the sculpture was equally devoted to the personality of the King, the north and south external facings of the chapel being covered with representations of the two principal moments of his coronation, when the crown was placed on the royal head and when the peers did fealty to the new king. In the other two principal reliefs the King is galloping at full speed against a carefully delineated background whose horizon rises almost to the top of the composition (Plate 162). The significance of these scenes is unknown, though they presumably record episodes in the military life of King Henry. A sense of scale and perspective was as despised by these fifteenth-century artists as it was by their predecessors. But whereas earlier artists distorted and exaggerated with a primarily aesthetic purpose in mind, the Westminster sculptor has distorted merely to emphasize the details of his story. For example the unfortunate persons hanging from the battlements of a castle in the background of one of the galloping scenes are made taller than the castle wall, merely so that there can be no mistake about the artist's intention.

This earnestness of purpose and clumsiness of execution are repeated in the major statuary, for which two octagonal stair turrets at the west of the chantry form openwork scaffolding supports. This extraordinary lattice-work system, which may have been inspired by the stair turrets at the Sainte-Chapelle in Paris, is an architectural fantasy whose brilliance the sculptor was unfortunately unable to match. The heavy head of a

king with his matted beard is in line of descent from the Westminster Hall and Canterbury screen figures, but the draperies are caught up in irregular folds that have not hitherto been seen (Plate 161). Other statues, like that of Saint John the Baptist, have the bulging eyes and flattened features of contemporary alabaster panel-carving (Plate 160B). All these statues are handled in a solemn, static manner, the draperies entirely conceal the shape of the body, and the faces lack expression and subtlety. Neither the sturdy realism of the London tomb-makers of the early fifteenth century nor the impersonal delicacy of the midland alabaster effigy-carvers seem greatly to have influenced these London freestone imagers. There can be no doubt, however, that one or two of these statues show clear evidence of an attempt to imitate the drapery and figure style of the early Flemish artists, Jan van Eyck and Roger van der Weyden. The strange vertical zigzag hem of the drapery of a king, and the crossed hands, bare, turned-back head and the deep clumsy crumpling of the drapery over her knees of the Virgin of the Annunciation are all to be found in Flemish paintings (Plate 163).[37] Despite his rather clumsy handling, particularly of the drapery, the sculptor of this Virgin has succeeded in capturing something of the grace and innocence of early Flemish art.

The second quarter of the fifteenth century was the period of activity of the only medieval sculptor of whose career we have any substantial knowledge. In 1409 there was a young apprentice carpenter in London called John Massingham, and twenty years later a sculptor of the same name makes his appearance at Canterbury doing work about the city such as an inn sign for the Sun Tavern in 1436.[38] Between 1438 and 1442, John Massingham 'factor imaginum' and his two assistants, Thomas Whitlock and John Massingham junior, spent many months each summer at Oxford, working on Archbishop Chichele's new foundation of All Souls.[39] Massingham was paid 4s 8d per week in addition to board and lodging and was thus by now evidently a sculptor of some standing. Upon what he based this reputation we do not know, though he may have been responsible for the four outer kings on the screen at Canterbury. The most important sculpture at All Souls was the imagery for the great reredos in the chapel, the principal statues for which were carved in January 1442 by the Massinghams *père et fils* whose joint weekly wage now amounted to 8s. Of this there survives only the tabernacle work of niches and pedestals, which bear a close resemblance to the contemporary work on Henry V's chantry. The other statuary consisted of two life-size figures of Archbishop Chichele and Henry VI and a relief slab of the Resurrection, set in the gate tower. The slab is known to have been renewed in 1826–7, and the two statues, now removed to the cloister, are in such excellent preservation that they must also be viewed with some suspicion.[40] There is thus nothing at All Souls that can definitely be ascribed to the chisel of Massingham. His movements in the next few years are unknown, but there is a strong presumption that he took a hand in the sculpture of some of the statuary for Henry V's chantry, particularly since he is known to have become a citizen of London at least by 1449.[41] In this year he made an image of the Virgin for the high altar in the old church at Henry VI's new foundation of Eton College, for which he was paid the very large sum of £9 6s 8d. But it is a very revealing commentary on the medieval attitude to sculpture that the painter of this statue, Robert Hickling, received £6 13s 4d for his pains, or over two-thirds the reward of Massingham.[42]

The sum of course includes the cost of materials, in particular the gilt, but these payments for carving and painting show the relatively humble role still assigned even to the most outstanding sculptor of the day.

<div align="center">★</div>

The greatest achievement of the mid fifteenth-century sculptors was not any of the King's works at Westminster, Eton, or King's, nor even Archbishop Chichele's foundation of All Souls: it was the chantry chapel erected by the executors of Richard Beauchamp, Earl of Warwick, at Saint Mary's, Warwick.[43] The Earl was one of the greatest and richest magnates of the realm, a man who was spending over £5500 a year,[44] and when he died in 1439 after a distinguished military career he left instructions for the erection of a chantry chapel in his memory. Comparison with the Chartreuse de Champmol, erected half a century before by the Duke of Burgundy, can only be invidious. But in a minor key and with less extravagant display, erected at a cost of under £2500, the Beauchamp chapel is to England what Champmol was to France. Building began in 1443 and progressed fairly rapidly, the roof being on by 1447 and the windows finished two years later. All the surviving contracts, for the glass, the woodwork, and the marble and copper work of the tomb, prove that the executors dealt with the leading Londoners in the various crafts, and there is therefore a strong presumption that the architectural sculpture was also London work. It has been claimed that there is documentary evidence to show that a great deal of the sculpture was done by John Massingham, but this is unfortunately incorrect.[45] In the vault are a series of circular bosses like that in Henry V's chantry, but here decorated at the sides with naturalistic foliage of strawberry, blackberry, rose, and even parsnip – a repertoire entirely different from that of the late thirteenth-century sculptors. These plants from the English garden found their way into fifteenth-century manuscripts as a result of the growing sense of realism and thence spilled over into sculpture. There is very little animal carving in the chapel except an energetic little scene of combat in a corner of the internal string course (Plate 167A). Both in this and in the usual run of leaves and berries along the string course there is proof of vigour of design and perfect technical mastery.

A principal feature of the chapel is the east window, whose jambs and mullions are entirely covered with double rows of statues set between the usual heavily ornamented pedestals and canopies. At the apex of the window is the Almighty seated in the radiating aureole that was already familiar to fifteenth-century artists in all media. The remaining figures comprise the nine orders of the Hierarchy of Angels, together with four female saints.[46] The figures of the angelic host are heavily charged with late medieval intellectual symbolism. The seraph is usually associated with flames, so here at Warwick he stands in a sea of fire, his hair is a radiating wheel of flames, and much of his clothes is of fire. Around his neck are star-studded clouds, and the waters lap his waist. Half a century later Colet described the cherubim as 'most glorious beings of light, shining in nature beyond aught that can be conceived, with the multitudinous wisdom of God.' Thus the cherub wears a star-tipped crown, bears an enormous collar of radiating beams around his neck, and has another large wheel-shaped star within a border of clouds behind his calves. For reasons which are not yet clear the cherub stands on water, possibly the 'waters which were above

the firmament'. The angel of the Expulsion is covered with small feathers that may perhaps be copied from the feathered tights worn by actors in mystery plays, and is adorned with a star necklace and cloud and star girdle (Plate 166A). The symbolism is here very obvious, since he bears an apple branch in one hand and in the other an enormous sword. Below this elaborate, theological exercise in stone are four female saints with their usual attributes (Plate 166B). Despite the extraordinary elaboration of symbolic detail these statues have a quiet, restful appearance with no trace of violent movement. They are very close in style to the Canterbury kings and the two statues at All Souls, and evidently come from the same workshop, if not from the same hand. There is no hint here of the crumpled draperies of Flemish painting whose influence has been noticed in some of the contemporary carvings of Henry V's chantry at Westminster. If these carvings are indeed by Massingham, this would not be surprising, for he would be an old man by now and unlikely to be open to new ideas.

The centre of the chapel is occupied by the tomb upon which lies the effigy of the Earl. The tomb itself is of Purbeck marble supplied by John Bord (or Bourd) of Corfe Castle, Dorset, 'according to a portraiture delivered to him', the contract being sealed in 1447.[47] The author of the 'portraiture' is not known, but the association of the London marbler John Essex of Saint Paul's churchyard with one of the other tomb contracts suggests that he may have been responsible. He was a man of some distinction, being later consulted when Henry VI was contemplating the erection of his own funeral monument at Westminster.[48] The design is somewhat old-fashioned, with the usual 'housings' for individual weepers, each with his armorial escutcheon below. There is no hint of the new Burgundian method of reconstituting the funeral procession by bringing the weepers into direct relationship with one another, freed from the cramping isolation of the niches.[49]

Within these niches are set a series of aristocratic relatives of the Earl interspersed with scroll-bearing angels, all in cast copper, gilded and polished. They were cast in 1452–3 by a founder of London, William Austen, according to 'patterns made of timber', and were gilded by 'Bartholomew Lambespringe, Dutchman'. Austen was certainly no more than the artisan responsible for carrying out orders, being paid a mere 13s 4d apiece for the weepers. Lambespringe, on the other hand, was responsible for the polishing and gilding and for making 'the visages and hands and all other bares of the said images, in most quick and fair wise.' His reward for the thirty-two images was £40, exclusive of the cost of the gold. But there is no reason to suppose that he was the designer, whose anonymity is impenetrable despite the wealth of documentary evidence. The male weepers are all dressed in their Parliament robes, displaying tippets barred with ermine and gold appropriate to their rank. But the carver of the wooden models has reversed the pattern, so that the tippets appear at the left shoulder instead of the right. This display of Parliament robes links the designer with London, where perhaps a year or two before there had been carved on Henry V's chantry the rows of peers in Parliament attending the Coronation. In Lambespringe's instructions the essential adjective is 'quick'. This did not mean that Lambespringe was to make true portraits of the individuals represented, but that his weepers were to be life-like representations of mourners with sorrowing faces and downcast eyes beneath their hoods (Plate 165). These tragic expressions, these heavy

hoods and covered hands and the careless crumple of the thick draperies are further clear signs of the impact of Flemish–Burgundian sculpture upon English art. Beginning with the mourners on the tomb of Philippe le Hardi at Champmol in about 1404–12, these intensely dramatic figures had slowly spread over northern Europe.[50] Two heads from the Abbey of Anchin, near Douai, though more coarsely executed in the rougher medium of free-stone, are very similar in pose and facial expression to the Warwick figures.[51] Hardly less close, particularly in the emphasis upon the bone structure of the face, is a late fifteenth-century Burgundian statue at Mesmont (Côte-d'Or).[52] The draperies at Warwick are precisely what is expected in a work influenced by Burgundian art of the middle of the century in transition from the billowing extravagance of Sluter to the simpler lines of the late fifteenth-century 'apaisement du style'. It is tempting to speculate on the possible role of the 'Dutchman' Lambespringe in influencing the design of these weepers; at all events whoever was responsible was an artist of exquisite refinement and sensitivity.

The central feature of the whole chapel is the life-size cast copper effigy of the Earl, which is one of the greatest achievements of the English medieval sculptor (Plate 164). The initial contract for this image was drawn up in 1449 between the executors and four London craftsmen, Roger Webbe, barber-surgeon, William Austen, founder, John Massingham, 'kerver', and Bartholomew Lambespringe, goldsmith. Unfortunately the seventeenth-century abstract clearly omits all but the first and last paragraphs of the contract, so that there is no mention of the tasks assigned to Austen, Webbe, and Massingham.[53] But as Austen's duties were later defined as the casting of the image 'according to patterns', it is evident that it was in the making of the wooden model that Massingham and Webbe were to be employed. It must be remembered that the Earl had now been dead ten years, and it is possible that Webbe had been his doctor and was therefore thought to be the most reliable source of information about his physical appearance. Alternatively Webbe was associated with Massingham simply to give general anatomical advice in accordance with the desire for realism. Certainly the careful veining of the temple and hands of the image reflects a conscientious fidelity to minute physical detail. One might therefore with some confidence ascribe the effigy to Massingham, advised by Webbe, were it not for a mysterious and incomplete entry in the accounts for 1448–9: '... Clare pictori pro effigie picture [sic] – 8. 0. 0',[54] which seems to suggest that the original design was the work of a painter named Clare. Such division of the artist's function was certainly not unknown in the Middle Ages. For example in 1511–14 no less a person than Torrigiani seems to have been obliged to execute the effigy of Lady Margaret Beaufort in West-minster Abbey according to a design made by the painter Meynnart Vewicke.[55] In view of this uncertainty, it must reluctantly be admitted that it is impossible to point to any surviving piece of sculpture which can confidently be ascribed to the hand and brain of John Massingham.

The effigy, like that of the Black Prince half a century before, is cast as an independent statue, the back being as perfectly finished as the parts that are visible.[56] The casting is in seven pieces, made from a soft alloy with a copper content as high as 84 per cent.[57] The softness of the metal helps to explain the importance of the role of Lambespringe, whose finishing process by means of engraving, polishing, and gilding was evidently regarded

as of greater artistic significance than the actual casting by Austen. The armour is of great interest since it exactly reproduces a contemporary suit of the finest Milanese workmanship. Evidently some suits of this armour had reached London by the 40s, since a number of brasses of 'Series D' also reproduce it.[58] In view of these brasses there is nothing surprising in finding this armour on the effigy, and suggestions that the suit was a personal possession of the late Earl or that it proves direct artistic connexion with north Italy or south Germany need not be entertained.[59] The effigy provides the most outstanding example that had yet been seen in England of the new realism: both in the human anatomy and in the smallest details of the armour there is displayed a meticulous fidelity to nature. Whether the long face and straight nose is a true representation of the late Earl's appearance, we cannot say. But it is certain that the artist has deliberately set out to reproduce a living person in real armour, and it is this interpretation of the artist's function that is important.

Writing in 1646, Bruno Ryves recorded that the tomb and effigy of Richard Beauchamp, Earl of Warwick, is 'in the opinion of judicious observant Travellers esteemed the rarest Piece erected for any Subject in the Christian World.'[60] If the tombs of the Dukes of Burgundy at Champmol are excluded on the ground that they were not 'subjects', it must be conceded that this claim of the seventeenth-century antiquary is not entirely without foundation.

CHAPTER 15

THE LAST PHASE

⟨CIRCA 1460–1540⟩

As knowledge deepens both of the architectural and the economic history of the fifteenth century, it becomes apparent that a good deal of building that is conventionally labelled 'fifteenth century' in fact belongs to the period 1460–1530. Furthermore, the evidence is increasing for believing that political and economic recovery from anarchy and slump began at about the same time. The year 1485 is ceasing to have over-riding significance as a landmark in political history as the achievements of the Yorkists in beginning the restoration of administrative order are put in their right perspective. Similarly such indications of economic activity as are available – the figures for foreign trade and the evidence of extensive conversion to pasture farming to cope with an increasing demand for wool – bear witness to reviving prosperity in the last third of the century.

But it is important to realize that there is no direct correlation between general economic prosperity and the investment of capital in architectural or sculptural undertakings. An examination of the wills of the nobility shows convincingly that in the fifteenth and early sixteenth centuries testators were devoting a much higher proportion of their disposable property to tombs, chantries, and the saying of masses than in the century before.[1] Anxiety about the prospects of salvation and an increased interest in securing a worthy memorial combined to stimulate this process. Churchwardens' accounts show a parallel devotion of the resources of the less affluent to the building and adornment of churches,[2] and the extraordinary architectural and sculptural output of the last phase of the Middle Ages is to be attributed as much to a quickened interest in religious construction–whatever may have been its cause – as to an increase of available capital. This combination of individual benefactions and parish subscriptions provided the money for a lavish re-equipment of the internal fitting of churches; wooden screens and pulpits, alabaster images and panels were everywhere in high demand. Whatever opinion there may be about quality, there can be little doubt of the extraordinary expansion of quantity. Big workshops sprang up in the main cities which produced more or less standardized articles to serve a wide local market. There is some reason to think that never before or since were so many sculptors in active employment in England, and never were their financial rewards so high. The exceptional individual has usually obtained his deserts, but only in the fifty years before the Dissolution of the Monasteries did the sculptor force his way on a substantial scale into the ranks of the urban bourgeoisie. In the forty years from 1423 to 1462, only five alabastermen or carvers were admitted Freemen of York, in the years from 1463 to 1502 there were fifteen, and from 1503 to 1542 there were twenty-seven.[3] Never before or since in England have the sculptor's labours been rewarded with high civic dignities. Edward Hilton, 'image-maker', was Sheriff of Nottingham in 1484–5; Walter Hilton, 'alabasterman', was Mayor of Nottingham in 1489–90 and again in 1496–7;

Thomas Drawswerd, 'carvour', was Mayor of York in 1514–15 and again in 1522–3; William Carver, *alias* Bromflet, was Wakeman of Ripon in 1511.[4]

The reassertion of the political authority of the Crown was both cause and effect of its success in tapping sufficient of the new wealth to restore Crown finances. As a result, the court under Henry VII and his son resumed its natural place as the leading patron of sculptors and architects, the most obvious symbol of which is of course Henry VII's Chapel at Westminster and the monuments it contains. But this patronage was inevitably more cosmopolitan and up to date in its scope than that of lesser men, and it is *via* the court that Italian Renaissance art made its earliest impact upon medieval sculpture. The engagement first of Guido Mazzoni then of Torrigiani for the royal tombs, the use of Giovanni da Maiano to decorate Wolsey's Hampton Court with terra-cotta medallions, were signs of a new influence upon sculpture that bore no relation whatsoever to the native medieval past. But so different was this Italian Renaissance art that for the most part there was little intermingling with the older style, and it never became a very significant factor in Early Tudor sculpture.

Far more important in its effects was the migration of Low Countries artists into London and their employment by the Crown. The close commercial links between London and Antwerp through the channelling of the expanding English cloth trade into these two ports resulted in an intimate exchange of goods, persons, and ideas. Though the Englishman William Berkeley was the chief 'Kerver' in the royal chapel of Windsor, the really important figure sculpture for the rood-screen in 1477–8 was entrusted to two Flemings, Diricke van Grove and Giles van Castell.[5] It is interesting to note that they were still paid after the medieval fashion of so much a foot; there was no hint as yet of the emergence of the Renaissance concept of the individual genius of the artist and the unique merit of his work. In 1492 a Laurence Emler made a statue for Tower Bridge; in 1501 a 'Laurence Kerver' was doing heraldic sculpture for the King; five years later a Swabian of the same name obtained naturalization and a Laurence Ymbar made a bid for the contract for the design of the effigies for Henry VII's tomb at Westminster.[6] The presumption is that these references are to the same man, a German sculptor working in London. It was a Flemish engraver, Alexander of Bruchsal, who designed the third set of coinage for Henry VII in 1494. Flemish glaziers settled in Southwark were responsible for the glass of King's College Chapel, contracted for in 1515, and may well have been also employed at Westminster, though there is no documentary evidence for this.[7] The bronze screen that surrounds the tomb of Henry VII at Westminster was the work in 1505–6 of 'Thomas Ducheman', possibly in association with the Flemish painter Meynnart Vewicke.[8] It was the latter who in 1511–12 drew the 'patrons' from which Pietro Torrigiani cast the bronze effigy of the king's mother, Lady Margaret Beaufort.[9] And there has even survived a page from a sketchbook by an early sixteenth-century Flemish artist which includes drawings of English fan-vaults and window tracery, almost certainly taken from King's College, Cambridge, and some sketches of figures and heads.[10]

Imported works also played their part in disseminating Flemish styles and ideas. The bronze grille around the tomb of Charles Somerset, Earl of Worcester, at Windsor, is almost certainly the work of the Malines founder Jean van den Eynde of about 1520, the

brass lectern at Norwich is from the same mould as another from Bornival, near Nivelles, and the great cast bronze cooking pot for the nuns of Lacock Abbey was made by Peter Wagherens of Malines in 1500.[11] Easily the most powerful influence on English sculpture during the Early Tudor period was the result of this migration of artists and objects, a style conveniently, if inaccurately, described as Flemish. But its acceptance involved no radical break with the past, since it was itself rooted in medieval art.

Stylistic development is far from clear in the last seventy years of the Middle Ages, and there is greater diversity between different sculptural trades and regions than before. There is a western and a northern style of wood-carving; alabaster tomb-effigies seem to bear little relation to architectural statuary, and in local churches there is evidence of a triumphant revival of what can only be described as primitives. The study of this last phase must consequently be heavily compartmented and be subordinated to factors of psychology, geography, or technology as much as to the evolution of style.

<p style="text-align:center">*</p>

One of the most obvious features of fifteenth-century mentality is its melancholy and its morbidity. Deep emotional instability found expression in an excitable oscillation between spiritual exaltation and abasement, between a display of worldly pride and an extravagant rejection of the good things of life. In a period of political unrest and religious uncertainty, coming at a time when the expectation of life seems to have been lower than at any time since the Conquest, a preoccupation with death was only to be expected. By the beginning of the fifteenth century French artists were beginning to place great emphasis on the macabre tale of the Three Living and the Three Dead, and on lavish embroidery upon the theme of the Dance of Death.[12] Sculptors in their turn adopted this harping upon death, and as early as the very beginning of the century French memorial effigies are found which take the form of emaciated corpses.[13] Not content with this ghastly representation the sculptors hastened to press home the moral. As an epitaph to Archbishop Chichele of Canterbury, there was inscribed the forbidding legend:

> Pauper eram natus, post primas hic elevatus,
> Jam sum prostratus et vermibus esca paratus.
> Ecce meum tumulum. MCCCCXLIII.[14]

Other inscriptions were more terse and even more directly addressed to the reader: 'Sum quod eris, fueram quod es'.

It appears to have been in England in the late 1430s that the most impressive illustration of the theme of physical corruption was first developed. Above on the tomb slab lies the effigy in the glorious panoply of bishop or knight. Below, the walls of tomb and coffin are cut away to reveal the emaciated corpse within, naked on its winding sheet. Sometimes the stomach lies hollow and empty, eviscerated by the embalmer's knife, sometimes worms creep about the body upon their busy occasions. In the end even royalty succumbed to the fashion and Edward IV in his will ordered his body to be covered with a stone 'wrought with the figure of Dethe', while above in the chantry chapel was to be a splendid effigy in silver gilt, 'or at the lest coopre and gilt'.[15] Some indication of the ambivalent attitude of the patrons of these double tombs is provided by Bishop Beckington of

Bath and Wells. Secretary to the King and later Keeper of the Privy Seal, Beckington led an active career at the centre of the political scene. In 1451, thirteen years before his death, he constructed his chantry tomb in the south aisle of the choir of Wells, an alabaster effigy in full episcopal robes above, and the emaciated cadaver below. In the same year he contracted with the burgesses of Wells to provide them with a water supply in return for an annual visit in perpetuity by the city dignitaries to his tomb to pray for his soul, for which beneficial action he promised forty days' indulgence. In January 1452 the Bishop finally consecrated his tomb before a large congregation and proceeded to say mass for his own soul.[16]

This emphasis upon the corruption of the flesh as opposed to the salvation of the soul marks a profound psychological change in the human outlook.[17] In the fourteenth century smiling angels were confidently lifting the soul to Heaven; now physical decomposition is the principal subject of interest. Strangely enough this concentration upon the material finality of death found greatest popularity among the higher ecclesiastics of the age, and all but two of the early group of cadaver tombs of the 30s and 40s are of the clergy. But one of the earliest memorial representations of the corpse in English art, apart from one or two shroud brasses of the early 30s in Kent,[18] is nevertheless in memory of a layman, Sir John Golafre, at Fyfield, Berks (Plate 168). It sets a uniform iconographical pattern of cropped hair, taut neck muscles, hollow eye-sockets, and left hand held across the genitals that was to last for over a hundred years.

At the very end of the medieval period, just at the time of the Reformation, this macabre genre reached its apogee in the tomb of John Wakeman. It might be supposed that a man who was employed as chaplain by Henry VIII, and who when the crisis came moved serenely from last Abbot of Tewkesbury to first Bishop of Gloucester, was of a prudent and worldly disposition. But his tomb at Tewkesbury, which was almost certainly erected in his lifetime as Abbot, tends to belie this judgement. Upon the slab lies a corpse in the actual process of putrefaction, upon which are feeding worms, lizards, mice, frogs, and snails. A parallel to this extreme morbidity is the brass at Oddington, Oxon, of the Rev. Ralph Hamsterley who died in 1518, in which the waving tails of hungry worms are prominent elements in the composition (Figure 9).[19]

There were not many of these cadavers carved in the fifteenth century – I know of less than twenty – so that the theme was evidently not universally popular. In particular the carvers of alabaster tombs whose products still dominated the field seem to have been reluctant to add this novelty to their repertoire.[20] But a number, principally of ecclesiastics, continued to choose this macabre form of memorial right through the sixteenth century, now more frequently without the superimposed effigy in life, and that of Precentor Bennet of Salisbury who died in 1558 differs little from that of Bishop Beckington a century earlier. It is a medieval tradition which triumphantly survived the impact of Reformation and Renaissance, to provide one element in the mental attitude of the metaphysical poets and a continuing theme of the seventeenth-century tomb-carvers.

A further consequence of this concern with the physical aspect of death was the corollary of an increasing preoccupation with blood and suffering. The Virgin was depicted seated in an attitude of desolation with the naked body of the dead Christ lying across

Figure 9. Shroud-brass of the Rev. Ralph Hamsterley. *c.* 1510–15. Oddington, Oxon

her knees. Introduced into continental art before 1360, there are a number of such representations by the alabaster carvers of the late fourteenth and early fifteenth centuries.[21] 'Swet Jhesu,' wrote Richard Rolle, 'thy body is lyke a boke written al with rede ynke; so is thy body al written with rede woundes. Now, swete Jhesu, graunt me to rede upon thy boke and somewhat to undrestond the swetnes of that writinge.'[22] Like that of so many mystics, Rolle's imagery was couched in terms of blood. And so in presentations of the Crucifixion, blood is shown spurting out of the wounds, to be caught in cups and goblets held by angels; later still the blood falls into the Fountain of Life around the Cross, or is used in a spiritual wine-press. Such was the emphasis upon suffering that the instruments of torture themselves became objects of worship, and appear in a series of early sixteenth-century wooden bosses in the presbytery of Winchester, along with other gory emblems of the Passion such as Malchus and his severed ear (Plate 167B). These emblems are set upon shields, and by a typical late medieval conceit are regarded as *Arma Christi*, the heraldic blazoning of Jesus.[23] The vigorous character of these bosses is typical of the bold carving and simplicity of statement of the carvers of the sixteenth century who turned their backs on the cramped detail of their predecessors. Apart from the emblems of the Passion, the bosses show a rich variety of royal Tudor arms and heraldic combinations associated with Bishop Fox. The heraldry indicates that they were carved between the official engagement of Henry and Katherine of Aragon in 1503 and their marriage in 1509.

<p style="text-align:center">*</p>

Evidence of ever more extensive manufacture and trading in alabaster panels accumulates steadily during the late fifteenth and early sixteenth centuries, and the trade had by now become sufficiently large to warrant distribution by travelling salesmen working for the manufacturers. We hear of one such salesman, William Bott, in 1491, and another, John Broke, 'factor', in 1521.[24] The alabaster carvers, ever sensitive to the needs of a mass market, were of course affected by the fifteenth-century passion for morbidity. Their Crucifixions were bloody; they specialized in the martyrdoms of the saints. Disembowelling, boiling, shooting with arrows, beheading, there was no form of violent death they did not carve to gratify the wishes of their patrons.[25] Besides these stock panels there grew up in the late fifteenth century a large-scale trade in little plaques with the device of Saint John the Baptist's severed head upon a charger, often associated with the Lamb and sometimes with attendant saints.[26] The records suggest that Nottingham was a principal if not the only centre of manufacture of these devotional objects. In 1491, Nicholas Hill, alabasterman of Nottingham, sued his travelling salesman for the value of no less than fifty-eight such heads that the latter had been given to sell.[27] The heads were very cheap, at between 1s and 1s 6d each, and were evidently sold to the laity on a large scale. The precise purpose of these heads and their relationship to the sacrament is far from clear, but there is some evidence to suggest that they were adopted as their badge by certain guilds, in particular the Corpus Christi Guild of York. The York service books seem to offer an explanation of their significance: 'Caput Johannis in disco: signat corpus Christi: quo pascimur in sancto altari: Et quod ecclesie gentium tribuitur in salutem ac remedium

animarum. It seems clear, therefore, that these heads were hung up in private rooms as devotional objects of practical assistance in the salvation of the soul.

Although the vast bulk of the surviving alabaster heads is evidently the product of cheap mass production, documents of the late fifteenth and early sixteenth centuries prove that heads in alabaster or precious metal were common possessions of kings and noblemen. It is to be supposed that these were of exceptional quality, and a unique head with its original paint in the Victoria and Albert Museum is probably one of these rare pieces (Plate 169). The red blood dripping from the head wound vindictively inflicted by Herodias in her moment of triumph, the parted lips and eyes squinting in death beneath the heavy lids, the spiral tufts of hair framing the pallid face, all combine to create a most powerful and grisly impression. There is no good reason to doubt the English provenance of this alabaster, outstanding though it is from the general ruck. There is no evidence that other countries made such alabaster heads, and the position and angle of the wound, and the very distinctive artificial arrangement of the hair are just the same as those of heads of accepted English provenance.[28] There is nothing that can help to narrow the date of this remarkable carving, which may belong to any time in the last century of the medieval period, from 1440 to 1540.

Of the tormented conscience and half-suppressed hysteria to which these gruesome sculptures bear witness, the carvers of alabaster tomb-effigies remained largely oblivious. Smooth and impressive as ever, their style altered but little generation after generation, and were it not for the changes in armour and costume it would be difficult to detect much development. Of London works in the grand manner the period is singularly deficient, the only probable exception being the elaborate tomb of Alice, Duchess of Suffolk, at Ewelme, Oxon (Plate 170). The Duchess died in 1477 and there seems no reason to doubt that the effigy was carved in the 70s. Lying in calm repose in her widow's veil and barbe – her husband was murdered in 1450 – with the Garter ribbon around her left arm, she has the same air of aristocratic detachment as Queen Joan half a century before. The face is now longer and heavier and the carving simpler and more boldly undercut. The angels supporting the cushion lie right back and wear the feathered tights that were seen in the statues of the Beauchamp Chapel (Plate 166A). The tomb-sides with rows of shield-bearing angels below ogee canopies have hardly altered in the fifty years since the Lowick tomb. But below, barely visible through openwork tracery, lies the peculiarly horrible cadaver of an emaciated and shrunken elderly female; the breasts are shrivelled and sagging and every muscle is stretched taut in the grip of *rigor mortis*. By this cadaver the alabaster tomb-makers proved that when required they could excel in the macabre genre, even if it lay outside the normal practice of their trade.

In the middle of the century the Nottingham centre continued to distribute the usual military effigies displaying in meticulous detail the plated extravagances of the new Milanese-inspired armour. The only change was that it had become a universal practice to depict the knight bare-headed. A fine example of this group is the effigy of Robert, Lord Hungerford, in Salisbury Cathedral, which probably dates from about 1460 (Plate 171). Almost identical copies of this effigy survive at Christchurch, Hants, and Dunmow Priory, Essex, which suggests that in the tomb trade standardization was on the increase.

Both the Ewelme and the Salisbury effigies have none of the rich, jewelled texture of the early fifteenth-century effigies; they obtain their effects rather by bolder cutting of such detail as remains and by a more strongly developed sense of modelling.

The same qualities may be seen in a group of three Dorset effigies at Puncknowle and Melbury Sampford, which are probably the work of yet another *atelier*, possibly at Bristol (Plate 173). They are remarkable for the abandonment of the standard bare-headed design in favour of one showing the late fifteenth-century fighting helmet, the salet. Furthermore, all lie on Purbeck marble tombs beneath Purbeck marble canopies, which strengthens the suggestion of local workmanship. The two Melbury Sampford effigies, which are firmly dated to 1467,[29] display a feature that was to become very common, a smooth curve of mantling running down the side of the tomb from beneath the knight's head.

Twenty years later, by the end of the century, large clumsy heads with long hair come into fashion, and it becomes hard to distinguish the style of any one workshop. A tomb to one of the Redman family at Harewood, Yorks (Plate 172A), is presumably a product of the York sculptors. The lady and the angels have the protuberant button eyes of the figures on contemporary alabaster panels, but the draperies and armour are far more competently, if coldly, executed. The effigy of the Earl of Wiltshire at Lowick, North-ants, which must be a midlands product, shows the same large, coarse face with long hair. The Earl is wearing over his armour a tabard bearing elaborate heraldic blazonry that was originally coloured, a symptom of the increasing emphasis on heraldry in the art of the Early Tudor period. The ancient arrangement on the tomb-sides of weepers or angels holding shields is abandoned in favour of a simple and elegant design of small shields set in lozenge-shaped panels, a system repeated on contemporary Nottinghamshire tombs at Holme Pierrepoint and Strelley.[30]

The art of brass engravers during the third quarter of the fifteenth century bears little relationship to the coldly competent style along traditional lines of the alabaster tomb-makers. There was a sharp decline in the size of slabs in the 1460s, evidently to keep up the demand by reducing prices. At the same time, the engraving became more and more slipshod and shallow-cut, and the boldness of pattern essential to brass design was lost in a spread of hatched shading. Nevertheless the engravers were enabled to do full justice to the extravagances of late fifteenth-century armour and female head-dresses, and brasses like that to Ralph and Anne Saint Leger at Ulcombe, Kent (Figure 10), make full use of these possibilities. Apart from the hatched shading, the extraordinary butterfly head-dress of the lady and the enormous shoulder-, elbow-, and knee-pieces of the knight, the principal impression is one of an increased angularity, particularly noticeable in the sharp folds of the lady's drapery over her feet. This is a feature of architectural statuary from Henry V's chantry onwards, but one which hardly ever appears in the alabaster tomb-effigies. By the turn of the century both armour and female costume had become less extravagant and the designs of tomb-makers and engravers draw together again. Indeed it is in 1508 that we obtain the first documentary proof that the alabaster tomb-maker also designed brasses when required to do so.[31]

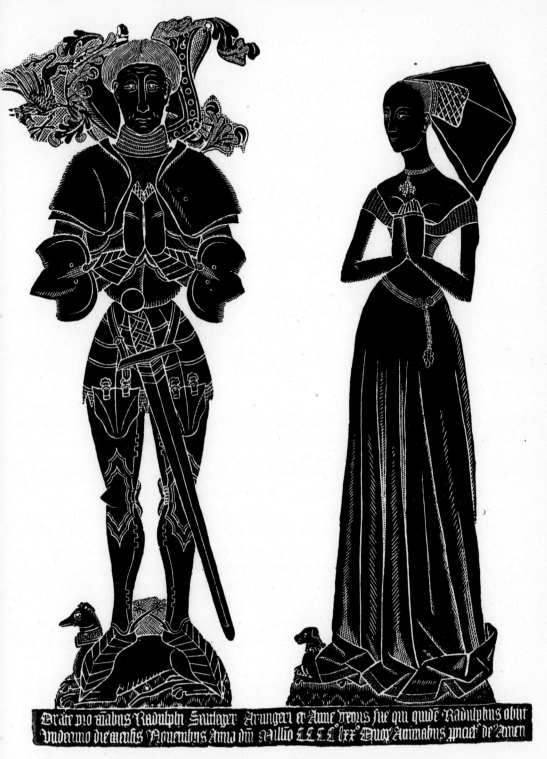

Figure 10. Brass of Ralph and Anne St Leger. *c.* 1470. Ulcombe, Kent

Before turning to the dominant style of the London court artists of the Tudor period, some indication must first be given of the wide variety of provincial schools. In the last twenty years of the century, there was erected at York another of those screens bearing statues of the ancestors of the English royal house of which that at Canterbury was an earlier example. The documentary evidence is very unsatisfactory, and unless the entry in the Fabric Rolls for the payment in 1478–9 of 14s 7d to James Dam for carving 175 crockets refers to the screen, there is nothing in the printed extracts to throw light upon its date.[32] The designer of the screen itself was probably the cathedral master mason William Hyndeley, a Norwich man, but the sculptor or sculptors of the statuary may have been any of a number of carvers at work in the cathedral in the last quarter of the century. Unless the statues were carved at the very end of the century, there is no reason whatever to connect them with Thomas Drawswerd, who was only admitted Freeman of the City in 1495 and who first appears in the Fabric Rolls in 1498–9.[33]

Of the fifteen statues set in heavily wrought canopied niches, all but one are said to be original. It is open to question, however, whether they were not a little touched up in 1814–18, when the Gothic Revivalist sculptor Francis Bernasconi carried out some repairs to the screen.[34] Great pains have been taken to vary the appearance of the individual kings by differences in dress and face. But for all the skill in carving and the deep undercutting, there is an unmistakable awkwardness about all these statues. King Stephen's hair fuzzes out in a wide curly wig beneath the crown, and he wears tight hose and a knee-length jerkin, perhaps in an attempt to convey the psychological levity and irresponsibility of his character compared with the weighty solemnity of the law-giver Henry II in the adjoining niche (Plate 174). There is a desperate striving after effect, exemplified in the matted hair and curly beards of Stephen and Henry II, or the ludicrous grimace on the face of King Henry V. These look like imitations of contemporary German art, for example a statue at Heilbronn, in Würtemburg.[35] Despite their obvious provincialism, these carvings represent an important element in late medieval art, a determined search for individuality emphasized by vigorous expressions and gestures and a great variety of costume, and executed in the round with exaggerated undercutting.

An interesting aspect of late fifteenth-century art is that alongside the more familiar sculptural developments there ran a stream of primitive carvings to be found in all regions and all media. It is not merely a case of naïve versions of more sophisticated works with which we are confronted, but a deliberate revulsion of local sculptors against the humanistic art of the previous three hundred years, a harking back to the Romanesque concept of art as a system of symbols conveyed by elementary repetitive pattern. The 'Image of Pity', a half-length statue of the Risen Christ, became very popular in the late fifteenth century since prayers to it were officially credited with great efficacy in procuring the remission of years in Purgatory. A figure of this sort in an exterior niche high up in the tower of Fairford church, Glos, is an excellent example of late fifteenth-century distortion of the human body and human features (Plate 178A).[36] Facial details, beard, loin-cloth, and crown of thorns are all treated as flat linear patterns upon a pyramid-shaped structure resting on the two stout pillars of the thighs. In its own way a work of great merit, this late medieval 'primitive' lies right outside the main trends of contemporary art.

In wood-carving, which was one of the most prolific and inventive of late medieval arts, the same pattern-making element asserts itself from time to time. The great hammer-beam roofs of East Anglia with their serried rows of angels gleaming darkly in the shadows are masterpieces of technical accomplishment. But at Upwell, Norfolk, beneath the spreading wings of one of these angels, is a scene of monsters devouring a human being that bears all the signs of a throw-back to a more primitive style (Plate 179A). This is shown not so much in the subject matter, so common in Romanesque art, as in the rigid subordination of nature to an imposed pattern. The barred bodies of the dragons, the fan-shaped arrangement of corkscrews that serve for hair, the parallel scoring of the jerkin, the elementary grouping of facial details, the absence of genuine modelling, all betray a fixed hostility to representational art.

In the remoter areas of the west and north, even the writ of the alabaster tomb-makers did not run unchallenged, and sculptors made effigies in local stone that bore no relation to the standard alabaster product. Of these a remarkable example is the effigy of Prior Leschman of Hexham Abbey, who died in 1491 (Plate 178B).[37] In concept it is linked to the cadavers of the south, for it represents the Prior immediately after death, with cowl pulled over his eyes, sunken cheeks, and down-drawn mouth. This particular type with the hood over the eyes is of continental origin and may be seen at Bruges in the much earlier brass of Joris de Munter, and in a destroyed effigy at Saint-Denis of a monk who died in 1482.[38] But the effigy is treated in the flat as a study in symmetrical pattern of parallel lines more rigid and unaccommodating than any seen in England since the episcopal effigies of the late twelfth century. Thanks to this stark simplicity of design the effigy is both more horrifying and more artistically successful than the realistically rotting corpses of the representational sculptors of the south.

This last phase of medieval sculpture was exceedingly prolific in output, much of it evidently the product of workshops situated in the main provincial centres such as Norwich, York, Nottingham, or Exeter. A great deal of this output was in wood, and was devoted to the production of stalls, benches, and screens, with their rood images. During this period the popularity of Saint George was rapidly increasing; he is depicted more and more frequently in wall paintings, and he even appears as one of the figures in rood screens. A surviving statue at Coventry of Saint George in armour of about 1470–90 gives some idea of that combination of firm modelling, stumpy figure-work, and pedestrian design that characterized much of the provincial sculpture of the late fifteenth century (Plate 172B). The prosaic handling of this statue forms striking contrast with the dynamic treatment of the same theme by the alabaster carver fifty years before (Plate 148A).

Cut off by their geographical remoteness from the French and Flemish influences that were affecting artists farther south, the wood-carvers north of the Trent confined themselves to the erection of screens and stalls of a conservative type, examples of which survive from Manchester in the west to Bridlington in the east and which range in date from 1489 to 1527. The whole group is nowadays commonly regarded as the work of a group of carvers at Ripon headed by one William Carver, *alias* Bromflet.[39] All that the documentary evidence proves, however, is that this Ripon group was responsible

for a statue at Kirkstall before 1518, the stalls at Bridlington in 1518–19, and for other work at Ripon in 1518–21.[40] That William Carver *alias* Bromflet settled at Ripon, became Wakeman of the town in 1511, and was at the head of a workshop producing wood-carving in the accepted regional style, is undisputed. But one would expect the great city of York to be the main centre of such activity, and there is evidence to suggest that this is in fact the case. A William Brounflete, carver, was admitted Freeman of the City in 1482–3 and it seems likely that he was the future Wakeman of Ripon.[41] Furthermore, the register of Freemen shows a considerable increase of carvers achieving this dignity, some of whom specifically describe themselves as 'carvour alias junour'.[42] It is surely more probable that the main centre of this prolific output of wood-carving was at York and that Bromflet migrated or returned to Ripon to set up on his own after training in the workshops of York. It may well be that the organization of a highly integrated system of mass production of stalls, canopies, and screens for the north at this period was the basis of the successful and prosperous career of Thomas Drawswerd.

An extremely interesting feature of this woodwork is its standardization of sizes and of designs, indicating a considerable degree of prefabrication. Equally significant is the fact that a number of misericords are directly copied from the woodcuts of an extremely popular fifteenth-century work, the *Biblia Pauperum*.[43] This contained visual representations of the principal scenes of the Bible story and was the work of a Flemish artist of about 1430–50. It ran through a number of Dutch and German xylographic editions and was then set up in print, first at Bamberg and then at Paris. The misericords at Ripon bear the dates 1489 and 1494, and of these four are directly copied from this source, while other misericords here and elsewhere have been identified as deriving from other contemporary woodcuts. Thus the scene of Samson carrying the gates of Gaza is a spirited and vigorous sculptural interpretation of the woodcut in the *Biblia Pauperum* that adheres faithfully to the main lines of the original (Plate 179B). These misericord carvings at Ripon and others in Henry VII's chapel at Westminster prove that the invention of wood-blocks and then of printing was already beginning to affect the position of the illuminated manuscript as the source of iconography for the sculptor.[44]

Another example of a strongly marked local school is provided by a number of fonts in East Anglia. It was a common fifteenth-century innovation to depict the scene of the Crucifixion surrounded by the seven sacraments of the Church, which all derived their efficacy from that act of sacrifice. A series of forty-two octagonal fonts, all but two of which are to be found in Norfolk or Suffolk, are carved with these scenes of the sacraments.[45] This geographical distribution strongly suggests a Norwich workshop and Flemish influence, and the triptych of the Seven Sacraments by Roger van der Weyden, now in the Antwerp Museum, shows the same scenes. But the details of the iconography are different, and in any case this composition was known elsewhere in England, occurring in glass at Bristol and Malvern before 1450. A considerable number of these fonts are dated, and they appear to have been carved over a long period between 1463 and 1544. The earliest, at Saint Peter Mancroft, Norwich, is painted on flat stone panels.[46] Five years later, in 1468, we have evidence of a fully carved version at East Dereham, with the Crucifixion and the seven sacraments on the panels of the bowl, eight apostles on the

stem below, and the four evangelists with their symbols at the corners.[47] As might be expected over a period of eighty years, both the style of sculpture and the iconography of the different scenes vary considerably, and although certain fonts are evidently by the same hands, there is no great continuity of workshop style. All that remains constant is the shape of the octagonal bowl and pedestal and the subject matter of the seven sacraments.

Devonshire in the late fifteenth and early sixteenth centuries seems to have been experiencing something of an economic renaissance, and a consequence of increased capital accumulation and of close commercial links between Exeter and Normandy and Flanders was an outburst of architectural and sculptural activity evidently influenced from abroad. The upper tier of statues of the west front screen at Exeter is usually attributed to the late fourteenth century on the grounds that a shield over the centre doorway bears the royal arms quartered with those of Edward the Confessor, as used by Richard II (Plate 175). But there are good grounds for believing that this is not the arms of Richard II at all, for the arrangement is the reverse of that used by Richard and the reduction of the fleur de lis to three was not adopted in England till Henry IV's second seal of 1408.[48] In any case this shield provides no evidence for the date of the detached statues above it and in the adjacent niches, which could have been set in place much later. Moreover, the style of the central figure of the Coronation of the Virgin and the attendant Apostles precludes a fourteenth-century date.[49] The realistic treatment of the heads of the apostles and the great variety of headgear are both late fifteenth- or early sixteenth-century features based on Flemish examples, and conclusive evidence is provided by the high-domed crown of Christ which is of a type unknown in English art before the last quarter of the fifteenth century.[50] These Apostles therefore take their place with those of Henry VII's chapel at Westminster as evidence of the retarded effect of Flemish and Burgundian realism at long last making its appearance in English architectural statuary. They are the English equivalent of the contemporary statues around the choir screen at Albi, to which indeed they bear some resemblance.

Apart from this experiment in external statuary on the grand scale, Devon stone-carvers tended to follow the Franco-Flemish fashion for small-scale pictorial art. Influenced probably by the crowded compositions of Flemish retables, they developed a homely but energetic style of panel sculpture in relief. The best of such reliefs are set at the ends of the tomb of the Kirkham chantry chapel at Paignton, of about 1490–1500 (Plate 181). Every surface both inside and out of this remarkable monument is plastered with statues and reliefs. The suggestion of foreign influence is here strongly supported by the fact that the iconography of the scenes, the Holy Family and the Mass of Saint Gregory, is drawn from German originals and differs from that in current use by the English alabastermen.[51] Later on the exuberant wealth of the Devonshire cloth merchants spilled over into the construction of richly decorated chantries, the Greneway aisle at Tiverton of about 1517 and the Lane aisle at Cullompton of nine years later. The exterior of the former is covered with a host of miniature carvings, of which the most attractive is the 'ship frieze' showing with a wealth of detail the type of vessel upon which Greneway had laden his wares (Plates 180A and B). There are traces of Renaissance motifs incorporated in these carvings, and the wooden door to the aisle is covered with Renaissance pilasters and arabesques.[52] With the

ostentatious display of merchant marks upon buildings largely reconstructed with commercial wealth, that of John Barton at Holme (Notts), John Thame at Fairford, Thomas Spring at Lavenham, and John Greneway at Tiverton, a new phase in patronage appeared to be opening before the medieval sculptor.

But greater even than the output of the Devon imagers was that of the wood-carvers. The last seventy years of the Middle Ages saw a great demand for pews, pulpits, and screens both to adorn and to make more comfortable the somewhat bare interiors of the medieval churches. It is no exaggeration to say that there could have been hardly a parish in Devon in 1545 that had not been able to purchase an elaborately carved and painted rood screen from the local workshops.[53] One would have thought that this extraordinary output of woodwork, with its strongly marked local characteristics, would have been centred on large-scale workshops at Exeter under the direction of a great sculptural contractor. But despite the opportunity, it seems clear that no such entrepreneur emerged. Exeter was of course the home of a number of craftsmen, and it was to Exeter that the churchwardens of Pilton in Somerset turned in 1521, when they wanted advice about some carving. But there is a certain amount of evidence to show that the demand was mostly met by a number of craftsmen scattered about the villages of the interior. The screen, rood-loft, and other woodwork for Stratton, Cornwall, was executed between 1531 and 1538 by John Daw, 'kyrver' of Lawhitton, a tiny hamlet near Launceston, and by John Pares, 'kyrver' of North Lew, a small village some fourteen miles away. The fact that the whole job cost no less than £108 is proof of the wealth and religious zeal of the Cornish parishioners in the years immediately before the Reformation. The contract is interesting since it shows wide knowledge of sculptural and building activity in the area. It specifies that the main screen was to be copied from Saint Kew, the rood images from Liskeard and the side screens from Saint Columb. Probably on completion of this contract, John Pares (or Parrys) began the screen at Atherington, Devon, where the work was eventually completed by two new sculptors, Roger Down and John Hyll, 'carpenters, carvers, and joiners' from Chittlehampton, another little village near by.[54]

Apart from the rood images, the carving of these screens was largely confined to the spandrels of the arch that supported the rood-loft, and to the cornice above it. These cornices were decorated with variations on the most familiar of late medieval decorative motifs, the 'trayles' of running vine-scroll. In the last twenty years of the fifteenth century, the leaves were undulating, short and stubby, and with high ribbed veins, as at Berry Pomeroy (Plate 182B). The sense of pattern is already dissolving into a loose mesh of interlace and the carver's virtuosity is displayed in the elaborately twisted stems of the vine. By now the surface texture is broken up by every possible device of punching and ribbing, so that the original simple rhythm is difficult to detect. An example at Banwell of the related Somerset school, that is dated by documents to 1521–2, shows the leaves now longer and flatter with internal ripples and little eyes, while the loose interlace has gained in importance (Plate 182A).[55] Finally in the late 30s and early 40s, as at Atherington and Lapford, Devon, the leaves have become very long indeed, and the interlace is yet more irresponsible (Plate 183A). At the same time a new leaf style has been introduced and the spandrels of the coving have Renaissance profile heads in medallions (Plate 183B).

Surviving examples of this short-lived Early Renaissance style are more numerous in the west country than anywhere else in England, and it seems clear that French influence from Rouen and Brittany must have been responsible for introducing these motifs into the pattern books of the Devon carvers. Screens like those at Atherington or Lapford provide the rare examples of English sculpture in the early 1540s in which traditional styles and Renaissance motifs were being satisfactorily blended together.

<p style="text-align:center">★</p>

The central story of the last phase of medieval sculpture is the evolution of an Early Tudor court style whose ultimate expression was the decoration and statuary of Henry VII's Chapel. Behind this astonishing building lies over a generation of development, powerfully affected by continental and in particular Flemish influence. The most direct evidence of this influence is a fragmentary Virgin and Child in Winchester Cathedral, which is one of the major achievements of medieval art (Plate 184). This exquisitely sensitive carving stands by itself without any parallel in this country, and for a long time it has been ascribed to the early fourteenth century. But neither the treatment of the eyes nor the naturalistic crumple of the drapery folds of the Virgin's sleeve are at all like fourteenth-century work. On the other hand, the long uncovered hair and the low crown of the Virgin do not become common again till the second half of the fifteenth century and there can indeed be little doubt that the statue belongs to this period.[56] The nearest parallels are some Madonnas from Brabant and Flanders of the last third of the fifteenth century that retain the refined, aristocratic faces of the paintings of Roger van der Weyden, but develop a simpler, less richly pictorial style of drapery.[57] The tight bodice crumpling over the stomach, the smooth-hung cloak, the long tresses, the child on the right arm are all repeated in a late fifteenth-century statue from Brabant.[58] Every artist who attempts to depict the Virgin and Child is faced with an all but insoluble moral problem. On the one hand he must reveal the sanctity of the Virgin and the divinity and majesty of Christ, and on the other he must give some impression of the human mother-and-child relationship. It is just this difficult balance between majesty and humanity that is here so brilliantly achieved. The intellectualism and the refined tenderness of expression, the precise contours and the taut economy of volume are all qualities of van der Weyden's art repeated in this masterpiece of an unknown sculptor. It is a tragic indication of our losses by destruction and neglect that only this single fragmentary piece survives of the work of an artist who must have been the outstanding genius of his generation.

Even the obstinately conservative midland alabaster carvers were affected by the new Flemish influence, and a wall-monument to Robert Gylbert of the 1490s at Youlgreave, Derbyshire, is an evident copy of the designs of the contemporary Tournai tomb-makers.[59] The strangely clumsy zigzags of the drapery round the feet are precisely those of midland panel carvings, but the arrangement of the family kneeling in tiers on either side of a Virgin and Child with the inscription running around the edge is that of the Tournai workshops.

Of architectural statuary of the late fifteenth century, hardly a trace has survived the fury of the iconoclasts, although the empty niches in every cathedral in England provide

ample witness to the intense activity of the imagers during this period. Some of the loose heads and torsos now in the triforium museum at Winchester Cathedral probably came from the great screen of about 1480. Unfortunately none of the heads fits the torsos, and there is nothing to help associate these fragments with any particular part of the Cathedral.[60] One group of torsos has been shown by comparison with a dated alabaster to be of mid fifteenth-century date (Plate 160A), and a few heads also seem to belong to the second or third quarter of the century, and may well come from the screen. They are not of very high quality and are very much closer to the style of the alabaster panel carver than to that of the London imager whose work survives at Saint Mary's, Warwick. There is no attempt at characterization, hair and beards are treated in spirals and curling tufts, and the heads are long and heavy.[61]

The most important late fifteenth-century architectural statuary to give some idea of the style of the London artists are the figures in the screenwork at either end of the Divinity School in Oxford. The vault and screenwork were in course of construction between 1479 and 1483 and the statuary is even more closely dated to 1481.[62] The main statues are saints and evangelists within niches, grouped below a Crucifixion over the east door and a Madonna over the west. The Madonna group shows the Child reading a book, an arrangement very rare in England but found occasionally in north French and Flemish art. In style they show some relationship to the sculpture at Saint Mary's, Warwick, some thirty years before (Plate 166B). But faces, attitudes of the head, gestures, and draperies are rather more violent and expressionistic, and the folds of the cloaks are crumpled in the sharp, vivid angles of some of the statues of Henry V's chantry carved under Flemish influence in the 1440s. The book-holding figures of Apostles, some with bifid beards, are one more example of the continuing influence upon European sculpture of the great statues around the Puits de Moïse at Champmol, carved by Claus Sluter three-quarters of a century earlier. Indeed the figure of Saint Paul at the east end (Plate 176) is very close to a mid-century Burgundian statue of Saint John the Baptist at Châteauneuf (Côte-d'Or).[63] It is interesting to observe that the drapery is arranged in an identical manner, but that the handling by the Oxford sculptor is far more schematic and summary in its angularities, betraying the connexion with the statuary of Henry V's chantry carved some thirty years before. The statue of one of the Evangelists at the west end (Plate 177) is almost certainly the work of a different artist who treats his heavy draperies in a far more accomplished manner. A fall of cloth with wide sinuous folds is hung before the body, a typical fifteenth- and early sixteenth-century Flemish characteristic that persists as late as the sculpture at Brou.[64]

The virtual lack of stylistic development in London architectural statuary during the half-century from 1435 to 1485 is very unusual, and one is tempted to speculate on the possible influence of the Massinghams. The younger of the two was last heard of as an apprentice at All Souls in 1432. Did fidelity to his father's teaching arrest development in London during the barren years of the mid-century?

The vault of the Divinity School is perhaps the earliest large-scale example of the use of pendant bosses. The wooden bosses of the south aisle of Ewelme of about a decade earlier bear Gothic lettering, but these Oxford bosses break new ground in the extensive use of such lettering in high relief as decorative motifs. The majority of these letters can

be identified as the initials of University dignitaries of the decades preceding 1482, which suggests that the design was imposed upon the artist by the fact that most of the academic worthies were not armigerous. At all events the lettering gave scope for that deep under-cutting and bold outline drawing that were beginning to supersede the older flat and crowded compositions.

By the 80s it is clear that in all branches of sculpture London artists were experimenting in a new manner with strong emphasis on mass and volume, and a growing interest in portraiture. An early example of the style is the alabaster tomb of Sir John Crosby at Great Saint Helen's Church, London, evidently a posthumous work of the 80s. Lady Crosby's body is finely modelled, strong individuality is shown in the faces of herself and her husband, and her head-dress is handled with a feel for the three-dimensional solidity of stone that is something quite new to alabaster carving. The same powerful sculptural style with its high finish and sense of volume is repeated in the effigies of Sir Giles and Lady Daubeney at Westminster Abbey, which probably date from the first few years of the new century.[65]

The effect of this feeling for the three-dimensional qualities of stone upon the architec-tural imager can be observed in some heads at Saint Cuthbert's, Wells (Plates 186A and B). The reredos of the south transept with a Tree of Jesse was the work of a local sculptor, John Stowell, in 1471.[66] But these heads bear no relation to this undertaking and must belong to the reredos in the north transept, for which no documentary evidence has survived. Of the artificial conventions of the fifteenth-century imager only the elaborate sinuosities of the hair remain, and the sharp features beneath beetling brows and the complicated headgear of these two apostles mark them off from earlier architectural statuary.

Far more subtle examples of early sixteenth-century realistic portraiture in stone are provided by a group of heads at Winchester Cathedral.[67] The modelling is more delicate, details such as the lines around the eyes and on the forehead are carefully incised, and the treatment of the hair has lost the stereotyped undulation of the Wells heads (Plates 185A and B). A marked feature is the deep, scowling grooves between the eyes, a trick also found at Westminster.

The *locus classicus* for early sixteenth-century architectural sculpture is not in these frag-mentary remains at Wells or Winchester, but in the astonishing range of statuary around the interior of Henry VII's chapel at Westminster. When viewed in the context of these fragments and of the effigies of Sir John Crosby and Sir Giles Daubeney, the statues in the chapel fall into place as part of a general stylistic trend in southern English art in the first decades of the sixteenth century. To understand Henry VII's chapel we must turn to an important and much neglected work of the London sculptors, Prince Arthur's chantry at Worcester, probably executed in about 1504-6, soon after the Prince's premature death. The numerous little figurines that still adorn the screenwork form the stylistic link between the statues of the Oxford Divinity School and those of Henry VII's chapel. Some present the most baroque drapery treatment of the whole period, others are almost identical with the Divinity School apostles, and yet others have the varied headgear and something of the massive body treatment of the statues at Westminster. There can be

little doubt that at Worcester we can study the Westminster workshop in its formative stage, though the great artist of the prophets had not yet made his appearance.

The foundation stone of the royal chapel was laid on 23 January 1503, though it does not appear to have been fully completed until some sixteen years later. Designed to house the mortal and – it was hoped – sanctified remains of Henry VI, the chapel was to be the visible witness of the hereditary legitimacy and practical power of the new Tudor monarchy. Around the shrine of Henry VI were to be grouped the tombs of Lady Margaret Beaufort and of Henry VII himself and his wife Elizabeth of York. Above in the panels of the great fan vaulting, below in a continuous frieze supported by angels, in the openwork panels of the bronze gates and in glass quarries in the windows, appeared on a large scale and in infinite repetition the Tudor badges of rose and portcullis. Gazing down upon the tombs were ranged serried rows of apostles, saints, and prophets, covering the whole gamut of the late medieval religious hierarchy. Their purpose was explained in the royal will of 1509: 'I trust also to the singuler mediacions and praiers of all the holie companie of heven; that is to saye, Aungels, Archaungels, patriarches, prophets, Apostels, Evangelists, martirs, confessours, and virgyns....'[68] The appearance amid this distinguished host of one or two obscure Breton saints proves that the design if not the execution of these statues had been arranged during Henry's lifetime; it reflects the personal loyalty of the King to those local thaumaturges to whom he had appealed during his years of exile before the battle of Bosworth.

The detailed supervision of the building was entrusted first to the Abbot of Westminster and then to Prior Bolton of Saint Bartholomew, Smithfield. As a result the accounts have not been preserved in the public records and we do not know the names of the sculptors. This is particularly unfortunate since it is very important to decide whether or not foreign artists were employed. The supreme example of Flemish art of the period, the rival mausoleum built by Margaret of Austria at Brou, bears no relation whatever to the architectural design or the sculptural style of Westminster. Moreover, though there is ample evidence for the employment of Flemish artists at this period, it is equally clear that English sculptors were very active about the court. With the exception of the two Flemings mentioned earlier, all those employed at Windsor were natives, and the names of workmen in the accounts for the heraldic sculpture in the great hall at the Tower and at Westminster Hall in 1501 are exclusively English.[69] The James Halys who in 1501 was working on heraldic sculpture for the King at Greenwich and on the royal barge, and who later designed the cast bronze effigy of the Earl of Derby for Burscough, Lancs, would seem to have been an Englishman. Though the Italian Guido Mazzoni, *alias* Paganino, made a bid for the royal tomb and though Pietro Torrigiani finally obtained the contract, there was no lack of English competitors. In the bids to design the effigies, Drawswerd of York undercut Laurence Ymbar by 43 per cent and the founder was to have been Humphrey Walker.[70] The architectural style of the chapel is a development of that of Saint George's Chapel, Windsor, the work of an Englishman Henry Janyns, and its designer may have been Robert Virtue.[71] Its sculptural decoration marks the culmination of a generation of experiment and development among royal carvers that began under William Berkeley at Windsor in 1479–83, continued with sculpture at the Tower

and Westminster Hall and elsewhere for the marriage of Prince Arthur in 1501–2, and with the construction of the Prince's chantry at Worcester, and culminated in the internal carvings at King's College, Cambridge, which were designed by Thomas Stockton, the royal joiner, and executed in 1512–13.[72]

Heraldic sculpture had occupied a prominent place in the decoration of churches ever since the late thirteenth century, but the scale of the King's College carvings and the total absence of any religious themes mark the apogee of dynastic display. These six-foot rampant greyhounds and dragons supporting the royal arms, these immense and deeply undercut roses and portcullises set off against the bare Perpendicular panelling are the boldest and most energetic expression of the triumphant self-assertion of the new Tudor monarchy (Plates 187A and B). This was an international feature of the age: San Juan de los Reyes at Toledo, of about 1475, has the same huge crowned escutcheons as those at King's, and the Château de Chambord of about 1526 is a dazzling example of comparable French employment of royal heraldry.

To the minute intricacy of early fifteenth-century art has succeeded a sculptural style based on the elimination of distracting detail, and the cultivation of a ferocious vigour of design conceived on a grand scale. As such it has much in common with poster art, and there is reason to believe that it is from the temporary decorations for royal pageantry that this style evolved. In preparation for the marriage of Prince Arthur with Princess Catherine of Aragon, in 1501 the most elaborate works were ordered for Westminster Hall, the Tower, Greenwich, Eltham, and elsewhere. They consisted of an infinite repetition in glass and in sculpture of the royal arms, badges, devices, and supporters.[73] The relative restraint in the use of these motifs at Windsor and their extraordinary display at Worcester, King's, and Westminster suggest that the decisive factor in creating the popularity of the new motifs was these 1501 wedding preparations to celebrate the sealing of a union that was the culmination of the prestige policy of the Tudor dynasty.

The Windsor frieze of angels and the heraldry of King's are both to be found at Westminster, but subordinated to the display of the tiers of statuary that fill the available wall surface. The angels themselves are of a type common to both the Low Countries and England,[74] and there can be little doubt that the sudden outburst of sculpture making full use of the three-dimensional possibilities of stone must also be attributed to Flemish and Brabanter influence. The long tradition of retables with free-standing figures firmly and freely carved to form *tableaux vivants* is evidently at the back of such scenes as the martyrdom of Saint Sebastian at Westminster.[75] Inevitably the sculpture of this great range of about a hundred statues varies considerably in quality, but the majority are characterized by an extreme boldness of carving in depth, by vigorous and often forbidding facial expressions, and by the extraordinary variety and intricacy of the headgear. Though these qualities are present in some degree in late fifteenth-century Low Countries sculpture of images, tomb-weepers, and retables, the closest parallels are with German art. But work identical with these Westminster carvings has still to be found abroad, and the problem of the exact source of this remarkable style remains obscure.[76]

The greatest sculptor employed at Westminster devoted himself to the rows of prophets in the westernmost bays of the triforium of the nave (Plates 189 and 190B). These statues are

undoubtedly the most successful essays in exploiting the plastic qualities of stone of the whole English Middle Ages. There is feeling for form and volume, and sensitivity to the possibilities and limitations of sculpture in stone. The extravagant hats are not mere photographic reproductions of nature but are subjected to the needs of the material. For example the long flat brim sweeps down at the back to merge with the shoulder of the prophet (Plate 190B). The works of this outstanding artist may be identified by the very strongly marked facial expressions. Their common characteristics are the rough treatment of the hair, the prominent cheek-bones and big noses, the strong lines running down from the nostrils, the wide mouth with full lower lip and the jutting chin. Even his less accomplished disciples achieved something of the same feeling for stone (Plate 190A), while others experimented in a vigorous realism that put spectacles on the nose of Saint Matthew and a pen-holder at his side, and gave him an ink-stand held by an angel (Plate 188A).[77] The drapery style of this last group, with heavy swathes of cloth hanging down in front of the body, is also found in the statuary of Cardinal Morton's tomb in Canterbury Cathedral of the 1490s, and is a development of the Flemish-inspired figures of the Divinity School at Oxford and of Prince Arthur's chantry (Plate 188B).

The complete absence of architectural statuary for the next twenty years, before the Reformation put a stop to all such undertakings, makes it impossible to tell to what extent this extraordinary style with its dramatic content and its plastic handling made a durable impact on English art. So far as the surviving evidence goes, it was a style without imitation, and the artists found no further employment. But this is almost certainly untrue, and one can only regret that time has destroyed all evidence of their further activity.[78]

The tomb of Henry VII as it stands to-day was not begun till after 1512, and is an Italian work by Torrigiani which lies outside the scope of this volume. But preparations for its construction had begun as early as 1501 at Windsor, and in 1505 Thomas Ducheman began work on the bronze grille that was to surround it. He was paid £51 8s over a period of seven months,[79] but Henry in his will of April 1509 refers to the grille as still unfinished. We cannot tell for certain, therefore, when and by whom the bronze statuettes of the grille were made. Of the sixteen original figures only six have survived. Their drapery style is the same as that of some of the stone statuary of the chapel, and the patterns were probably the work of one of the sculptors employed on the building.[80] They are in the accepted Anglo-Flemish style and it is impossible to prove the nationality of the artist.[81]

*

Apart from the Westminster figures, evidence of English sculpture during the last thirty years before the Reformation is to-day pitifully small. What little has survived, however, suggests that this remarkable style failed to dominate all workshops, even in the capital.

The combination of the popular taste for the macabre, the influence of religious drama, and greater experience in handling free-standing statuary, led to the development on the Continent of new sculptural themes. By the beginning of the sixteenth century, the artists of France and Italy were carving life-size *tableaux* of the Deposition from the Cross, the 'Pietà', the Lamentation over the dead Christ, and the Entombment. Though many of these sixteenth-century works survive abroad, in England the thoroughness of Reformation

iconoclasm ensured the destruction of all examples. But there is no reason to doubt that similar *tableaux* were also carved in England, and a recent discovery beneath the floor of the former chapel of the hospital of Saint Thomas of Acon in Cheapside, London, has confirmed this inference. There was brought to light a life-size stone figure of the dead Christ stretched out upon the bier, which was evidently originally accompanied by mourners and belonged to a scene of the Lamentation of Christ.

The patron was probably an ecclesiastic who had seen similar work abroad. The sculptor was an Englishman who seems to have been unfamiliar with this composition, and was faced with the problem of devising a suitable iconographical pattern. For the figure of Christ he turned to the stock cadaver in English tomb-sculpture, with thrown-back head, straight torso, prominent leg muscles, and left hand folded across the body. But the round, bulging eyeballs derive not from the cadavers, but from the style of the alabaster carver. Indeed the sculptor seems to have adhered rather too faithfully to his model, and has repeated the deep gash over the left eye that was a standard feature of the alabaster heads of Saint John the Baptist (Plate 169).

The relentless realism of the drapery style is unusual in early sixteenth-century England, though elaborately irregular crumpling of this kind can be found on some of the little statues from Prince Arthur's Chantry at Worcester, and more fitfully in Henry VII's Chapel some years later. Its source is probably Flemish. Certainly it has nothing to do with Renaissance influence, here visible only in the beautiful Roman lettering of the inscription. In this figure, therefore, we have a work of the first third of the sixteenth century by an English sculptor of undoubted competence but limited originality. His theme was borrowed from abroad, but all the elements which influenced his treatment could be found in the London of his day. The figure has a certain emotional appeal derived from its realistic handling, but it lacks the power and intensity of great art.

The midlands carvers of alabaster tombs in the decades before the Reformation remained almost entirely oblivious of the London style of realistic portraiture, strong sense of volume, and heavy draperies. There is some evidence that the centre of this trade was now shifting from Nottingham to Burton-on-Trent. As early as 1462 there are records of alabaster image-makers at Burton, and in 1481 we find Robert Bocher and Gilbert Twyst, 'alablasturman', selling their wares as far afield as Saint Albans, Wallingford, and Newbury.[82] A contract of 1508 gives the names of two Burton tomb-makers, Henry Harpur and William Moorecock, who made two surviving tombs at Great Cubley, Cheshire, and Chesterfield, Derbyshire.[83] On the basis of this evidence it is possible to ascribe a whole series of tombs up to 1540 to a Burton workshop. A characteristic of the weepers of this series is the extraordinary zigzag folds at the bottom of the dress, a crude rendering of the sprawling draperies of Early Flemish paintings.[84]

Three interrelated examples survive to show the style of the London tomb-carvers in the 1530s, and of these the finest is to Sir Richard Knightley at Fawsley, Northants. Though there are many links with the Burton school, continental influence predominates, and the result is a style very different from that of the midlands carvers. The sense of volume so noticeable in the Westminster statues is reflected in the heavy body and powerful portrait head of Sir Richard (Plate 191A), and the Early Tudor passion for heraldry is

expressed by the extreme care with which the tabard is carved and painted with the Knightley arms. At Sir Richard's side lie his gloves, a French trick that dates back at least to the beginning of the sixteenth century.[85] The tomb itself is of black marble against which are set the white alabaster angels and weepers, a combination which is itself evidence of Flemish influence. The shield-supporting angels at the end of the tomb still kneel in the accustomed manner, but their tight curls and voluminous draperies are new Flemish elements in the traditional alabaster tomb-sculpture (Plate 191B). The weepers are engaging little models of the children in well-composed pairs, swaying towards each other in conversational pose (Plate 192). That the artist responsible for this tomb was not fully at home with the new style is proved by his primitive handling of the children's features, and by clumsy carving of the architectural details of the black marble tomb.

The output of tomb-sculpture was unaffected by the political and religious changes of the Reformation, and in consequence some continuity of medieval sculpture both in the Burton and the London styles was secured. Renaissance decoration was introduced, and even the Burton workshop of Richard and Gabriel Royley added 'French pilasters' to its repertoire for the decoration of tomb-sides.[86] But in some workshops the style of both effigies and weepers altered little before the advent of Maximilian Colt and Nicholas Stone, though Flemish strapwork and canopy ornament transformed the setting in which they were placed.[87]

<p style="text-align:center">*</p>

It is abundantly clear from this survey of early sixteenth-century sculpture that it was vigorous, progressive, and adaptable. Its output was prodigious and the quality was clearly improving and in many cases was as high as at any time in the Middle Ages. It was an art that was very far from dying from inaction or withering away in the face of Renaissance influence. The causes of its collapse in the 1540s must be sought entirely in political decisions that decisively and abruptly cut off demand. The dissolution of the monasteries in the late 30s destroyed one powerful set of patrons, and the subsequent dismantling and looting of the buildings was an ill-omen for the future. But more important was the doctrinal change that led to an intensive iconoclastic attack on religious imagery between 1547 and 1553. All over England churchwardens' accounts record payments for the dismantling of the big rood images with which every church was equipped. So complete was this destruction that of the thousands of these crucifixions with the flanking Mary and John, hardly a single one has survived intact to the present day. These orders effectively discouraged both the parish and the greater patrons from embarking upon fresh sculptural expenditure, and the condemnation of chantries and the confiscation of their assets was a clear warning of the impermanence of such investments. More doctrinal changes in quick and erratic succession further weakened confidence in the stability of the Establishment, and effectively diverted surplus wealth into other channels. The very tepid loyalty which was all the Elizabethan settlement could inspire in the first generation of its existence was ill-calculated to attract lavish patronage, and church-building inevitably languished. Since with the sole exception of the tomb-maker the output of the medieval sculptor had been largely devoted to religious imagery and the decoration of religious architecture, the consequence of these measures was an abrupt

contraction of employment. Between 1503 and 1542 twenty-seven carvers and alabaster-men were admitted Freemen of York, but in the next forty years there was not a single one.[88] Medieval sculpture was strangled by decrees of the State, ruthlessly enforced in the interests of ideological conformity. Lacking time to evolve alternative means of employment in secular architecture, the sculptural profession suffered a sudden eclipse, and only those with a well-established business in the tomb trade were able to carry over into the new age the traditional craftsmanship of the medieval carver. The history of English medieval sculpture does not draw quietly to a close; it is cut off sharp.

NOTES

INTRODUCTION

1. J. Strype, *Ecclesiastical Memorials*, I (1721), 252. The accounts for the demolition of Barking Abbey, Essex, are in Bodl. Rawlinson MSS, D. 782.

2. R. Willis and J. W. Clark, *The Architectural History of the University of Cambridge*, II (1886), 38, n. 3.

3. *Calendar of State Papers, Foreign, 1547–53* (1861), 55.

4. F. Bligh Bond and Dom Bede Camm, *Rood Screens and Rood Lofts*, II (1909), 289.

5. J. Strype, *Annals of the Reformation*, I (1735), 171.

6. R. Steele, *Catalogue of Tudor and Stuart Proclamations* (Oxford, 1910), no. 526.

7. R. Willis and J. W. Clark, *op. cit.*, I, 443.

8. *Sir William Dugdale's Book of Monuments*, the possession of the Earl of Winchilsea and at present on loan to the British Museum.

9. Richard Culmer, *Cathedral News from Canterbury* (1644), 21.

10. Bruno Ryves, *Mercurius Rusticus* (1646), 220.

11. C. H. Firth and R. S. Rait, *Acts and Ordinances of the Interregnum*, I (1911), 265.

12. C. H. Evelyn White, 'Journal of William Dowsing...' *Suff. Inst. of Archaeol. & Nat. Hist. Proc.*, VI (1888). J. G. Cheshire, 'William Dowsing's Destructions in Cambridgeshire'. *Cambs and Hunts Archaeol. Soc. Trans*, III (1909–14).

13. C. H. Evelyn White, *op. cit.*, 244.

14. N. H. Nicholas, *Testamenta Vetusta* (1826), *passim*.

15. *Archaeol. Jnl*, VIII (1851), 81. R. Willis and J. W. Clark, *op. cit.*, I, 402, n. 3. Bishop Hobhouse, 'Churchwardens' Accounts', *Somerset Record Soc.*, IV (1890), 132–3.

16. R. E. Swartwout, *The Monastic Craftsman* (Cambridge, 1932), Appendix I.

17. T. G. Jackson, *Wadham College, Oxford* (Oxford, 1893), 48.

18. R. Willis and J. W. Clark, *op. cit.*, I, 482. Cf. also the contract for statues at Saint George's Chapel, Windsor, in 1477–8 (W. H. St. J. Hope, *Windsor Castle*, II (1913), 399).

19. P. Freeman, *The Architectural History of Exeter Cathedral* (1888), 123–4, n. 35. In 1339–40 John of Burwell was paid a mere 2s for carving the central boss of the Ely Octagon (F. R. Chapman, *The Sacrist Rolls of Ely*, II (Cambridge, 1907), 98).

20. See *supra*, p. 120. It is impossible to give any simple multiple by which medieval money can be converted into its equivalent in 1955. As some guide, however, one can cite the money wage, without food, of the semi-skilled medieval mason, hewer, and layer. This was about 4d a day from 1280 to 1350 and about 6d a day from 1350 to 1540. The hours worked varied between about eight and twelve according to the time of year. Allowing for holidays a mason at Eton College in the 1440s was earning about £7 10s a year. The annual earnings of his successor to-day would be well over forty times as much (D. Knoop and G. P. Jones, *The Medieval Mason* (Manchester, 1933), 109–29, 235–9).

21. D. Knoop and G. P. Jones, *op. cit.*, 21, n. 1. W. R. Lethaby, *Westminster Abbey and the King's Craftsmen* (1906), 192. This last is the highest wage-rate for a medieval sculptor that I know.

22. *All Souls Building Accounts*, his transcripts of which Professor E. F. Jacob was so kind as to lend to me.

23. Kendrick, I, figure 14 and plate 35. p. 5

24. *Birmingham Archaeol. Soc. Trans*, XLVIII (1922), figures on page 139. p. 6

CHAPTER I

1. To what extent the Irish were themselves responsible for this synthesis, of which the finest example is the manuscript illumination of the Book of Durrow, is a question upon which scholars are still undecided. The extreme Irish point of view is presented by Françoise Henry, *Irish Art in the Early Christian Period* (1940). The extreme contrary opinion was advanced by F. Masai, *La Miniature dite Irlandaise* (Brussels, 1947), and a more modest and balanced approach made by W. Oakeshott, *The Sequence of English Mediaeval Art* (1950), Appendices I, II. See also F. Henry, 'Les Débuts de la Miniature Irlandaise', *Gazette des Beaux-Arts* (1950), part I. p. 8

2. Cf. the comparisons made by G. C. Curle, 'The Chronology of the Early Christian Monuments of p. 9

Scotland', *Proc. Soc. Ant. of Scotland*, LXXIV (1939–1940), plates 19 and 20; and by A. W. Clapham, 'Notes on the Origins of Hiberno-Saxon Art', *Ant.*, VIII (1934).

p. 9 3. For a general account of this burial see *The Sutton Hoo Ship Burial* (British Museum, 1947). The arguments for the ceremonial nature of the whetstone are set out by R. L. S. Bruce-Mitford, 'Sutton Hoo', *Suff. Inst. Archaeol. & Nat. Hist. Proc.*, XXV (1950), 8, 57–8.

p. 10 4. *The Hodeoporicon of Saint Willibald*, quoted by A. W. Clapham, *English Romanesque Architecture before the Conquest* (1930), 62, n. 2.

5. Bede, *Vita Sanctorum Abbatum...*, Migne, *Patrologia Latina* (Paris, 1862), XCIV, cols. 716–18. Eddius, *Vita Wilfridi Episcopi. Historians of the Church of York*, Rolls Series, 1 (1879), 22.

6. The most valuable accounts of this monument are to be found in:
 G. Baldwin Brown, *The Arts of Early England*, V (1921), chapter 7.
 F. Saxl, 'The Ruthwell Cross', *Jnl Warb. Court. Insts*, VI (1943). To be treated with reserve.
 M. Shapiro, 'The Religious Meaning of the Ruthwell Cross', *Art Bull.*, XXVI (1944).

p. 11 7. Gavin Bone, *Anglo-Saxon Poetry* (1943), 58.

p. 12 8. The mid sixth-century Syriac manuscript of the Gospels of Rabula provides the closest parallel both for layout and for iconography. But this manuscript, which is a century and a quarter earlier than Ruthwell, does no more than support the thesis of the Levantine origin of the style. Thus the Christ Triumphant theme is common enough, but standing over a carefully distinguished lion and dragon, and not, as at Ruthwell, two identical animals; but the Rabula Gospels do contain a representation of Christ and Mary Magdalene. For the vine-scroll, see E. Kitzinger, 'Anglo-Saxon Vinescroll Ornament', *Ant.*, X (1936).

9. E. Gilbert, 'Anglian Remains at Saint Peter's, Monkwearmouth', *Archaeol. Aeliana*, 4th series, XXV (1947).

10. The setting of the human figure in an arched frame may also derive from late Roman tomb slabs still visible in the area. Evidence that the Anglo-Saxons made use of Roman antiquities is provided by the fact that the chancel arch of the church at Escomb, Co. Durham, is probably a re-erected Roman work; Bede refers to the use of an old sarcophagus for Christian burial; in 685, the inhabitants

of Carlisle showed Saint Cuthbert some of the antiquities of the town.

11. The leg of the eagle of Saint John on the cross head, and the now missing foreleg of the donkey in the Flight into Egypt scene (G. Baldwin Brown, *op. cit.*, V, plates 16 and 18).

12. Was it Wilfred's death that stopped the plans for erecting another similar monument, the massive stone block for which still lies roughly hewn in the moorland quarry above Bewcastle? *Op. cit.*, V, figure 9, page 104.

13. *Op. cit.*, V, 144–5.

14. Dr Saxl's contrary hypothesis is based exclusively upon the argument that the drapery of the Bewcastle figure is nearer the classical prototype than that of Ruthwell. In point of fact on the main figure of Christ in Majesty the drapery is too different to bear comparison, and in any case the quasi-certainty of fresh Mediterranean imports between Ruthwell and Bewcastle destroys the basis for this form of argument.

15. It seems likely that similar sculptural work was being performed in western Wessex, since in the twelfth century at Glastonbury there were two tall crosses with figure-work, one of which was dated by its inscription to about the turn of the century (William of Malmesbury, *Gesta Regum Anglorum*, Rolls Series, 1 (1887), 25).

16. Except for one panel at Florence, the Casket is now in the British Museum (O. M. Dalton, *British Museum, Catalogue of Ivory Carvings* (1909), no. 30). M. H. Longhurst, *English Ivories* (1926), I, 65–6. Baldwin Brown, *op. cit.*, VI (1), 135. A. S. Napier, *The Franks Casket* (1900).

17. A. S. Napier, *op. cit.*, 20, n. 1.

18. J. Romilly Allen, *Early Christian Monuments of Scotland* (1903), figures 235 and 321. Cf. Kendrick, I, 123, n. 2.

19. E. Kitzinger and D. McIntyre, *The Coffin of Saint Cuthbert* (1950).

20. Kendrick, I, plate 49.

21. E. Kurth, 'Ecclesia and an angel on the Andrew Auckland cross', *Jnl Warb. Court. Insts*, VI (1943). Kendrick, I, 142.

22. There are a number of these idols at White Island (Co. Fermanagh) and Lismore (Co. Waterford). By the eighth century the favourite Anglo-Saxon decoration of interlacing bands spread to Ireland and whole crosses began to be covered with thick irregular patterns, occasionally enlivened by sections of Celtic spiraliform and pelta designs. The cross and pillars at Carndonagh (Co. Donegal) are

good examples of this type, which is evidently closely related to the style of the Book of Durrow.

By the middle of the century the superb artistic achievements of the Irish metalworker inspired the stone sculptor to emulation, and in Co. Tipperary, for example at Ahenny, were produced a number of wheel-head crosses with rope edges, large bosses, and a complete carpet coverage of carefully designed and executed interlace and spiral patterns. These crosses show a sense of architectural planes and surfaces, and a feeling for three-dimensional form in the cross itself, though the decoration remains obstinately linear and abstract. The carefully proportioned trapezoidal bases of these crosses are covered with obscure figure scenes in the shallowest relief in which both men and animals are portrayed as lifeless paste-board dolls scattered over the surface with a total lack of regard for composition or design. The Irish equivalent of the storied scenes of the Franks Casket, they lack the vigour and zest of the Anglo-Saxon version, though they too appear to show the same intellectual confusion between Christian and pagan mythology. All these pieces of sculpture are illustrated in F. Henry, *La Sculpture irlandaise* (Paris, 1932).

23. H. Shetelig, *Viking Antiquities in Great Britain and Ireland*, v (1940), chapter 1.

24. F. Henry, *Irish Art in the Early Christian Period* (1940), 120.

25. This brooch, the Irish metalwork counterpart of the Anglo-Saxon Lindisfarne Gospels, is a tiny three and a half inch cloak fastening for priest or king. The abstract motifs of the brooch, the bands of spiral or ribbon animal ornament, the strips of regular interlace, the hook-beaked bird's head terminals, are all to be found in the manuscript, and the relation of the two works in their different media is clearly extremely close. It is indeed this similarity of certain features and the unique nature of others which make the more extreme claims of the Irish or Anglo-Saxon protagonists in the battle for the Lindisfarne Gospels appear somewhat otiose. No single simple source can explain this fertile artistic outburst in the Northumbrian manuscript and the Irish metalwork.

CHAPTER 2

1. Kendrick, I, plate 65. E. H. Zimmermann, *Vorkarolingische Miniaturen* (Berlin, 1916), plate 281. An alternative date is *c.* 980–1020, when Ottonian manuscripts were reproducing some of these Carolingian features (cf. H. Jantzen, *Ottonische Kunst* (1947), plates 41 and 43). But I cannot see the validity of the observations and comparisons of D. Talbot Rice,

English Art, 871–1100 (1952), 96–8. The arguments for a late seventh-century date are confined to the statement of the excavator of Reculver Church that the original *opus signinum* pavement stopped against the great masonry base of the cross (C. R. Peers, 'Reculver: its Saxon Church and Cross', *Archaeol.*, LXXVII (1927), 247). If this is so, it can only be concluded that the existing fragments are not part of the original cross, but of one erected at a later date on the same base. For another fragment, see R. F. Jessup, 'Reculver', *Ant.*, x (1936), plate 3.

2. M. Longhurst, 'The Easby Cross', *Archaeol.*, LXXXI (1931). Though the location of Easby indicates influence from York, it is a remarkable fact that the only other surviving sculpture of this high quality comes from Hoddam in far-off Dumfries. (R.C.H.M., *Scotland, Dumfries* (1920), figure 75). Here all that is left are the battered remains of a huge cross head containing busts very similar to those at Easby, together with long-necked fantastic animals of the Mercian school.

3. For a close parallel with a Carolingian ivory, see E. Kitzinger, 'Anglo-Saxon Vinescroll Ornament', *Ant.*, x (1936), plate VI, A and B.

4. E. Kurth, 'The Iconography of the Wirksworth p. 21 Slab', *Burl. Mag.*, LXXXVI (1945).

5. Cf. Kendrick, I, plates 57, 58, 65, and 66; even p. 22 the violently twisted head is found in a Lorraine manuscript of about 780 (E. H. Zimmermann, *op. cit.*, plate 330). One side of the shaft is illustrated by J. Baron, 'Sculptured Stones at Codford Saint Peter and Heraldic Stones at Warminster', *Wilts Archaeol. Mag.*, xx (1882). A serious difficulty remains in the lack of a ninth-century parallel to the bamboo-like edges of the panels, which are certainly found in the late tenth-century shaft at Sockburn (plate 18A). But it is not unlikely that both derive from an unlocated or long destroyed manuscript source, and this feature by itself is insufficient to support a late tenth-century date for Codford.

6. Kendrick, I, figure 24, page 151. G. Baldwin Brown, *The Arts in Early England*, v, 318.

7. Kendrick, I, plate 61. p. 23

8. Some cast and chased metal heads of pins found in the River Witham, near Lincoln, show very similar stylistic features and were probably adornments of a shrine or bookcover from some Fenland monastery. They display the same rampant animals in heraldic postures, rigidly affronted and enmeshed in the elaborate interlace of their own limbs, and the same footed reptiles vertically viewed. The only significant difference from the casket is the harsh silhouette technique imposed by the material, in contrast to the

rounded surfaces of the bone. Kendrick, I, plate 71. R. A. Smith, 'Examples of Anglian Art', *Archaeol.*, LXXIV (1923-4), figure 13.

p. 23 9. This dating was conclusively established by A. W. Clapham, 'The carved stones at Breedon-on-the-Hill, Leics.', *Archaeol.*, LXXVII (1927). Kendrick, I, 172-8. The relationship to late eighth-century manuscripts of the cup capitals, the pronounced central pleat of the drapery, the heraldic animals and the pelta, diagonal fret and trumpet spiral designs makes a recent suggestion of a tenth-century date appear somewhat preposterous.

p. 25 10. Cf. an almost identical animal in a contemporary Mercian manuscript. E. H. Zimmermann, *op. cit.*, plate 292A.

11. More wildly lavish in surface display than this court work, the round-shafted crosses at Masham in Yorkshire, and more particularly at Wolverhampton, are two of the largest monuments of the age. The Wolverhampton cross, itself possibly a re-used Roman column from Uriconium, with its horizontal zonal divisions, its rich decorative patterns, its contorted and rampant Mercian animals, its fleshy Frankish acanthus scrolls and its ornamental triangular pendants, provides an extraordinary combination of motifs drawn from a wide range of sources but all welded into a whole by reduction to lush surface pattern.

The metalworkers of this mid ninth-century Wessex period naturally found the fashion for rich decoration far more to their taste than the sculptors in stone. It is indeed to tiny metal objects that such a style is best adapted, and it is consequently upon a number of such objects – now widely scattered thanks to Viking looting – that the West Saxon 'rococo' of the mid ninth century is best seen. King Ethelwulf's own ring from Laverstock, Wilts., a trefoil silver plaque from Kirkoswald, Cumb., a sword pommel from Wallingford, Berks., silver mounts from a hoard at Trewhiddle, Cornwall, brooches from Beeston Tor, Staffs., all of these show the same family characteristics of loose-knit, sprawling, unmethodical surface ornament more lavish and less confined by the needs of organized composition than in the original inspiration in Canterbury school manuscripts. In the Trewhiddle mounts the animals within their triangular enclosures dominate the tiny beaded frames, and sprawl out into the scallops of the lower edge, and on the Wallingford sword the ornamental bands of formal Frankish acanthus and wispy Wessex animal designs wander vaguely over the pommel and spread along the bar and guard (cf. Kendrick, I, plates 78 and 79).

12. A silver sword handle from Fetter Lane in the p. City of London shows scrolls of acanthus type on the boss, treated in a spiral Celtic manner. On the handle itself, against an ivy-leaf pattern of foreign origin, there are animal patterns of spinning snakes and bipeds that are purely barbaric – indeed Celtic – in treatment, even if their immediate origin may be found in contemporary manuscript illumination (Kendrick, I, plate 79(1)).

13. F. Cottrill, 'Some Preconquest Stone Carvings in Wessex', *Antiq. Jnl*, XV (1935).

14. Cf. F. Henry, *La Sculpture irlandaise* (Paris, p. 1932).

CHAPTER 3

1. In Mercia the two crosses in the market-place p. at Sandbach in Cheshire show the lavish decorative effect of the Mercian style, together with the prominently displayed theme of the old Northumbrian inhabited vine-scroll. But the figure style with rows of schematically disposed, harshly silhouetted dolls with huge ungainly heads is clear evidence of Irish influence and was immediately attractive to the newcomers (Kendrick, I, plate 95).

2. For a drawing, see R.C.H.M., *West Dorset* p. (1952), 158.

3. The most persuasive advocate of these tenth-century northern crosses is T. D. Kendrick, 'Late Saxon Sculpture in Northern England', *Brit. Archaeol. Assn Jnl*, 3rd Series, VI (1941).

4. A good example of Anglo-Danish sculpture in p. this style of shortly after the middle of the tenth century is the cross shaft at Kirkby Stephen in Westmorland. The beginning of a triangular pediment at the bottom, and the fact that the fragment is part of a cross shaft, indicate borrowings from Anglian art. But the figure enmeshed and imprisoned in interlace, the strange volutes that resemble horns at the back of the head, and the use of space-filling knobs and frequent 'free circles' in the interlace are Jellinge features.

5. Kendrick, II, plate 65.

6. E.g. Ellerburn, Middleton, Nunnington, Pickering (W. G. Collingwood, *Northumbrian Crosses of the Pre-Norman age* (1927), figures 138, 139, and 143).

7. All these features raise problems which it is not p. easy to resolve. The wheel-head cross, which possibly originated in the Chi-Rho monogram, was becoming popular throughout the ninth century, but the earliest examples of the free wheel-head as the apex of a cross shaft seem to be found in Norse work of the early tenth century in the Isle of Man, whence the design spread slowly across the whole of England

north-west of Watling Street. The first round-shaft cross of which we know is that at Reculver which, it has been suggested, took its inspiration from the carved pillar known to the Carolingian Rhineland. Another type, however, appears in the ninth century, of which the best example is the Mercian pillar at Wolverhampton, which may be dated to the middle of the century. The important new element at Gosforth is the fact that the base is plain and only the upper part is ornamented in a series of horizontal bands, while at the junction are found triangular decorated pendants. This design would suggest the copying in stone of croziers and processional crosses, whose enriched metalwork mounts join the wooden stem with exactly the same supporting pendants. These pendant triangles became a familiar feature on cross shafts both round and square in this late Anglo-Saxon period. At the same time, they tend to become associated with the round-shafted base sliced off into a square upper shaft. This is found in the ninth century on one or two great sculptured crosses in Yorkshire, for example at Dewsbury, but it was apparently not until the tenth or eleventh century in the north-west Mercia and south Lancashire area that it became a frequently employed cross type. But the chronology of this series of sliced round-shaft crosses in the midlands and the north is highly speculative and is complicated by the fact that there is a cross of Mercian type at Llantysilio-yn-Ial, Denbighshire, which purports by its inscription to date from the early ninth century. But the theory that this slicing method was the transference into stone of the Norse woodcarver's technique when confronted with a round tree-trunk is not an adequate explanation, since the earliest example is pre-Viking and the distribution pattern of the series lies largely outside the area of Viking settlement. All that can be said with safety is that this type of cross was known in the ninth century, that a similar type with a quite different ornamental system became common later on in north-west Mercia, and that Gosforth must be regarded as a unique northern outlier of this second group. See T. Pape, 'Round-shafted Pre-Norman Crosses in the North Staffordshire area', *Trans North Staffs Field Club* (1945–6). Kendrick, II, 72–5. V. E. Nash-Williams, *The Early Christian Monuments of Wales* (1950), 123–4, plate 36.

8. H. Shetelig, 'Manx Crosses', *Saga Book of the Viking Club*, IX, part 2 (1925). The dating system of P. M. C. Kermode, *Manx Crosses* (1907), is disproved by Shetelig.

9. C. A. Parker and W. G. Collingwood, 'A Reconsideration of the Gosforth Cross', *Cumb. and Westm. Archaeol. Soc. Trans*, 2nd Series, XVII (1916–

1917). It is argued here that the scenes can be made to represent the events told in the Voluspá if one works in a clockwise direction beginning with the bottom of the south side and moving alternately up and down – surely a highly improbable method of arrangement.

10. H. R. Ellis, 'Sigurd in the Art of the Viking Age', *Ant.*, XVI (1942).

11. G. Baldwin Brown and Mrs A. Christie, p. 33 'Saint Cuthbert's Stole and Maniple at Durham', *Burl. Mag.*, XXIII (1913).

12. For example at Steventon, Hants (Kendrick, I, plate 98). The harsh enigmatic figure of an angel on the apse-wall at Deerhurst may perhaps be ascribed to this period, largely for lack of a better alternative. But the dating is highly insecure and in any case, though done on a large scale and in the grand manner, its forbidding mask-like features owe nothing to the gentle classicism of the court (Kendrick, I, plate 103 (2)).

13. What was once part of a round shaft and is now the font at Deerhurst, and a wall panel at Bradford-on-Avon, both show the tight double spiral ornament which was an ancient and unquestionably Irish feature (Kendrick, I, plate 104). Unfortunately the dating of both these sculptures is highly speculative and not everyone would ascribe them to the first half of the tenth century.

14. F. Wormald, *English Drawings of the Tenth and* p. 34 *Eleventh Centuries* (1950).

15. Kendrick, II, plate 2.

16. *Op. cit.*, plate 7. p. 35

17. Officially reported to have been stolen during the war, these ivories are in fact still in the museum.

18. *Op. cit.*, plates 20 (1), 8.

19. The tall shaft at Leeds is datable to about the p. 36 middle of the eleventh century, and reproduces the ancient layout of the vine-scroll decoration on the sides and alternate panels of interlace and human figures on the face, that was first seen at Bewcastle 350 years before. The vine-scroll is now a coarse and clumsy pattern with emphasis on the sinuous stem-line, while the leaves are mere lumpy appendages which seem to owe more to a dim memory of acanthus scrolls than to any vine. Grace and vivacity have gone. The interlace consists of poorly conceived and irregular knots and even the symmetrical section with a repetitive horizontal twist is irritating in its bungling eccentricity (Kendrick, II, plate 41 (1)).

20. This carving is an exception to the rule of p. 37 dreary and incompetent work in the south midlands between 950 and 1066, whose only interest is to show the admixture of artistic influences that lay behind

them. In Northamptonshire there are clumsy combat-carvings that are derivative from the Derby cross shaft (Kendrick, II, plate 52 (2)). At Hickling in Nottinghamshire there is a grave slab whose bears at head and foot show influence from Brompton, whose animals are the Levisham type of Scandinavian adaptation of the old Anglian beast, and whose slack method of handling design is Jellinge in feel (Kendrick, II, plate 53). East Anglia in the eleventh century produced numerous examples of grave slabs and small crosses decorated with simple forms of interlace. Their key-cross pattern is a southern derivative, but otherwise the clumsy interlace is allied to similar Anglo-Danish work further north (cf. Cyril Fox, 'Anglo-Saxon Monumental Sculpture in the Cambridge District', *Camb. Ant. Soc. Proc.*, XXIII (1920–1921)). Thanks to the bombing of All Hallows, Barking, during the 1939–45 war there have come to light fragments of a cross shaft which show that London also possessed a school of sculpture in the early eleventh century that was influenced by these midland styles. The layout is that of the old panelled cross which survived in the north at Leeds, but whose existence as far south as London had not previously been suspected. Its figure sculpture, which once displayed a Christ in Majesty and Saints Peter and Paul, shows the influence of southern manuscripts in the short cloaks and crinkled hose. This influence is further strengthened by a panel of faintly recognizable Winchester acanthus arranged in a diagonal crisscross pattern and now adorned with the grape-clusters of the old Northumbrian vine-scroll. One of the animal panels presents a straightforward copy of the affronted twin beasts familiar to Northumbrian sculpture since the ninth century. This London carving, though devoid of artistic merit, thus shows an interesting admixture of old northern sculptural types and new southern manuscript influences and an even more interesting freedom from Scandinavian contact which otherwise would never have been expected in south-east England at this period (cf. Kendrick, II, chapter 10. T. D. Kendrick and C. A. Ralegh Radford, 'Recent Discoveries at All Hallows, Barking', *Antiq. Jnl*, XXIII (1943)).

p. 37 21. W. Bonser, 'Survival of Paganism in Anglo-Saxon England', *Birmingham Archaeol. Soc. Trans*, LVI (1932). M. A. Murray, 'Female Fertility Figures', *Jnl Roy. Anthropol. Inst.*, LXIV (1934). E. M. Guest, 'Irish Sheel-na-Gigs in 1935', *Jnl Roy. Soc. Ant. Ireland*, LXVI (1936). M. A. Murray, 'Fertility Figures', *Man* (1929), 99. D. P. Dobson, 'Primitive Figures on Churches', *Man* (1930), 8; (1931), 3.

p. 38 22. *V.C.H. London*, I (1909), 167–8. One of Canute's ministers was a man called Tokig, who

appears in documents between 1019 and 1043, and whose tombstone this might possibly be.

23. Kendrick, II, plate 78 (1) and figure 13.

24. Here and there in the West Riding of Yorkshire, at Staveley, Barwick-in-Elmet, Otley, and above all on the cross at Leeds which has already been described, scroll patterns of a definitely Ringerike type appear on otherwise standard Anglian crosses. Similarly at Bibury, in Gloucestershire, there is a grave-stone upon which a figure-of-eight scroll, in essence not unlike that on the Winchester plate, becomes a conventional design of limp flaccid lines, lion masks and clumsy scroll foliage. Here the sculptor contrives to lose both the formal beauty of the Southern manuscript style, from which these features are derived, and the brilliant extravagance of the Scandinavian manner.

25. Brit. Mus. Cott. MS. Tib. C. VI fol. 10 verso, as pointed out by Dr G. Zarnecki. p.

26. *Historians of the Church of York*, Rolls Series, II p.
(1886), 354. William of Poitiers, in Migne, *Patrologia Latina*, CXLIX (1853), col. 1267.

27. E.g. the Hildesheim door; the cover of Pierpont Morgan MS. 708; British Museum, Arundel MS. 60; a bronze pectoral (W. L. Hildeburgh, 'A medieval bronze pectoral Cross', *Art Bull.*, XIV, 1932).

28. A. Goldschmidt, *Die Elfenbeinskulpturen*, II (1918), nos 23 and 172; IV (1926), no. 308.

29. A. Goldschmidt, *German Illumination*, II, plates 3, 6, 84, and 96. Kendrick, II, plate 40 (3). A work that displays in a rather different manner the interplay of various influences is another Crucifixion panel, at Stepney, London. Here Christ is in the more familiar drooping posture, the loin-cloth and the draperies of Saint John and the Virgin are obviously in the Winchester manner, and the feet of Saint John overstepping the frame is a typical trick of the Winchester school. But the Maltese cross shape, the heavy acanthus border and the angels in their medallions above the cross arms are all symptoms of imported work. The result is a graceful and elegant little composition in thin relief, closely resembling the ivory upon which it was plainly modelled. O. M. Dalton, 'A Relief representing the Crucifixion … at Stepney', *Proc. Soc. Antiq. Lond.*, XXII (1907–8), 225.

30. Kendrick, II, plate 21 (1). A. Goldschmidt, *Die Elfenbeinskulpturen*, I (1914), no. 114; II (1918), nos 68 and 86.

31. Cogent arguments in favour of a pre-Con p.
quest date for the Langford Clothed Crucifix and the Barnack Majesty have been put forward by A. W. Clapham, 'Some Disputed Examples of Pre-Con-

quest Sculpture', *Ant.*, XXV (1951). The extreme – and to me untenable – view which places everything in the pre-Conquest period and attributes it all to Byzantine influence is set out by D. Talbot Rice, *English Art, 871–1100* (1952), chapter 5, section 2.

32. H. P. Mitchell, 'Flotsam of later Anglo-Saxon Art', I, *Burl. Mag.*, XLII (1923), 69. D. Knowles, *The Monastic Order in England* (1949), 535–6.

33. Migne, *Patrologia Latina*, CXLIX (1853), col. 1267.

34. H. P. Mitchell, 'English or German? – A Preconquest Gold Cross', *Burl. Mag.*, XLVII (1925).

42 35. Cf. Kendrick, II, plate 8.

36. M. C. Ross, 'An Eleventh Century English Book-cover', *Art Bull.*, XXII (1940). M. Harrsen, 'The Countess Judith of Flanders and the Library of Weingarten Abbey', *Papers of the Bibliographical Society of America*, XXIV (1931). It is fair to say that opinion is divided on whether or not to ascribe this cover to English or continental workmanship; for although the manuscript is undoubtedly English, the cover might have been added after Judith fled abroad (cf. *Pierpont Morgan Library, Exhibition of Illuminated MSS* (1934), 12).

37. T. D. Kendrick, 'An Anglo-Saxon Cruet', *Antiq. Jnl*, XVIII (1938).

CHAPTER 4

46 1. The theory of direct continuity advanced by Professor F. Wormald (articles in *Brit. Archaeol. Assn Jnl*, 3rd Series, VIII (1943); *Proc. Brit. Acad.*, XXX (1944); *Archaeol.*, XCI (1945) requires modification in the light of the recent researches of Dr Pächt, 'Hugo Pictor', *Bodleian Library Record*, III (1950), and T. S. R. Boase, *English Art, 1100–1216* (Oxford, 1953).

47 2. T. D. Kendrick, 'Flambard's Crozier', *Antiq. Jnl*, XVIII (1938).

48 3. Cf. an angel and a lion on an early eleventh-century porphyry altar (*Burl. Mag.*, XLII (1923), 64, plate I).

49 4. G. Zarnecki, *English Romanesque Sculpture, 1066–1140*, figure 27. Cf. *Ant. Jnl*, XV (1953), plate 27.

5. Cf. E. Maclagan, *The Bayeux Tapestry* (1943), figure 22.

6. See *Brit. Archaeol. Assn Jnl*, 3rd Series, VIII (1943), plate 13A.

50 7. *Loc. cit.*; cf. also the pre-Conquest ivory penner (M. H. Longhurst, *English Ivories*, figure 35, no. XXXVI).

8. C. E. Keyser, *A List of Norman Tympana and Lintels* (1927), figure 85.

9. An analogous type of scroll occurs once in the sculptures of the Reading cloister (a fragment now on the wall of a private house at Shiplake) datable to the third decade of the twelfth century, and on a capital in the triforium of Christchurch, Hants, of about 1130.

10. The elaborate capital found at Westminster, p. 51 with figure sculpture under a trefoil arch and inscribed with the names of Abbot Crispin and William II, has now disappeared and only a drawing survives. But it is impossible to believe that it dates from this early period (W. R. Lethaby, *Westminster Abbey Re-examined* (1925), figure 18).

11. See note 5. J. Romilly Allen, 'Sculptured Norman Capitals at Southwell Minster', *Associated Architectural Soc. Reports*, XXI, part 2 (1892), 239. W. J. Conybeare, 'The Carved Capitals of Southwell Minster', *Brit. Archaeol. Assn Jnl*, 2nd Series, XXXIX (1934). C. E. Keyser, 'The Norman Architecture of Notts.', *Brit. Archaeol. Assn Jnl*, 2nd Series, XIII (1907), figures 28–31.

12. T. D. Kendrick, 'Instances of Saxon Survival in Post-Conquest Sculpture', *Camb. Ant. Soc. Proc.*, XXXIX (1938–9).

13. A. B. and A. Wyon, *The Great Seals of England*, 1887, nos 17–29.

14. In East Anglia the survival or revival of Anglo- p. 52 Saxon influence can be detected not in figure drawing or technique, but in pure pattern. A late tenth-century manuscript in the British Museum, the Bosworth Psalter, shows initials with cats' heads and two-strand interlace with sharp elbow points, whence sprout little tufts of acanthus foliage. The same combination, less the cats' heads, appears again upon a mid eleventh-century bronze escutcheon found in a Scandinavian grave at Saffron Walden, Essex, and all three features reappear once more as the decoration of one side of an early twelfth-century font at Toftrees in Norfolk. In this case, it is hard to avoid the suspicion that the same style of manuscript initial was maintained in the scriptorium of one of the Fenland monasteries, spreading thence first to metalwork in the eleventh and then to stone sculpture in the twelfth century. But this is pure supposition and the question of revival or survival of influence is here almost impossible to determine with confidence (T. D. Kendrick, *op. cit.*).

15. For further information about this painted p. 53 decoration, see E. W. Tristram, *English Medieval Wall Paintings: Twelfth Century* (1944). He illustrates (plate 90) a late eleventh-century capital from Saint Nicholas Priory, Exeter, in which both sculpture and painting can be seen together.

p. 53 16. J. Bilson, 'Le Chapiteau à godrons en Angleterre', *Congrès Archéologique de France*, LXXV (1908).

17. For Norman ornament of the late eleventh and early twelfth centuries, see R. Fage, 'La Décoration géométrique dans l'école romane de Normandie', *Congrès Archéologique de France*, LXXV (1909). V. Ruprich-Robert, *L'Architecture normande aux XIᵉ et XIIᵉ siècles en Normandie et en Angleterre* (Paris, 1884–9). 'Le Chapiteau normand au XIᵉ et au XIIᵉ siècles', *Gazette Archéologique*, IX (1884). M. Anfray, *L'Architecture normande* (Paris, 1939), livre VI. There is no valid reason for supposing that the chisel was unknown to the early Norman carvers, for it is evident that pre-Conquest sculpture could not have been worked with any instrument as clumsy as an axe. The well-known change from axe to chisel in the twelfth century applies only to the tool used for the final dressing of the masonry (cf. the remarks of Salzman, 333).

p. 54 18. L. Grodecki, 'Les Débuts de la sculpture romane en Normandie. Bernay', *Bulletin Monumental*, CVIII (1950).

19. G. G. King, 'The Triumph of the Cross', *Art Bull.*, XI (1929), 317–18. As late as the thirteenth century, the monks of Saint Albans were hopefully – if unsuccessfully – putting a papal seal displaying the *Agnus Dei* on the top of their tower to ward off lightning (Salzman, 381).

20. C. E. Keyser, *A List of Norman Tympana and Lintels* (1927), figure 62.

21. When alone it often consists of a symmetrical arrangement of demi-palmettes, a common motif of early eleventh-century French sculpture, and found in Normandy at Bernay (*op. cit.*, figure 29D, and *Bulletin Monumental*, CVIII (1950), 40, figure 14).

22. Keyser, *op. cit.*, figure 40.

CHAPTER 5

p. 56 1. The evidence for the dating and stylistic connexions of the Canterbury capitals is drawn from the definitive work of Dr G. Zarnecki, *Regional Schools of English Sculpture in the Twelfth Century* (unpublished D.Phil. thesis at London University, 1950), 35–60; he has summarized some of his conclusions in *English Romanesque Sculpture, 1066–1140* (1951).

p. 57 2. *Op. cit.*, figure 40.

p. 58 3. The affinity of the capitals with Canterbury is shown, amongst other things, by the appearance of goats and of a dragon head with the same curious lobes as on a Canterbury capital. But the differences are also noticeable and it seems unlikely that any Canterbury craftsmen actually worked at Romsey.

4. C. J. P. Cave, 'Capitals from the Cloister of Hyde Abbey', *Antiq. Jnl*, XXV (1945); for manuscript parallels, see G. Zarnecki, *Thesis* (cit. note 1 above), 97, 131.

5. For full illustrations, see *Brit. Archaeol. Assn Jnl*, 2nd Series, XXIV (1918), figures 53, 58–65. p.

6. The significance of this Reading work was first pointed out by Dr G. Zarnecki in his thesis, and some of his conclusions have been summarized in *English Romanesque Sculpture, 1066–1140*. 'The Buried Sculpture of Reading Abbey', *Illustrated London News*, 16 Apr. 1949. 'The Coronation of the Virgin on a capital from Reading Abbey', *Jnl Warb. Court. Insts*, XIII (1950).

7. Kendrick, II, plate 73 (1), page 74. Another piece p. of evidence of Scandinavian influence at Reading comes from a springer with a three-strand interlace pattern which closely resembles that of a Viking metal brooch from Saffron Walden, Essex (Kendrick, II, plate 83 (2)). Sculpture under strong Ringerike influence at this period can also be found on capitals at Romsey, Hants, and Steyning, Sussex, both products of this southern Benedictine school, and on a font at Stoke Canon, Devon.

8. The same school spread particularly to the Oxford area, owing most probably to a transfer of a group of Reading masons to Saint Frideswide's, Oxford, where the capitals of the chapter-house show the same foliate strapwork and little cats' heads. The remarkable extension of the employment of beakhead ornament throughout the area is a feature of the 1150s and is to be found as far west as Gloucestershire, and a number of the heavily sculptured tympana and fonts of the district, including another Coronation of the Virgin at Quenington, Glos., must also be ascribed to this source. The whole Cotswold area was evidently enjoying a period of great prosperity during the middle of the twelfth century, and such church building as is not due to the later wool boom of the fifteenth and early sixteenth centuries is predominantly of this date. So powerful was the impression made by the Reading *atelier* that its influence spread out across almost the whole south midlands, and even Saint Albans, one of the greatest and richest Benedictine houses in the country, does not seem to have broken away from Reading influence. All that survives are the capitals of an interlacing arcade on the inner south wall of the south transept, which show similar patterns of loose strapwork with cat's head bindings, the same curled-over leaves, the same decorated abaci, and the same curling volutes

and leaf terminals that were to be seen on at least one capital from Reading cloister. There is, however, rather greater delicacy and subtlety to the patterned ornament, the cats' heads have become smaller and are more plastically conceived, and some of the leaves show the Anglo-Saxon feature of penetration by the interlacing stems, a trick also found in the mid-century Winchester Bible (W. Oakeshott, *The Artists of the Winchester Bible* (1945), plate 4). All the same it seems possible that this Saint Albans work was executed by the first group of Reading masons who moved on after the completion of the cloister. But no traces remain of what was apparently the most outstanding sculptural achievement at Saint Albans at this period, the shrine of Saint Alban. This was made by the great goldsmith Anketil, who had now become a monk, and is a rare twelfth-century example of the work of a monastic craftsman (H. T. Riley, *Gesta Abbatum Monasterii Sancti Albani*, Rolls Series (1867), I, 83–4). Another exception to the norm of lay artists is Hugh of Bury Saint Edmunds, who in about 1130–40 carved the great door of the church and the statues over the rood screen (W. Dugdale, *Monasticon Anglicanum*, III (1821), 162–3). In the main, however, the beginning of the twelfth century witnessed the full emergence of the professional lay craftsmen superseding the ecclesiastics themselves, even in the minor arts. The latter henceforward confined their personal activities to the illumination of manuscripts and the overall supervision of general iconographical schemes.

9. Evidence of the wide distribution of this theme is provided by a closely similar design on a tympanum at Koubatchi in far-off Daghestan (J. Baltrusaitis, *Art sumérien, art roman* (Paris, 1934), figure 38).

61 10. An incomplete list of English beakheads was published by J. Salmon, 'Beakhead Ornament in Norman Architecture', *Yorks. Archaeol. Jnl*, XXXVI (1944–7). The *lacunae* have been filled by G. Zarnecki, *Thesis (supra cit.)*, 108, n. 2.

62 11. H. H. King and O. M. Dalton, 'A carved ivory fragment of the twelfth century discovered at Saint Albans', *Antiq. Jnl*, II (1922).

12. *V.C.H. Northants.*, II (1906), 474, 478. The capitals are said to have been heavily restored in the nineteenth century (*op. cit.*, 197, n. 2).

63 13. G. Zarnecki, *English Romanesque Sculpture, 1066–1140* (1951), figures 39 and 40.

14. Full illustrations of the sculpture of these three churches are to be found in *Brit. Archaeol. Assn Jnl*, 2nd Series, XXIII (1917), figures 5–9, 14–16, 23–9, and 41–7.

15. *V.C.H. Northants.*, II (1906), 102; III (1930), 56.

16. A. Baker, 'Lewes Priory and the Early Group of Wall Paintings in Sussex', *Wal. Soc.*, XXXI (1942–1943), 33–4. A. Goldschmidt, *Die Elfenbeinskulpturen*, IV (1926), 11–12. p. 64

17. M. H. Longhurst, *English Ivories* (1926), figure 25.

18. See Saxl, plates 13–28. The date has long been disputed. No room is now left for further argument after the detailed confirmation by Dr G. Zarnecki of Sir Thomas Kendrick's original suggestion (Lecture by G. Zarnecki to the Royal Archaeol. Inst. of Great Britain, 3 Dec. 1952). p. 65

19. W. R. Lethaby, 'Fragments of a carved and painted rood from South Cerney Church, Glos', *Proc. Soc. Antiq. Lond.*, 2nd Series, XXVIII (1915–16).

20. For example a wooden head in the Museum at Lleida, Catalonia (*L'Art de la Catalogne*, Éditions 'Cahiers d'Art' (Paris, 1937), plate 57).

CHAPTER 6

1. The earliest signs of this development of the southern Benedictine school are to be found in the much battered doorways of the chapter-house and dorter at Rochester, probably inserted after the fire of 1137. The former, an arch of two orders resting on a pair of large semicircular shafts divided by a smaller pillar, bears scalloped capitals with the usual acanthus decoration. In addition, however, there is a set of delicately executed heads in high relief, projecting from the centre of the capital. The doorway to the dorter contains a tympanum which at last depicts a Biblical theme, that of the sacrifice of Isaac. The modelling is still fairly flat, and the figure style is nervous and energetic, taken from insular manuscripts and ivories, and shows little understanding of the virtues of clear statement. The novelty lies less in the treatment than in the undertaking of a didactic theme on such a large surface as a tympanum. p. 66

2. This school has been brilliantly and carefully analysed by Dr G. Zarnecki, in his thesis, and I am deeply indebted to him.

3. W. Dugdale, *Monasticon Anglicanum*, VI (1830), 345. Not 1148 as has hitherto been stated; see G. Zarnecki, *Thesis (cit. note 1, supra p. 242)*, 236–7.

4. A detailed account of the Reading influence on this school, but one which greatly exaggerates its importance and which neglects all other factors, is given by Selma Jónsdóttir, 'The Portal of Kilpeck Church', *Art Bull.*, XXXII (1950). p. 67

p. 67 5. Other Reading influence can be detected in the lions of the Shobdon font and the Leominster capitals, and the shaft with clasped and beaded medallions at Shobdon.

6. *Op. cit., passim.* A close parallel to the Hereford pipe-like scrolls ending in foliate tufts and enveloping human beings is to be found on a capital at Saint-Eutrope, Saintes (Charente-Maritime).

7. Kendrick, II, plates 78–81.

p. 68 8. Late twelfth-century architectural sculpture at Killeshin, Dysert O'Dea, and Inchagoile all show a few features also to be found in the Hereford school. While the possibility of influence back to Ireland is not entirely to be discounted, it seems more likely that these late works were repeating elements of a style hitherto practised in wood, but now absorbed into late Anglo-Norman architecture in stone. For these buildings, see F. Henry, *La Sculpture irlandaise* (Paris, 1932), plates 132, 134, and 148.

9. G. R. Lewis, *The Ancient Church of Shobden* (1852).

p. 69 10. The church of Kilpeck had been given to the monastery of Saint Peter's, Gloucester, in 1134, so that the cost of building the chancel, if not the nave, must have been borne by the monks (*Historia et Cartularium Mon. S. Petri Gloucestriae*, Rolls Series (1863), I, 16, 91). But there is no evidence whatever of any stylistic connexion with Gloucester, and it is clear that the monks merely hired the local school of masons.

11. Kendrick, II, plate 89.

12. This distinctive feature with its prominent ears and scorings round mouth and eyes may well be derived from the tenth-century boar's head at Deerhurst. Another local western trick found at Kilpeck is that of starting the chevron voussoirs not direct from the abacus, but after the insertion of a plain or decorated segmental block (cf. Castle Moreton, Upleadon, Sherborne, etc.).

13. *Jnl Roy. Anthropol. Inst.*, LXIV (1934), plate 12, no. 29.

14. Something of the same striated cloaks and mournful stare is to be found on the later English or Norwegian ivory chess-men from the Isle of Lewis, now in the British Museum (O. M. Dalton, *Catalogue of the Ivory Carvings of the Christian Era in the British Museum* (1909), plate 40).

15. R. Jullian, *L'Éveil de la sculpture italienne* (Paris, 1945), I, plates 48 and 43.

p. 70 16. *Op. cit.*, plate 53.

17. In France one of the earliest representations of a Virgin and Child alone on a tympanum occurs at just this moment in the 40s, at Chartres (É. Mâle, *L'Art religieux du XII^e siècle en France* (Paris, 1928), 431). Although the Fownhope Virgin is unique in wearing the cruciform halo normally confined to Christ or God the Father, there can be little serious doubt of her identity.

18. At Fownhope and elsewhere the fat scrolls are supported by little foliate tufts that loop themselves over the encircling bands. This is obviously a vestigial remnant of the Winchester school acanthus, whose great frilly volutes curled over in the same manner, and had reached the sculpture of the mid twelfth-century Marches by way of the manuscript. The central-facing Christ is also seen in mid twelfth-century English work on the seal of Abingdon Abbey (P. and G., figure 157).

19. Compare the treatment of the two halves of the outer voussoirs of the Kilpeck south door, or the work at Brinsop, evidently designed by the master and executed by a far less gifted assistant, as Dr Zarnecki has pointed out.

20. The futility of trying to establish the existence of a fully-fledged 'Cluniac' style in England is demonstrated by the font at the Priory of Lenton, Notts, which, like Lewes, was a direct daughter house of Cluny itself. The font is hewn from a large rectangular block and is ornamented with scenes of the Life of Christ carved in very shallow relief. The style is linked with that of other midland work, such as the font at West Haddon, Northants, but is quite unlike anything at either Cluny itself or Lewes (*Brit. Archaeol. Assn Jnl*, 2nd Series, XIII (1907), figure 33; XXXIII (1927), 193, 197).

21. W. H. St J. Hope, 'The Architectural History of the Cluniac Priory of Saint Pancras at Lewes', *Sussex Archaeol. Collns*, XXXIV (1886), 74, 89. F. Spurrell, 'Architectural Relics of Lewes Priory', *op. cit.*, VI (1853). W. H. Godfrey, 'Architectural Fragments', *op. cit.*, LXXXV (1946). J. Romilly Allen, 'A sculptured Norman Capital from Lewes Priory, Sussex', *Proc. Soc. Antiq. Lond.*, 2nd Series, XV (1893–5), 199.

22. A. Baker, 'Lewes Priory and the Early Group of Wall Paintings in Sussex'. Wal. Soc., XXXI (1942–1943).

23. Projecting heads and lions above the capitals of doorways or windows are found at Ferrara. They are frequently used as bases for pillars, a device that spread west into Provence and north into South Germany. Cf. Mario Salmi, *Romanesque Sculpture in Tuscany* (Florence, 1928), figure 137. T. Krautheimer-Hess, 'The original Porta dei Mesi at Ferrara

and the Art of Niccolò', *Art Bull.*, XXVI (1944), figure 19. R. Jullian, *op. cit.*, I *passim*.

72 24. The distinctive vertical knot at Christ's waist may be seen in an illumination of the contemporary Shaftesbury Psalter (Millar, I, plate 33C).

25. A. W. Clapham, *English Romanesque Architecture after the Conquest* (Oxford, 1934), 35.

73 26. Cf. the font at Coleshill, Warw., P. and G., figures 162 and 172.

27. M. R. James, 'The Abbey of Saint Edmund at Bury', *Camb. Ant. Soc.*, 8vo Publ. XXVIII (1895).

28. G. Zarnecki, *Later English Romanesque Sculpture, 1140–1210*, 23, plates 57–8. Saxl, plates 34–53.

74 29. The same theme of the punishment of the vice of Luxuria had already occurred on a large scale at Moissac and elsewhere in South France (J. Adhémar, *Influences antiques dans l'art du moyen-âge français* (1939), 198–9).

75 30. G. Zarnecki, *op. cit.*, 21–4, plates 52–3.

31. A. W. Clapham, 'The York Virgin and its date', *Archaeol. Jnl*, CV (1948).

32. For parallels ranging from the tenth to the thirteenth century, see F. Saxl and R. Wittkower, *British Art and the Mediterranean* (1948), 27; D. Talbot Rice, *English Art, 871–1100* (Oxford, 1952), 116–18.

33. *Yorks. Archaeol. Jnl*, XXIX (1927–9), 132.

34. P. and G., figure 125.

76 35. Saxl, plate 92.

36. Symeon of Durham, *Historiae Dunelmensis Ecclesiae Continuatio Prima*, Rolls Series (1882), 142 (I owe this reference to Professor T. S. R. Boase).

37. Saxl, plates, 88–91.

38. R. Jullian, *op. cit.*, I, plates 39, 46, and 54. D. M. Robb, 'Niccolò: a North Italian Sculptor of the Twelfth Century', *Art Bull.*, XII (1930).

39. W. Anderson, 'Romanesque Sculpture in Southern Sweden', *Art Studies*, VI (1928).

40. G. Zarnecki, *op. cit.*, 20-1, 29-31.

CHAPTER 7

77 1. Translated by G. G. Coulton, *A Mediaeval Garner* (1910), 72.

2. J. Bilson, 'The Architecture of the Cistercians...', *Archaeol. Jnl*, LXVI (1909), 192, n. 1 and 5.

3. 'Inde etiam in claustris monachorum grues et lepores, damulae et cervi, picae et corvi:...quae omnia nequaquam monachorum paupertati consulunt, sed curiosorum oculos pascunt'; Migne, *Patrologia Latina*, CXCV (1855), col. 572.

4. The Abbey owned both the manor and rectory p. 78 of Foston (*V.C.H., Yorks, N.R.*, II (1923), 135–7). There is little sign of the school at work in the Cathedral itself and Archbishop Roger's crypt capitals of the 1170s are not related to the style. But some of the Cathedral dignitaries certainly patronized the school, for Alne belonged to the Treasurer (*op. cit.*, II, 91) and Bishops Wilton to the Archbishop himself. Information is not yet available of the date of acquisition, but by the reign of Richard II the Dean and Chapter had appropriated the rectories of Stillingfleet and Saint Lawrence extra Walmgate, York; by 1534 the Archdeacon of York had appropriated the rectory of Brayton, and the rectory and manor of Riccall supported a Prebend (Browne Willis, *A Survey of the Cathedrals...*, I (1742), 27, 91, 158). The advowson of Barton-le-Street was owned by the alien priory of Holy Trinity, York (*V.C.H., Yorks, N.R.*, I (1914), 472), Fishlake by the Cluniac priory of Lewes (*Ass. Architectural Soc. Reports*, IV (1857), 91), and Birkin by the Templars after 1152 (F. Bond, *Gothic Architecture in England*, 1905, 639).

5. Kendrick, II, plate 84. p. 79

6. Bestiaries in manuscript begin as early as the p. 80 fifth century. They are collections of moralized tales of animals, the majority entirely fantastic, from whose activities it was possible to draw ethical conclusions. Appealing thus to the strong sense of symbolism, the love of the exotic, and the passion for instruction of the early medieval monk, it is not surprising that the *Physiologus*, as the first of the bestiaries was called, enjoyed great popularity. At least one copy seems to have been present in most twelfth-century libraries. Judging from the surviving examples, it seems to have been particularly popular in England, and the development of the bestiary has sometimes been ascribed to this country.

7. These figures strongly resemble another high p. 81 up on the tower at Langford, in Oxfordshire, but the beaded arches which surround them make it certain that the whole group of panels is a product of the mid twelfth century and not of the eleventh century itself. A late twelfth-century psalter from Yorkshire, now in the Hunterian Museum, Glasgow, has pictures of little skirted figures that resemble both Anglo-Saxon miniatures and the Barton-le-Street panels, and provides evidence of the manuscript link (Millar, I, plate 60A).

8. Cf. R. Jullian, *L'Éveil de la sculpture italienne*, I (Paris, 1945), 100, plates 21, 42, and 58. A. Kingsley Porter, *Romanesque Sculpture of the Pilgrimage Roads*, Boston, (1923) VII, figures 952 and 959. D. M. Robb,

'Niccolò: A North Italian Sculptor of the Twelfth Century', *Art Bull.*, XII (1930), figures 5–8, 32.

p. 81 9. In York Minster itself, at the very end of the century, this greater skill in modelling, due possibly to Lincoln influence, is to be observed in a grand composition on the subject of the torments of Hell, of which there has survived only a huge slab now in the Cathedral crypt, and a tympanum in the Museum. These fragments are of even more terrifying ferocity and diabolical ingenuity than the Lincoln panels with the same theme. The advanced date of the composition is evidenced by the fuller modelling of the hideous devils tearing at the little anthropomorphized soul of the dying sinner, which are treated plastically in all their scales and wrinkles (Saxl, figure 49, plates 93–5).

10. A similar development occurred farther south. In the remote rural area of the Broadlands of East Anglia between Norwich and the sea, in the third quarter of the century there flourished a local school specializing in the lush geometrical decoration of door arches. Although sternly rejecting all animal, vegetable, or human additions to their repertoire, these sculptors contrived to achieve a rich effect by lavish employment of such motifs as chevrons and star-patterns, double cones, cheese mouldings, medallions set on ridges, concave ovals and wedge-shaped drilled blocks. Good examples of the style are provided by the doorways of the little churches of Hales, Heckington, and Heckingham (C. E. Keyser, 'A Day's Excursion among the Churches of South-East Norfolk', *Archaeol. Jnl*, LXIV (1907)).

p. 82 11. H. P. Mitchell, 'English Enamels of the Twelfth Century, I,' *Burl. Mag.*, XLVII (1925). W. Oakeshott, *The Artists of the Winchester Bible* (1945). The reason for thinking that the plaque was not designed by the Master of the Leaping Figures himself is that the latter invariably shows the stomach with a softly curving loop under the belly, while the Masters plaque has the firm V-fold of the Lambeth Bible. (I am indebted to Professor T. S. R. Boase for calling my attention to this point.) The purpose of the plaque is obscure; it may perhaps have been part of one of the gifts of Henry to Winchester cathedral, either the 'tabula aurea...ornata esmallis...' or the 'cassula aurea signata cum esmallis desuper...' (E. Bishop, *Liturgica Historica* (Oxford, 1918), 399–400).

12. Millar, I, plates 37–8. F. Saxl and R. Wittkower, *British Art and the Mediterranean* (1947), plate 27A. See Saxl, plates 84–7.

p. 83 13. H. Brakspear, 'Malmesbury Abbey', *Archaeol.*, LXIV (1912–13). 'A West Country School of

Masons', *Archaeol.*, LXXXI (1931), 5. Saxl, plates 54–83.

14. G. Zarnecki, *Later English Romanesque Sculpture, 1140–1210* (1953), 40–1, plate 95.

15. Though more solidly constructed and more naturally proportioned, the beautiful figure of an angel on the lead font at Halstow, Kent, has similar draperies clinging round the elongated thigh, and the slight bend of one knee countered by the turn of the head in the reverse direction gives the same impression of airy elegance. The thin, wispy foliage scrolls above the arches are also similar to those surrounding the Malmesbury medallions (*Brit. Archaeol. Assn Jnl*, 2nd Series, XXXIX (1933), 312).

16. For the Kempley wall paintings, see E. W. Tristram, *English Medieval Wall Painting, Twelfth Century* (1944), 42–4; for the Psalter of Henry of Blois, see *British Museum Reproductions from Illuminated MSS*, series III (1925), plate 7; and O. E. Saunders, *English Illumination* (Paris, 1928), I, plate 38; for the Winchester Bible, see W. Oakeshott, *op. cit.*

17. M. Aubert, 'Le Portail royal...de Chartres', *Bulletin Monumental*, C (1941). In view of the failure of these Rochester figures to imitate the second phase statuary of Chartres, they can hardly be later than 1155–60. On the other hand, they cannot be much earlier, in view of the obvious influence of mid-century Poitevin work.

18. The cause of this allegory was the saying of Christ: 'The queen of the south shall rise up in the judgement with the men of this generation and condemn them; for she came from the utmost parts of the earth to hear the wisdom of Solomon, and behold, a greater than Solomon is here' (Luke, xi, 31). It is significant of the confusion to which this allegory naturally gives rise that until the twentieth century these statues at Rochester were supposed to represent Henry I and Queen Matilda.

19. C. E. Keyser, *A List of Norman Tympana and Lintels* (1927), figure 127.

20. *Op. cit.*, figure 129.

21. See *supra*, p. 88.

22. F. Bond, *Fonts and Font Covers* (1908), 82.

23. Millar, I, plate 39.

24. W. Oakeshott, *op. cit.*, plates 4 and 11.

25. Farther to the west in Gloucestershire, at Micheldean and Newnham to the west of the Severn, and Rendcombe to the east, is a group of stone fonts of a very different style. These take up again the *homme-arcade* layout familiar since the days of Rome, in which rows of apostles are displayed beneath semicircular arches supported by thin pillars. The

style of this group is further evidence of a mid-century geometrical return to barbaric tastes: pillars and arches are elaborately adorned with beading, chevron, spirals, and other patterns, while the draperies of the apostles have been reduced to flat linear patterns of lozenge, chevron, and parallel incisions on oblong blocks from which protrude feet and head, the whole being reminiscent of the aesthetic concepts that lay behind the apostle figures of the Book of Kells, four centuries before. Another example of this style occurs on a Purbeck marble slab of a bishop at Exeter (P. and G., figure 648).

26. There are still forty-nine examples of Tournai marble fonts in this area (G. C. Dunning, 'The Distribution of Black Tournai Fonts', *Antiq. Jnl*, XXIV (1944), 66).

27. It is becoming increasingly evident that Henry of Blois played as predominant a role in the art of the mid twelfth century as he did in its politics. Nor was his patronage exercised entirely in one direction. Some pages of the manuscripts made at Winchester bear strong marks of Anglo-Saxon calligraphic influence, while others are the first examples of the latest humanistic style of Byzantium. There is evidence to suggest that he employed an artist from the school of the celebrated Mosan enameller, Godefroid de Huy, to make a set of plaques including one with a portrait of Henry himself with a highly laudatory inscription, all possibly for the shrine of Saint Swithin at Winchester (H. P. Mitchell, 'Some Enamels of the school of Godefroid de Claire', IV, V, *Burl. Mag.*, XXXV (1919)). As will be seen later, he certainly used an antique intaglio for a finger ring, and shipped antique statuary from Rome, and it is here suggested that it was he who imported the Tournai fonts. The list of his gifts to Winchester of gold and silver metal-work, jewellery and vestments, reads like the inventory of an Emperor's treasury (E. Bishop, *Liturgica Historica* (Oxford, 1918), 398–401). All this many-sided and lavish patronage of the visual arts, together with his recorded interest in natural phenomena, suggests that it was as much a fundamental difference of temperament as quarrels over Church politics that led Saint Bernard to describe Henry as 'the old whore of Winchester' (D. Knowles, *The Monastic Order in England* (Cambridge, (1949), 290).

28. F. Rolland, 'L'Expansion tournaisienne au XIᵉ et XIIᵉ siècles: art et commerce de la pierre', *Annales de l'Académie Royale d'Archéologie de Belgique*, LXXII (1924), 206–7.

29. J. Romilly Allen, 'Fonts of the Winchester Type', *Brit. Archaeol. Assn Jnl*, L (1894), and C. H. Eden, *Black Tournai Fonts in England* (1909).

30. G. C. Druce, 'Lead Fonts in England…', *Brit. Archaeol. Assn Jnl*, 2nd Series, XXXIX (1934).

31. H. Woodruff, 'The Illustrated Manuscripts of Prudentius', *Art Studies*, VII (1929).

32. One mask on the font at Stogursey, in Somerset, actually bears a double curving volute on the forehead whose ancestry can be traced back to pre-Roman art in England. p. 90

33. A. C. Fryer, 'A Group of Transitional Norman Fonts', *Brit. Archaeol. Assn Jnl*, 2nd Series, VII (1901). F. Bond, *op. cit.*, 200–1.

34. C. E. Keyser, *op. cit.*, figure 87.

35. *Op. cit.*, figure 117.

36. *Op. cit.*, figure 116.

37. R.C.H.M., *City of Oxford* (1939), 151. p. 91

38. This view is supported by the penetration into this region of the Gloucestershire type of hood-mould terminal with its dragon head; e.g. Binsey, Oxon.

39. For example, Stoke-sub-Hamden, Somerset, or Little Paxton, Hunts. (Keyser, *op. cit.*, figures 69 and 73).

CHAPTER 8

1. For some of these theories, cf. Pol Abraham, 'Nouvelle Explication de l'architecture religieuse gothique', *Gazette des Beaux-Arts* (1934), I. J. Summerson, *Heavenly Mansions* (1949). H. Seydlmayr, *Die Entstehung der Kathedrale* (Zürich, 1951). H. Focillon, *Art d'occident* (Paris, 1947), 143–8. p. 94

2. *Brit. Archaeol. Assn Jnl*, 3rd Series, VIII (1943), plate 19B. p. 95

3. Cf. J. Adhémar, *Influences antiques dans l'art du moyen-âge* (1939).

4. G. H. Pertz, *Monumenta Germaniae Historica… Scriptores*, XX (1868), 542. L. C. Lloyd and D. M. Stenton, *Sir Christopher Hatton's Book of Seals* (Oxford, 1950), no. 466.

5. E. W. Tristram, *English Medieval Wall Painting: The Thirteenth Century* (Oxford, 1950), 25, 130. P. Nelson, 'Some British Medieval Seal-Matrices', *Archaeol. Jnl*, XCIII (1936), nos 24–31.

6. J. Bony, 'French Influence on the Origins of English Gothic Architecture', *Jnl Warb. Court. Insts*, XII (1949). C. M. Girdlestone, 'Thirteenth-Century Gothic in England and Normandy', *Archaeol. Jnl*, CII (1945). For twelfth-century examples of the use of dog-tooth, see F. Bond, *Gothic Architecture in England* (1905), 77. p. 96

p. 96 7. A. Goldschmidt, 'English Influence on Medieval Art on the Continent', *Medieval Studies in memory of A. Kingsley Porter*, II (New Haven, Conn., 1939), 723.

p. 97 8. C. E. Woodruff, 'The Financial Aspect of the Cult of Saint Thomas of Canterbury', *Archaeol. Cantiana*, XLIV (1932), 16.

9. R. Willis, 'Architectural History of Worcester Cathedral', *Archaeol. Jnl*, XX (1863), 99–100.

10. C. E. Cheney, 'Church-Building in the Middle Ages', *Bulletin of the John Rylands Library*, XXXIV (1951–2).

p. 98 11. Arguments for the falsity of the architectural claims of the best known of these clerics in charge of building administration are put forward by A. H. Thompson, 'Master Elias of Dereham and the King's Works', *Archaeol. Jnl*, XCVIII (1941). But see also Salzman, 9–10.

12. The history of Purbeck marble is to be found in G. Dru Drury, 'The Use of Purbeck Marble in Medieval Times', *Dorset Nat. Hist. and Archaeol. Soc. Proc.*, LXX (1948). *V.C.H. Dorset*, II (1908), 331. P. and G., 568. A. Anderson, *English Influence in Norwegian and Swedish Figure Sculpture in Wood, 1220–1270* (Stockholm, 1949), 55.

p. 99 13. J. Hutchins, *History…of Dorset*, I (1861), 466.

14. *Loc. cit.*

15. For example at Westminster in 1292, there were employed John, Edward, William, Hugh, and Peter 'de Corf', a total of five out of 137 masons ('Gleanings from Old Documents', *Masonic Magazine*, IV (1876–7), 616–18).

16. G. G. Scott, *Gleanings from Westminster Abbey* (1863), 242.

17. J. G. Noppen, 'Building by Henry III, and Edward, Son of Odo', *Antiq. Jnl*, XXVIII–XXIX (1948–9). E. F. Jacob, 'The Reign of Henry III, some Suggestions', *Trans Roy. Hist. Soc.*, 4th Series, X (1927). Many of Henry's instructions are to be found in Salzman, 382–7, and T. Hudson Turner, *Some Account of Domestic Architecture in England*, I (1851), chapter 5.

p. 100 18. There was a Terence of the third quarter of the century at Saint Albans (L. W. Jones and C. R. Morey, *The Miniatures of the Manuscripts of Terence* (Princeton, N.J., 1931), 91).

19. There are two other ciboria which evidently come from the same workshop, the Kennet Ciborium, now on loan to the Victoria and Albert Museum, and the Malmesbury Ciborium, in the Pierpont Morgan Library, New York. There have also survived, now widely scattered throughout the collections of Europe and America, a group of seven enamel plaques with scenes from the Legend of Saints Peter and Paul. These are characterized by short heavy bodies with huge bearded heads, whose expression is extremely forbidding. The drapery is mostly of thin texture with multiple folds and is hitched up over a tight waist-belt. At the same time the vivacity of the scenes is created by the use of artificial gestures, particularly of an extremely exaggerated curving forefinger, which is essentially a Romanesque device. The style of these plaques is further advanced than that of the Warwick Ciborium. But owing to the ubiquity of the new influences and the similarity of the reaction to them there is no certainty that the plaques are of English workmanship. Similarities exist with some Canterbury glass of the turn of the century and with some English manuscripts of the early thirteenth century. On the other hand there are technical and stylistic likenesses to twelfth-century enamels of west and north Germany, so that it is impossible to be dogmatic on the subject (Tancred Borenius and M. Chamot, 'On a Group of Early Enamels, possibly English', *Burl. Mag.*, LIII (1928)).

20. See *supra*, p. 246, note 9. The earliest example p. of sculpture in the round in Yorkshire is a fragmentary statue from Bridlington Priory, dating to about the last decade of the century (G. Zarnecki, *Later English Romanesque Sculpture, 1140–1210* (1953), plates 115–6).

21. For full photographs, see R. Marcousé, 'Figure Sculpture in Saint Mary's Abbey', *Yorks. Museum Papers* (1951), no. 1.

22. The battered statue of Christ discovered after further excavation in 1952 cannot belong to the door, since it is evidently a work of the late thirteenth or early fourteenth century.

23. Millar, I, plates 51–2. R. A. B. Mynors, *Durham Cathedral Manuscripts* (Oxford, 1939), plate 49.

24. R. Willis, *The Architectural History of Canterbury Cathedral* (1845), 61.

25. Full illustrations of these Canterbury bosses are to be found in C. J. P. Cave, 'The Roof Bosses of Canterbury Cathedral', *Archaeol.*, LXXXIV (1934).

26. This criss-cross pattern of long stalks has a history that goes back to Anglo-Saxon sculpture at All Hallows, Barking, and Sompting, Sussex. It was revived in the late 1130s on a capital at Steyning, Sussex, and now, half a century later, it appears again at Oxford.

27. The mixture of foliage types is so complete on p. all major buildings that it is not really possible to

detect any clear localization except in terms of stylistic handling. For example, the Purbeck marble tomb of Bishop Marshall in Exeter Cathedral, dating from the first decade of the century, originally had a side bearing three quatrefoils with flat trefoil finials. Of these finials, one has a central spine running right down the leaf, one a hollow leaf, and the third the spine entering deep into the leaf. All three distinct types were evidently equally familiar to this west-country sculptor (H. E. Bishop and C. Ralegh Radford, 'Bishop Henry Marshall's Tomb in Exeter Cathedral', *Antiq. Jnl*, XXI (1941)).

28. The progress of stiff-leaf foliage from 1190 to 1253 can be followed in the bosses at Lincoln. Those of the main vault of Saint Hugh's choir, contemporary with the Wells transepts, bear irregularly disposed designs in which the pattern tends to be lost in the complexity of the foliage (Cave, 'The Roof Bosses of Lincoln Cathedral', *Archaeol.*, LXXXV (1935), plate 7 (1) and (4)). Later, in the great transepts and chapter-house, the bosses are far more skilfully composed in spirals, there is greater depth in the modelling, and the leaf forms are more varied, with the spine beginning to press into the leaf (*op. cit.*, plate 7 (2) and (6)). Later still, in the nave, the spine is pressing so deep into the leaf that the latter is curling back over itself, the undercutting is more pronounced, and the domination of the spiral pattern over the complicated mass of leaves is more obvious. At the same time there are examples of new types of leaves with serrated edges and thin veins and accompanied by grape-berries, evidence of fresh French influence inaugurating the period of naturalistic foliage (*op. cit.*, plate 7 (3) and (7-9)).

104 29. The man with a thorn in his foot is derived from an extremely popular and much copied classical bronze of the same subject. It is perhaps no coincidence that it occurs most frequently in twelfth-century sculpture in the south-west of France, which was just the area whose influence was greatest upon the west of England (J. Adhémar, *Influences antiques dans l'art du moyen-âge français* (1939), 189-191).

30. P. and G., figures 647-8.

31. *Op. cit.*, figures 649-50.

32. The closest parallels to this piece of wood-carving are the late twelfth-century Westminster Psalter (Millar, I, plates 62-3) and the Canterbury glass of the series of c. 1200 (B. Rackham, *The Ancient Glass of Canterbury Cathedral*, 1949, plate 7). On the other hand there may well have been a substantial time-lag between painting and sculpture, and this is borne out by the identity of the facial type with an early thirteenth-century Purbeck marble head from Rochester and another from the west front of Peterborough (P. and G., figures 226 and 301). For similar French wood-carving of the same period, see the Virgin and Child at Gassicourt (Seine-et-Oise) (M. Aubert, *Gothic Sculpture in France, 1140-1225* (Florence, 1929), plate 44B).

33. J. Wickham Legg, *Inventories of Christchurch, Canterbury* (1902), 47-9. W. R. Lethaby, *Westminster Abbey Re-examined* (1925), figure 172.

34. Otto Homburger, *Der Trivulzio-Kandelaber* (Zürich, 1950). Almost the only open metalwork of this late twelfth- and early thirteenth-century period that can with assurance be ascribed to English workmanship are the crozier heads of Bishops of Saint David's discovered when their tombs were opened in the early nineteenth century (*Archaeol.*, LX, part 2 (1907), plate 53).

35. Saxl, plates 99-100. p. 105

36. R. Willis, 'The Architectural History of the Cathedral of Worcester', *Archaeol. Jnl*, XX (1863), 99-104. For full illustrations, see Elijah Aldis, *Carvings and Sculptures of Worcester Cathedral*, 1873. The stiff-leaf is of a rather squat variety, with very depressed spines, and there are numerous foliated dragons and monsters, such as occur in the Wells nave and porch, and in manuscripts.

37. Cf. the Psalter of Robert de Lindeseye, which dates to shortly before 1222 (Millar, I, plate 70); or W. R. Lethaby, 'English Primitives, I', *Burl. Mag.*, XXIX (1916).

38. One fragment, found in the early nineteenth p. 106 century and now lost again, showed scroll and animal designs of extreme richness carved in what is described as 'blue lias' (R. Warner, *An History of the Abbey of Glaston* (1826), page xiii. I owe this reference to Professor T. S. R. Boase). The style is identical with that of a black marble fragment from Old Sarum and both are probably imports from Tournai.

39. W. H. St J. Hope, 'On the Sculptured Doorways of the Lady Chapel of Glastonbury Abbey', *Archaeol.*, LII (1890). J. A. Robinson, 'On the rebuilding of Glastonbury after the fire of 1184', *Archaeol. Jnl*, LXXXV (1928), 18-20.

40. J. A. Robinson, 'Effigies of Saxon Bishops at Wells', *Archaeol.*, LXV (1913-14).

CHAPTER 9

1. In the general stylistic interpretation of this p. 108 Wells sculpture, I have in the main followed the lead given by A. Andersson (*English Influence in Norwegian and Swedish Figure Sculpture in Wood, 1220-70*

(Stockholm, 1949), 15–55), though I disagree with him in his rejection of the effigies of the Saxon bishops as an antecedent factor, and I have been unable to detect his Intermediate Group. The series begins shading off into new mannerisms in the upper tiers, and the setting up of such rigid categories seems unwarranted. The iconography was worked out fifty years ago by W. H. St J. Hope and W. R. Lethaby ('The Imagery and Sculptures on the West Front of Wells Cathedral Church', *Archaeol.*, LIX (1904)), and there is still nothing to add to that analysis. The dating of the front is discussed by John Bilson ('Notes on the Earlier Architectural History of Wells Cathedral', *Archaeol. Jnl*, LXXXV (1928), 65–7), and the names of some of the masons at work are given by J. A. Robinson ('Documentary Evidence relating to the Building of Wells Cathedral', *Archaeol. Jnl*, LXXXV (1928), 15). For photographs of French comparisons, see M. Aubert, *Gothic Sculpture in France, 1140–1225* (Florence, 1929), and P. Vitry, *Gothic Sculpture in France, 1226–70* (Florence, n.d.).

p. 110 2. A. B. and A. Wyon, *The Great Seals of England* (1887), no. 41.

p. 112 3. Some of the best figures are those of warriors in full thirteenth-century armour of heavy, flat-topped helmet and chain mail, covered with a surcoat. It is noticeable that the mail is carved as if running in bands along the arm, instead of round the arm, which was the common method of the day. Subsequent tomb figures of knights show sometimes one and sometimes the other method, but attempts to call horizontal bands a feature of London workshops and vertical bands that of a Wells or Bristol school seem hardly to be justified by the available evidence. Cf. A. Andersson, *op. cit.*, 46–7.

4. The identical pose appears in the figure of Saul from the Rutland Psalter of about 1250. Millar, I, plate 78.

5. Cf. the same gesture made by one of the Lincoln Apostles a hundred years before (plate 53).

6. T. D. Atkinson, *Archaeol.*, LXXXV (1935), 161.

p. 113 7. It should not be forgotten that some ninety years earlier Henry of Blois had imported to Winchester a shipload of antiques from Rome, so that the existence of a classical model here is far from unlikely. For the Chartres figures, see E. Houvet, *La Cathédrale de Chartres, Portail Nord* (Chelles, n.d.), plate 18.

8. C. J. P. Cave, 'The Roof Bosses of Lincoln Minster', *Archaeol.*, LXXXV (1935), plate 7.

p. 114 9. T. Rymer, *Foedera...*, VIII (1729), 510.

10. J. Harvey, *Henry Yevele* (1944), 49.

11. *Op. cit.*, 30. N. H. Nicholas, *Testamenta Vetusta* (1826), I, *passim*.

12. J. Weever, *Ancient Funerall Monuments* (1631), 18–19.

13. J. Raine, *Fabric Rolls of York Minster*. Surtees Soc., XXXV (1858), 39.

14. Shields by 1300 are normally short and heater- p. shaped rather than long and kite-shaped as was common half a century before. But a dated example of the heater shield is provided by the Cantelupe tomb at Hereford of 1282–4, while an effigy at Dorchester, Oxon., commonly dated *c.* 1310, shows a long shield stretching from shoulder to knee. Very little reliance can therefore be placed upon this factor. Headgear is equally of little help, once the false assumption that large coal-scuttle heaumes disappeared by 1250 has been discarded (A. Andersson, *op. cit.*, 54, n. 2). The steel cap beneath the chain mail was certainly flatter before 1250 and subsequently rounder in form. But when no cap at all was worn early effigies show the rounded shape, while a head at Exeter commonly dated to about 1280 shows the squared top of the 1230s and 40s (P. and G., figure 686). The rounded cap protruding beyond the head, apparently a feature of the 60s, also occurs thirty years later at Hornby, Yorks. Surcoats worn calf- or ankle-length up to about 1260 had given way to thigh-length fashion by 1320, but the stages in the process were far from regular or uniform. Examples usually dated between about 1310 and 1320 at Dorchester, Oxon., Aldworth, Berks., Bristol, and Exeter, show long surcoats, two from Dodford, Northants., and Tollard Royal, Wilts., usually dated to about 1310 are short, and surcoats falling only just below the knee occur without interruption from the Salisbury effigy of the 1230s to the effigy of Aymer de Valence at Westminster of the 1320s (P. and G., figures 726, 727, 699, 697; 676, 724; 680, 671, 732, and 729). After 1260 the sword belt was usually attached to the scabbard in two places instead of one, but exceptions to this rule continue at least as late as 1300 (A. Hartshorne, 'The Sword Belts of the Middle Ages', *Archaeol. Jnl*, XLVIII (1891)). Knee-caps of leather or metal began creeping in by about 1260 and elbow-caps twenty-five years later, but their use was far from standard before the early fourteenth century.

With regard to the accessories of the effigy, canopies were not used over military effigies and are therefore of no value in the dating of this most difficult series. The use of a lion couchant as a foot-rest was introduced in the West in the 1240s, for it occurs on an effigy of the Wells school at Shepton Mallet, Som., but not on Longespée at Salisbury of about

1230–40. In the thirteenth century the head was generally supported by a single oblong flat cushion or a fat bolster and it was only in the late 80s that the court school introduced the two cushions of which the upper was set diagonally. P. and G. illustrate some west-country effigies with double cushions to which they give dates of *c.* 1260–80 (figures 682, 683, 671, and 693); for different reasons I believe that all these should be ascribed to the late 80s or 90s and may thus be regarded as under Westminster influence; this is a judgement with which Andersson is in agreement (*op. cit.*, 5, n. 4). On the other hand, this new practice was far from universal, and single cushions are still met with in western effigies at least as late as the turn of the century (P. and G., figure 699). Angels holding the double cushions are equally a Westminster feature derived from France, which spreads erratically throughout the West at about the same time.

A valuable contribution to a study of local schools ought to be provided by a methodical analysis of the geological nature of the surviving effigies, which would make possible firm attributions to different quarries. This has already been done in Gloucestershire and Somerset under the leadership of Dr A. C. Fryer, 'Monumental Effigies made by Bristol Craftsmen, 1240–1550', *Archaeol.*, LXXIV (1923–4). 'Monumental Effigies in Somerset', *Somerset Archaeol. and Nat. Hist. Soc. Proc.*, LXI–LXVI (1915–20). These surveys cover products from three oölite quarries, Dundry, near Bristol, Doulting, near Wells, and Ham Hill. Unfortunately these geological distinctions do not seem to involve any clear-cut stylistic differences by which a hypothesis of three distinct schools could be constructed.

15. The original situation of the tomb was in the Lady Chapel, which was certainly finished by the 1230s, and it was moved to the nave by Wyatt in 1789 (J. R. Planché, 'On the Sepulchral Effigies in Salisbury Cathedral', *Brit. Archaeol. Assn Jnl*, xv (1859), 125).

16. Stothard, plate 17.

17. *Archaeol.*, LXXIV (1923–4), plate 1, nos 3–5.

18. *Loc. cit.* Dr Fryer's geological evidence for the numerous effigies of 1250–80 seems convincing proof that Bristol became a major centre soon after the middle of the century.

19. P. and G., 588–91, ascribe the cross-legged attitude to the London marblers and date it at about 1240–50. But their examples of the latest straight-legged effigy at Sandwich (figure 667), and the earliest cross-legged figures in the Temple (figure 665) are both, I believe, wrongly dated. The former seems

to be a French-inspired effigy which may well date to the 1280s, to judge by the canopy and shield, while the latter with its half-turned body and richly carved shield is evidently also a work at least as late as the 70s. Similarly the drapery style, the short shield and the elbow-caps of the effigy at Salisbury, which Prior and Gardner claim as one of the first examples of the sword-drawing type (594–5), all suggest a date at least as late as the 1270s. Nor is there any reason to date the Walkern effigy as early as 1245 (*op. cit.*, figure 668). See also Andersson, *op. cit.*, 53.

20. G. Dru Drury, 'The Use of Purbeck Marble in Mediaeval Times', *Dorset Nat. Hist. and Archaeol. Soc. Proc.*, LXX (1948), 89. p. 116

21. Andersson, *op. cit.*, figure 15.

22. See *supra*, p. 104.

23. This information about the state of the body is derived from an account of the opening of the tomb by V. Green, *An account of the discovery of the body of King John in the Cathedral Church of Worcester, July 17 1797* (1797), 4.

24. In 1873 the effigy was gilded all over by official restorers. But before this act of vandalism the effigy was painted, though this may have been carried out at any time in the Middle Ages, and not necessarily when the effigy was carved. The dalmatic was crimson with blue-green lining, the tunic yellow, the hose red, and the shoes black (Stothard, plate 11). The credit for pointing out the influence of metalwork on King John's effigy must go to Andersson, *op. cit.*, 59–61.

25. P. and G., figures 652–3. p. 117

26. *Op. cit.*, figures 658–9.

27. Heavily restored by Richardson in the early nineteenth century, the effigies were largely destroyed by German bombing in 1941, though five casts exist in the Victoria and Albert Museum (A 1938 – 6 to 10). The only effigy that did not belong to the series was brought from Yorkshire in about 1682 (R.C.H.M., *London*, IV (1928), plates 182–7. E. Richardson, *The Monumental Effigies of the Temple Church* (1843). E. Hatton, *A New View of London*, I, (1708), 574).

CHAPTER 10

1. T. J. Pettigrew, 'On the Ancient Royal Palace of Clarendon', *Brit. Archaeol. Assn Jnl*, xv (1859). p. 118

2. Cf. the head of Saint Laurence from Münster, a work of about 1260–5 (E. Panofsky, *La scultura tedesca dall' XI al XIII secolo* (Milan, 1936), plate 64).

p. 118 3. W. H. St J. Hope, 'Images of Kings in the Cathedral Church of Salisbury', *Wilts. Archaeol. and Nat. Hist. Mag.*, XXXIX (1917), 505. P. and G., figures 233–4, 280–1.

p. 120 4. *Brit. Archaeol. Assn Jnl*, 3rd Series, VIII (1943), figures 19 and 20. *Archaeol.*, LXXXIV (1934), plate 13.

5. Quoted from J. Dart, *Westmonasterium* (1723), by J. G. Noppen, 'Recently cleaned sculptures at Westminster', *Burl. Mag.*, LVIII (1931), 140.

6. W. R. Lethaby, *Westminster Abbey and the King's Craftsmen* (1906), 81–5. *Westminster Abbey Re-examined* (1925), 70.

p. 121 7. The excellent preservation of the statues is to be explained by the fact that they were concealed behind panelling from the late seventeenth to the mid nineteenth centuries. The arrangement of the doorway can be seen in Lethaby, *Westminster Abbey Re-examined*, figures 71 and 102. He produced convincing arguments to show that the modern restoration with a Christ in Majesty in the centre (R.C.H.M., *London*, I (1924), plate 158) does not conform to the original design. The entry relating to Yxeworth was printed by J. G. Noppen, *Antiq. Jnl*, XXVIII (1948), 147; the original 1253 roll was published by G. G. Scott, *Gleanings from Westminster Abbey* (1863).

8. An English manuscript illumination of the Annunciation, dated to about 1250, shows the angel in precisely the same stance with the heel of the left and the toes of the right foot facing towards the front, though in other details there is little similarity with the Westminster figure (Millar, I, plate 83).

9. A relationship to this Westminster figure can perhaps be seen in the clumsily executed lady N 74 from the north tower of Wells (*Archaeol.*, LIX (1904), plate 49).

10. The other doorway leading from the cloister to the chapter-house vestibule is now only a battered shadow of its former self. Its theme was the Tree of Jesse, the ancestors of Christ being set one above the other around the voussoirs of the arch. The tympanum was filled with a central Virgin and Child on a pedestal flanked by two full-length angels, the whole background being covered with stiff-leaf foliage. The tympanum was originally blue and the foliage picked out in red and gold.

p. 122 11. Identical little lions occur in the contemporary Missal of Henry of Chichester, a Salisbury manuscript (O. E. Saunders, *A History of English Art in the Middle Ages* (Oxford, 1932), figure 40).

12. Cf. especially the statue of Saint Peter in the north transept of Rheims (P. Vitry, *Gothic Sculpture in France, 1226–70*, plate 39).

13. P. and G., figures 82 and 284.

14. C. J. P. Cave and L. E. Tanner, 'A Thirteenth Century Choir of Angels in the North Transept of Westminster Abbey and the Adjacent Figure of Two Kings', *Archaeol.*, LXXXIV (1934). This style did not remain confined to Westminster, a head similar to no. 19 being found on the canopy of the tomb of Archbishop de Gray at York (P. and G., figure 231).

15. R.C.H.M., *London*, I (1924), plates 6, 88, and 89.

16. Photographs of many of these minor Westminster sculptures are to be found in: J. G. Noppen, 'Sculpture of the School of John of Saint Albans'. *Burl. Mag.*, LI (1927); 'Further Sculptures of the Westminster School', *loc. cit.*, LIII (1928); 'Recently cleaned Sculptures at Westminster Abbey', *loc. cit.*, LVIII (1931); R. P. Howgrave-Graham, 'Westminster Abbey. Various Bosses, Capitals and Corbels of the Thirteenth Century', *Brit. Archaeol. Assn Jnl*, 3rd Series, VIII (1943); 'Westminster Abbey: the Sequence and Dates of the Transepts and Nave', *loc. cit.*, XI (1948); L. E. Tanner, *Unknown Westminster Abbey* (1948). The statue in private hands which Mr Noppen suggested might be a stray survival from the north transept porches (*Burl. Mag.*, LIII (1928), 250) has now been identified with some certainty as coming from Strasbourg.

17. In about 1254 Robert of Beverley was paid 32s for carving four bosses (*Antiq. Jnl*, XXVIII (1948), 147).

18. F. Wormald, 'Paintings in Westminster Abbey', *Proc. Brit. Acad.*, XXXV (1949), 164–5.

19. The cost was £5350 18s 8d (J. Bentham, *The Conventual and Cathedral Church of Ely* (1812), 148).

20. This aspect of Westminster Abbey is brought out by G. Webb, 'The Decorative Character of Westminster Abbey', *Jnl Warb. Court. Insts*, XII (1949). He does not accept that the diaper was coloured (p. 16). For details of the original colouring, see W. R. Lethaby, *Westminster Abbey Re-examined*, 205. J. G. Noppen, *Burl. Mag.*, LVIII (1931), 139.

21. *Brit. Archaeol. Assn Jnl*, 3rd Series, VIII (1943), plate 3, figure 12; plate 4, figure 14. Manuscript illuminators such as the artist of the contemporary Amesbury Psalter were indulging in identical lively postures and trailing draperies (cf. the angel medallion on the Crucifixion folio), and it seems uncertain which medium was the prime source (Millar, I, plate 81).

22. Andersson, *op. cit.*, 82, n. 3, has examined this question, and though he has found occasional use of this device on the Continent, it remains far from

common and may well be an English development. It occurs earlier on the 'Coronation' boss of Ely Presbytery (C. J. P. Cave, *Roof Bosses in Mediaeval Churches* (Cambridge, 1948), figure 85) and on a Lincoln school statue at Croyland, Lincs. (P. and G., figures 361 and 362).

23. P. and G., figure 315.

24. *Op. cit.*, figure 264.

25. *Op. cit.*, figure 361.

26. For other figures from a buttress of the Angel Choir (now adorned with modern heads), see *op. cit.*, figure 374. I find it difficult to accept the face of 'Queen Margaret' on the buttress of the porch as a genuine piece of thirteenth-century sculpture. If the head itself is original, as seems proven, then the features must surely have been severely recut in the nineteenth century (A. Gardner and R. P. Howgrave-Graham, 'The "Queen Margaret" Statue at Lincoln', *Antiq. Jnl*, XXIX (1949), 87).

27. P. and G., figure 234.

28. Another very striking wooden statue in Norway showing the influence of Westminster is that of Saint Michael, now in the museum at Trondheim, which came originally from the church of Mosviken on the other side of the fjord (A. Andersson, *op. cit.*, figures 30 and 31).

CHAPTER 11

1. F. Wormald, 'Paintings in Westminster Abbey', *Proc. Brit. Acad.*, XXXV (1949); E. W. Tristram, *English Medieval Wall Painting: Thirteenth Century* (Oxford, 1950), plates 1–14; A. G. I. Christie, *English Medieval Embroidery* (Oxford, 1938), plates 95–100.

2. For example the gablet over the head of an effigy at Hereford (P. and G., figure 721), or the Bishop's Throne at Exeter, erected in 1312–17. An equally early northern example occurs at Edenham, Lincs. (*op. cit.*, figure 714).

3. Cf. P. Vitry, *Gothic Sculpture in France, 1226–70*, plates 19, 30, 56, 57, 63, and 68.

4. It is recorded that in the nineteenth century 'A great quantity of painted ornament was discovered and destroyed.' For full illustrations and suggestions of the different artists at work, see A. Gardner, 'The Lincoln Angels', *Lincoln Minster Pamphlets*, no. 6 (1952).

5. *Op. cit.*, 11.

6. *Op. cit.*, 8.

7. Coins of Edward I were found under the foundations, which fixes a definite *terminus post quem* (Gleeson White, *The Cathedral Church of Salisbury* (1896), p. 71). In the nineteenth century Burges carried out substantial though skilful restoration of these reliefs, providing many of them with new heads. He found many traces of the rich colouring that originally covered the whole of the carving, and the cold whiteness of its present-day appearance bears no relation to the medieval condition. One of the original painted heads is now in the Victoria and Albert Museum (A44–1916).

8. Cf. *Antiq. Jnl*, XII (1932), plates 79 and 80. Similar work is found in a manuscript of *c*. 1280 at Saint John's College, Cambridge (*Victoria and Albert Museum, Catalogue of Exhibition of English Mediaeval Art* (1930), plate 43). p. 132

9. W. R. Lethaby, *Westminster Abbey and the King's Craftsmen*, 1906, figures 20 and 21. 'The Romance Tiles of Chertsey Abbey', *Wal. Soc.*, II (1912–13), plates 38 and 39. Cf. P. and G., figures 278 and 279.

10. Cf. W. R. Lethaby, *loc. cit.* 'English Primitives', IV. *Burl. Mag.*, XXX (1917).

11. E. Millar, I, plates 95–6. Salzman, 163. The passion of the court artists for shields in the last years of the century is very remarkable, perhaps the most striking evidence being the painting of about 150 coats-of-arms on the canopy of Edmund Crouchback's tomb in Westminster Abbey (R.C.H.M., London, I (1924), 24). The most important surviving example of the wholesale use of heraldic shields for sculptural purposes occurs on the gatehouse of Butley Priory, Suffolk, where were displayed no less than seven rows. According to the heraldry, the date of the gatehouse is fixed between 1308 and 1334 (J. N. L. Myres, 'Butley Priory, Suffolk'. *Archaeol. Jnl*, XC (1933), 189, n. 1). p. 133

12. The date of these shields has been the subject of dispute, some arguing that the first five bays of the nave were completed by Henry III in 1260–9, and others that they were almost entirely the work of Edward I, probably in the 80s. This latter was Sir George Gilbert Scott's view, based on alterations in the mouldings, and is supported by the derivative statement of the Elizabethan chronicler, Holinshed, that 'the new worke to the end of the choir was fully finished in 1285' (G. G. Scott, *Gleanings from Westminster Abbey* (1863), 31–2. Raphael Holinshed, *Chronicles* (1587), *sub anno* 1285). Furthermore, it is evident on historical grounds that the arms of Simon de Montfort are unlikely to have been placed in the royal church by Henry III after about 1259, though

such action would not be impossible for Edward I a quarter of a century later. Finally the close similarity between these shields and those on the Crouchback tomb and the Eleanor crosses, and the sudden popularity of shields for ornament in the 80s and 90s seems to clinch the argument for a date not earlier than about 1280.

p. 134 13. P. and G., figure 676.

14. *Op. cit.*, figure 68.

15. E. A. Greening Lamborn, 'The Shrine of Saint Edburg', *Oxon Archaeol. Soc. Rep.*, LXXX (1934). *V.C.H., Oxon*, II (1907), 93. J. C. Blomfield, *History of the Deanery of Bicester*, part 2 (1884), 107.

16. For an account of gesso technique, see A. Hartshorne, etc., *Some Minor Arts* (1894), 62–4.

p. 135 17. *Archaeol. Jnl*, LXVII (1910), 54, n. 1. E. W. Tristram, *op. cit.*, 406.

18. The effigy of Walter de Merton was the work of Master John of Limoges. Including carriage, the price came to £40 5s 6d (E. Hobhouse, Bishop of Nelson, *Sketch of the life of Walter de Merton* (Oxford, 1859), 50). Unfortunately we cannot compare costs with those of a Purbeck marble effigy since no such account exists.

19. M. Aubert, *Musée du Louvre: description raisonnée des sculptures*, I (Paris, 1950), 181–3, figure 264.

20. Two Limoges enamel effigies formerly at Fontaine-Daniel and Évron (Maine) were very similar indeed to the Valence figure, except that they were bare-headed (Bodl., Gough Drawings – Gaignières, 14, fols 200 and 205).

p. 136 21. For the use of brass rings and lead joints, see G. G. Scott, *Gleanings from Westminster Abbey* (1863), 32, 197.

22. A. J. K. Esdaile, 'The Sculptor and the Brass', *Monumental Brass Soc. Trans*, VIII (1943–51), 37, 140.

23. For example *Birmingham Archaeol. Soc. Trans*, XLIX (1923), plate 15, figure 2.

24. R. R. Sharpe, *Calendar of Letter-books of the City of London: Letter-book L* (1912), 233.

25. P. and G., figure 711.

p. 138 26. The only surviving canopy is to be found at Cobham, Kent, *c.* 1320. H. W. Macklin, *The Brasses of England* (1907), 28. For the identification of these features with the court school, see J. M. Hastings, 'The Court Style', *Architectural Review*, CV (1949), 3.

27. N. Pevsner, *The Leaves of Southwell* (1945), 53–63. Lynn White, jnr, 'Natural Science and Naturalistic Art in the Middle Ages', *American Historical Review*, LII (1946–7).

28. Millar, I, plates 95, 96, and 100.

29. W. R. Lethaby, *Westminster Abbey Re-examined*, figures 33–4 and 52. W. H. St J. Hope, *Windsor Castle*, I (1913), 56. C. J. P. Cave, 'Roof Bosses of Lincoln Minster', *Lincoln Minster Pamphlets*, no. 3 (1949), 7. p.

30. In France the movement had begun by about 1235 and is to be seen at Chartres and Amiens (M. Jalabert, 'La Flore gothique', *Bulletin Monumental*, XCI (1932)).

31. The adoption of naturalistic foliage by the Purbeck marblers can be narrowed to between 1270 and 1288. The shrine of Saint Swithin at Winchester must be after 1269, since it copies the twisted columns of the Cosmati shrine of Saint Edward at Westminster. On the other hand the bones of Saint Frideswide were translated in 1289, which obviously marks the completion of the new shrine at Oxford (see J. D. Le Couteur and D. H. M. Carter, 'Notes on the Shrine of Saint Swithin', *Antiq. Jnl*, IV (1924), whose dating to about 1250 cannot be accepted).

32. The swan song of this naturalistic foliage in northern sculpture is to be found on the capitals of the chapter-house at York, which seem to have been completed by about 1308. The capitals of the nave, begun in 1291, are already more stylized than those of Southwell, with strong emphasis upon bossy undulation.

33. On 23 July 1296, the Bishop asked the Dean's permission for the Canons to build the north side of the cloister, the outer wall to the south being already up (Lincoln Cathedral Archives, Sutton's Register, fol. 145 verso–146). I am very grateful to Miss R. I. Hill for her kindness in providing me with a transcript of this document. For photographs, see E. Venables, 'The Bosses of the Eastern Walk of the Cloisters of Lincoln Cathedral', *Associated Architectural Societies' Reports*, XX (1889), 179.

34. The bosses and corbels of the presbytery were p. painted in 1301–2. But their carving might have preceded this moment by as much as six years, as occurred in the case of the eastern choir bosses, whose carving began in 1303–4, and were not in place and painted till 1308–9 (H. E. Bishop and E. K. Prideaux, *The Building of Exeter Cathedral* (1922), 39–40, 47). Considerable confusion seems to exist about the role of the sculptor William of Montacute. Bishop and Prideaux claim for him the carving of these presbytery corbels, but without giving any supporting evidence (*op. cit.*, 42). Lethaby and Freeman, quoting from the Fabric Rolls, observe that William appears in 1302 at work on the choir doors, in 1303–4 on the high vault bosses of the choir, and in 1313 on corbels

and bosses. (P. Freeman, *The Architectural History of Exeter Cathedral* (1888), 59. W. R. Lethaby, 'How Exeter Cathedral was built', *Architectural Review*, XIII (1903), 175). E. K. Bishop and G. R. Holt Shafto, *Bosses and Corbels of Exeter Cathedral* (1910), 11, 186, claim the presbytery corbels for William, but say they were carved in 1301–4, which is impossible if they were in place and painted by 1301–2. It seems clear therefore that we do not know the artist of the presbytery corbels and bosses – unless he was Master Roger, the master mason – and that William was the sculptor of the markedly inferior work in the choir (cf. Professor N. Pevsner's remarks in C. J. P. Cave, *Medieval Carvings in Exeter Cathedral* (1953), 28–9). Because Montacute is in Somerset, it is false to imagine William as necessarily a man with purely local experience: there was a Henry of Montacute at work on Saint Stephen's Chapel at Westminster in 1292 (*Masonic Magazine*, IV (1876–7), 617).

35. E. Hutton, *The Cosmati* (1950). W. R. Lethaby, *Westminster Abbey and the King's Craftsmen* (1906), chapter 15. *Westminster Abbey Re-examined* (1925), chapter 12.

36. E. W. Tristram, *op. cit.*, 405–6.

37. J. G. Edwards, 'Edward I's Castle Building in Wales', *Proc. Brit. Acad.*, XXXII (1946).

38. A possible representation of one of these French crosses was published by Dr Joan Evans, 'A Prototype of the Eleanor Crosses', *Burl. Mag.*, XCI (1949). It may, however, be a 'Montjoie', erected by Charles V a century later.

39. Originally the tombs of William de Valence, John of Eltham, and the children of Henry III probably lined the south side of the chapel, and were subsequently removed to make way for others (W. R. Lethaby, *Westminster Abbey Re-examined* (1925), 277–8).

40. The accounts of the Eleanor Trustees for 1291–3, from which the details of the construction of the crosses and tombs are derived, were published by Beriah Botfield, *Manners and Household Expenses of England*, ed. Hudson Turner, Roxburghe Club (1841). The long-vanished monument at Lincoln was drawn for Sir William Dugdale in 1640 or 1641. Both effigy and tomb appear identical with that at Westminster (Dugdale's *Book of Monuments*, fol. 98 verso. I am indebted to the Earl of Winchilsea for permission to examine this volume).

41. F. Devon, *Issues of the Exchequer from Henry III to Henry VI* (1837), 99.

42. W. R. Lethaby, *Westminster Abbey and the King's Craftsmen* (1906), 287, figure 97.

43. John had been undermaster of the works during the building of Vale Royal Abbey in 1278–80 (D. Knoop and G. P. Jones, *The Medieval Mason* (Manchester, 1933), 96).

44. P. and G., figure 395.

45. Cf. P. and G., figure 388.

46. *Op. cit.*, figure 385.

47. The colouring of both effigy and relief is well shown by Stothard, plates 42 and 43. For a photograph of the effigies of the Earl and Countess, see R.C.H.M., *London*, I (1924), plate 185.

48. The drapery style of the Countess is almost identical with that of a lady on a slab at Ourscamps in France, apparently of about 1296 (Bodl., Gough Drawings – Gaignières, 13, fol. 53).

49. P. and G., figure 672.

50. Bodl., Gough Drawings – Gaignières, 14, fols 223 and 232.

51. Cf. the tombs of Philippe de France and the Countess de Joigny at Joigny (Yonne) (M. Aubert, *Musée du Louvre: description raisonnée des sculptures*, I (Paris, 1950), no. III. *La Sculpture française au moyen-âge* (Paris, 1946), 301). One of the earliest French examples of this system of which records survive seems to be the tomb of Marie de Bourbon, who died in 1274 (Bodl., Gough Drawings – Gaignières, I, fol. 78; cf. *op. cit.*, 11, fol. 94; 13, fol. 106; 14, fol. 232).

52. Crossley, 47. The date given is incorrect.

53. G. Marshall, 'The Shrine of Saint Thomas de Cantelupe in Hereford Cathedral', *Woolhope Club* (1930–2).

54. E. S. Prior, *A History of Gothic Art in England* (1900), figure 232. P. and G., figure 719. The attribution of the Chichester figure to Lady FitzAlan and its dating to about 1280 are both purely conjectural, though admittedly not impossible.

55. Beriah Botfield, *op. cit.*, 124, 133, 114, 123, and 128. R. R. Sharpe, *Calendar of Letter-books of the City of London: Letter-book D* (1902), 288–9. Salzman, 28.

56. For the other works which can definitely be attributed to the Court school of this brilliant period, see Count Paul Biver, 'Tombs of the School of London at the Beginning of the Fourteenth Century', *Archaeol. Jnl*, LXVII (1910).

57. For an exhaustive survey of all the surviving wooden effigies, see A. C. Fryer, *Wooden Monumental Effigies in England and Wales* (1924).

58. Salzman, 119.

59. P. and G., 666 (The tomb in Shropshire is at Berrington, not Bessington).

p. 144

p. 145

p. 146

p. 147

p. 148 60. A. C. Fryer, *op. cit.*, plate 4.

61. While London undoubtedly took the lead, local craftsmen soon adopted the new material and by the second decade of the fourteenth century began turning out wooden effigies in the style of the local freestone or marble effigies, or in imitation of the London products. Near London an example of this development is the double tomb at Clifton Reynes, Bucks, and in the North an effigy at St Andrew Auckland, Co. Durham (Fryer, *op. cit.*, plates 8 and 15).

62. W. F. Creeny, *Illustrations of incised Slabs on the Continent of Europe*, 1891, no. 26 (at Évreux). There is a similar slab at Gothem, Belgium, and the large *ailettes* of the Septvans brass are found on others at Gothem and Abee (*op. cit.*, nos 33, 27, and 34). The effigy at Gretz (Seine-et-Marne) is of the same type.

63. D. M. Sherlock, *Tiles from Chertsey Abbey* (1885). Bodley MS. 264 (*New Pal Soc.*, 1st series (1905–6), plate 67).

p. 149 64. Cf. the remarks of R. Koechlin, *Les Ivoires gothiques français*, I (Paris, 1924), 110–11.

65. T. Borenius and E. W. Tristram, *English Medieval Painting* (Paris, 1927), plate 41.

66. *Somerset Archaeol. and Nat. Hist. Soc. Proc.*, LXVI (1920), plates 5–7. P. and G., figure 644.

p. 150 67. Stothard, plate 36; cf. F. W. Galpin, 'Notes on the tomb...of...Hatfield Broad Oak', *Essex Archaeol. Soc. Trans*, n.s., IV (1892–3).

68. P. and G., figures 725 and 682. The double cushion, the drapery treatment, and the huge lion all show that this last effigy cannot be earlier than the last fifteen years of the century. The Durham school also produced their version of the same model in an effigy at Sockburn, enlivened by the billowing draperies of the *atelier* (*Archaeol. Aeliana*, 4th Series, VI (1929), plate 3).

69. E. M. Jope, 'Abingdon Abbey Craftsmen and Building Stone Supplies', *Berks. Archaeol. Jnl*, LI (1948–9).

70. R.C.H.M., *London*, IV (1929), plate 183 and 186. The earliest of the series of effigies near by at Aldworth bears no trace of the Dorchester combination of old-fashioned stylistic tricks and details of costume with a highly developed emotionalism and sense of movement.

71. P. and G., figures 12 and 675.

72. The swine round the arch over the tomb and at the foot of the effigy evidently represent the Swinfield rebus. Bishop Swinfield possessed a strong sense of family loyalty and the more lucrative offices at Hereford were filled with Swinfields. The most likely candidates for this tomb are John de Swinfield who was Treasurer in 1292–4 and still alive in 1311, or Gilbert de Swinfield, the Chancellor, who died in 1299 (F. T. Havergal, *Fasti Herefordenses* (Edinburgh, 1869)).

73. M. D. Anderson, *The Medieval Carver* (Cambridge, 1935), 95–148. Evans, 38–44.

74. Quoted by J. C. Dickinson, *Antiq. Jnl*, XXXI (1951), 91, n. 1.

75. Some idea of the quality of the figure-work of this East Anglian manuscript school of the first decade of the century may be obtained from the Swinburne Pyx, now in the Victoria and Albert Museum. Probably made for one of the Norfolk family of Reymes in about 1310, it is a round silver box with scenes from the New Testament set against diapered and enamelled grounds. Of the two surviving scenes, that of the Virgin and Child is iconographically almost identical with an illumination of the Peterborough Psalter and that of the Nativity is equally close to a page from an allied manuscript now in the Cambridge University Library. It is evident that all stem from a common book of patterns, and the chief importance of this pyx is to show the close inter-relation between these minor arts, and to prove the existence of the *basse-taille* enamel technique domiciled in East Anglia some thirty years before the manufacture of the Lynn Cup (Charles Oman, 'The Swinburne Pyx', *Burl. Mag.*, XCII (1950)).

76. N. Pevsner, *The Leaves of Southwell* (1945), figure 9 and plate 27.

77. An original capital is now in the Victoria and Albert Museum (A 102–1916).

78. A. W. Goodman, 'The Choir Stalls, Winchester Cathedral', *Archaeol. Jnl*, LXXXIV (1927).

79. S. C. Cockerell and M. R. James, *Two East Anglian Psalters*. Roxburghe Club (1926), plate 6. Cf. also Millar, I, plate 100.

80. P. and G., figure 365.

81. For an illustration of this effigy in its original colours of pink and blue, see T. and G. Hollis, *Monumental Effigies of Great Britain*, 1840, plate 23. Both the material and the style of the lady's effigy differ from those of the knight by whom she now lies. Nevertheless there seems little doubt that these two Bedale effigies belong to the same monument to Brian Fitzalan, for in the early eighteenth century they still lay together upon the original tomb in the south aisle, 'mausoleo variis coloribus auroque olim pulcherrime obducto'. This tomb is itself very im-

portant since the weepers include a kneeling angel holding a shield. This was a characteristic device of the York alabaster tomb-makers a century later and thus suggests a continuity of local tradition (Roger Gale, *Registrum Honoris de Richmond* (1722), 242).

82. W. Oakeshott, *The Sequence of English Medieval Art*, 1950, plate 35.

83. E. Panofsky, *La scultura tedesca dall' XI al XIII secolo* (Milan, 1936), plates 95–101. This German realism affected Flanders and Paris by about 1300 in the head of the effigy of Philippe III by Pierre de Chelles (M. Aubert, *La Sculpture française au moyen-âge* (Paris, 1946), 336).

84. The headless statue at York (P. and G., figure 368) would appear to be a London work of about 1325, the closest parallel to its drapery style and pose being the weepers from the Valence tomb at Westminster (*op. cit.*, figure 433).

There is every reason both architectural and stylistic for thinking that the mutilated figure of a Virgin and Child over a door in the north aisle of York nave is a work of the second third of the fourteenth century at the very earliest (P. and G., figure 366). The nave walls were not completed till 1324 and the glazing of the west window till 1338; moreover, French sculpture and ivories seem to show conclusively that the drapery of the Virgin arranged like a double shawl with two hems running horizontally across the body at knee-length is a development that does not occur before about 1330 (cf. R. Koechlin, *op. cit.*, no. 156. L. Lefrançois-Pillion, 'Les Statues de la Vièrge à l'Enfant dans la sculpture française au XIVe siècle', *Gazette des Beaux-Arts* (1935) II, 134, figure 7; 135, figure 11; 148, figure 23; 207, figure 4).

85. The Durham *atelier* retained the sword-drawing pose for knights some time after it had been abandoned at York (C. H. Hunter Blair, 'Mediaeval Effigies in the County of Durham', *Archaeol. Aeliana*, 4th Series, VI (1929), plate 3).

86. *Yorks. Archaeol. Jnl*, XXVII (1923–4), 118.

87. Cf. incised slabs at Gothem, Belgium (F. W. Creeny, *op. cit.*, nos 27, 33), and other slabs and effigies formerly at Ardenne, Jouy, Chaalis, Hervaulx, and Chaloche (Bodl., Gough Drawings – Gaignières, *passim*).

88. A valuable corpus of Yorkshire military effigies of the late thirteenth and early fourteenth centuries was published by W. M. I'Anson, 'Some Yorkshire Effigies'. *Yorks. Archaeol. Jnl*, XXVII (1923–1924). 'The Mediaeval Military Effigies of Yorkshire', parts 1 and 2. *Op. cit.*, XXVIII–XXIX (1924–9). I am unable to agree with his dating system, which

claims to an accuracy the evidence does not warrant and seems generally some twenty years or more too late, as Sir James Mann has pointed out (*op. cit.*, XXIX, 1929, 235). In consequence his ascription of effigies to particular persons is very much open to question, and his use of the phrase 'the Cheyne atelier' for the workshop producing the florid effigies is entirely unjustified. Indeed the Norton-on-Tees effigy, on which appear the rebus J and three links of a chain, looks much more like an imitation by another workshop. In my view Mr C. H. Hunter Blair may also have slightly post-dated some of the early effigies in Durham and Northumberland (*Archaeol. Aeliana*, 4th Series, VI and VII (1929–30)). But owing to lack of firmly dated changes in military equipment displayed on effigies, a really satisfactory dating system is rendered all but impossible.

89. Salzman, 34–5. D. Knoop and G. P. Jones, *op. cit.*, 74, 142.

90. Cf. the ivory 'Vierge de la Sainte-Chapelle' p. 154 (R. Koechlin, *op. cit.*, no. 95, plate 31) or stone statues from Saint-Nazaire at Carcassonne and Marle (Aisne) (Lefrançois-Pillion, *op. cit.*, 131, figure 2; 141, figure 14).

CHAPTER 12

1. E. S. Prior, *A History of Gothic Art in England* p. 156 (1900), chapter 9.

2. Really large-scale architectural sculpture was still undertaken, for example a now vanished ten-foot image in Reigate stone for Saint Stephen's Chapel, Westminster, in 1333 (Salzman, 130).

3. M. Jalabert, 'La Flore gothique', *Bulletin Monumental*, XCI (1932).

4. Evans, plates 38A, 18, and 10. p. 158

5. *Op. cit.*, plates 13 and 73. The Gloucester canopy is certainly heavily restored, but is unlikely to have departed substantially from the original (cf. *op. cit.*, 164, n. 4).

6. The medieval authority for the dating of the cloister, William of Worcester, states clearly that Bishop Walpole (died 1299) only built three bays next to the chapter-house, and that 'The residue towards the church, together with the door thereof ... was made at the expense of Master John of Ely, Bishop of Norwich [1299–1325] and other friends'. Accounts for the year 1310 mention the purchase of thirty marble pillars, sufficient for about three bays, though there is no proof that these were for this northern section of the east walk (D. J. Stewart, 'Notes on Norwich Cathedral. The Cloisters', *Archaeol. Jnl*, XXXII (1875), 166, 168).

p. 159 7. G. Sarton, *Introduction to the History of Science,* III (Washington, D.C., 1947), part 1, 11–12.

8. Crossley, 54, 60.

9. Stothard, plates 48 and 49. R.C.H.M., *London,* I (1924), plate 186.

10. Inspired presumably by the relative similarity to the Crouchback effigy, the R.C.H.M. has put the effigy at about 1310, while agreeing that the rest of the tomb is about 1324 (*op. cit.,* 24).

p. 160 11. The same theme had been painted on the spandrel of the canopy of the tomb of Countess Aveline a quarter of a century before, and it occurs in the obituary roll of Lucy, Prioress of Hedingham as early as about 1230 (*Vetusta Monumenta,* VII (1893–1906), plate 15).

12. Very similar weepers and a canopy of English design are to be found on the mid-century tomb of Bishop Bernard Brun at Limoges. This would appear to be an example of English influence on French monumental sculpture (A. Michel, *Histoire de l'art,* 1906, II, part 2, figure 447).

13. This use of a diaper background to figure-work was familiar to manuscript illuminators, and occurs on a large scale later on in the Ely Lady Chapel (O. E. Saunders, *English Illumination,* II (Paris, 1928), plate 107. Millar, II, plate 1).

14. Cf. the fillet of the remarkably classical trumpeter from the Ormesby Psalter, or the head-dresses of several ladies from the same manuscript (S. C. Cockerell and M. R. James, *Two East Anglian Psalters* (Roxburghe Club, 1926), plates 14, 7, and 13). Cf. also the flying ends of the bandage covering the eyes of the Synagogue of the much restored chapter-house doorway at Rochester, perhaps datable to 1342 (P. and G., figure 393; W. H. St J. Hope, *The Architectural History of the Cathedral Church and Monastery of Saint Andrew at Rochester* (1900), 83); the closest parallel is the two-way flying mantling of an armorial crest in the Luttrell Psalter of about 1340 (E. G. Millar, *The Luttrell Psalter* (1932), plate 4E).

15. See Stothard, plate 64. The handling of this equestrian relief is closely paralleled by the design of the reverse of the Great Seal of October 1327, where is found the same arched tail, prancing attitude with extended forelegs and nearly vertical hindlegs, diagonal sweep of the caparison and forward slant of the rider's leg. So close is the comparison that it seems not unlikely that the designer of the relief was also that of the seal (A. B. and A. Wyon, *The Great Seals of England* (1887), no. 54). Precisely the same features occur in a miniature by a London artist in the Treatise of Walter de Milemete, which is also firmly dated to

1326–7 (M. R. James, *The Treatise of Walter de Milemete* (Roxburghe Club, 1913), plate 69). The same change of style between the two canopy horsemen is to be seen in the Exchequer seals of Edward I and Edward III, the latter being almost certainly designed in the previous reign (*Archaeol.,* LXXXV (1935), plate 84, nos 1 and 3).

16. L. Richardson, 'The Stone of the Canopy of p Edward II's Tomb in Gloucester Cathedral', *Bristol and Glos. Archaeol. Soc. Trans.,* LXX (1951), 144. Clunch was used in the court tombs at Ifield, Sussex, and Waterperry, Oxon. The Eltham tomb is a mixture of alabaster and black composition and the shrines of Saints Paulinus and Ythamar made for Rochester in 1344 were of marble and alabaster (W. H. St J. Hope, *op. cit.,* 117).

17. Cf. the head of God in the Psalter of Robert de Lisle (Millar, II, plate 9).

18. C. J. P. Cave, *Roof Bosses in Medieval Churches* (Cambridge, 1948), figure 124. C. Woodforde, *Stained Glass in Somerset,* 1946, plate 5. E. K. Prideaux and G. Holt Shafto, *Bosses and Corbels of Exeter Cathedral* (1910), nos 52, 53, 60, 62, and 135. A. Gardner, *English Medieval Sculpture* (Cambridge, 1951), figure 375.

19. Cf. Stothard, plate 46, with the central figure p of Prior and Gardner, figure 433.

20. The letter (Westminster Abbey Muniments, no. 6300XX) is dated 24 Aug. 1339, and orders the transfer of John's body from the place where it lies to a more suitable position 'entre les roials', around the Confessor's Chapel. There is no reference to moving a tomb, and one must surely presume that no monument had yet been erected (I am indebted to Mr R. P. Howgrave-Graham, F.S.A., for his kindness in supplying me with a précis of this document).

21. Crossley, 57.

22. The background is usually, but incorrectly, described as of black marble, as pointed out by A. Gardner, *Alabaster Tombs of the Pre-Reformation Period in England* (Cambridge, 1940), 15, n. 1.

23. These are of one of the Ifield family at Ifield, Sussex (Stothard, plate 59; P. and G., figure 734); of Robert Fitz-Ely at Waterperry, Oxon; and of one of the Lucy family at Lesnes Abbey, Kent, now in the Victoria and Albert Museum (A 10–1912) (A. W. Clapham, *Lesnes Abbey* (1915), plates 19 and 20). The two former, probably of about 1330–40, are identical examples of a standard model. Upon both a tiny bat-like creature peers out from beneath the top inner corner of the shield, thus converting a serious functional need for support at a weak point into

a characteristically whimsical little joke. All three preserve traces of original painting and gilding.

24. E. W. Brayley and J. Britton, *The History of the Ancient Palace and Late Houses of Parliament at Westminster* (1836), 157.

25. A. Hartshorne, 'On the Brass of Sir Hugh Hastings in Elsing Church, Norfolk', *Archaeol.*, LX (1907).

26. Similar commemoration of the heroes of a campaign, this time that of Crécy of 1346-7, appears in the coats-of-arms on the east window at-Gloucester. ·

27. H. Druitt, *Costume on Brasses* (1906), 154-6. W. H. St J. Hope, 'Postscript to A. Hartshorne', *op. cit.*, *Archaeol.*, LX (1907). A. R. Wagner and J. G. Mann, 'A Fifteenth Century Description of the Brass of Sir Hugh Hastings at Elsing, Norfolk', *Antiq. Jnl*, XIX (1939). Personal examination of the brass with the aid of a magnifying glass in 1952 showed that all but a dozen microscopic particles of what seemed to be glass have now disappeared.

28. F. Blomefield, *Topographical History of Norfolk*, I (1805), 105.

29. For example Professor Prior claimed it as English (P. and G., 658) and Mr Hartshorne as foreign (A. Hartshorne, *op. cit.*, 28). The argument for a foreign origin is weakened by the existence at Wimbish, Essex, of another brass in exactly the same style and using the same unique system for showing chain mail (J. G. Mann, 'Armour in Essex', *Essex Archaeol. Soc. Trans*, XXII (1936), plate 4a).

30. H. W. Macklin, *The Brasses of England*, 1907, chapter 5. W. F. Creeny, *A Book of Facsimiles of Monumental Brasses on the Continent of Europe*, 1884. S. Collon-Gevaert, *Histoire des arts du métal en Belgique*, Brussels, 1951, 284-302. Macklin's theory that the brasses were the work of artists of one of the Baltic ports, perhaps Lübeck, ignores the decisive documentary evidence produced by W. Brehmer, 'Lübeck's messingene Grabplatten aus dem vierzehnten Jahrhundert', *Hansische Geschichtsblätter*, IV (1880-3). In addition the distribution-pattern spreads down to Spain, far outside the range of Hanseatic trading, and the inscriptions on surviving brasses and palimpsests are all in Latin or Flemish (and occasionally Spanish), but never German.

31. Cf. the background to Edward III (Druitt, *op. cit.*, 154, plate 2) with that in a window in Oxford Cathedral, perhaps five or ten years later (J. A. Knowles, *The York School of Glass Painting* (1936), 107).

32. Cf. M. R. James, *The Treatise of Walter de Milemete* (Roxburghe Club, 1913), plates 2, 4, 61,

and 125. This manuscript of 1326-7 shows similar military weepers in affected attitudes set against diapered or scroll-work backgrounds.

33. W. W. Lillie, 'The Retable of Thornham Parva', *Suffolk Inst. of Archaeol. Proc.*, XXI (1933). Evans, plates 28 and 29. The scalloped halo occurs also in the Luttrell Psalter (E. G. Millar, *The Luttrell Psalter* (1932), plates 8, 34, and 36D).

34. Cf. Otto Pächt, 'A Giottesque Episode in English Medieval Art', *Jnl Warb. Court. Insts*, VI (1943). T. Borenius and E. W. Tristram, *English Medieval Painting* (Paris, 1927), plates 56-61. Another East Anglian work of the period is the Lynn Cup, an enamelled pint cup for secular purposes ornamented with scenes of aristocratic life; coursing, falconry, and toxophily on the lid, and gentlemen and ladies picking flowers on the sides of the bowl. These gay little figures with their trailing tippets and liripipes and their flowered backgrounds are similar in style to the weepers on the Hastings brass, and are the product of the same secular atmosphere which produced the little sporting vignettes of the illuminations of the Taymouth Horae and the Smithfield Decretals. The irregular shape of the side-panels, the bulging knots of the knop and the deeply indented base are all signs of the florid style of the 1340s (N. M. Penzer, 'The King's Lynn Cup', *The Connoisseur*, CXVIII (1946)). p. 167

35. A. C. Fryer, *Wooden Monumental Effigies in England and Wales* (1924), plate 16. Cf. also a stone effigy at Walsall, Staffs., of the second quarter of the century (*Birmingham Archaeol. Soc. Trans*, LXIX, 1951, plate 48).

36. E.g. the Peterborough Psalter, Millar, II, plate 25.

37. A. Heales, 'Easter Sepulchres', *Archaeol.*, XLII (1869). Evans, 169-71.

38. P. and G., figure 697. Stothard, plate 41. The pillar resting on the back of a lion appears in the Exeter sedilia and in the Shurland canopy, thus reinforcing the connexion.

39. Stothard, plates 66 and 67. p. 168

40. Evans, plate 68.

41. Bodl., Gough Drawings – Gaignières, 7, 8, 10, 12, and 13, *passim*.

42. E. S. Prior, *A History of Gothic Art in England* (1900), figures 282, 313. P. and G., figure 439. p. 169

43. A. B. and A. Wyon, *op. cit.*, no. 53.

44. Cf. R. Koechlin, *Les Ivoires gothiques français* (Paris, 1924), no. 131, plate 36.

45. M. R. James, *A Peterborough Psalter and Bestiary* (Roxburghe Club, 1921), fol. 9B. S. C. Cockerell and

M. R. James, *Two East Anglian Psalters* (Roxburghe Club, 1926), The Ormesby Psalter, plate 13. The head on a pair of legs on the Southwell screen, and the monk with animal legs on the fragment now in the Yorkshire Museum (nos 255–7), are also derived from the Ormesby Psalter (*op. cit.*, plate 13, and 27c).

p. 169 46. The Southwell screen with its many head stops and its extensive use of the ogee is also datable to the 30s. The Lincoln screen is probably a little later. The last of this series of screens is the Luttrell Tomb and Easter Sepulchre at Irnham, Lincs, which may well be a work of the 1360s or even 70s (E. Woolley, 'Some Nottinghamshire and Lincolnshire Easter Sepulchres', *Thoroton Soc.*, XXVIII (1924). 'Irnham and Hawton', *Brit. Archaeol. Assn Jnl*, 2nd Series, XXXV (1929). *Vetusta Monumenta*, III (1796), plate 32).

p. 170 47. D. J. Stewart, *The Architectural History of Ely Cathedral* (1868), 138. F. R. Chapman, *Sacrist Rolls of Ely*, I (Cambridge, 1907), 84, n. 1. Some of the detached statues were still being carved in 1356–9 when Walter Ymagour was paid £3 for five and Philip Wale £1 6s 8d for another four (*V.C.H. Cambs.*, IV, 1953, 61–2).

48. M. R. James, *The Sculptures in the Lady Chapel at Ely* (1895).

49. C. E. Keyser, 'Sculptured Cornices in Churches near Banbury…', *Antiq. Jnl*, IV (1924). A connexion with William of Wykeham, as suggested by Mr Keyser, is quite impossible.

50. The nave aisle of Gloucester bears the same proliferation of ball-flowers, and it is also commonly employed in Northamptonshire (Evans, 29, n. 2). The canopy over the effigy ascribed to Prior Sutton in Oxford Cathedral is also lavishly decorated with ball-flower (R.C.H.M., *City of Oxford* (1939), plate 94). The six-foot statues from the spire are now preserved in the cloister at New College. Their original appearance is now almost impossible to recapture, owing to the replacement of most of the heads in 1851 by a Mr Dunbar. Only statues E and G certainly retain their original heads and even these may have been touched up (T. G. Jackson, *The Church of Saint Mary the Virgin, Oxford* (1897), 144–5, plates 13–20).

51. See *supra*, p. 257, note 88.

p. 171 52. A. F. Leach, 'Memorials of Beverley Minster', I, pp. xxxiii, lxxviii–xcii, 3, 157, 171, 204; II, pp. xxxii–xxxiii, 299. Surtees Soc., XCVIII (1897); CVIII (1903).

53. J. Bilson, 'Beverley Minster', part 2, *Architectural Review*, III (1898), 251.

54. The theme of the bagpiper was very common in the fourteenth century partly by itself and partly as a member of the heavenly or earthly musicians who provided the stock decorative theme in sculpture, glass, and painting. It was perhaps taken from the standard representation of Joachim in the Wilderness, for example in an exactly contemporary stained-glass window in York nave (*Burl. Mag.*, XCIV (1952), 111, figure 25).

55. Evans, 171, plate 79.

56. P. and G., figures 16 and 367. Cf. also tombs p. at Sockburn and Norton-on-Tees, Durham (*Archaeol. Aeliana*, 4th Series, VI (1929), plates 3 and 6).

57. This grimacing supporter looks like an adaptation of the figure carved on an earlier corbel in the first bay of the nave at Exeter (C. J. P. Cave, *Medieval Carvings in Exeter Cathedral* (1953), plate 11).

58. P. and G., figure 370.

59. E. S. Prior, *History of Gothic Art in England* (1900), figure 282. Cf. the obverse of the Great Seal of June 1340 (A. B. and A. Wyon, *op. cit.*, no. 59), and late fourteenth-century figures at Raby, Bothal, Alnwick, and Hylton Castle.

60. The years 1312–25 saw great sculptural activity p. at Exeter. The work consisted of no less than four separate pieces of pinnacled screenwork, some of which still survives but deprived of the numerous statues that originally filled the niches. There was the towering wooden Bishop's Throne, perhaps designed by Master Thomas of Winchester, and built between 1312 and 1317. There was the screen, for which William Canon of Corfe supplied the marble and for which over sixty images were carved; of this only faint traces survive from which to reconstruct the original (P. Morris, 'Exeter Cathedral: A Conjectural Restoration of the Fourteenth Century Altar Screen', *Antiq. Jnl*, XXIII (1943)). There was the lofty, pinnacled sedilia, crazily perched on its slender brass columns, that used to bear three large statues; and there was the reredos with forty-eight images costing 1s 2d each, and a centre-piece of the Coronation of the Virgin adorned with metal lilies and a golden crown. It was probably for this last piece of sculpture that a London artist was hired at a cost of 39s. (All these details are derived from the Fabric Rolls, extracts from which are printed by P. Freeman, *The Architectural History of Exeter Cathedral*, 1888, and H. E. Bishop and E. K. Prideaux, *The Building of Exeter Cathedral* (1922), chapter 6.) For the importance of Bishop Grandisson as a patron, see F. Rose Troup, 'Bishop Grandisson: Student and Art-Lover', *Devon Assn.* LX (1928).

61. Freeman, *op. cit.*; Bishop and Prideaux, *op. cit.*, chapter 7.

62. Evans, plate 31.

63. O. M. Dalton, 'A Fourteenth Century English Ivory Triptych', *Burl. Mag.*, XLIX (1926). F. Saxl and R. Wittkower, *English Art and the Mediterranean* (1948), 33, figures 10 and 11. In his will drawn up in 1361, the painter, Master Hugh of Saint Albans, refers to 'unam tabulam de vi peces de Lumbardy', which cost him the very large sum of £20 (R. R. Sharpe, *Calendar of Wills in the Court of Hustings, London*, II (1890), 107). Bishop Grandisson himself possessed a frontal with 'demi-images of Roman work' and a cloth 'embroidered in Roman work' (F. C. Hingeston-Randolph, *The Register of John de Grandisson*, III (Exeter, 1899), 1517, 1514).

64. Cf. an oak coffer in the Victoria and Albert Museum (Evans, plate 36A).

65. J. N. Dalton, *Collegiate Church of Ottery Saint Mary* (Cambridge, 1917), 12, plate 23.

66. Lord Grandisson died in 1358, so the tomb must have been erected during his lifetime. Dr Evans attributes the tomb to his father William, but as he was buried at Abbey Dore this is very unlikely (F. C. Hingeston-Randolf, *op. cit.*, 111).

67. R.C.H.M., *Herefordshire*, I (1931), plate 137.

68. Cf. C. J. P. Cave, *op. cit.*, plate 50, boss no. 195, with E. K. Prideaux, 'Figure Sculpture of the West Front of Exeter Cathedral', *Archaeol. Jnl*, LXIX (1912), plate 10, statue no. B 27.

69. H. E. Bishop and E. K. Prideaux, *op. cit.*, 74, 81.

70. By Miss Prideaux's numbering, these are B 11–14, 19–20, 27–32, and an isolated upper tier statue, C 28. The date of the statues of the lower northern section of the front and the buttresses is very uncertain, but I would tentatively suggest early or mid fifteenth century. The whole of the upper tier except C 28 is late fifteenth century (see *infra*, p. 223).

71. M. R. James, *The Peterborough Psalter* (Roxburghe Club, 1921), fol. 19A. C. M. Church, 'The Prebendal Stalls and Misericords in the Cathedral Church of Wells', *Archaeol.*, LV (1897). All that the documents prove is that the stalls date from after 1325, and are not improbably after 1337.

72. For illustrations, see J. Carter, *Specimens of Ancient Sculpture and Painting now remaining in England* (1838), plates 9–12, and E. K. Prideaux, *op. cit.*

73. The Derby Psalter and Fitzwarin Psalter, *Jnl Warb. Court. Insts*, VI (1943), plates 21A and C; and 23B. It also occurs on a corbel of Tewkesbury choir.

74. For example the Saint-Omer, Peterborough, and Gorleston Psalters and the Bardolf-Vaux Hours. It also became an extremely popular theme for stained-glass windows, of which fifteen examples of the fourteenth century still survive (C. Woodforde, 'A Group of Fourteenth Century Windows showing the Tree of Jesse', *Journal of the British Society of Master Glass Painters*, VI (1935–7)).

75. Cf. the royal 'Brétigny' seal of 1360 (A. B. and A. Wyon, *op. cit.*, no. 63). p. 176

76. C. Woodforde, *op. cit.*, plate facing 184.

CHAPTER 13

1. The capitals and corbels of York presbytery p. 177 (1361–72) undoubtedly show the veined leaves, bold facial modelling, pierced eyes and spiral hair of the Beverley style. Robert of Patrington, the master mason for York, may perhaps have been a survivor from the Beverley yard (J. Raine, *Fabric Rolls of York Minster*. Surtees Soc., XXXV (1858), pp. xiv, xv).

2. T. Rickman, *Styles of Architecture in England*, edited by J. H. Parker (1881), 248.

3. *Bristol and Glos. Archaeol. Soc. Trans*, IX (1883–5), 177.

4. P. and G., 533. *Archaeol.*, XCIII (1949), 52. A. Gardner, *Alabaster Tombs* (Cambridge, 1940), 1.

5. M. L. Gadd, 'English Monumental Brasses of p. 179 the 15th and early 16th Centuries', *Brit. Archaeol. Assn Jnl*, 3rd Series, II (1937), 29.

6. J. P. C. Kent, 'Monumental Brasses: a new Classification of military Effigies, *c.* 1360–1485', *Brit. Archaeol. Assn Jnl*, 3rd Series, XII (1949).

7. For example p. 179

1397, Sir John de St Quentin, Brandesburton, Yorks.		£13 6s 8d
1398, Sir Thos. Ughtred, Catton, Yorks.		£10
1399, Sir Philip Darcy		£10
1403, W. Wolstonton, Great Bowden, Leics.		£15
1420, Sir Arnold Savage, Bobbing, Kent		£13 6s 8d

(H. Haines, *A Manual of Monumental Brasses* (1861), p. lviii).

Between 1465 and 1538, in the forty recorded cases of money left in wills for brasses, twenty-seven range from £1 to £2 13s 4d, of which sixteen were less than £1 13s 4d (R. H. D'Elboux, 'Testamentary Brasses'. *Antiq. Jnl*, XXIX (1949), 188).

p. 179 8. J. P. C. Kent, *op. cit.*, 87–8, referring to 'Series E' of *c.* 1420–44.

9. Alexandre de Berneval, employed to purchase the alabaster for Fécamp Abbey in 1414, sailed from Harfleur to Newcastle, and thence travelled to Chellaston. He refers to Prentice as 'le marchant qui le vent', as if he were the only available purveyor of alabaster in the vicinity (J. Bilson, 'A French Purchase of English Alabaster in 1414', *Archaeol. Jnl*, LXIV (1907)).

10. W. St J. Hope, 'On the early Working of Alabaster in England', *Archaeol. Jnl*, LXI (1904), 227. Robert Halstead (Henry Mordaunt, Earl of Peterborough), *Succint Genealogies …* (1685), 188–9.

p. 180 11. G. M. Bark, 'A London Alabasterer in 1421', *Antiq. Jnl*, XXIX (1949), 89.

12. F. Palgrave, *The Antient Kalendars and Inventories of the Treasury of his Majesty's Exchequer*, III (1836), 245.

13. *Revue Belge d'Archéologie et d'Histoire de l'Art*, II (1932), 17, 26; V (1935), 339, 341. An even earlier example is the tomb of Othon de Bourgogne at Cherlieu made by Pepin le Huy in 1311–12, which included 'des arches et des ymages d'alebastre' (*Oud-Holland*, LIV (1937), 121).

14. W. H. St J. Hope, *loc. cit.*, 224–7.

p. 181 15. P. and G., figure 466.

16. E. W. Brayley and J. Britton, *The History of the Ancient Palace and Late Houses of Parliament at Westminster* (1836), 164–6, 175–6.

17. Lincoln Dean and Chapter Muniments, A/1/10: '…ac etiam [Welbourne] fecit fieri reges in fine occidentale.' I am indebted to Miss Kathleen Major for her kindness in transcribing this extract for me.

18. The documents are printed in S. R. Wigram, *The Cartulary of the Monastery of Saint Frideswide at Oxford* (Oxford Hist. Soc., XXXI), II (1896), 4–13. For coloured reproductions, see T. and G. Hollis, *Monumental Effigies of Great Britain* (1840), plates 15, 25, and 26.

p. 182 19. P. and G., figures 758 and 760.

20. That it is a London work is suggested by the upright angels looking horizontally and with carefully carved wings, which are quite unlike the type that can be associated with Nottingham a generation later (see P. and G., 449, n. 1). It is probable that this tomb is not earlier than about 1375 since in his will of 1369 the Earl ordered the rebuilding of the chancel in which he was to lie (N. H. Nicholas, *Testamenta Vetusta*, I (1826), 79). A known London product of the same period was the alabaster effigies of John of Gaunt and his wife in old Saint Paul's, which were ordered in 1374. The elaborate tomb in which the effigies were laid was the work of Henry Yevele and Thomas Wreck and cost £486 (S. Armitage-Smith, *John of Gaunt's Register, II*, Camden Soc., 3rd Series, XXI (1911), no. 1394; J. Harvey, *Henry Yevele* (Oxford, 1944), 30; W. Dugdale, *The History of Saint Paul's Cathedral* (1716), 90).

21. In his will in the same year, Lord Despencer p. ordered his body to be buried on the south side of Tewkesbury near his ancestors, but made no provision for building any tomb or chantry (N. H. Nicholas, *op. cit.*, 1, 99).

22. T. Borenius and E. W. Tristram, *English Medieval Painting* (Paris, 1927), figures 57 and 61. There are one or two early fourteenth-century French examples of the kneeling statue, for example at La Theuilloye, near Arras, probably carved in 1324 (*Oud-Holland*, LIV (1937), 118, n. 1), but they are very unlike this Tewkesbury figure. Imitation of the Westminster paintings seems on the whole a more likely source of inspiration than direct French influence (É. Mâle, *L'Art religieux de la fin du moyen-âge en France* (Paris, 1931), 429–30).

23. At Bakewell, Derbyshire, there is a monument to Sir Godfrey and Lady Foljambe of about 1375 which takes the form of a canopied wall recess filled by vertical half-length alabaster figures of a knight and lady, with cushions incongruously stuffed behind their heads (P. and G., figure 544). Judging by its location, this is more likely to be a Nottingham than a London work.

24. Cf. H. David, *Claus Sluter* (Paris, 1951), plates 2 and 3.

25. A complete list of surviving effigies is contained in A. Gardner, *Alabaster Tombs* (Cambridge, 1940), 88–103. I am uneasy about his grouping of effigies according to the basic types of armour. As a result his 'Group II' includes the simple early tombs such as that at Warwick together with the group of the first two decades of the fifteenth century with their rich and elaborate ornamentation, such as those at Lowick, Northants, and North Leigh, Oxon.

26. Introduced in the Somerset area in the 1320s, as at Limington and Pendomer, it spread slowly over the west of England (A. C. Fryer, 'Monumental Effigies in Somerset', part 2, *Som. Archaeol. and Nat. Hist. Soc. Proc.*, LXII (1917), plates 7 and 8). It is found on the effigy of Sir Hugh Despencer at Tewkesbury, presumably a London work of about 1350–60 (A. Gardner, *op. cit.*, figure 123), and its achievement of general popularity can be precisely dated to 1387–8 when Richard Lord Poynings and Sir John Monta-

cute in their wills both deliberately specified this particular feature for their tombs (N. H. Nicholas, *op. cit.*, I, 123–4).

27. P. and G., figure 409.

28. W. St J. Hope, *op. cit.*, 223, n. 4.

29. J. P. C. Kent, *loc. cit.*; we have no record of the names of brass engravers, but it may well be that the royal seal engravers, William Geyton in 1380–1 and Peter de Hiltoft in 1391–2, were also responsible for brasses (F. Devon, *Issues of the Exchequer from Henry III to Henry VI* (1837), 214, 246). Besides these military effigies there are some forty-five male civilian brasses surviving from the period 1350–1400 (J. V. B. Torr, 'A chronological List of early male Civilians', *Monumental Brass Soc. Trans*, VII (1934–42), 240).

30. The characteristic details of Series B change too frequently to be easily summed up, and reference must be made to the drawings and explanations of J. P. C. Kent (*op. cit.*). The simplest way of grasping the differences between the three shops is by studying examples from the illustrations in *Victoria and Albert Museum, Catalogue of Rubbings of Brasses and Incised Slabs* (1929):

			Plate
Series A:	1368	Drayton Beauchamp, Bucks.	6
	1394	Sheldwich, Kent	10
	1410	Little Shelford, Cambs.	12
Series B:	*c.* 1380	Fletching, Sussex	8
	1405	Rougham, Suffolk	12
Series C:	1400	Playford, Suffolk	7
	c. 1408–9	Laughton, Lincs.	10

31. J. P. C. Kent, *loc. cit.*, 78. Compare the figure of Sir Robert with that of Sir Robert Drury at Rougham, Suffolk, of 1405 (V. & A. *Catalogue*, plate 12), and contrast it with the Broughton, Lincs., brass (*op. cit.*, plate 7) which represents the standard product of Series B at the time of Sir Robert's death in 1391.

32. For the date, see *supra*, p. 174. The bosses are illustrated in C. J. P. Cave, *Medieval Carvings in Exeter Cathedral* (1953).

33. C. J. P. Cave, 'The Roof Bosses of Gloucester Cathedral', *Bristol and Glos. Archaeol. Soc. Trans*, LIII (1931).

34. J. H. Parker, *The Architectural Antiquities of the City of Wells* (1866), 31–4.

35. R. Willis, 'Architectural History of Winchester Cathedral', *Archaeol. Inst. Proc.* (1845), 57–9.

36. J. Harvey, *Gothic England* (1948), 56.

37. John is described as 'Inceptor et Consultor inceptionis facture stallorum novorum'. For a full account and illustrations of these stalls, see M. D. Anderson, *The Choir Stalls of Lincoln Minster* (Lincoln, 1951).

38. Illustrations of 38 of these misericords are to be found in R.C.H.M., *City of Oxford* (1939), plates 154–8. p. 189

39. Cf. *op. cit.*, plate 156, N. 5; 158, S. 16, 21, with M. Rickert, *Reconstructed Carmelite Missal* (1952), plate 19C.

40. A full and scholarly survey of these early alabasters has been made by W. L. Hildburgh, 'English Alabaster Tables of about the Third Quarter of the Fourteenth Century', *Art Bull.*, XXXII (1950). This article largely supersedes W. H. St J. Hope and E. S. Prior, *Illustrated Catalogue of the Exhibition of English Medieval Alabaster Work*, Society of Antiquaries (1913), 26–8; and P. Nelson, 'Earliest Type of English Alabaster Panel Carvings', *Archaeol. Jnl*, LXXVI (1919).

41. The surviving, though admittedly very incomplete, records of the poll-tax of 1381 for York make no mention of alabastermen, and none of that trade became a Freeman of the City before 1457 (F. Collins, *Freemen of York*, I, 177. Surtees Soc., XCVI (1896). I owe the reference to the poll-tax returns to the kindness of Professor Carus-Wilson). I cannot accept Dr Hildburgh's conclusion (*op. cit.*, 20) that the production of this early group of alabasters was virtually confined to the Nottingham area, the arguments for which appear to be circular. Dr Hildburgh himself admits (8; 9, n. 31) that it is almost impossible to distinguish between Nottingham and London work at this early stage, which would seem to remove all basis for such a conclusion. The fact that alabaster figures for a reredos for Durham were ordered from London about 1373–4 proves conclusively that there was a shop producing images and panels in the capital at least by that date. For the natural outlet for Nottingham panels would be down the Trent to Hull or York, and not across country to London (J. Raine, *Historiae Dunelmensis Scriptores Tres*, 136. Surtees Soc., IX (1839)).

42. W. L. Hildburgh, *op. cit.*, figure 7. Cf. for example the draperies of the Montagu weepers at Oxford of the late 40s (plate 122A), or of the apostles on the desk fronts of the stalls at Lincoln of about 1380 (M. D. Anderson, *op. cit.*, figure 40). Dr Hildburgh rightly rejects the comparisons made with the Eltham weepers by Professor Prior.

43. See *supra*, p. 180.

44. W. L. Hildburgh, *op. cit.*, figures 1 and 4. p. 190

45. P. and G., figure 542.

p. 190 46. An Ascension (P. and G., figure 540) is probably a work of the same artist.

47. W. L. Hildburgh, *loc. cit.*, figure 27.

48. W. L. Hildburgh, 'A Group of Panels of English Alabaster', *Burl. Mag.*, XLVI (1925). The very broad heads are found in contemporary illuminations.

p. 191 49. Photographs of all three Flawford statues are to be found in W. H. St J. Hope, *op. cit.*, 225-7.

50. Cf. Hildburgh, *op. cit.*, *Art Bull.*, XXXII (1950), figures 2 and 4; 13, 14, and 27.

51. Of course this detail was common to all the arts in England in the late fourteenth century, for example a Tewkesbury boss of about 1345-55 and the Norwich Retable of about 1400 (*Archaeol.*, LXXIX (1929), plate 29, figure 4; T. Borenius and E. W. Tristram, *op. cit.*, plate 71). A very detailed and careful examination of the inter-relation of the late medieval stage and the iconography of alabaster panels is made by W. L. Hildburgh, 'English Alabaster Carvings as Records of the Medieval Religious Drama', *Archaeol.*, XCIII (1949).

52. Evans, plate 54. The plate taces of the man and the slightly horned head-dress of the lady strongly suggest a date in the 1420s. For the oddity of these 'Trinity' compositions, see W. L. Hildburgh, 'Iconographical Peculiarities in English Medieval Alabaster Carvings', *Folk-Lore*, XLIV (1933), 50-6.

p. 192 53. *Select Cases in Chancery*, 1364-1471, ed. W. P. Baildon. Selden Soc., X (1896), 45-6.

54. P. Pradel, 'Les Tombeaux de Charles V', *Bulletin Monumental*, CIX (1951).

55. F. Devon, *Issues of the Exchequer...* (1837), 189. He is referred to as Hennequin, a common Flemish alternative for Jean.

56. Illustrated R.C.H.M., *London*, I (1924), plates 187 and 199. T. and G. Hollis, *Monumental Effigies of Great Britain* (1840), plate 49. J. G. Noppen, 'A Tomb and Effigy by Hennequin of Liége', *Burl. Mag.*, LIX (1931). The head of Philippa is very similar to that from another white marble effigy, probably of Marie de France and also by Jean, which is now in New York (W. H. Forsyth, 'A Head from a royal Effigy', *Bulletin of the Metropolitan Museum of Art*, 2nd Series, III (1944-5)).

57. G. G. Scott, *Gleanings from Westminster Abbey* (1863), 49-51.

58. It is certainly posthumous since it was ordered by the Prince in his will (J. Nichols, *A Collection of all the Wills...of the Kings and Queens of England* (1780), 66-7).

59. W. H. St J. Hope, 'On the Funeral Effigies of p. the Kings and Queens of England', *Archaeol.*, LX (1907), 532, plate 58. The Stephen Hadley to whom payment is recorded for the effigy was merely the member of the King's household who in turn paid the unknown sculptor (F. Devon, *op. cit.*, 199).

60. W. R. Lethaby, *Westminster Abbey and the King's Craftsmen*, 1906, p. 289.

61. T. Rymer, *Foedera,...* VII (1729), 795-8.

62. H. F. Westlake, *Westminster Abbey*, II (1923), 470.

63. F. Devon, *op. cit.*, 263, 270. Nicholas Broker did not die till 1426 (R. R. Sharpe, *Calendar of Wills in the Hustings Court*, II (1890), 440). But he must presumably have retired from business long before that, since in 1413 the task of designing and casting the effigy of Mary Bohun, mother of Henry V, for Newark Hospital, Leicester, was entrusted to a William Godezer, citizen and coppersmith of London (F. Devon, *op. cit.*, 321). This effigy has long since disappeared and we have no record of its appearance.

64. Salzman, 130. There are three similar statues p. preserved in the Hall (R.C.H.M., *London*, II (1925), plate 174). They would appear to be the remnants of the rows of royal statues on the exterior of the north front of the Hall. There were thirteen kings and four queens still on this front at the time of Anne Boleyn's coronation in 1533 (Bodl. Rawlinson MS., D 775), by 1780 there were only eight, and in 1863 even these were reported to have disappeared (J. Nichols, *op. cit.* (1780), 268. *Notes and Queries*, 3rd Series, III (1863), 7).

CHAPTER 14

1. R. Willis and J. W. Clark, *The Architectural History of the University of Cambridge*, I (1886), 370. p.

2. H. Anstey, *Epistolae Academicae Oxon.*, Oxford Hist. Soc., XXXV (1898), 192.

3. A. B. and A. Wyon, *The Great Seals of England* (1887), no. 73.

4. See *supra*, p. 261, n. 7. p.

5. H. K. Cameron, 'The Metals used in Monu- p. mental Brasses', *Monumental Brass Soc. Trans*, VIII (1943-1951), 109.

6. The identification of the stones used in these south-western effigies has been worked out under the direction of Dr A. C. Fryer, 'Monumental Effigies made by Bristol Craftsmen, 1240-1550', *Archaeol.*, LXXIV (1923-4). 'Monumental Effigies in Somerset', parts 8-10, *Som. Archaeol. and Nat. Hist. Soc. Proc.*, LXVIII-LXX (1922-4).

7. P. and G., figure 760.

8. N. H. Nicholas, *Testamenta Vetusta*, II (1826), 765. That the Courtenay effigy is posthumous and therefore carved about 1397–1400 is proved by the Archbishop's will and codicil (L. L. Duncan, 'The Will of William Courtenay, Archbishop of Canterbury', *Archaeol. Cantiana*, XXIII (1898)).

9. A London tomb of a few years later, perhaps *c.* 1410, is that of Robert, Lord Willoughby d'Eresby and his wife at Spilsby, Lincs. This reproduces the niche system for little statuettes along the edges of the slab found in the royal tombs at Westminster, and repeated on that of Henry IV at Canterbury.

10. Hartley Withers, *The Cathedral Church of Canterbury* (1897), 87; and *Archaeol. Cantiana*, VIII (1872), 298.

11. In the will the site of the tomb was left to be chosen by Archbishop Arundel (J. Nichols, *A Collection of all the Wills ... of the Kings and Queens of England* (1780), 203).

12. E. W. Tristram, 'A Royal Tomb at Canterbury', *Canterbury Cathedral Chronicle* (Apr. 1937).

13. F. Devon, *Issues of the Exchequer ...* (1837), 338, 357.

14. G. M. Bark, 'A London Alabasterer in 1421', *Antiq. Jnl*, XXIX (1949), 89.

15. A. Gardner, *Alabaster Tombs*, figures 19–22.

16. This decoration occurs frequently from about 1400 to 1440, mostly in the midlands, and is very probably the mark of the Nottingham workshops. If this is so it would identify the tombs at Swine, Yorks, and at Staindrop, Durham, and with the latter the now destroyed tomb at Nantes, as all of Nottingham origin.

17. The licence to endow the chantry was only granted to the widow in 1438, twenty-seven years after Sir William's death. But the style of the architecture, which strongly suggests Richard Winchcombe's work, and the costume and armour of the effigies make it certain that the chapel and tomb were erected by 1425 at the latest (*Cal. Patent Rolls, H.VI*, III (1907), 306).

18. P. Nelson, 'English Alabasters of the Embattled Type', *Archaeol. Jnl*, LXXV (1918), plates 19, 20, and 21.

19. T. Rymer, *Foedera*, VIII (1729), 510.

20. Crossley, 27.

21. A. Hartshorne, 'Notes on Collars of SS', *Archaeol. Jnl*, XXXIX (1882). Waterton himself had every right to the collar. He was a member of a family prominent in Lancastrian service, was one of the first to rally to Henry on his landing at Ravenspur in 1399, and finally became Chief Steward in the northern parts of the Duchy (R. Somerville, *The Duchy of Lancaster*, I (1953)).

22. *c.* 1392 Lord Berkeley, Wotton-under-Edge, Glos.

c. 1406 Earl of Warwick, St Mary's Warwick, War.

d. 1413 Lord Ferrers of Chartley, Merevale, War.

d. 1419 Lord Camoys, Trotton, Sussex.

c. 1420 Lord Bourchier, Halstead, Essex.

also d. 1399 Duchess of Gloucester, Westminster Abbey, Middx.

23. J. P. C. Kent, 'Monumental Brasses: a new classification of military effigies, *c.* 1360–1485'. *Brit. Archaeol. Assn Jnl*, 3rd Series, XII (1949), 81–7.

24. W. H. St J. Hope, *The Stall Plates of the Knights of the Order of the Garter, 1348–1485* (1901), 13–15.

25. F. Sandford, *A Genealogical History of the Kings of England* (1677), 238.

26. P. and G., p. 479. p. 206

27. D. M. Robb, 'The Iconography of the Annunciation in the Fourteenth and Fifteenth Centuries', *Art Bull.*, XVIII (1936).

28. W. L. Hildburgh, 'A Group of Medieval English Alabaster Carvings at Nantes', *Brit. Archaeol. Assn Jnl*, 3rd Series, XI (1948). W. L. Hildburgh, 'English Alabaster Carvings as Records of the Medieval Religious Drama', *Archaeol.*, XCIII (1949), 83.

29. W. L. Hildburgh, 'A Datable English Ala- p. 203 baster Altar-piece at Santiago de Compostella', *Antiq. Jnl*, VI, 1926. A very large English contingent of pilgrims visited Compostela this year (T. Rymer, *op. cit.*, XI, 371–7, 380).

30. The trick also helps to date a set of alabaster apostles (R. P. Bedford, 'An English Set of the Twelve Apostles, in Alabaster', *Burl. Mag.*, XLII (1923)).

31. P. and G., figures 488 and 489. p. 204

32. C. Cotton, 'The Screen of the Six Kings in Canterbury Cathedral', *Canterbury Cathedral Chronicle*, Apr. 1935. They cost 53s 4d the pair.

33. It is dated by an entry in the Sacrist's Roll recording the placing of the last stone (L. E. Tanner, *Unknown Westminster Abbey* (1948), 37, n. 23). For illustrations, see R.C.H.M., *London*, I (1924), plates 41–3.

34. The late M. R. James observed of an early fifteenth-century illuminated Life of Saint Edward at

Trinity College, Cambridge, that 'both in selection and composition the pictures in our MS are so closely related to the sculptures that the latter might well be supposed to have been adapted from them'. I have not seen the MS. and am therefore unable to confirm this suggestion (M. R. James, *Trinity College, Cambridge: The Catalogue of the Western Manuscripts*, I (Cambridge, 1900), no. 214, p. 286).

p. 205 35. All the available evidence about the memorial to the King has been assembled by W. H. St J. Hope, 'The Funeral, Monument and Chantry Chapel of King Henry the Fifth', *Archaeol.*, LXV (1913–14). For other illustrations, see R.C.H.M., *London*, I, plates 129–40, and A. Gardner, *English Medieval Sculpture* (Cambridge, 1951), figures 465–76.

36. A witness many years later stated that two or three years before Henry VI's deposition, Thirsk went up into the chantry and discussed the royal tomb. Since Thirsk retired in 1452 it must be presumed that the witness had muddled up his dates. It is puzzling none the less that two other witnesses also describe the event as taking place in about 1458 (A. P. Stanley, *Historical Memorials of Westminster Abbey* (1869), 572).

p. 206 37. Compare A. Gardner, *op. cit.*, figure 468, and E. Renders, *Jean Van Eyck et le polyptyque* (Brussels, 1940), plate 4, and the paintings of statues on the outside of the Ghent polyptych. Compare the Virgin with E. Renders, *op. cit.*, plate 14, and L. Baldass, *Jan van Eyck* (1952), plates 120 and 121.

38. John Harvey, *Gothic England* (1948), 82, and Salzman, 32.

39. I am much indebted to Professor E. F. Jacob for his generosity in lending me his transcripts of all entries in the Building Accounts that relate to Massingham and his assistants.

40. Illustrated in A. Gardner, *op. cit.*, figures 458–459. They are stylistically quite close to the kings of the Canterbury screen, and I am inclined to think them either genuine or very faithful copies of the originals.

41. J. G. Nichols, *Description of the Church of Saint Mary, Warwick, and of the Beauchamp Chapel* (N.D. [1838]), 31.

42. R. Willis and J. W. Clark, *op. cit.*, I, 402, n. 3.

p. 207 43. The documentation of the chantry and its sculpture is very confused. The original contracts and accounts were seen in the seventeenth century but have since disappeared. An abstract of the contracts and some notes on the accounts were made for the Warwick antiquary Sir Simon Archer in the seventeenth century. This abstract apparently contains omissions and mistakes in the vital places. It turned up among the Archer MSS in 1945 (P. Styles, *Sir Simon Archer*, Dugdale Society Occasional Papers, no. 6 (1946), 24), but cannot now be found among these papers at Shakespeare's Birthplace, Stratford-on-Avon. It was printed, with omissions, by W. Dugdale, *The Antiquities of Warwickshire* (1656), 354–6, and a complete and rather more accurate version of the same manuscript was reprinted by J. G. Nichols, *op. cit.*, in 1838, from a copy by R. B. Wheler.

44. *Bristol and Glos Archaeol. Soc. Trans*, LXX (1951), 105.

45. John Harvey, *Gothic England*, 99, says that Massingham was paid £66 for his work between 1447 and 1449. The early nineteenth-century fair copy of the seventeenth-century abstract of the original accounts, which was used by him (Shakespeare's Birthplace, Stratford-on-Avon, Wheler MSS, vol. 99, 50–61), admittedly reads for the year 1448–9: 'John Massingham, Carvor, in prestum 66.–.8'. But this is an evident error for 66/8 as proved by the fact that this and three other items are made to total £22 7s and that the figure is given as 66/8 in J. G. Nichol's version of Wheler's transcript (*op. cit.*, 35). As will be seen, this money advanced in prest was most probably for his work on the tomb effigy.

46. For excellent photographs of all the architectural sculpture and an exhaustive analysis of its interpretation, see P. B. Chatwin, 'The Decoration of the Beauchamp Chapel, Warwick, with special reference to the Sculptures', *Archaeol.*, LXXVII (1927).

47. The abstract of the contract bears the date 35 H.VI, or 1457. This is an obvious error for 25 H.VI, since the accounts show Bord at work in the chapel in 1447–8 (J. G. Nichols, *op. cit.*, 32, 34, 35). In any case the tomb would certainly not be ordered nine or ten years after the contracts for the pavement on which it is set and the effigy it supports.

48. A. P. Stanley, *op. cit.*, 577. The witness put the event at about 1454; but see *supra*, n. 36.

49. Cf. H. Drouot, 'Le Tombeau de Saint-Bertrand-de-Comminges et le thème des pleurants', *Gazette des Beaux-Arts* (1925), II, 253.

50. M. Aubert, *La Sculpture française au moyen-âge* (Paris, 1946), 374–5.

51. C. Enlart, 'Deux Têtes de pleureurs du quinzième siècle', *Mémoires de la Société Nationale des Antiquaires de France*, LXII (1901).

52. H. David, *De Sluter à Sambin*, I (Paris, 1933), figure 41.

53. That there are these large omissions is proved by the fact that (*a*) as it stands the only person concerned in the contract is Lambespringe; (*b*) this is in date the first contract for the effigy. Would a contract for polishing the image and preparing it for gilding be likely to be made nine months before the contract for the casting? ·

54. J. G. Nichols, *op. cit.*, 35.

55. R. F. Scott, 'On the Contracts for the Tomb of the Lady Margaret Beaufort ...', *Archaeol.*, LXVI (1914–15). Cf. K. Harrison, *The Windows of King's College Chapel* (Cambridge, 1952), 19.

56. See Stothard, plate 124. Stothard turned the effigy over to have a look! Originally the effigy was fully gilt by Lambespringe, and was regilt in 1682 by Nicholas Paris, a Warwick watchmaker, at Sir William Dugdale's expense (J. Britton, *The Architectural Antiquities of Great Britain*, IV (1814), 17).

57. J. N. Friend and W. E. Thorneycroft, 'Examination of a Fifteenth Century "Brass"', *Jnl of the Inst. of Metals*, XXXVII (1927).

58. J. P. C. Kent, *op. cit.*, 83. J. G. Mann, 'Armour in Essex', *Essex Archaeol. Soc. Trans*, XXII (1936–40), plate 6, A and B.

59. Viscount Dillon, 'The Warwick Effigy', *Archaeol. Jnl*, LXXIII (1916).

60. Bruno Ryves, *Mercurius Rusticus* (1646), 60.

CHAPTER 15

1. N. H. Nicholas, *Testamenta Vetusta* (1826), I, *passim*.

2. For example, the expenditure by the small parish of Yatton, Somerset (Bishop Hobhouse, 'Churchwardens' Accounts', *Somerset Record Soc.*, IV (1890)), or the wills printed by L. L. Duncan, 'Testamenta Cantiana', *Archaeol. Cantiana* (1907).

3. F. Collins, *Freemen of York*, I, *passim*. Surtees Soc., XCVI (1896).

4. W. H. Stevenson, *Records of the Borough of Nottingham* (Nottingham, 1882–1914), III, 2, 16, 86, 459–60, and 482. F. Collins, *op. cit.*, 237, 244. J. S. Purvis, 'The Ripon Carvers', *Yorks Archaeol. Jnl*, XXIX (1927–9), 183.

5. W. H. St J. Hope, *Windsor Castle*, II, 399, 402.

6. C. Welsh, *History of the Tower Bridge* (1894), 67. Brit. Mus., Egerton MSS, 2358, fol. 8. *Cal. Patent Rolls*, 1494–1509 (1916), 473, 487. *Letters and Papers of Henry VIII*, I, part 1 (1920), no. 307. Cf. also *Archaeol.*, LX (1907), 550.

7. K. Harrison, *The Windows of King's College Chapel* (Cambridge, 1952), 23, and chapter 2.

8. P.R.O. *Exchequer, Treasury of Receipt, Misc. Books, 214*.

9. R. F. Scott, 'On the Contracts for the Tomb of the Lady Margaret Beaufort ...', *Archaeol.*, LXVI (1914–15).

10. E. Croft Murray, 'A Leaf from a Flemish Sketchbook of the Early Sixteenth Century', *British Museum Quarterly*, XVII (1952).

11. C. C. Oman, 'The Founders of Malines and England', *Oud-Holland*, L (1933), part 2. p. 213

12. J. Huizinga, *The Waning of the Middle Ages* (1924), chapter 11. É. Mâle, *L'Art religieux de la fin du moyen-âge en France* (1931), part 2, chapter 2. E. C. Williams, 'The Dance of Death in Painting and Sculpture in the Middle Ages', *Brit. Archaeol. Assn Jnl*, 3rd Series, I (1937), 'Mural Paintings of the Three Living and the Three Dead in England', *Brit. Archaeol. Assn Jnl*, 3rd Series, VII (1942).

13. É. Mâle, *op. cit.*, figure 394.

14. J. Weever, *Ancient Funerall Monuments* (1631), 228.

15. W. H. St J. Hope, *op. cit.*, II, 376.

16. A. Gardner, *Alabaster Tombs*, figure 194. Hist. MSS Commission, *Dean and Chapter of Wells MSS*, I (1907), 433. P. Dearmer, *The Cathedral Church of Wells* (1898), 126. p. 214

17. A. Tenenti, *La Vie et la mort à travers l'art du XV^e siècle* (Paris, 1952).

18. The popularity of shroud brasses increased steadily at the end of the Middle Ages. Twenty examples have survived from 1450 to 1499 and forty-three from 1500 to 1549 (H. W. Macklin, *The Brasses of England* (1907), 210–15).

19. J. V. B. Torr, 'The Oddington Shroud Brass and its lost Fellows', *Monumental Brass Soc. Trans*, VII (1934–42), 225.

20. Two certain exceptions are the cadavers below the tombs at Arundel, Sussex, and at Ewelme, Oxon.

21. P. and G., figures 409 and 571A. Cf. Mâle, *op. cit.*, 126. p. 216

22. H. E. Allen, *English Writings of Richard Rolle* (Oxford, 1931), 36.

23. C. J. P. Cave, 'The Bosses on the Vault of the Quire of Winchester Cathedral', *Archaeol.*, LXXVI (1926–7).

24. W. H. Stevenson, *op. cit.*, III, 18. *Archaeol.*, XLI, 347.

p. 216 25. P. and G., figures 571B, 572B, 573, 575, and 578.

26. All the available evidence on these heads has been collected by W. H. St J. Hope, 'On the sculptured alabaster tablets called Saint John's Heads', *Archaeol.*, LII (1890). See also W. L. Hildburgh, 'Iconographical Peculiarities in English Medieval Alabaster Carvings', *Folk-Lore*, XLIV (1933), 143–9.

27. W. H. Stevenson, *op. cit.*, III, 18.

p. 217 28. For the head wound, see W. St J. Hope, *op. cit.*, plate 21 (2); 22 (1); 23 (1). The blood running down either side of the nose is repeated in plate 24. The hair style is similar to that of plate 23 (2). See W. L. Hildburgh, 'Some Unusual Medieval English Alabaster Carvings', *Antiq. Jnl*, VIII (1928), 62–3.

p. 218 29. One has an inscription recording that it was erected in 1467 by William Brouning. The other, which is virtually identical, now has an inscription to Sir Giles Strangways, but this is a false claim made by the sixteenth-century owner of the manor. The original inscription, which was seen by Leland, proves that the tomb was erected in memory of William Brouning's father, John (*The Itinerary of John Leland*, ed. L. Toulmin Smith (1907), I, 247).

30. A. Gardner, *op. cit.*, figure 209. Crossley, 142. The Lowick tomb is certainly *post* 1498, since it was ordered by the Earl in his will (N. H. Nicholas, *op. cit.*, 437).

31. A contract was entered into by Henry Harpur and William Moorecock, alabastermen of Burton-on-Trent, to make a tomb for Henry Foljambe at Chesterfield, Derbyshire. The tomb is constructed with the usual weepers round the sides and is topped by a brass. The whole tomb was to cost £10, and the completion date was Oct. 1510 (*Collectanea Topographica et Genealogica*, I (1834), 354–5).

p. 220 32. J. Raine, *Fabric Rolls of York Minster*, Surtees Soc., XXXV (1858), 79, 83. Raine seems convinced that a number of entries refer to the screen, but none of the evidence he prints is quite convincing on this point. See also J. Browne, *Fabric Rolls and Documents of York Minster* (1863), 174–5.

33. J. Raine, *op. cit.*, 91–2. F. Collins, *op. cit.*, 220.

34. T. Allen, *History of Yorkshire*, II (1831), 97. R. Gunnis, *Dictionary of British Sculptors, 1660–1851* (1953), 51. But in 1793 the appearance of the Kings was not very different from that of to-day (J. Carter, *Specimens of Ancient Sculpture . . .* (1838), plates 106–10).

35. W. Pinder, *La scultura tedesca nel XV secolo* (Verona, 1936), plate 103.

36. This statue cannot possibly have been in this very obscure position from the start. What is not clear is whether it belongs to the reconstruction of the church by John Thame at the end of the century or to earlier work by the Earls of Warwick.

37. C. H. Hunter Blair, 'Prior Leschman's Chantry Chapel in Hexham Priory Church', *Archaeol. Aeliana*, 4th Series, VII (1930).

38. Bodl., Gough Drawings – Gaignières, 12, fol. 20.

39. Every aspect of this local group has been carefully examined in two important articles by J. S. Purvis, 'The Ripon Carvers and the lost Choirstalls of Bridlington Priory', *Yorks Archaeol. Jnl*, XXIX (1927–9).

40. J. T. Fowler, *Memorials of Ripon*, III, Surtees Soc., LXXXI (1886), 199–206; IV, Surtees Soc., CXV (1908), 294–6.

41. F. Collins, *op. cit.*, I, 205.

42. *Op. cit.*, 216, 233.

43. J. S. Purvis, 'The Use of Continental Woodcuts and Prints by the "Ripon School" of Woodcarvers in the early sixteenth century', *Archaeol.*, LXXXV (1935).

44. J. P. Berjeau, *Biblia Pauperum*, 1859, plate 29. J. S. Purvis, *op. cit.*, *Archaeol.*, LXXXV (1935), 118, figure 9. J. L. Barnard, 'Carved Misericordes in the Chapel of King Henry VII at Westminster', *The Sacrist*, I (1871).

45. A. C. Fryer, 'On Fonts with Representations of the Seven Sacraments', *Archaeol. Jnl*, LIX (1902); LXXXVII (1930).

46. A. C. Fryer, *op. cit.*, supplement, *Archaeol. Jnl*, XC (1933).

47. The stone was brought from Kings Lynn, and the sculptor paid a total of £11 0s 2d (F. Blomefield, *Topographical History of Norfolk* (ed. C. Parkin), X (1809), 211–12).

48. E. K. Prideaux, 'The Figure Sculpture of the West Front of Exeter Cathedral', *Archaeol. Jnl*, LXIX (1912), no. C 16. T. F. Tout, *Chapters in Administrative History*, Manchester, V (1930), appendix, plate 4, no. 6. *Archaeol.*, LXXXV (1935), plate 97 (2). A. B. and A. Wyon, *The Great Seals of England* (1887), 44.

49. Prideaux, *op. cit.*, nos C 11–15, 17–22.

50. The arched crown first appears on the coinage in the second issue of Henry VII, in 1490. It is found in the wall paintings of Eton College Chapel of 1479–88 (W. Oakeshott, *The Sequence of English Medieval Art* (1950), plate 51).

51. G. McN. Rushforth, 'The Kirkham Monument in Paignton Church', *Exeter Diocesan Architectural and Archaeol. Soc. Trans*, xv (1927–9).

52. E. K. Prideaux, 'Late Medieval Sculpture from the Church of Saint Peter, Tiverton', *Archaeol. Jnl*, LXXV (1918).

53. F. Bligh Bond and Dom Bede Camm, *Roodscreens and Roodlofts* (1909), contains photos and inventories of the screens of Somerset, Devon, and Cornwall.

54. Bishop Hobhouse, *Churchwardens Accounts* (Somerset Record Soc., IV, 1890), 74. R. W. Goulding, *Blanchminster Charity Records* (Louth, 1898), 91. P.R.O. *Early Chancery Proceedings*, 1116/49. (I owe the two last references to Mr Martyn Jope and Dr W. G. Hoskins.)

55. S. C. Taylor, 'Banwell Screen and Roodloft', *Bristol and Glos Archaeol. Soc. Trans*, XXXV (1912).

56. H. David, *De Sluter à Sambin* (Paris, 1933), 321–7.

57. Compare the high forehead, long tresses, and refined expressions of the Virgin in the paintings of Eton College Chapel of 1479–88 (W. Oakeshott, *op. cit.*, plate 51), a work undoubtedly influenced by Flemish art.

58. J. Destrée, 'Étude sur la sculpture brabançonne au moyen-âge', chapter 4. *Annales de la Société d'Archéologie de Bruxelles*, IX (1895), plate 15. Cf. Comte J. de Borchgrave d'Altena, 'Des Caractères de la sculpture brabançonne vers 1500'. *Loc. cit.*, XXXVIII (1934), figure 39. E. Renders, *Van der Weyden, Flémalle, Campin* (Bruges, 1931), plates 2A, 10, and 21.

59. A. Gardner, *op. cit.*, figure 4. Cf. P. Clemen, *Belgische Kunstdenkmäler*, I (Munich, 1923), plates 288–99.

60. The whole collection has been published by T. D. Atkinson, 'Medieval Figure Sculpture in Winchester Cathedral', *Archaeol.*, LXXX (1935).

61. *Archaeol.*, LXXXV (1935), plate 53, and figures 2, 4, and 5.

62. In 1481 the University wrote to Bishop Kempe describing the activity of the workmen: 'pars sculpendis imaginibus, pars jam formatas imagines arcualiter situando mirifice conantur' (H. Anstey, *Epistolae Academicae Oxon.*, II, Oxford Hist. Soc., XXXVI (1898), 471).

63. H. David, *op. cit.*, I, figure 8. Cf. also the architectural statuary painted by van der Weyden on the Miraflores Altarpiece (E. Panofsky, *Early Nether-landish Painting* (Cambridge, Mass., 1953), figure 320).

64. Cf. David, *op. cit.*, figures 19 and 52; it occurs again in the statuary of the tomb of Cardinal Morton in Canterbury Cathedral Crypt, which was erected in the late 90s.

65. A. Gardner, *op. cit.*, figures 242 and 280. R.C.H.M., *London*, I (1924), plate 188.

66. There is a transcript of the original contract in Brit. Mus. Egerton MSS 2747. The fragmentary scroll-bearing figures of a very conventional nature that are preserved in the church are probably Stowell's work.

67. *Archaeol.*, LXXXV (1935), plate 53, figures 5 and 6; plate 54, figures 1–4. Plate 53, figures 3 and 6; plate 54, figure 4, are the work of one artist; plate 54, figures 1–3, of another.

68. E. W. Brayley and J. P. Neale, *Westminster Abbey* (1818), I, Henry VII's Chapel, 7.

69. W. H. St J. Hope, *Windsor Castle*, II (1913), 398–406. Brit. Mus. Egerton MSS 2358.

70. *Op. cit.*, fols 45 and 48. *Letters and Papers of Henry VIII*, I, part 1 (1920), no. 307.

71. W. R. Lethaby, *Westminster Abbey Re-examined* (1925), 161–6.

72. *King's College Building Accounts*, 1509–15. (I owe this reference to Mr Arthur Oswald.)

73. Brit. Mus. Egerton MSS 2358, *passim*.

74. Cf. P. and G., figure 523, with J. Destrée, 'Études sur la sculpture brabançonne au moyen-âge', chapter 4, *Annales de la Société d'Archéologie de Bruxelles*, XIII (1899), figure 46.

75. A. Gardner, *English Medieval Sculpture* (Cambridge, 1951), figure 492. Cf. J. Destrée, *op. cit.*, figure 47.

76. It is very suggestive that almost all the sculptors known to be in royal employment in the period seem to be either Flemish or German. 'Master Laurence' (? Ymbar) with 'Fredrik his mate', 'Wechon Kerver', and Hans van Hoof, made the funeral effigy of Queen Elizabeth of York in 1503 (*Archaeol.*, LX, 1907, 550) and Thomas Ducheman the screen for the royal tomb in 1505 (*supra*, p. 230).

77. Over a century earlier the statue of Jeremiah on the Puits de Moïse at Champmol had been given gilded spectacles.

78. For example there were no less than 260 pieces of sculpture in Bishop West's Chantry at Ely, of the late 20s and early 30s, not one of which now survives. It is interesting to note that some of the statues for this dazzling essay in sculptural virtuosity with its

p. 227

p. 228

p. 229

p. 230

complex mixture of Gothic and Renaissance features were the work of an Englishman, Edmund Moore (*V.C.H. Cambs*, IV, 1953, 73).

p. 230 79. P.R.O. *Exchequer, Treasury of Receipts, Misc. Books, 214*, 15, 52. I am much indebted to Mr Lawrence Tanner for his kindness in drawing my attention to this document.

80. R.C.H.M., *London*, I, plate 123; cf. plate 205, with plate 123A.

81. In 1949 there came to light a pair of pipe-clay statuettes now in the Victoria and Albert Museum, one of which was apparently cast from the same mould as the bronze figure of Saint John on the grille (A76/1949). The other probably represents one of the now missing figures from the grille. The habit of making pipe-clay images was itself a Low Countries practice.

p. 231 82. W. H. St J. Hope, 'On the Early Working of Alabaster in England', *Archaeol. Jnl*, LXI (1904), 239.

83. *Collectanea Topographica et Genealogica*, I (1834), 354–5.

84. A. Gardner, *Alabaster Tombs*, figure 69. Cf. L. Baldass, *Jan van Eyck* (1952), plate 87. For an alabaster panel with the same zigzags, see E. Maclagan, 'An English Alabaster Altar-piece in the Victoria and Albert Museum', *Burl. Mag.*, XXXVI (1920), plate 2.

85. Bodl., Gough Drawings – Gaignières, 1, p. fol. 90; 5, fol. 63; 6, fol. 25; 11, fol. 102; 13, fols 14 and 107. They are found on English tombs after about 1515 at Eye, Hereford., Elford, Staffs, and Coleshill, War. (A. Gardner, *op. cit.*, figures 225, 256, and 285).

86. P. B. Chatwin, 'Monumental Effigies in the County of Warwick', part 3, *Birmingham Archaeol. Soc. Trans*, XLVIII (1922), 139, 141.

87. J. G. Mann, 'English Church Monuments, 1536–1625', Wal. Soc., XXI (1932–3).

88. F. Collins, *op. cit., passim.* P

BIBLIOGRAPHY

Unless otherwise stated, the place of publication is London

WORKS COVERING THE WHOLE PERIOD

I. GENERAL

GARDNER, A. *English Medieval Sculpture.* Cambridge, 1951.

PRIOR, E. S., and GARDNER, A. *An Account of Medieval Figure-Sculpture in England.* Cambridge, 1912.

SAUNDERS, O. E. *A History of English Art in the Middle Ages.* Oxford, 1932.

VICTORIA AND ALBERT MUSEUM. *Catalogue of an Exhibition of English Medieval Art.* 1930.
 Very valuable collections of photographs of sculpture are to be found in the Conway Library of the Courtauld Institute and at the National Buildings Record.

2. MINOR ARTS

CHAMOT, M. *English Medieval Enamels.* 1930.

DALTON, O. M. *Catalogue of the Ivory Carvings of the Christian Era in the British Museum.* 1909.

LONGHURST, M. H. *Catalogue of the Carvings in Ivory, Victoria and Albert Museum.* 1927.
English Ivories. 1926.

OMAN, C. C. 'Medieval Brass Lecterns in England', *Archaeol. Jnl*, LXXXVII, 1930.

WYON, A. B., and A. *The Great Seals of England.* 1887.

3. SCULPTORS

ANDERSON, M. D. *The Medieval Carver.* Cambridge, 1935.

HARVEY, J. *English Medieval Architects: a Biographical Dictionary down to 1540.* 1954.
 (This invaluable work appeared too late to be used in this volume.)

KNOOP, D., and JONES, G. P. *The Medieval Mason.* Manchester, 1933.

SALZMAN, L. F. *Building in England down to 1540.* Oxford, 1952.

SWARTWOUT, R. E. *The Monastic Craftsman.* Cambridge, 1932.

PRE-CONQUEST SCULPTURE
(CHAPTERS 1–3)

I. GENERAL

(a) England

BRØNDSTED, J. *Early English Ornament.* 1924.

BROWN, G. Baldwin. *The Arts in Early England,* V, 1921; VI, 1930.

CLAPHAM, A. W. *English Romanesque Architecture before the Conquest.* Oxford, 1930.

COLLINGWOOD, W. G. *Northumbrian Crosses of the Pre-Norman Age.* 1927.

KENDRICK, T. D. *Anglo-Saxon Art to A.D. 900.* 1938.
Late Saxon and Viking Art. 1949.

RICE, D. Talbot. *English Art, 871–1100.* Oxford, 1952.

SHETELIG, H. *Viking Antiquities in Great Britain and Ireland.* Oslo, 1940.
 A card-index and collection of photographs of the whole corpus of English cross-sculpture is kept in the Department of British and Medieval Antiquities, British Museum.

(b) Rest of the British Isles

ALLEN, J. Romilly. *Early Christian Monuments of Scotland.* Edinburgh, 1903.

CURLE, C. L. 'The Chronology of Early Christian Monuments of Scotland', *Proc. Soc. Ant. Scotland,* LXXIV, 1939–40.

HENRY, F. *La Sculpture irlandaise pendant les douze premiers siècles de l'ère chrétienne.* Paris, 1932.
Irish Art in the Early Christian Period. 1940.

KERMODE, P. M. C. *Manx Crosses.* 1907.

NASH-WILLIAMS, V. E. *The Early Christian Monuments of Wales.* Cardiff, 1950.

PORTER, A. Kingsley. *The Culture and Crosses of Ireland*. Yale, 1931.

SHETELIG, H. 'Manx Crosses', *Saga Book of the Viking Club*, IX, part 2, 1925.

2. PARTICULAR

BRUCE-MITFORD, R. L. S. 'The Sutton Hoo Ship-Burial', *Suffolk Inst. of Archaeol. and Nat. Hist. Proc.*, XXV, 1950–2.

CLAPHAM, A. W. 'The Carved Stones at Breedon-on-the-Hill, Leicestershire', *Archaeol.*, LXXVII, 1927.
'Note on the Origins of Hiberno-Saxon Art', *Ant.*, VIII, 1934.
'Some Disputed Examples of Pre-Conquest Sculpture', *Ant.*, XXV, 1951.

COTTRILL, F. 'Some Pre-Conquest Stone Carvings in Wessex', *Antiq. Jnl*, XV, 1935.

ELLIS, H. R. 'Sigurd in the Art of the Viking Age', *Ant.*, XVI, 1942.

FOX, C. 'Anglo-Saxon Monumental Sculpture in the Cambridge District', *Cambs. Ant. Soc. Proc.*, XXIII, 1920–1.

JESSUP, R. F. 'Reculver', *Ant.*, X, 1936.

KENDRICK, T. D. 'Late Saxon Sculpture in Northern England', *Brit. Archaeol. Assn Jnl*, 3rd Series, VI, 1941.

KENDRICK, T. D., and RALEGH RADFORD, C. A. 'Recent Discoveries at All Hallows, Barking', *Antiq. Jnl*, XXIII, 1943.

KITZINGER, E. 'Anglo-Saxon Vinescroll Ornament', *Ant.*, X, 1936.

KITZINGER, E., and MCINTYRE, D. *The Coffin of Saint Cuthbert*, 1950.

KURTH, E. 'Ecclesia and an Angel on the Andrew Auckland Cross', *Jnl Warb. Court. Insts*, VI, 1943.
'The Iconography of the Wirksworth Slab', *Burl. Mag.*, LXXXVI, 1945.

LONGHURST, M. 'The Easby Cross', *Archaeol.*, LXXXI, 1931.

MITCHELL, H. P. 'Flotsam of later Anglo-Saxon Art', *Burl. Mag.*, XLII, 1923; XLIII, 1924.
'English or German?–A Pre-Conquest Gold Cross', *loc. cit.*, XLVII, 1925.

PAPE, T. 'Round-shafted Pre-Norman Crosses in the North Staffordshire Area', *North Staffs Field Club Trans*, LXXX, 1945–6.

PARKER, C. A., and COLLINGWOOD, W. G. 'A Reconsideration of the Gosforth Cross', *Cumb. and Westm. Archaeol. Soc. Trans*, 2nd Series, XVII, 1916–17.

PEERS, C. R. 'Reculver: its Saxon Church and Cross', *Archaeol.*, LXXVII, 1927.

ROSS, M. C. 'An Eleventh Century English Book-cover', *Art Bull.*, XXII, 1940.

ROUTH, T. E. 'A Corpus of the Pre-Conquest carved Stones of Derbyshire', *Derbyshire Archaeol. and Nat. Hist. Soc. Jnl*, LVIII, 1937.
'The Rothbury Cross-Shaft and the Sproxton Cross', *Leics. Archaeol. Soc. Trans*, XX, 1938–9.

SAXL, F. 'The Ruthwell Cross', *Jnl Warb. Court. Insts*, VI, 1943.

SEAVER, E. I. 'Some Examples of Viking Figure Representation in Scandinavia and the British Isles', *Medieval Studies in Memory of A. Kingsley Porter*, ed. R. W. Koehler, Harvard, 1939.

SHAPIRO, M. 'The Religious Meaning of the Ruthwell Cross', *Art Bull.*, XXVI, 1944.

SMITH, R. A. 'Examples of Anglian Art', *Archaeol.*, LXXIV, 1923–4.

Victoria County History (articles on 'Anglo-Saxon Remains' in vol. I for each county).

ROMANESQUE SCULPTURE
(CHAPTERS 4–7)

I. GENERAL

BOASE, T. S. R. *English Art, 1100–1216*. Oxford, 1953.

CLAPHAM, A. W. *English Romanesque Architecture after the Conquest*. Oxford, 1934.

RUPRICH-ROBERT, V. *L'Architecture normande aux XI^e et XII^e siècles en Normandie et en Angleterre*. Paris, 1884.

SAXL, F. *English Sculptures of the Twelfth Century*. 1954.

ZARNECKI, G. *Regional Schools of English Sculpture in the Twelfth Century* (unpublished D.Phil. thesis at London University. 1950).
English Romanesque Sculpture, 1066–1140. 1951.
Later English Romanesque Sculpture, 1140–1210. 1953.

2. PARTICULAR

ALLEN, J. Romilly. 'Sculptured Norman Capitals at Southwell Minster', *Associated Architectural Soc. Reports*, XXI, part 2, 1892.

'A Sculptured Norman Capital from Lewes Priory, Sussex', *Proc. Soc. Antiq. Lond.*, 2nd Series, XV, 1893–5.

'Fonts of the Winchester Type', *Brit. Archaeol. Assn Jnl*, L, 1894.

BILSON, J. 'Le Chapiteau à godrons en Angleterre', *Congrès Archéologique de France*, LXXV, 1908.

BOND, F. *Fonts and Font Covers.* 1908.

BRAKSPEAR, H. 'Malmesbury Abbey', *Archaeol.*, LXIV, 1912–13.

'A West Country School of Masons', *loc. cit.*, LXXXI, 1931.

CAVE, C. J. P. 'Capitals from the Cloister of Hyde Abbey', *Antiq. Jnl*, XXV, 1945.

CLAPHAM, A. W. 'The York Virgin and its Date', *Archaeol. Jnl*, CV, 1948.

CONYBEARE, W. J. 'The Carved Capitals of Southwell Minster', *Brit. Archaeol. Assn Jnl*, 2nd Series, XXXIX, 1934.

DRUCE, G. C. 'Lead Fonts in England . . .', *loc. cit.*, XXXIX, 1934.

DUNNING, G. C. 'The Distribution of Black Tournai Fonts', *Antiq. Jnl*, XXIV, 1944.

EDEN, C. H. *Black Tournai Fonts in England.* 1909.

FRYER, A. C. 'A Group of Transitional Norman Fonts', *Brit. Archaeol. Assn Jnl*, 2nd Series, VII, 1901.

HOPE, W. H. St J. 'The Architectural History of the Cluniac Priory of Saint Pancras, Lewes', *Sussex Archaeol. Collns*, XXXIV, 1886.

JOHNSTON, P. M. 'Studland Church, and some remarks on Norman Corbel Tables', *Brit. Archaeol. Assn Jnl*, 2nd Series, XXIV, 1918.

'Romanesque Ornament in England', *loc. cit.*, XXX, 1924.

JÓNSDÓTTIR, Selma. 'The Portal of Kilpeck Church', *Art Bull.*, XXXII, 1950.

KENDRICK, T. D. 'Flambard's Crozier', *Antiq. Jnl*, XVIII, 1938.

'Instances of Saxon Survival in Post-Conquest Sculpture', *Cambs. Ant. Soc. Proc.*, XXXIX, 1938–1939.

KEYSER, C. E. 'The Norman Doorways . . . of Berks and Bucks', *Berks, Bucks, and Oxon Archaeol. Jnl*, VI, 1900.

'A Day's Excursion among the Churches of South-East Norfolk', *Archaeol. Jnl*, LXIV, 1907.

'The Norman Architecture of Notts.', *Brit. Archaeol. Assn Jnl*, 2nd Series, XIII, 1907.

'Some Norman Capitals from Sonning, Berks . . .', *Proc. Soc. Antiq. Lond.*, XXVIII, 1915–16.

'Notes on the Churches of Seaton, Wakerley, and Wittering', *Brit. Archaeol. Assn Jnl*, 2nd Series, XXIII, 1917.

'Notes on the Churches of South Stoke, North Stoke, Ipsden and Checkendon', *loc. cit.*, XXIV, 1918.

A List of Norman Tympana and Lintels. 1927.

KING, H. H., and DALTON, O. M. 'A Carved Ivory Fragment of the Twelfth Century, discovered at Saint Albans', *Antiq. Jnl*, II, 1922.

LETHABY, W. R. 'Fragments of a carved and painted Rood from South Cerney Church, Glos', *Proc. Soc. Antiq. Lond.*, 2nd Series, XXVIII, 1915–16.

LEWIS, G. R. *The Ancient Church of Shobdon.* 1852.

MITCHELL, H. P. 'Some Enamels of the School of Godefroid de Claire', *Burl. Mag.*, XXXV, 1919.

'English Enamels of the Twelfth Century', *loc. cit.*, XLVII, 1925; XLIX, 1926.

SALMON, J. 'Beakhead Ornament in Norman Architecture', *Yorks Archaeol. Jnl*, XXXVI, 1944–7.

SPURRELL, F. 'Architectural Relics of Lewes Priory', *Sussex Archaeol. Collns*, VI, 1853.

ZARNECKI, G. 'The Coronation of the Virgin on a Capital from Reading Abbey', *Jnl Warb. Court. Insts*, XIII, 1950.

GOTHIC SCULPTURE
(CHAPTERS 8–15)

I. GENERAL

EVANS, J. *English Art, 1307–1461.* Oxford, 1949.

GARDNER, S. *English Gothic Foliage Sculpture.* Cambridge, 1927.

HARVEY, J. H. *Gothic England: a Survey of National Culture, 1300–1550.* 1947.

PRIOR, E. S. *A History of Gothic Art in England.* 1900.

2. THIRTEENTH-CENTURY SCULPTURE
(CHAPTERS 8–10)

(a) Westminster Abbey

CAVE, C. J. P., and TANNER, L. E. 'A Thirteenth Century Choir of Angels in the North Transept of Westminster Abbey', *Archaeol.*, LXXXIV, 1934.

HOWGRAVE-GRAHAM, R. P. 'Westminster Abbey. Various Bosses, Capitals, and Corbels of the Thirteenth Century', *Brit. Archaeol. Assn Jnl*, 3rd Series, VIII, 1943.

'Westminster Abbey: the Sequence and Dates of the Transepts and Nave', *loc. cit.*, XI, 1948.

LETHABY, W. R. *Westminster Abbey and the King's Craftsmen*. 1906.

Westminster Abbey Re-examined. 1925.

NOPPEN, J. G. 'Sculpture of the School of John of Saint Albans', *Burl. Mag.*, LI, 1927.

'Further Sculptures of the Westminster School', *loc. cit.*, LIII, 1928.

'Recently cleaned Sculptures at Westminster Abbey', *loc. cit.,* LVIII, 1931.

'Building by Henry III and Edward, the son of Odo', *Antiq. Jnl*, XXVIII–XXIX, 1948–9.

ROYAL COMMISSION ON HISTORICAL MONUMENTS, *London*, I, 1924.

SCOTT, G. G. *Gleanings from Westminster Abbey*. 1863.

TANNER, L. E. *Unknown Westminster Abbey*. 1948.

WEBB, G. 'The Decorative Character of Westminster Abbey', *Jnl Warb. Court. Insts*, XII, 1949.

WESTLAKE, H. F. *Westminster Abbey*. 1923.

(b) Elsewhere

ALDIS, E. *Carvings and Sculptures of Worcester Cathedral*. 1873.

ANDERSSON, A. *English Influence in Norwegian and Swedish Figure Sculpture in Wood, 1220–70*. Stockholm, 1949.

BORENIUS, T., and CHAMOT, M. 'On a group of early enamels, possibly English', *Burl. Mag.*, LIII, 1928.

GARDNER, A., and HOWGRAVE-GRAHAM, R. P. 'The "Queen Margaret" Statue at Lincoln', *Antiq. Jnl*, XXIX, 1949.

HOMBURGER, O. *Der Trivulzio-Kandelaber*. Zürich, 1950.

HOPE, W. H. St J. 'On the Sculptured Doorways of the Lady Chapel of Glastonbury Abbey', *Archaeol.*, LII, 1890.

HOPE, W. H. St J., and LETHABY, W. R. 'The Imagery and Sculptures on the West Front of Wells Cathedral Church', *Archaeol.*, LIX, 1904.

LETHABY, W. R. 'Notes on Sculptures in Lincoln Minster', *Archaeol.*, LX, 1907.

MARCOUSÉ, R. *Figure Sculpture in Saint Mary's Abbey, York*. York, 1951.

SHARPE, E. *The Ornamentation of the Transitional Period of British Architecture*. 1871.

TURNER, T. Hudson. *Some Account of Domestic Architecture in England*, I, 1851.

3. SCULPTURE OF THE DECORATED PERIOD

(CHAPTERS 11–12)

BISHOP, H. E., and PRIDEAUX, E. K. *The Building of Exeter Cathedral*. Exeter, 1922.

BOTFIELD, B. *Manners and Household Expenses of England*, ed. T. Hudson Turner. Roxburghe Club, 1841.

CAVE, C. J. P. *Medieval Carvings in Exeter Cathedral*. 1953.

DALTON, O. M. 'A Fourteenth Century English Ivory Triptych', *Burl. Mag.*, XLIX, 1926.

FREEMAN, P. *The Architectural History of Exeter Cathedral*. Exeter, 1888.

GARDNER, A. *The Lincoln Angels*. Lincoln, 1952.

HEALES, A. 'Easter Sepulchres', *Archaeol.*, XLII, 1869.

JACKSON, T. G. *The Church of Saint Mary the Virgin, Oxford*. Oxford, 1897.

JAMES, M. R. *The Sculptures in the Lady Chapel at Ely*. 1895.

KEYSER, C. E. 'Sculptured Cornices in Churches near Banbury ...', *Antiq. Jnl*, IV, 1924.

LAMBORN, E. A. Greening. 'The Shrine of Saint Edberg', *Oxon Archaeol. Soc. Rep.*, LXXX, 1934.

MARSHALL, G. 'The Shrine of Saint Thomas de Cantelupe in Hereford Cathedral', *Woolhope Club Trans*, 1930–2.

MORRIS, P. 'Exeter Cathedral: A Conjectural Restoration of the Fourteenth Century Altar Screen', *Antiq. Jnl*, XXIII, 1943.

OMAN, C. 'The Swinburne Pyx', *Burl. Mag.*, XCII, 1950.

PENZER, N. M. 'The King's Lynn Cup', *The Connoisseur*, CXVIII, 1946.

PEVSNER, N. *The Leaves of Southwell*. 1945.

PRIDEAUX, E. K. 'Figure Sculpture of the West Front of Exeter Cathedral', *Archaeol. Jnl*, LXIX, 1912.

STEWART, D. J. 'Notes on Norwich Cathedral. The Cloisters', *Archaeol. Jnl*, XXXII, 1875.

WOOLLEY, E. 'Some Notts and Lincs Easter Sepulchres', *Thoroton Soc. Trans*, XXVIII, 1924.

'Irnham and Hawton', *Brit. Archaeol. Assn Jnl*, 2nd Series, XXXV, 1929–30.

4. LATE MEDIEVAL SCULPTURE
(CHAPTERS 13–15)

ATKINSON, T. D. 'Medieval Figure Sculpture in Winchester Cathedral', *Archaeol.*, LXXXV, 1935.

CHATWIN, P. B. 'The Decoration of the Beauchamp Chapel, Warwick, with special Reference to the Sculptures', *Archaeol.*, LXXVII, 1927.

CHITTY, H., *Medieval Sculptures at Winchester College*. Oxford, 1932.

FRYER, A. C. 'On Fonts with Representations of the Seven Sacraments', *Archaeol. Jnl*, LIX, 1902; LXXXVII, 1930; XC, 1933.

HOPE, W. H. St J. *The Stall Plates of the Knights of the Order of the Garter, 1348–1485.* 1901.

'The Funeral, Monument, and Chantry Chapel of King Henry the Fifth', *Archaeol.*, LXV, 1913–1914.

NICHOLS, J. G. *Description of the Church of Saint Mary, Warwick, and of the Beauchamp Chapel.* n.d. [1838].

OMAN, C. C. 'The Founders of Malines and England', *Oud-Holland*, L, 1933.

PRIDEAUX, E. K. 'Late Medieval Sculpture from the Church of Saint Peter, Tiverton', *Archaeol. Jnl*, LXXV, 1918.

5. ALABASTERS
(a) General

HILDBURGH, W. L. 'Iconographical Peculiarities in English Medieval Alabaster Carving', *Folk-Lore*, XLIV, 1933.

'English Alabaster Carvings as Records of the Medieval Religious Drama', *Archaeol.*, XCIII, 1949.

'English Alabaster Tables of about the Third Quarter of the Fourteenth Century', *Art Bull.*, XXXII, 1950.

HOPE, W. H. St J. 'On the sculptured Alabaster Tablets called Saint John's Heads', *Archaeol.*, LII, 1890.

'On the early Working of Alabaster in England', *Archaeol. Jnl*, LXI, 1904.

HOPE, W. H. St J., and PRIOR, E. S. *Illustrated Catalogue of the Exhibition of English Medieval Alabasters.* Society of Antiquaries, 1913.

NELSON, P. 'English Alabasters of the Embattled Type', *Archaeol. Jnl*, LXXV, 1918.

'The Earliest Type of English Alabaster Panel Carvings', *Archaeol. Jnl*, LXXVI, 1919.

(b) Particular

BAUM, J. 'Fourteenth Century Alabaster Reliefs of the Epiphany', *Art Bull.*, XV, 1933.

BECKETT, F. 'Engelske Alabast-tavler in Danmark', *Tidsskrift for Industri*, VI, 1905.

BEDFORD, R. P. 'An English Set of Twelve Apostles in Alabaster', *Burl. Mag.*, XLII, 1923.

BIVER, Count P. 'Some Examples of English Alabaster Tables in France', *Archaeol. Jnl*, LXVII, 1910.

BOUILLET, Abbé. 'La Fabrication industrielle des retables en albâtre (XIVᵉ–XVᵉ siècles)', *Bulletin Monumental*, LXV, 1901.

BURRELL, H. J. E., and BENTON, G. M. 'The English Alabaster Carvings of Cambridgeshire ...', *Cambs. Antiq. Soc. Proc.*, XXXIV, 1932–3.

HILDBURGH, W. L. 'Two Alabaster Tables', *Proc. Soc. Antiq. Lond.*, 2nd Series, XXVIII, 1915–16.

'Some English Alabaster Tables', *Proc. Soc. Antiq. Lond.*, 2nd Series, XXXII, 1919–20.

'Notes on some English Alabaster Carvings', *Antiq. Jnl*, I, 1921.

'Notes on some English Medieval Alabaster Carvings', *Antiq. Jnl*, III, 1923.

'An Alabaster Table of the Annunciation with the Crucifix', *Archaeol.*, LXXIV, 1923–4.

'Notes on some English Alabaster Carvings', *Antiq. Jnl*, IV, 1924.

'A Group of Panels of English Alabaster', *Burl. Mag.*, XLVI, 1925.

'Notes on some English Alabaster Carvings in Germany', *Antiq. Jnl*, V, 1925.

'A Datable English Alabaster Altar-piece at Santiago de Compostella', *Antiq. Jnl*, VI, 1926.

'Some Unusual Medieval English Alabaster Carvings', *Antiq. Jnl*, VIII, 1928.

'Further Notes on English Alabaster Carvings', *Antiq. Jnl*, X, 1930.

'Miscellaneous Notes concerning English Alabaster Carvings', *Archaeol. Jnl*, LXXXVIII, 1931.

'An English Alabaster in Holland', *Antiq. Jnl*, XII, 1932.

'Further Miscellaneous Notes on Medieval English Alabaster Carvings', *Antiq. Jnl*, XVII, 1937.

'Some presumably datable Fragments of an English Alabaster Retable ...', *Antiq. Jnl*, XXIV, 1944.

'Medieval English Alabaster Figures of the Virgin and Child', *Burl. Mag.*, LXXXVIII, 1946.

'An English Alabaster Carving of *Saint Michaeol weighing a Soul*', *Burl. Mag.*, LXXXIX, 1947.

'A Group of Medieval English Alabaster Carvings at Nantes', *Brit. Archaeol. Assn Jnl*, 3rd Series, XI, 1948.

HOPE, W. H. St J. 'A Note on some Alabaster Sculptures of Nottingham Work', *Archaeol. Jnl*, LXIV, 1907.

'A curious Type of stone Saint John's Head', *Antiq. Jnl*, XVII, 1937.

KORNFELD, H. 'An English Alabaster Relief', *Burl. Mag.*, LXI, 1932.

LONG, E. T. 'English Alabaster Tables in Dorset', *Dorset Nat. Hist. and Antiq. Field Club Proc.*, XLIX, 1928.

MACLAGAN, E. 'An English Alabaster Altar-piece in the Victoria and Albert Museum', *Burl. Mag.*, XXXVI, 1920.

'Medieval Alabasters from Naworth Castle', *Antiq. Jnl*, XII, 1932.

NELSON, P. 'Some Examples of English Medieval Alabaster Work', *Archaeol. Jnl*, LXXI, 1914.

'Ancient Alabasters at Lydiate', *Lancs and Cheshire Hist. Soc. Trans*, LXVII, 1915.

'Some Unusual English Alabaster Panels', *Lancs and Cheshire Hist. Soc. Trans*, LXIX, 1917.

'Some Further Examples of English Medieval Alabaster Tables', *Archaeol. Jnl*, LXXIV, 1917.

'A Doom Reredos', *Lancs and Cheshire Hist. Soc. Trans*, LXX, 1918.

'Some Fifteenth Century Alabaster Panels', *Archaeol. Jnl*, LXXVI, 1919.

'English Medieval Alabaster Carvings in Ireland and Denmark', *Archaeol. Jnl*, LXXVII, 1920.

'Some Unpublished English Medieval Alabaster Carvings', *Archaeol. Jnl*, LXXVII, 1920.

'The Woodwork of English Alabaster Retables', *Lancs and Cheshire Hist. Soc. Trans*, LXXII, 1920.

'An English Fifteenth Century Alabaster Reredos of Saint Edmund', *Lancs and Cheshire Hist. Soc. Trans*, LXXV, 1923.

'Some Unpublished English Medieval Alabaster Carvings', *Archaeol. Jnl*, LXXXII, 1925.

'Some Unpublished English Alabaster Carvings', *Archaeol. Jnl*, LXXXIII, 1926.

'Some Additional Specimens of English Alabaster Carvings', *Archaeol. Jnl*, LXXXIV, 1927.

'Miscellaneous Notes concerning English Alabaster Carvings', *Archaeol. Jnl*, LXXXVIII, 1931.

ROSTAND, M. A. 'Les Albâtres anglais du XVe siècle en Basse-Normandie', *Bulletin Monumental*, LXXXVII, 1928.

SQUILBECK, J. 'Quelques Sculptures anglaises d'albâtre conservées en Belgique', *Antiq. Jnl*, XVIII, 1938.

TAVENDER, A. S. 'Three Medieval English Alabasters in French Churches', *Speculum*, XXIV, 1949.

6. BRASSES

(a) General

BOUTELL, C. *Monumental Brasses and Slabs*. 1847.

The Monumental Brasses of England. 1849.

CAMERON, H. K. 'The Metals used in Monumental Brasses', *Monumental Brass Soc. Trans*, VIII, 1943–51.

DRUITT, H. *A Manual of Costume as illustrated by Monumental Brasses*. 1906.

GADD, M. L. 'English Monumental Brasses of the 15th and early 16th Centuries', *Brit. Archaeol. Assn Jnl*, 3rd Series, II, 1937.

GIUSEPPI, M. S., and GREEN, R. A. *An Appendix to a List of Brasses in the British Isles, by Mill Stephenson*. 1938.

HAINES, H. *A Manual of Monumental Brasses*. 1861.

KENT, J. P. C. 'Monumental Brasses – A New Classification of Military Effigies, *c.* 1360–1485'. *Brit. Archaeol. Assn Jnl*, 3rd Series, XII, 1949.

MACKLIN, H. W. *The Brasses of England*. 1907.

STEPHENSON, M. *A List of Monumental Brasses in the British Isles*. 1926.

VICTORIA AND ALBERT MUSEUM. *Catalogue of Rubbings of Brasses and Incised Slabs*, ed. M. Clayton. 1929.

(b) Particular

ANDREWS, W. F. *Memorial Brasses in Hertfordshire Churches*. Ware, 1903.

BADGER, E. W. *The Monumental Brasses of Warwickshire*. Birmingham, 1895.

BELCHER, W. D. *Kentish Brasses*. 1888, 1905.

BELOE, E. M. *A Series of Photolithographs of Monumental Brasses in Norfolk*. 1890–1.

COTMAN, J. S. *Engravings of Sepulchral Brasses in Norfolk and Suffolk*. 1839.

DAVIS, C. T. 'The Monumental Brasses of Here-fordshire and Worcestershire', *Birmingham and Midland Institute (Archaeol. Section) Trans*, 1884–5.

D'ELBOUX, R. H. 'Testamentary Brasses', *Antiq. Jnl*, XXIX, 1949.

DUNKIN, E. H. W. *The Monumental Brasses of Cornwall*. 1882.

FARRER, E. *A List of Monumental Brasses in Suffolk.* Norwich, 1903.

HARTSHORNE, A. 'On the Brass of Sir Hugh Hastings in Elsing Church, Norfolk', *Archaeol.*, LX, 1907.

ISHERWOOD, G. *Monumental Brasses in the Bedford-shire Churches*. 1906.

KITE, E. *The Monumental Brasses of Wiltshire*. 1860. *Monumental Brass Soc. Trans, passim*.

MORLEY, H. T. *The Monumental Brasses of Berkshire*. Reading, 1924.

Oxford Portfolio of Monumental Brasses, I–IV. Oxford, 1898–1901.

THORNELY, J. L. *The Monumental Brasses of Lancs and Cheshire*. Hull, 1893.

TORR, J. B. V. 'A Chronological List of early Male Civilians', *Monumental Brass Soc. Trans*, VII, 1934–42.

'The Oddington Shroud Brass and its lost Fellows', *loc. cit.*, VII, 1934–42.

WAGNER, A. R., and MANN, J. G. 'A Fifteenth Century Description of the Brass of Sir Hugh Hastings at Elsing, Norfolk', *Antiq. Jnl*, XIX, 1939.

WOODMAN, T. C., *The Sussex Brasses*. Hove, 1903.

7. ROOF BOSSES

(a) General

CAVE, C. J. P., *Roof Bosses in Medieval Churches*. Cambridge, 1948.

(b) Particular

CAVE, C. J. P., 'The Bosses on the Vault of the Quire of Winchester Cathedral', *Archaeol.*, LXXVI, 1926–7.

'Roof Bosses in the Nave of Tewkesbury Abbey', *Archaeol.*, LXXIX, 1929.

'The Roof Bosses in Chichester Cathedral', *Sussex Archaeol. Collns*, LXXI, 1930.

'The Roof Bosses in Gloucester Cathedral', *Bristol and Glos Archaeol. Soc. Trans*, LIII, 1931.

'The Roof Bosses in Ely Cathedral', *Cambs. Antiq. Soc. Proc.*, XXXII, 1930–1.

'The Wooden Roof Bosses in the FitzAlan Chapel, Arundel, and in Poling Church', *Sussex Archaeol. Collns*, LXXIII, 1932.

'The Roof Bosses in the Transepts of Norwich Cathedral Church', *Archaeol.*, LXXXIII, 1933.

'The Roof Bosses in Canterbury Cathedral', *Archaeol.*, LXXXIV, 1934.

'The Roof Bosses in Worcester Cathedral', *Worcs Archaeol. Soc. Trans*, n.s., XI, 1934.

'The Roof Bosses of Lincoln Cathedral', *Archaeol.*, LXXXV, 1935.

'The Roof Bosses in the Chancel of Salle Church', *Norfolk Archaeol. Soc., Original Papers*, XXV, 1933–5.

'Notes on some further Roof Bosses in Ely Cathedral', *Cambs. Antiq. Soc. Proc.*, XXXVII, 1935–6.

'The Roof Sculptures of Durham Cathedral', *Archaeol. Aeliana*, 4th Series, XIV, 1937.

'Roof Bosses at Lechlade', *Bristol and Glos Archaeol. Soc. Trans*, LX, 1938.

'The Roof Bosses in the Cathedral and in the Church of St John the Baptist at Peterborough and in the Cathedral at Ripon', *Archaeol.*, LXXXVIII, 1938.

Medieval Carvings in Exeter Cathedral, 1953.

HOPE, W. H. St J. 'The Heraldry and the Sculptures of the Vault of the Divinity School at Oxford', *Archaeol. Jnl*, LXXI, 1914.

VENABLES, E. 'The Bosses of the Eastern Vault of the Cloisters of Lincoln Cathedral', *Associated Architectural Soc. Rep.*, XX, 1889.

8. TOMBS AND EFFIGIES

(a) General

CROSSLEY, F. H. *English Church Monuments, 1150–1550*. 1921.

FRYER, A. C. *Wooden Monumental Effigies in England and Wales*. 1924.

GARDNER, A. *Alabaster Tombs of the Pre-Reformation Period in England*. Cambridge, 1940.

HOLLIS, T., and G. *Monumental Effigies of Great Britain*. 1840–2.

STOTHARD, C. A. *The Monumental Effigies of Great Britain*. 1817.

WEEVER, J. *Ancient Funerall Monuments*. 1631.

(b) Particular

BARK, G. M. 'A London Alabasterer in 1421', *Antiq. Jnl*, XXIX, 1949.

BIVER, Count P. 'Tombs of the School of London at the Beginning of the Fourteenth Century', *Archaeol. Jnl*, LXVII, 1910.

BLAIR, C. 'Pre-Reformation Effigies of Cheshire', *Lancs and Cheshire Antiq. Soc. Trans*, LX, 1948; LXI, 1949.

BLAIR, C. H. Hunter. 'Medieval Effigies in Northumberland', *Archaeol. Aeliana*, 4th Series, VII, 1930.
 'Medieval Effigies in the County of Durham', *Archaeol. Aeliana*, VI, 1929.

BLOXHAM, M. H. 'The Sepulchral Remains and Effigies in the Cathedral Church of Worcester', *Archaeol. Jnl*, XX, 1865.

BOWER, Canon. 'Effigies in the Diocese of Carlisle', *Cumb. and Westm. Archaeol. Soc. Trans*, XV, 1898–9.

CHANCELLOR, F. *The Ancient Sepulchral Monuments of Essex*. 1890.

CHATWIN, P. B. 'Monumental Effigies in the County of Warwickshire', *Birmingham Archaeol. Soc. Trans*, XLVII, 1921; XLVIII, 1922.

CROSSLEY, F. H. 'Medieval Monumental Effigies of Cheshire', *Lancs and Cheshire Hist. Soc. Trans*, LXXVI, 1925.

FRYER, A. C. 'Monumental Effigies made by Bristol craftsmen (1240–1550)', *Archaeol.*, LXXIV, 1923–4.
 'Monumental Effigies in Somerset', *Somerset Archaeol. and Nat. Hist. Soc. Proc.*, LXI–LXXI, 1915–25.

GALPIN, F. W. 'Notes on the tombs... of... Hatfield Broad Oak', *Essex Archaeol. Soc. Trans*, n.s., IV, 1892–3.

HARTSHORNE, A. *The Recumbent Monumental Effigies in Northamptonshire*. 1876.

HOPE, W. H. St J. 'On the Funeral Effigies of the Kings and Queens of England', *Archaeol.*, LX, 1907.

HUMPHREYS, J. 'Monumental Effigies in the Churches of Worcester', *Birmingham Archaeol. Soc. Trans*, XXXVII, 1911.

I'ANSON, W. M. 'The Medieval Military Effigies of Yorkshire', *Yorks Archaeol. Jnl*, XXVIII–XXIX, 1924–9.

JEAVONS, S. A. 'The Monumental Effigies of Staffordshire', *Birmingham Archaeol. Soc. Trans*, LXIX, 1951; LXX, 1952.

LAWRANCE, R. H., and ROUTH, T. E. 'Military Effigies in Nottinghamshire before the Black Death', *Thoroton Soc. Trans*, XXVIII, 1924.
 'The Military Effigies of Derbyshire', *Derbyshire Archaeol. and Nat. Hist. Soc. Jnl*, XLVI, 1924–5.

LONG, E. T., 'Pre-Reformation Dorset Church Monuments', *Dorset Nat. Hist. and Antiq. Field Club Proc.*, XLVI, 1925.

NOPPEN, J. G. 'A Tomb and Effigy by Hennequin of Liège', *Burl. Mag.*, LIX, 1931.

PLANCHÉ, J. R. 'On the Sepulchral Effigies in Salisbury Cathedral', *Brit. Archaeol. Assn Jnl*, XV, 1859.

RICHARDSON, E. *The Monumental Effigies of the Temple Church*. 1843.

ROBINSON, J. A. 'Effigies of Saxon Bishops at Wells', *Archaeol.*, LXV, 1913–14.

ROGERS, W. H. H. *The Antient Sepulchral Effigies and Monumental and Memorial Sculpture of Devon*. Exeter, 1877.

ROPER, I. M. *The Monumental Effigies of Gloucestershire and Bristol*. Gloucester, 1931.

RUSHFORD, G. McN. 'The Kirkham Monument in Paignton Church', *Exeter Diocesan Architectural and Archaeol. Soc. Trans*, XV, 1927–9.

TRISTRAM, E. W. 'A Royal Tomb at Canterbury', *Canterbury Cathedral Chronicle*, April 1937.

9. WOODWORK

(a) General

BOND, F. *Wood Carvings in English Churches. I. Misericords*. Oxford, 1910.
 Wood Carvings in English Churches. II. Stalls and Tabernacle Work. Oxford, 1910.

COX, J. C. *Pulpits, Lecterns and Organs in English Churches*. 1915.
 Bench Ends in English Churches. Oxford, 1916.

COX, J. C., and HARVEY, A. *English Church Furniture*. 1907.

HOWARD, F. E., and CROSSLEY, F. H. *English Church Woodwork*. 1927.

VALLANCE, A. *English Church Screens*. 1936.
 Greater English Church Screens, 1947.

(b) Particular

ANDERSON, M. D. *The Choir Stalls of Lincoln Minster*. Lincoln, 1951.

BARNARD, J. L. 'Carved Miserecordes in the Chapel of King Henry VII at Westminster', *The Sacrist*, I, 1871.

BOND, F. Bligh, and CAMM, B. *Rood Screens and Rood Lofts*. 1909.

CHURCH, C. M. 'The Prebendal Stalls and Misericords in the Cathedral Church of Wells', *Archaeol.*, LV, 1907.

CROSSLEY, F. H. 'On the Remains of Medieval Stallwork in Lancashire', *Lancs and Cheshire Hist. Soc. Trans*, LXX, 1918.

'The Church Screens of Cheshire', *loc. cit.*, LXIX, 1917.

CROSSLEY, F. H., and RIDGWAY, M. H. 'Screens, Lofts, and Stalls situated in Wales and Monmouthshire', *Archaeol. Cambrensis*, XCVII–1942– (in progress).

GOODMAN, A. W. 'The Choir Stalls, Winchester Cathedral', *Archaeol. Jnl*, LXXXIV, 1927.

HUDSON, H. A. *The Medieval Woodwork in Manchester Cathedral*. Manchester, 1924.

LILLIE, W. W. 'Screenwork in the County of Suffolk', *Suffolk Inst. of Archaeol. and Nat. Hist. Proc.*, XX–XXII, 1928–36.

LONG, E. T. 'Church Screens in Dorset', *Archaeol. Jnl*, LXXXI, 1924.

PURVIS, J. S. 'The Ripon Carvers ...', *Yorks Archaeol. Jnl*, XXIX, 1927–9.

'The Use of Continental Wood-cuts and Prints by the "Ripon School" of Woodcarvers ...', *Archaeol.*, LXXXV, 1935.

TAYLOR, C. S. 'Banwell Screen and Rood Loft', *Bristol and Glos Archaeol. Soc. Trans*, XXXV, 1912.

THE PLATES

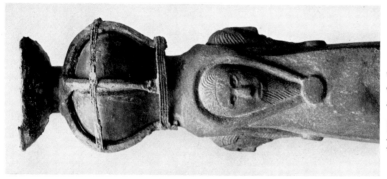

(B) Head of whetstone. Sutton Hoo, Suffolk. Early seventh century. *British Museum, London*

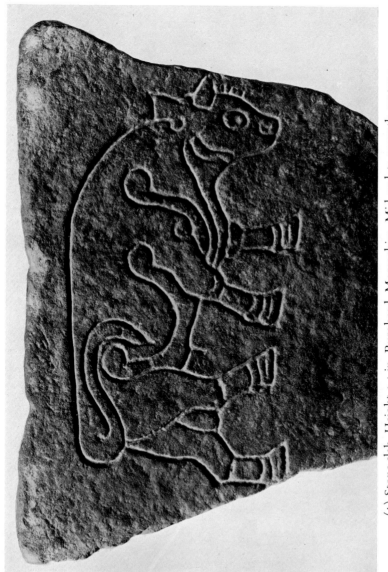

(A) Stone slab. Height *c.*4 in. Burghead, Morayshire. Mid or late seventh century. *British Museum, London*

I

Stone cross-shaft. Ruthwell, Dumfries.
Last quarter of the seventh century

2

Stone cross-shaft. Ruthwell, Dumfries.
Last quarter of the seventh century

3

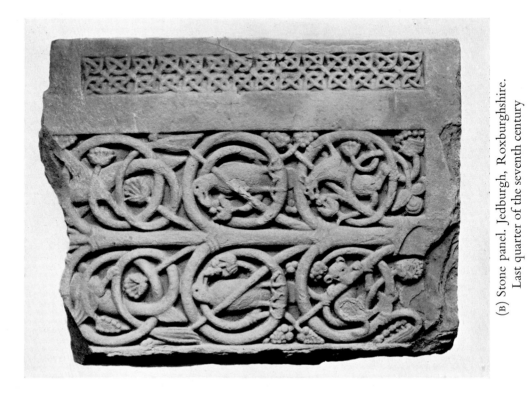

(B) Stone panel. Jedburgh, Roxburghshire.
Last quarter of the seventh century

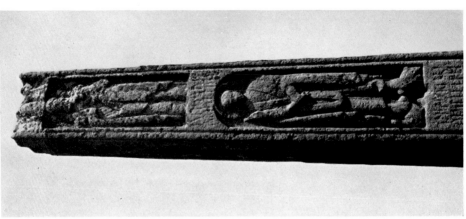

(A) Stone cross-shaft. Bewcastle,
Cumberland. End of seventh century

4

The Franks Casket, whalebone. Length 9 in. End of the seventh century. *British Museum, London*

5

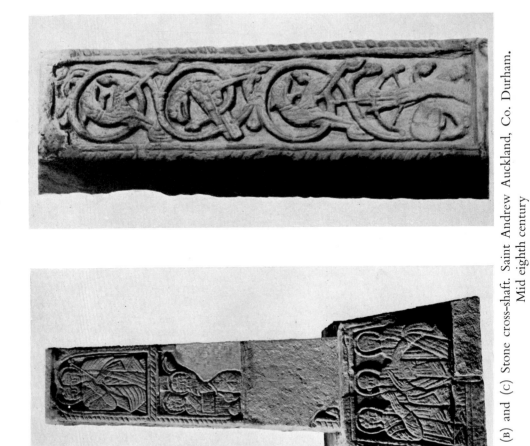

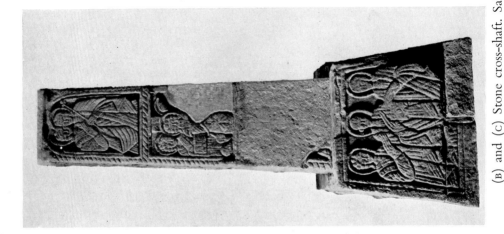

(B) and (C) Stone cross-shaft. Saint Andrew Auckland, Co. Durham.
Mid eighth century

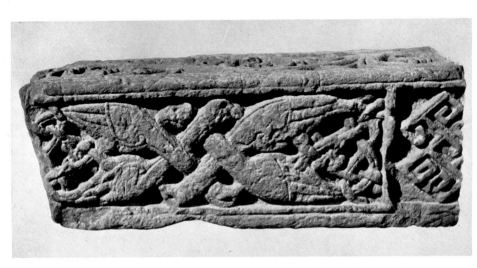

(A) Stone cross-shaft. Aberlady,
Haddingtonshire. Early eighth century

6

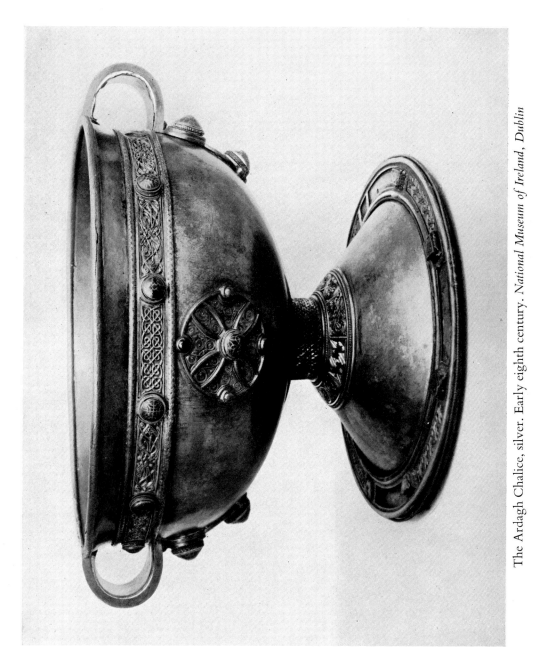

The Ardagh Chalice, silver. Early eighth century. *National Museum of Ireland, Dublin*

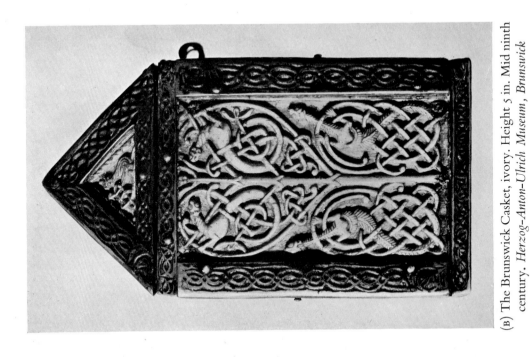

(B) The Brunswick Casket, ivory. Height 5 in. Mid ninth century. *Herzog–Anton–Ulrich Museum, Brunswick*

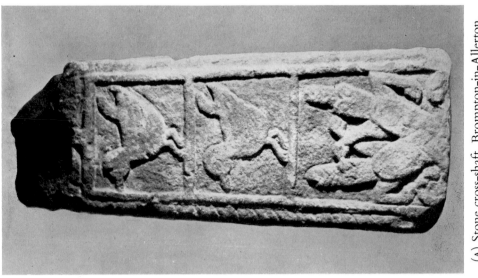

(A) Stone cross-shaft. Brompton-in-Allerton, Yorks, N.R. Mid eighth century

(B) The Ormside Bowl (detail), silver. Early ninth century. *Yorkshire Museum, York*

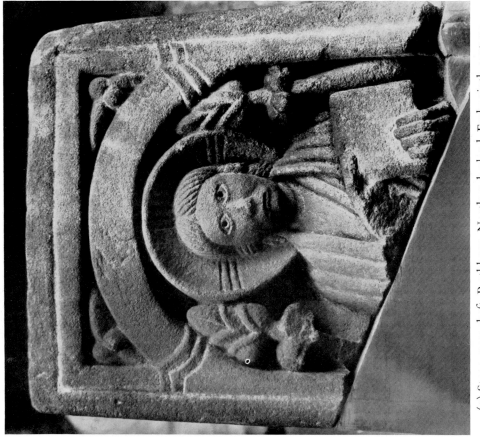

(A) Stone cross-shaft. Rothbury, Northumberland. Early ninth century. *Blackgate Museum, Newcastle-on-Tyne, Northumberland*

9

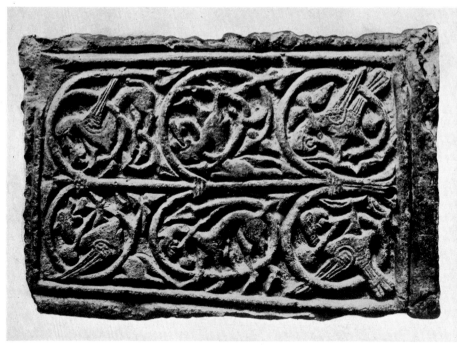

(B) Fragment of stone cross-shaft. Height 2 ft 11 in. Croft, Yorks, N.R. Early ninth century

(A) Fragment of stone cross-shaft. Height 14 in. Reculver, Kent. First half of the ninth century. *Canterbury Cathedral Crypt*

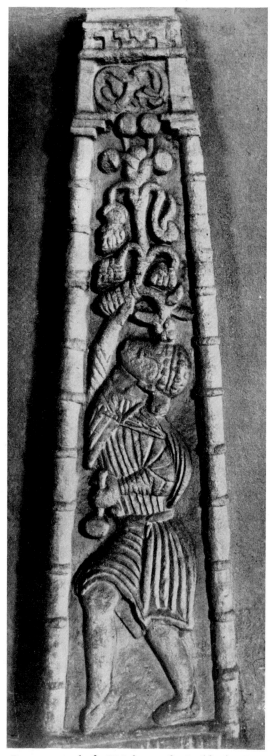

Stone cross-shaft. Height *c.*4 ft. Codford Saint
Peter, Wilts. First quarter of the ninth century

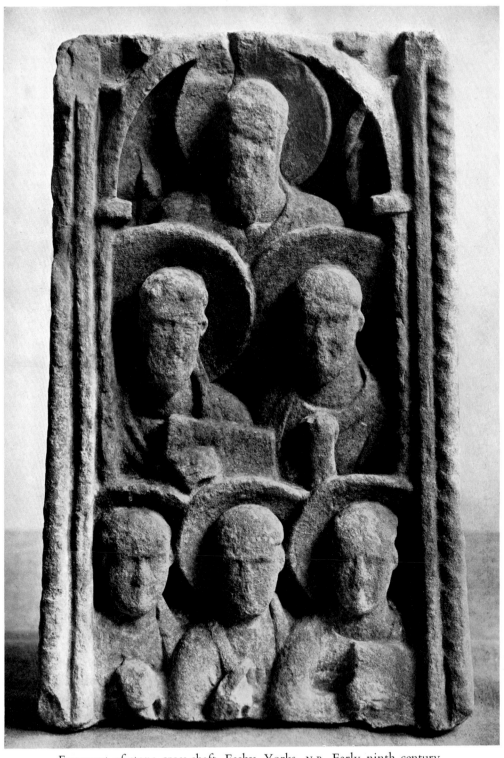

Fragment of stone cross-shaft, Easby, Yorks, N.R. Early ninth century.
Victoria and Albert Museum, London

12

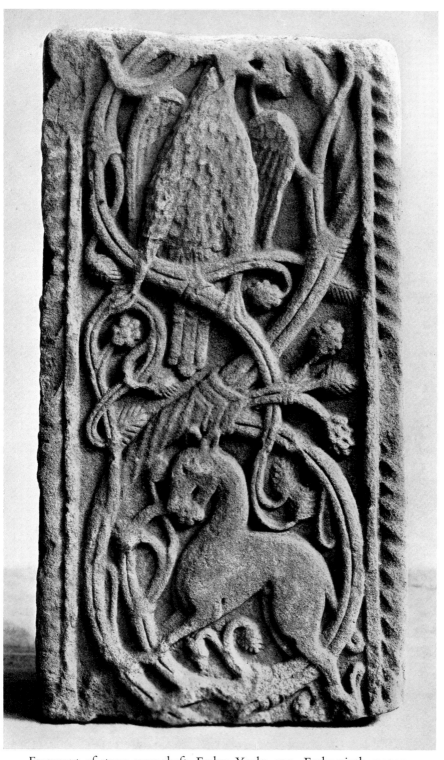

Fragment of stone cross-shaft. Easby, Yorks, N.R. Early ninth century.
Victoria and Albert Museum, London

13

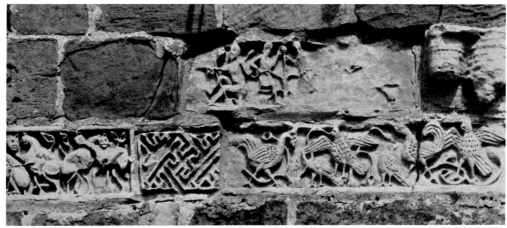

(A) Stone frieze. Breedon-on-the-Hill, Leics. First half of the ninth century

(B) Stone panel. Height *c.* 2 ft. Breedon-on-the-Hill, Leics.
First half of the ninth century

14

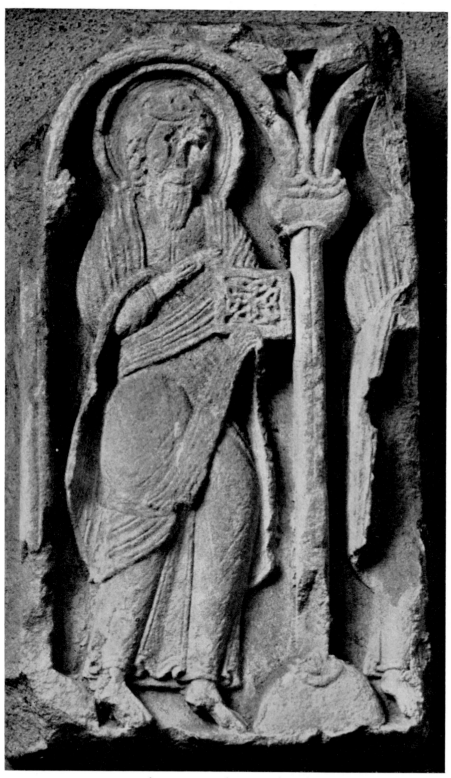

Stone panel. Castor, Northants. Mid ninth century

15

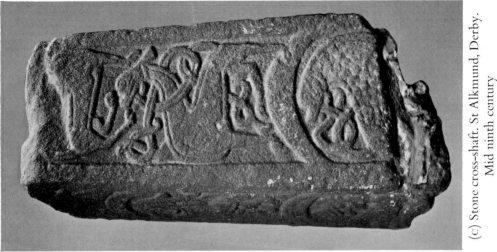

(c) Stone cross-shaft. St Alkmund, Derby.
Mid ninth century

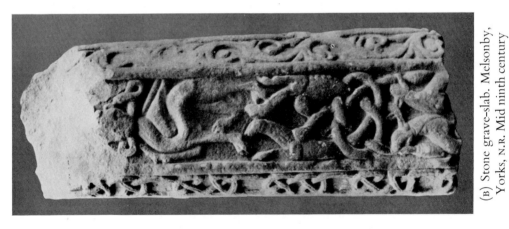

(B) Stone grave-slab. Melsonby,
Yorks, N.R. Mid ninth century

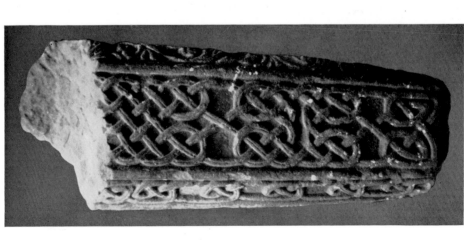

(A) Stone grave-slab. Melsonby,
Yorks, N.R. Mid ninth century

16

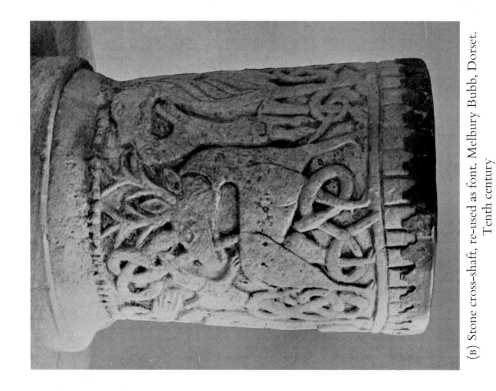

(B) Stone cross-shaft, re-used as font. Melbury Bubb, Dorset. Tenth century

(A) Stone cross-shaft. Colerne, Wilts. Third quarter of the ninth century

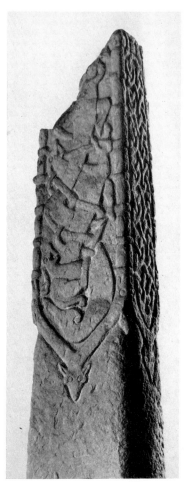

(A) Stone cross-shaft. Sockburn, Co. Durham.
Mid or late tenth century

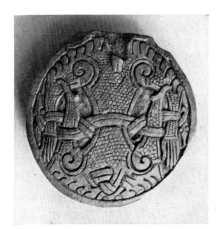

(B) Bone clasp. Diameter *c.* 2½ in.
The Thames, London. Second half of
tenth century. *British Museum, London*

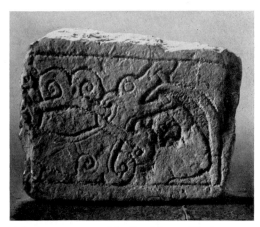

(C) Stone grave-slab. Levisham, Yorks, N.R.
End of tenth century

18

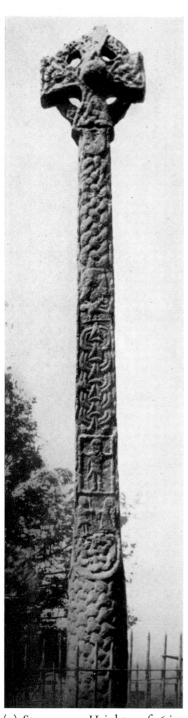

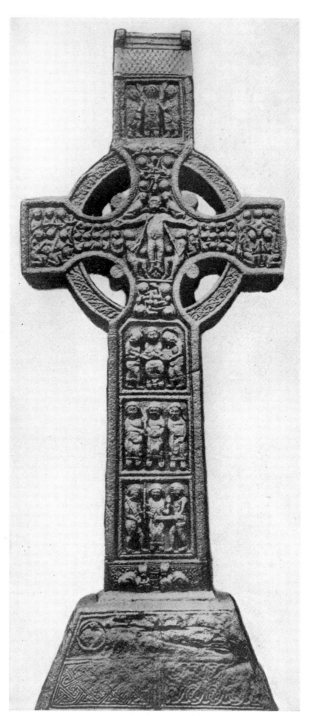

(A) Stone cross. Height 14 ft 6 in.
Gosforth, Cumberland. *c.* 1000

(B) Stone 'Cross of Muiredach'. Monasterboice, Louth.
First quarter of tenth century

(A) Stone panel. Length *c.* 5 ft. Bradford-on-Avon, Wilts. Late tenth century

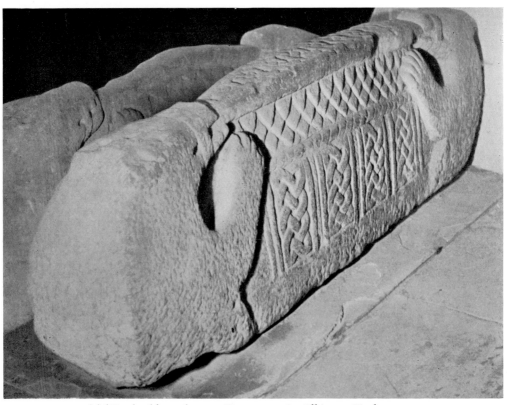

(B) 'Hogback' tombstone. Brompton-in-Allerton, Yorks, N.R.
Late tenth or early eleventh century

Stone slab. Height *c.*6 ft. Romsey, Hants. First half of the eleventh century

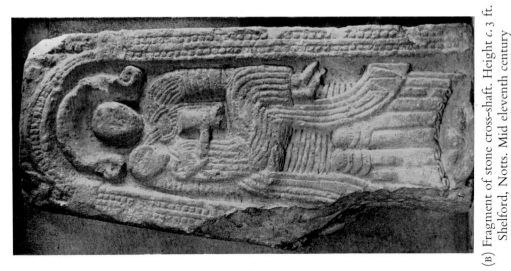

(B) Fragment of stone cross-shaft. Height c. 3 ft. Shelford, Notts. Mid eleventh century

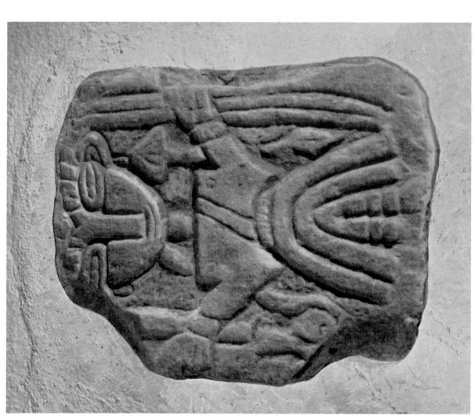

(A) Stone panel. Buckland Newton, Dorset. Eleventh century

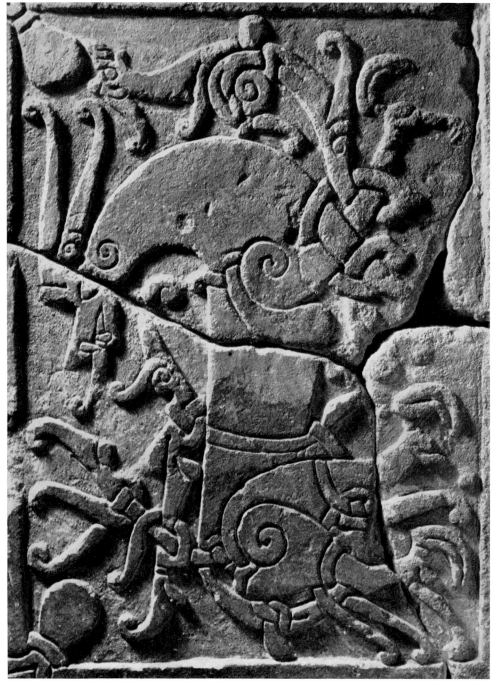

Stone tombstone. Width 2 ft. Saint Paul's churchyard, London. c. 1130–40. *Guildhall Museum, London*

23

Stone slab. Height *c.*7 ft. Bristol Cathedral.
Mid eleventh century

24

Reliquary cross with ivory figure. Height of figure *c.* 5 in. *c.* 990–1030.
Victoria and Albert Museum, London

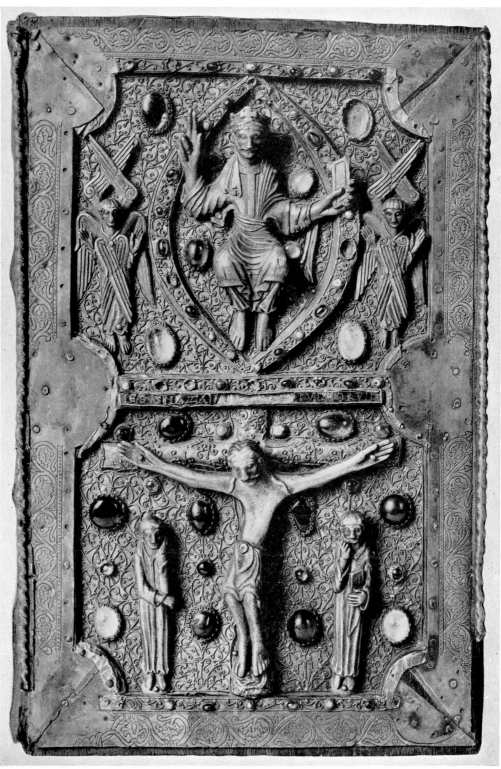

Metal book-cover. Mid eleventh century. *MS.708, Pierpont Morgan Library, New York*

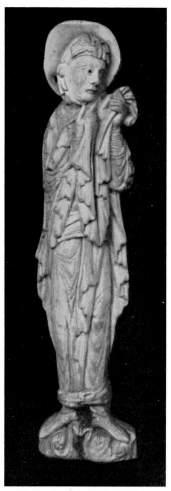

(A) Ivory statuette. Height
c. 4½ in. First quarter of the
eleventh century.
*Musée des Beaux-Arts,
Saint Omer (Pas-de-Calais)*

(B) Ivory plaque. Height c. 3 in. Early eleventh century.
Winchester Museum, Hants

(A) Bronze knocker. Durham Cathedral. First quarter of the twelfth century

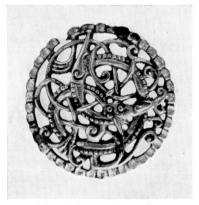

(B) Gilt bronze brooch.
Diameter $1\frac{1}{2}$ in. Pitney, Somerset.
Late eleventh century.
British Museum, London

28

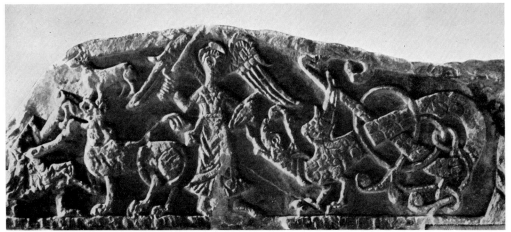

(A) Stone tympanum. Southwell Minster, Notts. Mid or late eleventh century

(B) Detail of stone panel. Jevington, Sussex. Early twelfth century

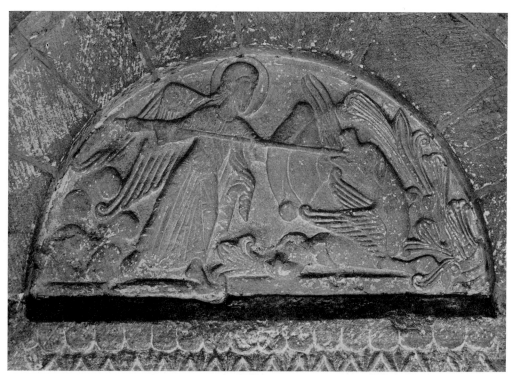

(A) Stone tympanum. Moreton Valence, Glos. Early twelfth century

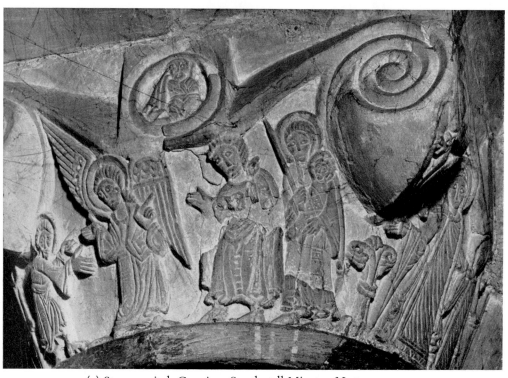

(B) Stone capital. Crossing, Southwell Minster, Notts. *c.* 1109–14

30

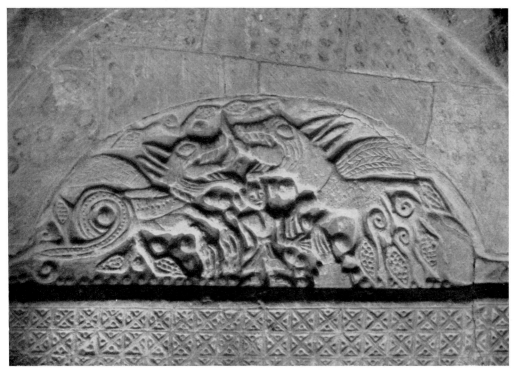

(A) Stone tympanum. Leckhamstead, Bucks. Late eleventh century

(B) Stone font. Topsham, Devon. Early twelfth century

31

(A) Stone capital. Durham Castle Chapel. *c.* 1172

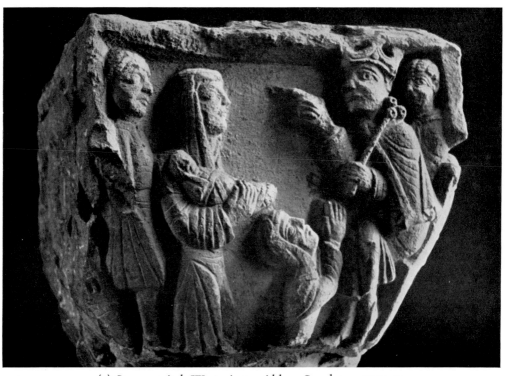

(B) Stone capital. Westminster Abbey, London. *c.* 1110–30

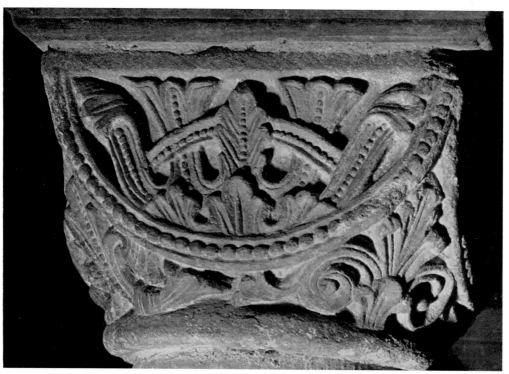

(A) Stone capital. Crypt, Canterbury Cathedral, Kent. *c.* 1115–25

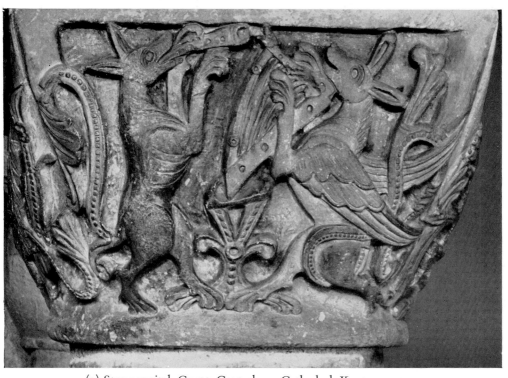

(B) Stone capital. Crypt, Canterbury Cathedral, Kent. *c.* 1115–25

33

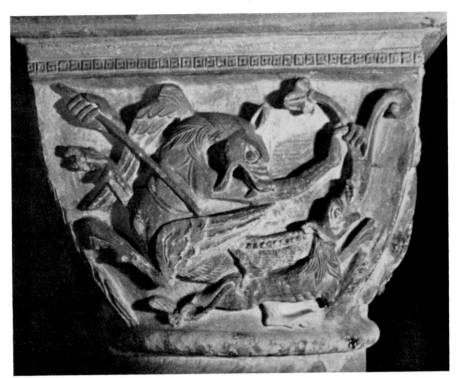

(A) Stone capital. Crypt, Canterbury Cathedral, Kent. *c*.1115–25

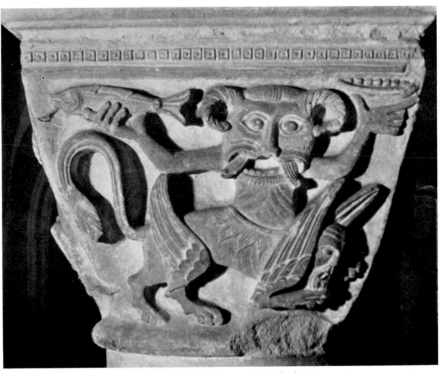

(B) Stone capital. Crypt, Canterbury Cathedral, Kent. *c*.1115–25

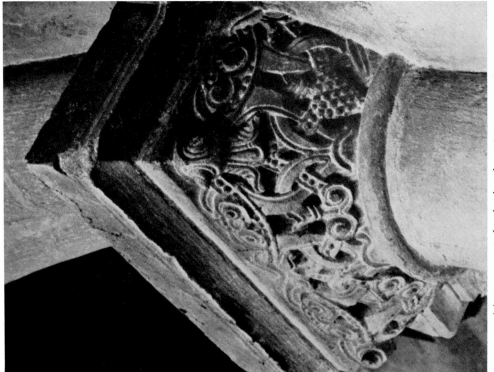

35

(A) Stone capital. Saint Bartholomew Hyde, Winchester, Hants. *c.* 1135–41

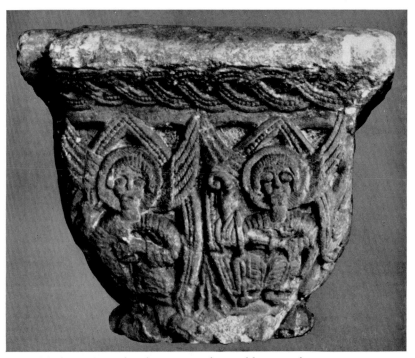

(B) Stone capital. Cloister, Reading Abbey, Berks. *c.* 1130–40.
Reading Museum

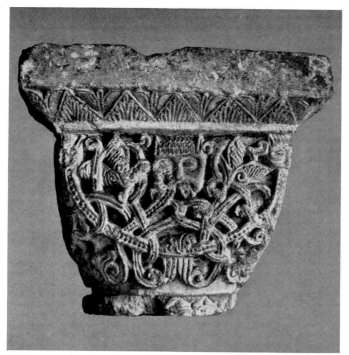

(A) Stone capital. Cloister, Reading Abbey, Berks. *c.* 1130–40.
Reading Museum

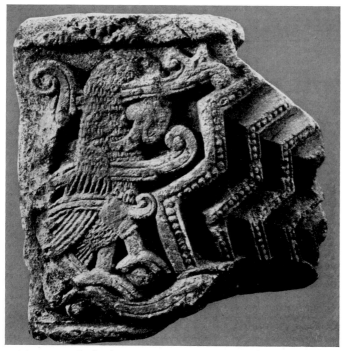

(B) Stone relief. Cloister, Reading Abbey, Berks. *c.* 1130–40.
Victoria and Albert Museum, London

37

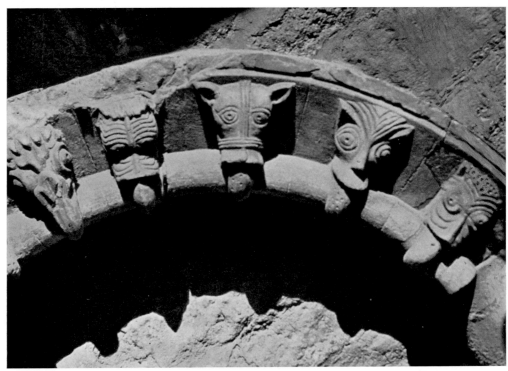

(A) Stone voussoirs. St Ebbe's, Oxford. *c.* 1140–50

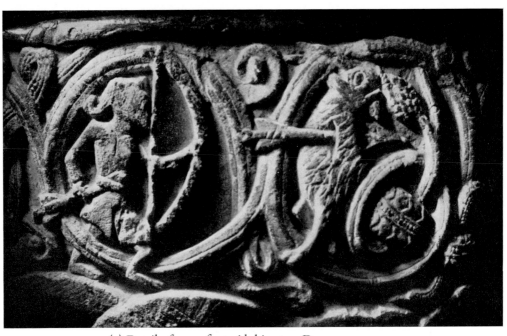

(B) Detail of stone font. Alphington, Devon. *c.* 1120–40

38

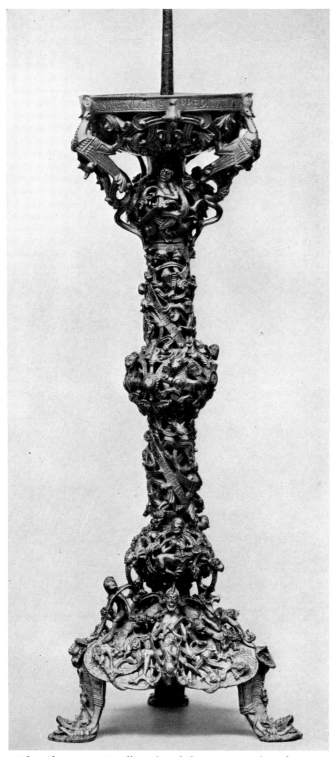

The Gloucester Candlestick, gilt bronze. Height 1 ft 4 in.
1104–13. *Victoria and Albert Museum, London*

Stone panel. Height *c.* 3 ft 6 in. Chichester Cathedral, Sussex.
Second quarter of the twelfth century

Whalebone panel, English or north French. Height 1 ft 2 in.
Early twelfth century. *Victoria and Albert Museum, London*

41

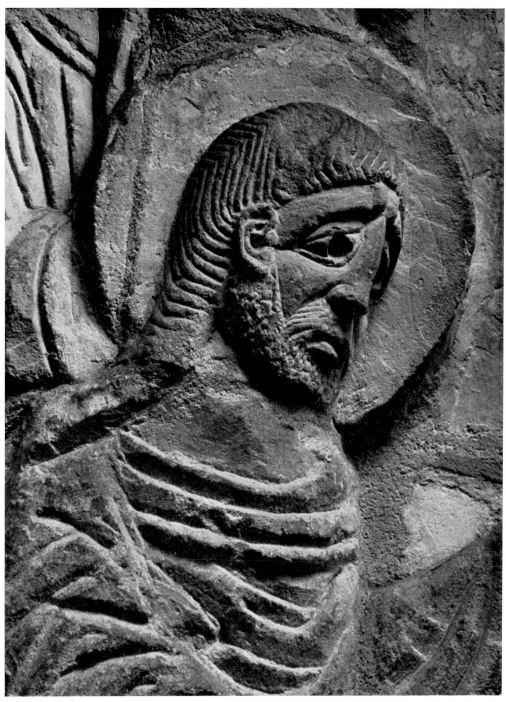

Detail of a head from stone panel. Chichester Cathedral, Sussex.
Second quarter of the twelfth century

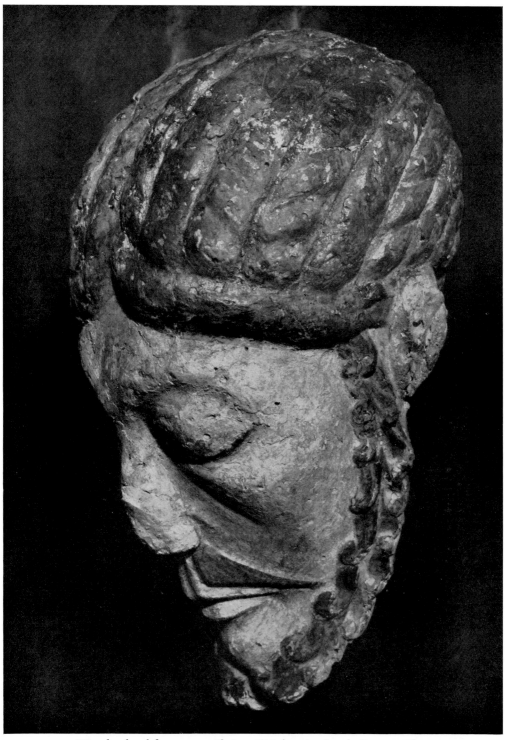

Wooden head from a crucifixion. Height 6 in. South Cerney, Glos.
Second quarter of the twelfth century

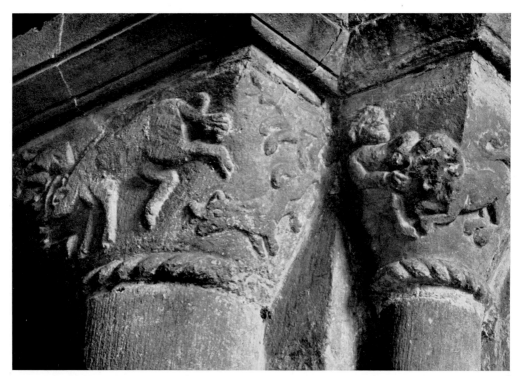

(A) Stone capital. Castor, Northants. *c.* 1124

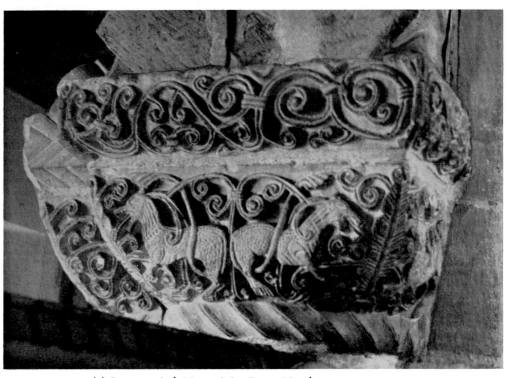

(B) Stone capital. Nave, Saint Peter, Northampton. *c.* 1145–55

44

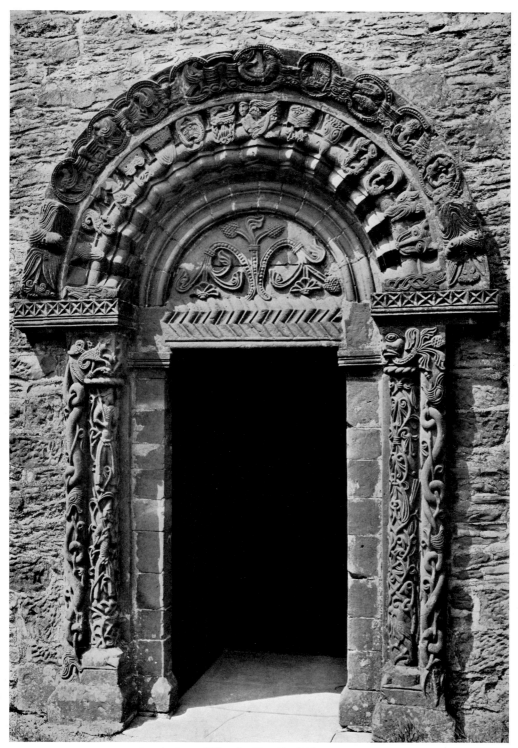

South door. Kilpeck, Herefordshire. c. 1145–50

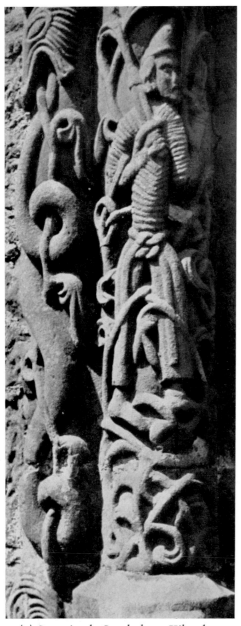 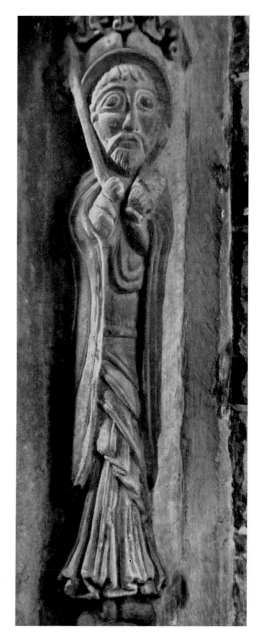

(A) Stone jamb. South door, Kilpeck,
Herefordshire. *c.* 1145–50

(B) Stone jamb. Chancel arch, Kilpeck,
Herefordshire. *c.* 1145–50

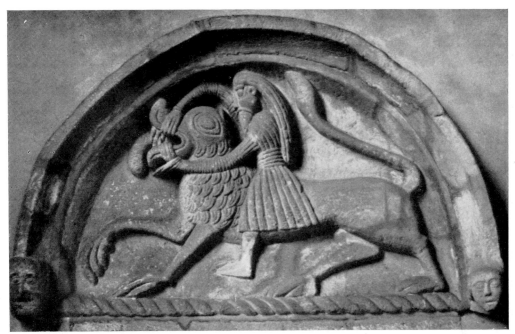

(A) Stone tympanum. Stretton Sugwas, Herefordshire. *c.* 1140–50

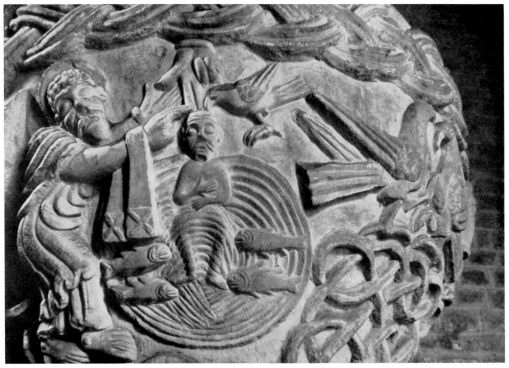

(B) Stone font. Castle Frome, Herefordshire. *c.* 1140–50

47

(A) Stone capital. West door, Leominster, Herefordshire. *c*.1145

(B) Stone font. Eardisley, Herefordshire. *c*.1150–5

(A) Stone capital, probably from cloister. Norwich Cathedral,
Norfolk. *c.* 1140

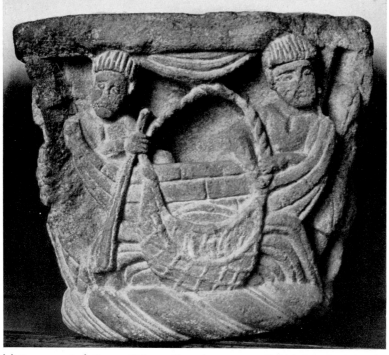

(B) Stone capital. Lewes Priory, Sussex. *c.*1140–5. *British Museum, London*

49

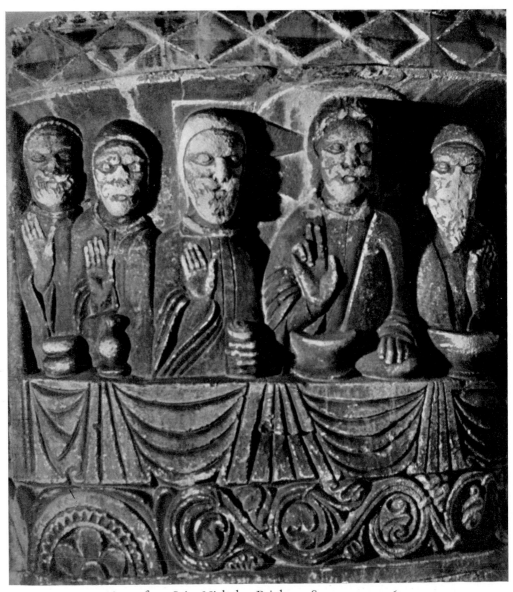

Stone font. Saint Nicholas, Brighton, Sussex. *c.* 1150–60

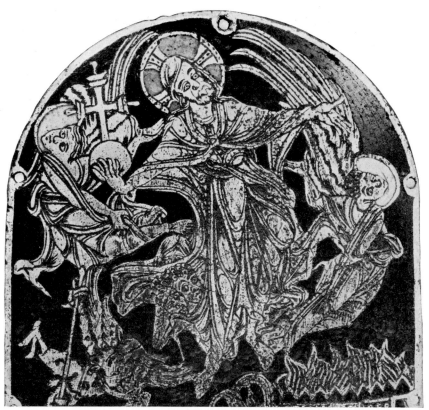

(A) The Masters Plaque, enamelled copper. Width *c.* 3½ in. Third quarter of the twelfth century. *Victoria and Albert Museum, London*

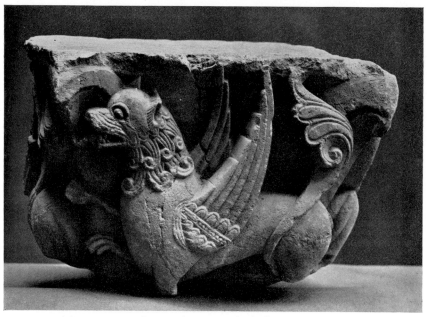

(B) Stone capital. Winchester Cathedral, Hants. *c.* 1145–50

(A) and (B) Stone frieze. West front, Lincoln Cathedral. c. 1141–50

52

Stone frieze. West front, Lincoln Cathedral. c. 1141–50

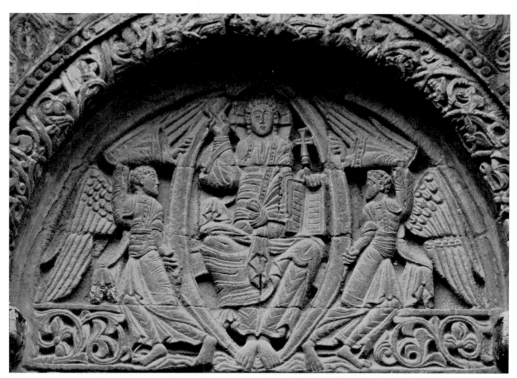

(A) Stone tympanum. Prior's Door, Ely Cathedral, Cambs. *c.* 1140

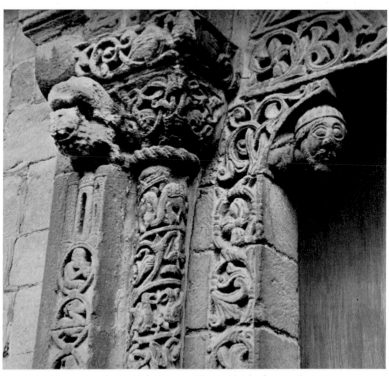

(B) Stone jamb. Prior's Door, Ely Cathedral, Cambs. *c.* 1140

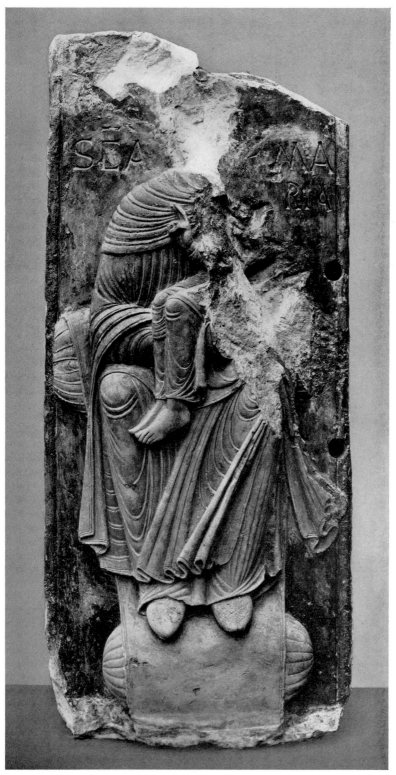

Stone relief. Height *c.* 3 ft. 6 in. York Minster. *c.* 1145–55

55

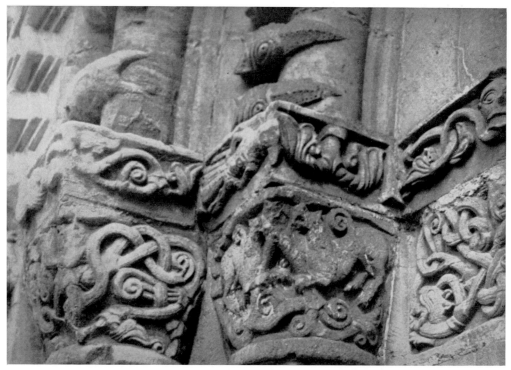

(A) Stone capitals. South door, Healaugh, Yorks, w.r. *c.* 1150–60

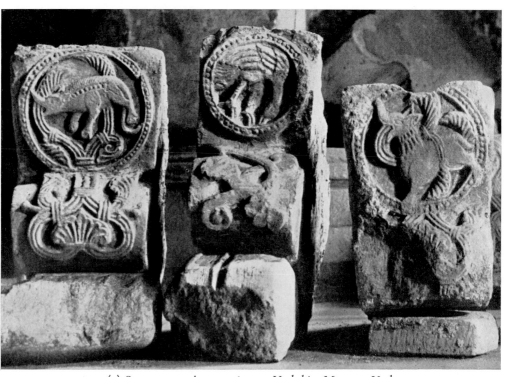

(B) Stone voussoirs. *c.* 1160–70. *Yorkshire Museum, York*

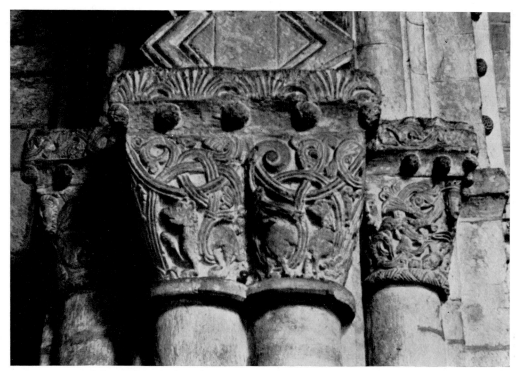

(A) Stone capitals. Chancel arch, Brayton, Yorks, W.R. *c.* 1155–65

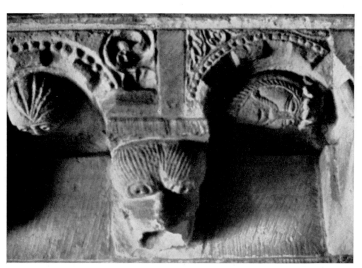

(B) Corbel table. Barton-le-Street, Yorks, N.R. *c.* 1160–70

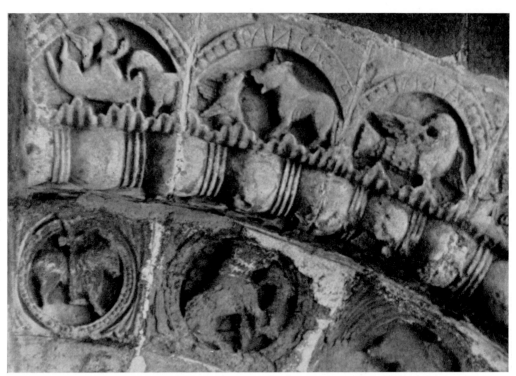

(A) Stone voussoirs. South door, Alne, Yorks, N.R. *c.* 1160–70

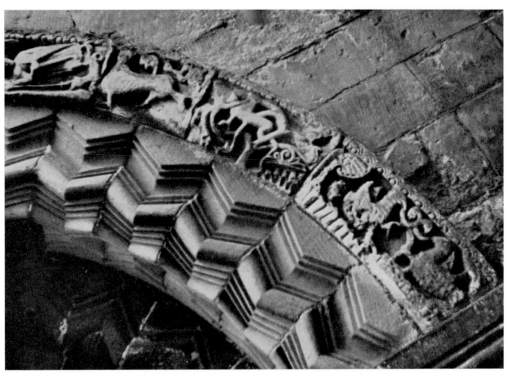

(B) Stone voussoirs. Originally on south door. Barton-le-Street, Yorks, N.R. *c.* 1160–70

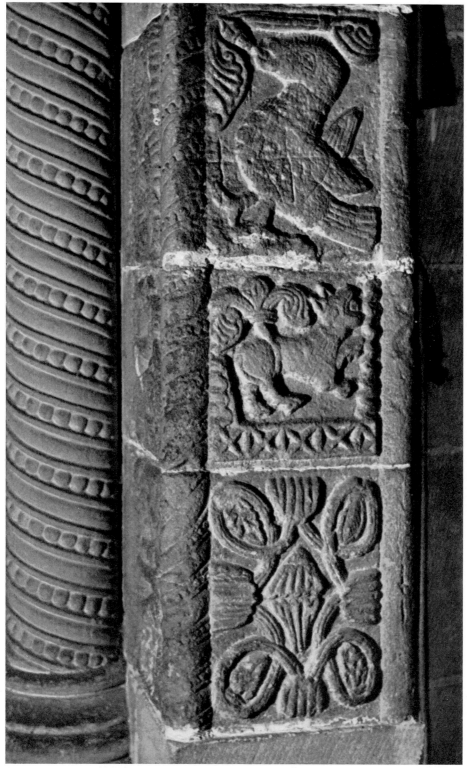

Stone door jamb. Barton-le-Street, Yorks, N.R. *c.* 1160–70

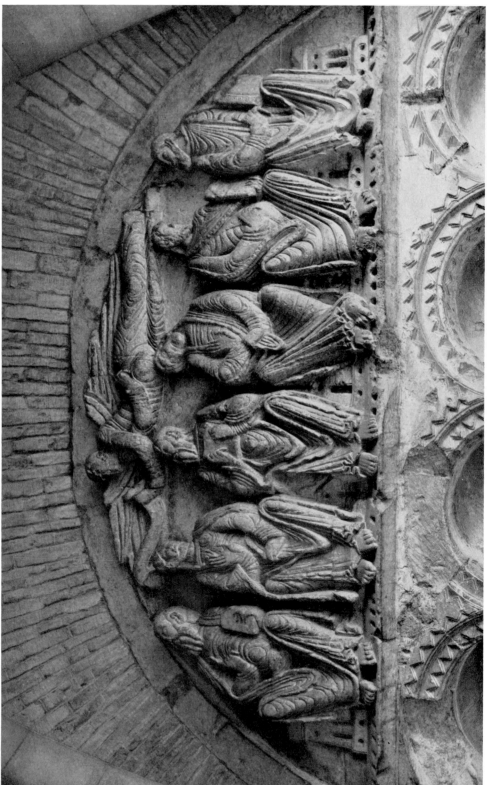

Stone tympanum. Under south porch, Malmesbury Abbey, Wilts. c. 1155–65

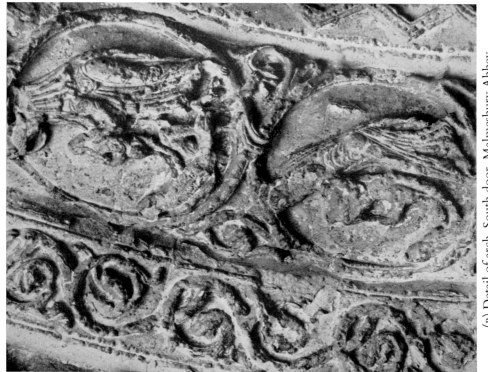

(B) Detail of arch. South door, Malmesbury Abbey, Wilts. c. 1155–65

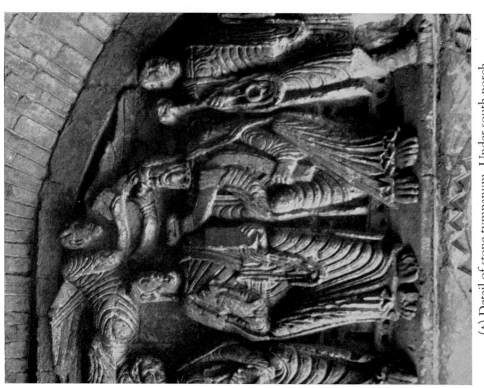

(A) Detail of stone tympanum. Under south porch, Malmesbury Abbey, Wilts. c. 1155–65

Ivory crozier. Mid twelfth century. *Victoria and Albert Museum, London*

Doorway. Durham Castle, Co. Durham. *c.* 1175–85

Stone panel. Probably from the screen, Durham Cathedral.
Third quarter of the twelfth century

(A) Stone tympanum. West door, Rochester Cathedral, Kent. *c.* 1150–5

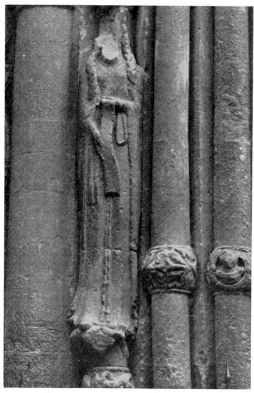

(B) Stone pillar-statue. West door,
Rochester Cathedral, Kent. *c.* 1150–5

65

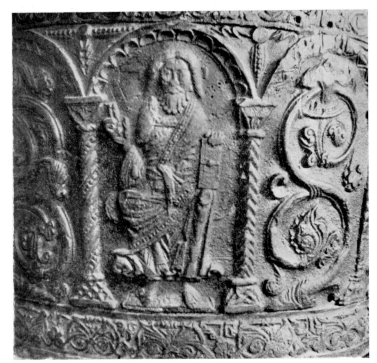

(A) Lead font. Sandhurst, Glos. Mid twelfth century

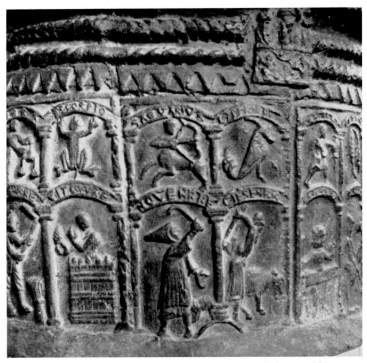

(B) Lead font. Brookland, Kent. Third quarter of the twelfth century

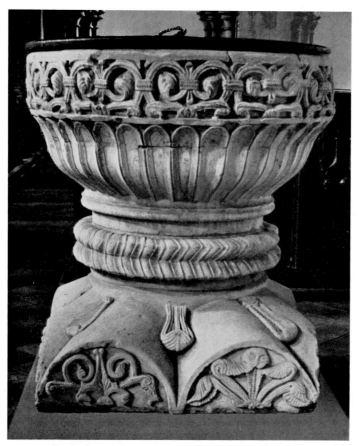

(A) Stone font. Aylesbury, Bucks. *c*.1170–80

(B) Stone font. Landrake, Cornwall. Last quarter of the twelfth century

67

Tournai marble font. Winchester Cathedral, Hants. c. 1160–70

(B) Stone washing fountain. Much Wenlock, Salop. Last quarter of the twelfth century

(A) Stone font. Southrop, Glos. Last quarter of the twelfth century

69

(A) Detail of stone jamb. Tower arch, Iffley, Oxon. *c.* 1175–82

(B) The Warwick Ciborium, copper with *champlevé* enamel. *c.* 1180–90.
Victoria and Albert Museum, London

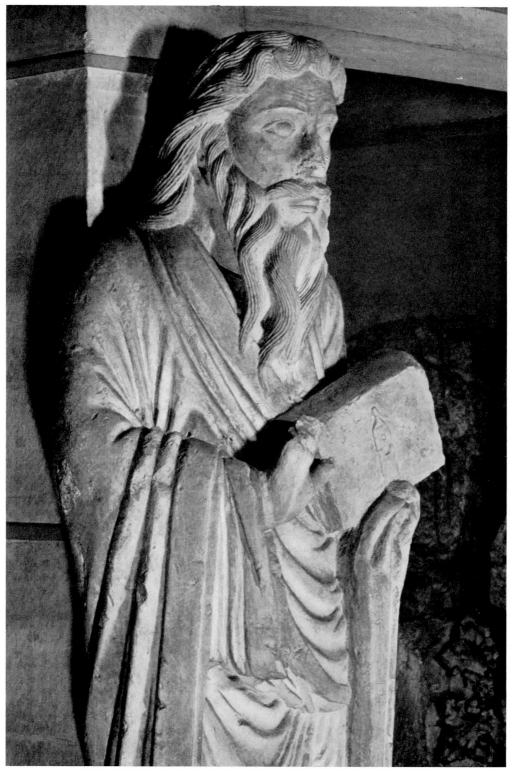

Stone figure of Moses. Saint Mary's Abbey, York. *c.* 1200–10. *Yorkshire Museum, York*

Stone figure of Saint John. Saint Mary's Abbey, York. *c.* 1200–10.
Yorkshire Museum, York

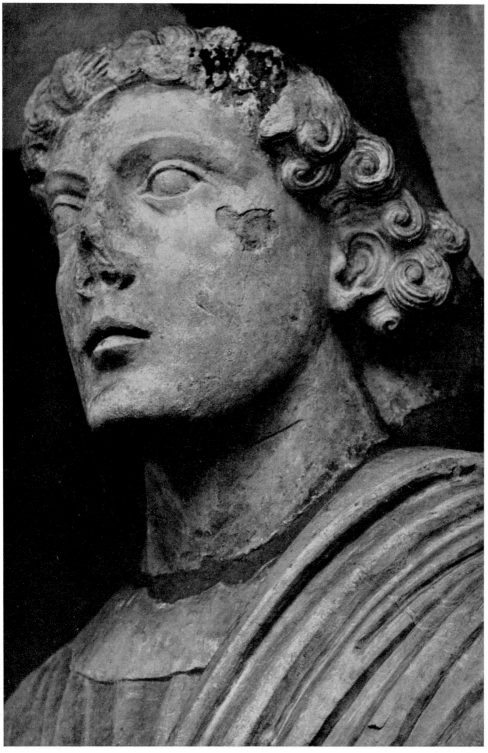

Head of stone figure of Saint John. Saint Mary's Abbey, York. *c.* 1200–10 (see plate 72).
Yorkshire Museum, York

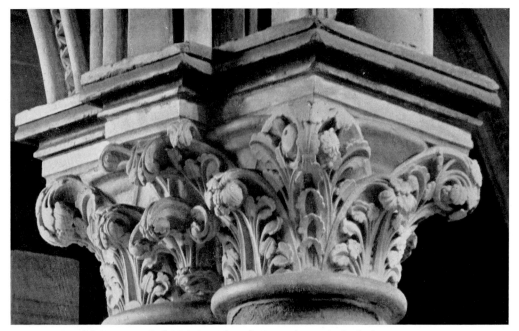

(A) Stone capital. Trinity Chapel, Canterbury Cathedral, Kent. 1182

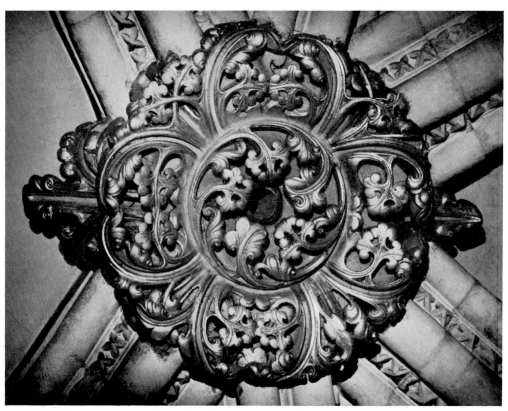

(B) Stone boss. High vault of crossing, Canterbury Cathedral, Kent. *c.* 1184

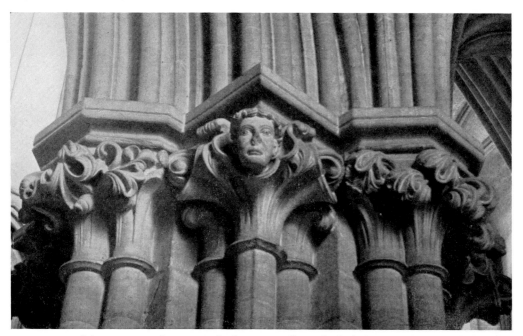

(A) Stone capitals. East end of nave, Wells Cathedral, Som. *c.*1200–10

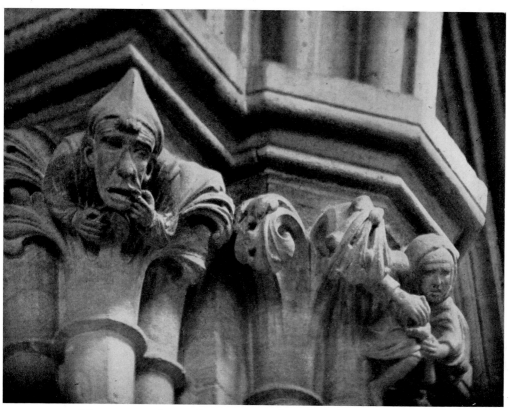

(B) Stone capitals. South transept, Wells Cathedral, Som. *c.*1200–10

75

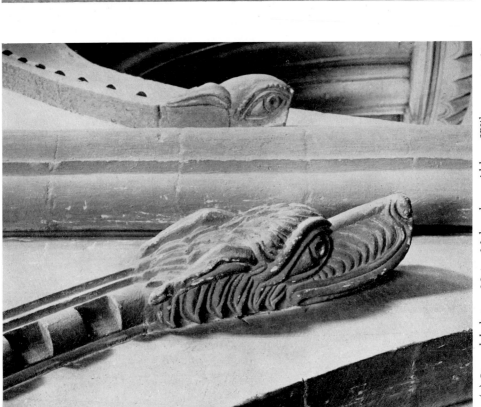

(B) Stone corbel. Wells Cathedral, Som. c. 1200–10

(A) Stone label stop. Nave, Malmesbury Abbey, Wilts. c. 1155–65

(B) Stone arch. North door of Lady Chapel, Glastonbury, Som. c. 1220–30

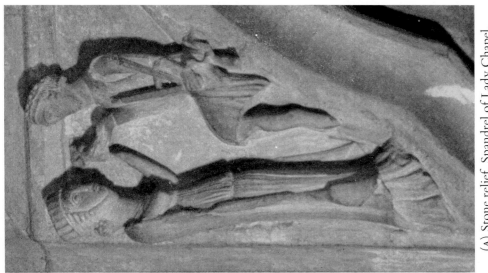

(A) Stone relief. Spandrel of Lady Chapel, Worcester Cathedral. c. 1225–30

77

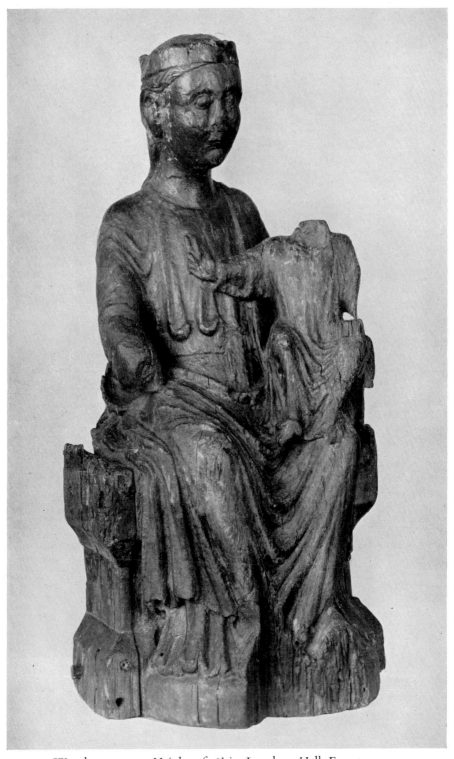

Wooden statuette. Height 1 ft 6½ in. Langham Hall, Essex. *c.* 1200.
Victoria and Albert Museum, London

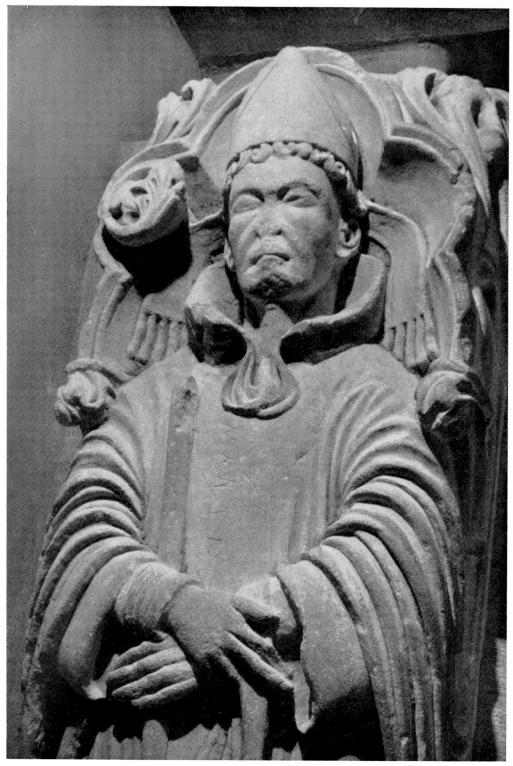

Stone effigy of Bishop Levericus. Wells Cathedral, Som. *c.* 1200–10

79

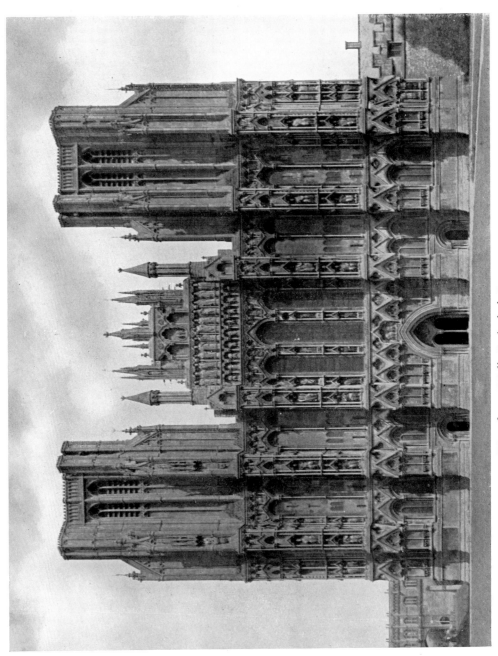

West front, Wells Cathedral, Som. c. 1230–55

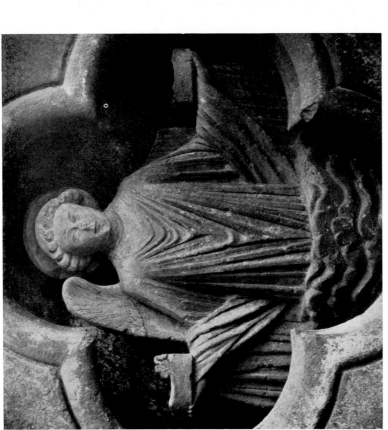

(A) and (B) Details of west front. Wells Cathedral, Som. c. 1230-40

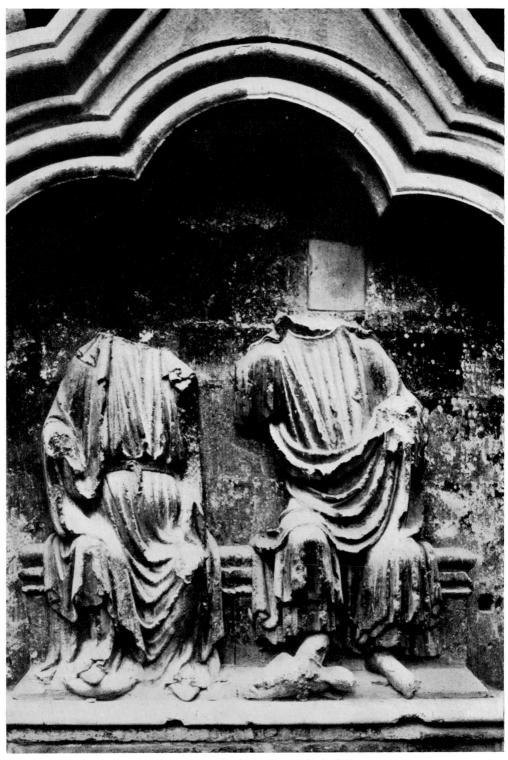

Stone tympanum. West front, Wells Cathedral, Som. *c.* 1230–5

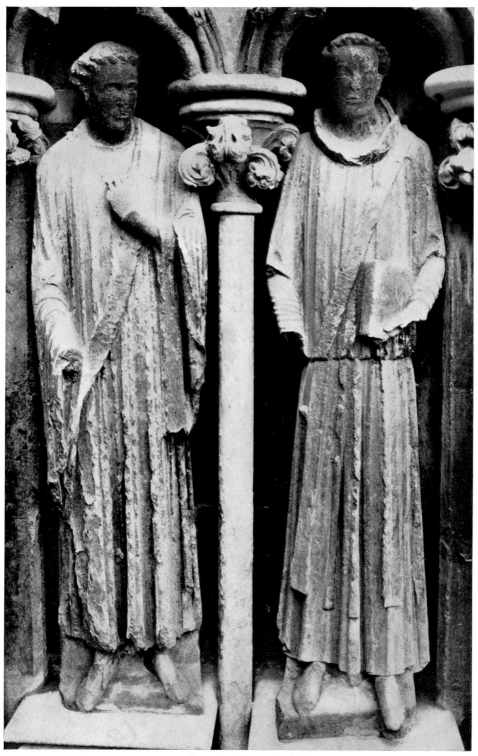

Stone statues. West front, Wells Cathedral, Som. *c.* 1230–5

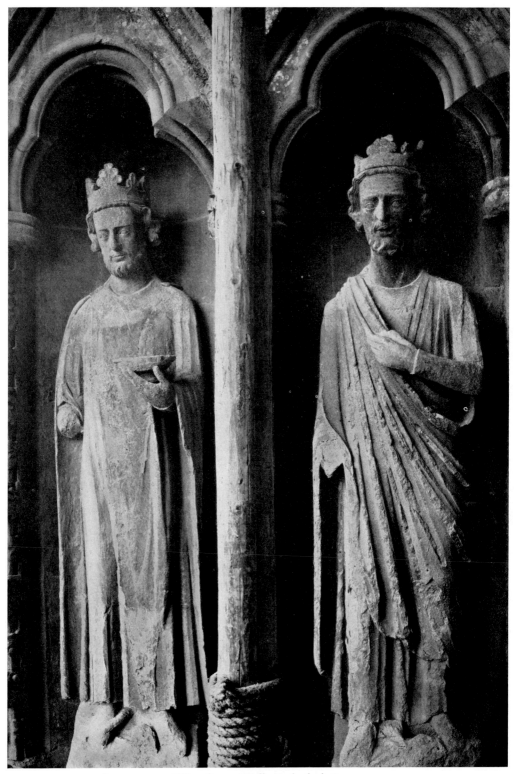

Stone statues. West front, Wells Cathedral, Som. *c.* 1230–40

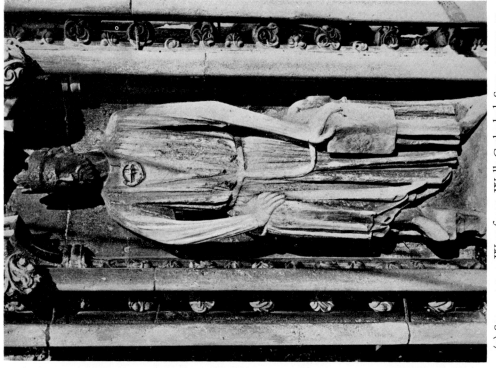

(B) Stone statue. West front, Wells Cathedral, Som. *c.* 1240–50

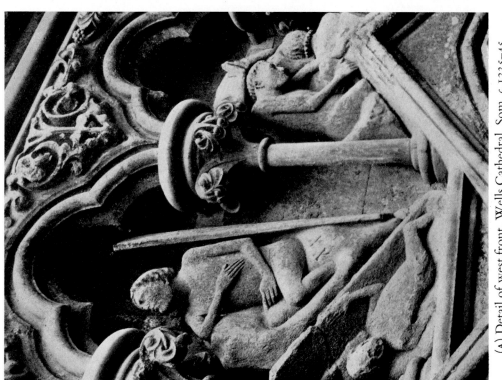

(A) Detail of west front. Wells Cathedral, Som. *c.* 1235–45

85

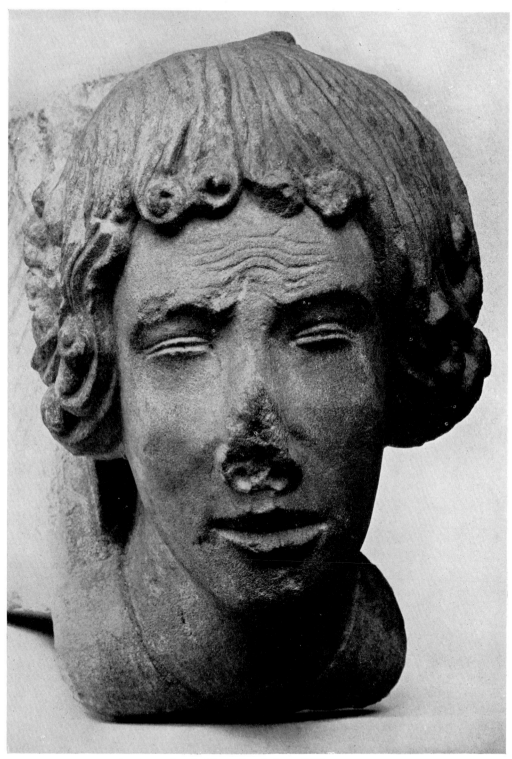

Stone head. Clarendon Palace, Wilts. *c.* 1240

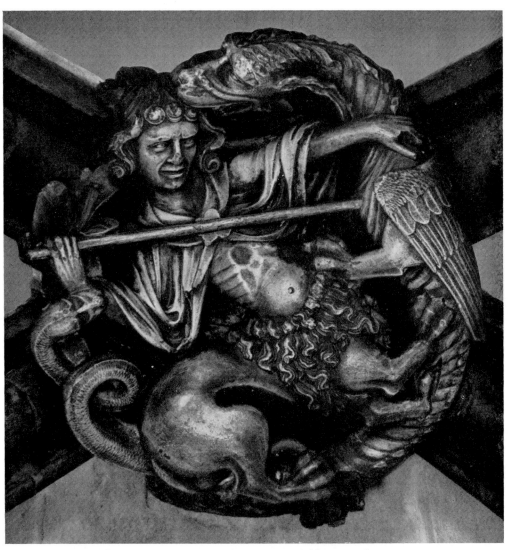

Stone boss. Muniment room, Westminster Abbey, London. *c.* 1250–8

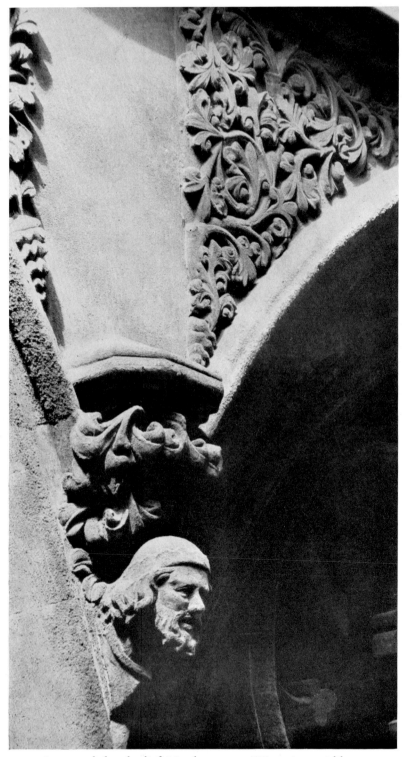

Stone corbel and relief. North transept, Westminster Abbey,
London. *c.* 1250–5

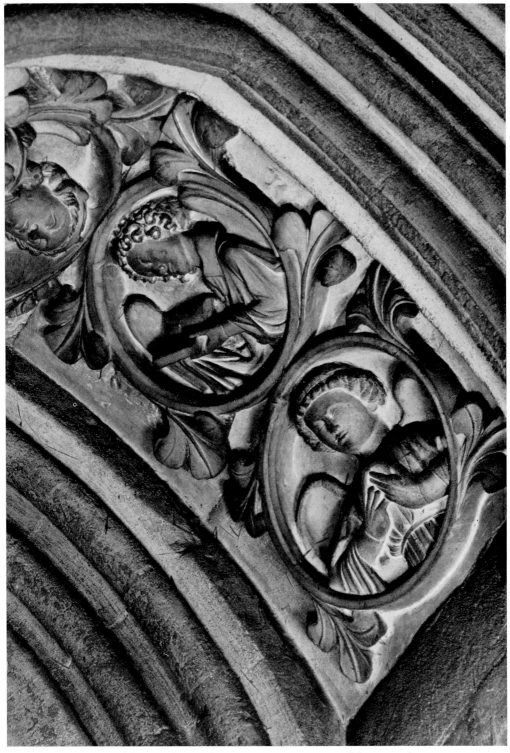

Stone relief. Window soffit, north transept, Westminster Abbey, London. *c.* 1254–8

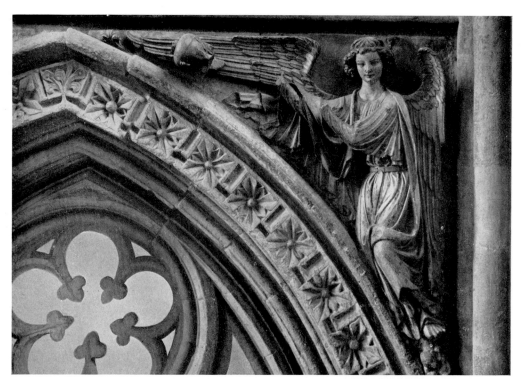

(A) Stone relief. East spandrel, south transept, Westminster Abbey, London. *c.* 1254–8

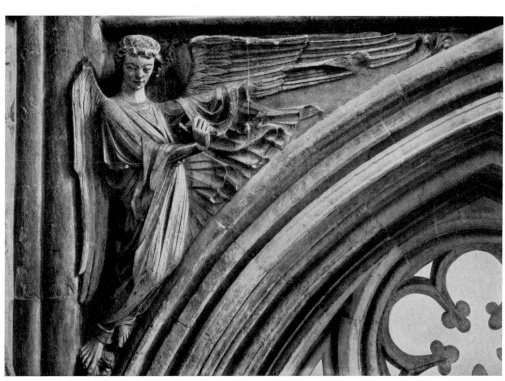

(B) Stone relief. West spandrel, south transept, Westminster Abbey, London. *c.* 1254–8

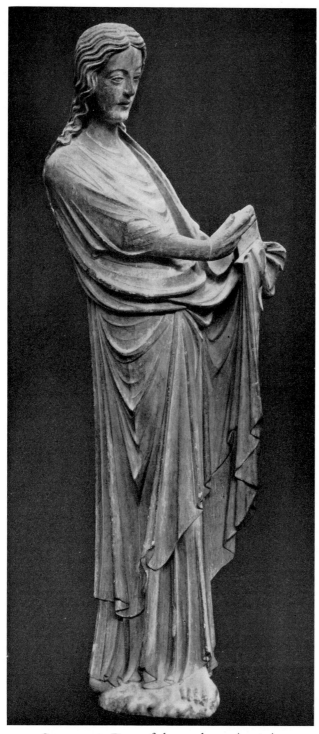

Stone statue. Door of chapter-house (*ex situ*),
Westminster Abbey, London. *c.* 1253

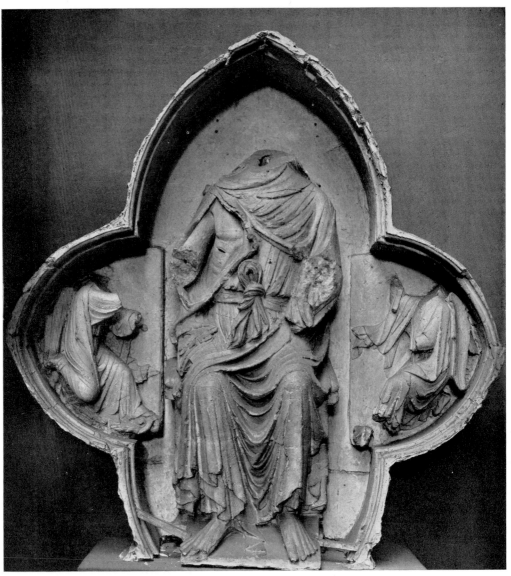

Stone tympanum (*from a cast*). Judgement Porch, Lincoln Cathedral. *c.* 1260–5

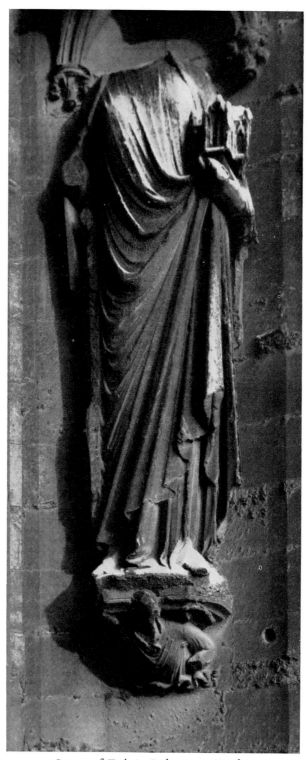

Statue of *Ecclesia*. Judgement Porch,
Lincoln Cathedral. *c.* 1260–5

99

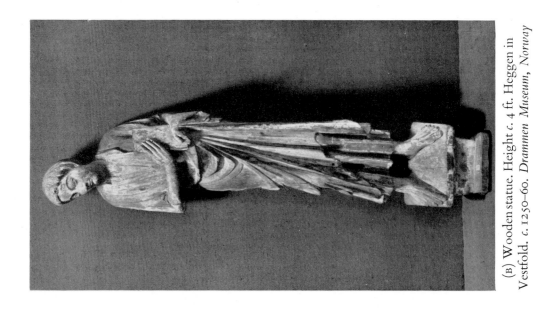

(B) Wooden statue. Height *c.* 4 ft. Heggen in Vestfold. *c.* 1250–60. *Drammen Museum, Norway*

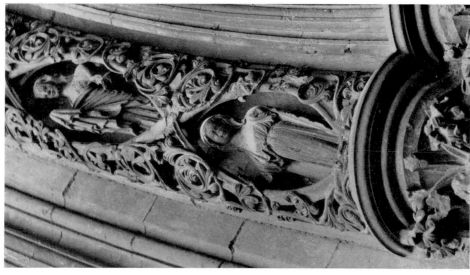

(A) Details of sculpture. Judgement Porch, Lincoln Cathedral. *c.* 1260–5

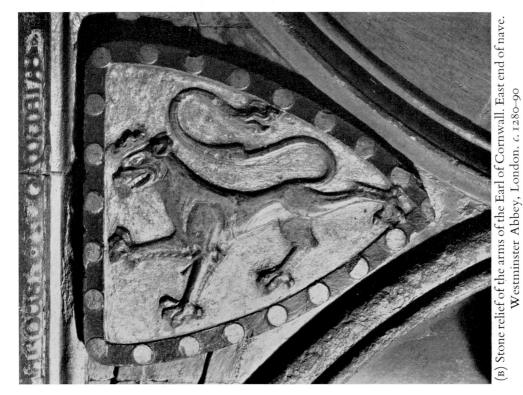

(B) Stone relief of the arms of the Earl of Cornwall. East end of nave. Westminster Abbey, London. *c.* 1280–90

(A) Stone relief. Chapter-house, Salisbury Cathedral, Wilts. *c.* 1272–80

Stone relief. Angel choir, Lincoln Cathedral. c. 1270–80

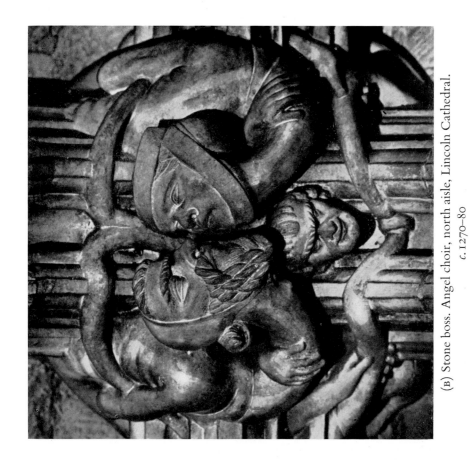

(B) Stone boss. Angel choir, north aisle, Lincoln Cathedral. *c*. 1270–80

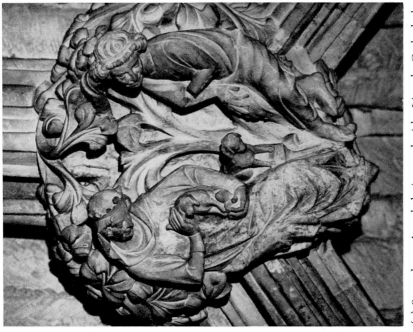

(A) Stone boss. Angel choir, south aisle, Lincoln Cathedral. *c*. 1270–80

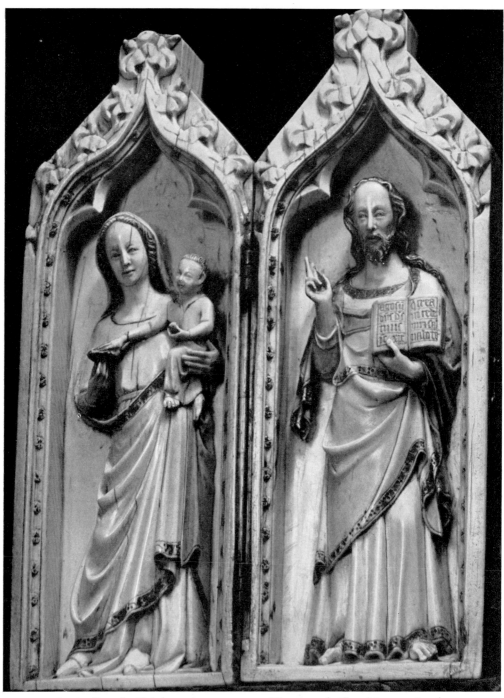

Ivory diptych. Height 8½ in. *c*. 1305–15. *Victoria and Albert Museum, London*

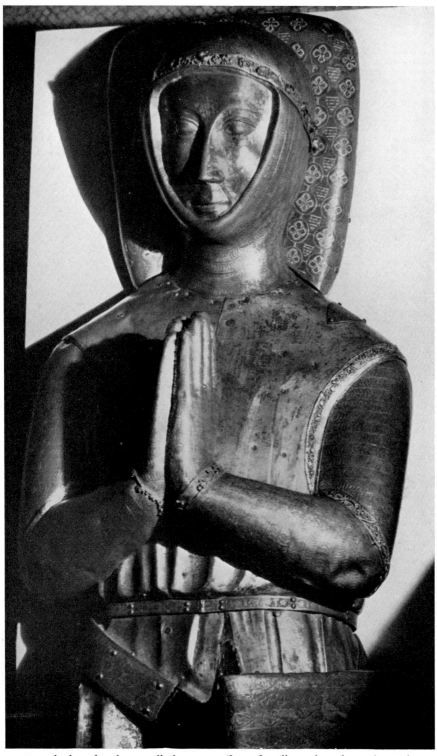

French chased and enamelled copper effigy of William de Valence (*ex situ*).
Westminster Abbey, London. *c.* 1290–1300

(A) Stone capital. Passage, Southwell Minster, Notts.
c. 1290–5

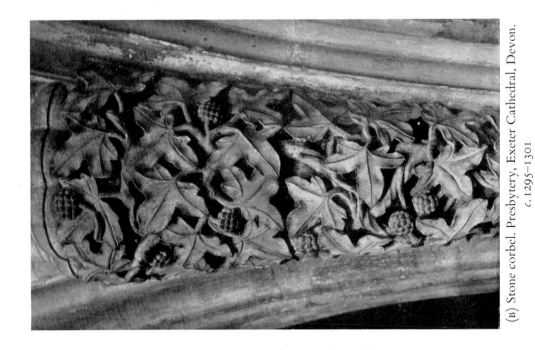

(B) Stone corbel. Presbytery, Exeter Cathedral, Devon.
c. 1295–1301

(B) Spandrel of wooden stalls, by William Lyngwode.
Choir, Winchester Cathedral, Hants. 1308–9

(A) Wooden boss. Cloister, Lincoln Cathedral.
c. 1297–1300

Head of bronze effigy of Queen Eleanor of Castile, by William Torel.
Westminster Abbey, London. 1291–3 (*see* Plate 109A)

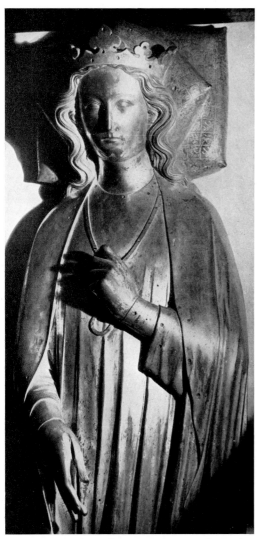

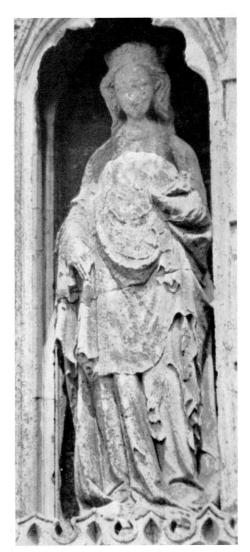

(A) Bronze effigy of Queen Eleanor of Castile, by William Torel (*ex situ*). Westminster Abbey, London. 1291–3

(B) Stone statue of Queen Eleanor of Castile, by William of Ireland. Hardingstone, Northants. 1291–2

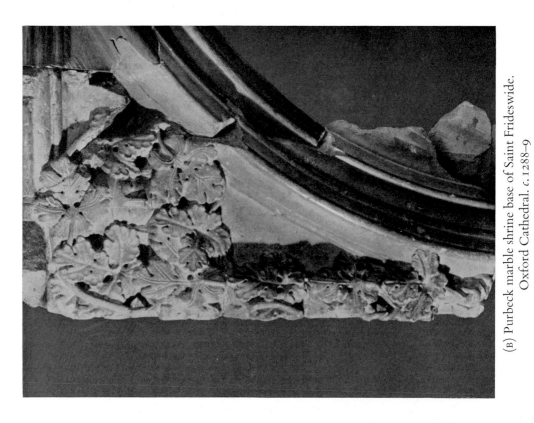

(B) Purbeck marble shrine base of Saint Frideswide. Oxford Cathedral. *c.* 1288–9

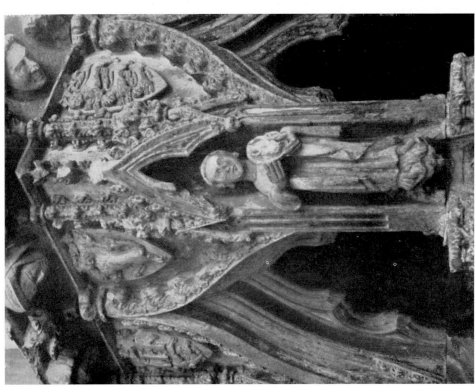

(A) Purbeck marble shrine base of Saint Edberg. Bicester Priory, Oxon. *c.* 1305–11. *Stanton Harcourt, Oxon*

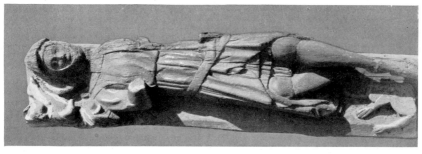

(c) Wooden effigy. Burgh-
field, Berks. *c.* 1305–10

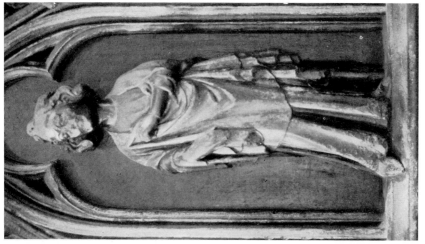

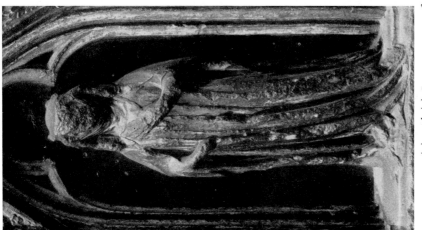

(A) and (B) Stone weepers from tomb of Edmund Crouchback.
Westminster Abbey, London. *c.* 1295–1300

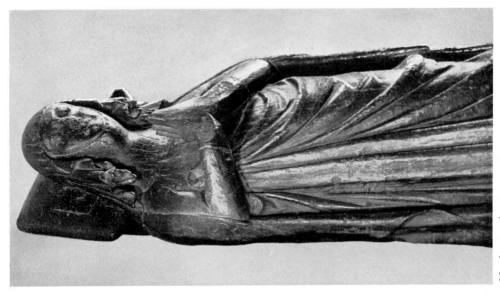

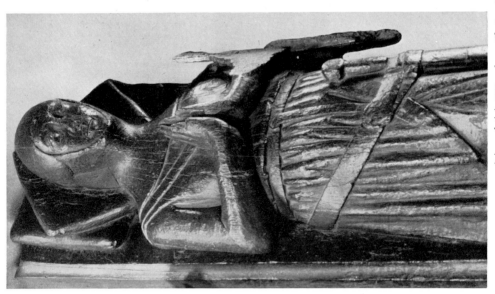

(A) and (B) Wooden effigies. Woodford, Northants. c. 1280–90

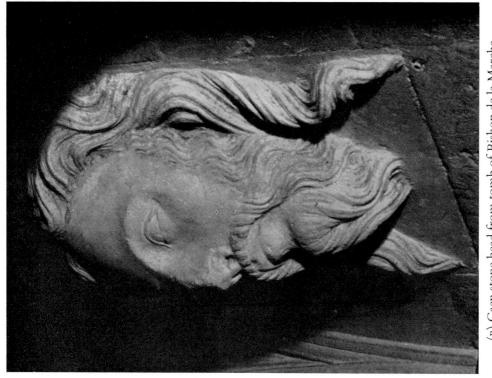

(B) Caen stone head from tomb of Bishop de la Marche. Height 1 ft 6 in. Wells Cathedral, Som. c. 1305–10

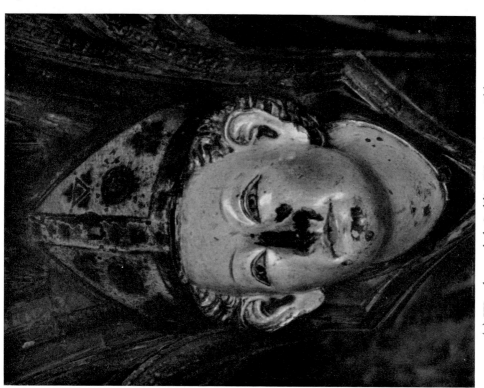

(A) Wooden corbel. Sedilia, Westminster Abbey, London. c. 1308

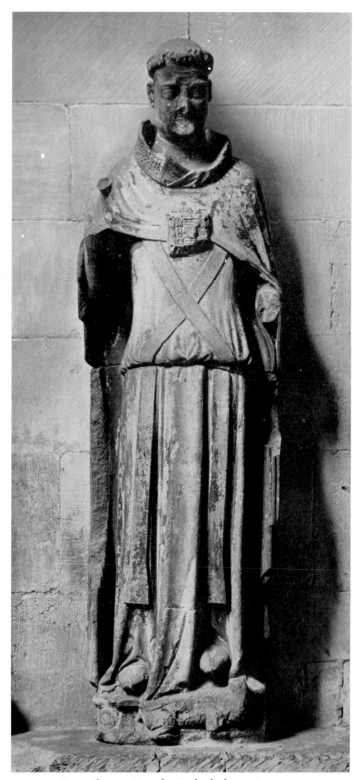

Stone figure. Lincoln Cathedral. *c.* 1280–1300

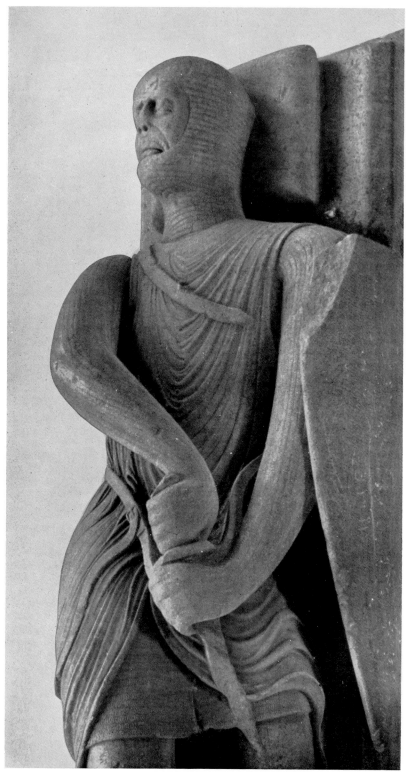

Stone effigy. Dorchester, Oxon. *c*. 1295–1305

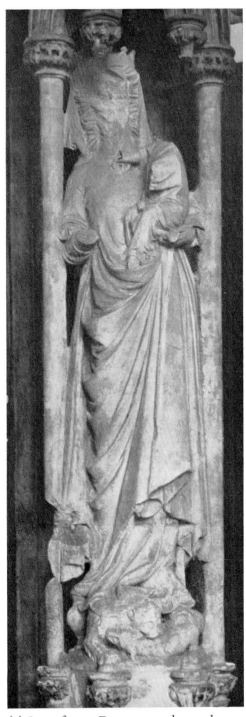 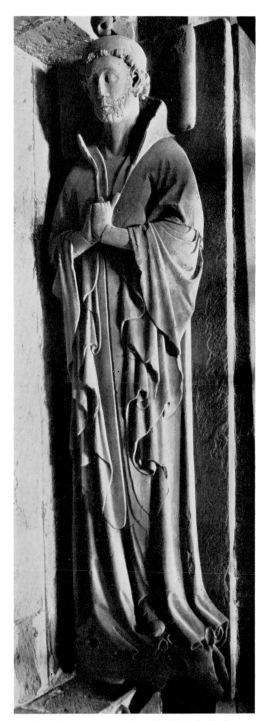

(A) Stone figure. Doorway to chapter-house, York Minster. *c.* 1300–8

(B) Stone effigy. Hereford Cathedral. *c.* 1310

(B) Stone effigy of Lady Fitzalan. Bedale, Yorks, N.R. *c.* 1300–10

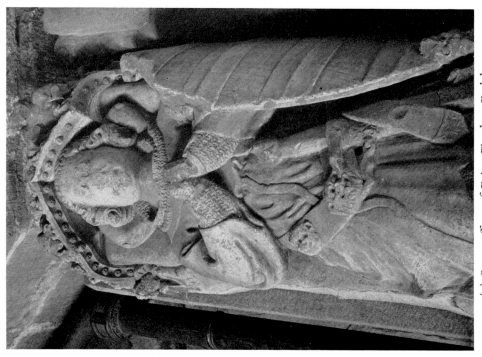

(A) Stone effigy of Brian Fitzalan. Bedale, Yorks, N.R. *c.* 1300–10

117

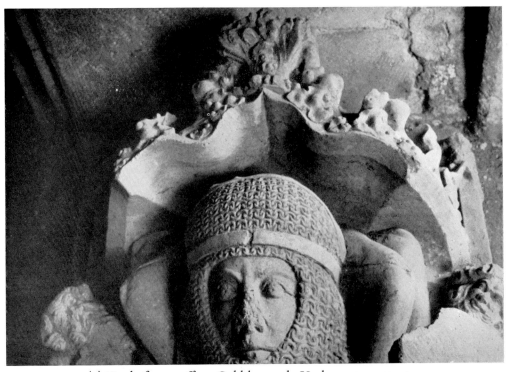

(A) Head of stone effigy. Goldsborough, Yorks, W.R. *c.* 1320–30

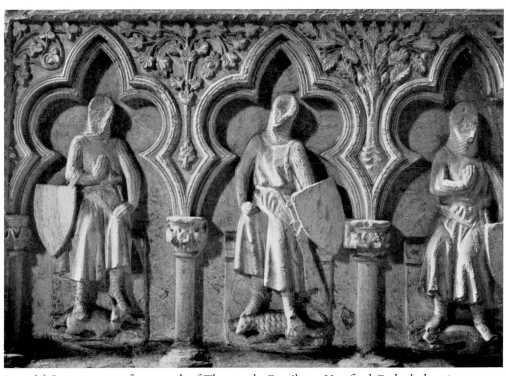

(B) Stone weepers from tomb of Thomas de Cantilupe. Hereford Cathedral. 1282–4

118

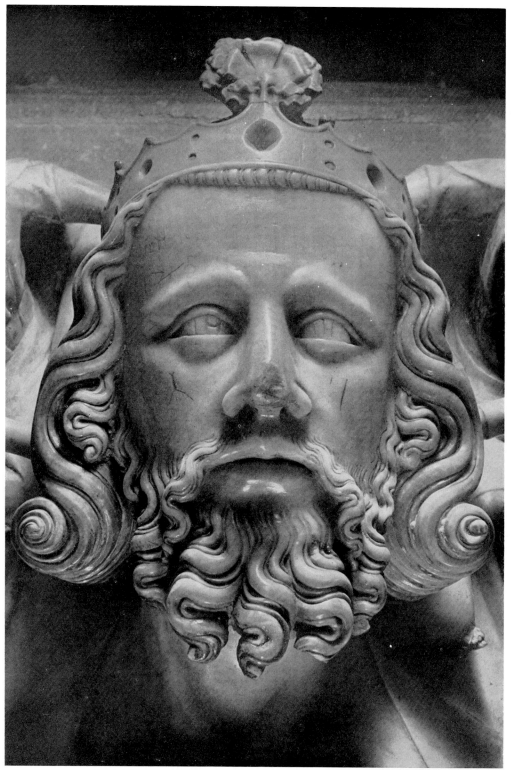

Head of alabaster effigy of Edward II. Gloucester Cathedral. *c.* 1330–5

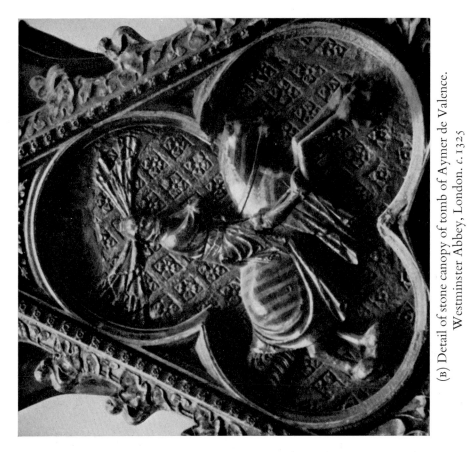

(B) Detail of stone canopy of tomb of Aymer de Valence.
Westminster Abbey, London. *c.* 1325

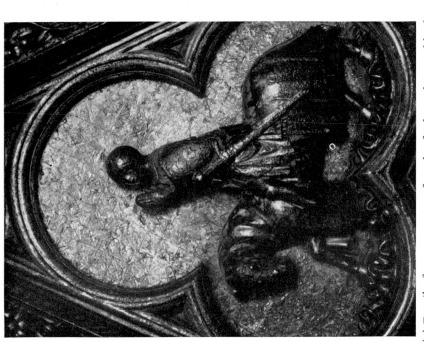

(A) Detail of stone canopy of tomb of Edmund Crouchback.
Westminster Abbey, London. *c.* 1295–1300

Stone effigy. Aldworth, Berks. c. 1320–30

(B) Stone weeper from tomb of Aymer de Valence. Westminster Abbey, London. *c.* 1325

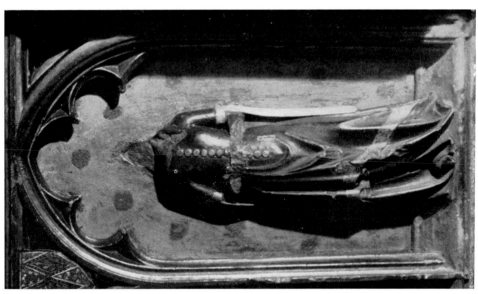

(A) Stone weeper from tomb of Lady Elizabeth Montagu. Oxford Cathedral. *c.* 1348–50

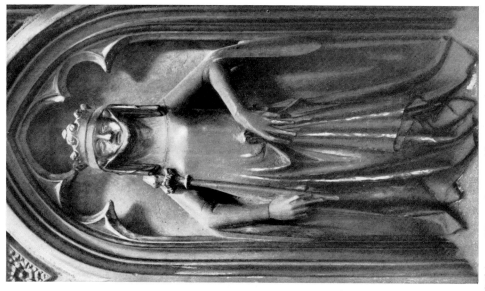

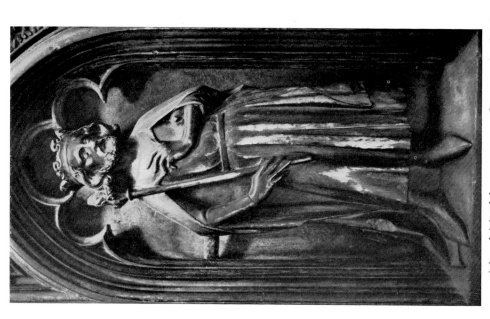

(A) and (B) Alabaster weepers from tomb of John of Eltham. Westminster Abbey, London. *c.* 1340

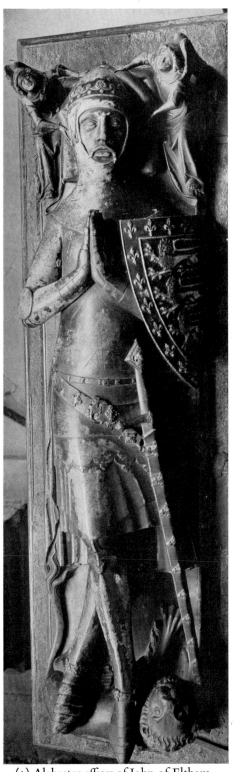 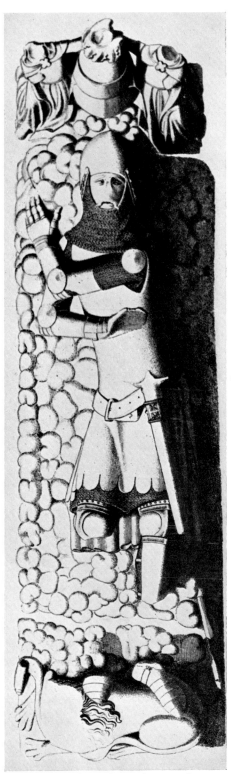

(A) Alabaster effigy of John of Eltham.
Westminster Abbey, London. *c.*1340

(B) Stone effigy of Sir Oliver Ingham.
Ingham, Norfolk. *c.*1340

Stone Easter Sepulchre. Hawton, Notts. *c.* 1330

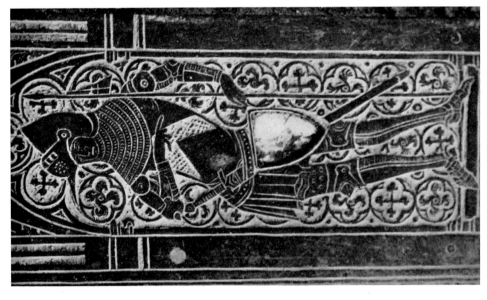

(A) and (B) Details from the brass of Sir Hugh Hastings. Elsing, Norfolk. *c.* 1347–8

126

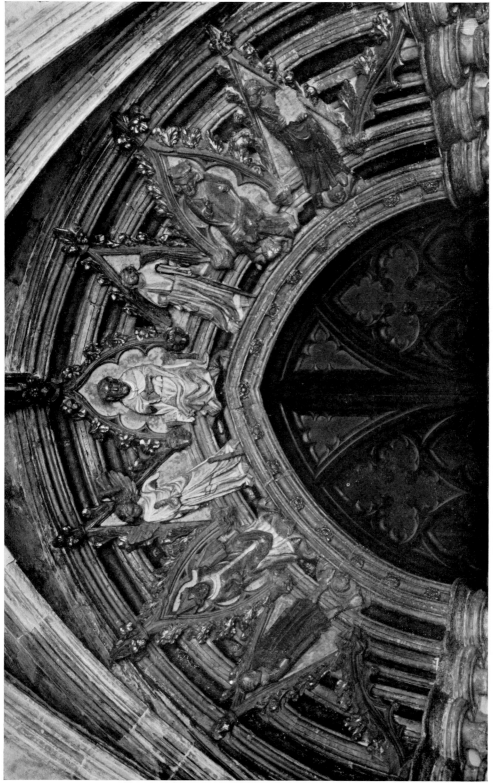

Prior's Door. Cloister, Norwich Cathedral, Norfolk. c. 1310

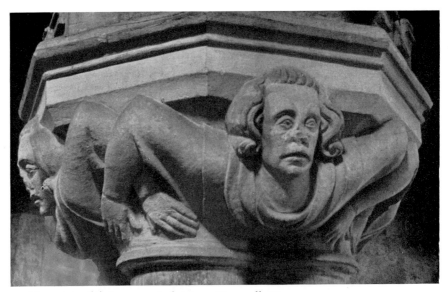

(A) Stone capital. Nave, Hanwell, Oxon. *c.* 1330-40

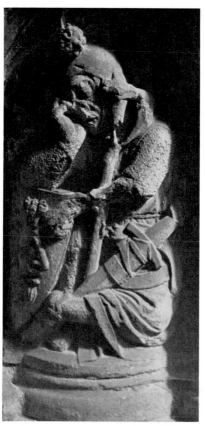

(B) Stone base of Easter Sepulchre.
Hawton, Notts. *c.* 1330

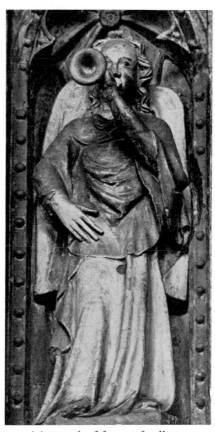

(C) Detail of front of gallery.
Exeter Cathedral, Devon. *c.* 1330–40

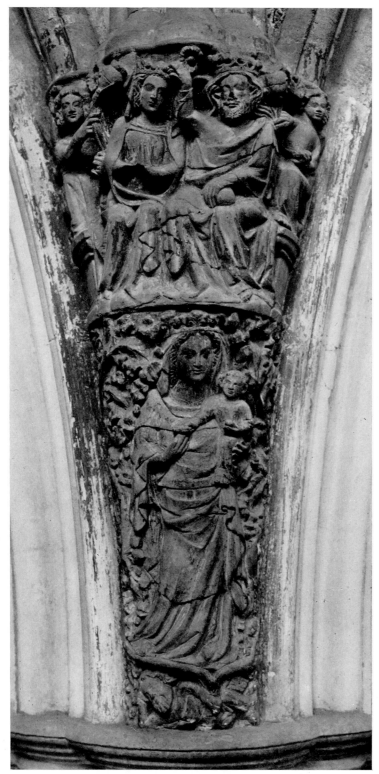

Stone corbel. Nave, Exeter Cathedral, Devon. *c.*1330–40

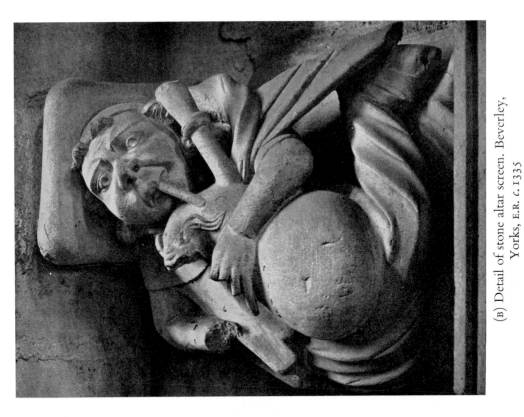

(B) Detail of stone altar screen. Beverley, Yorks, E.R. c. 1335

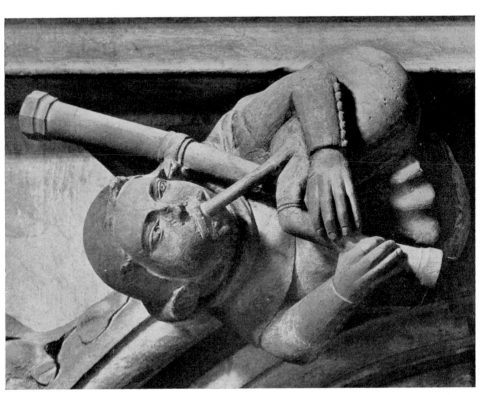

(A) Stone label stop (partly restored). North aisle arcade of nave, Beverley, Yorks, E.R. c. 1320–30

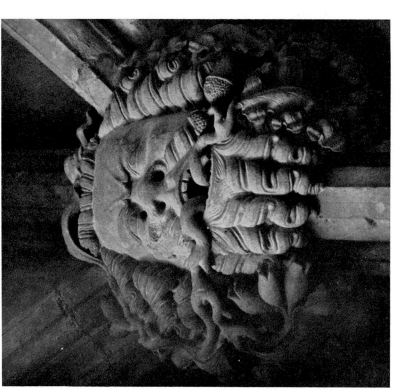

(A) and (B) Bosses of stone altar screen. Beverley, Yorks, E.R. c. 1335

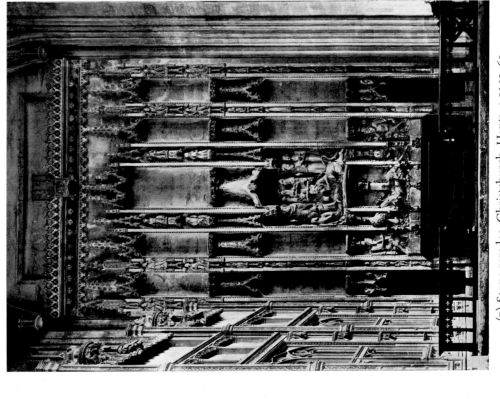

(B) Stone reredos. Christchurch, Hants. *c.* 1350–60

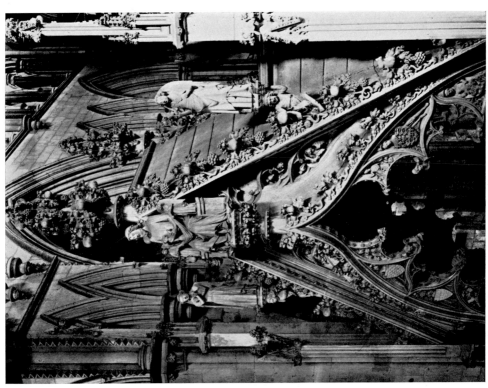

(A) Percy tomb. Beverley, Yorks, E.R. *c.* 1342–5

132

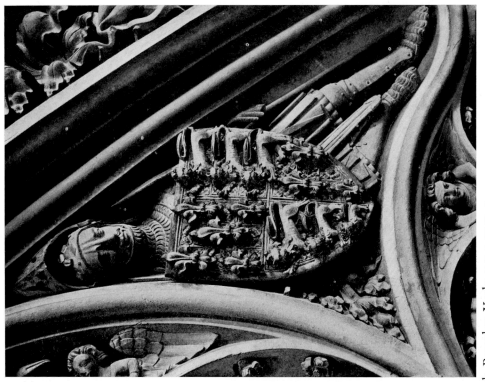

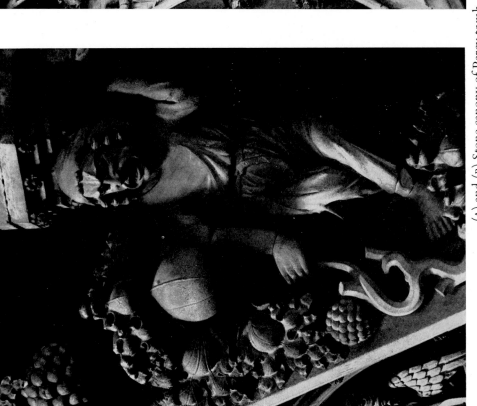

(A) and (B) Stone canopy of Percy tomb. Beverley, Yorks, E.R. c. 1342–5

133

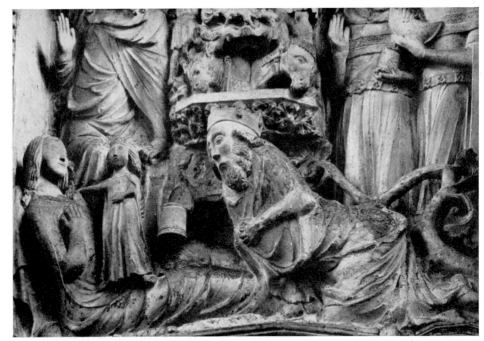

(A) Detail of stone reredos. Christchurch, Hants. *c.* 1350–60 (see Plate 132B)

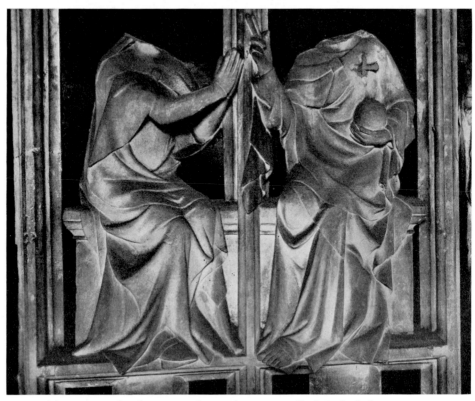

(B) Stone tomb of Peter, Lord Grandisson. Hereford Cathedral. *c.* 1345–55

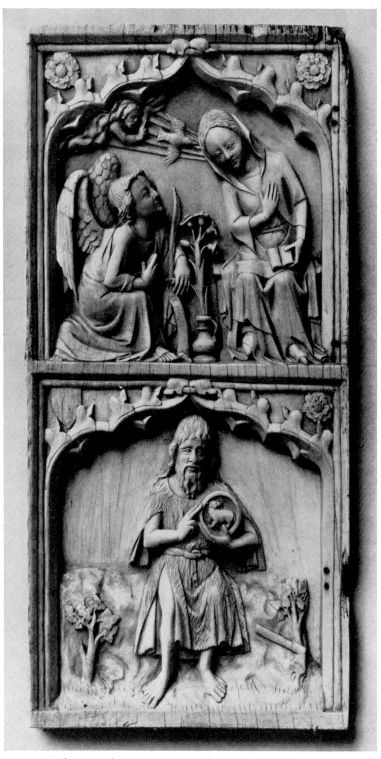

The Grandisson Ivory. Height *c.* 10½ in. *c.* 1335–45
British Museum, London

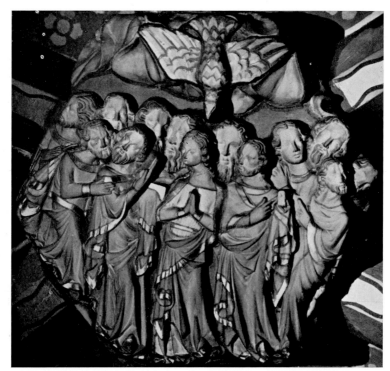

(A) Stone boss. Nave, Tewkesbury Abbey, Glos. *c.* 1345–55

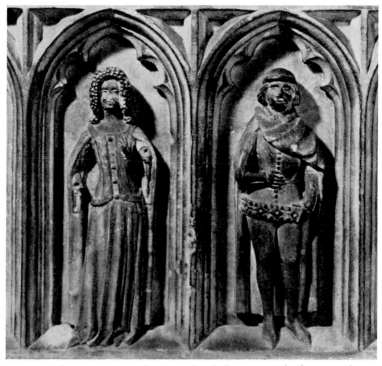

(B) Alabaster weepers from tomb of Thomas, Earl of Warwick.
Saint Mary, Warwick. *c.* 1375–80

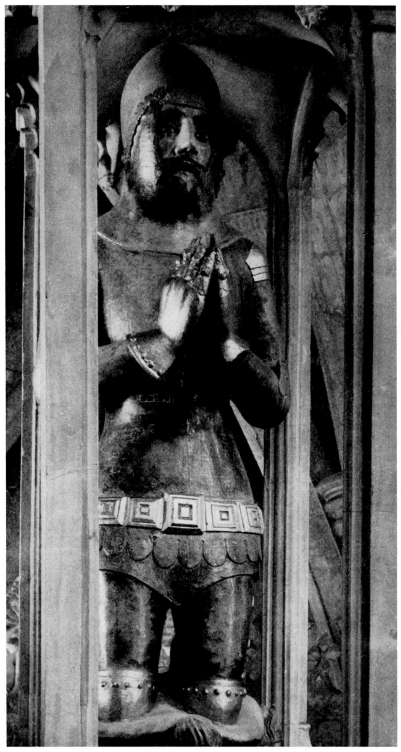

Stone effigy of Edward, Lord Despencer. Roof of chantry,
Tewkesbury Abbey, Glos. *c.* 1370–5

137

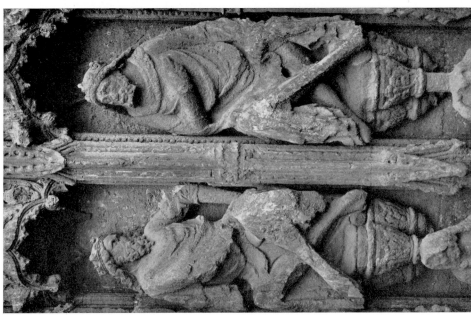

(A) Stone statues. West front, Exeter Cathedral, Devon. *c.* 1350–65

(B) Stone statue. West front, Lincoln Cathedral. 1360–80

138

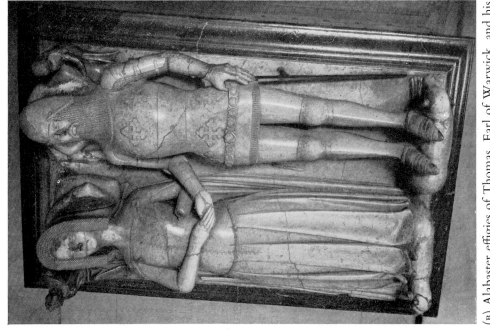

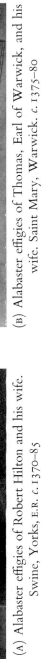

(B) Alabaster effigies of Thomas, Earl of Warwick, and his wife. Saint Mary, Warwick. *c.* 1375–80

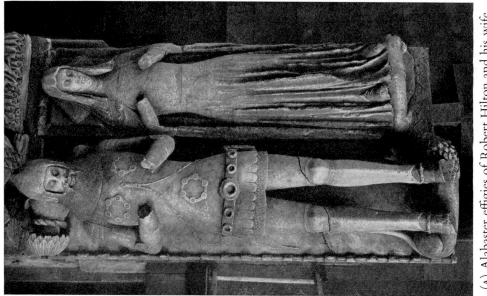

(A) Alabaster effigies of Robert Hilton and his wife. Swine, Yorks, E.R. *c.* 1370–85

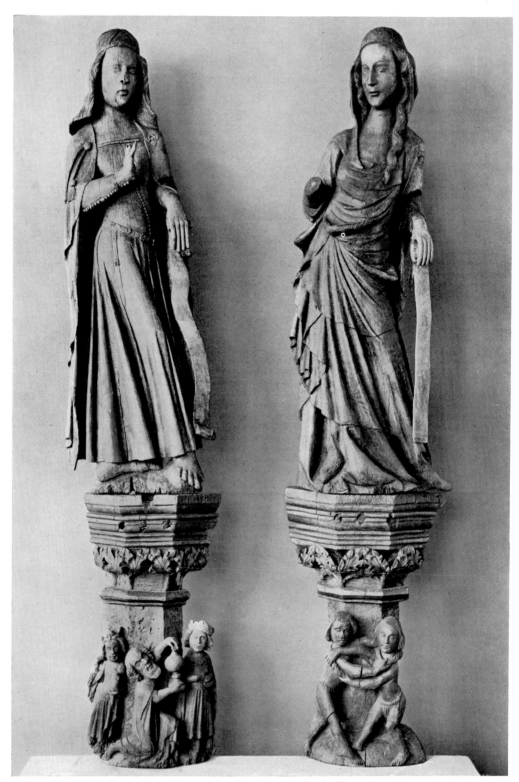

Wooden statues. Height *c.*6 ft. Vicars Hall, Wells, Som. *c.*1350–60

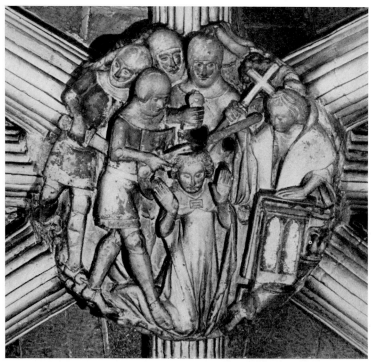

(A) Stone boss. Nave, Exeter Cathedral, Devon. *c.* 1353–60

(B) Ivory fragment. Mid
fourteenth century.*Victoria
and Albert Museum, London*

(C) Stone cornice. Nave, Winchester Cathedral, Hants.
Early fifteenth century

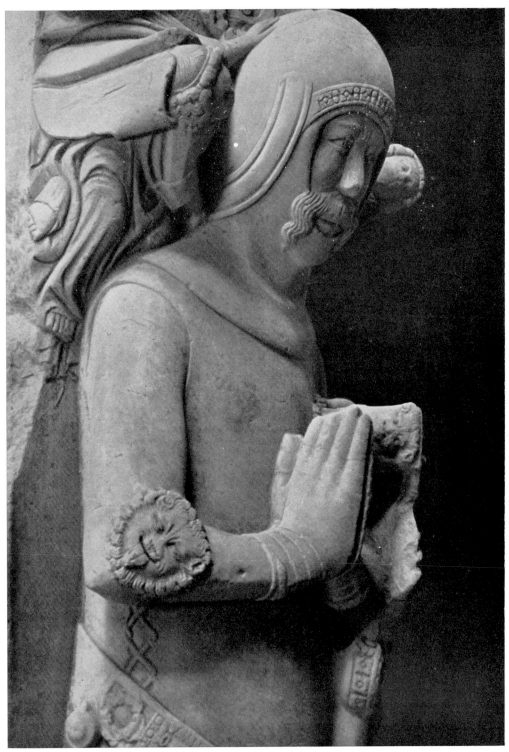

Clunch effigy of Sir John Lyons. Warkworth, Northants. *c.* 1350–60

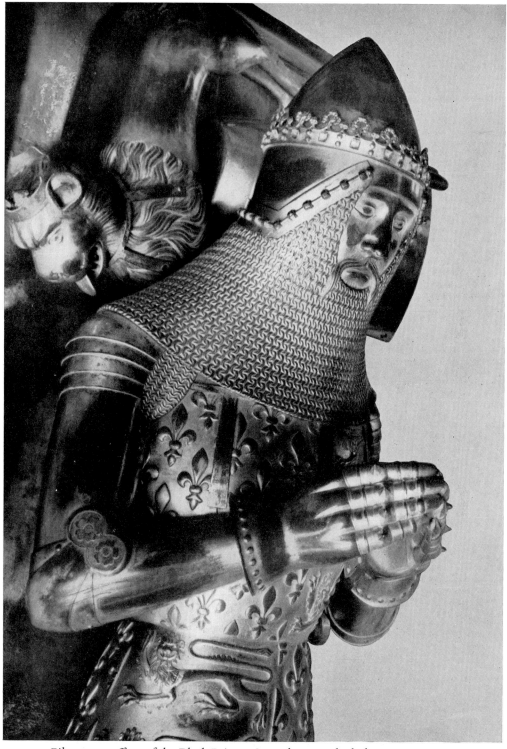

Gilt copper effigy of the Black Prince. Canterbury Cathedral, Kent. *c.* 1377–80

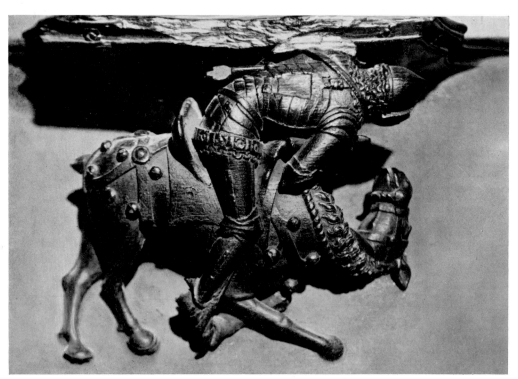

(A) Wooden misericord. Lincoln Cathedral. *c.* 1380

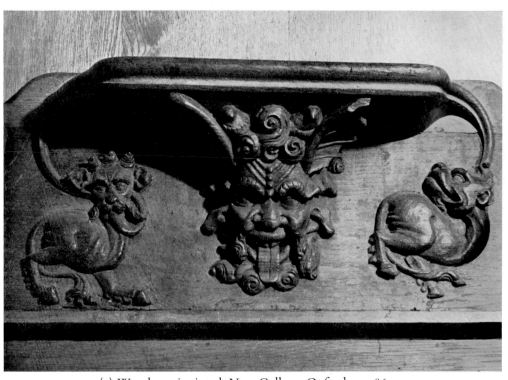

(B) Wooden misericord. New College, Oxford. *c.* 1386–95

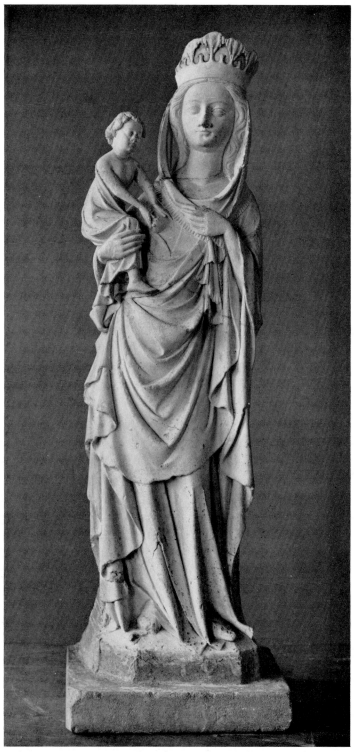

Alabaster statuette. Height 2 ft 8 in. Flawford, Notts. *c.* 1350–70.
Nottingham Castle Museum and Art Gallery

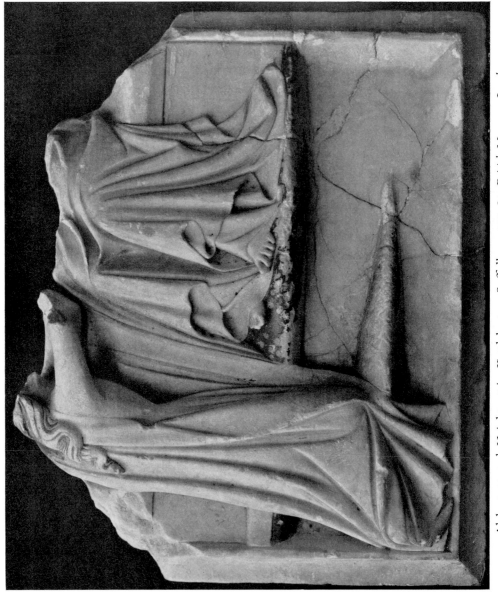

Alabaster panel. Height *c.* 9 in. Kettlebaston, Suffolk. *c.* 1370–80. *British Museum, London*

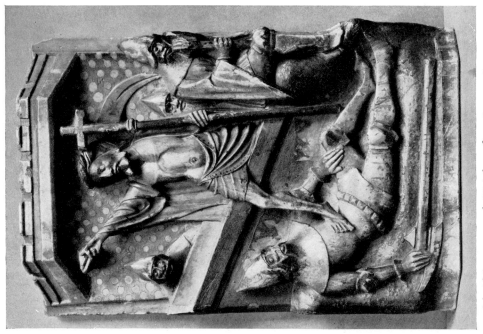

(B) Alabaster panel. Height 1 ft 5½ in. c. 1380–1400.
Victoria and Albert Museum, London

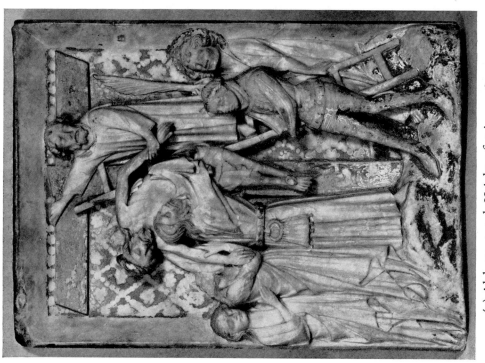

(A) Alabaster panel. Height 1 ft 9 in. c. 1380–5.
Victoria and Albert Museum, London

147

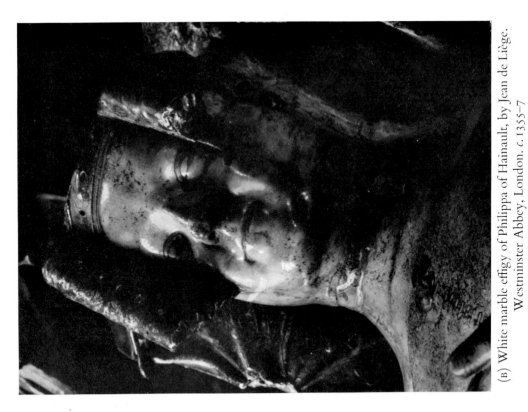

(B) White marble effigy of Philippa of Hainault, by Jean de Liège. Westminster Abbey, London. c. 1355–7

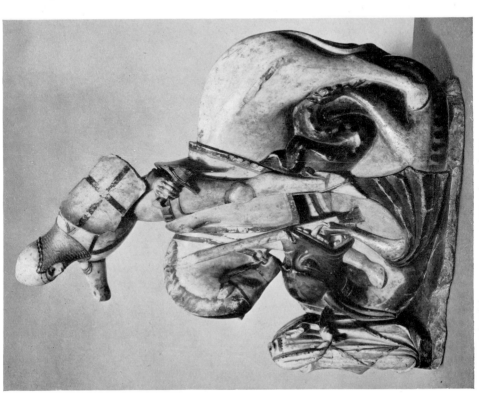

(A) Alabaster statuette. Height 2 ft 8 in. c. 1400–20. National Gallery of Art, Washington, D.C., Samuel H. Kress Collection

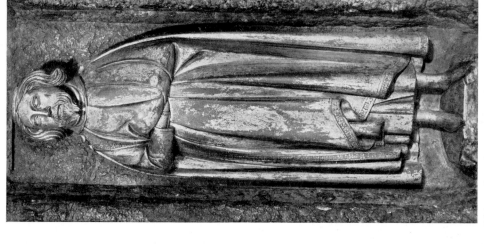

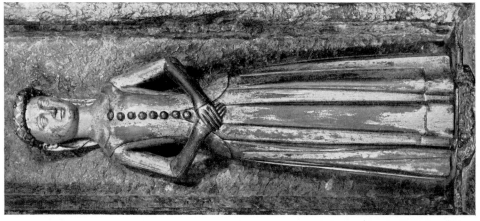

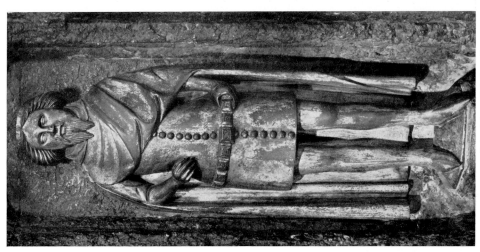

(A), (B) and (C) Gilt copper weepers from the tomb of Edward III. Westminster Abbey, London. *c.* 1377–80.

149

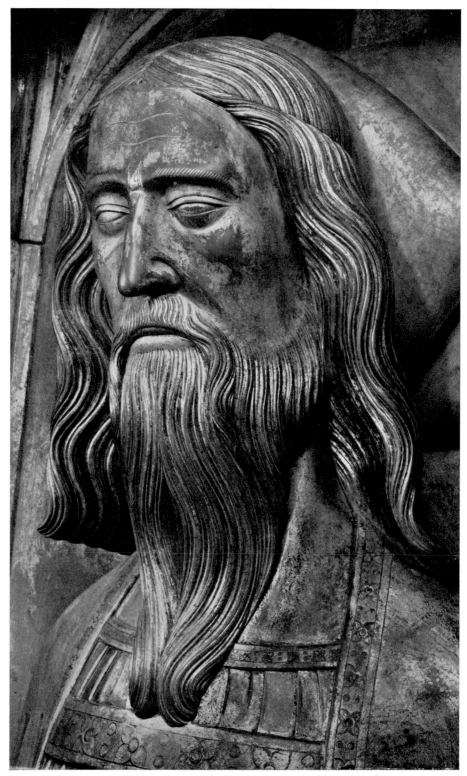

Head of gilt copper effigy of Edward III. Westminster Abbey, London. *c.* 1377–80

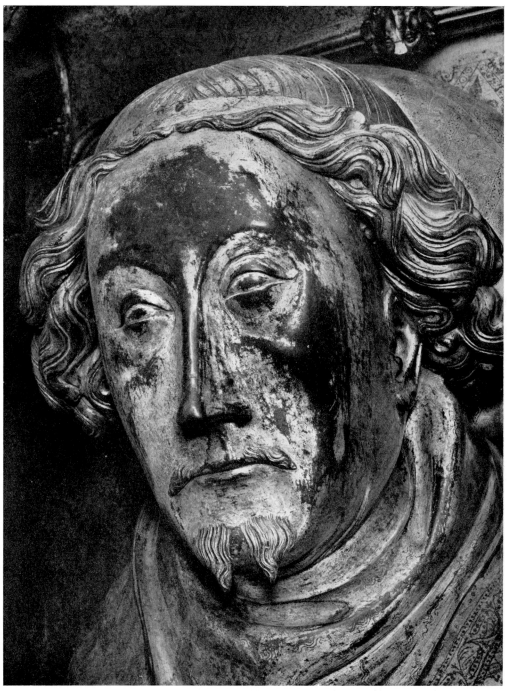

Head of gilt copper effigy of Richard II, by Nicholas Broker and Godfrey Prest.
Westminster Abbey, London. 1394–6

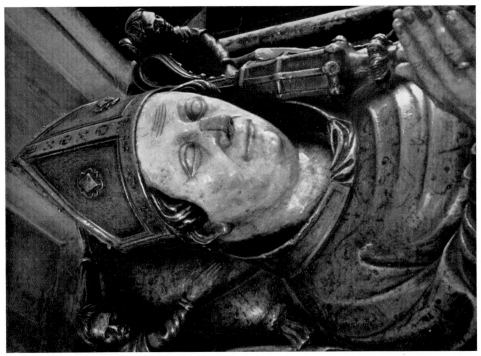

(B) Alabaster effigy of William of Wykeham. Winchester Cathedral, Hants. *c.* 1399–1403

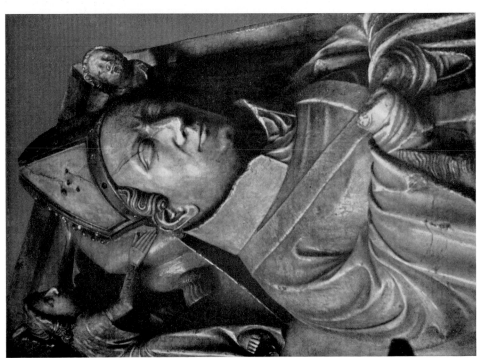

(A) Alabaster effigy of Archbishop Courtenay. Canterbury Cathedral, Kent. *c.* 1397–1400

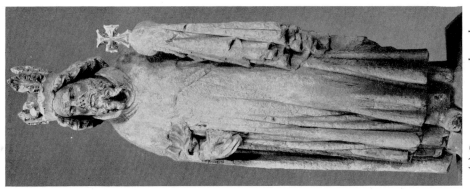

(B) Stone statue, perhaps by Thomas Canon (*ex situ*). Westminster Hall, London. 1385

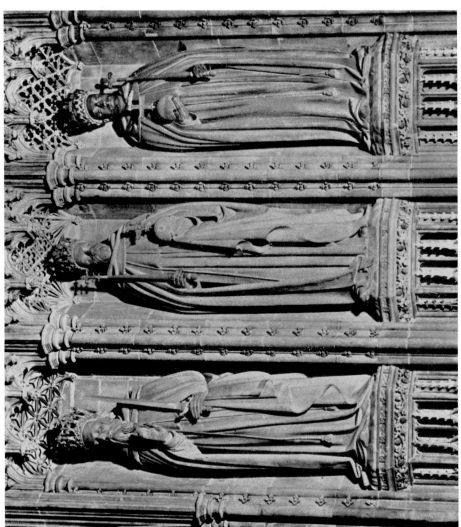

(A) Stone statues. The screen, Canterbury Cathedral, Kent. 1411–30

153

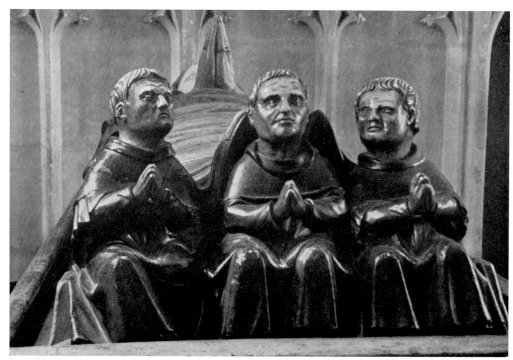

(A) Foot of alabaster effigy of William of Wykeham. Winchester Cathedral, Hants. *c.* 1399–1403

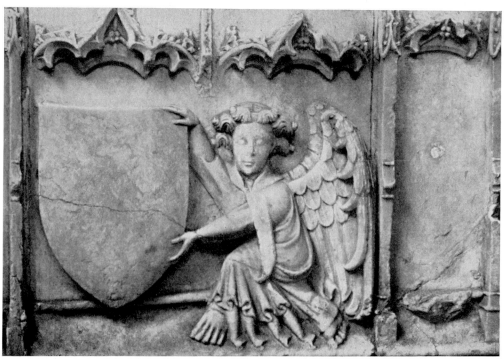

(B) Alabaster panel from the tomb of Sir Richard Redman. Harewood, Yorks, W.R. *c.* 1430

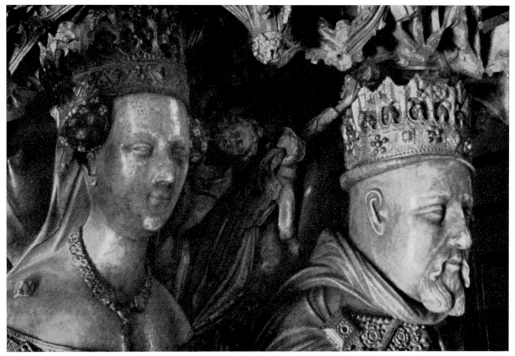

(A) Alabaster effigies of Henry IV and Queen Joan. Canterbury Cathedral, Kent. *c.* 1410–20

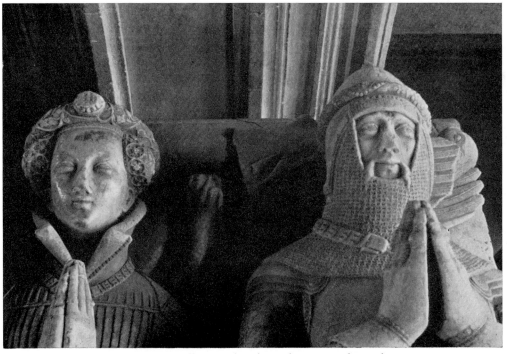

(B) Alabaster effigies of Sir William and Lady Wilcote. North Leigh, Oxon. *c.* 1415–25

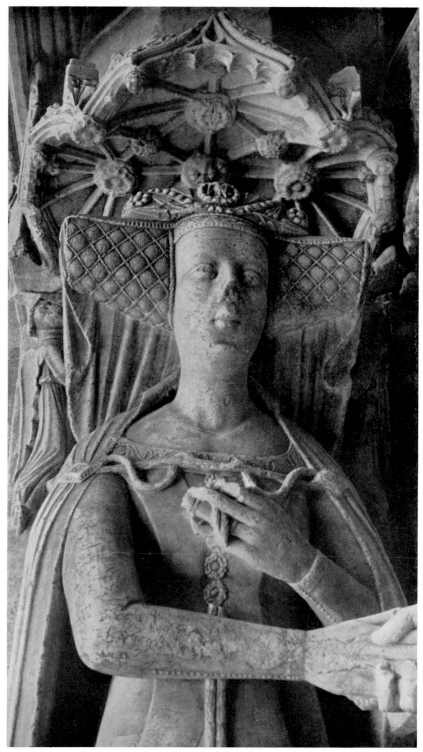

Alabaster effigy of the wife of Ralph Greene, by Thomas Prentys and
Robert Sutton. Lowick, Northants. 1419

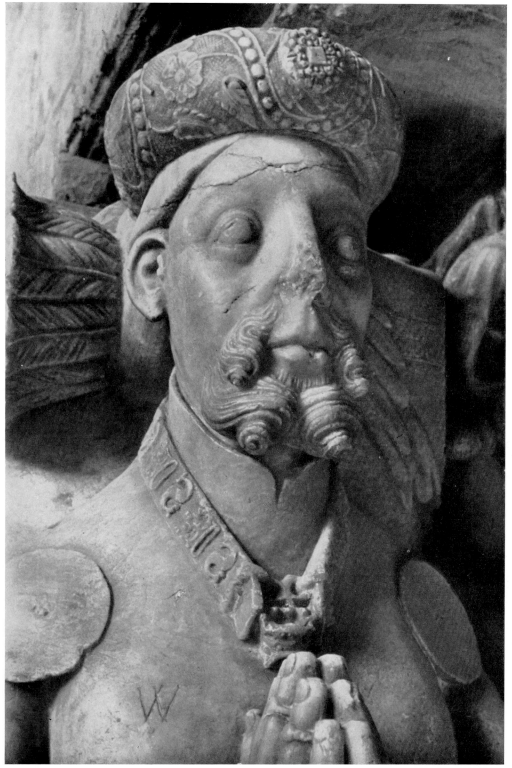

Head of alabaster effigy of Robert Waterton. Methley, Yorks, w.r. *c.* 1425

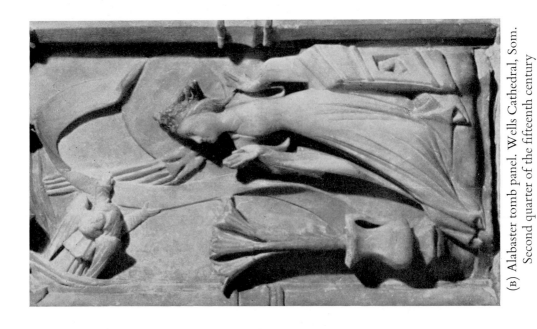

(B) Alabaster tomb panel. Wells Cathedral, Som. Second quarter of the fifteenth century

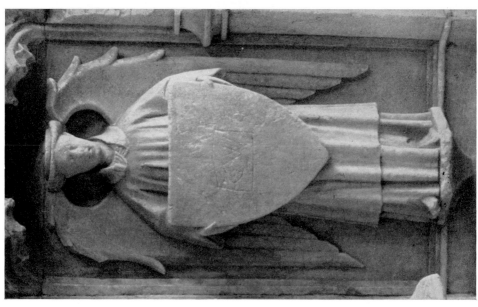

(A) Alabaster panel from the tomb of Robert Greene, by Prentys and Sutton. Lowick, Northants. 1419

158

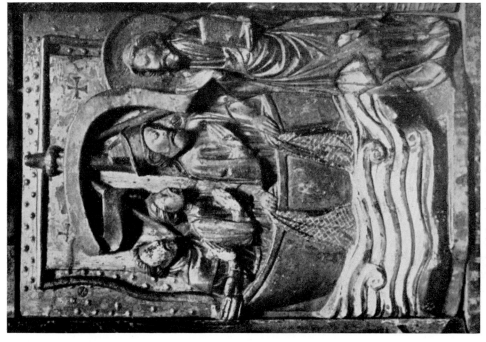

(B) Alabaster panel. Height 1 ft 4¼ in.
Santiago de Compostela, Galicia, Spain. 1455–6

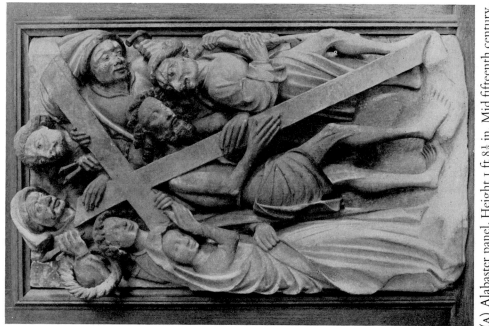

(A) Alabaster panel. Height 1 ft 8½ in. Mid fifteenth century.
Musée Thomas Dobrée, Nantes (Loire-Inférieure)

159

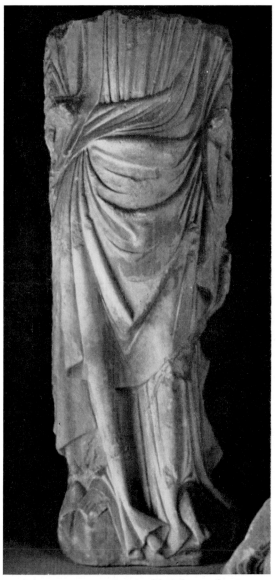

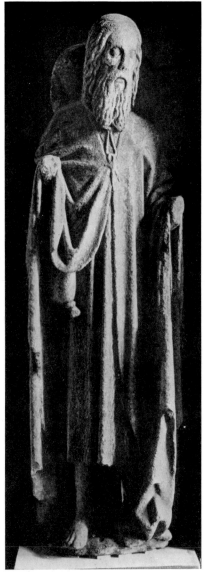

(A) Stone statue. Original height *c.*3 ft 6 in.
Winchester Cathedral, Hants.
Mid fifteenth century

(B) Stone statue from Henry V's
Chantry (*ex situ*). Westminster
Abbey, London. *c.* 1441–50

160

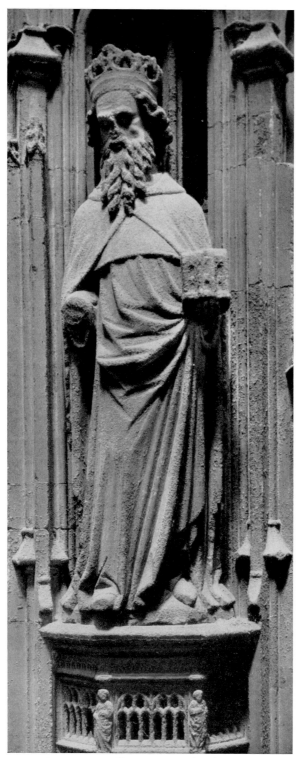

Stone statue from Henry V's Chantry.
Westminster Abbey, London. *c.* 1441–50

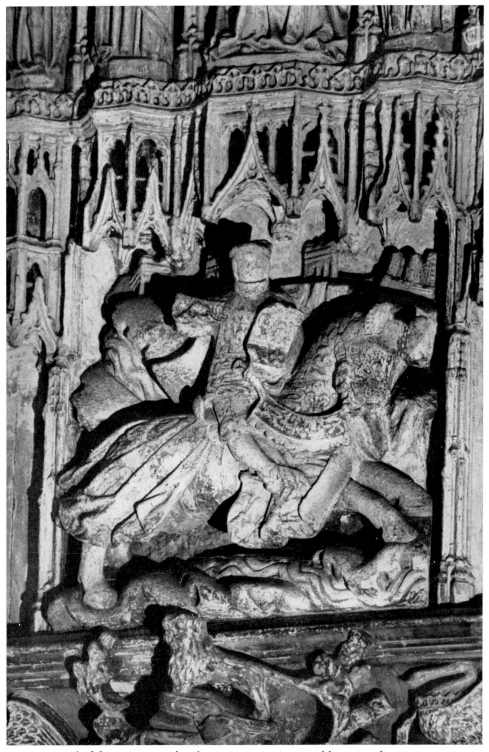

Stone relief from Henry V's Chantry. Westminster Abbey, London. *c.* 1441–50

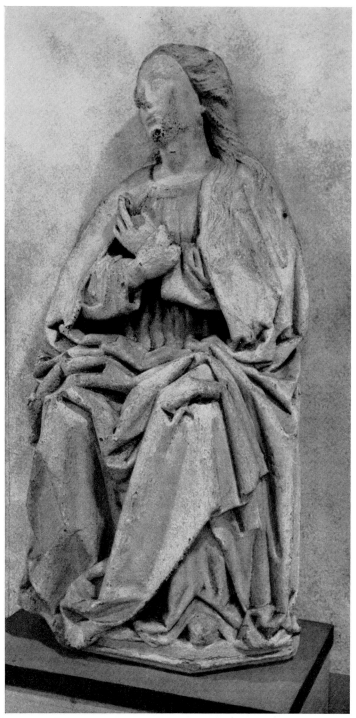

Virgin of the Annunciation, from Henry V's Chantry (*ex situ*)
Westminster Abbey, London. *c.* 1441–50

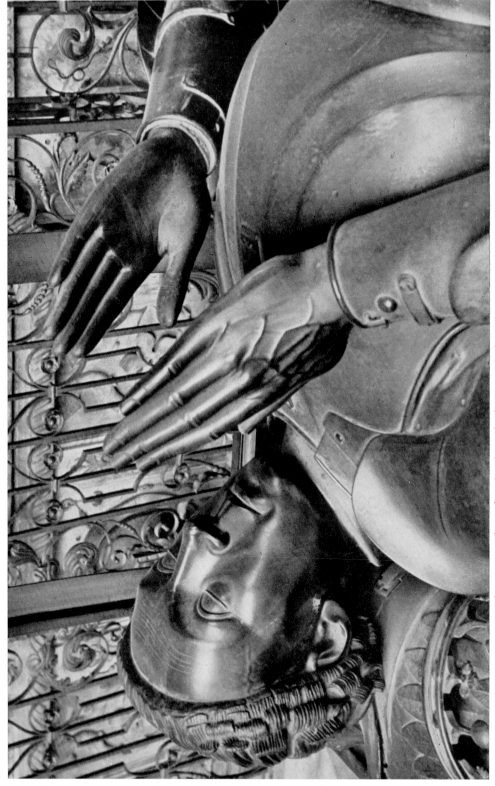

Gilt copper effigy of Richard, Earl of Warwick, by John Massingham and others.
Saint Mary, Warwick. 1449–50

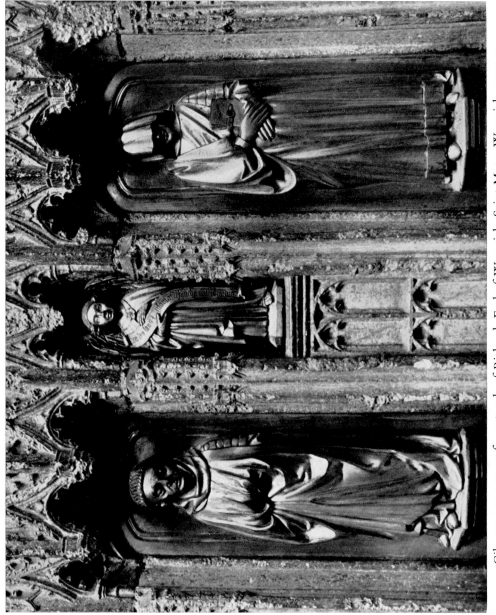

Gilt copper weepers from tomb of Richard, Earl of Warwick. Saint Mary, Warwick. 1452–3

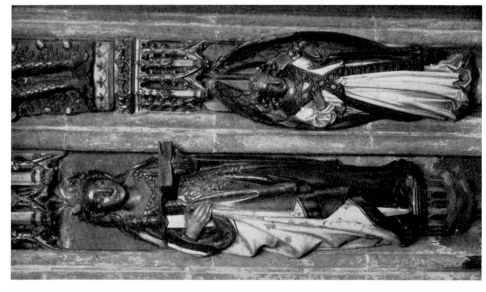

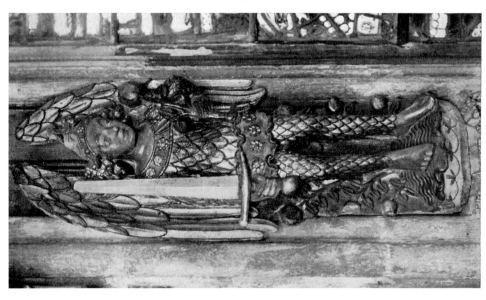

(A) and (B) Stone statues. East window, Beauchamp Chapel, Saint Mary, Warwick. 1443–7

(B) Wooden boss. Presbytery, Winchester Cathedral, Hants. 1503–9

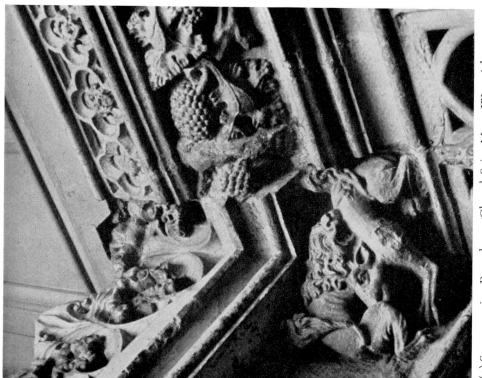

(A) Stone cornice. Beauchamp Chapel, Saint Mary, Warwick. 1443–7

167

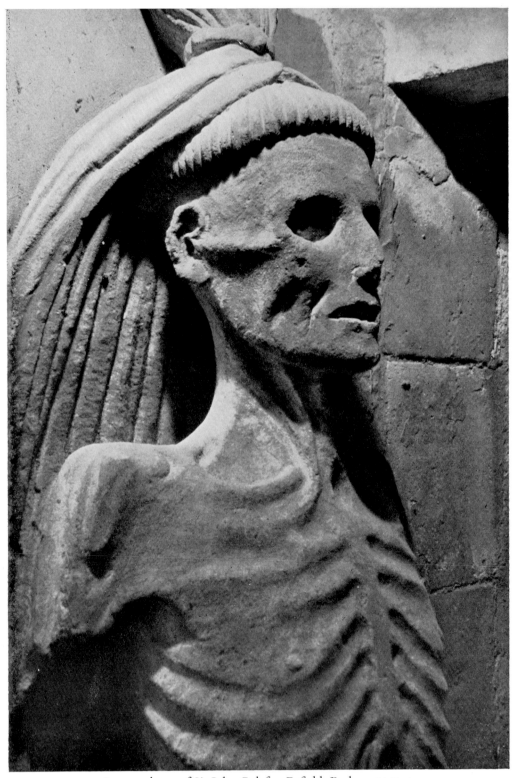

Stone cadaver of Sir John Golafre. Fyfield, Berks. *c.* 1440–5

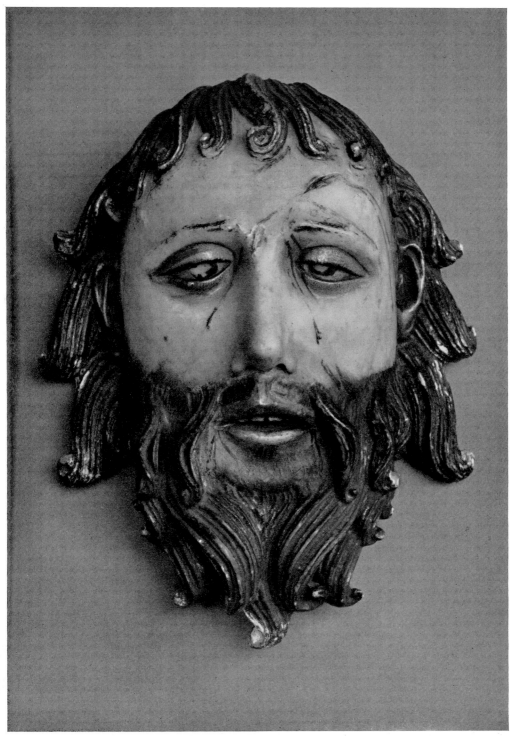

Alabaster Head of Saint John. Height 7¾ in. c. 1440–1540. *Victoria and Albert Museum, London*

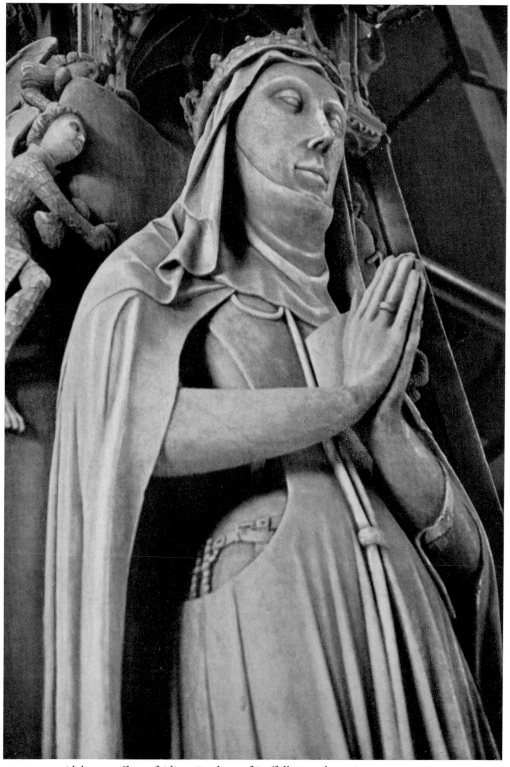

Alabaster effigy of Alice, Duchess of Suffolk. Ewelme, Oxon. *c.* 1470–80

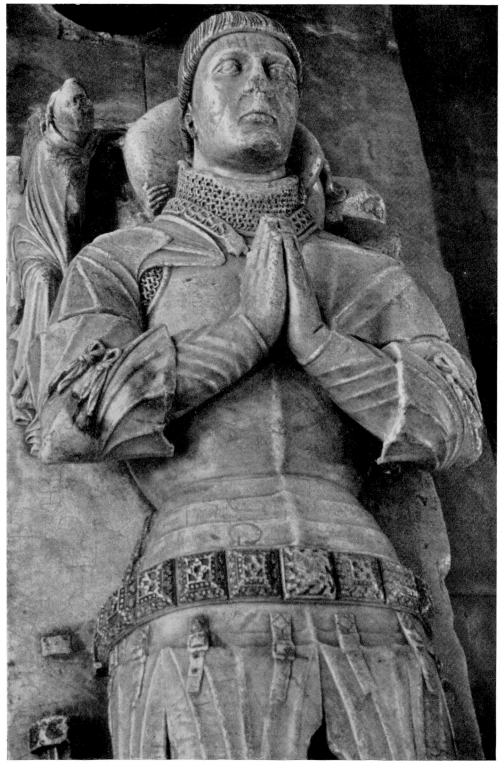

Alabaster effigy of Robert, Lord Hungerford, Salisbury Cathedral, Wilts. *c.* 1460

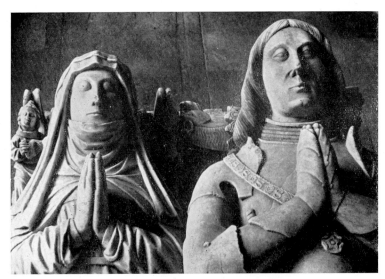

(A) Alabaster effigy of Sir Richard and Lady Redman.
Harewood, Yorks, w.r. *c.* 1490–1500

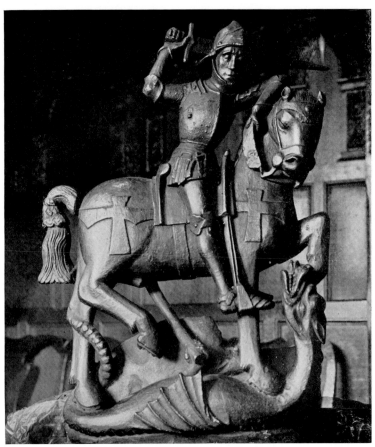

(B) Wooden statuette. Height 2 ft 4½ in. Saint Mary's Hall, Coventry.
*c.*1470–90. *Guildhall, Coventry, War*

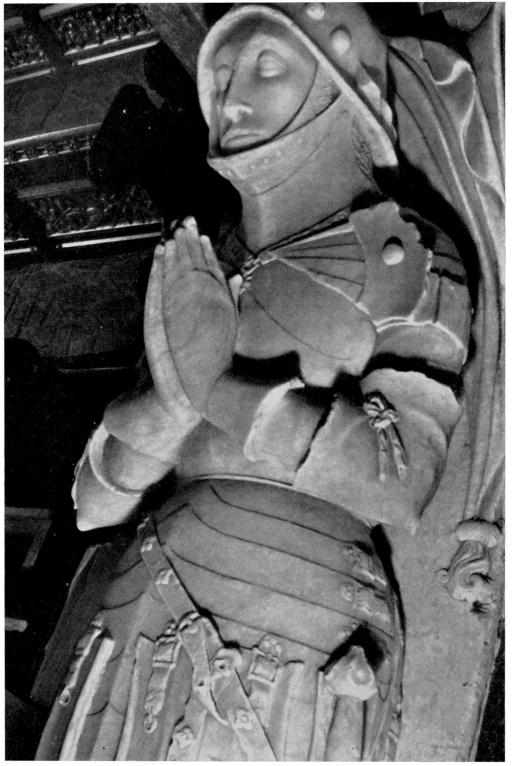

Alabaster effigy of John Brouning. Melbury Sampford, Dorset. 1467

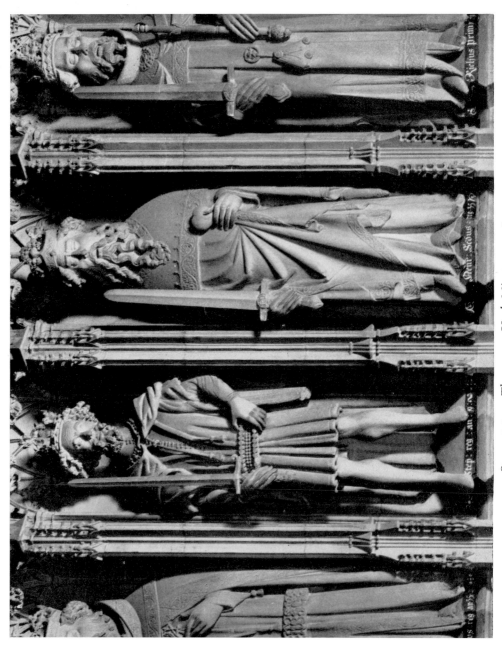

Stone statues. The screen, York Minster. *c.* 1480–1500

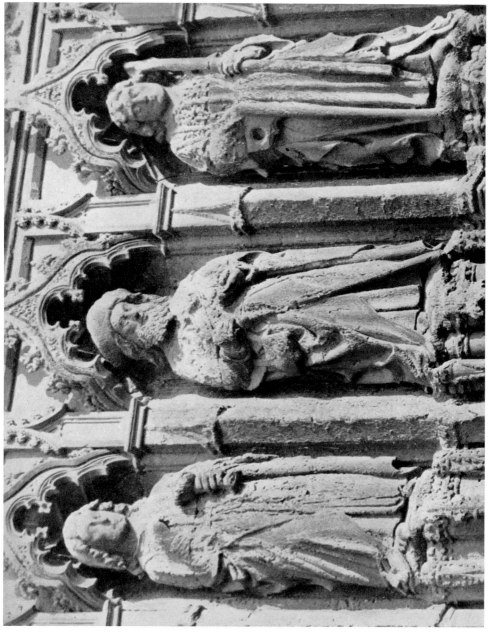

Stone statues. West front, Exeter Cathedral. Last quarter of the fifteenth century

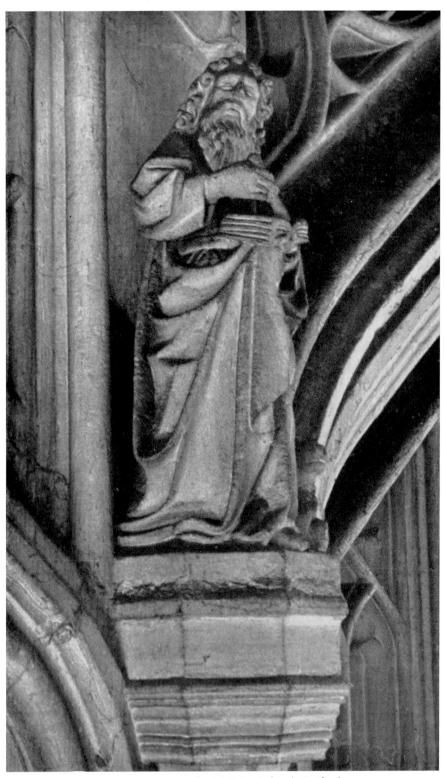

Stone statue. Screenwork, Divinity School, Oxford. 1481

176

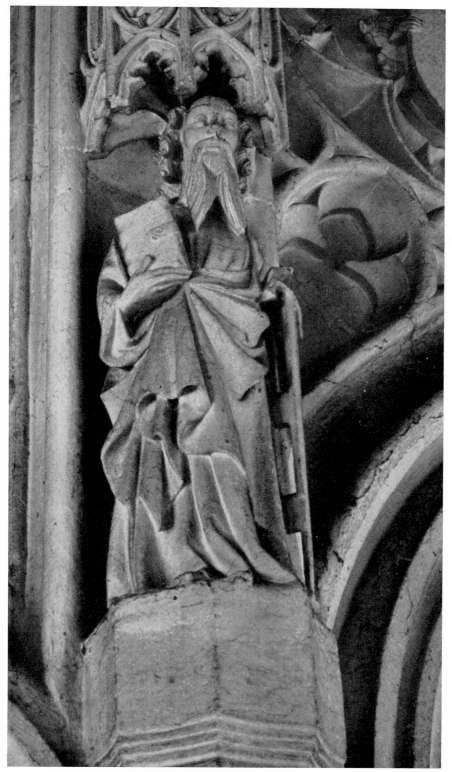

Stone statue. Screenwork, Divinity School, Oxford. 1481

177

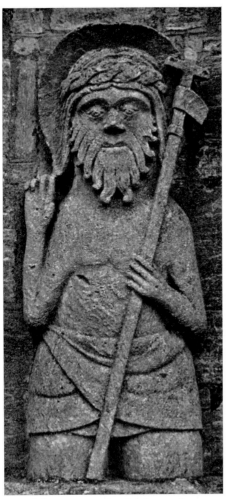

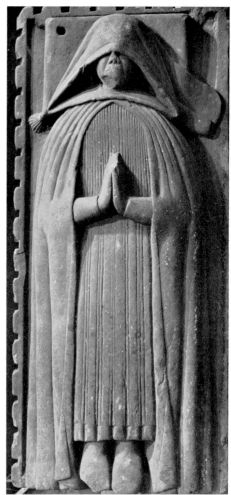

(A) Stone statue. Height *c*. 4 ft.
Exterior of tower, Fairford, Glos.
Late fifteenth century

(B) Stone effigy of Prior Leschman.
Hexham, Northumberland.
c. 1491

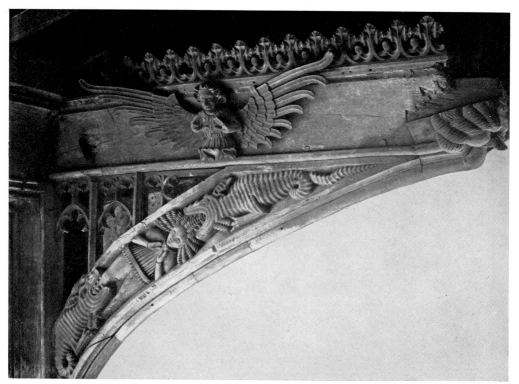

(A) Wooden roof. Upwell, Norfolk. Late fifteenth century

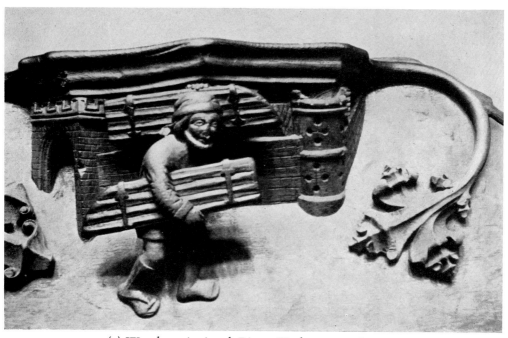

(B) Wooden misericord. Ripon, Yorks, W.R. 1489–94

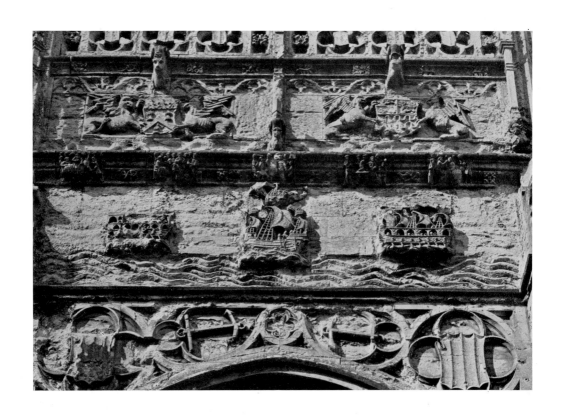

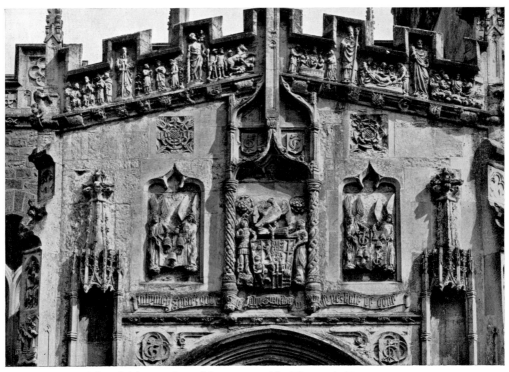

(A) and (B) Exterior of Greneway aisle. Tiverton, Devon. *c.* 1517

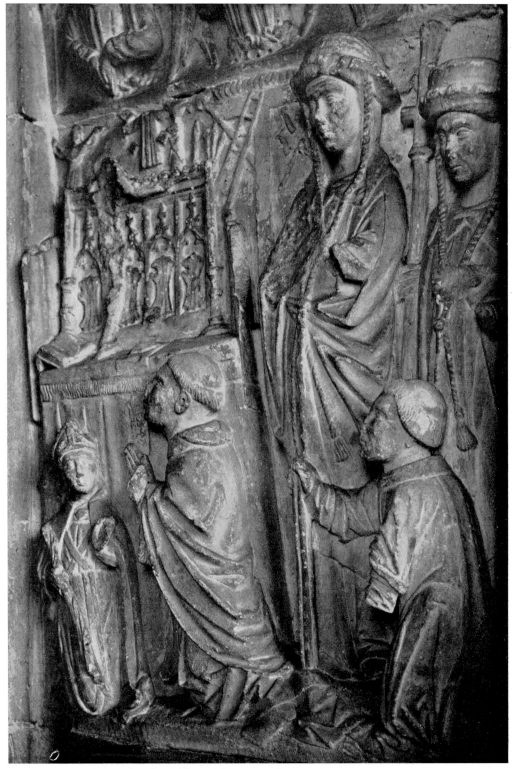

Stone panel. Kirkham Chantry, Paignton, Devon. *c.* 1490–1500

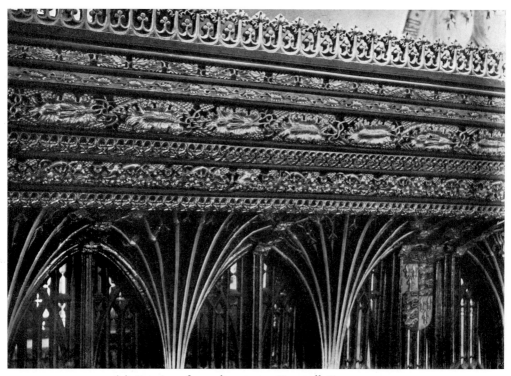

(A) Cornice of wooden screen. Banwell, Som. 1521–2

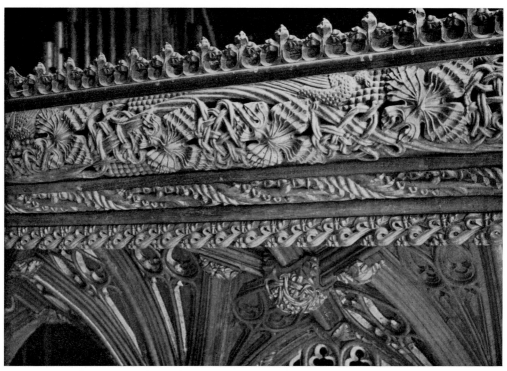

(B) Cornice of wooden screen. Berry Pomeroy, Devon. *c.*1480–1500

182

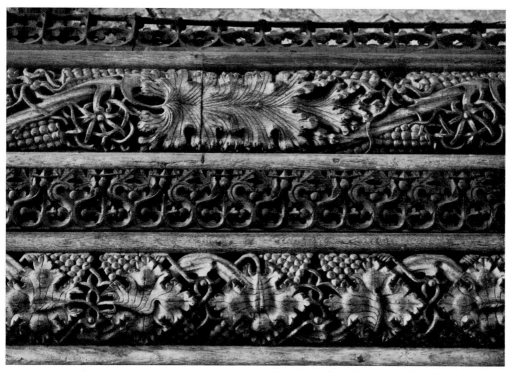

(A) Cornice of wooden screen, by Roger Down and John Hyll. Atherington, Devon. *c.* 1538–42

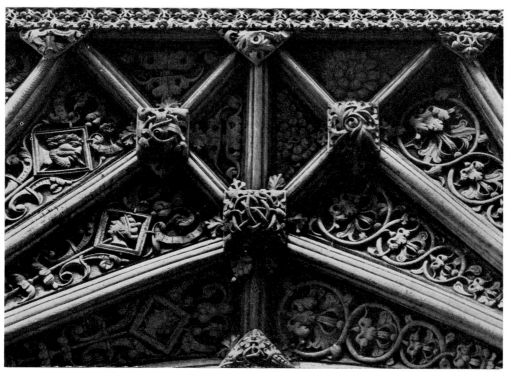

(B) Coving of wooden screen. Lapford, Devon. *c.* 1535–47

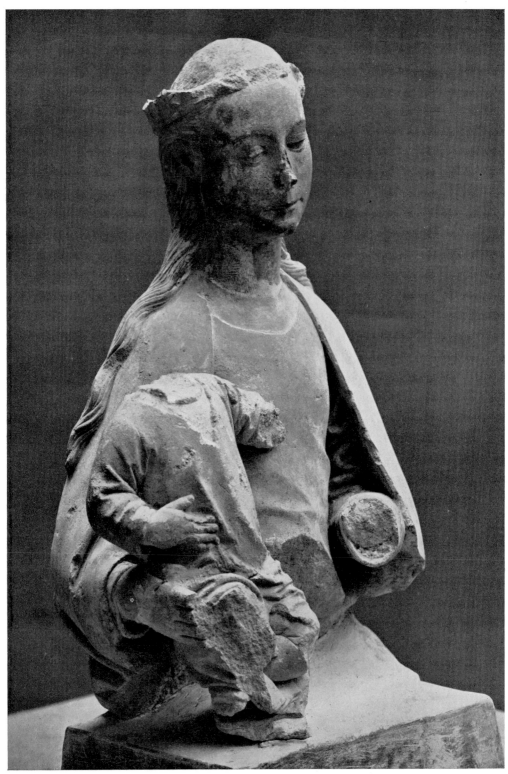

Stone statue. Height *c.* 1 ft 6 in. Winchester Cathedral, Hants. *c.* 1470–90

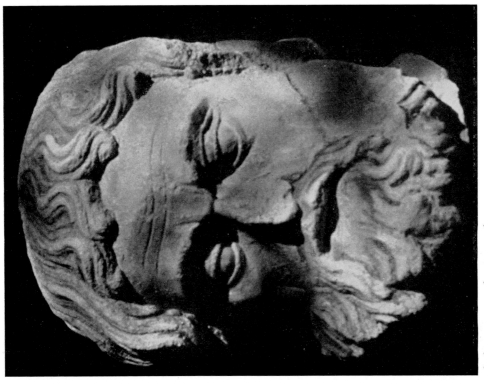

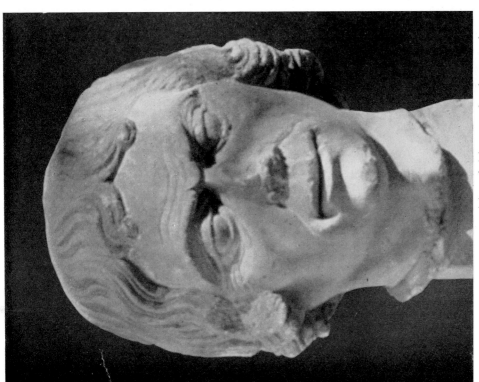

(A) and (B) Stone heads. Winchester Cathedral, Hants. Early sixteenth century

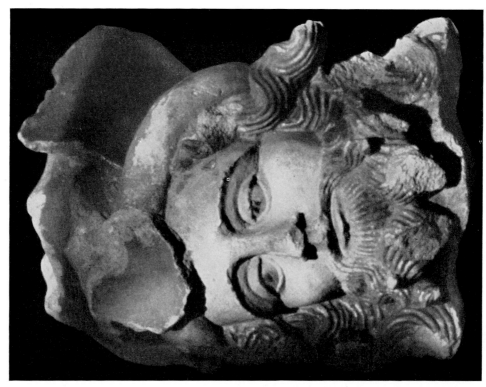

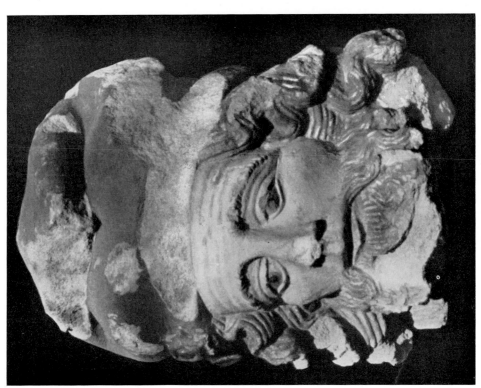

(A) and (B) Heads from stone reredos, Saint Cuthbert, Wells, Som. Early sixteenth century

186

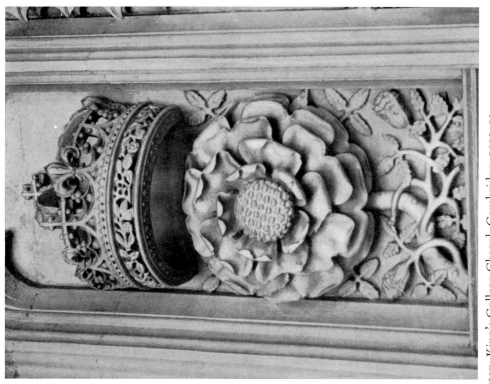

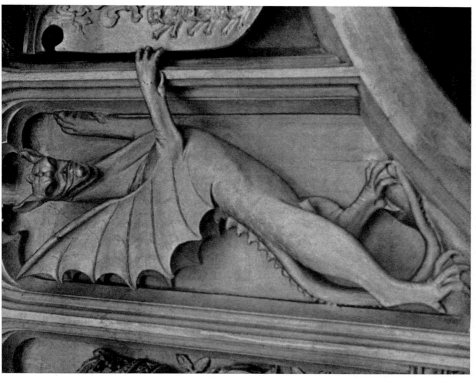

(A) and (B) Heraldic details in stone, by Thomas Stockton. King's College Chapel, Cambridge. 1512–13

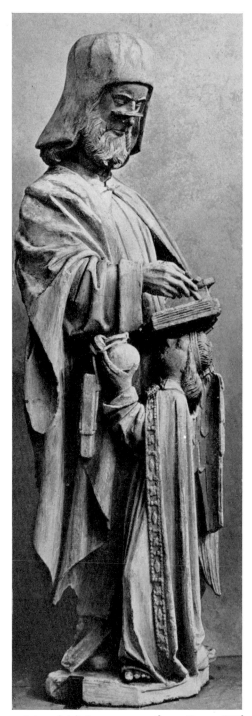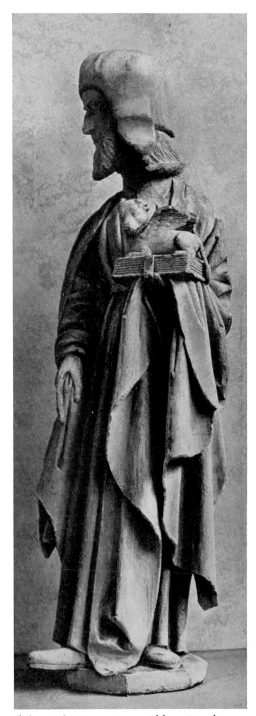

(A) and (B) Stone statues from Henry VII's Chapel (*ex situ*). Westminster Abbey, London. *c.* 1505–15

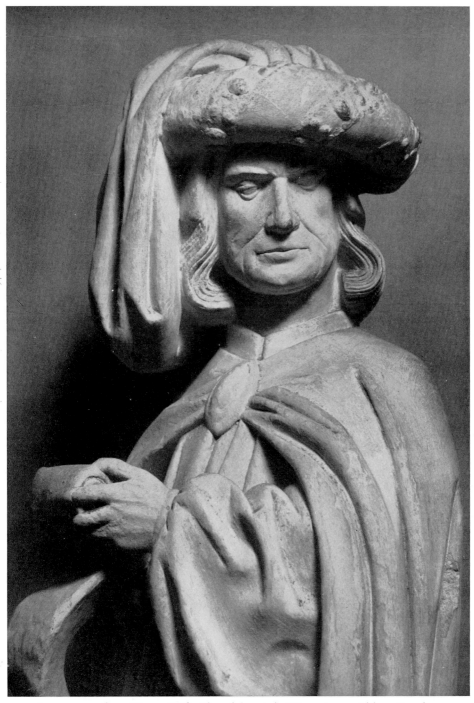

Stone statue from Henry VII's Chapel (*ex situ*). Westminster Abbey, London.
c. 1505–15

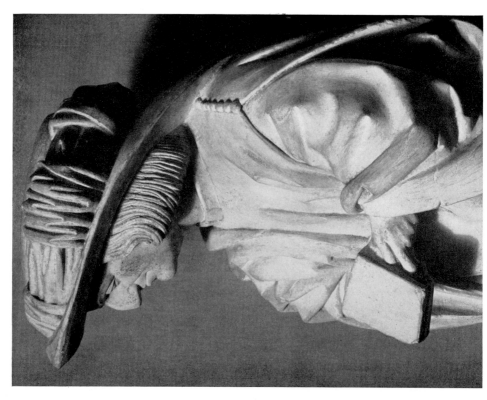

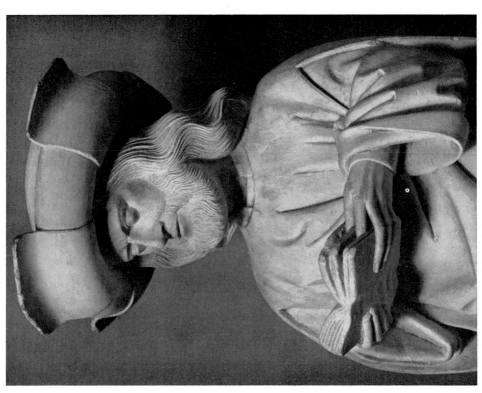

(A) and (B) Stone statues from Henry VII's Chapel (*ex situ*). Westminster Abbey, London. *c*.1505–15

190

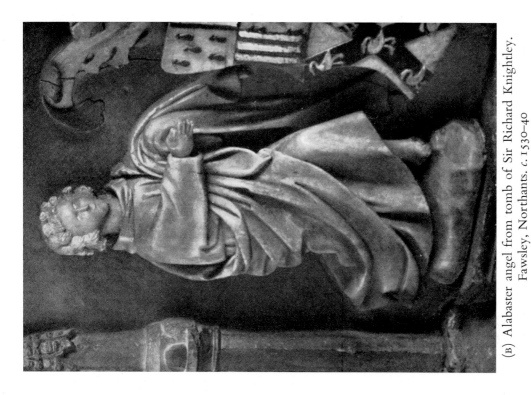

(A) Alabaster effigy of Sir Richard Knightley.
Fawsley, Northants. c. 1530-40

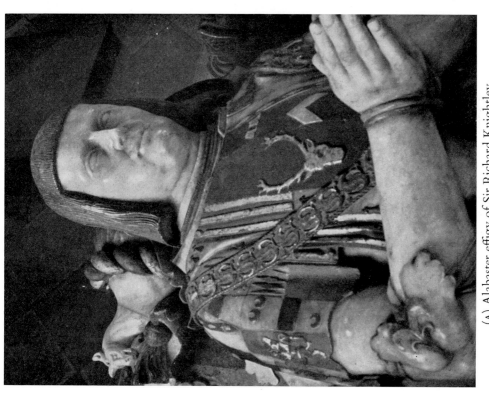

(B) Alabaster angel from tomb of Sir Richard Knightley.
Fawsley, Northants. c. 1530-40

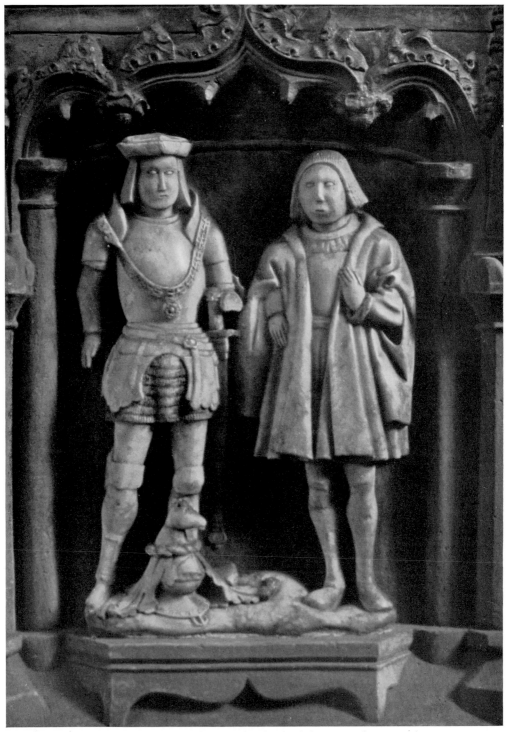

Alabaster weepers from the tomb of Sir Richard Knightley. Fawsley, Northants. *c.* 1530–40

INDEX

Numbers in *italics* refer to plates. Where several page references are given under a single entry, that in **heavy type** is the principal. References to the Notes are given only where they indicate matters of special interest or importance: such references are given to the page on which the note occurs, followed by the number of the chapter to which it belongs, and the number of the note. Thus 246(7)[15] indicates page 246, chapter 7, note 15.

B

VOLUMES OF THE PELICAN HISTORY OF ART
ALREADY PUBLISHED

★

MARGARET RICKERT
Painting in Britain: The Middle Ages

ELLIS K. WATERHOUSE
Painting in Britain: 1530 to 1790

JOHN SUMMERSON
Architecture in Britain: 1530 to 1830

ANTHONY BLUNT
Art and Architecture in France: 1500 to 1700

BENJAMIN ROWLAND
The Art and Architecture of India

GEORGE HEARD HAMILTON
The Art and Architecture of Russia

HENRI FRANKFORT
The Art and Architecture of the Ancient Orient

★